THE ARCHITECTURE OF MEDIEVAL BRITAIN

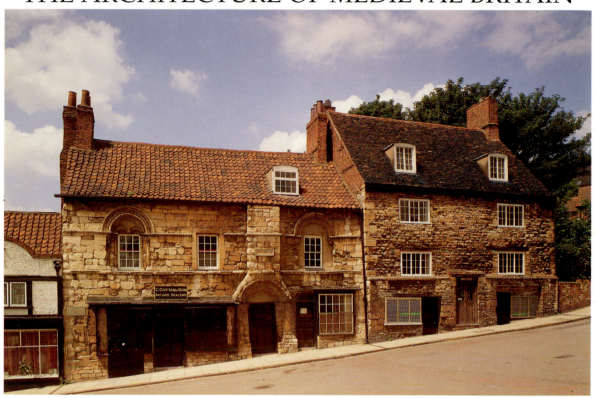

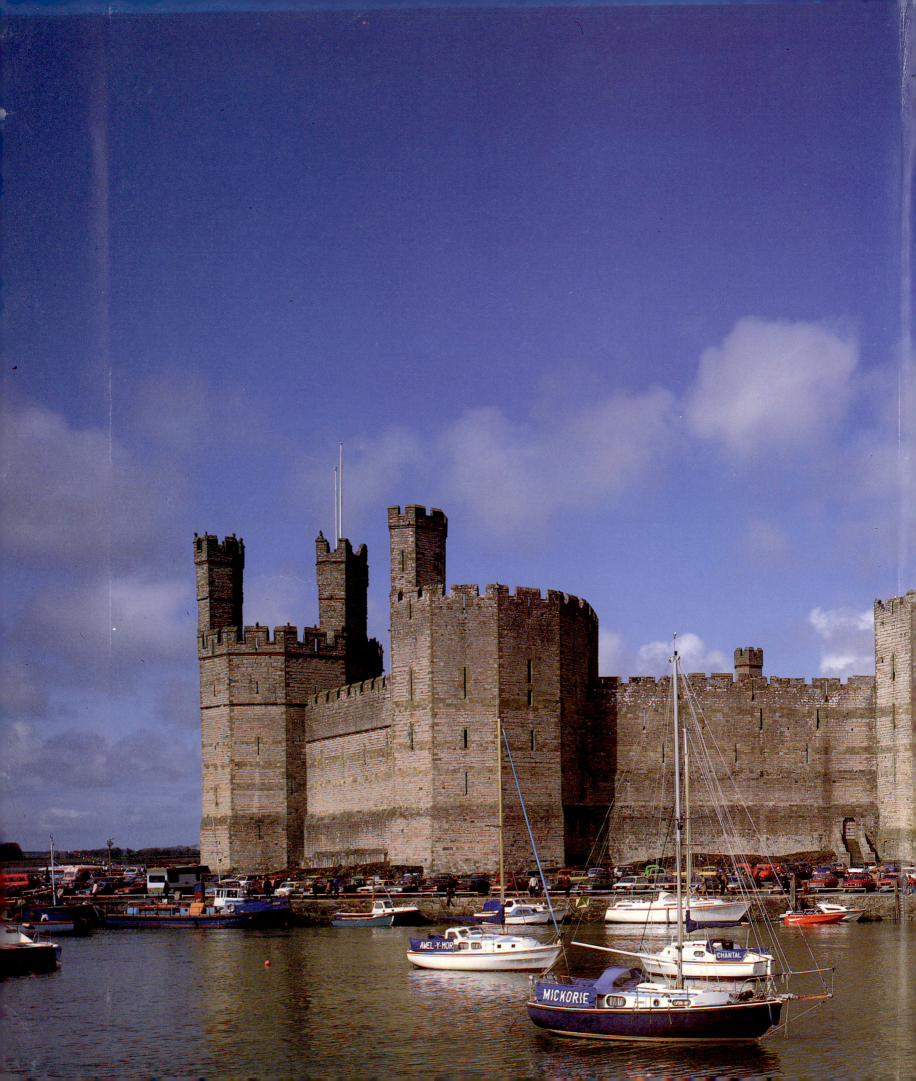

THE ARCHITECTURE
OF
MEDIEVAL BRITAIN

A Social History

COLIN PLATT

Photographs by
ANTHONY KERSTING

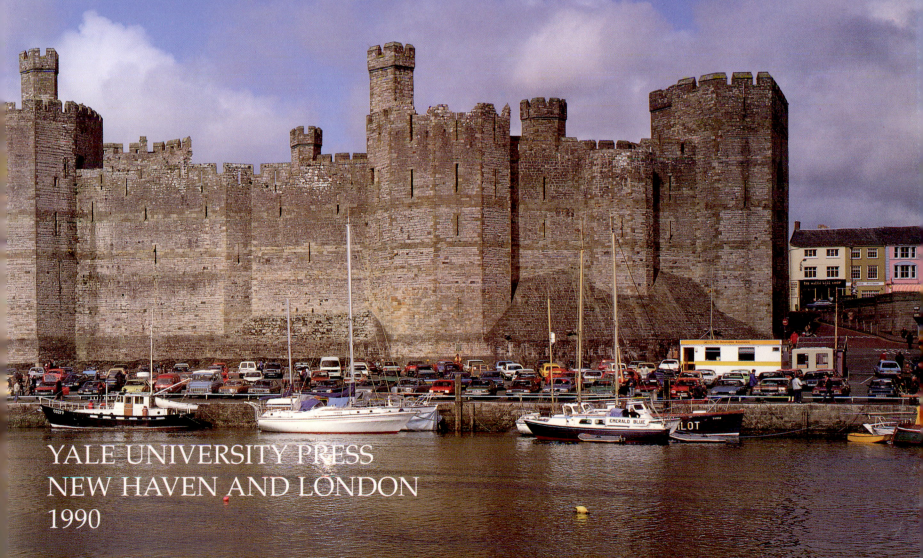

YALE UNIVERSITY PRESS
NEW HAVEN AND LONDON
1990

Copyright © 1990 by Yale University

Designed by John Nicoll
Set in Linotron Palatino by Excel Typesetters Company Ltd, Hong Kong
Printed in Hong Kong by Kwong Fat Offset Printing Co. Ltd

Library of Congress Cataloging-in-Publication Data

Platt, Colin.
 The architecture of madieval Britain: a social history/Colin
Platt.
 p. cm.
 ISBN 0-300-04953-6
 1. Architecture, Medieval – Great Britain. 2. Architecture – Great
Britain. I. Title.
NA963.P53 1991
720'.941'0902 – dc20 90-40029
 CIP

1. (half title page) 'The Jew's House', Lincoln: good-quality merchant housing of the late twelfth century, with comfortable living-quarters on the first floor, above the shop.
2. (title page) Caernarvon Castle, begun in 1283, was the showpiece fortress of Edward I's conquest and settlement of North Wales.

In memory of Christopher, my twin

> The good die first,
> And they whose hearts are dry as summer dust
> Burn to the socket.
>
> (William Wordsworth)

I would like to thank the many incumbents and owners who have allowed me to take new photographs for this book. I am especially grateful for the help given me by English Heritage, and by the Hon. Mrs. Gascoigne in allowing me to photograph at Stanton Harcourt.

Anthony Kersting

Contents

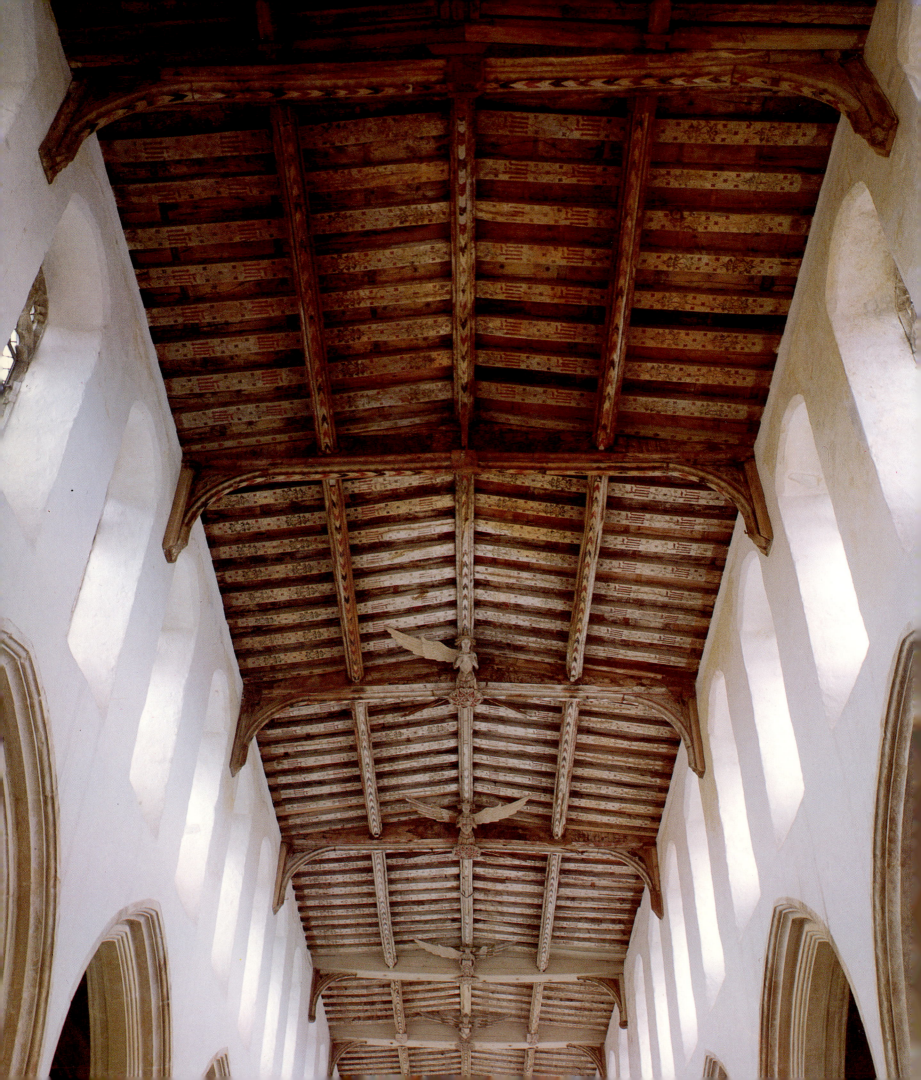

Preface

Francis Bacon – 'the wisest, brightest, meanest of mankind' – has this to say about the use of surplus wealth. 'Of great riches', he concludes, 'there is no real use, except it be in the distribution; the rest is but conceit. . . . Riches are for spending; and spending for honour and good actions.' Bacon's *Essays* were published in 1597. But his ideas had a much longer history. High in the list of chivalric virtues was the practice of 'great giving', or *largesse*. First promoted by twelfth-century troubadours, it was taken up by popular chivalric treatise-writers like Ramon Lull (d.1316), and became the necessary accompaniment of noble life-styles. 'Spend and God shall send', promises one fourteenth-century proverb; 'God loves a glad giver', advises another. At no period of history, from that day to this, has conspicuous waste had so many eager advocates or ready practisers.

This book is not just about 'dispendiousness'. Another of its themes is the growing demand for personal privacy; a third is improvements in domestic comfort. Life-styles are my subject, and buildings are my 'documents'. I shall show them to have been among the most sensitive and reliable of social indicators, as dear to the hearts of successful men as Freud's 'honour, power, riches, and the love of women', and as responsive to perceived needs and fashions. Antiquities – what Bacon dismissed as the 'remnants of history which have casually escaped the shipwreck of time' – are the honest face of the past. There has been no deliberate dissembling in chance survivals of this kind; no subsequent 'weeding' of the evidence has taken place. Ruins, unlike most archives, are naked truth.

'I do love these ancient ruins', says Webster's Antonio. And it is a passion which many of us share. There is hardly a building mentioned in this book which I have neglected to visit and record. However, what interests me chiefly is not architectural description, but the context and meaning of medieval buildings. I shall leave description, for the most part, to Tony Kersting's fine photographs, to the specialized monographs cited in my notes, and to Nikolaus Pevsner's indispensable county guides. My archive is the surviving building stock of medieval Britain, and I recommend it to my fellow historians. But I write about people, not things.

It goes without saying that the photographs in this book are not here just for decoration. Traditionally, academic history has been written without illustrations, or with very few. And it is not uncommon, even today, for professional historians to remain prejudiced against them. But in working with buildings, words are no substitute for images. Architects and archaeologists have always known this. Historians are beginning to learn the same. My training – separately – was in history and archaeology. And, since that time, I have written at the divide between those disciplines. Now, in partnership with a great photographer, I put my case for a genuine union of the two.

What I owe to others, both historians and archaeologists, will be obvious in the notes to my text; I could not have written without them. I have been fortunate, too, in an enlightened and creative publisher at Yale. However, my particular obligation today is to the University of Southampton – and especially to my colleagues, past and present, in the History Department here – for the freedom to walk by myself. I redeem that debt most gratefully with this book.

Southampton 1990

3. A tall clerestory and new nave roof at Blythburgh Church, in Suffolk, were the final stages of the general rebuilding of the second half of the fifteenth century.

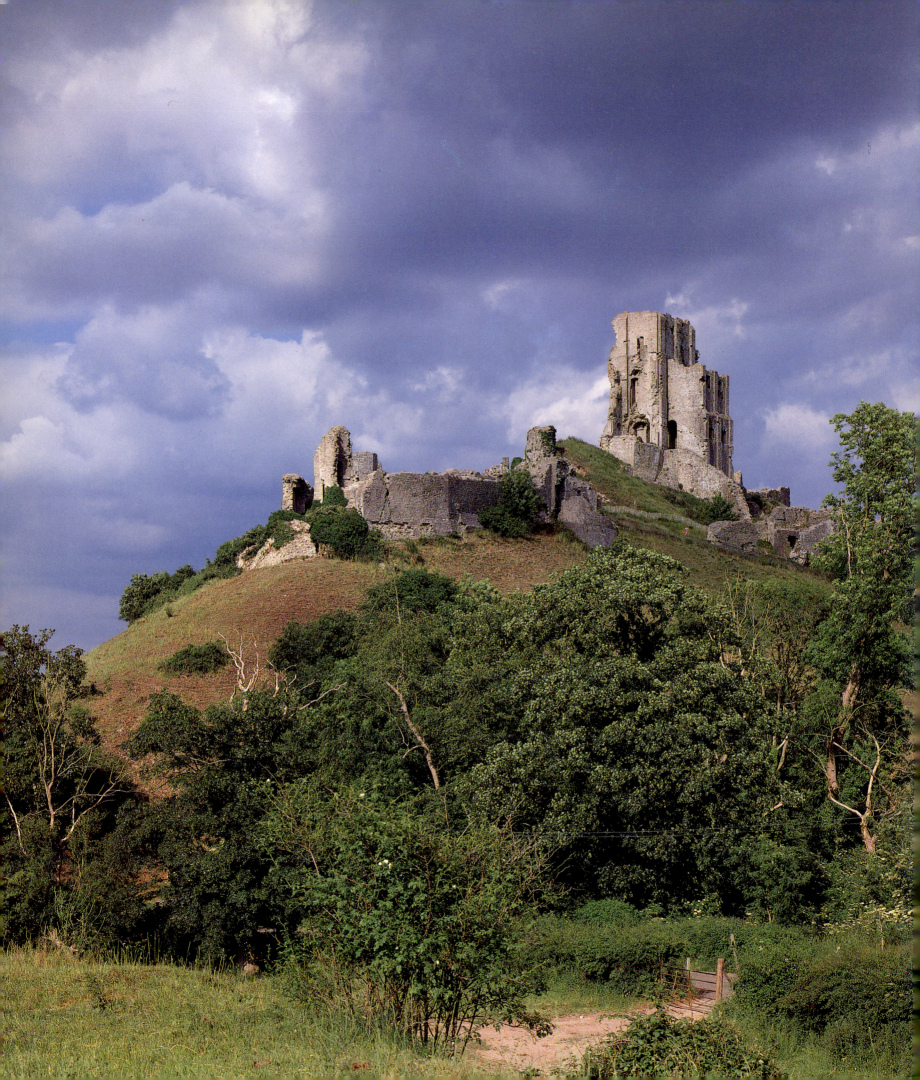

CHAPTER 1
Conquest and Aftermath

No conquest is free of catastrophe. Duke William came and took what he wanted. And of course there were those who got hurt. But obvious though that is, revisionist historians today dwell less on the changes imposed by the Normans than on what they were content to leave alone. That is not the way it looks in the building record.

Consider the case of St Augustine's Abbey, Canterbury, where the original conversion of the Anglo-Saxons had begun. To this holiest of native shrines, Abbot Scotland came in 1070 as the first Norman holder of his office. It was Scotland who started the rebuilding of the abbey church 'on nobler foundations' than before. Scotland completed a grand new presbytery over a fine crypt, and was also the builder of 'ample' transepts. But he found himself blocked at St Augustine's nave by an existing chapel, the burial-place of the missionary archbishop. In the monk Goscelin's words, 'What then can Abbot Scotland, the devout author of the work, do? He neither dares to move these holy shrines untouched for so great an age nor can the work begun proceed unless the obstacles are removed.' Scotland died before he could resolve the dilemma. His successor, Abbot Wido, was less scrupulous. Although instructed by the king to translate the relics of the saints with due ceremony,

> when he had carried up the tower with its lofty summit above the aforesaid transepts, [Wido] is on fire to continue the construction of the rest of the nave, and impatient of the delay in bringing forth the saints, with a heavy battering ram overthrows that sleeping chamber of the blessed ones and overwhelms so many princes of the heavenly kingdom, resting in their unbroken peace, the hastiness of his good intention being his only excuse for his carelessness.[1]

The story of St Augustine's, although more detailed than most, has nothing else about it to surprise us. Abbot Scotland's rebuilding 'on nobler foundations' was the shared ambition of every Norman incumbent, freshly appointed to an English abbacy or see. Even the venerable Bishop Wulfstan of Worcester, one of the very few Anglo-Saxons to survive William's reign in high office, became infected by this zeal for wholesale reconstruction, while admitting the folly of his ways: 'Wretches that we are, we destroy the work of saints because we think in our pride that we can do better.'[2] Inevitably, too, there were Norman prelates at least as insensitive as Wido. Paul of St Albans, himself a great builder and sweeper away of antique shrines, dismissed his predecessors, publicly and with contempt, as *rudes et idiotas*.[3] Paul's contemporary, Thurstan of Glastonbury, another former monk of Caen, 'became beside himself with rage' when unable to bend the community to his will. He called in his soldiers and hunted the monks through their own church. At the instance of the king, Thurstan had to be returned 'ingloriously to the monastery in Normandy whence he had come.'[4]

The massacre at Glastonbury followed Thurstan's over-hasty action in removing 'many ancient and favoured customs from the convent', changing 'certain practices according to the custom of his own country'. And it was these imported rules and rituals, largely based on the customs of the Norman abbey of Bec and published in Archbishop Lanfranc's *Decreta*, which provided another powerful drive towards rebuilding. Thus new and bigger churches were not just the reflection of Norman monumental ambitions. They proceeded from a home-

4. Corfe Castle, in the Purbeck Hills above Swanage, is an example of Norman exploitation of strong natural defences in castle-building soon after the Conquest.

5. The south transept of Paul of Caen's abbey church at St Albans, begun soon after 1077. While the huge scale of the work is Norman, there are still many indications of Anglo-Saxon craftsmanship, including the use of Roman brick in the triforium.

6. As at St Albans, the transepts at Winchester preserve the earliest post-Conquest work, built for Bishop Walkelin in the 1080s.

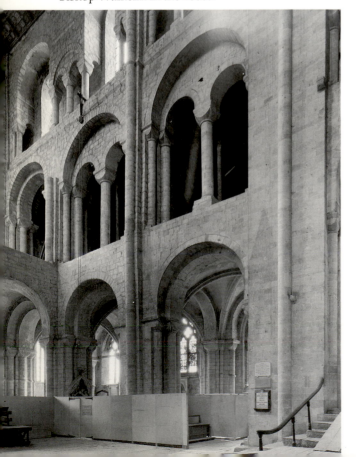

grown monastic reform which had matured already through something like half a century before the Conquest. Lanfranc's *Decreta*, where they touched architecture, were to be influential on the plans of at least fifteen major churches of the post-Conquest period, among them Paul's great abbey at St Albans.[5] For better or worse, they established a pattern of church-building uniformity familiar in Normandy but completely at odds with the existing Anglo-Saxon tradition.

Paul of Caen's new church at St Albans is the liturgical twin of Christ Church (Canterbury), as rebuilt by his uncle, Archbishop Lanfranc. In its turn, St Albans itself would influence the initial plans of dependent priories, colonized by Paul's monks and their successors, at Wymondham, Binham, and Tynemouth.[6] However, what is most immediately striking about the Norman church at St Albans is less the complex detail of its internal arrangements than the simple fact of its extraordinary size. By any standards, St Albans is a very big building, laid out from the first on a grand scale. But it was not unique even in its own day, being just one of a whole galaxy of comparable enterprises. When Thomas of Bayeux, the first Norman archbishop of York (1070-1100), rebuilt his cathedral next to the ruins he had found there, he was careful to exceed, both in width and in length, Archbishop Lanfranc's already ambitious contemporary reconstruction of the senior cathedral at Canterbury.[7] Abbot Serlo, another Norman, drew on the unexpected wealth of his compatriots in the region to build a new church for the Benedictines of Gloucester which was more ambitious by far than anything that had gone before on the same site.[8] At Winchester, Bishop Walkelin's cathedral, as laid out in 1079, was conceived on a scale then difficult to match in the Christian West, although Cluny's third rebuilding would surpass it.[9]

In Walkelin's new cathedral 'everything was immoderate'. Winchester exceeded in display, in complexity, and above all in scale, the great Anglo-Saxon church at Westminster Abbey, recently built for Edward the Confessor. Its models were the other major European churches going up at the time, among them St Sernin (Toulouse) and Santiago de Compostela. Its dimensions closely approximated to those of St Peter's, Rome, from which indeed they probably derived. Furthermore, along with every conceivable extra – aisled and galleried transepts, a big vaulted crypt, a handsome ambulatory and radiating chapels – Walkelin's cathedral was to have been crowned by a forest of towers which, if ever completed, would have risen from the transepts as well as from the crossing, from the east end as well as from the west.[10]

A cathedral like Walkelin's, or indeed an abbey church like Serlo's, could hardly have been built without access to extraordinary resources. Those resources were clearly present at Winchester, where court, monks and bishop came together. At Gloucester, the case was very different. Yet there, too, a significant part of the new church would be raised and consecrated within the lifetime of its first Norman abbot. Serlo shared Walkelin's passion for building. His roots similarly were in Normandy, where he had been a canon of Avranches before transferring his allegiance to the Benedictines of Mont-Saint-Michel. What he completed at Gloucester before his death in 1104 was a church very much in his native Norman tradition, which, while lacking its nave, was otherwise fully equipped with crypt, ambulatoried choir, radiating chapels and big transepts, the whole in use no later than 1100.[11]

Gloucester, in the remote south-west Midlands, was a frontier abbey of the Norman military and ecclesiastical settlement. Serlo drew his support from these circumstances. In 1070, four years after what he described as 'the great battle', Ermenfrid of Sitten, the papal legate, had issued a penitentiary addressed specifically to the victors at Hastings, including a significant clause: 'Anyone who does not know the number of those he wounded or killed must, at the discretion of his bishop, do penance for one day in each week for the remainder of his life; or, if he can, let him redeem his sin by a perpetual alms, either by

building or endowing a church.'[12] At first, most interpreted the legate's words as a direction to reward those communities at home on whose prayers they had been wafted, as by a favourable sea breeze, across the treacherous waters of the Channel. With few exceptions, the benefactions of the original settlers went, as we shall see, to Norman houses. However, it was not long before landowners began thinking more locally, taking their example from the top. Archbishop Lanfranc, although initially alienated by what he found at Canterbury, was soon able to number himself, without affectation, among the English.[13] And certainly by the time that Abbot Serlo began work on his new church, he could count on the generosity of Normans like himself in the lavish re-endowment of a former Anglo-Saxon community which had its roots in the late seventh century. During the 1090s, while building was in progress, the income of Gloucester Abbey more than doubled, the principal benefactors being precisely those Normans whose fortunes stemmed from the Conquest.[14] Such indeed were the circumstances that enabled our earliest antiquary, William of Malmesbury, to report: 'In every village, town and city you may see churches and monasteries rising in a new style of architecture.'[15] Born in 1095 of mixed Anglo-Norman parentage, William was an energetic traveller who, in this particular although not in all, undoubtedly knew what he was talking about.[16] In any event, the proof of what he said lies all around us.

Serlo's building programme, launched in 1089, coincided with that further expansion of Norman settlement into South Wales which could be relied upon to bring him new territories. Equally important were the changing attitudes of donors. Robert fitz Haimo, among the most active of the Glamorgan settlers, had once been a tenant of Bayeux Abbey, being a benefactor also of other major Norman houses at St Martin of Séez and Mont-Saint-Michel. He started with debts to clear at home. Yet before 1100, Robert had switched his allegiance to Gloucester Abbey, as had Hugh de Port, another former Bayeux tenant and Gloucester donor, who chose to end his days at Serlo's house as a member of the abbot's fast-growing community.[17] These changes of heart are not to be seen as individual conversions on the road to Damascus. What they reveal instead is a shared perception of the strength and permanence of Norman settlement, pushed forward everywhere on the backs of such adventurers, and secured by the shield of their castles.

The formula was already well tried. One of the local fortresses certainly known to Robert fitz Haimo would have been Chepstow Castle, on the way to those estates in South Glamorgan from which he carved his donations to Gloucester. And there, at Chepstow, the classic three elements of Norman conquest and settlement were clearly present from the start. First of these was the castle, built (or at least begun) by William fitz Osbern before his death in 1071. Next was the priory, founded by fitz Osbern as a dependency of the Benedictines of Cormeilles of whom he was the principal patron. Third was a community of merchants, a *Cheap-stow* (trading place), which eventually gave its name to the whole. There is nothing now of either priory or town which dates back as far as the first years of Norman settlement at Chepstow. But the huge bulk of the castle's keep is of fitz Osbern's day. It is the earliest secular monument of the Conquest period, and ranks among the most important buildings of its time.[18]

Chepstow Castle is strongly sited, on a narrow ridge overlooking the Wye. It is on the Welsh side of the river, and was plainly seen by fitz Osbern, companion of the Conqueror and first earl of Hereford, as a forward base in his campaign against Gwent, initiating the Norman movement into Wales. Obviously, Chepstow had to be defensible. Nevertheless, there is a domestic quality about the earl's building on the ridge which overturns the common view of such castles of the Conquest, derived from much later material. Fitz Osbern's rectangular building is not a conventional stone keep. It starts with a cellar (less to raise the

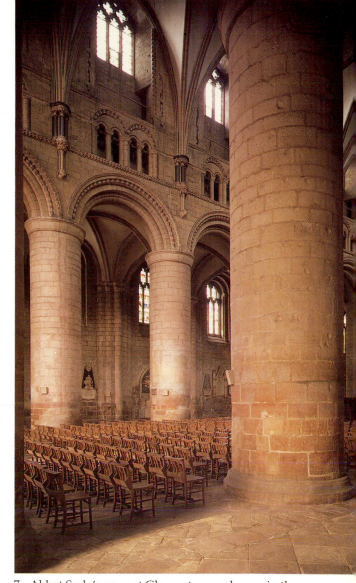

7. Abbot Serlo's nave at Gloucester was begun in the 1090s and finished before 1121.

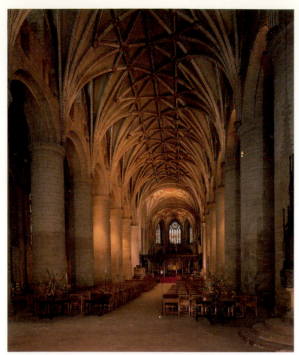

8. Tewkesbury Abbey's great nave, vaulted like Gloucester's at a later date, was otherwise the exact contemporary of Serlo's nave.

9. The priory church at Chepstow, of which this is the twelfth-century west portal, was the second element (after his fortress) of William fitz Osbern's pro-gramme of conquest and settlement in south-west Wales; the third, between castle and priory, was his borough.

building than to level the ground), over which are the earl's hall and his chamber. While playing some role in Chepstow's defensive system, of which it was the central element on the south, fitz Osbern's hall was not, as were the tall keeps of the next generation, securely built as a place of last resort. Its first function was to do honour to the earl.

Until recently, Chepstow seemed unique. It was difficult to place in a docu-mentary record which emphasized the military aspects of the Norman conquest and settlement at the expense of most other qualities. Yet the excavations of the 1970s at Castle Acre, in Norfolk, have uncovered the foundations of a 'country house' only a little later than Chepstow in date, built for a magnate of comparable status. William de Warenne was again one of that close circle of Duke William's advisers in which fitz Osbern himself had been prominent. Like the builder of Chepstow, Warenne waxed exceeding rich on the spoils of the Conquest, assem-bling lands in twelve counties before his death in 1088. The Warenne interests centred at Lewes, in Sussex, where William built a castle and founded, in due course, a major priory. But while Norfolk was never the Warenne heartland, the scale of the family's operations at Castle Acre was scarcely less significant than at Lewes. Alongside the big country house of the first William de Warenne, created earl of Surrey in 1088, was a market town, later enclosed within a rampart. Beyond that was a Cluniac priory – a daughter house of Lewes – founded by William's son, the second earl. As at Chepstow, although over a longer period, the characteristic elements of Norman settlement had again come together.

Most important of those elements, and central to them all, was the Warenne headquarters: the administrative focus of the family's estates in the locality, as well as the residence of the earls. It is not known when the Warennes first set up house at Castle Acre. But Gundrada, William de Warenne's first wife, died in childbirth there on 27 May 1085, and the implication must be that there was at least some major building on the site by that date: probably the first in the recently excavated sequence. What was found in those excavations is strikingly at odds – more even than is Chepstow – with received interpretations of the Conquest. William and Gundrada's house at Castle Acre was as domestic as fitz Osbern's hall at Chepstow Castle, and was even less obviously fortified. It was a hefty two-storeyed stone building, almost square in plan, with entrances at both ground and first-floor levels. Above, the hall and great chamber were comfortable apartments, well lit and individually heated. Below were domestic offices and stores, separately entered from a small surrounding court, of which the only defences, before the addition of the gatehouse, were a palisaded bank and circling ditch.[19]

There is nothing fortress-like about the earliest buildings at Castle Acre. They are indeed, as their excavators claim, better described as a substantial 'country house'. Major fortification of the site, taking the form of much-enlarged ramparts and a conversion of the house into a tower keep, was embarked on at Castle Acre no earlier than the 1130s and 1140s, during the civil wars of Stephen and Matilda. Until that time, the Warennes dwelt secure behind their low banks, less threatened by the Anglo-Saxons they had so cruelly displaced than by Normans like themselves, 'eager for rebellion, ripe for tumults, and ready for every sort of crime'. Orderic Vitalis, whose words these were, was also the author of what has since become one of the essential texts on the castles of the Conquest. 'The fortresses which the Gauls call castles,' Orderic wrote, 'had been very few in the English provinces, and for this reason the English, although warlike and courageous, had nevertheless shown themselves too weak to withstand their enemies'.[20] There is a good deal of truth in Orderic's analysis. He was perfectly right that whereas the Normans had become accustomed to castles both in government and war, the Anglo-Saxons, in a more law-abiding society, had yet

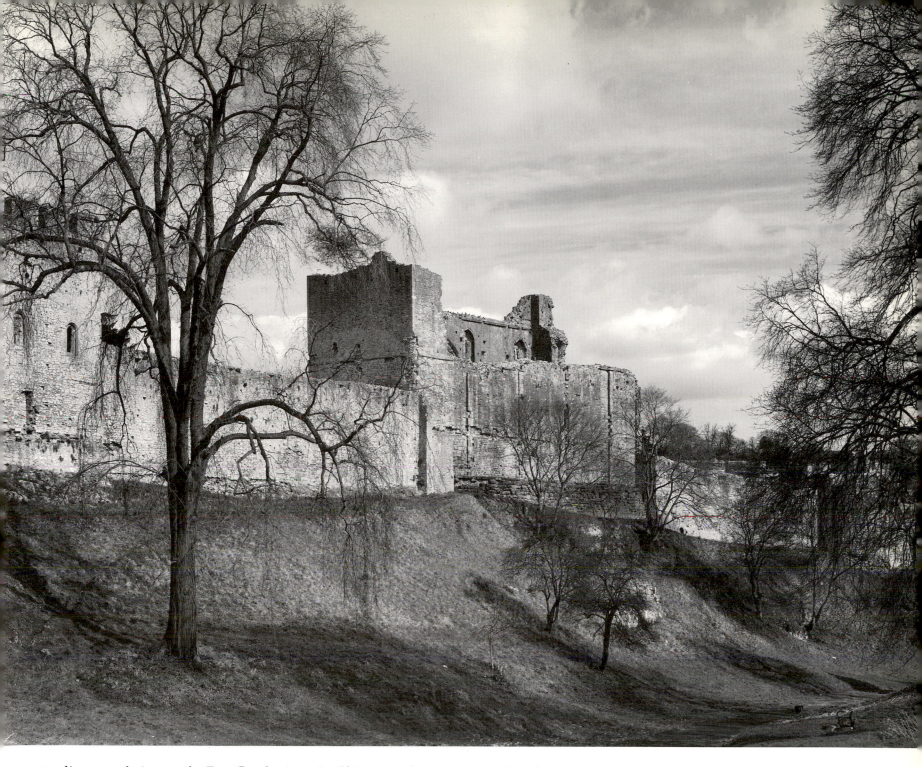

to discover their worth. But Castle Acre itself is enough to suggest that the Norman settlement process was not always conducted behind ramparts. And there are other reasons, too, for not taking Orderic too literally. Although born in England in 1075, Orderic had been sent to Normandy at the age of ten and had no personal experience of the events he described some sixty years after they had occurred. Those castles Orderic knew personally were already formula buildings, produced to a set plan, at least as much as were the Benedictine houses in which he spent most of his life.[21] What he could not have known, and what his words conceal, was the huge variety of the earliest castles, greater by far in the immediate post-Conquest decades than at any other time.

This variety opens windows of its own on the Conquest. It confirms the multi-origins of Duke William's mercenary host. It establishes the haste of the initial settlement. And it furnishes unequivocal evidence of the castle's immaturity in 1066, still experimental both in use and in plan. Certainly, there is no question of

10. William fitz Osbern's palace-keep (centre) at Chepstow Castle was built before his death in 1071. Like other stone towers of its period, it was residential, having the lord's hall and private chamber on the first floor.

the motte and bailey castle being the only fortress unit of the invading Normans. Castles in this mode, or in something very like it, were known in Normandy by the mid-eleventh century at the latest. In its most developed form, the motte and bailey was still in common use during the late twelfth-century Angevin settlement of Ireland. However, those very perfect earthworks, sharp of mound and broad of bailey, which survive on such Irish sites as Dromore (Down), Granard (Longford), or Knockgraffon (Tipperary), are less than useful as a guide – although often taken as such – to the castles of Duke William's much earlier English Conquest. If anything, they imply by their extreme uniformity of plan that the mature style had developed only slowly. Part of this development must have resulted from the continuing colonizing drive of Norman landowners, whether west into Glamorgan by way of Chepstow, or north across the Solway Firth into Galloway. The huge Mote of Urr, attributed to Walter de Berkeley, is the biggest of the twelfth-century Galloway mottes and baileys.[22] Also of about 1150, the characteristic pudding-shaped mound with half-encircling crescent bailey of Duffus Castle, built for Freskin of Moravia in northernmost Grampian, confirms the wide adoption by that date of this most typical of motte and bailey plans. Yet Scotland's Duffus, like its exact English equivalent at the Mandevilles' refortified Pleshey, was already three generations removed from the Conquest. Military engineering, in stone castles especially, was advancing very rapidly throughout this period. It is unlikely, even in the less sophisticated earthwork castle, to have stood entirely still.

If castles like Pleshey, Urr and Duffus, Dromore, Granard and Knockgraffon, are not to be projected back into the Conquest period, what then was the typical castle of the conquerors? The answer, of course, is that there was none. Back in Normandy itself, the fortified enclosure (now usually called a 'ringwork') was at least as common as the more familiar motte and bailey. There were mottes without baileys; baileys without mottes. Ramparts were crowned with stone walls or with timber palisades. Ditches might be single or multiple. Stone gatehouses, towers, and even rectangular stone keeps are known from the early eleventh century. An existing earthwork or a natural defence like a promontory were as likely to be used by the pre-Conquest castle-builder as by his cousin who came to England with Duke William.[23]

All these characteristics are present again in English castles after 1066, while some are identifiable even before. The Alfredian *burh*, typically a great communal earthwork fortress, had occasionally taken advantage of Iron Age ramparts. Roman defensive circuits, like those at Portchester, were to protect Anglo-Saxon communities in their turn. But of more significance to fortress studies, throwing new light on the origins of the private castle in this country, is irrefutable archaeological evidence, only recently available in print, of pre-Conquest manorial enclosures. At Goltho, in Lincolnshire, excavated in the 1970s, the earliest of a series of fortified manor houses has been dated to the mid-ninth century. With its substantial encircling rampart and deep outer ditch, much extended in a further rebuilding before the Conquest, Goltho's purpose was undoubtedly defensive. And it confirms at last what has long been mere hypothesis: that the Anglo-Saxons, whatever else they neglected in castles and their strategy, were at least fully acquainted with the ringwork.[24] Less certain is the emphasis the English may have placed on such defences, or the use they were to make of them in their wars. Yet here again the Goltho evidence is significant. In the 1080s, Goltho's fortifications were once more substantially remodelled. The existing ramparts were raised and the moat was re-cut. Across one corner, where it could command the gate, a new castle mound was erected, probably carrying a small tower. In a single campaign, the spacious residential enclosure of a pre-Conquest thegn had been totally transformed into the narrowly cramped fortress of a professional soldier, about as commodious internally as a modern frigate.[25]

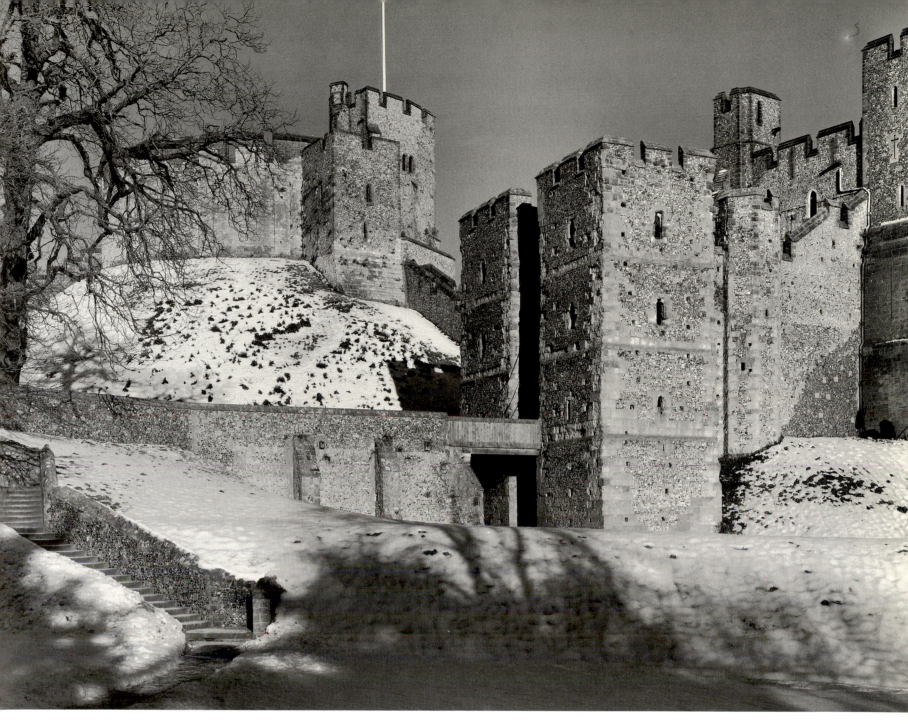

Important in Goltho's military transformation was the addition of a strong-point – a place of last resort – to which its captain might retreat in an emergency. But a mound like Goltho's had purposes other than defence. Intended as much to overawe and dismay, it had earned a place in the strategy of Norman settlement. Of the Conqueror's own castles, built during his northern campaigns of 1068-9, the mottes at Lincoln and at York are still prominent survivals. At Oxford, the tall castle mound, attributed to Robert D'Oilly, has been dated to 1071. And similarly early dates are usually given to Roger de Montgomery's mottes at Arundel and Hen Domen, as to the Carisbrooke motte of William (or Roger) fitz Osbern. While Oxford's bailey has almost disappeared, those of Arundel, Hen Domen and Carisbrooke are plain to see. Yet in no other way are these standardized fortresses. In scale most obviously but also in plan, Roger de Montgomery's two castles at Arundel and Hen Domen are so very unlike as to raise misgivings about their alleged common ownership.[26] Even more so, the fitz Osberns' castle at Carisbrooke, on the Isle of Wight, contrasts in every important particular with the same family's Welsh fortress at Chepstow. There, next to

11. The motte at Arundel, built by Roger de Montgomery, earl of Shrewsbury (1074–94), is one of the earliest of the post-Conquest castle mounds; in the late twelfth century, a stone shell-keep was built on the mound; the barbican (right) was added in 1295.

7

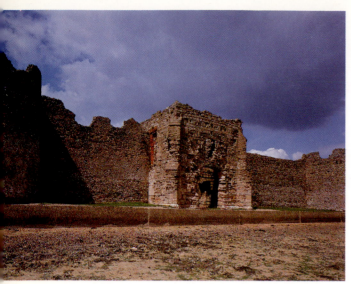

12. At Portchester, on the Hampshire coast, the Normans reused the defences of a Saxon Shore fort to enclose the outer bailey of their new fortress. Much of the curtain wall is of Roman build, though the Water Gate (centre) is a fourteenth-century addition.

13. Bramber Castle's stone gatehouse tower was originally the entrance to a large ditched and palisaded enclosure.

Gwent, a rugged promontory made a strong natural platform for William fitz Osbern's works, much as the Conqueror re-used the eminence at Corfe. But the Corfe model, for all its proximity to Carisbrooke, was not adaptable to the Isle of Wight's softer terrain. Existing ramparts, the former defences of an Alfredian *burh*, gave immediate temporary shelter to the Normans. As at the much smaller Goltho, while the Anglo-Saxon plan was retained by Carisbrooke's new garrison, the ramparts were transformed in a major rebuilding, being further strengthened by a great motte on the perimeter.[27]

Improvisation, very obviously a characteristic of these earliest castles, clearly contributed to their variety. At Pevensey, it was the Late Roman walls and ditches of a Saxon Shore fort that were adapted by Duke William for the protection of his army on landing. After Hastings, near which he raised the motte represented on the Bayeux Tapestry, William and his men took shelter within the Iron Age ramparts of Dover, just as Romans and Anglo-Saxons had done before them. Major defensive circuits, whatever their period, were irresistibly attractive to Norman settlers, not just of this but of subsequent generations. Understandably, during the crisis years of the western rebellions of 1067-9, the invaders' campaign fort at Castle Neroche (Somerset) was little more than a temporary bank-and-ditch defence, marking off a secure corner within substantial Iron Age ramparts.[28] Such precautions were the product of desperate times, but they could have more permanent consequences. In due course, the first Norman defences of Castle Neroche were to be succeeded by a large motte and bailey castle. Again, it was the Conqueror's own big ringwork, within another huge Iron Age hillfort at Old Sarum (Wiltshire), which induced Bishop Osmund to choose that remote and inconvenient location for the cathedral he re-sited from Sherborne. It was a legacy bitterly regretted by the bishop's successors and finally overturned, more than a century later, by a second move down on to the plain.

Roman fortresses, usually better placed than Iron Age hillforts and always on a less daunting scale, were even more to the taste of Norman builders. Pevensey's initial use as a forward base for William's invasion was quickly followed, on its grant soon afterwards to Robert of Mortain, by the building of a major castle across one angle. Portchester, in Hampshire, was another former Saxon Shore fort similarly brought back into service, as was Burgh Castle (Gariannonum), in Norfolk. Pushing west into Glamorgan, Norman settlers converted Roman forts to their own ends, raising great mottes at Cardiff, for example, and Loughor. Up in the north-west, the Westmorland forts at Brough (Verterae) and its neighbour Brougham (Brocavum), long since abandoned by their Roman garrisons, similarly returned to use under the invading Normans, to whom they offered some immediate protection.

To many of these sites, the Normans contributed that motte or strong tower which was rapidly becoming the *sine qua non* of the private castle. Such individual towers-of-last-resort had not featured in the thinking of Roman garrison commanders. Nor had they a clear role in the communal fortress, whether of the Anglo-Saxons or their Viking opponents. To the earliest post-Conquest castle-builders, towers were still not essential, failing to feature, for example, in either Duke William's ringwork at Old Sarum or at the Breton-inspired promontory fortress of Alan the Red at Richmond (North Yorkshire), datable no later than the 1070s. However, the basic ringwork defence, further strengthened only by a gatehouse, was not to last long as a castle type. Old Sarum's tower keep, built as one element of a major refortification, dates to the early twelfth century. Within a century of first building, Alan the Red's already formidable stone gatehouse at Richmond had been heightened to convert it into a still more powerful tower keep, while similar programmes of gatehouse-into-keep conversion occurred at Bramber, in Sussex, and Ludlow, in Shropshire, both originally simple castles of enclosure. There are known examples of ringworks at Aldingham (Lancashire)

and Rumney (Monmouthshire) where the ring was later filled to make a mound.[29] But a more characteristic conversion was probably that of Eynsford (Kent), at which the walled precinct of a wealthy country knight, vassal of the archbishop of Canterbury, was developed by his son into quite another sort of fortress, centring on a defensible stone hall-block, almost (but not exactly) a keep.[30]

Small, seldom visited, and only comparatively recently studied, Eynsford is less well known than it ought to be. Yet its strongly walled enclosure, equipped at first with just a timber watchtower, contrasts usefully with the more familiar mound-based castles usually seen as typical of the Conquest. Eynsford's probable building date is 1087-9, following the rebellion of Odo of Bayeux and in the lawless aftermath of the Conqueror's death, when Archbishop Lanfranc's estates were most at risk. Odo, bishop of Bayeux and earl of Kent, had himself once been a noted castle builder, formerly the associate in such works of the fitz Osberns. And there can have been no lack of recent models, whether in Kent or elsewhere, for the fortifications built to counter his aggression. Yet Eynsford, despite the examples to hand, was no more conventionally a motte and bailey castle than had been William fitz Osbern's much larger fortress at Chepstow. What William of Eynsford built was a thick curtain wall of coursed flintwork, circling a bailey of irregular plan. Where the ramparts of a ringwork might otherwise have been, stone walls had taken their place. The only concession to motte-raising at Eynsford was the low mound which carried its watchtower.[31]

Eynsford's irregular enclosure, so unlike the exact geometric planning of later earthwork castles, may repeat the line of pre-existing defences, as had certainly been the case at Bishop Odo's own Deddington (Oxfordshire), exactly following a Late Saxon circuit.[32] But such formless enceintes are clearly one of the identifying characteristics of the first settlement castles, of which Eynsford, even in the late 1080s, was representative. Thus there was to be nothing geometric about the original stone-walled baileys, both of the 1070s, of William de Braose's Bramber (Sussex) or of Peveril (Derbyshire), built for William Peverel, another loyal associate of the Conqueror and bailiff of his estates in the locality.[33] Nor was the more closely related Rochester, laid out as an irregular oval like Eynsford (and perhaps, indeed, its model), any more systematic in plan. Gundulf, bishop of Rochester from 1077, was an engineer of high repute, 'very competent and skilful at building in stone'. Thought to have been consulted in the building of the White Tower and in the Conqueror's even larger castle-palace at Colchester, Gundulf was satisfied at his own fortress at Rochester with a substantial stone curtain, replacing palisades on the ramparts of the first post-Conquest enclosure, and everywhere respecting their line.[34]

Gundulf was busy over those same years in the reconstruction of his cathedral, characteristically much grander than the Anglo-Saxon cathedral which preceded it. And it was there, rather than at the neighbouring castle, that he built the square defence work known as 'Gundulf's Tower'. Only in the late 1120s, under Archbishop William of Corbeil, was Rochester to be equipped with the great tower keep which is now the castle's most obvious feature. Nothing like it could have happened much earlier. Stone keeps were still highly exceptional at castles of the Conqueror's generation. The royal palaces at Colchester and at London (the White Tower), although well known to Gundulf and perhaps his work, were valueless to him as a model.

In part, this was a consequence of scale. Both Colchester and the White Tower were huge buildings. Like the new cathedral and abbey churches of Gundulf and his associates, the most obvious characteristic of the Conqueror's fortresses was their wholly unprecedented size. But they were specialized also and conservative in plan, belonging (as would so often be the case in these earliest post-Conquest buildings) to a very much older tradition. While usually described as

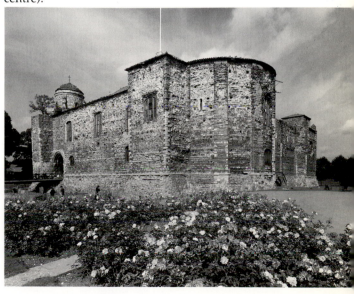

14. William the Conqueror's big residential palace-keep at Colchester Castle, showing the main entrance (left) and the projecting apse of the royal chapel (right centre).

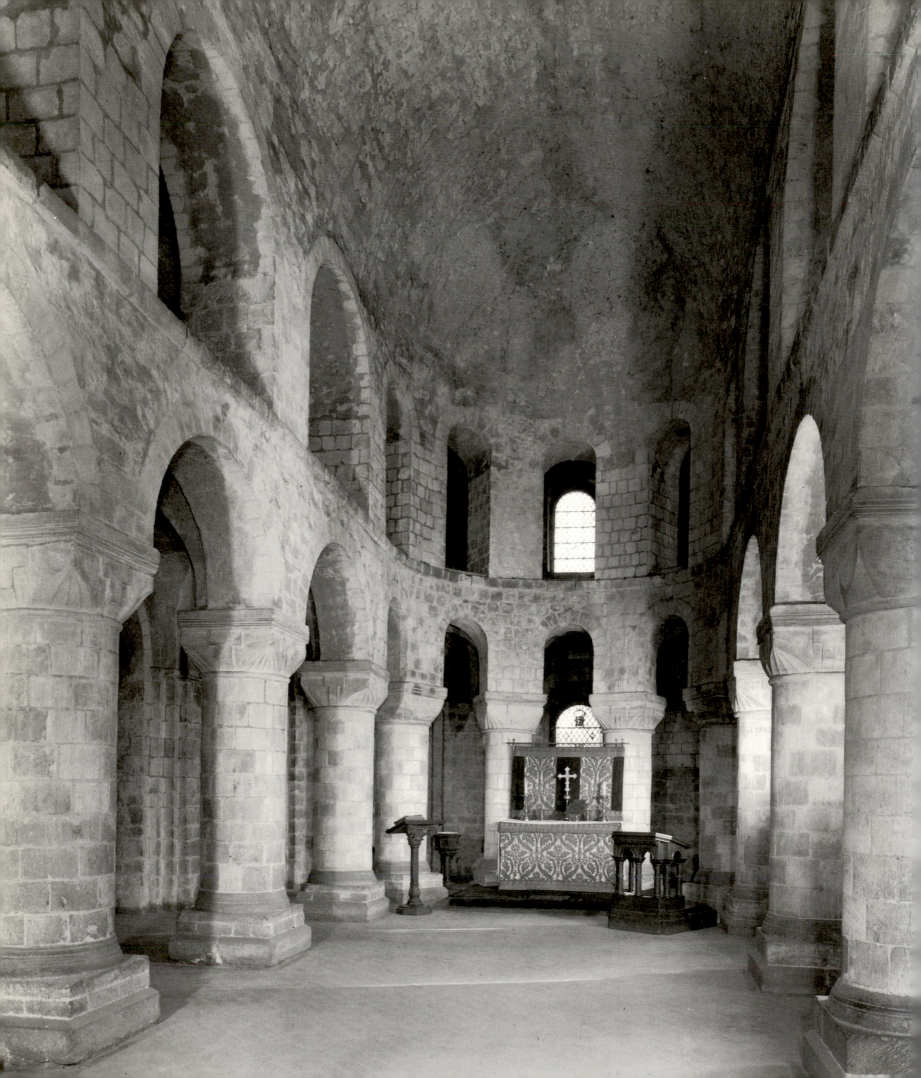

the first stone keeps in England, as assuredly in one sense they were, these castle-palaces of the mid-1070s were essentially backward-looking. They recalled similar fortress-palaces in tenth-century France, while being in no way the progenitors of such later tower keeps (among them Corbeil's Rochester) as sprang up in the wake of the Crusades. Colchester, with the larger floor area of the two, may have begun life as a single-storied building. The White Tower was of three storeys from the start. Both palaces had big chapels as a primary feature, and at each the hall was a deliberately grand apartment, fully appropriate to the pomp and majesty of the king.[35] Obviously, the enhancement of that majesty was the first purpose of such fortresses. Yet it removes them from the generality of English castles of their day, among which they stand out not as precedents but as anomalies: at once the first and the last of their kind.

Overall, a sense of unplanned but urgent drift – of unprecedented reactions triggered by exceptional circumstances – pervades the building history of the Conquest. Its consequences included further anomalies. Colchester itself lost its function as a palace very quickly, to be turned over to other purposes as a prison. And the fate of the Conqueror's great fortress, unheeded flotsam of the first Norman settlement, was reflected also in the experience of those other largely forgotten relics of the earliest post-Conquest decades: the distant English dependencies of Norman religious houses, known generically as the 'alien' priories. Of one of these, as early as the 1150s, an emissary from Fécamp reported to his abbot:

> when I arrived at Cogges I found the house empty of goods and full of filth . . . I was most dispirited by the devastation of the place, the shame of dishonour, the scarcity of things and the ruin of the house . . . now your compassion must rescue this place, or else without a doubt it will be reduced (which God forbid) to a complete wilderness.

Cogges indeed was rescued; its importance was restored as Fécamp's English outpost; and its accommodation was rebuilt shortly afterwards. Caught up in the Anarchy of Stephen's reign, it was perhaps the victim of exceptional misfortunes. Nevertheless, the emissary's report contained a passage of wider significance 'This place,' he continued,

> is subject to as many lords as it has neighbours . . . for deserts, as though for the best-tilled land, we are forced to render hidage, Danegeld, castle-guard, aids of sheriffs and the king's henchmen, and the other customs of royal revenue. The tyrannies of the archbishop, archdeacons and deans, to which it is insufferable to yield and ruinous not to yield, are the climax of our wrongs.[36]

Plainly, it was not for spiritual consolation that men looked to Cogges, but for revenues.

The distinction is important. Even at home in Normandy, where reform had passed its zenith before 1066, the many new monastic foundations of Duke William and his associates had owed less to grand design than to individual status-seeking and to the future care and protection of the soul. Orderic Vitalis, a monk in the duchy some decades later, knew the scene well. 'Every one of the great men of Normandy,' he wrote, 'would have thought himself beneath contempt if he had not made provision out of his estates for clerks and monks to serve in the army of God.'[37] Or, as Guitmund of Moulins-la-Marche put it, 'Our Lord Jesus Christ . . . who taught us what things are necessary for the good of our souls, admonished us to make gifts for his sake out of our possessions, so that in time we might receive an hundredfold.' Guitmund's donation to Saint-Père de Chartres was made, without concealment, 'in order to alleviate the heavy burden of our sins and ensure that there shall be no lack of men to pray daily for us'.[38]

Such beliefs had always been the inspiration of monastic founders. They never

15. The Chapel of St John shared the second floor of the White Tower (London) with the Conqueror's great hall and private chamber.

16. The parish church and manor of Cogges, in Oxfordshire, were held by the Benedictines of Fécamp (Normandy), who managed them as a dependent priory-cell.

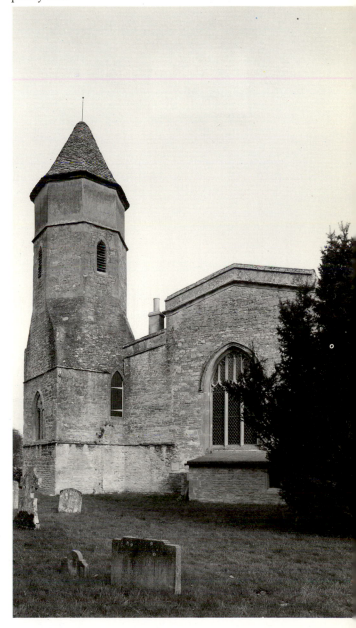

entirely evaporated, even in later climates of reform. What they spelled was property: a perpetual interest of the patron and his heirs in communities they considered their own. When Manasses Arsic, in the 1160s, spoke of 'my' monks at Cogges Priory, he was unselfconsciously continuing the practice of their founder, his namesake. With those other 'many lords' laying claim to Cogges' revenues, Manasses saw intervention as his right.[39]

Intervention, by the mid-twelfth century, was less acceptable than formerly. Standards in the Church were rising fast. Nevertheless, at the Conquest, it was precisely the close proprietary concern of Duke William and his associates in their existing monastic investment that brought English lands of every kind to the Norman houses. Links were direct and loyalties obvious. The Conqueror himself was especially generous to his recent personal foundations at St Stephen's and Holy Trinity (Caen). But he also rewarded such other earlier ducal houses as Jumièges and Saint-Wandrille, Fécamp and Mont-Saint-Michel.[40] William fitz Osbern, the duke's right-hand man, was the founder of two Norman communities, at Lire and Cormeilles, both of which took their tithe of his new wealth. To Lire, fitz Osbern gave six churches and their receipts on the Isle of Wight, in the vicinity of his fortress at Carisbrooke. Cormeilles, in its turn, got the priory at Chepstow when the earl took his army to the Marches.[41] It was Grestain, his father's foundation, that Robert of Mortain chose to reward with the Sussex manor at Wilmington, later the focus of wide-ranging holdings (both churches and manors) through Buckinghamshire and Northamptonshire, as well as beyond into Cambridgeshire and Suffolk.[42] Hugh of Chester transferred Tackley (Oxfordshire), with other valuable estates, to the abbey he had re-founded at Saint-Sever.[43] In the same county, Ivry's priory at Minster Lovell owed its beginnings to the abbey's founder, Roger d'Ivry, butler to the Conqueror; while Newington came to Longueville through the generosity of its founding patron, Walter Giffard.[44]

Among the more important properties to change hands in this way was the church, once a minster, at Wootton Wawen in Warwickshire, given to the monks of Conches Abbey (Normandy) by their founder's son, Robert de Stafford. Soon after the transfer, Wootton Wawen's value in tithes and other revenues caused it to be promoted to the status of priory cell. And it was thus that it remained through many vicissitudes until suppression in 1414. Wootton Wawen's experience is instructive. Although described as a 'priory' and managed for Conches Abbey by a 'prior', Wootton Wawen is unlikely ever to have had more than two monks resident at any one time or to have obeyed a monastic regime. As at many larger establishments, the monks shared their church with the parish. But their domestic buildings, west of that church, were non-conventual. Like any laymen, Conches' representatives at Wootton Wawen had their hall and chamber, kitchen, barn, stable and dovecot; all within a gated enclosure.[45] From 1178, the cure of souls in the parish was formally entrusted to a vicar. To the prior and his companion fell the charge of Conches' Warwickshire estates, which they ran essentially as a business. It was an isolated responsibility, not popular among monks with a genuine vocation, and always liable to fall into the wrong hands. Inevitably, Wootton Wawen had its share of bad appointments. Peter de Altaribus, one of the worst, was prior in 1280 when he had a fracas with his assistant, Roger de Pauliac. As later reported by the vicar among others, the prior hit Brother Roger on the nose and struck him between the eyes with his keys, calling him a 'leprous clown'. The set-to occurred at evensong time, and there were many witnesses present, including the prior's groom, the vicar's clerk and his chaplain, the miller, carter, porter, wheelwright and cook, all but two of whom agreed that the prior was to blame, though provoked in some measure by Brother Roger. Peter de Altaribus, it was alleged, was frequently drunk; he was a bully, chasing his household from their beds late at night; he neglected hospitality,

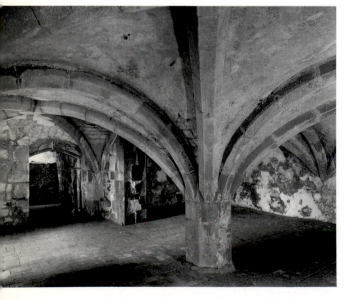

17. The vaulted undercroft of a domestic building at Wilmington Priory (Sussex), the principal English estate centre of the Norman monks of Grestain.

refused alms to the poor, wasted the priory's goods, and was notorious for his excesses throughout the neighbourhood. Both he and Brother Roger were recalled to Conches to submit to the discipline of their abbot.[46]

Nothing in this story has anything to do with religion. Nor was faith what the alien priories were about. For the great majority of these establishments, the title 'priory' was always a misnomer. Founded to care for the English properties of continental religious houses, they functioned as non-conventual estate centres. They served abbeys in western and central France – in Normandy, Brittany, and Anjou – but might also be attached to more distant houses, from Burgundy into Flanders and beyond. The isolation and consequent weakness of these outposts soon became evident. They had few friends in the locality and 'many lords'. Trouble began almost immediately. Soon after the Conquest, the Norman monks of Fécamp became locked in dispute with their Angevin brethren of Saumur over rights at St Nicholas, by Bramber Castle. William de Briouze, the castle's builder, had given the church to his monks at Saint-Florent (Saumur). But Fécamp's claims went back to an earlier gift, allegedly of Edward the Confessor, which had conferred on them Steyning and its neighbouring chapelries, among them St Nicholas at Bramber. In due course, a compromise was obtained, but the ill-will generated by this early encounter continued to injure the collegiate church which had risen on Fécamp's interest in the locality.[47]

Steyning lasted as a college no longer than the 1260s, after which its endowment reverted to Fécamp. It may once have functioned as a priory cell. Such obscure beginnings were not untypical, contributing to the weakness of the alien houses, many of which moved forward just as hesitantly. Of Saint-Sever's establishment at Tackley, for example, we know little except that the Norman monks, while still holding the church in 1158, had lost its patronage to the lord of the manor before 1200. Yet the surviving twelfth-century architectural detail at Tackley Church is of such superior quality as to suggest association with a priory cell.[48] More is known about the origins of Minster Lovell, thought to have been raised to priory status in the 1180s, when Maud Lovell gave Ivry the parish church at Minster on the understanding that monks should serve God there. But even here there is reason for uncertainty. By the late twelfth century, a new foundation of this kind stood out clearly as an anachronism. Maud's action, although not wholly without contemporary parallels, makes more sense as a confirmation than as a gift. Certainly there is little else to establish how Ivry may have organized those Oxfordshire estates bestowed on it by Roger the Butler a century before as part of its founding endowment.[49]

The slow definition of alien interests in England was a consequence of ambiguous objectives. No Norman house in receipt of English lands stood ultimately to gain by the reorganization of such territories as independent priories, returning only nominal rents to France. In due course, a few French abbeys espoused the cause of reform, being more likely to do so if spiritualities (churches and tithes) bulked large among the assets they received. However, most continued to view the windfall of their English estates not as an encouragement to missionary endeavour but as a cash resource, requiring nothing more of them than collection. The sums involved might indeed be considerable, constituting as much as a fifth of a Norman community's total revenues.[50] And while few were so dependent on their overseas lands, there was general reluctance to maintain more than a minimal supervisory presence at the English cells, every extra monk being a charge on the profits. Accordingly, the tiny two-monk establishment of Wootton Wawen quickly became the norm at alien houses. The disciplinary risks were plain to see. Gerald of Wales, never one to mince his words, was among several contemporary moralists to make capital out of them.[51] Yet even while Gerald wrote, Maud Lovell was making explicit provision at her 'priory' of Minster Lovell for 'one or two monks' only. Similarly, at Fécamp's Cogges there were

rarely more than two monks resident at any one time, occasionally joined by a third.[52] A single monk-bailiff, known as the proctor, was the sole representative or Longueville at Newington for a good part of that priory's existence.[53]

With profit alone as their guide, it was inevitable that the Norman houses recording the most substantial receipts from their English lands would also be those least committed to the foundation of expensive daughter priories.[54] Not all of them viewed it this way. Bec, for one, came to number four fully conventual priories amongst its English dependencies – at St Neots and Goldcliff, Cowick and Stoke-by-Clare. But Bec, uniquely, was at the forefront of contemporary ecclesiastical reform, the source of great dignitaries, themselves reformers, like Archbishops Lanfranc and Anselm. And Bec too drew the bulk of its English revenues from estates kept clear of missionary charges: most notably from its bailiwick of Ogbourne. There, in overall control of the bailiwick's twenty-four manors, Bec kept a manager once described as the 'prior, proctor or administrator of the priory, place, bailiwick or prebend of Ogbourne'.[55] Farmer, lawyer and man of affairs, the prior of Ogbourne was only incidentally a priest.

Bec's conventual priory at St Neots, in contrast, exhibited the colonization's more acceptable face. Neot was a Cornish saint whose relics, translated to Huntingdonshire in the 970s, had occasioned the building of a monastery. Surviving the Conquest as a dependency of Ely, the shrine attracted the attention of Richard de Clare, the first of a long-lasting Anglo-Norman line and son of Bec's earliest patron, Gilbert de Brionne. It was Richard fitz Gilbert, with his wife Rohais, who persuaded Anselm, lately raised to the abbacy of Bec, to send monks to reshape St Neots in Bec's image. At first reluctant to risk his monks in such a cause, Anselm yielded with the admonition:

> We are sending our brothers to you, as you commanded. And therefore we commend them to you; because they are going to England at your command and by your wish, what they do, and how and by what means they live, ought to be your care and consideration.[56]

Anselm's loyalty to Bec's premier lay patrons, reinforced by his devotion to St Neot, secured the priory's future. However, Bec's mission, if ever seen as such, never made much headway out of this remote East Anglian base. And it is significant that the next house in which the fitz Gilberts, as a family, took a deep personal interest was the priory they founded within their Suffolk castle at Clare, bringing spiritual solace to their household and to themselves.

At Clare, Bec's monks took over an existing collegiate church, too cramped for their purposes and soon abandoned for a more spacious site at Stoke. In similar circumstances, while Cluniac monks from Lewes initially sheltered within Castle Acre's great enclosures, it would not be long before they also moved to a virgin site, away from the Warennes' country house. At Pembroke, monks of Séez served God in the castle before resettlement at Monkton, near at hand. In practice, the Cross and the Sword dwelt uneasily together. Nevertheless, the presence of French monks in such great post-Conquest households clearly answered a deeply-felt need. Thus the fitz Gilberts of Clare, thinking of Bec as 'their' house, naturally preferred the company of Bec monks at their table. At Castle Acre, the Warennes introduced monks of the same Cluniac 'family' which they had first brought to England at Lewes.[57] Isolated at Pembroke among the alien Welsh, Arnulf de Montgomery needed the reassurance of French-speaking monks from his own family's abbey at Séez.[58]

Similar pairings of castle and priory have sometimes been seen as essential to the strategy of Norman settlement. On the Marches, this might indeed have been so. Elsewhere, the explanation is probably more human. Men of iron though they were, the conquerors missed the companionship of their folk. They wanted monks of their blood to share and console their English exile. Yet in only a few

14

cases, having regard to loyalties at home, were they prepared to provide for them adequately. Once again, exceptional circumstances had provoked reactions which would have burdensome consequences in later years.

Most of the fully conventual priories of the settlement period owed their origin to situations of this kind. It left many of them haplessly dependent. Tutbury Priory was among the few alien houses to shed its French allegiance in sufficient time to avoid the confiscations of 1414. But even Tutbury, luckier and longer lasting than most, experienced a sad history of misfortunes. Established in about 1080, the community at Tutbury had been imported by Henry de Ferrers from Saint-Pierre-sur-Dives, to be settled by the gate of his big promontory castle. The monks' initial endowment centred on the parish of Tutbury itself, served by their church to this day. As augmented by successive Ferrers earls of Derby, the priory's possessions came to include other parish churches and their tithes, with lands in both Staffordshire and Derbyshire. By the mid-twelfth century, Tutbury's monks were able to complete their church with lavish and confident display. But that prosperity was almost immediately under threat. There were local objections, led by the parish priests, to Tutbury's appropriation of tithes. More seriously, the priory's patrons quickly fell into dispute. Very probably, it was one such argument over competing rights with the abbot of Saint-Pierre which drove Earl Robert to violence. In 1260, shortly after coming of age, Robert attacked the priory and destroyed many of its buildings. It must have seemed like divine judgement when the earl lost his own lands six years later as a supporter of Simon de Montfort. However, the Ferrers' disinheritance of 1266 finally cut that umbilical cord which held the priory and its founders together. No successor at the castle could be expected to assume the same role. Indeed, the monks' resulting association with the earls of Lancaster, in particular with the stormily ambitious Earl Thomas (executed 1322), only brought them further trouble in its turn. Later in the 1320s, robbed of their goods and punitively fined, the monks of Tutbury were deeply in debt. The community became the victim of factional disputes between English and French monks, again bringing it into conflict with its patrons. In common with all the alien houses, the Anglo-French wars brought Tutbury within the grasp of the Crown. Only the priory's resolute Englishness and its conventual status, held on to by a whisker through the worst of its misfortunes, enabled Tutbury to survive the repeated confiscations which drove many of its kind to the wall.[59]

Roger of Poitou's priory at Lancaster, next to his castle, was one of those houses which ceased to be conventual shortly after 1414, on its transfer to the endowment of Syon Abbey. Founded within a decade of Tutbury, it had been similarly troubled throughout its existence first by quarrels with its neighbours, then by the oppressions of the Crown.[60] Lancaster's story is typical enough. Yet here, as at Tutbury, a more eventful and newsworthy later history disguises a prosperous past. Lancaster is a big church, over 150 feet long; somewhat bigger even than Tutbury. And while most of what remains there is of the fifteenth century and later, the overall scale had been determined very much earlier.

It is building evidence of this kind, significant in quantity but necessarily incomplete, which suggests another view of these original colonizations, less dismissive than the common verdict of today. No doubt the great majority of the dependent priories and cells were indeed 'small and inchoate' from the start. They were to prove themselves unquestionably, in the longer term, 'one of the most unfortunate by-products of the Conquest'.[61] However, this is by no means the entire story. On the one hand, it is perfectly true that the Bretons of Saint-Jacut-de-la-Mer never made much of their priory cell at Isleham, in Cambridgeshire, at which only a modest church (little more than a large chapel) still survives. Conventual life had ceased at Isleham before 1254, to be followed by merger with Saint-Jacut's associated cell at Linton.[62] Nevertheless, Isleham's

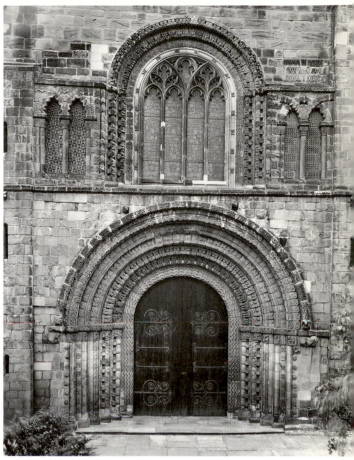

18. Tutbury, in Staffordshire, was one of the better-off alien priories, founded in c.1080 from Saint-Pierre-sur-Dives and sited next to the great Ferrers castle. The west facade of the priory church, richly decorated in the style of the 1160s or 1170s, confirms the community's prosperity at that date.

19. The priory church at Isleham, in Cambridgeshire, built by the Benedictines of Saint-Jacut-de-la-Mer (Brittany) but abandoned as early as the mid-thirteenth century when conventual life ceased on their estate.

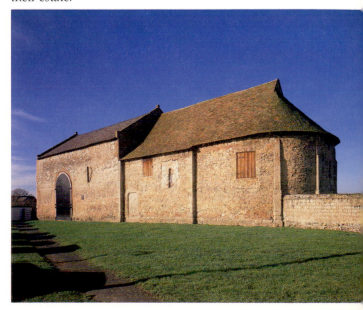

15

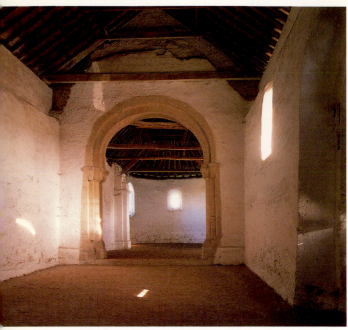

20. Saved by its early closure, the interior of the church at Isleham is unspoilt by later furnishings and additions.
22. (right) The nave arcades and clerestory of Fécamp's collegiate church at Steyning (Sussex), especially noted for the high quality of its Late Norman decorative work.
21. The lavish choir at Boxgrove Priory (Sussex), built in the 1220s for a Benedictine community engaged in separating itself from dependency on Lessay Abbey, in Normandy.

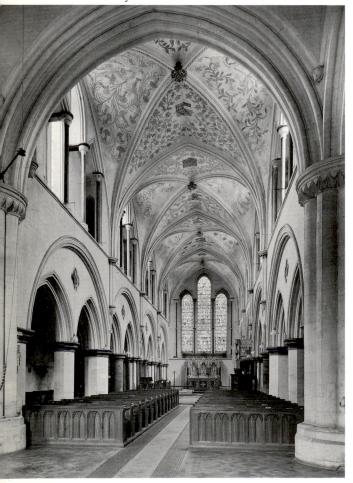

early failure has to be set against the very different experience of a priory like Lessay's Boxgrove, which had achieved its independence by the mid-fourteenth century, to survive thereafter in reasonable order until the Dissolution of 1536. Founded originally as a three-monk cell, Boxgrove quickly blossomed to full conventual status under the patronage of a local Sussex family. In the 1220s, when many of its equivalents had already lost all momentum, Boxgrove was still firmly on the ascent. It was then that the monks undertook a costly rebuilding of their choir, taking example from Chichester, their neighbouring cathedral, in the lavish use of Purbeck marble detailing, both in shafts and (more exceptionally) in capitals.[63]

Lessay's investment at Boxgrove, while certainly unusual in a Norman-held house, was not unique. At Pamber, in northern Hampshire, only the choir and crossing remain of Saint-Vigor's former priory church of Sherborne, founded by Henry de Port in the 1120s. Yet even now, shorn of chapels, transepts and nave, Pamber is plainly a major building, its choir extended generously in the thirteenth century at much the same period as Lessay's Boxgrove, although without the same extravagance of ornament.[64] Fully conventual priories like Boxgrove and Sherborne, Lancaster and Tutbury, each accommodating a substantial community, obviously required buildings of proportionate size. And it had been the cost of such provision, both in the short term and in the long, which had deterred the French houses from investing too much capital in similar ventures. Nevertheless, just as some set aside profit in the foundation of conventual priories, others found building irresistible. Steyning, we already know (see, p. 13), was an important Fécamp property, jealously guarded against competing Saumur interests in the region. Its collegiate church prospered following the Conquest, and this must be the reason for the exceptional scale and richness of the surviving building, noted especially for its Late Norman work: 'virile and inventive; certainly the best in Sussex, and among the best in the whole country'.[65] But no such role explains the huge cathedral-like parish church just downstream at New Shoreham, dependent on the Angevin Benedictines of Saint-Florent-de-Saumur, but neither collegiate nor monastic. Saint-Florent had rights, challenged by Fécamp, at William de Briouze's chapel by Bramber Castle. Its monks built substantially at Old Shoreham also, between Bramber and New Shoreham on the coast. At all of these, competition between the communities may be one explanation for such activity. Yet the fact remains that two French houses, each a major landowner in West Sussex from soon after 1066, were prepared to plough back their English receipts into ambitious building projects, not just in the immediate aftermath of the Conquest itself but also through much of the following century, most particularly (at New Shoreham) towards its end.[66]

It would be another century again before the nuns of Holy Trinity, Caen, halted building at their Gloucestershire parish churches at Avening and Minchinhampton, both generously laid out from the start. Avening, prettily set on its hillside, was already a big church by the mid-twelfth century when the nuns, holding the manor there, were confirmed in their ownership of the parish church also, disputed by Tewkesbury Abbey. Early in the fourteenth century, substantial transepts were added to Avening and the existing vaulted chancel was doubled in length with the addition of a second matching bay. No expense was spared on this chancel extension. Nor were financial constraints a very evident consideration in the contemporary rebuilding of the nuns' even grander Minchinhampton, as big under their ownership as it is today, and certainly one of the greater parish churches of the locality. Nothing is known of the circumstances of either rebuilding. Indeed, it is probable that the 'extraordinary and beautiful' south transept at Minchinhampton, as decorative outside as in, was the gift of an individual knightly donor whose chantry it subsequently became.[67] But decisions on the scale of each building, and at least a share of the costs, must have

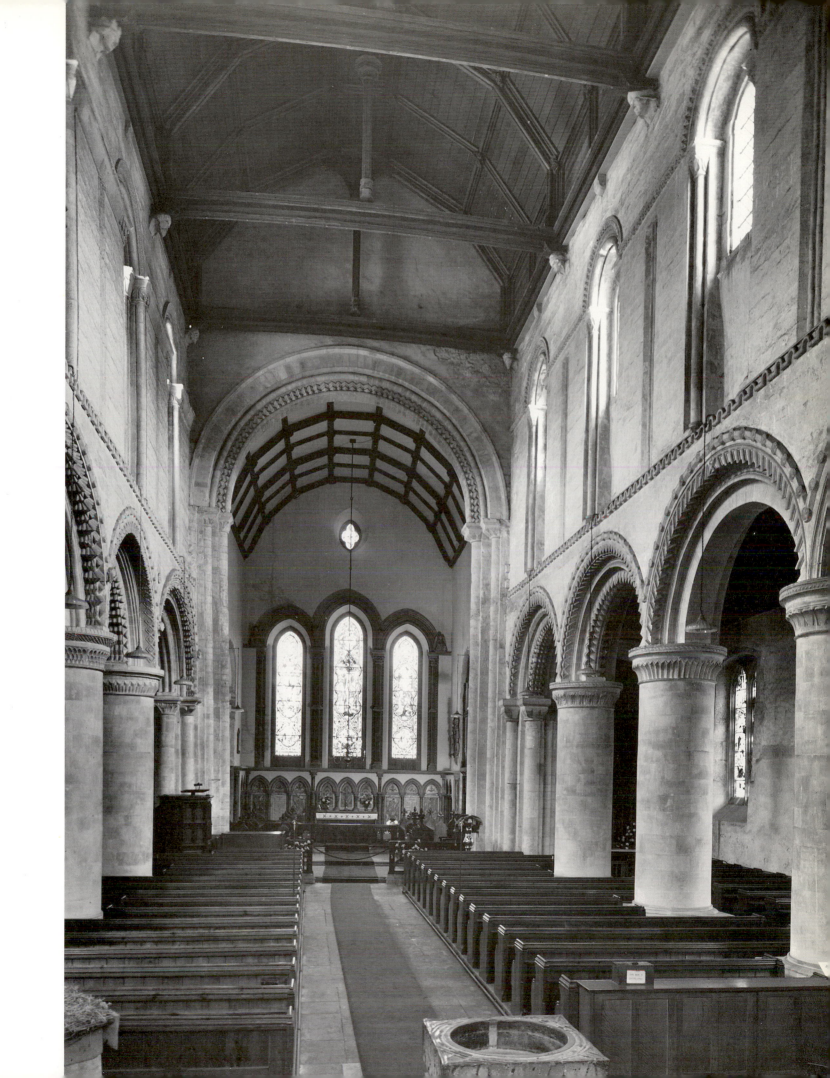

23. Avening Church, in Gloucestershire, was one of the English properties of the Norman nuns of Caen into which they put considerable investment.

fallen to the Abbaye aux Dames. Moreover, the quality of the work was no less high in the fourteenth century than it had been back in the twelfth.

In some degree, obviously, it was easier for the Norman abbeys to find occasional capital sums for the reconstruction of their parish churches than to tolerate permanent loss of revenues to daughter houses. But it is also true that most such investment decisions were made only when the Anglo-Normans had established their regime and when the settlement was widely recognized as irreversible. Before that, reactions had been more muted. Even the Conqueror, founder and principal benefactor of the nunnery at Caen, promised more than he ever gave away.

One of the promises William never fully kept was to Battle Abbey, the community he established on the site of Hastings, with its high altar where Harold had been slain. Battle was a memorial abbey, with no other purpose than to meet the conditions of William's vow:

> To strengthen the hands and hearts of you who are about to fight for me, I make a vow that on this very battlefield I shall found a monastery for the salvation of all, and especially for those who fall here, to the honour of God and of his saints, where servants of God may be supported: a fitting monastery, with a worthy liberty. Let it be an atonement: a haven for all, as free as the one I conquer for myself.[68]

The promise put heart into those dismayed by unfavourable omens, the most recent of which had been witnessed just before when the duke was offered his armour back to front. But then, as the Battle chronicler relates, 'the illustrious King William was fully occupied . . . and although he never actually forgot his vow, yet because of the preoccupations of this period, he put off its fulfilment (amongst other things) for a long time'. The delay was not the Conqueror's only failure. When, eventually, work began on the project, the steeply sloping battle-field site was found to be very unsuitable for building. On sandy inhospitable soil, it was inconvenient, barren and waterless. Yet the king overrode all objections. He commanded a start 'on the very spot where his enemy had fallen and the victory had been won'. And he made another promise: 'If, God willing, I live . . . I shall so endow that abbey that the supply of wine in it will be more abundant than that of water in any other great abbey.'[69] It was on this especially that he disappointed his monks, while endowing them comfortably before his death on a level somewhat lower than he had boasted

The king was mistaken, and the monks of Battle continued to have cause to regret the bullying terms of his endowment. Because of the site's steep southerly descent, expensive stepped undercrofts had to be built in the next century to provide a supporting platform for their dormitory. But that was a problem for the future. More immediate was the need to get something done while the king yet lived and could be reminded of the terms of his promises. Even so, the abbey's builders procrastinated, 'more interested in their own riches than in Jesus Christ'. William himself, although decisive when aroused, was too busy for the most part to intervene. With its roughly circular estate (the *banlieu*) – one league from the church to every compass point – Battle's geometrically imposed endowment caused problems from the start. All was improvisation, even the small town at the abbey's gates growing, as it were, by the merest happenstance:

> . . . the building of the church by now making headway, a great number of men were recruited, many from neighbouring districts and even some from across the sea. The brethren who were in charge of the building began to apportion to individuals house-sites of definite dimensions near the boundary of its site. These, with their customary rent and service, can be seen to have remained to this day just as they were then arranged.[70]

And so, much as the chronicler saw them, they still do.

Characteristically, Battle's religious allegiance had also been determined by pure chance. A former soldier, become a monk of Marmoutier on the Loire, had been present when the duke made his vow. Although himself from Touraine, William 'the Smith' had joined the Norman army 'when news of the duke's invasion of England was spread about . . . in the hope of profit for his church'. Seizing his opportunity, Brother William 'immediately he heard the vow . . . acted to make sure that everything went in accordance with it: he suggested that the monastery be founded specifically in veneration of the blessed Bishop Martin' (the soldier-saint of Marmoutier's own dedication), to which Duke William 'good naturedly' agreed.[71] 'In those days,' said the chronicler, Marmoutier 'was especially famous for the quality of its monastic life'. He spoke as advocate, of course. And the monks of Marmoutier who first settled Battle had no evident mission to disseminate that quality overseas. Hidden in their Sussex wilderness, out of which in due course they built a profitable estate, they kept the king's conscience in solitude. But Duke William was something of an expert in monasticism. He would not have listened on the battlefield to William the Smith, much less yielded afterwards to the monk's 'assiduous' reminders, had he not thought well of Marmoutier. The root of his confidence was Cluny.

Marmoutier, in Touraine, was no direct dependency of the great Burgundian abbey. But like many French communities – including some of the best of the Norman monasteries: Jumièges and Fécamp, Séez, Conches and Mont-Saint-Michel – Marmoutier owed its discipline to the precepts of Cluny, to which it had only recently been exposed. It had been Cluny, through William of Dijon, abbot of Fécamp, which had inspired the original Norman monastic reform, launched at the very start of the eleventh century. Even earlier, by way of Fleury, Cluny's influence had been felt in England in the mid-tenth-century reforming programme of Archbishop Dunstan and his episcopal associates. Like all such reforms, what had been stressed on each occasion was a return to the Rule, a restoration of discipline, and a regularization of the liturgy. These continued to be the message of Cluny which, its long history notwithstanding, had never been as strong as it became during the influential abbacy of Hugh of Semur (1049-1109), an aristocrat of the purest blood, invested during his lifetime with an 'aureole of veneration' unmatched by any churchman of his day.[72]

The precise moment at which the Conqueror turned to Abbot Hugh is far from clear.[73] If William found Marmoutier's links with Cluny reassuring, his first loyalties were to the indigenous Norman reformers of Bec and its affiliates, including his own Caen, where direct Cluniac influence was least strong. However, nobody in the king's position could have remained uninfluenced for long by the still growing reputation of Cluny. And it was inevitable that both William and Lanfranc, archbishop of Canterbury and former prior of Bec, should resort in their turn to the great Abbot Hugh for assistance in their problems of recruitment. Abbot Hugh took his time. Understandably reluctant to risk his monks at sea, he must have heard the story of Battle's loss of its first abbot, Robert Blancard, 'about to land in England when, by God's inscrutable judgement, the waves were whipped up and he was swallowed into the savage waters'.[74] Hugh was concerned, too, for the safety of his Cluniacs in a conquered and alien land. Only later, when a secure Norman presence had at last been established, did he allow himself to be persuaded to play his part, even then imposing harsh conditions on would-be benefactors.

It is a measure of Abbot Hugh's reputation that he got exactly what he wanted. Yet he knew little of England, and what he prescribed was not necessarily for the best in every circumstance. One achievement, though, was especially notable. Most architecturally sensitive of all their kind, the Cluniacs put their stamp on English monastic building, establishing new standards for their day. After

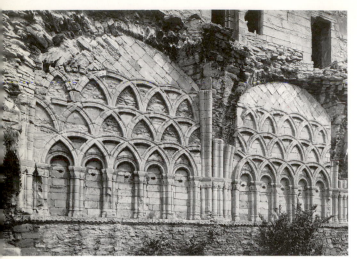

24. High-quality blind arcading in the former chapter-house at Much Wenlock, a Cluniac community introduced to Shropshire by Roger de Montgomery, first earl of Shrewsbury.

26 (right). Although laid out at full length from the start, only some four bays of Norwich's great nave had been completed before Bishop Losinga's death in 1119.

25. Bishop Herbert Losinga began his new cathedral soon after the transfer of the see to Norwich in 1094; this vaulted ambulatory, at the east end of his church, was probably ready by 1101.

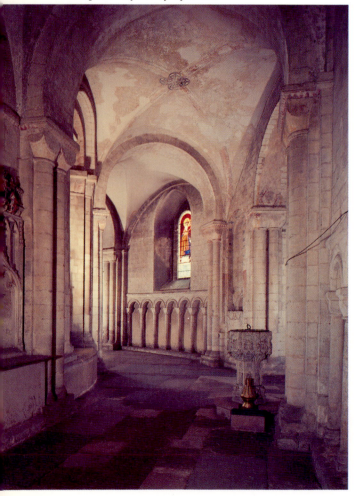

Lewes and Castle Acre, Pontefract, Thetford and Much Wenlock, none could remain in doubt about what constituted the ideal monastic plan. Abbot Hugh's vast basilica at Cluny, just then in the course of reconstruction, was exactly repeated in all but scale by William de Warenne's ambitious priory church at Lewes, first and always richest of the English Cluniac houses.[75] Lewes had the double transepts and multiple apses of Hugh's Cluny III, completed by Peter the Venerable. With only one pair of transepts but many altar-holding apses, the churches of the Warennes' Castle Acre, of Robert de Lacy's Pontefract, of Roger Bigod's Thetford, and Roger de Montgomery's Wenlock, were again grand buildings, almost identical in plan. All were accompanied by residential quarters of standard layout, built to surround a generous cloister. Each, in the east range, had a chapter-house and first-floor dormitory; each, across the south, had a big refectory. Closing the cloister, along the western range, might be prior's lodgings, guest accommodation and stores.[76]

Cluny's architectural model invited imitation, and arrangements like these, although rare in England before the Conquest, very soon became accepted as routine. But Cluny's message in other ways was less consistent than the pattern of its buildings. Too often, Cluniac monks were to be invited to England not for their quality but for their race. Like the monks of Fécamp, of Séez, Jumièges or Bec, they lacked an 'English dimension'.[77] And while this Frenchness was what initially recommended them, a longer-term consequence was the isolation of the Cluniacs, carrying the stigma of alien allegiance. Abbot Hugh's lack-lustre cooperation in their English settlement was certainly no help. When William de Warenne, in the late 1070s, promised Abbot Hugh a newly-built church with other endowments at Lewes sufficient to support a community of twelve, what he got was a party of just three monks, one of whom was almost instantly recalled. Reassured by additional guarantees, Hugh eventually relented. But Cluny's claim to Lewes had been all but sacrificed, in the interval, to the Angevins of Marmoutier. And the Cluniacs' lack of system in their English colonizations, fronted (as at Lewes) by diminutive founding parties, continued to expose them to random growth, determined more by whim than by strategy.[78]

In point of fact, Cluniac monks in the Conqueror's England contributed less to the Normanization of the Anglo-Saxon Church than either William or Lanfranc might have hoped. Early in the next century, successive waves of monastic colonization would indeed break over England. But the Cluniacs had no place in that company. They constituted the best of an old world, and were in no sense the pioneers of a new reform. Influential throughout the Christian West, Cluniac principles pervaded much of Lanfranc's thinking. Along with the customs of his own house at Bec, they feature in the *Consuetudines* of Christ Church, Canterbury, which Lanfranc compiled for the instruction of his monks. 'We send you,' he had said, 'the customs of our monastic life which we have compiled from the customs of those monasteries which in our day have the greatest prestige in the monastic order.'[79] Lanfranc's collections were eclectic, making room for Cluny's teachings as for those of Bec, although significantly ignoring Cluny's earlier contribution to the Anglo-Saxon *Regularis Concordia*. Through the archbishop's *Consuetudines*, as more directly through the churches and other buildings of their own communities in England, Cluniac architectural principles were disseminated. But such education was slow; it could not be arbitrarily imposed. To the normal delays of the building process were thus added the hesitations of sluggish communities, reluctant converts to change. At least one Norman bishop, attempting to force the pace, was driven to extreme exasperation by his monks. 'Behold', exclaimed Herbert Losinga at Norwich,

the servants of the king and my own are really earnest in the works allotted to them, gather stones, carry them to the spot when gathered, and fill with them

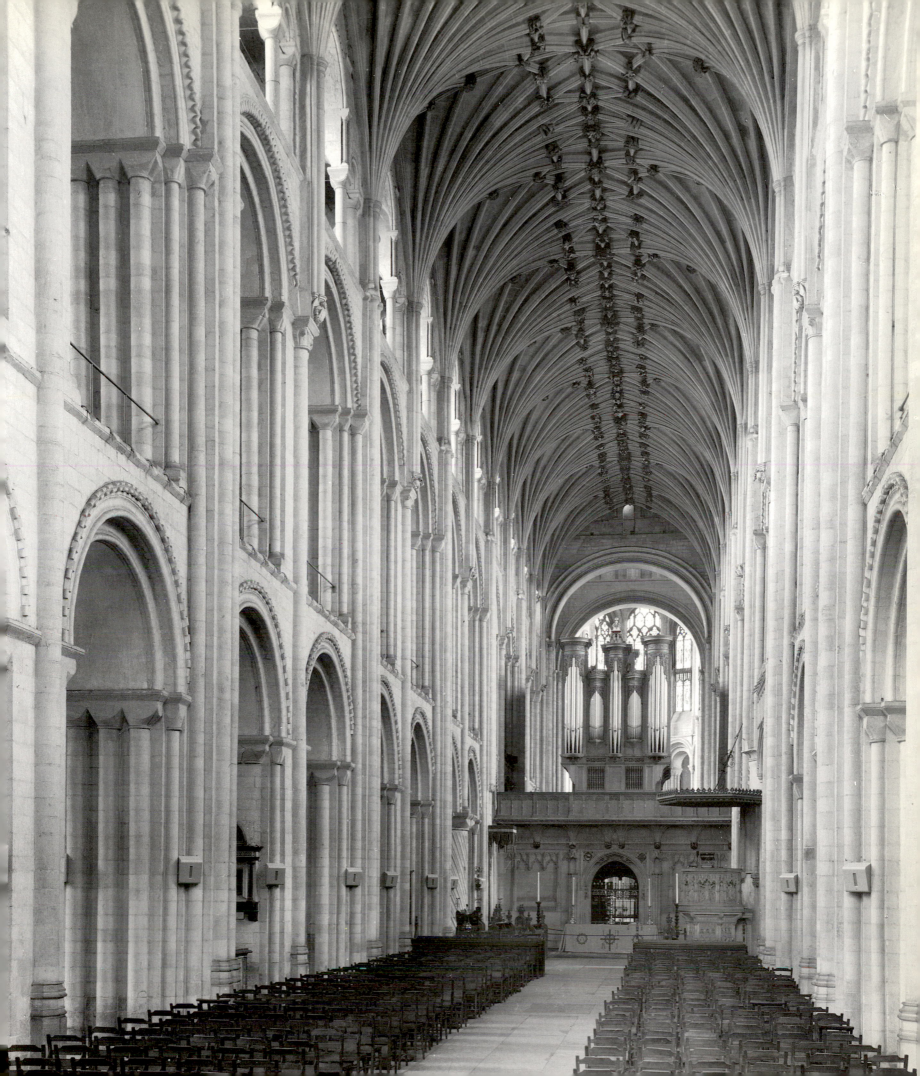

the fields and ways and houses and courts, and you meanwhile are asleep with folded hands, numbed as it were, and frostbitten by a winter of negligence, shuffling and failing in your duty through a paltry love of ease.[80]

The monks at Norwich were recently assembled. They were the guardians of the newest of the cathedral priories, founded by Bishop Herbert himself. If they felt this way, the situation at the major pre-Conquest houses could scarcely have been any better. These too had been influenced by Cluny. They had learnt to live by the precepts of St Dunstan's *Regularis Concordia* (*c.* 970), implemented by vigorous reforming bishops, Ethelwold of Winchester and Oswald of Worcester. During Edgar's reign (957-75), many had been reformed or founded anew in Fleury's image. Subsequently, the better governed had assembled huge estates which had never been more extensive than on the eve of the Conquest – on that day, to quote the Domesday formula, when 'King Edward was alive and dead'. Ely was one of them, re-founded by Bishop Ethelwold and so richly endowed as to offer pickings irresistible to the Normans. Twenty years later, on the Domesday reckoning, the monks of Ely had lost all but a quarter of their former dependants, never fully to recoup those losses.[81] Another of Ethelwold's houses, the wealthy abbey at Peterborough, had enjoyed great prosperity – a truly 'golden' time – under its well-connected superior, Abbot Leofric (1052-66). In 1070, Peterborough's first Norman abbot, Thorold of Fécamp, took office.

Then a monastery that had once been very rich was reduced to penury For the same abbot Thorold not only added nothing, but he badly broke up his compact estate, and gave lands to his kinsfolk and the knights who came with him, so that scarcely one third of the abbey estate remained in demesne. When he came the abbey was valued at one thousand and fifty pounds, which he so squandered that it was scarcely worth five hundred pounds.[82]

It had been Ely's misfortune to be caught up in Sweyn of Denmark's raid in the spring of 1070 and in the associated rebellion of Hereward the Wake. And it was the comparatively low profile of Ely's smaller neighbours, Thorney and Crowland, which kept them relatively immune from these disorders.[83] Yet even they experienced heavy losses during the post-Conquest decades, and it was the rare Anglo-Saxon community which could hope to share in the windfall profits of the invasion. Many, like Ely, lost more than they would later recover. A few, even in the short term, might be luckier. At Westminster Abbey, under Norman rule, the full intended endowment of the late king, Edward the Confessor, never came the way of his monks. Westminster lost, in less sympathetic times, the promised reversion of Martinsley, in Rutland, which it was to have had on the death of Queen Edith. Another rich estate, at Islip in Oxfordshire, became the scene of a long legal battle, not resolved until 1203. But Westminster, at least, had compensations. It used the bargaining power of its manor at Windsor, wanted by the Conqueror for afforestation, to secure Battersea and Wandsworth, Feering and Ockendon, lifting the community into that 'top flight of monastic wealth' on which the Confessor had indeed wished to place it.[84] Over those same difficult years, Bury St Edmunds never ceased to prosper under the leadership of Baldwin of Chartres (1065-97). Baldwin had been the Confessor's physician. He later treated the Conqueror, Archbishop Lanfranc and William Rufus, among others. Not only was he able to protect Bury's estates through the post-Conquest disorders, but he developed them and left them in good condition. Baldwin laid out the new town at Bury; he rebuilt the abbey's church and contributed generously to its library; he promoted the cult of St Edmund. In those days, William of Malmesbury later claimed, Baldwin 'renewed everything both within and without'. To Hermann, his biographer and one of his monks, Baldwin was 'the true father and illustrious restorer of his house'.[85]

Among the predators fought off by Abbot Baldwin were the bishops of Thetford, Arfast and Herbert Losinga, whose desire to move their see to a more appropriate location had caused them to hunger for the riches of Bury St Edmunds. Such transfers of sees – Bishop Osmund's earlier move from Sherborne to Sarum had been another – were characteristic of Lanfranc's post-Conquest rationalizations. By and large, they made excellent sense. But there was little to be gained by associating monks with the new cathedrals if they brought with them no initial endowment. After failing at Bury, Bishop Herbert's next move to Norwich, where he established a cathedral priory of his own in the mid-1090s, was of no more than limited success. Patrons, preoccupied with their own foundations, were hard to recruit.[86] At no time did the monks at Norwich accumulate more than half the riches of their older-established brethren at Bury. They remained, as Abbot Baldwin had no doubt feared, perpetually in competition with their bishop.

Baldwin anyway, like others of his race, had no experience of the monastic cathedral back home in France, and may well have viewed it with suspicion and antipathy. Such cathedrals had once been used as missionary outposts by the Carolingians. But they had since become secular, and it was only in England that the practice had been revived by the monastic reformers of King Edgar's reign: by St Dunstan at Canterbury, by St Ethelwold at Winchester, and by St Oswald at Worcester, with Sherborne following suit in 998 under St Wulfsin (Bishop Wulfsige III).[87] Within a decade of the Conquest, Bishop Osmund left his monks behind at Sherborne, removing to Sarum where he preferred the company of secular canons. Bishop Walkelin of Winchester may well have hoped for a similar result, engaging in bitter warfare with the monks of his cathedral priory from the moment he took office there in 1070.[88] Archbishop Lanfranc, in contrast, found good in the institution, or at any rate had no faith in the alternatives. At Christ Church, Canterbury, he kept his monks, using his influence to protect their brethren at Winchester. By 1133, when the last cathedral priory was founded at Carlisle, there were ten such institutions in England, each one of them potentially a minefield. Another of the Norman leadership's pragmatic solutions, while manifestly successful in the medium term, brought little but confusion in the long.

Lanfranc had before him the model of Worcester, harmoniously governed by its then prior, Aelfstan, in cooperation with Bishop Wulfstan, his brother. Wulfstan had been the previous prior of Worcester. A near neighbour was the equally distinguished Abbot Aethelwig of Evesham. In monks like these, Anglo-Saxon spirituality established its worth, to inspire at Evesham the only significant missionary endeavour of the Conqueror's reign: the resurrection of the shrines of the North.

These shrines were well known from the remarkable account of them, still widely read, in Bede's eighth-century *Historia Ecclesiastica*. Bede wrote his *History* before the destruction of the northern monasteries by the Danes. He had been a devotee of St Cuthbert, one-time bishop of Hexham and Lindisfarne, whose 'works of virtue, like those of the apostles, became an ornament to his episcopal rank'. And he spent his entire life as a monk of Jarrow, having moved there as a boy from neighbouring Wearmouth. All these centres of Northumbrian devotion became shrines in due course, another being the ancient abbey on the cliffs at Whitby, reputed especially for the quality of religious life under its first abbess, St Hilda (d.680), when 'after the example of the primitive church, no one was rich, no one was in need, for they had all things in common and none had any private property'.[89] Those principles had become dimmed before the Danes sacked Hilda's abbey in 867, bringing religious life at Whitby to an end for two centuries. Nevertheless, the memory of Whitby's prime had been kept fresh in Bede's writings, and it was the sad desolation of the abbey's ruins which

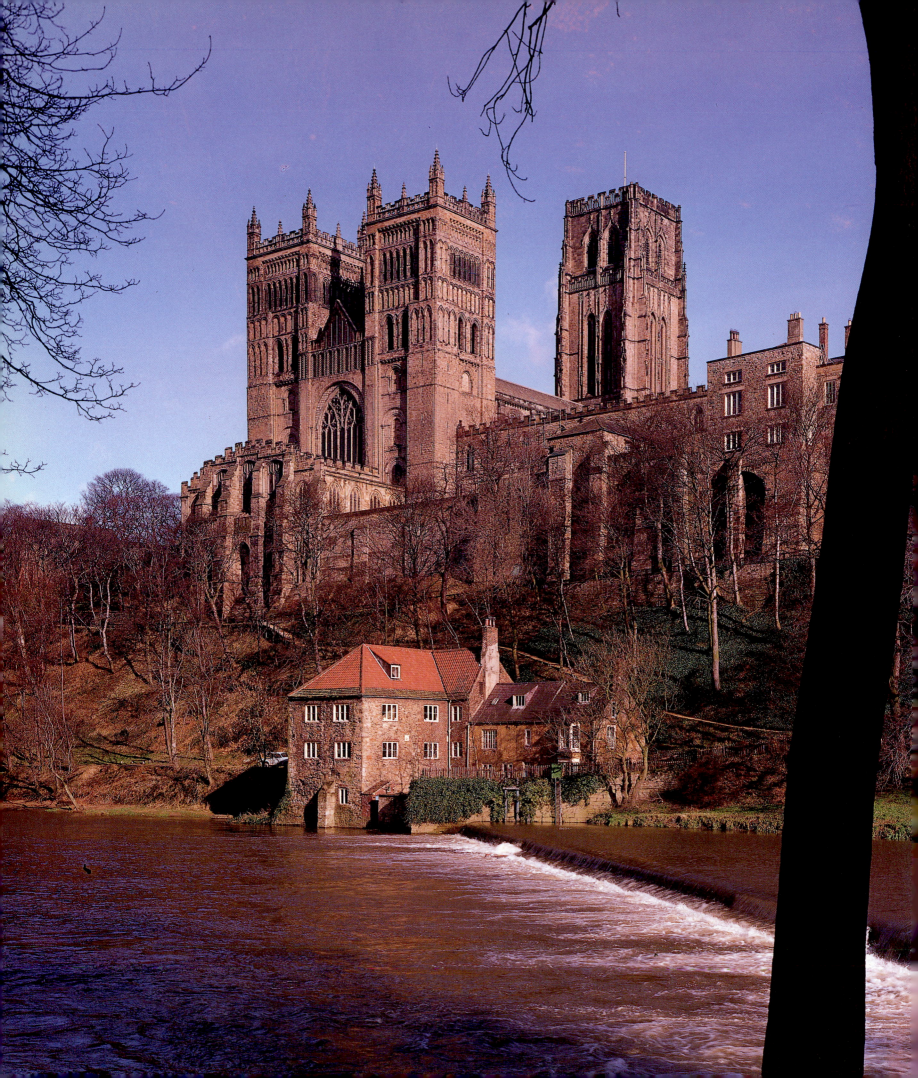

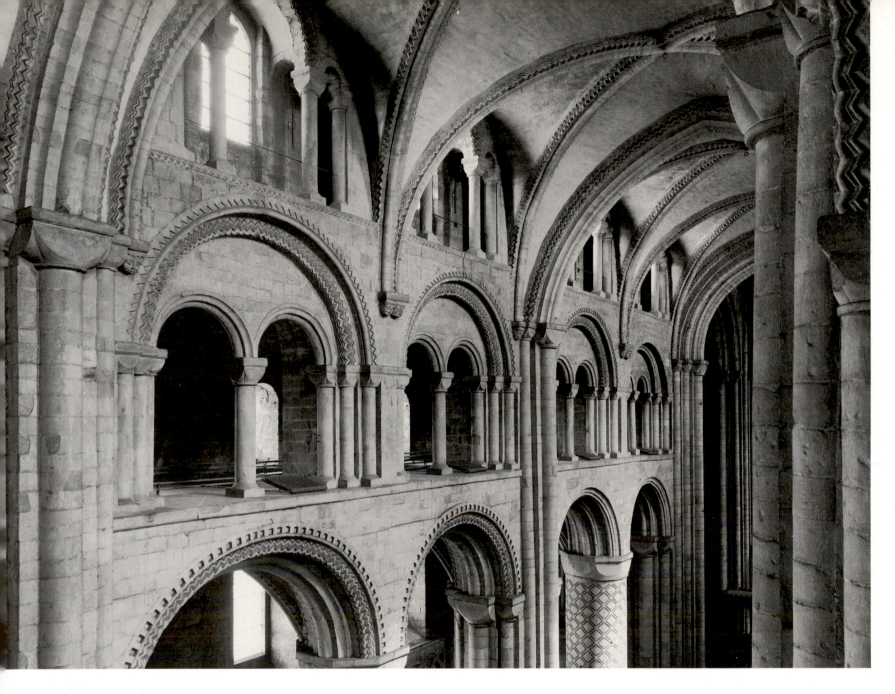

caused one witness, the Conqueror's knight Reinfrid, to lament that loss and to resolve on some form of renewal. Shortly after his experience, Reinfrid entered Aethelwig's community at Evesham, making converts to his idea of a return. And within ten years he was back at Whitby, which he re-founded in 1078. Reinfrid had set out for the North some five years earlier with two companions, Aldwin of Winchcombe and Aelfwig of Evesham. Together, they began a comprehensive northern resettlement, treading in Bede's footsteps, which took in Wearmouth (1075) and Jarrow (before 1083), Lindisfarne (1082) and Hexham (1113). They colonised Tynemouth (1083) and St Mary's, York (1088). At Durham, their example was influential in persuading Walcher, first Norman bishop and himself a reader of Bede, to consider reinstating monks at his cathedral. Murdered in 1080, Bishop Walcher never achieved that ambition. And it was his successor, William of St Calais, who brought monks to Durham in 1083, recruiting them from Wearmouth and Jarrow. Exactly ten years later, Bishop William laid the foundations of Durham's great cathedral, most important of the surviving monuments of the Norman settlement.[90]

William of St Calais' cathedral church at Durham was no bigger overall than its contemporaries. It was neither as elaborate as Bishop Walkelin's Winchester,

28. Rib-vaults of *c*.1130 in the nave at Durham, continuing the earlier vaulting (pioneering the method) of the chancel.

27. Durham Cathedral, seen from the south-west, on its promontory overlooking the River Wear.

25

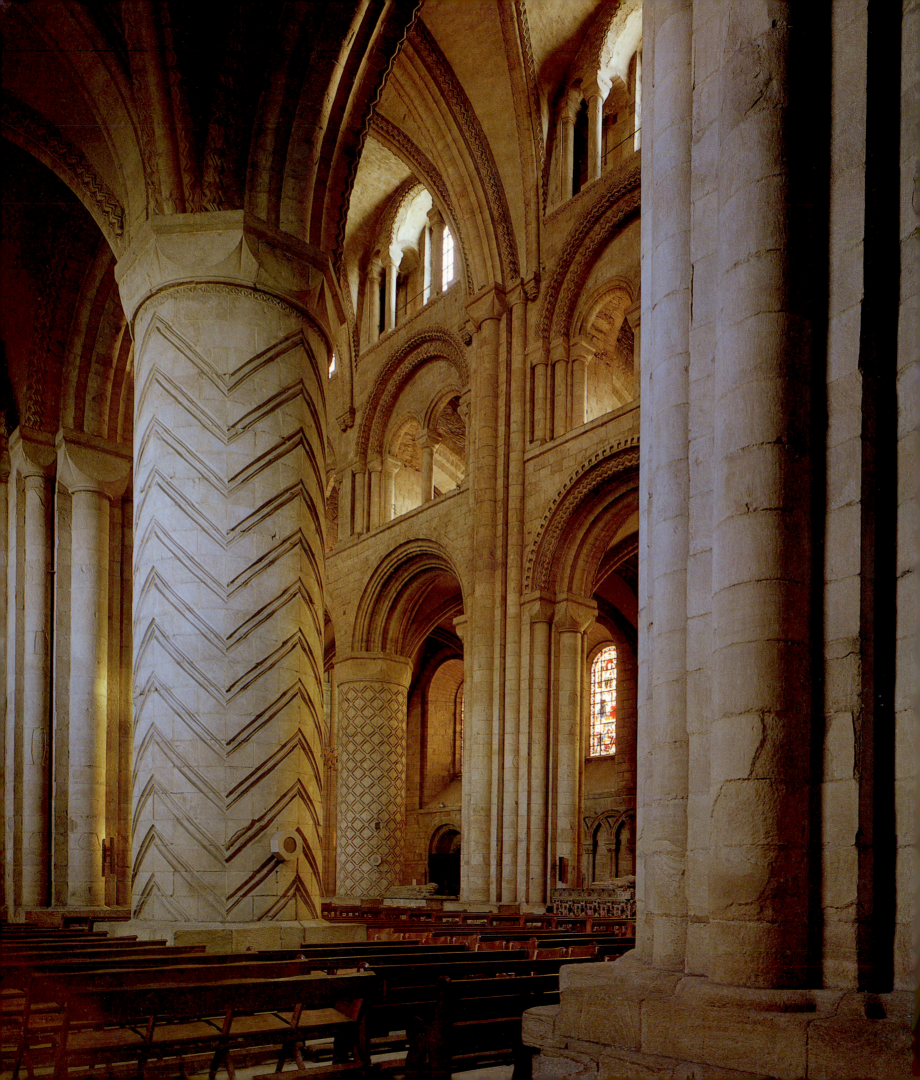

nor as long as Herbert Losinga's Norwich. Yet the situation of Durham was (and remains) quite exceptionally dramatic. Furthermore, the cathedral's relatively late starting-date enabled William of St Calais to draw on first-hand knowledge of many major churches, both in south and central England and on the Continent. Not all these churches were equally well crafted. Against Durham's 'niceness' of proportions may be opposed the muddle of contemporary Gloucester, or the even cruder Tewkesbury, with their absurdly ill-considered triforium galleries. Nor had the buildings of the Conqueror and his clergy been remarkable for innovation, their distinction lying rather in their size. Durham again stands apart. Here, for the first time in Northern Europe, ribbed vaults were pioneered as a complete roofing system, in place of the relatively unsophisticated stone tunnel vault or timber ceiling. Only at Durham, excellently proportioned and expensively roofed, did Anglo-Norman architecture of the immediate settlement period rise unquestionably into the very highest rank.[91]

Durham, in the mass, is a Norman building. Yet there are elements within it which are arguably English, among them ornamental detail and decorative effects which were to be imitated at churches as far apart as Herbert Losinga's Norwich, as Selby and Waltham, Lindisfarne, Dunfermline and Kirkby Lonsdale.[92] In other ways, too, a marriage of the cultures had occurred. From its beginnings in 1093, the great cathedral took only forty years to complete. It owed this despatch to the benevolent shade of St Cuthbert of Lindisfarne, whose incorrupt body, 'not only unspoiled and whole but even pleasantly warm to the touch', was the most famous relic of Anglo-Saxon England, freely accepted as such by the Normans.[93] St Cuthbert's new shrine was ready for him at Durham by 1104. His monk custodians, from this time forward, had no more potent weapon in their armoury.

Veneration of the saints was something in which men of all races could participate. When Stephen of Whitby re-settled Lastingham soon after 1078, he lost no time in building a fine crypt for the relics of St Cedd (d.664), monk of Lindisfarne and missionary bishop of the East Saxons. Yet within ten years, Stephen had moved on again to York, leaving just the crypt of the projected great church which was to have done honour to St Cedd and all his works. At Worcester, similarly, Bishop Wulfstan began his new cathedral with an expensive crypt, intended chiefly for the relics of St Oswald, the tenth-century reformer. While nothing as grand had been built in England before the Conquest, the relic-holding crypt was already well established, from its earliest examples at Ripon and Hexham, to Repton, Brixworth and Wing.[94] The Normans saw nothing there to dispute. Walkelin's crypt at Winchester, like Wulfstan's at Worcester, celebrated an earlier English holder of his office. And it was chiefly English relics which packed the new crypts of the great Norman churches at Thomas of Bayeux's York, at Abbot Scotland's Canterbury, at Gundulf's Rochester, or Serlo's Gloucester Abbey.

Under the guidance of the saints, healing might come in many forms, not least of its agencies being prosperity. In the alien company of great French noblemen – of William de Warenne, Roger Bigod, Robert de Lacy and Roger de Montgomery – likewise patrons of the Cluniacs, a wealthy Englishman and Londoner, Alwyn Child, became a major benefactor of La Charité-sur-Loire, joint founder (with William Rufus) of Bermondsey Priory.[95] Catastrophe leaves scars, those of the Norman Conquest being as difficult to remove as any other. But the condition itself is rarely permanent. When the first Cluniac monks arrived at Bermondsey in 1089, they came there from La Charité at the bidding of an Englishman. Reconciliation of a kind was on its way.

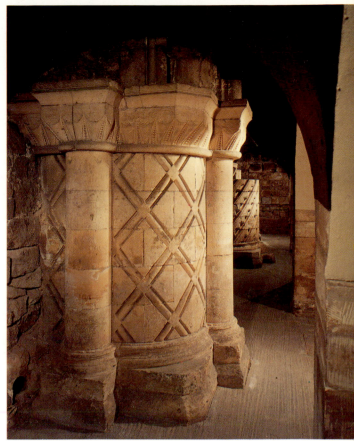

30. Piers in the twelfth-century undercroft at York Minster, ornamented in the distinctive Durham style.

29. (left) The nave arcade at Durham Cathedral, showing the varied ornament of the piers.

31. Bishop Wulfstan's late eleventh-century relic-holding crypt at Worcester Cathedral.

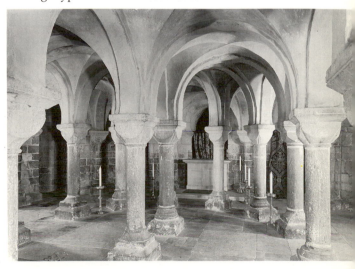

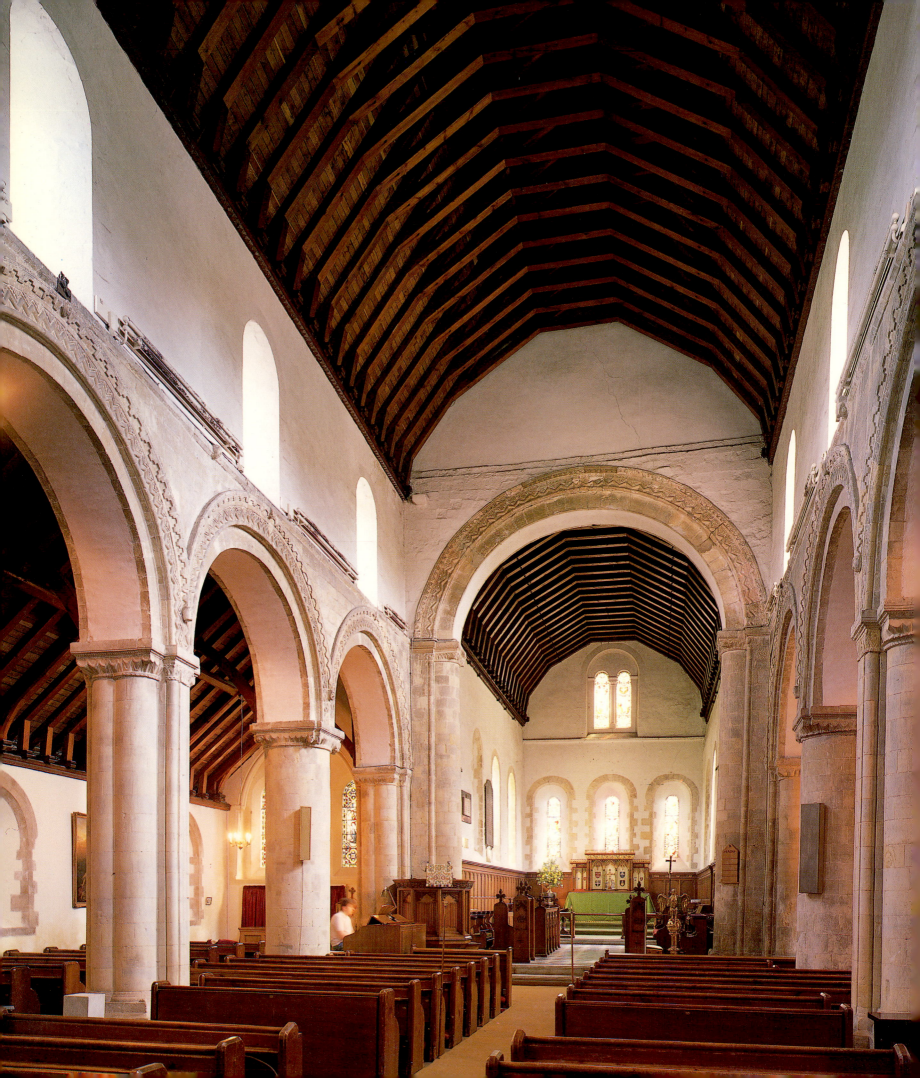

CHAPTER 2
New Directions

Church and castle, companions of the Conquest, are sometimes seen as equal instruments of oppression. And so, indeed, they must have seemed in the case of the alien priories. However, the parish church was another matter altogether. Some parish churches were sited within castle baileys: English Bicknor, Castlethorpe, and the first stone church at Castle Rising among others. Many, including Amberley and Haughley, Beverston and Kilpeck, Lympne, St Briavels and Moreton Corbet, were either drawn to the protection of a castle or manor house, or had themselves been the occasion for its placing. But it was not the parish churches as such that were under attack. If English priests felt threatened, as many did, it was less physical violence that they had to fear than the reforming attentions of their bishops.

That reforming zeal had little to do directly with the Normans. It had originated in the papacy at Rome, just then engaged in a damagingly personal confrontation with the German empire. And its driving force was an accelerating demand for clerical independence and for freedom from all lay interference. At the highest level, the issues were fought out in the Investiture Contest between pope and emperor, where what was at stake was the free election of bishops. But the principle of clerical immunity, once accepted on that plane, moved inevitably down into the parishes. Within scarcely more than a generation of the Conquest, laymen were to find it increasingly difficult to retain a financial interest in any church. When William de Warenne, settling there for the first time, had built a new stone church at Lewes below his castle, he believed himself entitled to grant it away freely where he wished.[1] Yet his son, as early as the mid-1090s, would already be taking another view, conveying outright to Lewes Priory those churches and tithes 'which I could not myself keep in my own hand or have at my disposal'.[2] Much later, Robert of Leicester (d.1190) told the story of his father's gift of the tithes of Sopwich and Ringston to the Norman monks of Lire. 'Ever since the Normans subjugated England,' he explained, 'my ancestors were always accustomed to give these tithes to whomever they wished.' His grandfather, Robert of Meulan, first earl of Leicester, had given them initially to Préaux Abbey, but had taken them back when the monks repeatedly complained that 'the violence of his officials made it so difficult to collect the tithes that they derived small benefit from them'. Robert II (1104–68) had likewise begun by treating the tithes as private property, until 'at last, being a just and devout man, he followed wiser counsel and was unwilling to use them for himself any longer, since he realized that they had once been tithes'. Earl Robert's solution was to give his father's tithes to the priests of his household – to Peter, his doctor, and then to Adam of Ely – afterwards donating them in perpetuity to the monks of Lire, which he confirmed 'in writing and by his seal' at the request and in the presence of his son.[3]

Transfers of this kind were not new. They had occurred before, but had been undertaken in the belief that the parish church, like any estate, remained essentially private property. One of the earliest records of such transactions occurs in the archives of Christ Church, Canterbury. It lists, among other rents and interests, the London churches which, by 1100, had become the property of the cathedral priory. And what it establishes is a steady trickle of formerly private churches into the hands of the monks.[4] Some of this movement had patently begun by the 1050s. It could have started much earlier, but took on new meaning under pressure from the Church and as a parochial system took shape. That

32. The parish church of St Margaret's at Cliffe, rebuilt on a grand scale in the 1140s shortly after the patronage of the mother-church at Dover was granted to Canterbury Cathedral Priory.

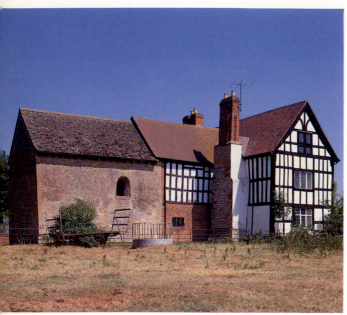

33. Attached to a later farmhouse, Odda's Chapel (Deerhurst) still preserves a private church or oratory of the immediate pre-Conquest generation, dedicated in 1056.

34. The surviving chancel arch at Odda's Chapel.

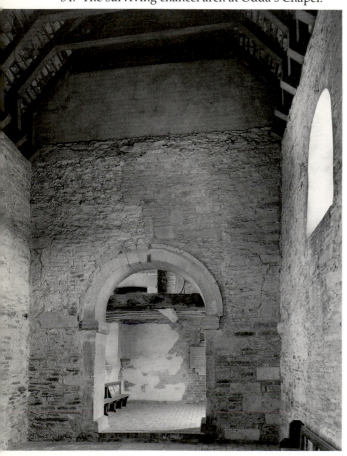

system, in one of its transitional stages, is again well displayed in another document from Canterbury Cathedral. The *Domesday Monachorum* of Christ Church (Canterbury) is a survey of the early twelfth century. It records, even at that date, the continuing dominance of the old Kentish baptismal churches, to which satellite chapelries attached. Both the number of the dependent chapelries and their distribution were at variance. Whereas St Martin at Dover had many dependencies, as did the greater minsters at Lyminge, Maidstone and Lympne, the baptismal church at Teynham had just four satellites and Charing only one. Some of these dependencies bore the names of their donors – of Siwold and Aelsi, Blaceman and Ordgar, all of whom had given churches to Lympne. Others were known simply by their dedications. But most were now called after the communities they served, among them Maidstone's Headcorn and Goudhurst, Marden and Boxley, Frinsted, Hollingbourne and Boughton Malherbe. A village church, shaped out of the field church or private chapel, had become the natural focus for each parish.[5]

The definition of the parish was the work of centuries. Inevitably, it created anomalies. Obvious among these was the uneven status of the Kentish minsters, some of which survived as major churches, others being reduced to insignificance. The same was true all over the country. It was their early role as minsters, not any later dignity, which explains the monumental quality of Brixworth and Repton, Wing, Stow and Worth. None grew significantly bigger in later years.[6] At the far end of the scale, a diminutive pre-Conquest oratory like Odda's Chapel at Deerhurst, while never promoted to parochial status, is typical of the two-cell nucleus – simple rectangular nave and small square chancel – out of which many parish churches then developed.[7] A comparative study of parish boundaries will reveal every kind and degree of inconsistency. Thus the pretty little Cotswold churches of Eastleach Turville and Eastleach Martin, serving distinct hamlets, are separated only by a stream. The Willingales (Essex) are adjoining parishes – Willingale Doe and Willingale Spain – which accommodatingly share the one churchyard. There are two churches again, within the same churchyard, in the Cambridgeshire village of Swaffham Prior. At Reepham (Norfolk), three churches almost touch. Yet the church next to Reepham market-place was not, in point of fact, of the parish at all but of the neighbouring township of Whitwell.[8]

Reepham is the most bizarre of these partnerships. However, the crowding of parish churches was itself not unusual, occurring most frequently in the towns. And what it may preserve is some earlier pattern of secular ownership, following the boundaries of private estates. Manorial churches, already very numerous before the Conquest, had commonly been built on the initiative of a thegn, specifically for his family and his tenants. In the circumstances, there was little to prevent a multiplication of private churches, many of which, in later years, achieved full parochial status. But there was nothing inevitable in a progression of this kind, for the manorial chapel, then as later, was as likely to revert to lay uses. Precious evidence of just such a reversion, hitherto unparalleled, has recently been recovered at Raunds, in Northamptonshire, during the course of a programme of excavations. Today, Raunds-Furnells is an open field, unmarked by settlement, to the north-west of the existing small town. Yet occupation there has been shown to stretch back as far as the late sixth century, one of its phases, towards the end of the ninth century, including the building of a diminutive stone church. Located close to the lord's hall, the church at Raunds-Furnells was plainly intended for private worship. It had the simple two-cell plan of many such buildings, including Odda's Chapel at Deerhurst, with no evidence of any subsequent extensions. Like the Deerhurst chapel, Raunds-Furnells failed to achieve independence as a parish church and was to enjoy a comparatively short life. Redundant already by the early twelfth century, it was rebuilt as the core of a new stone manor house which would extend eventually

across much of the original churchyard. Both the church and the graves given over to its custody were to be lost and forgotten until today.[9]

The significance of Raunds-Furnells is that it shows us unequivocally, at an exceptionally early date, the usual processes of church development in reverse. Raunds' great parish church, within sight of the manor, had stunted further growth beneath its shadow. Similar shake-outs, rationalizing the parishes and cutting back the number of private churches, eventually became necessary in the towns. The cathedral city of Winchester, with its resident bishop, was one of those to undergo some degree of parochial reorganization in the mid-twelfth century. But even so, of the fifty-seven parish churches thought to have been in use in the city in about 1150, all but three survived until 1300. And the first major pruning of the Winchester churches was to be postponed until after the Black Death.[10] In striking contrast to the under-churched new towns of the twelfth century and later – to major market towns or ports like Grantham and Swaffham, Boston, Hull or King's Lynn – the old provincial centres of Anglo-Saxon England bred private churches like locusts. There were the churches of Norwich, over fifty of which were recorded in Domesday, almost all pre-Conquest in origin.[11] Of Worcester's twenty-two churches, at least six (and probably many more) were Anglo-Saxon.[12] Canterbury, again, had twenty-two parish churches in about 1200; London had somewhat over a hundred.[13]

The inevitable consequence of great numbers was small size. London's first churches, beginning life as the chapels of lay proprietors, were as tiny as the parishes they served.[14] The same was true all over the country. Diminutive urban churches, no bigger than the thegn's estate chapel at Raunds-Furnells, which they closely resemble in plan, have been excavated at Winchester and Lincoln, Norwich and York.[15] Another, only recently, was found at Pontefract beneath the urban tenements of The Booths.[16] In almost every case, constricted sites and limited congregations kept these churches small. But their survival rate was strikingly high. Only four of Canterbury's many parish churches, in a city crowded with every kind of ecclesiastical facility, were lost before 1500.[17] And if fully a third of Winchester's churches fell into disuse during the fourteenth century, almost all of this loss occurred after the Black Death, paralleling the reduction of its citizenry. By 1600, Winchester was down to just twelve out of its original fifty-seven churches. Yet the later Middle Ages, far from visiting further poverty on the Winchester churches, had seen them prosper as never before. On Lower Brook Street, the little church of St Pancras, closed in 1526, continued to grow into the fifteenth century, by which time it had acquired a new south aisle. Its diminutive neighbour, St Mary in Tanner Street, while expanding not at all after its twelfth-century rebuilding, nevertheless survived until 1528.[18]

Both St Pancras and St Mary had begun on a tiny scale as the simplest of two-cell 'house' churches. Not long after the Conquest, and in the context of reform, they had each been considerably extended. They had come under the patronage of the cathedral priory, and took their place in the parochial system. Such changes, although very general, need not have been instant. Little, for example, separates an immediately post-Conquest rural church like Chilcomb, in Hampshire, from its Late Saxon models at Boarhunt or Corhampton, within a few miles of each other in the same county. At St Andrews (Fife), as late as the 1130s, the church of St Regulus, built for Bishop Robert, is still Anglo-Saxon in all but the peculiarities of its ornament.[19] Plainly, the simple two-cell plan – sometimes called the 'cellular linear' plan – was too basic not to have its continuators. Yet two things, in particular, distinguish these decades, each at least partly attributable to the Conquest. One was a standardization of ornament at the parish churches, more elaborate and ambitious than before. The other – and the more significant – was a general rebuilding on a much grander scale, usually undertaken in stone.

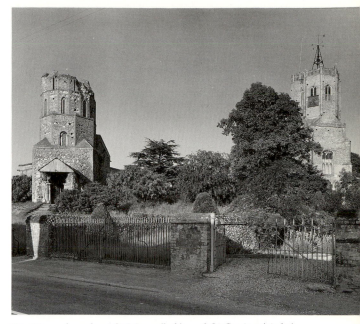

35. Two churches, St Mary (left) and St Cyriac (right), share the same churchyard at Swaffham Prior, in Cambridgeshire, probably marking an early estate boundary.

36. The nave and chancel arch of a little-altered Late Saxon village church at Corhampton (Hampshire), of which only the chancel has been refashioned.

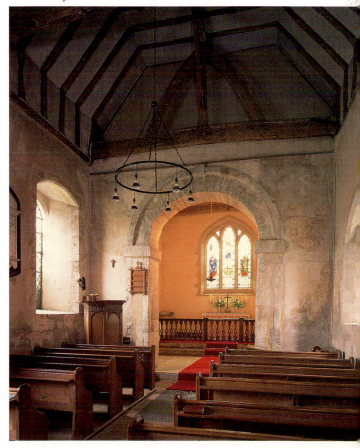

There was nothing new about the use of stone in church-building. We know of many Anglo-Saxon churches, from the minster down to the smallest parish, which were built of stone, and others, no doubt, are yet to be recovered by excavation.[20] Wooden churches, moreover, were never wholly to die out in medieval England, remaining not uncommon in the West Midland counties, where they might cluster (as in Cheshire) at Marton, Holmes Chapel and Lower Peover, all of the Late Middle Ages. Yet the limitations of the material are obvious. Only Greensted, of what must have been many pre-Conquest log-built churches, has survived to this day. And that must be counted something of a miracle. Of the three Cheshire timber-framed churches, each has had to be rebuilt, not once but on several occasions. For all its greater prime cost, the stone church gave promise – or at least prospect – of eternity.

Such a vision, becoming more attainable as Europe prospered, was beginning to seem especially worth pursuing. Bishop Altmann of Passau (1065–91), as his biographer later boasted, had found his churches timber and left them stone, furnishing them especially richly.[21] No Norman magnate, coming to England after 1066, would be willing to settle for less. William de Warenne's passing mention of his new *stone* church at Lewes, as further inducement to Abbot Hugh of Cluny, was no mere slip of the tongue.[22] And the rapidly changing status of many parish churches similarly brought about extensive rebuildings. Thus the notably lavish reconstruction of the parish church at Stoneleigh clearly followed Henry I's grant of its advowson to the wealthy priory of Kenilworth, founded by his official, Geoffrey de Clinton.[23] Stoneleigh's dedication to the Virgin Mary was a firm favourite with the Anglo-Normans. It is shared by Long Sutton, one of Lincolnshire's major parish churches, rebuilt towards the end of the same century. Long Sutton's transfer to the Cluniacs of Castle Acre, the Warenne foundation, is datable no later than 1180. To this end, William (son of Ernis) and his wife, Nicola, had assigned the monks three acres of land in Sutton-in-Holland, 'in the field called Heoldefen next the road, to build a parish church there'. Subsequently confirming the grant, William added: 'And my wish is that the earlier wooden church of the same vill, in place of which the new church will be built, shall be taken away and the bodies buried in it shall be taken to the new church' – all this towards the joint salvation of their souls.[24]

Long Sutton, on rebuilding, was a big church, even before subsequent extensions. Refashioned in stone, it had also been rethought in terms of scale. In the 1140s, St Margaret's at Cliffe, one of the Kentish churches listed in the *Domesday Monachorum*, had undergone a very similar transformation. Cliffe had been a dependency of the neighbouring collegiate minster at Dover, along with other lesser churches of the locality. Yet within scarcely a decade of Henry I's gift of Dover to Christ Church (Canterbury), Cliffe itself was being rebuilt on the grandest of scales, more appropriate to a priory than a parish.[25] Less monumental than Cliffe but more extravagantly ornate, the contemporary parish church at Stewkley, in Buckinghamshire, rivals another former minster, just down the road at Wing, to which it had once almost certainly been subordinate. Barely altered since its building in about 1150, Stewkley remains the quintessential Anglo-Norman parish church, joyously ostentatious and *nouveau riche*.[26]

Building activity in the twelfth century might take many forms. What is obvious is the high investment it required. Amongst parish churches, Melbourne (Derbyshire) is a substitute cathedral, associated with Ethelwulf, exiled first bishop of Carlisle (1133–56). It had a two-tower west facade, most exceptional in a parish church; its aisled nave was equipped with a clerestory, galleried internally like a priory; the chapels on the transepts were finished with apses, setting off the great apse of a tall chancel which rose to the full height of the nave. Melbourne's unusual plan, lacking chancel aisles, is of Germanic origin, paralleled neither in France nor in pre-Conquest England. And the same can be said

37. The log-built walls of the nave at Greensted Church (Essex) are the sole survivors of this pre-Conquest church-building tradition.

38. Festively ornate work of the 1150s at the parish church of Stewkley, in Buckinghamshire.

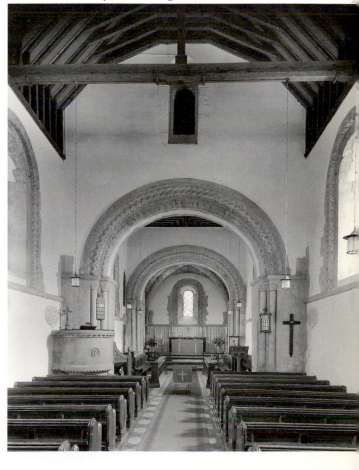

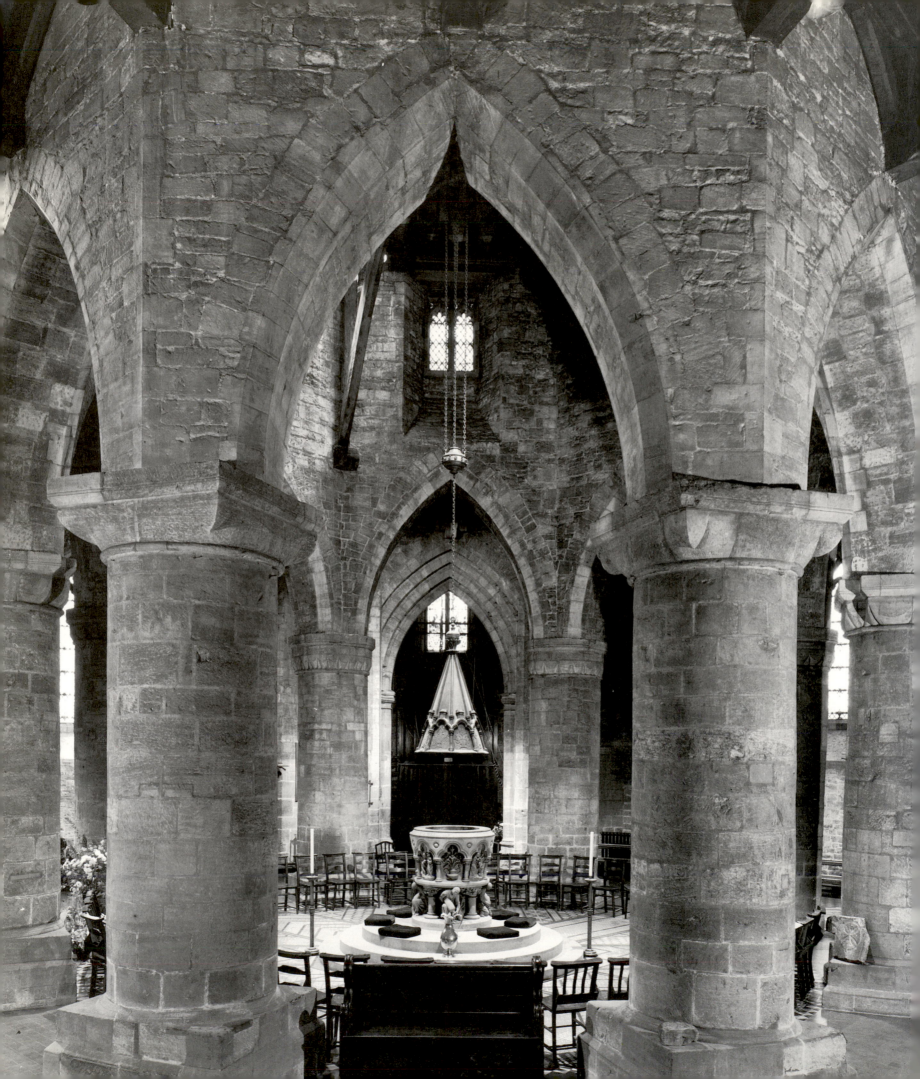

for the much humbler church at Langford (Essex), which has preserved the rare feature of a western apse, once matched by another on the east.[27] Aachen had been the model for Robert of Lorraine's chapel at Hereford, two-storeyed and centrally planned.[28] And there were other contemporary buildings, at least as exotic, in the circular parish churches of Cambridge and Northampton, evocations of the Holy Sepulchre at Jerusalem.

Ultimately, round churches of this kind are thought to have derived from the circular baptisteries of Northern Italy. However, the immediate occasion for such buildings in early twelfth-century England was the recent triumph of the First Crusade (1097–9), hugely significant for the promotion of lay piety. Many contemporaries saw the Crusaders' success as positive proof of the existence of God. Nothing was more likely to spur their devotion, nor to make them dig deeper in their pockets. Cambridge's round church, we are told, was the work of 'Randolf with the Beard', of Robert, of Auger and of 'others of the Fraternity of the Holy Sepulchre'. At Northampton's Holy Sepulchre, similarly datable to c. 1130, both the scale of the work and its excellent quality suggest patronage of an exceptional order. Certainly, this was a time of advancing prosperity at Northampton during which the borough rose swiftly from shire-town status to rank among the most notable of England's twelfth-century provincial centres. [29] Long after that particular economic tide had receded, Northampton's churches continued to carry its mark. Holy Sepulchre Church achieved its effects by an exceptional plan and by the overwhelming bulk of its masonry. The older St Peter's, nucleus of the Anglo-Saxon borough, was remarkable rather for its ornament. St Peter's, too, is of unusual plan. It has the big choir, or chancel, of a collegiate church, which it may yet have been at that period. The alternating piers of its nave arcades, round and quatrefoil, are seldom seen in churches of like status. But it is St Peter's decorative stonework, above all, which is outstanding. In its surviving arcades, a remarkable series of finely carved capitals supports arches enriched with zigzag ornament. Like the Buckinghamshire church at Stewkley, St Peter's (Northampton) is copy-book Anglo-Norman, but of a quality still higher and more costly.[30]

Northampton's major churches, although bigger than most, are not without parallels. Other twelfth-century parish churches – Holt and Rock in Worcestershire, Petersfield and East Meon in Hampshire, Caster near Peterborough, Walsoken in Norfolk, Berkswell in Warwickshire, Iffley in Oxfordshire, and many more – similarly combine ambitious planning with decorative treatments of some expense. At each of these, the ubiquitous zigzag, or chevron, of St Peter's (Northampton) occurs repeatedly in one form or another – on an arcade or a chancel arch, a doorcase or a vaulting rib; sometimes on all of them together. Nor was scale necessarily an inhibition. Some of the most elaborate of Anglo-Norman decorative schemes occur in churches of very small size, one of the finest of these being at Barfreston, in Kent, about midway between Canterbury and Dover. Barfreston Church is datable to the 1180s. Now celebrated chiefly for the quality of its stone-carving, both inside and out, it was once decorated also with a fine cycle of wall-paintings, lost during Victorian restorations. Patrixbourne, nearer Canterbury, was another such village church, slightly later than Barfreston but of almost equal elaboration when first built. Among the characteristics they share is a richly carved wheel window, high in the chancel gable, exceptional in churches of this rank.[31]

Plainly, whatever the source of contemporary investment in the parish churches, there was no shortage of available funds. Kilpeck, in the distant Marcher territory of Herefordshire, was remote from any obvious centre of enlightened patronage. Yet here, before the mid-twelfth century, Hugh de Kilpeck had built himself a church in the most lavish style: a treasure-house of stone-carved ornament in the native Herefordshire tradition, yet as diminutive as the community it served.[32]

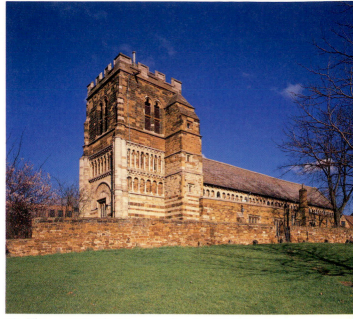

40. The great Anglo-Norman church of St Peter, in Northampton, remarkable for its ornate and costly blind arcading.

39. (left) The round nave and surrounding ambulatory of the parish church of Holy Sepulchre (Northampton), built in imitation of the rotunda of the original Holy Sepulchre (Jerusalem).

41. Carved capitals and zigzag ornament on the internal arcades at St Peter's (Northampton).

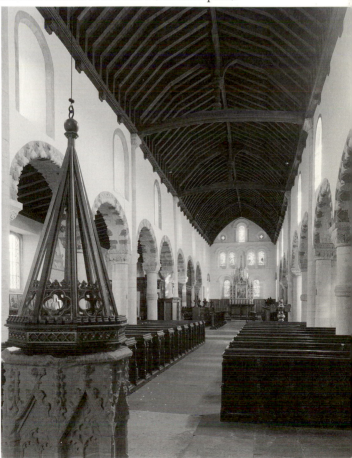

42. The ornate east facade and wheel window of the little Late Norman parish church at Barfreston, south of Canterbury.

44. (right) Parts of a complete early twelfth-century wall-painting scheme on the theme of *Salvation* at Clayton Church (Sussex); over the chancel arch, *Christ in Majesty*, with *Apostles* on each side.
45. (far right) A contemporary related scheme at Hardham Church; in the centre, a *Lamb of God*; in the top panels, an *Infancy of Christ* cycle, starting with the *Annunciation* (right) and ending with the *Massacre of the Innocents* (left).
46. (lower right) *Adam and Eve Tempted*, on the east face of the chancel arch at Hardham Church; the *Beginning of Sin* (in Hardham's chancel) is thus redeemed in this pictorial sequence by the *Birth of Christ* (in the nave).

43. Lavish stone-carving of the mid-twelfth-century Herefordshire School on the south door of Kilpeck Church.

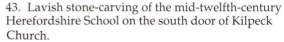

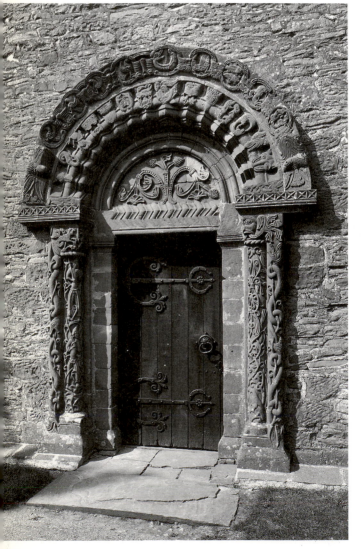

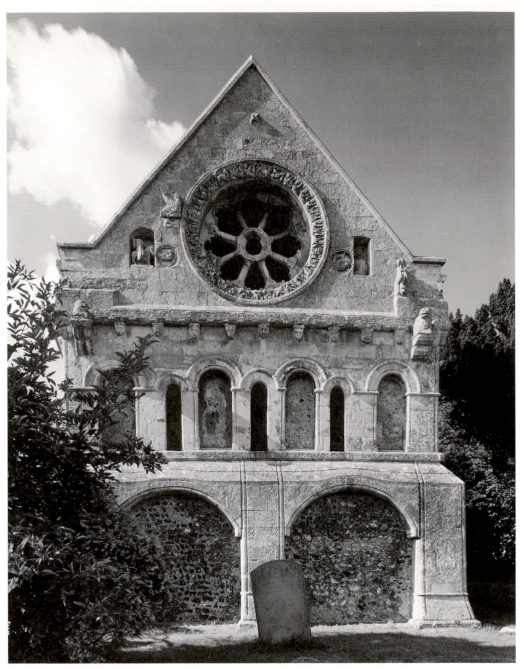

Another notable masterpiece of the so-called Herefordshire School of stone-carvers, datable to about 1140, is the great chalice-shaped font at Castle Frome. It occurs in a church no bigger than Kilpeck and, if possible, even more isolated.[33] In Sussex, similarly, the parish churches at Clayton, Coombes and Hardham are none of any great size. But all have costly schemes of high quality murals, no less choice in their way than the rich stonework of Herefordshire, attributable to before 1120.[34]

These Sussex mural schemes, occurring also at Westmeston and Plumpton, were once thought to have been financed by Lewes Priory. However, local landowning families, the de Briouzes or the Warennes, are just as likely to have been the patrons in this instance. And what plainly supported such benefactions, in the late eleventh and early twelfth centuries, was a rare combination of wealth and devotion, both markedly on the increase through this period. There are many indications in Domesday Book of landowners in the 1080s successfully maximizing their receipts by increasing rents and exacting dues at levels unprecedented before the Conquest.[35] None of this died with the Conqueror. Even

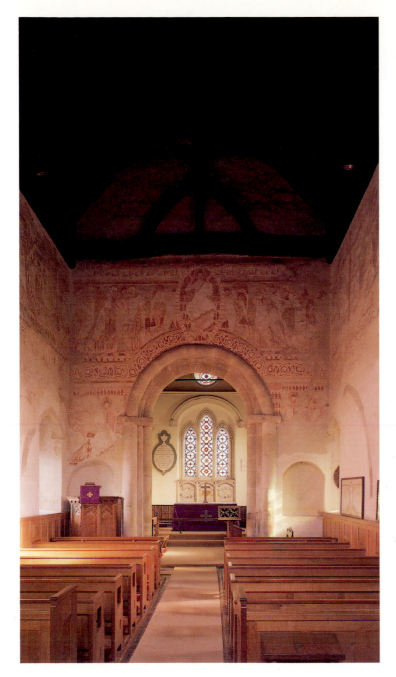

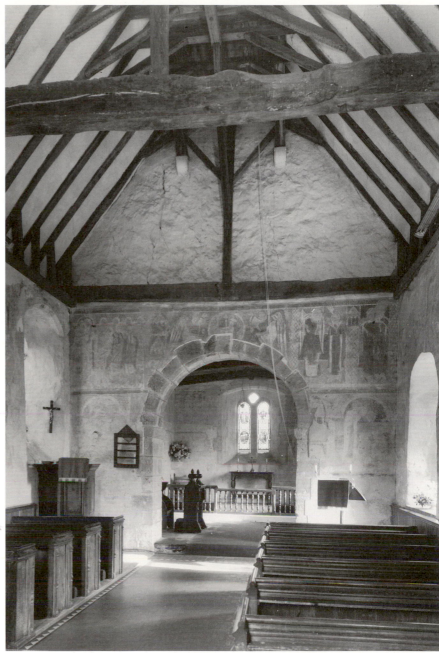

before William's death, some families (among them the fitz Osberns of Chepstow and Carisbrooke) had gambled and lost all that they had won. But others prospered, their numbers increased by those new men whom Henry I, ablest but most shadowy of kings, 'raised, so to speak, from the dust and placed over earls and castellans in power and wealth'.[36] What has often been viewed as a century of economic reverses – fatal for the property-holder, 'tumultuous and distracted', characterized by stagnant rents and splintering demesnes – can now be looked at very differently.[37] The de Briouzes and Warennes, builders of stone churches, were also pioneers in castle-building. Bramber, Lewes and Castle Acre all occur in our first list of stone fortresses.[38]

Others on that list include the big masonry keeps at Pevensey and Corfe, Portchester and Castle Rising, Canterbury and Sherborne, Rochester, Norwich and Castle Hedingham. Indestructibly strong, they exhibit also a significant new emphasis on the care and greater comfort of the person. Rochester's 'noble tower', one of the better preserved of these buildings, is a cheerless skeleton today. Yet it once held lodgings of great style and splendour, furnished there for

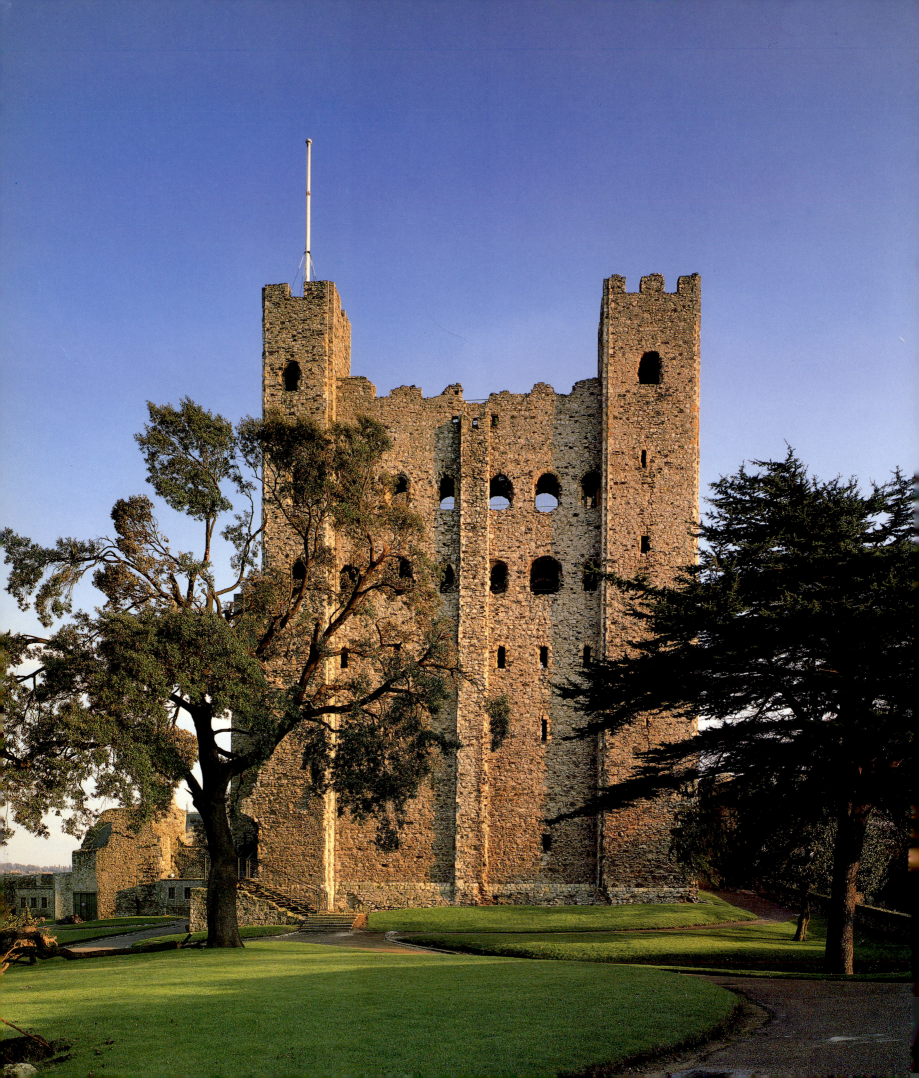

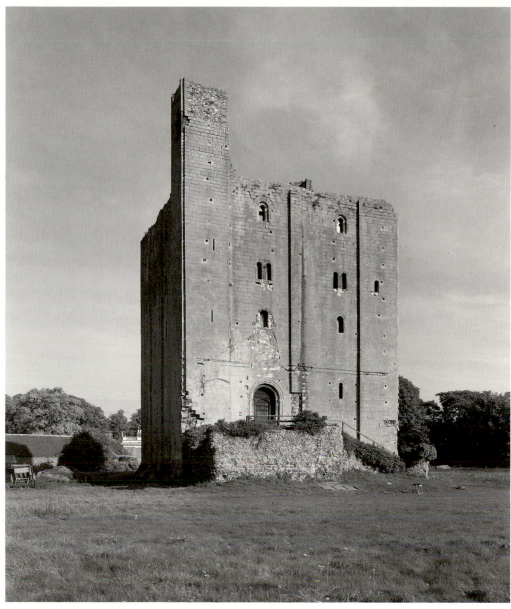

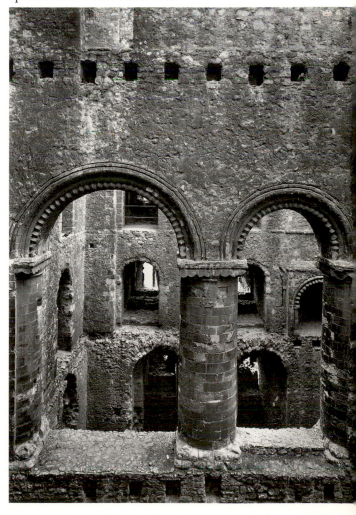

47. (far left) William of Corbeil's residential tower keep at Rochester Castle, built in 1127–36.
48. The tower keep at Castle Hedingham (Essex), built in the 1140s by Aubrey de Vere, first earl of Oxford.

48. The tower keep at Castle Hedingham (Essex), built in the 1140s by Aubrey de Vere, first earl of Oxford.
49. The arcade in the central spine wall of the keep at Rochester Castle, linking the archbishop's state apartments at second-floor level.

William of Corbeil (d.1136). Archbishop Corbeil's residence at Rochester began on the second floor with his state apartments, rising through two stages to give them extra dignity, and equipped, at the higher level, with a mural gallery. Above that again, the archbishop's private quarters included another hall, a bedchamber and personal chapel. Every appropriate surface, on all three stages, was enriched with high-quality roll mouldings and chevron ornament. [39]

The same degree of luxury, clear evidence of their wealth, characterized the de Veres' fortress at Castle Hedingham. The first Aubrey de Vere had come over with the Conqueror, from whom he had obtained great estates. His son, Aubrey II, further advanced the family fortunes as sheriff of many counties under Henry I, before promotion to the hereditary office of great chamberlain. The third Aubrey, created earl of Oxford in 1141, was probably the builder of the surviving keep at Castle Hedingham, least spoilt of the towers of its class. Castle Hedingham and Rochester are almost twins. But at Hedingham, the hall has been made even grander by a huge relieving arch, spanning its full width and doing away with the need for the central spine wall which at Rochester had been pierced by an arcade. Hedingham's many mural bedchambers, its purpose-built garderobes and broad newel stair, made it a residence no less comfortable than the archbishop's and entirely appropriate to an earl. [40]

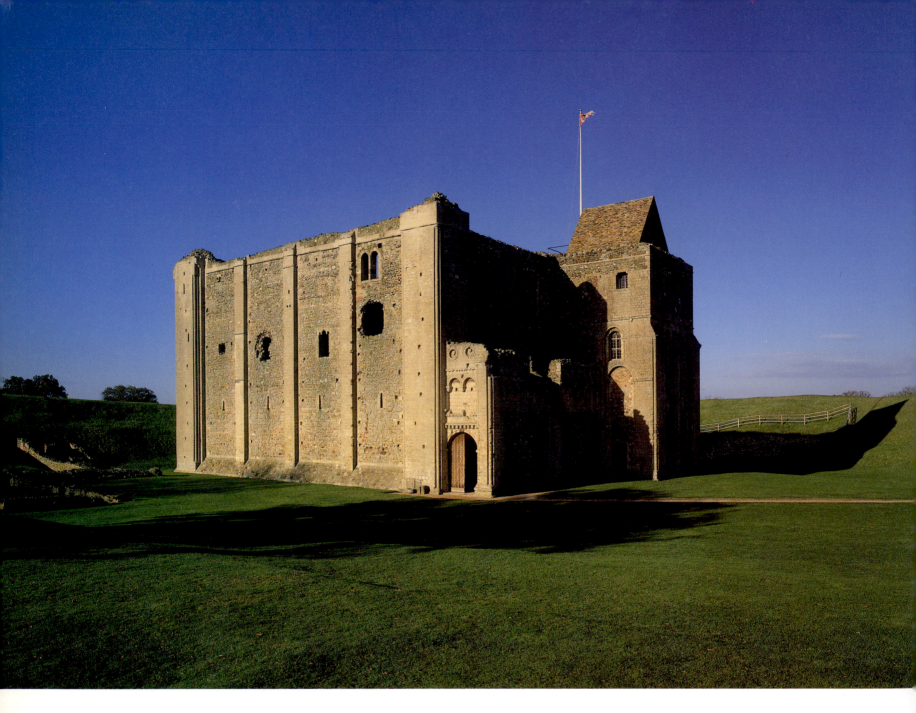

50. The palace-keep within the ramparts at Castle Rising (Norfolk), built in c. 1140 for William d'Aubigny, earl of Arundel, and for his new wife, 'Alice the Queen'; the forebuilding (right) carries an entrance stair to the principal apartments on the first floor.

Just what a man of wealth and rank had come to expect by the 1140s is probably best seen at William d'Aubigny's fortress-palace at Castle Rising. William was the son of one loyal official of Henry I, William d'Aubigny *Pincerna* ('the Butler'), and the nephew of another, Nigel d'Aubigny, who had once confessed to the king, when he thought he was dying, 'in your service and in my own affairs, I have committed many great sins and I have done few if any good deeds.'[41] The brothers had each accumulated great personal fortunes during Henry's reign. With Geoffrey de Clinton, founder of Kenilworth, they were among the king's favoured 'new men'. Yet it was the younger William's marriage to the late king's widow, Adela of Louvain ('Alice the Queen'), which brought the family especially to prominence. Granted the earldom of Lincoln in 1138–9, which he was to exchange for that of Arundel soon afterwards, William d'Aubigny II 'would recognize no one as his peer'.[42]

Earl William, cushioned by his wealth, steered a safe course through the shoals of Stephen's reign. And it says something for the security both he and Alice felt, through all the nineteen 'long winters' of the Anarchy, that the great house they built behind the ramparts of Castle Rising was more residence than fortress in its

40

planning. Certainly, Castle Rising lacks the military sophistication of Henry I's keep at Norwich, earlier than itself and of the same county. Yet it follows Norwich in other regards, and was clearly modelled at least in part on the king's fortress.[43] Castle Rising's accommodation, like that of Norwich, was concentrated on what would later be described as a *piano nobile* . Like Norwich again, it was approached by way of a stair-tower, or forebuilding, richly decorated externally with roundels, a blind arcade, and chevron ornament. At the top of the stairs, a fine square antechamber opened through a sumptuous portal into the great hall. Next to it, and on the same level, the earl's big personal chamber had a well-finished chapel of its own, and was fully equipped (as was the hall) with private garderobes. A service room and kitchen (with fireplace, drain and oven) completed William d'Aubigny's apartment.[44]

Exclusive arrangements of this kind, separating the magnate in his tower from his affinity in the bailey below, were still highly exceptional in the twelfth century. Most lords continued, as they had always done, to share the common life of the hall. But what began as the luxury of an archbishop or an earl became, in the longer term, the expectation of a much wider circle. If genuine personal privacy, for all but the few, remained elusive in medieval Britain, its pursuit was already evident at Castle Rising. Wealth had been the lubricant of change. In the particular circumstances of a well-judged marriage, William d'Aubigny built as he chose. Others, both then and later, took heart from a fair yield on their estates. Still more made their fortunes in the towns.

Such opportunities had not always been available. Many towns, even in the comparatively lightly urbanized societies of Northern Europe, had originated much earlier than the twelfth century. Of these, London's post-Roman revival had been evident already by *c*.600. Other major ports, at Ipswich and Southampton, became commercially prominent not very much later. Northampton, from the late seventh century, grew around the focus of a royal palace, while Norwich was plainly urban by *c*.1000, as was Bristol by the reign of King Cnut.[45] However, none of this activity, although reaching a new peak in the Late Saxon period, precluded further growth under the Normans. Each of these towns experienced major expansion in the twelfth century. Norwich was one of those, Southampton being another, which acquired a new French quarter following the Conquest. With the building of the castle and the cathedral, the Normans 'did more in fifty years to change the topography of Norwich than their successors were to accomplish in five hundred'.[46] Bristol, a comparative newcomer, had risen by the mid-twelfth century to be 'almost the richest city of all in the country, receiving merchandise by sailing-ships from lands near and far'. Particularly notable was the port's post-Conquest suburban spread across the Avon into the Redcliffe Fee, later a rival in wealth to the old borough.[47] Not much later, in the 1170s, William fitz Stephen began his biography of the murdered Thomas Becket with a famous panegyric upon the archbishop's birthplace, opening it thus:

> Amid the noble cities of the world, the City of London, throne of the English kingdom, is one which has spread its fame far and wide, its wealth and merchandise to great distances, raised its head on high. It is blessed by a wholesome climate, blessed too in Christ's religion, in the strength of its fortifications, in the nature of its site, the repute of its citizens, the honour of its matrons; happy in its sports, prolific in noble men.[48]

There is both rhetoric and myth in fitz Stephen's *Description*, but there is also deep personal knowledge – he was a Londoner himself – with a keen eye for the significant detail. 'Other cities have citizens', fitz Stephen noted, 'London's are called Barons.' For these self-styled noblemen and their matrons ('very Sabines'), London was 'a good city indeed – if it should have a good lord'.[49] The qualification was important. While fitz Stephen wrote, the exceptional privileges of

51. The interior walls of a big late twelfth-century merchant's house, known as 'King John's House', on the former quayside at Southampton. The *c*.1200 chimney (right) is an insertion, removed from a similar house at 79 High Street; but the first-floor window and sidewall fireplace (left) are original, once serving a comfortable hall or great chamber at this level.

London were under challenge. Towards the end of Henry I's reign, London had led the way in pioneering municipal self-government.[50] For a short while, under Stephen, it had enjoyed the independence of a commune. But that freedom had not survived the Anarchy. It never fully returned under Henry II: no friend of communes in his English kingdom, although not hostile to every kind of civic liberty.[51] More fortunate than London's citizens in winning Henry's trust were the men of Northampton – the forty *prudhommes* of the borough's first custumal – privileged in 1185 to collect and pay their taxes for themselves. But others, too, were learning the elements of communal responsibility, and four years later, on the old king's death, the most significant remaining barriers were let down. Northampton's next royal charter, in 1189, confirmed free election of the borough reeve. From 1200, the burgesses could choose their four coroners for themselves. By 1215, Northampton's chief officer was styled its 'mayor'.[52]

Such imported titles, redolent of the alien French commune, were not always acceptable to English burgesses. Southampton, after some decades of experiment, gave up its mayoralty in 1249, preferring the rule of a more traditional gild alderman.[53] However, it was not the office but its abuse which caused anxiety. Southampton's grant of the fee farm – of a fixed annual levy to be collected by the borough's officers under the direction of the mayor – had dated to 1199.[54] The following year, the ancient port at Ipswich was allowed the same privilege, and there, most exceptionally, the ensuing proceedings of this *annus mirabilis* were recorded. John gave Ipswich its charter on 25 May 1200. No time was lost in implementing it. Within a month, at a meeting of the whole town on 29 June, two bailiffs and four coroners had been chosen. On 2 July, as agreed at that meeting, a new governing body of twelve 'capital portmen' was elected. Just eleven days later, on 13 July, the council met for the first time. It settled procedures for the collection of the king's taxes, appointed new officers (bailiffs and a jailer), proposed the election of a chief executive (the alderman), and commissioned the cutting of a borough seal. On 10 September, the whole town met together again to confirm these decisions, reassembling by agreement on 12 October to discuss procedures and to choose an alderman, to establish a record, fix stipends, and view the seal.[55]

These Ipswich meetings, held in St Mary Tower churchyard to accommodate the crowd, included what was described as the 'whole town' (*tota villata*). But it was less democracy which united the community than privilege. One of the decisions taken on 13 July had been to limit toll exemptions within the borough to those prepared to play their part in its affairs. Nobody, not even the priors of the town's two Augustinian houses at Holy Trinity and St Peter, would be treated any differently in this case, and both, before 1200 was out, had bought their way into the franchise.[56] It was on similarly equal terms that the citizens of Oxford – 'We the citizens of Oxford of the commune of the city and of the Gild Merchant' – treated grandly with the rich canons of Osney. In 1191, confirming an earlier grant of lands, Oxford's citizens authenticated their charter with a municipal seal, now the first known example of its kind. The seal carries the legend: 'The common seal of all the citizens of Oxford'. And what it shows is a walled city within which are three towers, one perhaps belonging to St Martin's Carfax, where the portmanmoot is known to have assembled.[57]

Oxford's charter could be read as a 'Declaration of Independence'.[58] And although it could not, in point of fact, have had any such formal purpose, sentiments of that order underlie its wording, reappearing again on the seal. The walled city, identified by its 'ox passant', is no mere artistic convention. What it exudes is privilege: the same spirit of exclusiveness which inspired the Ipswich ordinances: the power to keep others out. Shortly afterwards, early in the next century, Oxford's defences were substantially remodelled.[59] Similar costly wall-building programmes characterized other major boroughs of the period.[60] And

a beginning was made also on town-house rebuildings, carried out increasingly in stone. Big stone merchant houses, still to be seen at Norwich, Lincoln and Southampton, were being built towards the end of the twelfth century.[61] They belong, as do wall-building and the negotiation of municipal charters, to an over-whelming surge of commercial confidence, the culmination of decades of growth. This confidence determined priorities. When the burgesses of South-ampton, shortly after 1200, began a new circuit of town walls, what they completed was the fortification of their two landward quarters, embellished on both sides with fine gates. Only much later, and then as the consequence of piracy in 1338, was Southampton's valuable waterfront enclosed. Considerations of profit had kept the quays open. The port's land defences were a sham.[62]

There is no better proof of the speeding up of the economy than the multipli-cation of markets and of new, or 'planted' boroughs, evident already before 1100 and peaking by 1250, or soon after.[63] Markets thrive especially on open ex-changes, and the great majority of these new communities were unenclosed. Take Banbury, for example, or Stow-on-the-Wold, both successful new settle-ments of the twelfth century. Ideally placed for trade on important road junc-tions, they were founded in each case by ecclesiastical entrepreneurs – by Alexander 'the Magnificent', bishop of Lincoln (1123–48), and by successive abbots of post-Conquest Evesham, culminating in a grant of market to Stow in 1107, one of the earliest so recorded. In each borough, a great central market-place still dominates the town plan, so extended as to have been subsequently built over. At Banbury, Alexander's castle was contemporary with his borough. Yet apart from Banbury's gates, used as collection points for tolls, the town had no other significant defences. Stow-on-the-Wold, from its inception, was exigu-ously defended, if at all.[64]

One shrewd commentator of the mid-sixteenth century, lamenting the decline of Tutbury and its neighbours ('which nowe are decayed and depopulated'), put his finger on the circumstances of their growth. William Humbertson, who wrote in 1559, was a surveyor. His theme was the early activity of the Ferrers earls of Derby in developing the estates near their fortress:

> Then begann they to devise to encrease their possessions withe people to defende them selves and ther countrye in tyme of warr, and to make the honor more populous and statelie, erected fre burroughes within six miles of the castle. One at Tutburye. One other at Agardisley called Newburghe [Newbor-ough], and one other at Uttoxather [Uttoxeter], and graunted to the Burgeseis and inhabytauntes of every of them suche parcells of lond to buylde upon, as in ther severall grauntes maye appere. And to make men more desirous to plant ther habytacions in those places procured for them markettes and Fayers wythin the same. And graunted to the burgeses dyvers lyberties of common of pasture, pawnage and estovers in ther forest of Neadwood, and also that they should be free of all toll, tonnage, pyckage, powndage, and other exaccions, within all their possessions.[65]

The Ferrers were optimists. They had reason to continue so over almost two centuries, for Staffordshire (their county) has never had more 'boroughs' than came to style themselves such before 1300. Yet only Uttoxeter, of the three Ferrers plantations, has survived to this day in good order. And the swift decay of the others – of Newborough and of the earls' own castle-town at Tutbury itself (in 1798, 'now only worthy of the name of a pleasant village') – is proof again of the exceptional opportunities which the Ferrers and their tenants had once enjoyed. In the twelfth century, landowners grew accustomed to think big. They laid out new boroughs with no thought of recession, frequently overestimating their potential. One of the most obvious characteristics of contemporary garrison towns like Warkworth (Northumberland), Appleby (Westmorland), Orford

52. Decorative blind arcades at first-floor level alone recall the former splendour of Roger of Salisbury's palace in the bailey of Sherborne Castle.

(Suffolk), or Weobley (Herefordshire), came to be the wide separation of castle and church, at each end of a long market street. It was in 1203 that Bishop's Castle, in Shropshire, another of these boroughs, received its grant of market. However, settlers were slow to take up the plots laid out by the bishop of Hereford's surveyors, and it would be many years yet before the development of Bishop's Castle reached anywhere near its parish church.[66] The implications of the borough's plan are nevertheless important. In the distant territories of the threatened Welsh March, every indicator still pointed to growth.

Borough-founding on this scale, bringing some 200 new towns into existence in as many years, establishes a high level of wealth creation. Nothing of this sort had been seen before, nor (after 1300) would it occur again for something like half a millennium. Investment in construction of any kind can rarely have seemed more secure. Roger of Salisbury, the king's justiciar, was the greatest building prelate of his period. As Henry I's chief minister from early in the reign, Bishop Roger accumulated a huge personal fortune which he put to good use in substantial building projects, the marvel of contemporary observers. One of these was the rebuilding of his cathedral at Salisbury (Old Sarum), thought unequalled by William of Malmesbury. Simultaneously, Roger reconstructed Sarum Castle and built himself a palace behind the ramparts at Sherborne which was later the model for the 'sumptuous palaces' of Henry of Blois, bishop of Winchester from 1129 and Roger's next equivalent as a builder.[67] Another major project was Roger's castle at Devizes – 'the most splendid in Europe', according to Henry of Huntingdon – with a church for the worship of its garrison. Today, nothing is left of Devizes Castle, but the church yields to none in display. A fine vaulted chancel, with complex blind arcading, ranks among the show-pieces of its period. A huge crossing, wide and well made, supports a tower of exceptional height. In no way would the bishop be outclassed.

Bishop Roger was an administrator. Saving only the cathedral of his diocese, he built castles more readily than churches. Neither his son, Roger le Poer (the Chancellor), nor his nephew, Bishop Nigel of Ely, are known to have been any

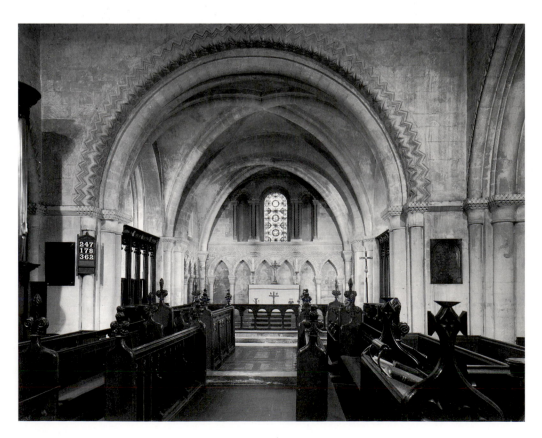

53. The vaulted chancel at St John's Church, Devizes, probably added in c.1125–35 by Bishop Roger, who also built a castle in the town.

more generous to the Church in this regard. However, in Alexander of Lincoln, the justiciar's other nephew and his close associate in government, the system bred a different sort of man. Bishop Alexander, too, had been a builder of castles and a founder of towns. One of his initiatives was the development of the market town at Banbury. He had grown rich, as had his relatives, in the warmth of the king's regard, perpetually active in the accumulation of still further resources for a see barely equalled in the land. These riches gave him scope as a patron. Before his death in 1148, Alexander 'the Magnificent', founder of towns, had become in his latter years the discriminating patron of a whole new generation of monastic reformers.[68]

By no means all the newly created wealth channelled into the religious houses of Alexander's own era supported those new causes which he favoured. Alexander's patron, Henry I, had chosen Cluniacs for the great royal abbey he established at Reading, preferring their attendance on his personal mausoleum.[69] Attracted by identical guarantees of quality and splendour, King Stephen turned to Cluny again for his monks at Faversham, tomb-church of a dynasty that never was. Throughout the country, building rarely slowed at the older Benedictine houses, picking up famously even at an abbey like Peterborough, prominent supporter of the *ancien regime*, which had found itself so disadvantaged by the Conquest.[70] However, the Benedictines, once and for so long without competition in their field, had begun to experience its chill. Henry himself, founding Reading in 1121, employed the vocabulary of a reformer. Everything in the house, the king prescribed, was to be held in common, just as St Benedict had originally provided: 'for monks should not have even their bodies and wills at their own disposal'. No under-age oblates were to be admitted to the community: only adults of sound and determinable resolve. Reading's lands were to be held in free alms, without feudal obligations; its offices were to be non-hereditary; no abbot might favour his family or friends; any surplus must be spent on hospitality and the relief of the poor, 'for let all guests that come be received like Christ . . . And let fitting honour be shown to all, but especially to churchmen and pilgrims.'[71]

Henry was no novice in such matters. From early in his reign, he had been the host and patron of Augustinian canons, many of whose greater houses, including his own Dunstable Priory, owed their endowments to the king and his servants. In this particular Alexander of Lincoln, when he brought Arrouaisians to Dorchester in 1140, was following a fashion not creating it. But the Arrouaisians were Augustinians of a *stricter* observance: the contemplative branch of a diversified congregation better known for its labours in the parishes.[72] And it was precisely this emphasis, present in all Bishop Alexander's monastic initiatives but little seen through earlier decades of the late king's reign, which had only recently achieved general prominence. Intending benefactors, aware for some time of the better options available, now felt equipped to afford them.

Surplus wealth was present and was important. But it was not the only facilitator of change. Anglo-Norman patrons, more at peace with themselves and with their tenants, developed their commitment to their English foundations and then began to vote with their feet for the new religious orders: for those invaluable 'Marthas' of Holy Church, the Augustinian canons, or for the contemplative 'Marys' of the latest wave of reform, amongst them most prominently the Cistercians. The generation which inherited during Henry I's reign was especially well equipped to make such choices. At the top of the pile, the Beaumont twins – Waleran of Worcester and Robert of Leicester – succeeded their father, Count Robert of Meulan, on 5 June 1118. Waleran died in 1166; Robert in 1168. From succession to death, through half a century of change, they changed direction as their consciences dictated.

Count Robert I, while loyal still to the family's Préaux and to other homeland

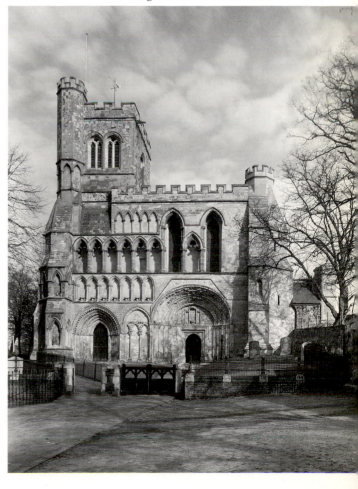

54. The west facade of Dunstable Priory, in Bedfordshire, one of the richer Augustinian communities.

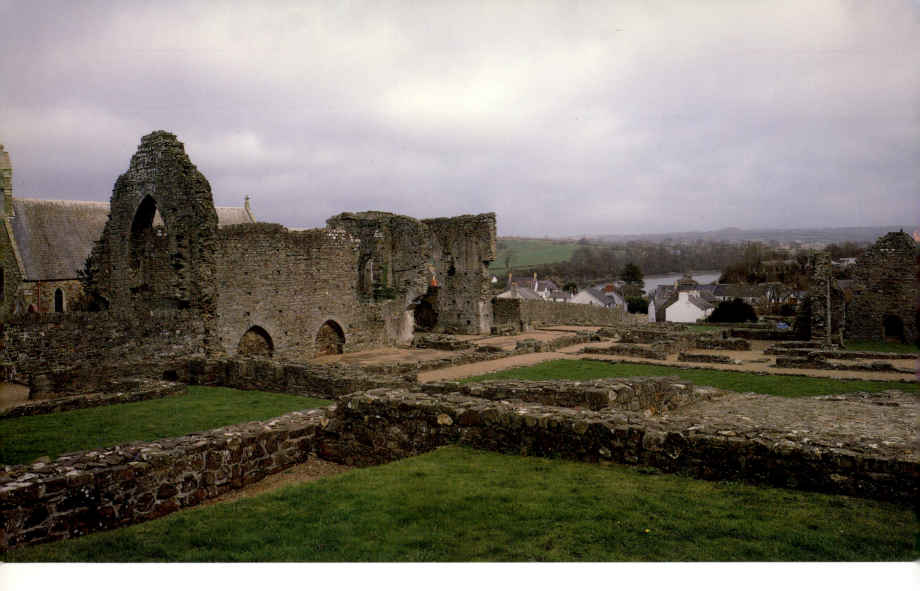

55. Anticipating the arrival of the more popular Cistercians, the monks of Tiron were among the first of the French hermit monks to colonize Britain, settling at St Dogmael's Abbey, near Cardigan, as early as 1115.

abbeys like Jumièges, had followed his own father, Roger de Beaumont (d.1093), as a founder of colleges of secular canons. Chief among these had been the college of St Mary de Castro, Leicester, richly endowed in 1107 to provide prebends for the count's chaplains and his clerks. But the college was short-lived. New ideas took hold in the immediately succeeding generation. Before 1140, Leicester College had been swallowed by Robert II's great abbey, entrusted to canons regular under the conveniently mild yoke of St Augustine, 'who drew his brethren to live together and tempered the rigour of his rule to their infirmity'.[73] Earl Robert chose Augustinians at Leicester, his *caput honoris*, because they suited his purpose very exactly. Like his father's secular canons, but under the discipline (however gentle) of a Rule, they looked after his churches and his priests. In other circumstances, Earl Robert could show a fiercer zeal as a reformer. Shortly after inheriting and while still in his teens, Robert had assisted a group of hermits in Whittlewood Forest (Northamptonshire) by giving them a plot of land for their chapel. His second foundation, in the forest of Breteuil, was again eremitical, significantly entitled *Le Désert*.[74] It was away in such wildernesses – St Dogmael's on the wild coast of Cardigan was one of them – that the new monasticism characteristically was born.[75]

In England, the movement had a distinct flavour of its own. At its launch, a group of secular priests, gathered at St Botolph's (Colchester) and in search of a collective discipline, had taken advice which directed them to the Rule of St Augustine. 'If you propose to assume the religious life,' they had been informed, 'there is in foreign parts a certain way of life,' wise and fine enough, but entirely unknown in these parts – the life and rule, that is to say, confirmed by the

authority of the most holy Augustine, the glorious doctor, which furthermore is termed by Catholics the canonical rule.'[76] This had been in the mid-1090s, and inspiration had come from within. In later decades, it was lay patrons like the Beaumont twins who increasingly took up the initiative.

Their motives were not always as white as snow. Even at Le Désert, Earl Robert's formal adoption of the hermits of Breteuil had been at least in part politically inspired. Some ten years later, when he settled Cistercians – among the first to reach England – at Garendon, in Charnwood Forest, there is reason to think that he became their patron for the discomfort of Ranulf, earl of Chester.[77] Without the spur of a grave political crisis, jeopardizing all that he had gained, Alexander of Lincoln might never have turned with the same enthusiasm to the support of either the Cistercians or their native imitators, the Gilbertines.[78] But politics alone explains little. In Charnwood Forest again, probably on the initiative of the Beaumont earls, the remote and isolated hermitages at Ulverscroft and Charley were gathered into the Augustinian congregation.[79] They were small and poor, vulnerable to every crisis, alone in wooded waste of which they were both the earliest and the principal colonizers.[80] Most English communities of such origins continued to live precariously, rarely aspiring to the devotional heights of their more famous Continental models at Hildemar's Arrouaise, William of Champeaux's St Victor, or Norbert of Xanten's Premontré. Yet they tapped for the first time a rich well of spirituality from which both the English and their conquerors drew comfort. Wulfric, renowned hermit of Haselbury Plucknett, was an Englishman. With many others of his generation he had become a recluse, choosing to react to the Norman settlement in this way. But he spoke French with ease, and he owed the bulk of his sustenance and his anchorite's cell to William fitz Walter, his Norman lord. Counselling William, among others, on the spiritual life, Wulfric directed all who came to him down the path of the new monasticism. Where that path forked between the Marthas and the Marys, Wulfric invariably put his money on the latter. 'Without hesitation,' wrote his biographer, 'he sent those to them [the Cistercians] who came to seek advice about the conversion of their way of life.' For the Augustinians, he exhibited little but contempt.[81]

Such opinions did the Augustinians less than justice. Wulfric was right to praise the Cistercians of his day, whom he must have found, to repeat William of Malmesbury's encomium, 'a model for all monks, a mirror for the diligent, a spur to the indolent'.[82] But he was wrong to dismiss the regular canons, and probably did his fellow villagers more harm than good by holding out against them at Haselbury. In point of fact, that dominant Augustinian characteristic of being all things to all men had never been more necessary to the Church. Like Wulfric himself, but in a more permanent fashion, the regular canons were willing custodians of the past. It was a small Augustinian community, for example, which tended the pre-Conquest shrine at Breedon-on-the-Hill, most dramatically sited of the ancient holy places, still entirely alone on its hilltop. Regular canons resettled Hexham, one of the centres of Northumbria's conversion. They became the continuators of forest and other hermitages, among them that little cell at Grafton Regis (Northamptonshire) which had failed already by the late fourteenth century, only to re-emerge unexpectedly during the recent excavation of an overlying fifteenth-century Woodville manor house.[83] They guarded famous relics, including Walsingham's venerated 'Holy House'.[84] They ran hospitals and schools; tended almshouses and retreats; cared with diligence for the leprous and the old.

Most particularly, it was to the parish churches that they were drawn. Wulfric, to be sure, would not have welcomed the canons' interest in Haselbury Church, and it was this that he successfully resisted.[85] Yet Haselbury itself was no model. Brihtric, its priest and Wulfric's friend, was a married man. He was succeeded

there in office by his son. And while clerical marriage and priestly dynasties were still not uncommon in twelfth-century England, they were coming increasingly under attack in the Church, along with all suggestion of lay ownership. The Augustinians at least offered an alternative. Augustinian canons only rarely themselves undertook the cure of souls in the parishes. Like monks, their vocation was essentially to choir and cloister. Nevertheless, as priests, they could take on such responsibilities if they chose, and it was precisely this flexibility in the roles they could assume which recommended regular canons to their patrons. Thus when the parish priests of Oxfordshire, in the late 1140s, were judged to be especially wanton, Augustinian canons at St Frideswide's (Oxford) were ready in the wings to take their place.[86] Yet these were the men who also tended a famous shrine, and who built a great church on its receipts.

Other religious orders similarly collected 'spiritualities' (parish churches and their tithes), and might continue to do so for many years in support of particular initiatives.[87] In the mid-twelfth century, while the Augustinians were making their collections, it was to Winchcombe, an ancient Benedictine house, that William de Solers transferred in perpetuity his demesne tithes at Postlip, 'which I and my ancestors have been accustomed to give at will to men of religion, priests and poor clerks, now to some, now to others.' Today, there is a church at Postlip of just that date, and a tithe barn of the Late Middle Ages.[88] But none saw the accumulation of parish churches to be as central to their strategy as did the Augustinians, who gathered them as assiduously as magpies. Prominent among such accumulators were the Arrouaisians of Notley, in Buckinghamshire, assemblers of no fewer than fifteen parish churches, including outliers in both Wiltshire and Norfolk. Spiritualities, in Notley's case, totalled at least two-thirds of its receipts.[89] Leicestershire's Owston was a smaller and more traditional house. Yet here, too, almost everything collected by this little community either began with the gift of a parish church and its glebe, or attached to one of those as its nucleus.[90] Thorney, in comparison, was a Benedictine house, active over the same period in the accumulation of parish churches and a close parallel to Notley in wealth. Yet at no time did Thorney obtain more than a quarter of its income from spiritualities, the rest being the return on its 'temporalities' – the rents and other receipts from its estates.[91]

The good fortune of the canons was that they were well equipped to receive just what others were most ready to give away. Lay proprietors of parish churches, until recently experiencing none of these misgivings, had begun to exhibit a deep unease. Churches, their glebes and tithes, had become too hot to hold. Characteristically, landowners qualified their gifts with new reservations: 'in as much as pertains to the right of lordship and advocacy', 'in as much as it is right for a lay person', 'in as much as belongs to lay gift'.[92] They welcomed the canons with relief. It was in the 1120s and 1130s, when compromise had been reached between Church and State and when doors were flung open to reform, that the Augustinians settled England in their greatest numbers, confident of the support of the king. Subsequently, the pace of Augustinian foundations continued brisk for another century, falling off significantly only after 1225, when every monastic order, regular canons included, yielded before the charisma of the friars.[93]

Henry I and his counsellors were hard-bitten men, skilled at recognizing a bargain when they saw it. They discovered what they needed in the canons. Of Henry's own Augustinian foundations, Cirencester became the wealthiest, but Dunstable (where there is still a great church) and Carlisle (the cathedral priory) were both important. Early in the reign, Queen Matilda had brought the Augustinians to London, and it was from Holy Trinity Aldgate that canons went out to colonize St Osyth's (Essex) and St Frideswide's (Oxford), both among the greater houses of the order. Other wealthy communities were Merton (1114) and

56. The canons' richly ornate choir at St Frideswide's (Oxford), reused from 1545 as the cathedral of the new Oxford diocese.

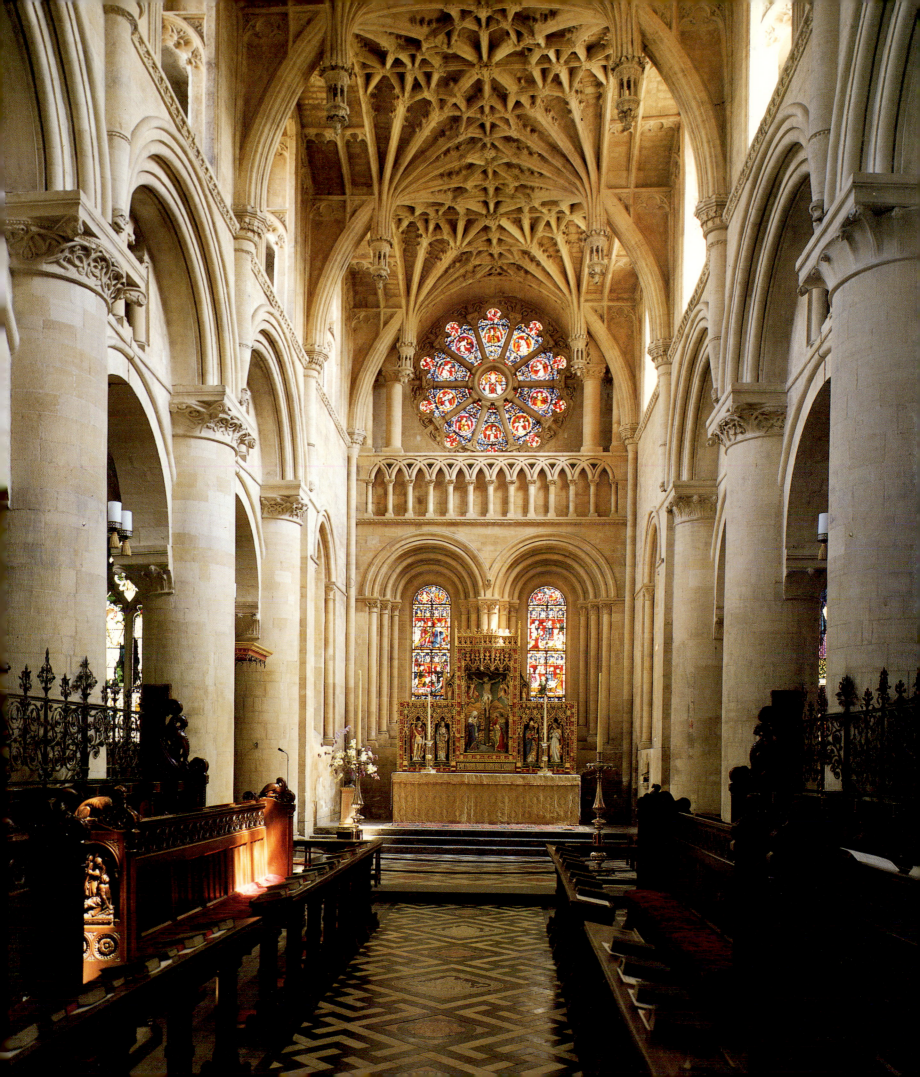

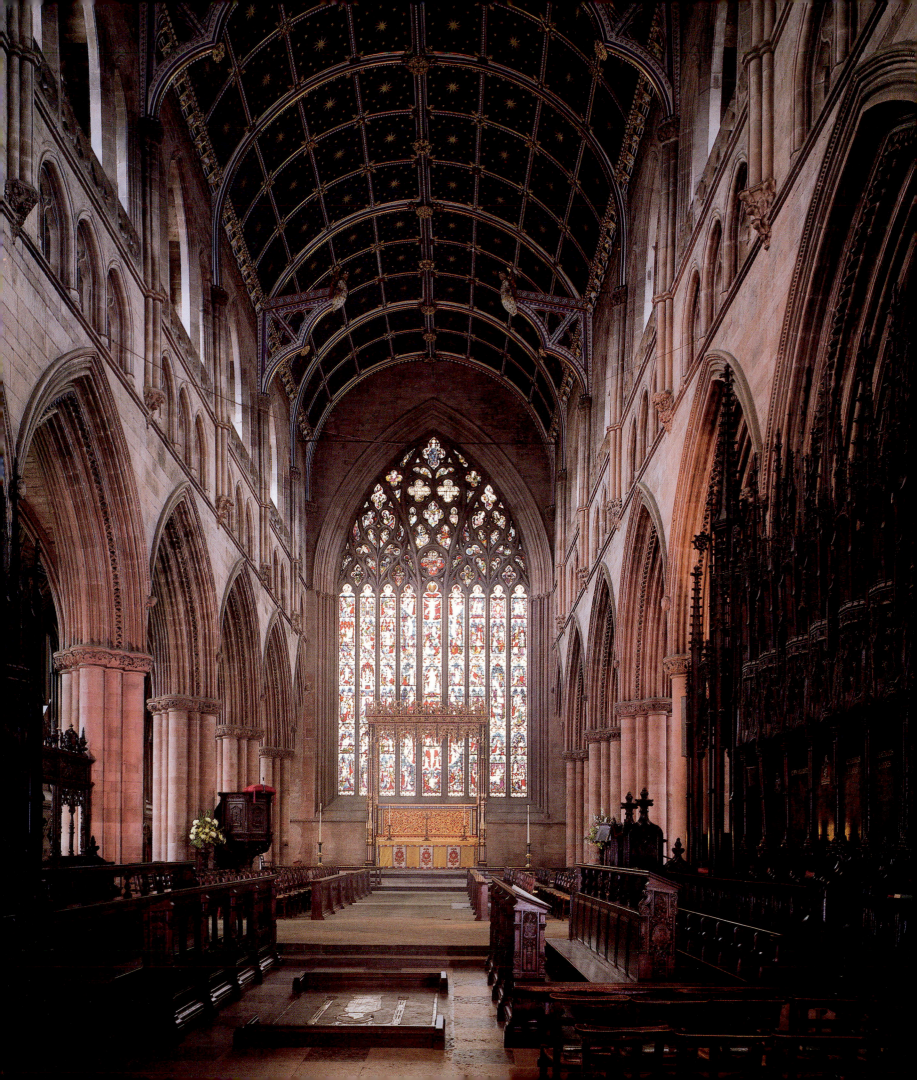

Kenilworth (1125), founded by Gilbert the Sheriff and Geoffrey de Clinton, most prominent of Henry's new men. The big houses at Launde (Leicestershire) and Osney (Oxfordshire), founded in 1119 and 1129 respectively, were each likewise the creation of Henry's sheriffs.[94]

Remote from the Conquest's crisis years, none of these houses – with the possible exception of Carlisle, on the Scottish border – need be seen any longer as deliberate instruments of Norman settlement. True, Geoffrey de Clinton built a great castle at Kenilworth, in addition to his priory within sight of it. Both Archbishop William of Corbeil, founding prior of St Osyth's, and the justiciar Roger of Salisbury, patron of St Frideswide's, similarly won distinction as fortress-builders. However, in England at any rate, the necessary association between castle and church had been lost. Monasteries retained their civilizing functions. They might still be used to tame a wilderness, but their communities could dwell there without fear.

Nowhere did monasteries perform this role more obviously than in the Scotland of the Canmore kings. Scotland's monastic settlement was a phenomenon almost exclusively of the twelfth century. But it had already taken something of its colour from Margaret of Hungary (d.1093), Malcolm III Canmore's queen. And it was Margaret's sons, Alexander I (1107–24) and David I (1124–53), who pushed through the most crucial of the changes. Margaret herself was a lady of exceptional piety, later canonized by Pope Innocent IV. Cultured, beautiful, and the mother of many children, she exercised an influence on the king and his court that was wholly, her biographer asserted, for the good: 'He saw that Christ truly dwelt in her heart . . . what she rejected, he [the king] rejected . . . what she loved, he for love of her loved too'.[95] Margaret had been brought up in Hungary, where her father Edward the Atheling spent his exile. But she was an Englishwoman, exiled herself to Scotland in the wake of the Conquest, and her contacts in religion remained at Canterbury, as rebuilt and reorganized by Lanfranc. Accordingly, Scotland's first exposure to Continental monasticism, at the royal tomb-church Margaret built at Dunfermline, brought it directly within the sphere of the Norman reform. One of the very few Benedictine houses ever founded in Scotland, Dunfermline carried none of the antique baggage of an English community like Glastonbury, looking rather to Bec or to Cluny for its models.

Dunfermline, re-endowed and rebuilt by David I in the 1120s, came to rank among the wealthiest communities of Northern Europe. It survives still as a magnificent fragment, preserving the nave of David's church, boldly decorated in the manner of Durham. At Durham's cell at Coldingham too, originating under Margaret's second son, Edgar (1097–1107), the Benedictines left something of a mark. Yet they were soon overtaken by events. On 11 November 1100, shortly after his accession, Henry I of England married Matilda, Margaret's eldest daughter, called 'the good queen' like her mother, of whom it would be said that 'the goodness that she did here to England cannot all be here written, nor by any man understood'.[96] Matilda's English benefactions were manifold and varied. In particular, she favoured the Augustinians.

Matilda's special concern was for her London community at Holy Trinity Aldgate. Nevertheless, she conceived a 'glowing love' also for Gilbert the Sheriff's Merton Priory, and it was from centres such as these, richly endowed by the Crown, that the message of the canons was diffused. The example of Henry I's court was irresistible. In Scotland, certainly, there would be no more talk of introducing communities of Benedictines. When Alexander I needed priests to settle Scone, he turned to the Augustinians of Nostell, in Yorkshire, taking a leaf from his sister's book and recruiting from a brotherhood dear to the English crown, personally favoured by King Henry.[97] Athelwulf, founder of Nostell and Henry I's confessor, was also the originator of the Augustinian priory at Carlisle which, in 1133, became the only English cathedral priory entrusted to the charge

57. The fourteenth-century choir of Carlisle Cathedral, as rebuilt after the fire of 1292. It was Henry I – always a special patron of the canons – who brought Augustinians to Carlisle in 1122–3, then raising their priory to cathedral status in 1133.

58. The nave arcade at Dunfermline Abbey, rebuilt by King David I in the late 1120s with decorated piers modelled on those of Durham Cathedral.

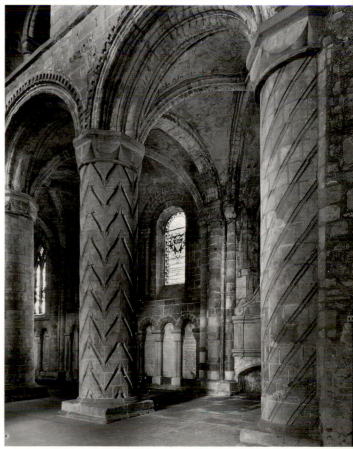

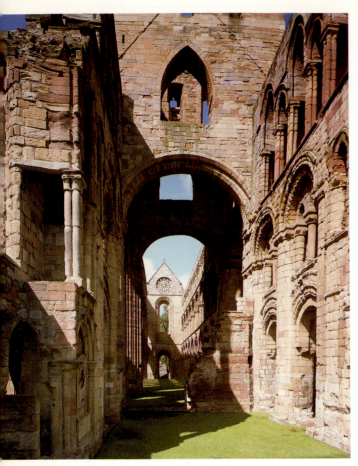

59. The huge abbey church of the Augustinian canons of Jedburgh, one of many monastic communities introduced to Scotland by David I (1124–53).

of regular canons. The link is plain between Carlisle and St Andrews to which Alexander, shortly before his death in 1124, moved Robert, prior of Scone. It took another two decades for the existing cathedral church at St Andrews to pass formally to the regular canons. When it did so, with the help of Athelwulf of Carlisle and under the charge of another former canon of Nostell, the combined endowments of cathedral and priory supported a community of unusual wealth, fully as rich in proportion as Christ Church (Canterbury), England's premier church.[98]

The exceptional scale of contemporary Scottish monastic endowments establishes the commitment of the Crown. It was Queen Margaret's early and personal interest which was the original fount of the huge fortune of Dunfermline. Few houses of canons in the much wealthier England ever equalled the resources of St Andrews or of Scone. Yet these were no more than a taste of things to come. When David I succeeded Alexander in 1124, he was already a rich man, married to one of England's wealthiest widows. He had been brought up in the South at his sister's court, and with all that he had learnt of English government, was aware also of the worth of the new monasticism. Before David's death in 1153, Scotland south of the Forth had been largely feudalized. A reorganization into counties under sheriffs had begun. There were new coastal towns and Norman-style castles. There was a centralized currency. A parish system, supported by tithes (the 'teind'), had been created. David 'illumined in his days his land with kirks and with abbeys'.[99]

With few exceptions, the monks and canons David preferred to introduce to Scotland were of the new persuasion, not the old. As earl of Huntingdon, David had been the patron of many different orders. Yet he had shown himself a connoisseur in religion as early as 1113 in the support of Tironensians at Selkirk.[100] And it was probably the influence of his sister, Henry's queen, which directed him in due course to the Augustinians. Holyrood Abbey, founded in 1128 near David's castle at Edinburgh, was colonized from Merton, especially dear to the late Queen Matilda. Ten years later, David brought Augustinian canons from St Quentin, near Beauvais, to settle his frontier abbey at Jedburgh. In 1140, it was the turn of the stricter Arrouaisians to be chosen for Cambuskenneth, near another royal fortress at Stirling.[101] All three abbeys, as had been the case at Alexander's Augustinian houses, were exceptionally richly endowed. A big detached bell-tower is all that is left of Cambuskenneth. Both Holyrood and Jedburgh preserve churches of extraordinary size.

David's patronage was not exhausted on either the Tironensians or the Augustinians. It was David who rebuilt his mother's Dunfermline, who supported Edgar's Coldingham, and who is generally thought to have been the founder of the little Cluniac priory at May. Significantly, too, he imported Cistercians, granting them Melrose in 1136, only four years after St Bernard's troops had first camped below the gloomy cliffs of Rievaulx. As abbot of Clairvaux, Bernard's plans for an English province of his order had been shaping for some years before his representatives brought their famous message to Henry I. 'In your land,' Bernard wrote to the king in 1131, 'there is a possession of my Lord and your Lord . . . I have arranged for it to be taken back, and have sent men from our army who will (if it is not displeasing to you) seek it out, recover it and restore it with a firm hand'.[102] The military metaphor is typical of Bernard, acceptable equally to his patrons. 'There still exists the letter', boasted a later chronicler,

which he [Bernard] wrote to the king . . . And this is what was done. His men were received with honour by the king and the kingdom, and they established new fortifications in the province of York. They constructed the abbey which is called Rievaulx, which was the first plantation of the Cistercian Order in the province of Yorkshire. Those who were sent were holy men, being monks who

60. The valley site of Rievaulx Abbey, colonized from St Bernard's Clairvaux in 1132, was typically Cistercian – remote and wild, but well watered.

glorified God in the practice of poverty. They dwelt in peace with all men, although they warred with their own bodies and with the old enemy. They showed forth the discipline of Clairvaux whence they came, and by works of piety they spread the sweet savour of their mother-abbey, as it were, a strong perfume from their own house. The story spread everywhere that men of outstanding holiness and perfect religion had come from a far land; that they had converse with angels in their dwelling; and that by their virtues they had glorified the monastic name. Many therefore were moved to emulate them by joining this company whose hearts had been touched by God. Thus very soon they grew into a great company[103]

That company, truly, was legion. From Rievaulx (1132) sprang David of Scotland's houses at Melrose (1136) and Dundrennan (1142), as well as the three English daughter communities of Warden (1136), Revesby (1143) and Rufford (1146). Before Bernard's death in 1153, Warden itself had given birth to Sawtry, Sibton, and Tilty; Melrose had spawned Newbattle, Holm Cultram, and Kinloss. Right at the beginning, on their way to Rievaulx, Bernard's monks had stopped at York in early March 1132, where their beliefs and their example had disturbed the calm of the Benedictine community at St Mary's. There was nothing especially wrong with St Mary's which, just a few years before, had been one of the

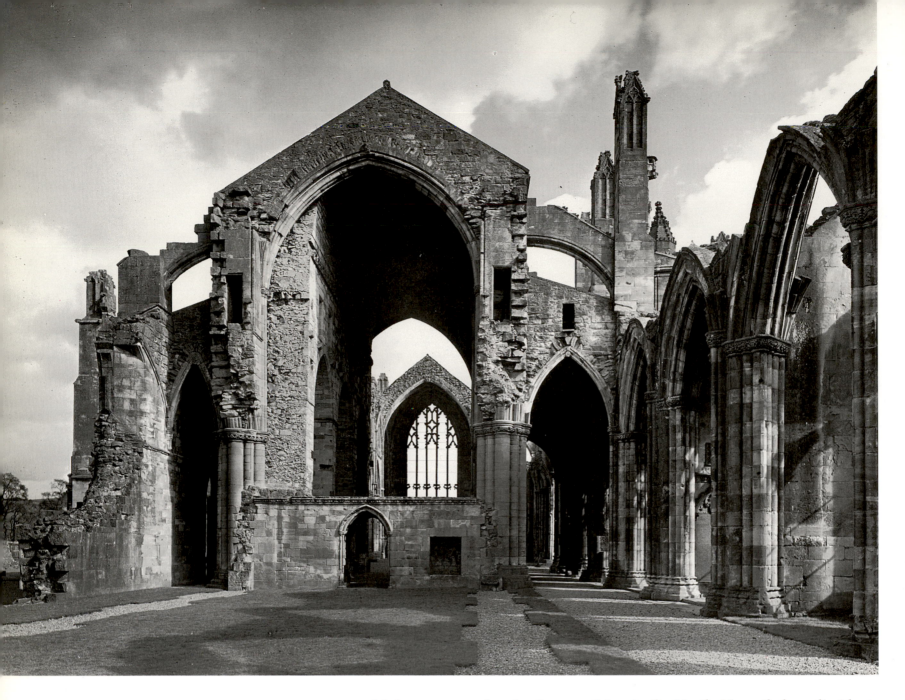

61. Melrose Abbey, founded by David of Scotland in 1136, was one of the first of Rievaulx's many daughter-houses. The church seen here was almost entirely rebuilt after the English pillaging of 1385.

chief ornaments of revived monasticism in the North. Nevertheless, dissidents began to reveal themselves at the house as soon as the Cistercians had moved on, and it was a party of these, led by Prior Richard, who broke away to found an abbey of their own. With Archbishop Thurstan's help, they established themselves on a valley site, not far from Ripon, settling there on 27 December 1132, in a place 'uninhabited for all the centuries back, thick set with thorns, and fit rather to be the lair of wild beasts than the home of human beings'.[104] Sheltering first under rocks and then under a great elm, the earliest days of the new community were inauspicious. Yet, within the year, Fountains Abbey (as they called it) had been welcomed by Bernard as a daughter house of Clairvaux. And it was under Bernard's spell that Fountains rapidly became the most successful propagandist of the Order. Only five years later, a party left Fountains to settle, after some early hesitations, at Alexander of Lincoln's Louth Park; another went to Newminster in 1138; a third departed for Kirkstead in 1139, while others split off in swift succession: to Woburn in 1145, to Kirkstall and Vaudey in 1147, to Meaux in 1151.[105]

Fountains enjoyed the patronage of an archbishop and a saint; Louth Park, of Alexander 'the Magnificent'; Melrose, of King David; Rievaulx, of a great baron

54

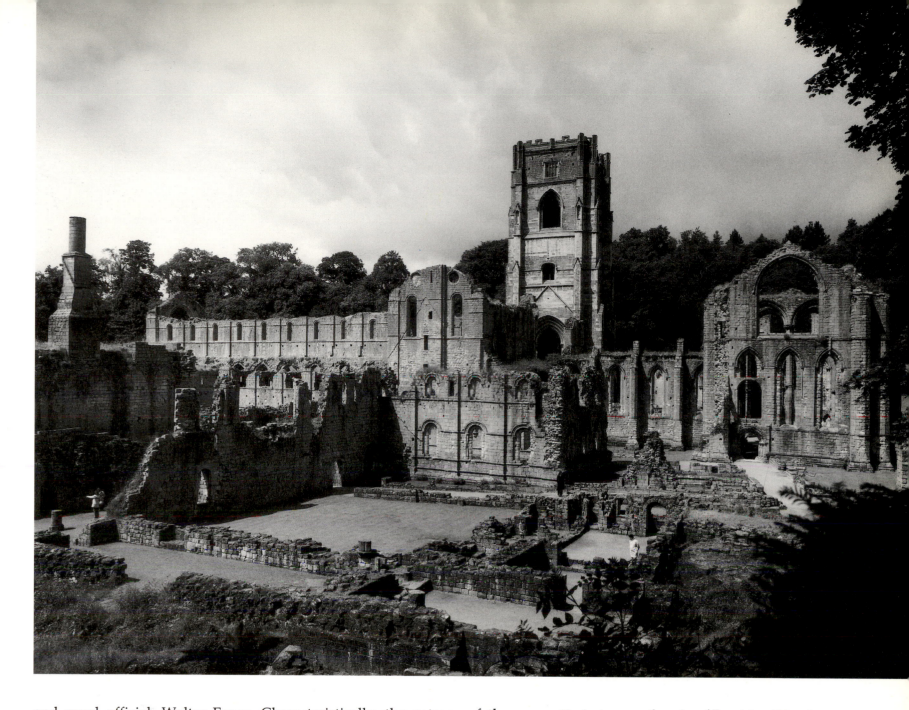

62. A view over the ruins of Fountains Abbey from the south-east; showing the great church (across the back), the chapter-house (centre), and the monks' dormitory (left).

and royal official, Walter Espec. Characteristically, the patrons of the new Cistercian houses were wealthy men, well connected in the Court or the Church.[106] They needed to be so, for though it is sometimes said that Cistercian houses were inexpensive to found – austerely built and sited 'in places remote from human intercourse' – the reverse was actually the case. No abbey, the statutes of the Order provided, might be established with less than twelve monks and an abbot. Lacking, by prescription, the resources of parish churches and their tithes, of manors, mills or feudal rents of any kind, Cistercian communities in their early years required an exceptional level of support. There was also the problem of new buildings. To the raw site at Fountains – a 'place of horror and vast solitude' – Bernard sent Geoffrey of Ainai, one of the principal monk-builders of his own abbey at Clairvaux, just then in the process of enlargement. Bernard had been at Clairvaux since 1115. By the mid-1130s, his community was bursting at the seams. When, at last, Bernard resolved to rebuild,

the brothers rejoiced. . . . The bishops of the region, noblemen and merchants of the land heard of it, and joyfully offered rich aid in God's work. Supplies were abundant, workmen quickly hired, the brothers themselves joined in the

55

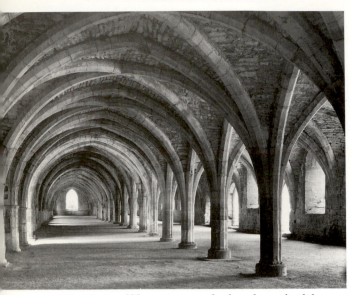

63. The twelfth-century vaulted undercroft of the west claustral range at Fountains Abbey, formerly supporting the lay brothers' dormitory.

64. Mellifont Abbey, in Louth, was the first (and always among the richest) of the Irish Cistercian houses, founded by Malachy of Armagh in 1142. A fine octagonal *lavatorium* was provided for the monks in about 1200, where they might wash their hands before entering the refectory.

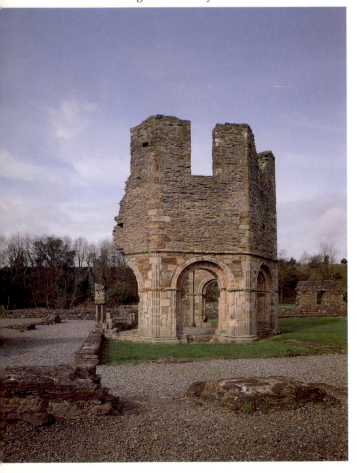

work in every way.... The abbey rose; the new-born church, as if it had a living soul that moveth, quickly developed and grew.[107]

Yet within less than a decade of the consecration in 1145 of Clairvaux II, work on a third church had begun. The pattern at Fountains was strikingly similar.

Monastic life at Fountains very probably began in the temporary timber buildings of which traces have recently been discovered. Very quickly, in not much more than a year or two, work on a stone church followed. But this, for all the apparent sophistication of its cruciform plan, was still on a very small scale. In particular, it was small in relation to the already spacious layout of the claustral buildings, characterized especially by a long west range, built to accommodate the lay brethren. Fountains was looted and burnt in 1146. And whether for this reason alone or because the abbey buildings had already proved too small, work started in 1150 on a much larger church, more than doubling the size of the old. A decade later, the reconstruction of the domestic ranges began. Today, the ruins at Fountains owe their extraordinary scale to the ambition of this second major programme of works.[108]

The rapid expansion of Fountains, as much in buildings as in the further colonization of distant houses, could only have occurred in circumstances exceptionally favourable to recruitment. At just this time, as we know of Abbot Ailred's Rievaulx, there came 'from foreign nations and distant lands a stream of monks who needed brotherly mercy and true compassion, and there they found the peace and sanctity without which no man can see God'.[109] Ailred let all comers in, so that they swarmed in his abbey like a hive of bees, some 600 before his death in 1167. Other superiors were more selective, taking advantage of their charisma, as St Bernard had done, to pick and choose the best. In point of fact, only about a sixth of Ailred's community were ever received into Rievaulx as monks; the rest were lay brethren and servants. And it was in the employment and accommodation of a celibate labour force of this kind – 'pious draught-oxen of Christ' – that the Cistercians made their most individual contribution to the architecture of twelfth-century monasticism. A Cistercian abbey, unlike a Benedictine, housed two communities, not one. It had two dormitories, two refectories, and two infirmaries. Its church was built for distinct congregations, isolated even in prayer.

One at least of these elements – the lay brothers' west range – had been present already in the first stone cloister at Fountains, before the fire of 1146. And what is significant about this building, as it would be again of the west range at Melrose, is its exceptional length. For all their practical services to the community, whether at the abbey itself or away on its outlying granges, Cistercian lay brethren were expensive, even burdensome, to accommodate. On such virgin sites as the white monks favoured, they added materially to prime costs. When William of Aumale brought Cistercians from Fountains to settle at Meaux, near Beverley in the East Riding, he 'had a certain great house built with common mud and wattle, where the mill is now established, in which the arriving lay brothers would dwell until better arrangements were made for them'. And this was no more than the beginning. A 'chapel, refectory, dorter, and cells for the porter and for guests' were the understood prerequisites of Cistercian settlement, required by the earliest statutes of the Order. Even Meaux's site itself had been no mean sacrifice, grudgingly yielded and only recently purchased at great expense for the earl's personal enjoyment as a deer park. Adam, pertinacious first abbot of Meaux's new community, would accept nothing else he was offered.[110]

On selecting the spot, Adam had declared: 'Let this place be called a palace of the eternal king, a vineyard of heaven, and a gate of life.' The ambition was fully realized, and although nothing now remains of Adam's achievement at Meaux, there are many other surviving examples of contemporary building programmes,

none of which came cheap to their patrons. Among these was the nave, austere but monumental, of Adam's parent house at Fountains. Further afield, that same seed at Mellifont, planted by Malachy of Armagh in 1142, grew as swiftly as Fountains into another great tree, branching for the Cistercians across Ireland. Again Bernard's Clairvaux had been the direct inspiration for this colonization. Malachy had visited Clairvaux on the way to Rome, shortly after resigning the archbishopric of Armagh. In his time, he had been a great promoter of church reform in Ireland, a Gregorian by conviction, much valued by the papacy for such services. He had become, like other leading churchmen of his day, a generous patron of the Augustinians. But what he experienced at Clairvaux in 1139–40 brought him at once into Bernard's allegiance. Malachy was to visit Clairvaux again in 1148, to expire there in the arms of its abbot. In the meantime, Bernard had lent him troops for the conquest of Ireland, much as Yorkshire had been captured for the Lord.

With other monks, including an Irish contingent trained at Clairvaux for the mission, Bernard sent Robert, his builder, to Ireland. The resulting architecture was unmistakably Burgundian. Mellifont's first plan, with its unusual array of alternating square and apsidal transept chapels, was in no way characteristically Cistercian. Yet it was not Irish either, and the many other churches of Mellifont's growing family kept more faithfully to the Bernardine ideal. Churches like Boyle (1161) and Abbeyknockmoy (1190) exhibit the simple geometry, known to have been favoured by the saint, of paired square-ended transept chapels flanking a short and lower presbytery. Their pointed Gothic arches and plain stone barrel-vaults derived directly from the Burgundy of Clairvaux. Only in stone-carving was native Irishness betrayed.[111]

St Bernard's French monks soon returned home. But they left a good deal behind them, including buildings unparalleled before their time. The consecration of the church at Mellifont in 1157 was indeed 'something of a national event'. Those present on the occasion included seventeen bishops, with the high king Murtagh MacLoughlin, himself a benefactor, and with the principal patron Donough O'Carroll, king of Uriel, 'who founded the entire monastery both [of] stone and wood, and gave territory and land to it, for the prosperity of his soul, in honour of Paul and Peter'.[112] Ireland had never seen such churches. It was a country of which the traditional building materials were wattle and daub; where the kings, as late even as 1228, had 'neither castles, nor halls, nor even timber houses or saddles for their horses, but huts of wattle, such as birds are accustomed to build when moulting'.[113] All the more influential, in consequence, was the Cistercian example, whether through buildings or monastic regime. To Ireland, to Scotland, and to the remoter parts of Wales – welcomed everywhere by royal or princely patrons – the Cistercians brought a vision of their own, so unfamiliar and alien as to become the focus, paradoxically, for national aspirations in these regions. The earliest Cistercian settlement of Ireland, reaching out from Mellifont in the 1140s and 1150s, had anticipated the Anglo-Norman conquests by a generation. Then, through the next half century after 1169, another ten Cistercian monasteries were founded. The two groups mixed as easily as oil and water.[114] In Scotland, great Cistercian communities like Melrose and Kinloss, Coupar Angus, Newbattle, and Dundrennan, were the undisguised instruments of royal policy.[115] In Wales, Strata Marcella and Llantarnam, with other Cistercian houses in the still to be conquered north and west of the principality, continued as Welsh in their allegiance, even in less free days, as the Anglo-Norman Tintern, Neath and Margam stayed English.[116] Here, if anywhere, was a politics of stone.

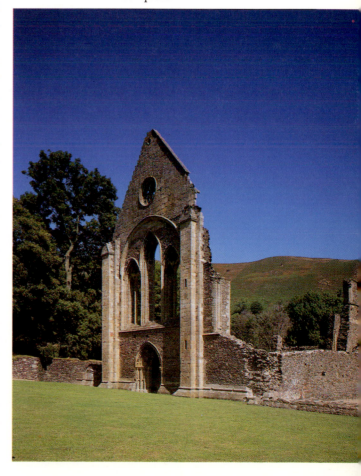

65. Valle Crucis Abbey, of which this is the thirteenth-century west front, was the wealthiest Cistercian house in North Wales. Founded in 1201 by Madog ap Gruffudd Maelor, the community never lost its allegiance to its native Welsh patrons, even after the Edwardian conquest.

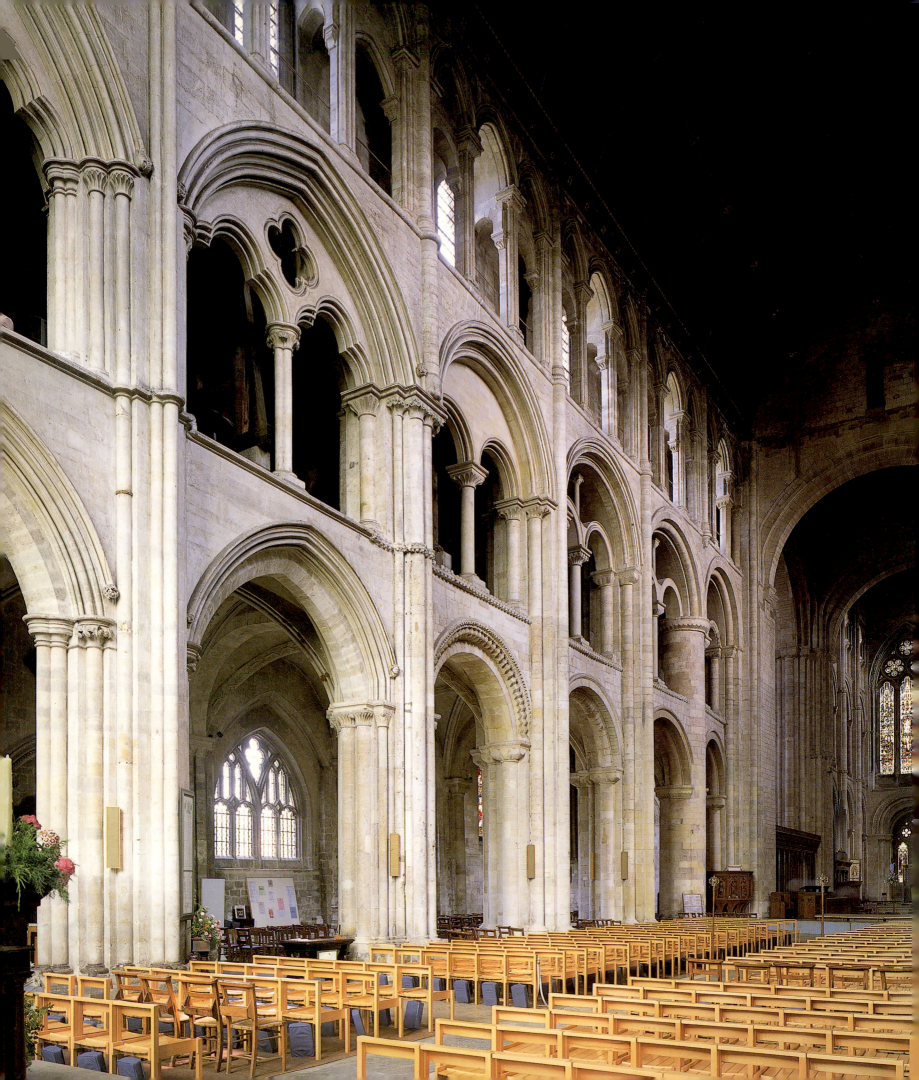

CHAPTER 3
Twelfth-Century Renaissance

It is a striking fact that through all the hurly-burly of the twelfth-century monastic renewal, only one native order – the Gilbertines – took hold in England, and even St Gilbert would have joined the Cistercians if they had let him. The Scottish kings, for all their deep personal interest in contemporary monasticism, supported no new order of their own. Neither the Irish nor the Welsh were any more innovative. Cultural dependence on Continental models was inevitable in the circumstances; never more so than in the late twelfth century, under the shadow of the Angevin 'empire'.

There are celebrated examples of the introduction of French Gothic to England. Best known, and certainly a major influence on its times, was the rebuilding of the choir of Canterbury Cathedral, damaged beyond repair by the fire of 1174. The monks gave the work to William of Sens 'on account of his lively genius and good reputation'.[1] But William had learnt his craft in the cathedrals of Northern France. When succeeded at Canterbury a few years later by another William – 'English by nation, small in body, but in workmanship of many kinds acute and honest' – the pattern he had established there was French. Before this, the new orders, starting from nothing on the virgin sites of the North, had themselves imported craftsmen and designs. The Gothic of Cistercian Roche comfortably predates Canterbury's choir. Furness and Byland, former Savigniac houses, were similarly pioneers of a new English Gothic, thoroughly founded in the French. The traditional view of both Cistercians and Savigniacs as 'missionaries of Gothic' in the North has still a great deal to recommend it.[2]

Less often stressed is the speed of transmission of the new ideas, away from such centres into the localities. What the monks brought in, others soon adopted as their own. It is not perhaps surprising that the rich nuns of Romsey (Hampshire), with their aristocratic connections, should have been persuaded before 1200 of the merits of Gothic, midway through the building of their huge nave. They had shown an interest already in the latest architectural fashions, marking them out as sophisticated patrons.[3] At other similarly ambitious churches of the 1170s and 1180s, among them Saumur's New Shoreham (Sussex) linked with Canterbury, Brinkburn Priory (Northumberland), and St David's Cathedral (Pembrokeshire), the two styles – Romanesque and Gothic: Norman and Early English – were thoroughly intermingled in the compromise we have come to call Transitional. But the movement spread more generally than that. Take a minor parish church like Seaton (Leicestershire), not known to have had a patron of special distinction. Even here, deep in the Midlands countryside, the change from the ebullient Late Norman of Seaton's south door to the much simpler emergent Gothic, distinctly classical in flavour, of its nave arcades (first the north, then almost immediately the south) was startlingly rapid and complete. At Barton-upon-Humber, in northern Lincolnshire, the church of St Mary's was growing fast in the late twelfth century. As at Seaton, a north aisle was built first, typically Late Norman in its motifs. Next the south aisle was added, again before 1200, entirely Early English in manner. At Youlgreave (Derbyshire), while the order of arcade-building was reversed, the change of styles occurred just as suddenly. Thus Youlgreave's south arcade, round-arched and clearly Norman,

66. The change from Late Norman (Romanesque) round-headed arches to Early English (Gothic) pointed arches is well marked in the nave arcades of Romsey Abbey.

67. The choir of Canterbury Cathedral, as rebuilt after the fire of 1174 in the new Gothic tradition of northern France.

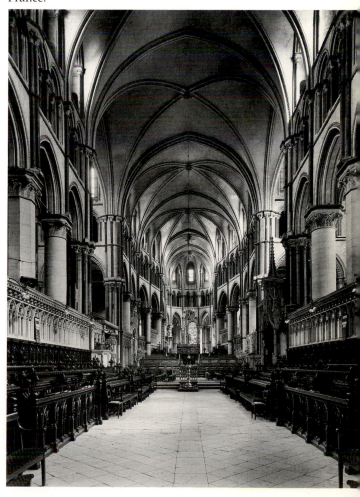

68. Saumur Abbey rebuilt the choir of its parish church at New Shoreham just as the new styles were being introduced; here, Late Norman windows behind the high altar have Early English lancets above, all datable to *c*.1170–80.

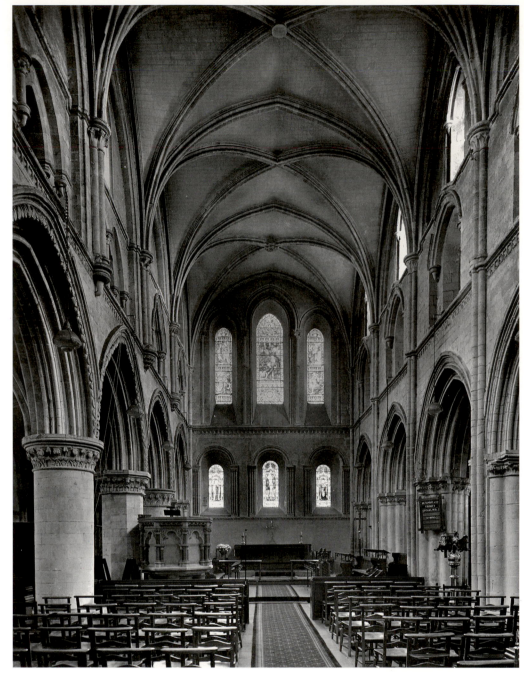

69. Gothic capitals support round-headed arches of Late Norman style in the upper chapel at Dover Castle, built for Henry II's personal use in the 1180s.

accompanies the near-contemporary pointed arches of a north arcade which is equally obviously Early English. Just a handful of years can have separated them.

There were conservatives present also in the localities. In the tiny parish church of Wartnaby, in Leicestershire, tucked away from the mainstream of events, there is a plainly 'Norman' south arcade which cannot date earlier than the thirteenth century. But Wartnaby was very much the exception. From the top down, and for several decades already, everything had pointed to change. Henry II's last and most expensive individual building project was the huge keep at Dover Castle, completed in the final decade of his reign. Dover's keep has two household chapels, placed one above the other in the forebuilding. Neither is as advanced architecturally as William of Sens' Canterbury choir, at that time still under construction. Yet at both, by the 1180s, the Late Norman style had distinctly caught a cold. Supporting the sumptuous zigzag rolls of a typically Late Norman palace interior, were the elegantly simple attached pilasters and crocket capitals of Gothic Canterbury.[4]

The surer decorative taste and apparently greater sophistication of Henry II's England are not especially difficult to explain. Henry's territories, on his accession in 1154, included more than half of France. For the king and his circle, spending much of their time there, the South was no *terra incognita*. One of Henry's daughters married William II of Sicily, another Alfonso VIII of Castile. Their mother, Eleanor, had been heiress of Aquitaine, bringing south-west France into union with Anjou and then into partnership with England. Nothing of comparable scale had been envisioned by the Anglo-Norman kings. Yet for exactly half a century from 1154, all this was the playground of the Angevins.

English art took its colour from these events. It became more exposed than ever to the 'missionaries of Gothic', almost all of them originating on the Continent. But it showed something else, specifically of the South, in a short-lived but deliberate classical revival, appropriately described as a 'Renaissance'. The 'Roman' touch of the arcades at Seaton was no mere accident. In late twelfth-century England, that earlier taste for Byzantine models which had found expression in manuscript illumination and in murals like those of Clayton in Sussex (before 1120) or Copford in Essex (by the mid-century), had grown into a partiality for Rome.

Something of this has been preserved in the historical record. Thus there is the well-known story of Henry of Blois' visit to Rome in 1151, when the bishop of Winchester showed great interest in Rome's monuments, buying antique statuary for his palace at Wolvesey. A little later Master Gregory, on his return from Rome, disarmingly confessed that he could hardly tear himself away from a marble statue ('rather a living creature than a statue') of the naked Venus: 'because of its striking beauty and a sort of magic attraction I was compelled to visit it three times, although it was two stadia away from my hostel'.[5] Anybody who has contemplated the Giannetta Baccelli nude at Knole, reclining at the foot of the Great Staircase, will know precisely what Gregory meant.

To this may be added the evidence of architecture. Lost to us now under the park at Blenheim is 'Rosamund's Bower', once part of the royal palace at Woodstock. There, Henry II built himself a love pavilion – a place of courts, pools and fountains – where he could dally, Sicilian-style, with his mistress.[6] Yet if the Bower has gone, the influence of Sicily, in particular of Byzantine-inspired Sicilian mosaics, is apparent in wall-paintings of the period: in those of the great cathedrals at Canterbury and Winchester, as also perhaps at remote little Kempley, a tiny parish church in thinly-populated western Gloucestershire, where one of the finest of such mural schemes has been preserved.[7]

Other southern flavours are still more obvious. William of Sens had used Roman-style 'Corinthian' capitals in his choir at Canterbury. They occur again at St Nicholas at Wade, in north-east Kent, associated there with 'wild' native ornament, typical of what had begun to go wrong with Late Norman. Over-the-top ornamental extravagance had come to characterize a style for which there was no other way forward. Nowhere is this better shown than at Climping, in West Sussex, where the perversely inventive ornament of the Late Norman south tower contrasts with the cool Early English of nave and chancel, not many years later in date.[8] The austerity of the new styles, Early English as well as classical, was at least in part a reaction against such barbarism. But it came from another source as well. One of Henry of Blois' major parish churches, on which he spent a great deal of money, was the typically Late Norman East Meon (Hampshire), known especially for its splendid crossing tower. East Meon is of mid-century date, and is copy-book Late Norman in choice of ornament. Yet it was at precisely this time, in 1151, that Bishop Henry left Winchester on the trip to Rome which introduced him to classical monuments. Almost twenty years later, towards the end of his long life, Henry embarked on his last great project: the completion of the church of the hospital at St Cross of which, in his youth, he had been the

70. *St Paul and the Viper*, a wall-painting in the Byzantine 'damp-fold style' in St Anselm's Chapel, Canterbury Cathedral, probably commissioned by Archbishop Thomas Becket to mark the translation there in 1163 of Anselm's relics.

71. The late twelfth-century south arcade of St Nicholas at Wade (Kent), mixing columns and capitals in the classicizing Canterbury style with 'wild' native ornament, especially inventive in the easternmost arch (left).

72. Late Norman ornament at its most bizarre in the lancet window and west door of the church tower at Climping (Sussex).

founder. St Cross is no ordinary hospital chapel. Its chancel aisles, first to be finished, carry expensive Late Norman ornament. Vault and crossing, reached before 1200, are Gothic. Sandwiched in between, on the upper chancel walls, is work which is plainly classical in emphasis.[9]

It is this classicism – more an instinct than a style – which was introduced in the churches of Henry II's latter years, manifesting itself in rigidly symmetrical ornament-free interiors and in the occasional antique detail of a pair of capitals. There are Corinthian capitals, for example, in the Templar sanctuary at Sompting (Sussex), added to an existing church in the 1180s when it came into the possession of the knights. Castle Hedingham (Essex), a complete church interior of the same decade, has an austerity and control in quite a different league from the unbridled exuberance of Stewkley Church (Buckinghamshire), less than a generation its senior. Plain Transitional nave arcades at Staindrop (Co. Durham); a multi-windowed, obtrusively symmetrical, but still Norman chancel at Farnham (West Yorkshire) – these and many others show the widespread adoption, before 1200, of new standards of taste and good order in church-building.

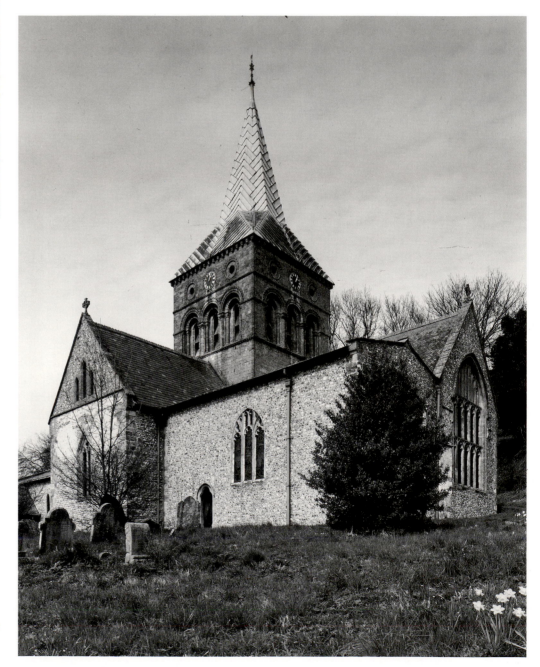

73. The great crossing tower at East Meon Church (Hampshire) is still typical Late Norman work, built in the mid-twelfth century for Henry of Blois, bishop of Winchester (1129–71).
74. (far right) Late Norman and Early Gothic combine with classicizing work in the chancel at St Cross (Winchester), one of Bishop Henry's final projects.

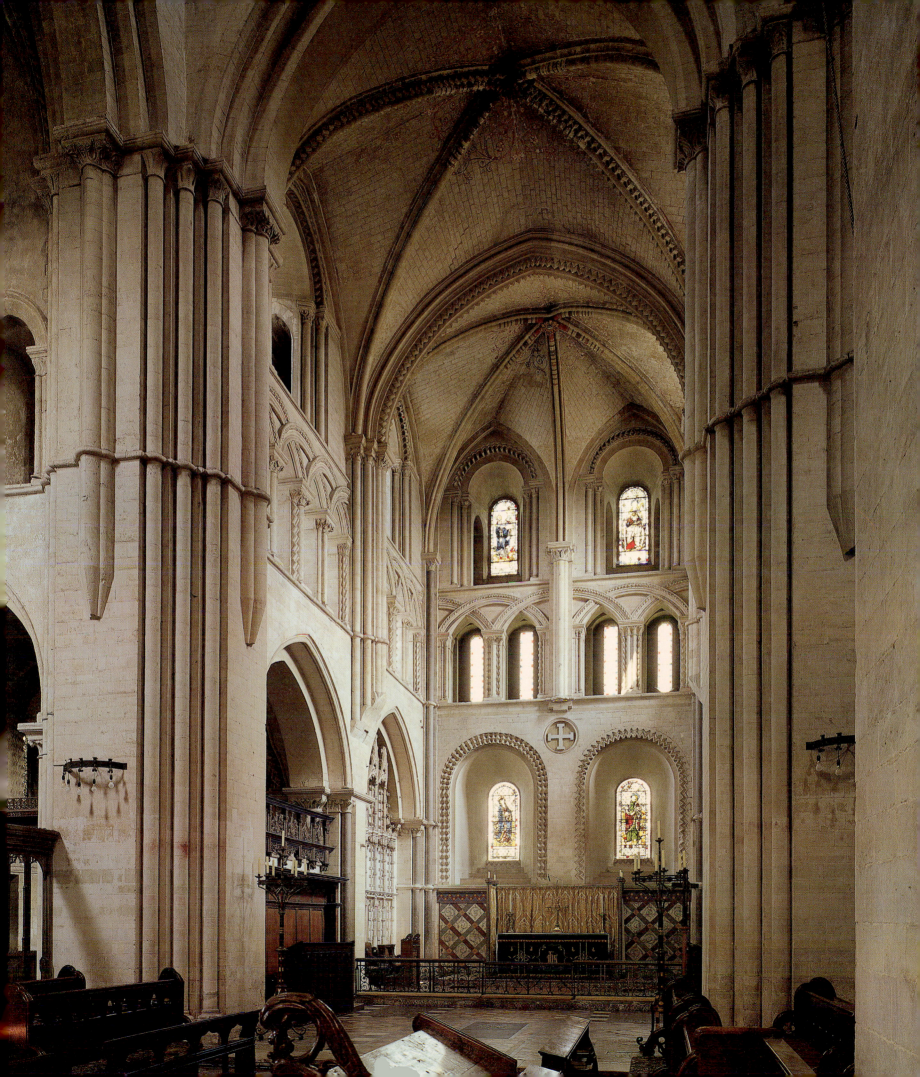

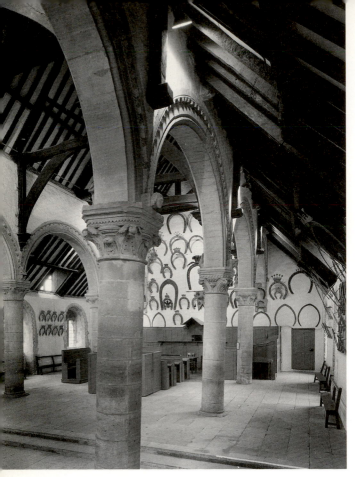

75. 'Corinthian' capitals in the hall arcades at Oakham Castle (Rutland), showing the spread of Canterbury influence in the 1180s.

77. The vaulted undercroft supporting the first-floor hall of the manor house at Burton Agnes, datable to *c.*1170–80.

76. Henry III's Great Hall at Winchester Castle, built between 1222 and 1235, and furnished with Purbeck marble columns.

Domestic architecture could scarcely remain unaffected by these events. There is indeed something Sicilian – or perhaps of Crusader Palestine – in the piped water system of Henry II's keep at Dover Castle, unprecedented outside the greater monasteries of that date.[10] And where, as at Oakham, a contemporary castle interior has been preserved, there are classicizing capitals, Corinthian in style, of which the only likely source is the choir at Canterbury.[11] In any event, rising expectations of domestic comfort continued to push up building standards. Oakham Castle's hall is entirely of stone, and if there is no way of telling how many comparable halls were still at that time being built of timber – and at least one, at Henry of Blois' Farnham Castle, certainly was [12] – the choice of stone for prestige domestic building had become as natural as for fortifications and for churches.

Many years before, in the late 1090s, William II had built the great stone hall at Westminster for which, both then and afterwards, there were few if any parallels on the Continent. William Rufus, it was reported, bragged that Westminster was 'too big for a chamber and not big enough for a hall'.[13] Yet in truth, it was too large to be of value as a model. The new class of stone halls, of which Oakham in the 1180s was representative, grew not from the extravagant precedent of Westminster Hall, but from a more straightforward translation of timber into stone, reproducing the aisled halls of the Anglo-Saxons. One such hall of the 1180s, complete with nave and aisles like a church, became the parish church of the layfolk of Ramsey when they could no longer be accommodated at the abbey. It serves the same purpose today.[14] And certainly the aisled plan, well suited to timber-framing, continued to have major advantages. Stone-built aisled halls of the Oakham and Ramsey type were already familiar before the end of the twelfth century. They continued to be built well into the thirteenth century and came to include such huge covered spaces as Henry III's great hall at Winchester Castle and the hall of Hugh du Puiset at Bishop Auckland (Co. Durham), now the chapel of the episcopal palace. In addition, there were smaller versions of the same, as in the short but lofty hall at Warnford (Hampshire), just behind the parish church, a former manor house of the lesser nobility.[15]

The aisled hall plan was not the only one in use at this period. At great buildings and small, from castles like Christchurch (Dorset), Grosmont (Mon-

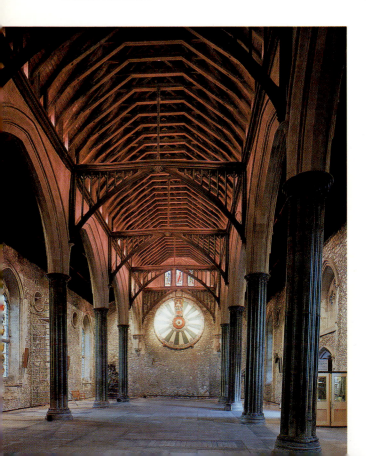

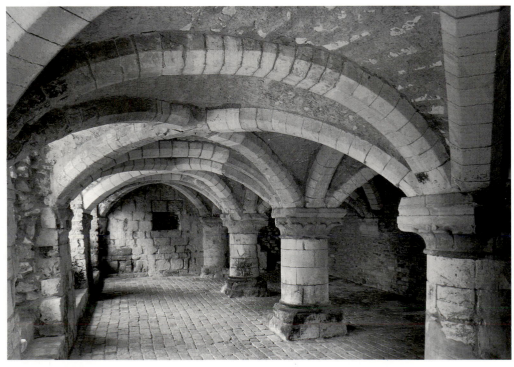

64

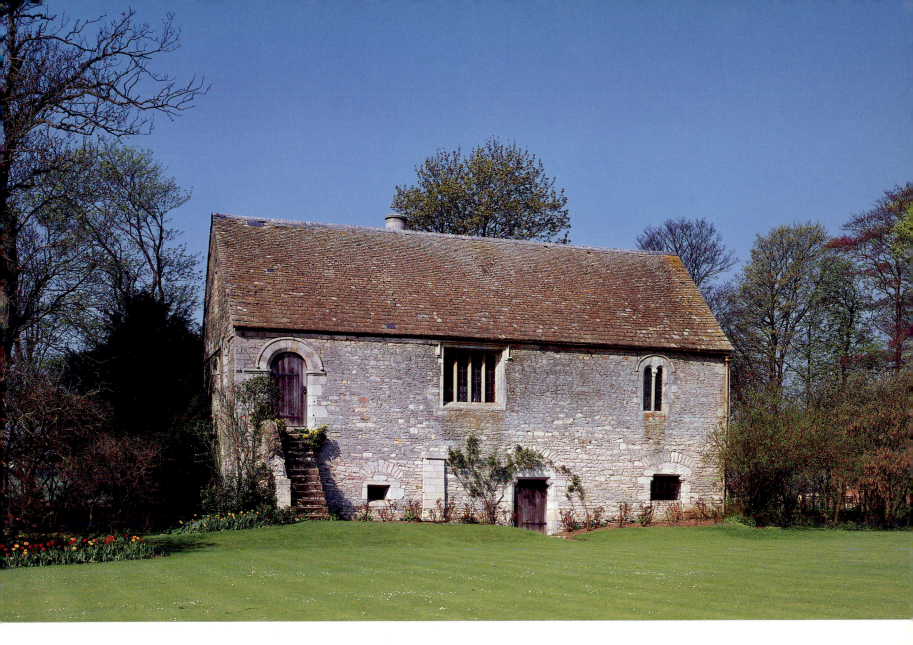

mouth) and Manorbier (Pembroke) at one end of the scale, to contemporary manor houses like Burton Agnes (Yorkshire) and Boothby Pagnell Lincolnshire) at the other, stone-built first-floor halls were a natural development on the more primitive accommodation offered in earlier decades by the tower keep. They shared the keep's characteristics of a defensible basement and an entrance approached by a stair. But what they promised at last was a standard of comfort beginning to resemble our own. Christchurch Castle's hall, placed over its gloomy undercroft, was furnished with good-sized windows fitted with window-seats, and was heated not – as had been customary – by a brazier or central hearth, but by a sidewall fireplace complete with chimney. Next to the hall, and on the same level, was a smaller private chamber, or lord's solar.[16] Just that plan, with only minor variations, was repeated at Grosmont and Manorbier, at Burton Agnes and Boothby Pagnell. What it brought to prominence was light and heat – big windows and sufficient fireplaces – in the search for greater comfort for the lord.[17]

Some of these buildings have remained in occupation through eight centuries. For the first time, that is, English domestic architecture had achieved a quality and a permanence not found before except in churches. This was as true of the larger urban dwelling as it was of the castle and the manor house. At both Lincoln and Southampton, merchant houses of the 1190s differ scarcely at all in plan from the contemporary Burton Agnes or Boothby Pagnell. New and still ripe for

78. The first-floor hall (left) and chamber (right), with outer stair approach, of the *c.*1200 manor house at Boothby Pagnell.

79. The stone hall-and-chamber block at Christchurch Castle, datable to *c.*1160.

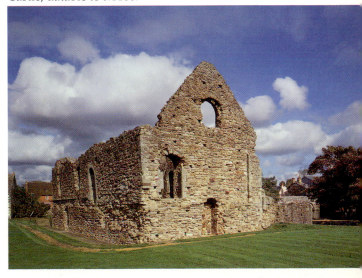

comment in the early thirteenth century, they have been recognized ever since as important buildings, securing a place in local myth and legend as the so-called 'Jew's House' of Lincoln, or as Southampton's 'palaces' of King John and King Canute.[18] In 1189, London's earliest known building regulations, fitz Ailwin's Assize, ordered stone in place of timber and tiles instead of thatch as a precaution against fire in the city.[19] London was rich and could afford such measures, not least because of Angevin trade.

Another clear consequence of Angevin connections overseas was a fresh sophistication in military engineering. Not every innovation of late twelfth-century castle architecture can be laid at the door of the Angevins. However, what is certain is that Henry II and his associates were building castles in England no less pioneering than those of France, and with very much the same characteristics. The earthwork castle, little changed in plan, was still being erected in frontier regions (see p. 6). Where it had survived from some earlier military settlement – as at Tickhill or Tutbury, Berkeley or Arundel, Tamworth or Pickering, Trematon, Berkhamsted or Okehampton – stone walls might take the place of timber palisades in a programme of simple substitution. Yet even on an old site like the motte at Tickhill, new ideas had begun to find a place. Tickhill, as refortified for Henry II, was furnished with a decagonal stone tower on the flat surface of the motte, of which only the foundations now remain. This was no mere shell-keep, replacing a palisade. What it recalls is the sophistication of a tower-house.[20]

Towers in medieval fortresses never lost their purpose. They were vantage points, residences, and symbols. But what especially characterized tower-building from the mid-twelfth century was a period of exceptional experiment. For two generations and more, towers were being built in a variety of plans difficult to parallel even amongst late-medieval castles of chivalry. Some, like Newcastle and Scarborough, Bamburgh and Carlisle, Norham and Brougham, Middleham, Dover and Carrickfergus, were huge hexahedrons, square or rectangular in plan, essentially palace-keeps of the old style. Others, including Portchester, Appleby and Chepstow, added extra storeys to the same end. A third category, represented at Richmond and Ludlow, rose on the arch of an earlier gatehouse. The resulting square keeps were rooted in Anglo-Norman tradition. More novel were the stone towers, polygonal or circular, which had begun to take the place of timber watchtowers.

80. Henry II built his 'great and splendid' keep at Scarborough between 1158 and 1168, replacing an earlier baronial fortress which he had appropriated at the beginning of his reign.
81. The early twelfth-century keep at Portchester Castle, to which another stage was added in the 1170s.
82. The polygonal tower keep at Orford Castle, built in 1166–73 as a royal residence, with self-contained lodgings for Henry II and his household.

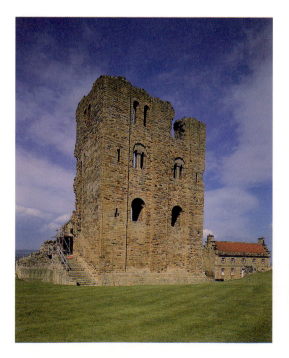
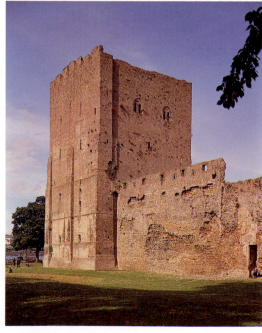
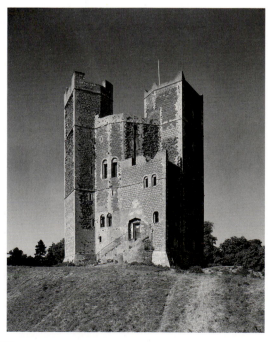

Towers like these have sometimes been seen as residual keeps. But this was not, in point of fact, how they functioned. The Angevin tower keep was less a place of last resort than a lordly residence. It had quality and sophistication thrust upon it. One of the most complex of these buildings, and certainly the most expensive, was the tower-house at Orford on the Suffolk coast, built by Henry II in 1166–73 as a counter to the Bigods' nearby fortress at Framlingham.[21] Orford's tower was polygonal on the outside and circular within, having two central halls, one above the other, well lit and separately heated by sidewall fireplaces. Attached turrets on three sides carried additional accommodation, providing two self-contained suites for the king and his associates, each with hall and kitchen, bedchambers and garderobes of its own. Over the entrance vestibule, the household chapel had a chamber annexed for the priest. Water might be drawn from a well in the basement or taken from a cistern at roof level. A fine newel stair rose the full height of the building.[22]

Orford's accommodation is unusually complete. It is also, in its provision of mural chambers at mezzanine level, exceptionally sophisticated in plan. But the tower is only one of a class. Other similar survivals include Henry II's Chilham (Kent), of 1171–4, and Conisbrough (Yorkshire), completed in the 1180s for the king's half-brother, Hamelin Plantagenet. There are the foundations of Henry's Tickhill and the shell of John's Odiham, each of polygonal plan. Robert de Roos' tower at Helmsley has a rounded outer front. And there are the many tower keeps of contemporary France, among them Orford's closest parallel in the 'Tour de César' at Provins and Henry II's own tower on the motte at Gisors, adding to an earlier fortification.[23]

Tower-building in France reached a pitch of invention during the latter years of Philip Augustus (1180–1223). Meanwhile, stone towers were rising everywhere and at many different scales, a common factor being their use as the lord's residence. Moreton Corbet, in Shropshire, is a modest rectangular tower keep of about 1200, unremarkable in almost every way. Yet at first-floor level, in what must have been the lord's hall, there is a fine sidewall fireplace at least as elegant as any of the king's. Peveril's small square keep of the mid-1170s has no comparable fireplace and must have been heated by movable braziers. But the first-floor hall of Henry II's 'Castle of the Peak' had generous windows; it was equipped with mural passages and with a private garderobe; the keep's stonework was well crafted and its design sophisticated, its roof gable hidden away

83. Hamelin Plantagenet's fine cylinder keep at Conisbrough, in South Yorkshire, was built as his personal residence.
84. A residential tower keep of *c*.1180 at Brough Castle, in Cumbria; the first-floor hall (over a storage basement) had two storeys of chambers above.
85. Robert de Roos (d. 1227) added this tower keep to the defences of Helmsley (North Yorkshire). On the far side, overlooking the moat, it was furnished with a semicircular front.

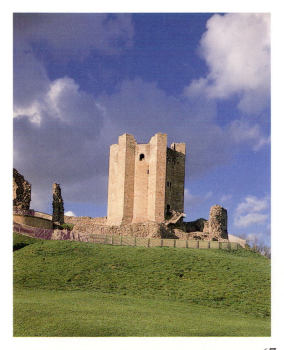

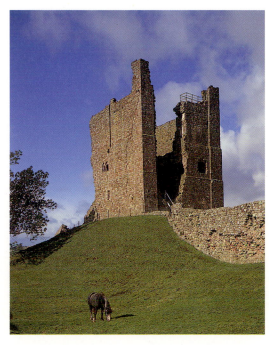

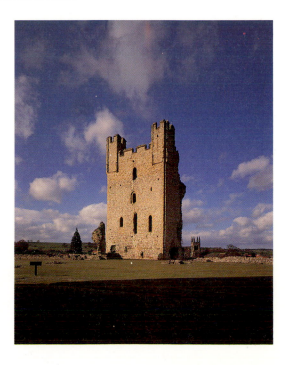

neatly behind the parapet.[24] A near-contemporary of Peveril was the tower keep at Brough, built in about 1180 and at first equipped with a hidden gable of the same kind. Brough had a store at ground level and spacious apartments above, including a hall on the first floor and a chamber on the second, to which a third residential tier was quickly added.[25]

Brough's tower, solidly founded on rock, endured better than those keeps on man-made mounds where no special provision was made to prevent subsidence. Duffus Castle, in Elgin, offers one of the more spectacular examples of motte-surface landslips, even after centuries of consolidation and settlement. Yet the problem was well recognized by the more alert twelfth-century castle-builders, and there is evidence of expenditure on underground works almost as generous as on the towers they supported. One solution, adopted earlier at modest timber castles like South Mimms, was to build the tower first and only then to heap a mound round its base.[26] There are equivalent stone cores within the mottes at Ascot Doilly and Totnes, Farnham and Lincoln, Aldingbourne and Saffron Walden.[27] Another remedy was to abandon the motte's surface and to build against its side, as at the big royal castle at Guildford.[28] A third measure, clearly seen at Berkeley and at Farnham again, was to case the entire mound in a stone shell.[29]

Neither the tower at Farnham nor the motte's later casing are closely datable. The former may be as early as the late 1130s; the latter is probably after 1155. If those dates are correct, Farnham pioneered a new kind of tower in which height was given precedence over residential space, substantially reducing floor areas. Much of the expense of a tower keep like Farnham's was incurred in preparing the foundations. They were not, at Henry of Blois' castle, especially well conceived, and indeed there was always an element of experiment in such buildings. More satisfactory in every way was the founding of a watchtower on an undisturbed natural surface, as at Brough or the contemporary Goodrich. The tower at Goodrich – like the one at White Castle, a few miles to the west, of which only the foundations now remain – was a miniature keep, with a hall on the first floor (entered at that level) and a chamber on the next floor above.[30] But it was never a castle in its own right. From this time forward, emphasis began to shift from the keep to its surrounding curtain: the one tower replaced by the many.

What was new was not the stone curtain wall but the systematic spacing of its towers. Back in Antiquity, the Romans had developed the projecting mural, or flanking, tower to command both wall-walk and outer face with cross-fire. And it was probably the Roman *castrum* which provided the model for such outstandingly regularly planned fortresses as Belvoir, in the Holy Land, rebuilt for the Hospitallers after 1168 and well known to crusaders from the West. While work was in progress on Belvoir, the attention of Western Christendom was uniquely focused on the Holy Land, as Saladin moved in on Jerusalem. Henry II, who never went on crusade, promised to do so many times. After Jerusalem's fall in 1187, Richard I was among those who tried to get it back. Everybody at Court, from the 1170s or earlier, hung daily on the tidings from the East.

The consequences for Western castle-building are obvious. Conisbrough's tower keep, already a pioneering work, was not the only innovation at this single-period fortress, contemporary with Henry II's Dover. As important was Hamelin Plantagenet's new stone curtain, replacing a palisade, round the irregular oval of the existing bailey. Two characteristics of that curtain are especially striking, and both probably derive from the Crusader Kingdom, where they occur at castles like Sahyun. One was the incorporation of solid half-round towers along the wall's length. The other was the splaying of the wall-base as a protection against mining and for bouncing out missiles on assailants.[31] Hamelin himself is not remembered as a crusader. But his father-in-law, Earl William, had died on crusade, and among Hamelin's associates at Henry II's

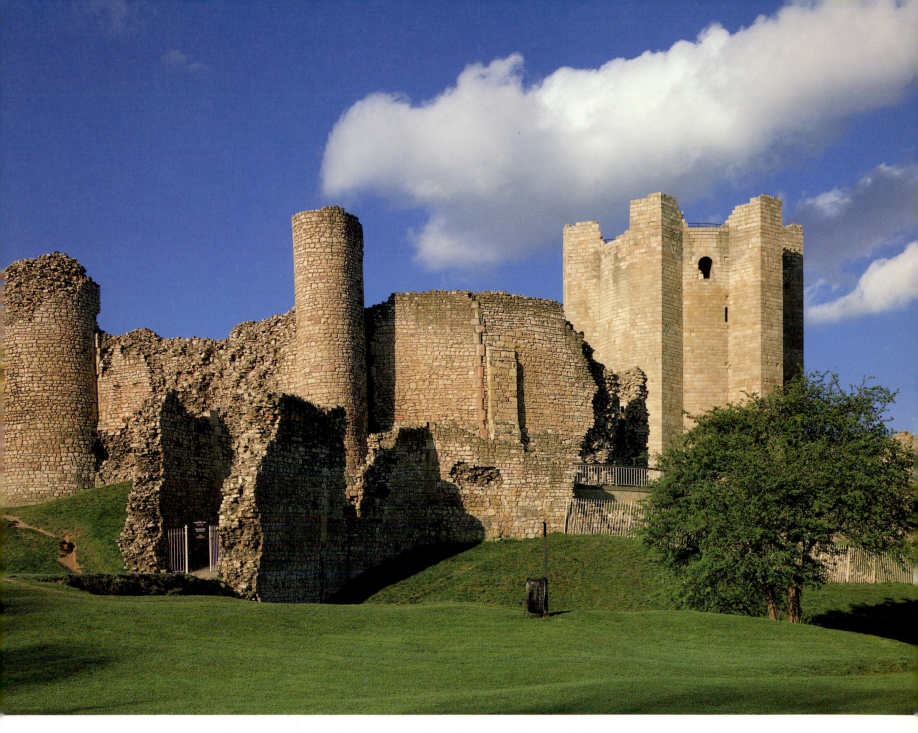

court were many who had fought in Christian Palestine. They knew military engineering on its moving frontier: what we might now call 'state of the art'.

This new expertise, exploited to the full, characterized Richard I's 'Fair Castle of the Rock' at Château-Gaillard. Richard built his Normandy fortress in less than two years, between 1196 and 1198, shortly after returning home from Crusade. He packed it with everything he had learnt. Not all this knowledge derived directly from the Holy Land. Richard was an experienced soldier before he ever went there. But whatever the source of change, castle architecture had entered a new phase. Château-Gaillard's tower keep – beak-shaped in plan, boldly machicolated, and generously splayed at the base – was nevertheless almost wholly ornamental. It sheltered behind a barbican and two other defensive lines. It could have played little part in resisting an attacker who, by the time he reached it, must already have been acknowledged to be the victor.[32]

Château-Gaillard had the strong towered curtain seen already at Henry's Orford in the 1170s. In the following decade, Hamelin's Conisbrough had been similarly defended. Then in the 1190s, just when Château-Gaillard was under

86. The innovatory towered curtain of the 1180s at Conisbrough probably reflected recent castle-building experience in the Holy Land.

69

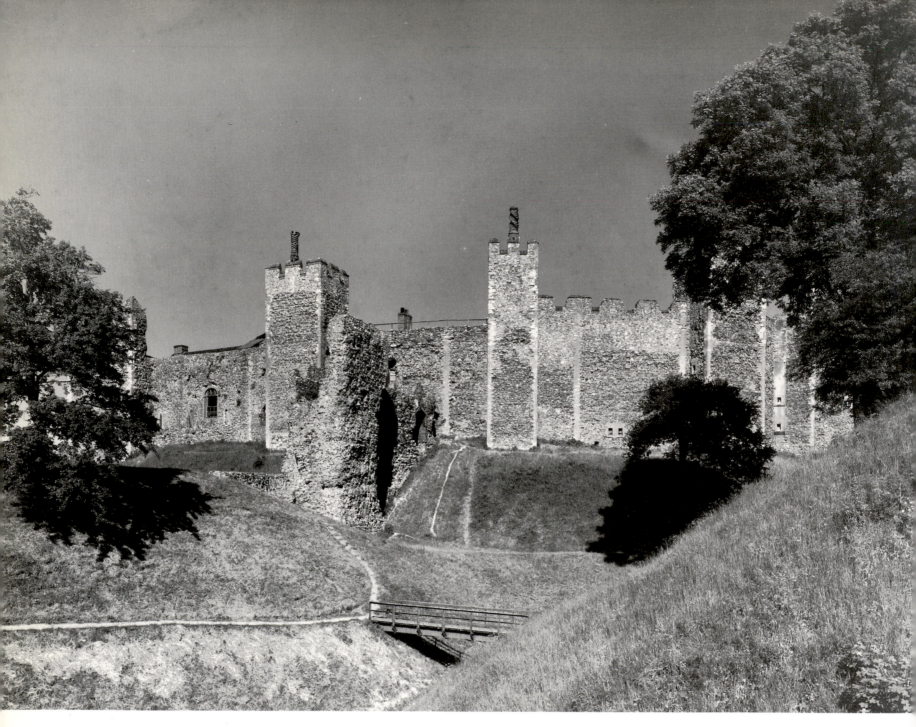

87. The towered curtain at Roger Bigod's Framling-ham Castle, one of the first major English fortresses to do without a keep of any kind.

construction, Roger Bigod at Framlingham built himself a fortress which did away entirely with the keep, relying exclusively on the strength of a towered curtain.[33] Yet at none of these castles are multiple defences preserved as systematic as those of Château-Gaillard. And it was the calculated exploitation of concentric defence which was the chief contribution of Richard I and his generation to military engineering. Even this was not wholly new. Dover Castle, remodelled extensively for Henry II in the 1180s, was still unfinished when Château-Gaillard was laid out. It is a remarkable building – a point of reference in castle architecture – not least for the fact that, even before Henry's death in 1189, it had begun to be equipped with a second outer curtain, designed to circle and duplicate the first. It was this outer ring, completed by King John and subsequently extended by his son, which held fast during the siege of 1216. Neither then nor later were the inner curtain of Dover or its huge palace-keep ever tested by direct siege assault.[34]

The next stages at Dover, refortified after the siege at a cost equivalent to Henry II's own heavy expenditure on the fortress, belong to another era alto-

gether of castle-building. However, the professionalism of siege warfare was now obvious to all, as was the heavy price of providing against it. In the meantime, it had been the king himself whose outlawing of private fortresses had contributed to the disappearance of the earthwork castle.[35] And in truth such castles had lost their purpose for a society which, knowing very well how to enter any fortress, preferred to seek its remedies in the law. For a century or more, private castle-building fell off dramatically in England. When revived again, it would be recognized by all not as a threat to the State but as an individual precaution against social tumult, the consequence of pre-plague overcrowding.

The improved public order of Angevin England, which made the private castle redundant, had other more positive effects. It provided the context for urban growth and for the foundation of many new towns. In the North, it encouraged seigneurial investment in planned villages.[36] Always prominent in such initiatives were the ecclesiastical entrepreneurs who, deprived of the rule of law in Stephen's reign, had now seen it re-established by the Angevins. A leading founder of new villages was the bishop of Durham; at Winchester, the bishop was a busy creator of new towns. All over the country, monastic landowners profited from the generosity of competing patrons to enlarge and exploit their estates. This was not yet the era of the most efficient 'high farming' which, like military engineering at its apogee, would distinguish the thirteenth century, not the twelfth.[37] Nevertheless monks, both old and new, continued to do well in Angevin England. Some, indeed, had only just landed on its shores.

Most important of the newcomers were the Premonstratensian 'white' canons, greatly influenced by St Bernard's 'white' Cistercians. An early Premonstratensian house was Easby, in North Yorkshire, founded shortly after 1150. But the canons had first arrived in England in 1143, settling at Newsham, in Lincolnshire. Four years later, they were at Alnwick (Northumberland), and it was from Alnwick that they were called to Dryburgh (Berwick) in 1150, on the invitation of Hugh de Moreville, constable to David I of Scotland. Dryburgh, like many of the new religious foundations of King David and his circle, was richly endowed from the start. Today, what remains of its buildings is of evident and appropriate quality. But this was not the common lot of most Premonstratensian houses. If the Cistercians had drawn support from the comital classes, from the earls and from the higher feudatories, Premonstratensian patrons were characteristically *curiales*, or civil servants. Along with would-be barons and other men on the make, they bought the best spiritual protection available to them at the time, but drove a hard bargain when they did so.[38]

Fully representative of this curial class and latterly a good friend of the Premonstratensians, was Rannulf de Glanville, Henry II's chief justiciar. In 1171, a decade before promotion to high office, Rannulf had settled Augustinian 'black' canons at Butley, in Suffolk. Like other men of religion including Cistercians by that date, the canons of Butley, although already rich, had at once busied themselves in the purchase of more lands. And it was this manifest greed, so Gerald of Wales tells us, which deflected the chief justiciar from his first allegiance, turning him instead to the Premonstratensians. In 1183, Rannulf established white canons at Leiston, in the same county. He never raised them, as he first proposed, to high rank among the communities of their order. However, even before his own loss of office in 1189 shipwrecked all such plans, Rannulf had limited Leiston's canons significantly. The abbey's foundation charter guarded against future trading in land: all that the canons owned must have been given to them 'without recompense and in free alms'; nor were they to arrogate to themselves rights which properly belonged to their tenants.[39] If Rannulf could help it, and if his charter were observed, no white canon would go the way of the black.

Rannulf's patronage of the Premonstratensians extended well beyond Leiston.

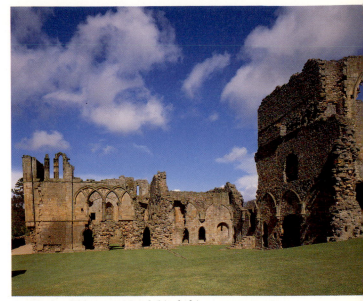

88. Easby Abbey, in North Yorkshire, was among England's pioneer Premonstratensian houses. It was founded in the early 1150s by Roald, constable of Richmond, next to an existing parish church. The west range (centre) held both the canons' dormitory and guests' quarters.

89. The Premonstratensian settlement of Scotland began at Dryburgh in 1150. The abbey was rich, and the canons were able to build their church – of which this is the north transept – in the latest Gothic style, called by the Scots 'First Pointed'.

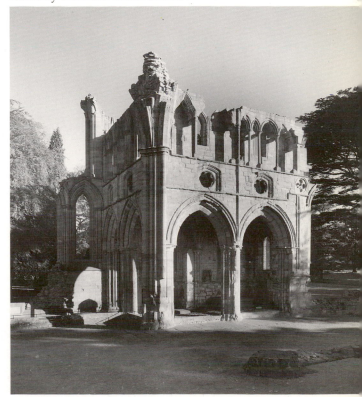

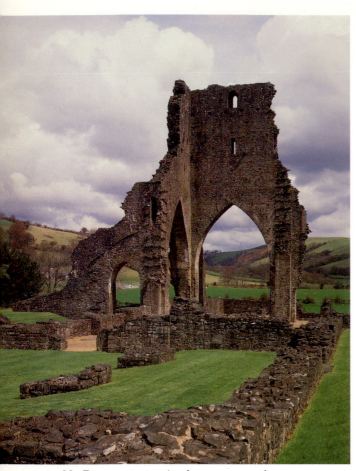

90. Premonstratensian houses were often as remote as Cistercian, but were usually less well endowed. Talley, in South Wales, was founded by Rhys ap Gruffudd in the 1180s. Its community never completed the church laid out by the first canons at that time.

He had a family connection, by way of his brother Gerald, with Welbeck Abbey, one of the earliest and best endowed of the English houses. It was from Welbeck that the community of Leiston was recruited. Other Welbeck canons went to West Dereham, in Norfolk, founded in 1188 by Rannulf's nephew, Hubert Walter, subsequently chief justiciar in his turn. Leiston itself was the source of recruits for Langdon (Kent), of which the founders in 1189 were Rannulf's daughter, Matilda, and son-in-law, William d'Auberville. Another daughter, Helewise, founded Coverham (Yorkshire), originally settled at Swainby. A second nephew, Theobald Walter, elevated the hospital at Cockersand (Lancashire) into a Premonstratensian community.[40]

Associated with these foundations were two Premonstratensian abbeys, each of conspicuous isolation. Shap Abbey, colonized from Cockersand, is tucked into the folds of a cold Westmorland heath, poorer and more remote than any contemporary community of Cistercians. Shap enjoyed a brief prominence under Abbot Richard Redman (d.1505), and it was then that its great tower was built. But its story is otherwise little known.[41] Talley, in Carmarthenshire, was the Premonstratensians' only Welsh house, almost as distant and as poverty-stricken as Shap. It was founded by Rhys ap Gruffudd, prince of Deheubarth, probably after consultations with Rannulf de Glanville, with whom the prince was acquainted. Although begun with great optimism in the late 1180s, Talley never grew on the scale first intended. Its church was reduced and its cloister cut down no later than the early thirteenth century.[42]

Both Talley and Shap drew the greater part of their revenues, such as they were, from parish churches. The canons themselves, like their Augustinian brethren, are known to have served their own churches, at least in the earlier years. And it was precisely the utility of arrangements of this kind which recommended regular canons to their benefactors. Less self-absorbed than the Cistercians, who had refused the distraction of parochial cures, and less particular about the other lands they received, the Premonstratensians also enjoyed an advantage over the Augustinians in the sweet savour of their reputation for self-denial. Premonstratensians were known for their 'pitiable poverty', their 'abundant want'. They laboured hard and kept long vigils. Their clothes teemed with vermin.[43] God and Man loved them for it.

Discriminating founders sought out the same characteristics in other orders. David I of Scotland (1124–53), most expert of patrons and a supporter of the white canons at Dryburgh, had also favoured black canons in his day (see p. 52) Early in his reign, in 1128, he had entrusted Holyrood (Edinburgh) to the Augustinians; ten years later, he gave them the great Roxburgh abbey at Jedburgh. Yet within two years of Jedburgh's foundation, David had turned to the Arrouaisian canons – a contemplative branch of the Augustinian family, favoured by Malachy of Armagh. Cambuskenneth, David's rich Arrouaisian foundation close to his castle at Stirling, was founded soon after Malachy's visit to the Scottish court in the autumn of 1140.[44] The Irishman had just returned from France, where his search for models of monastic observance had introduced him primarily to St Bernard's Cistercians, but had taken him also to the Augustinians of Arrouaise, under their notable Abbot Gervase. It was the Arrouaisian use, stricter than most, which Malachy took home with him to Ireland.[45]

Henry II of England, unlike King David, was no saint. Nevertheless, in common with many contemporary public figures, including his own chief justiciar, he applauded asceticism when he saw it. 'Well known', it was claimed, was Henry's 'love of men with a reputation for holiness, a grace he had received from God'.[46] And although there was political calculation also in his behaviour towards the monks, the nature of Henry's foundations fully accorded with the claim, as did the company he kept. Both Ailred of Rievaulx and Gilbert of Sempringham were familiars of the king. It may have been one of these who drew

Henry's attention to an Augustinian community at Haughmond, in Shropshire, which (against the use of the order) affected the white habit of hermit monks where it ought in normal circumstances to have worn black. Haughmond's abbot from the 1160s was Alfred, Henry's former tutor (*nutricius*). Under the sun of the king's benevolence, the abbey was entirely rebuilt.[47]

More equivocal might be the case of the new religious foundations forced on the king by remorse following the murder of Archbishop Thomas Becket. Yet at each of these he took the side of reform. The most expensive of the three undertakings was at Waltham, in Essex, where a notoriously lax community of secular canons was pensioned off to make room for an Augustinian colony, hand-picked from three houses – Cirencester, Osney, and St Osyth's – considered to be among the best of their order. Waltham was already a big collegiate church before the king laid claim to it. However, it was to be enormously extended after 1177, in partial commutation of the crusading vow which had been Henry's first reaction to the murder.[48] That same year, Henry cleared Amesbury (Wiltshire) of its concupiscent abbess and licentious nuns, to re-found the house as a Fontevraldine priory and to build there a new church and cloister.[49] Henry's third expiatory foundation, also of that time, was the Charterhouse at Witham (Somerset), colonized directly from La Grande Chartreuse and England's first penetration by Carthusians. Witham, under its Prior Hugh of Avalon – another well-known face at Court – established new parameters of 'abundant want', exceeding even those of the Premonstratensians.

Witham, a 'wild and lonely place' in Selwood Forest, was semi-eremitical. Its monks were confined for the most part to their cells, having little human contact to sustain them. As one of Witham's first inmates complained to Prior Hugh:

> Wretch, you have deluded us . . . taking us away from our pleasant dwellings and a civilised way of life. You have forced us to lurk amongst beasts and thorns, as if there were not places of monastic retirement in the world. The whole land is full of communities of monks, and the mutual support provided by the communal life provides us with a sufficiently good example of religious perfection. Here, alone and without companionship, we become torpid and dull through boredom, seeing no one for days at a time whose example can inspire us, and having only the walls which shut us in to look at.

The complainant, Alexander of Lewes, took himself off. 'Since we know better', he claimed, 'we must not and cannot endure this unprofitable and narrow way of life any longer. We are going to seek something saner . . . '.[50] Alexander had a point. Britain was not yet ready for the Carthusians. The order's success in England came much later, chiefly after the Black Death. It was slower still to penetrate Scotland, and never reached Ireland at all.

Equally in advance of contemporary English taste was Henry II's patronage of the Order of Grandmont, of which in France he was a generous advocate. Early in the thirteenth century, Grandmontines did indeed reach England, to settle three priories – Alberbury (Shropshire), Craswall (Herefordshire), and Grosmont (North Yorkshire) – of truly exemplary poverty. 'They have shut out avarice and embraced poverty', said the bishop of Tournai, 'and their prayers are not disturbed by the baaing of sheep and the lowing of oxen.'[51] Yet in the 1180s, just as Henry made arrangements to lay his bones amongst them, the Grandmontines fell into schism. As their own Prior Gerard reported:

> Both clerks and lay brothers share one church, cloister, chapter-house, refectory and dormitory; there is no distinction in their dress or tonsure. They wear sackcloth next their skins . . . When they have entered the solitude of the Order, they never go back to this world, either on business or to visit their kinsfolk, or to make purchases at markets or fairs, or to appear in courts of law, but they are as men who are dead to this world.[52]

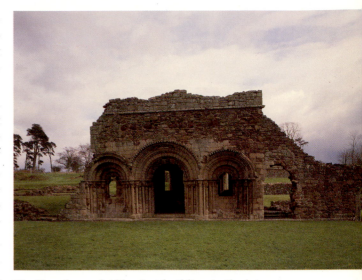

91. Haughmond Abbey's rebuilding in the late twelfth century included a fine chapter-house, of which this was the entrance from the cloister.

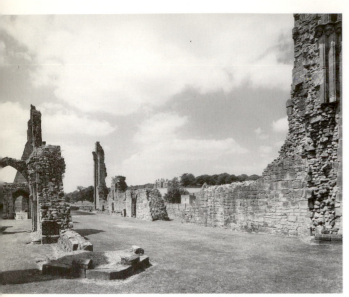

92. The church at Bayham Abbey was begun early in the thirteenth century, on the merger of two smaller Premonstratensian communities neither of which could have survived on its own.

93. Sophisticated Late Norman ornament and blind arcading in the great chapter-house of the Victorines of Bristol Abbey.

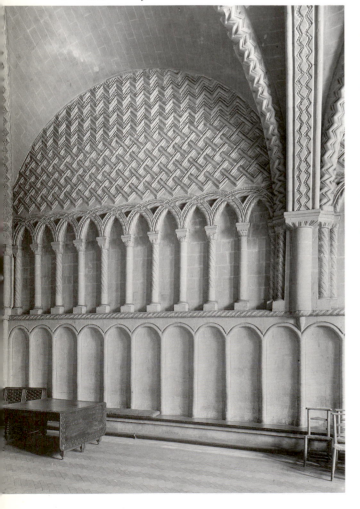

Responsibility without power turned lay brethren against monks. There were riots at Grandmont: monks were held captive and the prior expelled. Government by the unworldly made no sense.[53]

Henry II, put off by these ructions, chose Fontevrault instead as his tomb-church. What he got from the nuns of Fontevrault was quality and wealth; what he contributed was more of each kind. Stephen of Muret, founder of Grandmont, had once told his followers: 'I have remained in my hermitage for nearly fifty years, some of them years of plenty, others of scarcity, but I have always had enough. So will it be with you if you keep my commandments.'[54] But they had kept his commandments and they had lost their peace. And it must have been clear to all, on Grandmontine and other evidence, that St Stephen's individual imitation of Christ was no prescript for a major monastic order. With few exceptions, it was not the little and poorer houses which kept their morals most intact, but the wealthier establishments in the public eye – Durham and Fountains, Evesham, Glastonbury and Winchcombe: all busy self-renewers to the end.

Ascetic communities, in the event, had the same need of adequate endowment as any other. True, Brinkburn's canons were plain Augustinians, not identified (so far as we know) with reform. Yet they shared many characteristics with the ascetics. They dwelt alone in the 'perfect seclusion' of a steep Northumberland valley, on a site such as hermit-monks might have envied. Their church, too, was of that restrained perfection and dignity of line more usually associated with Cistercians. Its date is especially important. When building began there in the late 1180s, as much as fifty years after the priory's foundation, Brinkburn's canons had only just won their independence. For the first and last time, they were experiencing an episode of support and re-endowment, without which they might very well have foundered.[55]

The risk was real enough. Collapses could and did occur within the space of a single generation. One of these brought down the little priory at Wickham Skeith (Suffolk), founded in the late 1130s by Robert de Saukevilla when he joined the Benedictines of Colchester. Robert's son, Jordan, wound up the small establishment, returning its four monks to their mother abbey.[56] Brockley and Otham, both Premonstratensian houses, were similarly ill-endowed from the start. Founded contemporaneously in the 1180s, they had to be rescued thirty years later in a merger at Bayham (East Sussex), beginning there entirely afresh. Afterwards, supported by its joint endowment, Bayham survived in good order. It was this community which, as late as Wolsey's enforced suppression of 1525, so held the loyalty of local men that they were willing to risk their freedom in its cause.[57]

Certainly the wealthiest communities of regular canons included many which embraced the reforms. Carlisle, the canons' only English cathedral priory – they had another at St Andrews, in Scotland – at least toyed with such allegiances in the 1140s, while temporarily under Scottish control.[58] Dorchester was Arrouaisian, and so were Hartland and Lilleshall, Missenden, Notley and Lesnes. Wigmore was Victorine, as was the affluent Bristol Abbey, subsequently the post-Reformation cathedral. Both Arrouaisians and Victorines were ascetics. As such, they won the support of committed reformers like Malachy of Armagh, who caused them to dominate the Augustinian congregation of Ireland.[59] While less comprehensively successful in twelfth-century England, they nevertheless attracted mighty patrons. At Bristol today, a huge Late Norman chapter-house, of exceptional decorative richness, is the most impressive survival of the abbey's first-phase Victorine settlement. It has an elaborate pillared and vaulted vestibule; great zigzag-ornamented cross-ribs span its principal chamber, of which each wall is enriched with blind arcades. This is not provincial work. And it must reflect the concern of Henry II himself, awakened even before his accession. Henry fitz Empress had been in Bristol as a boy, in the household of his mother's

chief lieutenant, Robert of Gloucester. And it was early in the 1140s, while Henry was there, that Robert fitz Harding began his project to reclaim for Christ a site associated in folk memory with St Augustine's Canterbury mission. Victorines were chosen for the task. Known principally for the excellence of their scholarship, they had arrived in England just a few years before: at Shobdon, then moving on to Wigmore. In France, their friends included Matilda the Empress, co-founder with Henry of Notre-Dame-du-Voue (Normandy), and patron of Abbot Gilduin of St Victor (1113–55). Richard of Warwick, Bristol's first abbot, was one of Gilduin's own men. He had spent some time at Wigmore on the way, and presided over an expansion which knew no bounds once the young king came into his own.[60]

Henry II's inbred preference for ascetics, even before Becket's murder in 1170, is clear enough. It was widely shared by the best spirits of his day. But choices of this kind, while diverting patronage towards new ends, had yet to cause serious hardship to the older religious houses, from the Benedictines through to the Cistercians. Rich as they were, both white monks and black employed the swelling surpluses on their accumulated estates to build as though the Devil were behind them. A case in point is Benedictine Peterborough. Formerly among the wealthiest of the Anglo-Saxon houses, Peterborough Abbey had been caught seriously wrong-footed by the Conquest. The community had suffered especially badly under Abbot Thorold (1070–98), its first Norman abbot. But when, in the mid-twelfth century, Hugh Candidus told the story of how Thorold had 'squandered' Peterborough's resources, reducing them to less than half their former worth (see p. 22), the abbey's recovery was already well advanced.[61] Throughout the twelfth century, following the fire of 1116, a great new church advanced steadily westward, on a scale more appropriate to a cathedral. The monks' choir and presbytery were finished by the 1140s; the nave was complete before 1190; a fine west front, of very original design, had been added by 1238.[62]

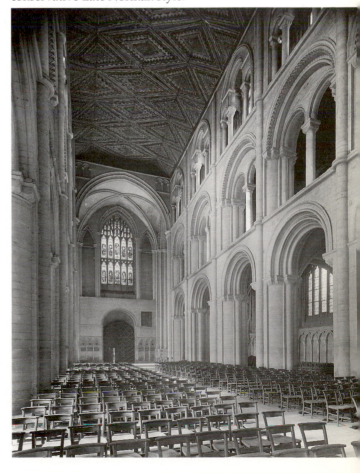

94. Peterborough Abbey, badly affected by the Conquest, recovered sufficiently in the following century to complete its new nave by 1190, still in a conservative Late Norman style.

As though in compensation for its earlier misfortunes, Peterborough was exceptionally well placed to take advantage of new market opportunities. It started with a rich, if depleted, pre-Conquest endowment. It had a fine collection of celebrated relics, most notably the arm of St Oswald of Northumbria (d.642), one of the very few saints of Anglo-Saxon England whose cult had won a following on the Continent. More important than these, Peterborough's situation between forest and fen gave it resources until then very little exploited. Neither patronal benevolence nor pilgrim offerings could have achieved the same results on their own. What guaranteed Peterborough's prosperity was the growing demand for cultivable land to house and maintain a population steadily on the increase through these centuries. Peterborough's monks became professional agriculturalists. They cleared their forests and drained their fens, exploiting to the limit their corporate wealth in open competition with their neighbours.[63] 'Concerning this marsh,' said Matthew Paris of southern Lincolnshire,

a wonder has happened in our time; for in the years past, beyond living memory, these places were accessible neither for man nor for beast, affording only deep mud with sedge and reeds, and inhabited by birds, indeed more likely by devils. . . . This is now changed into delightful meadows and also arable ground.[64]

What Matthew Paris described was the work of Benedictines like himself: monks of Spalding, Thorney and Crowland. They had taken these marshes – 'black waters overhung by fog'[65] – and they had reclaimed them so successfully as to increase population densities by anything between five and sixty times.[66] Little of this often remarkable growth was achieved as a consequence of new patronage. Benedictine patrons, in these latter days, were of lower social status

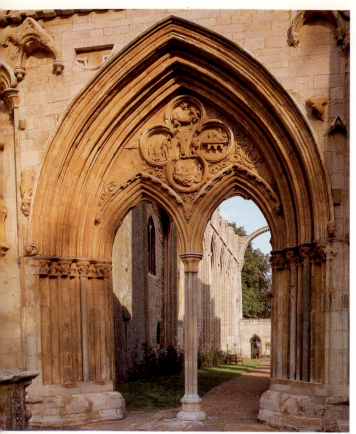

95. A carved *Life of St Guthlac* (673–714), over the west door of Crowland Abbey, celebrates one of the first settlers of the Lincolnshire Fens.

96. The Lady Chapel at Glastonbury Abbey, built immediately after the great fire of 1184 had almost totally destroyed the monks' church.

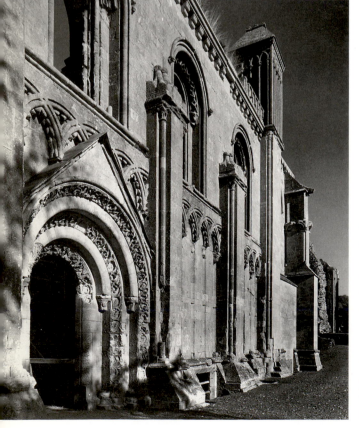

than before. Recruited ever more narrowly from among the monks' own tenants, they were numerous still, but gave less.[67]

In the thirteenth century, when Matthew Paris wrote, many of these gifts were in fact disguised sales. With their brethren at Peterborough to the south, the monks of Thorney and Crowland assumed a high profile in the land market. They had begun by recovering their own alienated property, dispersed by Thorold of Peterborough and his like. But they soon became busy in purchases and exchanges, buying out local families which had got into difficulties, while themselves having access to ready capital. Before the end of the twelfth century, such entrepreneurial activity had roused violent passions in the locality. In 1189, the men of Holland, 'variously armed', broke into Crowland's precinct, which they partitioned briefly amongst themselves. Fenland pastures, once accessible to all, had been drained and enclosed by Crowland's abbots. Arable took the place of grazing; fishing and wild-fowling had been pushed back north towards the sea. A traditional way of life was at an end.[68]

Huge increases in land values, concentrating especially within the twelfth and thirteenth centuries, inevitably resulted in ambitious building programmes, permanently marking the landscape. In particular, there is the testimony of the Fenland parish churches: a tight concentration of unexampled treasures at Whaplode and Gedney, Long Sutton and Leverington, West Walton, Walsoken, and many more. Of the religious houses, only Peterborough has survived fully intact, saved by its promotion to cathedral. Spalding has gone. Thorney and Crowland are battered shells. Even so, the quality of the work at Crowland is significant. Dating to the 1260s, Crowland's ornate west front is in the most lavish court style of Henry III's Westminster, as costly as the Angel Choir at Lincoln. Especially rich in its surviving sculptures, Crowland's nave facade still carries a quatrefoil *Life* of the royal hermit Guthlac (673–714) – landing, ordination, interment, apotheosis – first to make his home amongst these marshes.[69]

Another relevant image – of building works in progress – is given special prominence in Guthlac's quatrefoil. The Saint directs Satan to fetch stone for Crowland Abbey, shortly to take the place of his former hermitage. Both Crowland and Thorney were pre-Conquest foundations. Sheltered by their isolation, they had avoided the worst consequences of the Norman settlement in the region and, by 1150 at the latest, were comfortably back on track to prosperity. Even their greater and more exposed neighbours – Ramsey, Ely, and Peterborough – had triumphed over their disabilities by this period. While never recovering in full what the Normans took from them, these former stars of the tenth-century monastic firmament were again back in business as mighty builders.

Everywhere the scale of buildings was transformed. Romsey was a royal nunnery, close to the king's treasury at Winchester, and certainly better off than most. Nevertheless, it required unusual confidence for the nuns and their advisers to embark on a building programme in *c*.1120 which, over the next century, totally eclipsed an earlier church since found to underlie their later crossing. At Muchelney, in Somerset, the surviving crypt of the Anglo-Saxon abbey church is again dwarfed by what followed in the twelfth century. Yet big though it was, Muchelney's Norman church was only half the size of its near neighbour at Glastonbury, rebuilt twice in the Conquest's aftermath, then totally reconstructed on a still grander scale following the disastrous fire of 1184.[70]

Glastonbury's post-Conquest rebuilding was started by Thurstan of Caen, its first Norman abbot. His successor Herluin (1100–18), another monk of Caen, 'considering that the church begun by his predecessor did not correspond to the greatness of the possessions [of Glastonbury], razed it completely and began a new building, on which he spent £480.' Then Henry of Blois (1126–71), holding Glastonbury in plurality with the see of Winchester,

adorned the place with very fine buildings, a kingly palace called the castle, a bell-tower, chapter-house, cloister, lavatory, refectory, dormitory, infirmary with its chapel, a fine outer gate of squared stones, a large malthouse and stables, completing these from the foundations upwards.[71]

Abbot Robert (1173–80) added the chamber and chapel which, alone with Bishop Henry's bell-tower, survived the fire of 1184. Dismayed by this catastrophe, Glastonbury's monks nevertheless began building again almost immediately. They patched their burnt nave for temporary use, and before the decade was out had completed the new Lady Chapel at the west end of their church which is Glastonbury's most significant survival. The building is important for two reasons. First, although plainly rushed, it was not in the least bit economical. 'Correspond[ing] to the greatness' of the abbey, Glastonbury's Lady Chapel was of the highest decorative quality. Second, its design was entirely up to date, conceived at just that transition between full-dress Late Norman and an imported French Gothic at last coming to be applied with understanding. The Lady Chapel's windows are round-headed; its interior is enriched with intersecting blind arcades and zigzag ornament. But its vaults are fully pointed, and the crocket-capitals of the external buttresses which support those vaults are French Gothic 'of exactly that moment'.[72]

Work at Malmesbury Abbey, in northern Wiltshire, parallels Late Norman Glastonbury. Malmesbury's Benedictines, like those of Glastonbury, were of Anglo-Saxon origin. But they had been ruled by Norman abbots – Thorold of Fécamp, Warin of Lire, Godfrey of Jumièges and their successors – from 1067. And they were soundly situated, a century later, for a thoroughgoing reconstruction of their church. Not a great deal is left of that rebuilding. Both chancel and crossing have been lost. What remains is the truncated nave of the late 1160s, begun during the abbacy of Gregory of Lire (d.1168), and re-roofed in the early fourteenth century. Again the source is probably French. Big pointed arches in

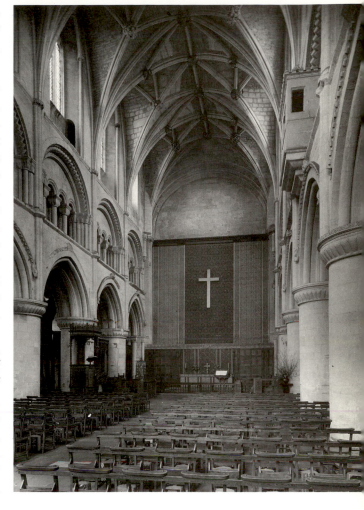

97. Transitional work of the late 1160s at Malmesbury Abbey, where first-period Gothic arches in the nave arcade support a Romanesque (Late Norman) triforium.

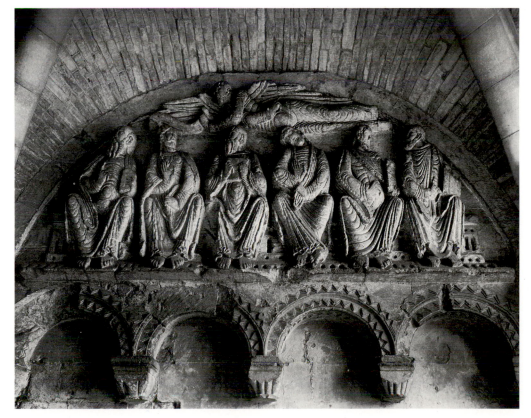

98. High-quality carvings of seated Apostles (under an Angel) in the south porch at Malmesbury, clearly influenced by the sculptures at Autun.

the nave arcades support galleries conventionally Late Norman. Similar juxtapositions, rare in England as early as this, were already familiar in Burgundy. Likewise, the rich south-porch carvings for which Malmesbury is well known – a Creation Cycle, the Twelve Apostles, and a Christ in Glory – have close earlier parallels at Autun.[73]

In the presence of sculptures of Malmesbury's quality, or of an exceptional building like the Lady Chapel at Glastonbury, we can feel the throb of an economy in lift-off. During just those years, Glastonbury launched the systematic drainage and reclamation of the Somerset Levels which would yield it some of its most valuable estates.[74] Muchelney Abbey, Glastonbury's companion on the Levels, from the comparative flood security of its eponymous 'Great Island', multiplied its holdings many times.[75] Contemporaneously, on the quite different sandy soils of the Hastings Beds, the monks of Battle lost no opportunity to bring their waste into active production and profitability. This was 'difficult and uninviting country . . . a region of forest, cattle, swine, and of relatively little arable'.[76] But the monks at once attracted fresh settlement, not least by their own vigour as builders. They feudalized their estates, apportioning them to a new class of knights. They made their forests available, on attractive terms, to immigrant families of peasant assarters. And then, like their brethren at Peterborough and elsewhere, they exploited every opening available to them in the law to resume those lands or to cream off their receipts. Abbot Ralph (1107–24), a former monk of Bec and prior of Caen, led the way. Before the end of his abbacy, the wholesale clearance of the Battle *banlieu* had already quadrupled land values in the region. The stage was set for another phase of exploitation which, from the 1160s, engrossed peasant holdings in favour of the monks, enormously increasing profits on the Battle demesnes as large-scale cattle-ranching took the place of peasant homesteads.[77]

One form of action triggered off another. Abbot Ralph, the reclaimer, was also well known as a builder. Neither the first nor the last of his kind, he was busy especially on the buildings of Battle's outer court, and finished the great circuit of its precinct wall. Before Ralph's time, under Gausbert of Marmoutier (1076–95), the abbey church had at last reached 'its longed-for completion'. It had been dedicated at a 'magnificent' ceremony on 11 February 1094, when the king and eight bishops were present, among them the mighty builders Gundulf of Rochester, Walkelin of Winchester, Osmund of Salisbury, William of Durham and Ralph of Chichester, each professionally interested in works of this kind and the initiator of a cathedral of his own. After all was done, there was a party: 'a suitable banquet was then offered to everyone out of love, and the occasion ended most joyfully.'[78]

Nothing in monastic building is ever ended. Abbot Ralph of Bec's next-but-one successor was Walter de Lucy (1139–71), brother of Richard de Lucy 'the Loyal', Henry II's chief justiciar. It was the well-connected Walter who began the resumption of Battle's alienated lands, and it was during his long abbacy that the abbey's cloister was reconstructed, splendidly finished with marble columns and fine pavement. So successful were the monks of Battle in developing their estates that they had bought out or otherwise downgraded their independent peasantry before 1200, converting arable clearings into grassland.[79] Next, they turned to the expropriation of their own *banlieu*'s knights, ploughing surplus profits into a rebuilding programme which kept craftsmen busy throughout the next century and which gave added stimulus to the economy. It was during the thirteenth century that Battle's already large church was enormously extended and that the reconstruction took place, on a much grander scale, of the monks' guest-house and of their three claustral ranges.[80]

Among those most likely to benefit from activity of this kind were the burgesses newly settled at Battle's gates. They became as busy as the monks

99. The church at Guisborough was a building site through most of the priory's existence, giving permanent employment to generations of local craftsmen. This surviving east end was the first stage of a second major rebuilding, following the fire of 1289.

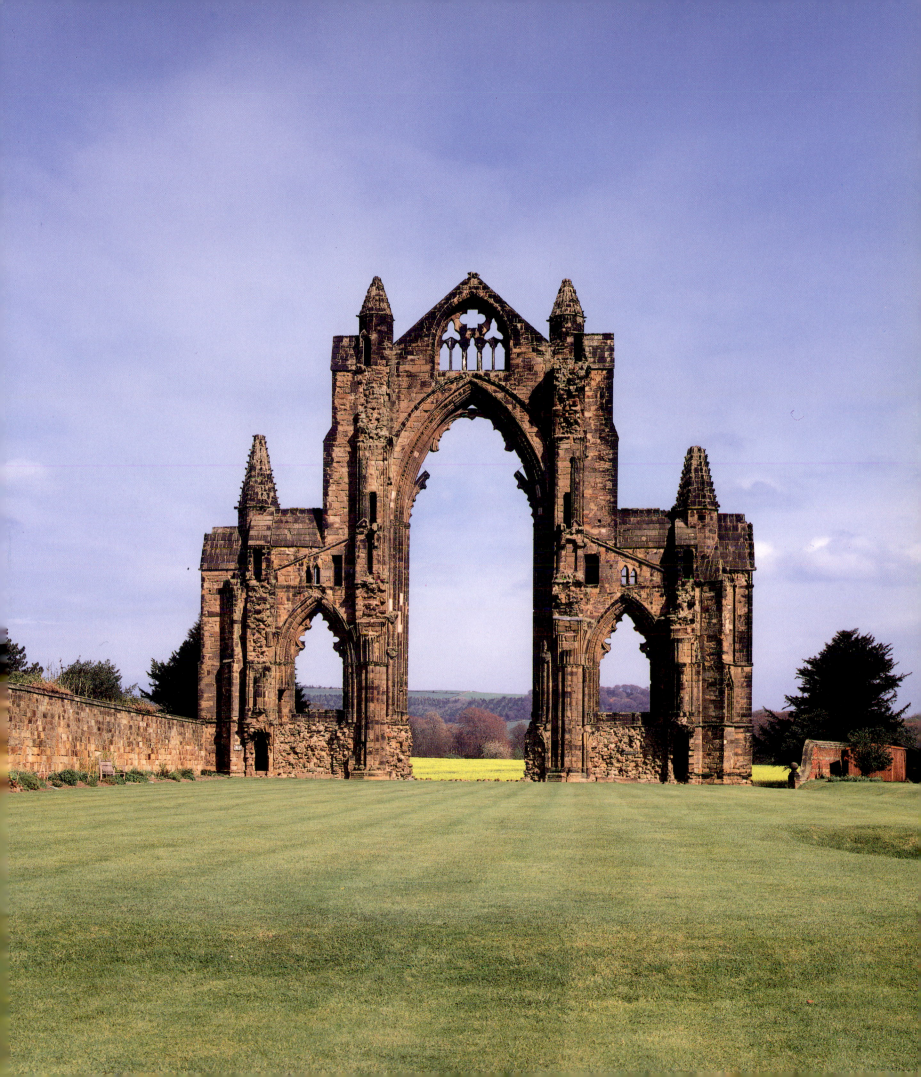

themselves in the regional land market: buying, selling, and leasing plots, frequently at the cost of the *banlieu*'s lesser gentry, who were also under pressure from the abbot.[81] Particularly well placed during these years were the master craftsmen – masons and carpenters, plumbers, glaziers and painters – whose work was never finished at the abbey. Local dynasties of such craftsmen are recorded at Guisborough Priory, permanently employed on the canons' building projects as one great church succeeded another. These men owned property in Guisborough, raised children there, gave money to the fabric fund of the church on which they laboured, and left their bodies for burial within it. They could afford to take the long view. Guisborough's first church and associated buildings took most of the twelfth century to build; its second, much extended, was begun in the first decades of the next century; its third, following the fire of 16 May 1289, was still unfinished in the 1330s and after.[82]

Guisborough was a wealthy Augustinian house, rich by the standards of its order. But much poorer communities, infected by the times, were just as active in pursuing their rebuilding. One of these was Brecon, billed today as 'pre-eminently the most splendid and dignified church in Mid-Wales', and in use since 1923 as a cathedral. Brecon, for all its current dignity, started life as a Marcher colony of the Sussex monks of Battle, and was never more than modestly endowed. Yet here, soon after 1200 and just as work began again at Battle Abbey, Brecon's small community launched its own comprehensive modernization. Starting with the rebuilding of their chancel, Brecon's monks chose a Gothic (Early English) design of the highest quality – strictly symmetrical, lavishly windowed, and very costly. They never built anything better, and failed even to vault what they had begun. However, they were at work again before the end of the same century, following the long interruption of the Welsh wars. And it was then that they undertook the reconstruction of their nave, enlarging it with aisles north and south. When eventually the church was complete, there were other tasks still to finish: on the claustral ranges, prior's lodging, and walled precinct.[83]

Dependent or free, while times were favourable and patrons willing, it was difficult to hold the monks back. Brecon probably owed its new buildings less to Battle Abbey than to successive lords of Brecknock – de Breos, de Bohun and Stafford. Between them, they kept the monks funded through three centuries. In contrast, Ewenny Priory (Glamorgan), a dependency of Gloucester Abbey, took shape almost entirely during the century-long lordship of Maurice de Londres and his line, having little other capital to support it. Described by Gerald of Wales in 1188 as a 'little cell' of Gloucester and still, on its suppression in 1540, one of the poorest and smallest of the Benedictine houses, Ewenny nevertheless attracted considerable expenditure in the late twelfth century, beginning – as so often – with the choir. It was under William de Londres, son of Ewenny's founder, that the former parish church was modified for the monks. The parochial nave (still in use today) remained little altered. But the chancel was lengthened, and a big crossing and double-chapelled transepts were added. Before 1300, Ewenny's patronal family had lost interest in the priory and further work there ceased. Last in the building sequence was a refashioning of the monks' two gatehouses. As modernized in the late thirteenth century with enlarged entrance passages, portcullises, and flanking towers, they were the keys to a walled and towered precinct, exceptionally early and complete, for which Ewenny is now usually remembered.[84]

Like Ewenny and Brecon, other Benedictine dependencies, equally remote, were furnished with big churches in the twelfth century. Among these were Durham's Coldingham, Reading's Leominster, St Albans' Binham and Wymondham, each of which preserves a fine building. Furthermore, what the monks spent gladly on their outlying estates, they multiplied many times on their buildings at home, often with further help from their friends. Thus Hugh du

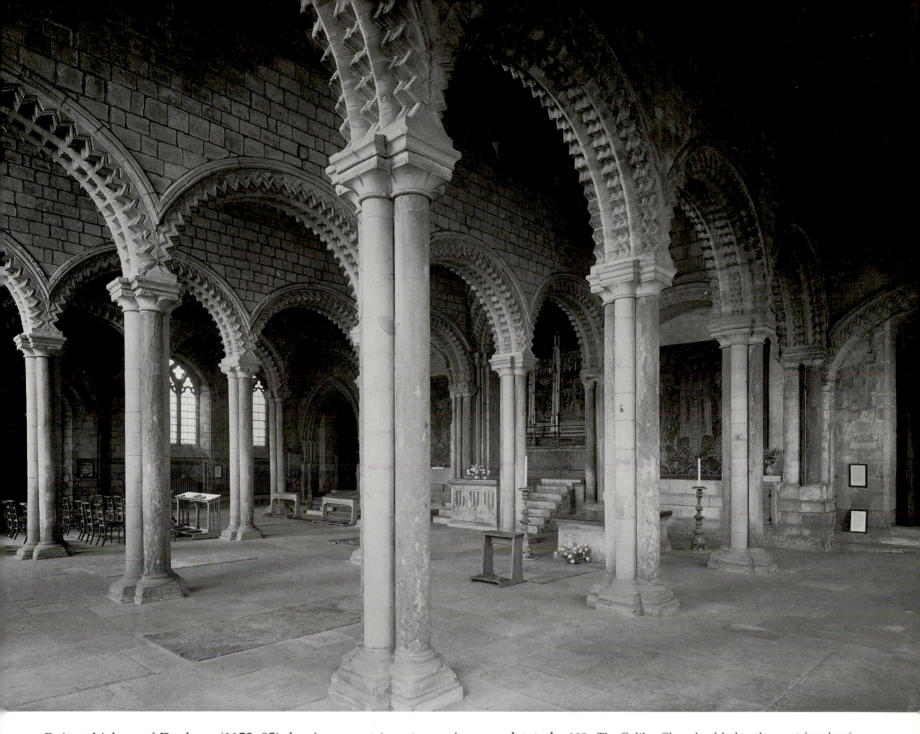

Puiset, bishop of Durham (1153–95), having spent 'great sums' on an aborted Lady Chapel at the east end of his cathedral, immediately 'began another at the west [the Galilee], in which,' Geoffrey of Coldingham explains, 'there should be admission of women who, though they had no actual access to the privacy of the holy places, might have some comfort from the sight of them'.[85] Durham, of course, was a monastic cathedral, where women were necessarily unwelcome beyond a point – still clearly marked – in the nave. Even so, Bishop Hugh's solution was unusual. First, his siting of the new chapel against the cathedral's west facade made it more of a vestibule, or narthex. Second, he stinted nothing on the work he put in hand, unmindful of the 'great sums' already wasted. Durham's Galilee has a spacious central nave, lined up on the earlier west portal, with paired equal-sized aisles to north and south. Its arcades are Late Norman in their waterleaf capitals and zigzag ornament, yet have all the new-found delicacy of emergent Gothic: the style Hugh himself would adopt at his palace of Bishop Auckland, for the great hall which was one of his last projects.[86]

Hugh du Puiset's delight in the new was widely shared by other leading

100. The Galilee Chapel, added to the west facade of Durham Cathedral by Bishop Hugh du Puiset in the 1170s, has both the extravagance of Late Norman and the delicacy of Gothic, brought together in a single costly building.

prelates and their biographers. Like him, John de Cella, abbot of St Albans (1195–1214), was to have his own share of disappointments. It was his lot to watch the newly carved work of the abbey's west front – 'unnecessary, trifling, and beyond measure costly' – slip and fall by its own weight, 'so that the wreck of images and flowers was a cause of smiles and laughter to those that saw it'. But while failing ever to complete that facade, Abbot John overcame his humiliations, winning applause from his community by rebuilding the monks' refectory ('dark and dilapidated') and their dormitory ('ruinous and tottering from age'), rendering them 'very beautiful' and 'new and splendid' respectively.[87]

Adjectives of this order – 'splendid' and 'admirable', 'wonderful', 'incomparable', 'graceful' and 'exquisite' – became common currency at St Albans, most artistically aware of the English houses. William of Trumpington (1214–35), next in the abbacy after John, remained a monk of St Albans all his days. He spent his entire life in the bustle of a building site, and may never have wished for greater calm. William completed and furnished 'in admirable manner' the newly built dormitory; gave it 'beds of oaken timber, and assembled the convent therein'. He 'beautified the church wonderfully', whitewashing its walls, and fitting a decorative ceilure over the choir screen and rood recently finished by that 'incomparable painter and sculptor', the sacrist Walter of Colchester. William reroofed the north and south aisles with 'oaken timber excellently tied and joined with rafters', and raised and releaded the tower, strengthening it 'wonderfully ' and displaying better its 'smooth, graceful and slender shape'. He built many new pentices and cloisters throughout the monastery, 'so that those going by should not be annoyed and bespattered by dripping'; demolished the old Chapel of St Cuthbert, and 'built a new one most handsomely of chiselled stone, with glass windows and all other fittings'; made an 'admirable' altar for the re-sited shrine of St Amphibalus (Alban's mentor), with a reredos 'exquisitely painted'; and re-windowed and glazed his abbey church which, 'illuminated with the gift of fresh light', appeared 'almost like new'.[88]

Matthew Paris (d.1259), historian of St Albans, was one of William of Trumpington's own monks. His *Gesta Abbatum*, listing William's works among others, had an evident didactic and inspirational purpose, furnishing *exempla* for those who came after. Yet it is not, on that account, to be mistrusted. In a community as sensitive to history as to the arts, Matthew Paris was both chronicler and painter of distinction. When, in the next abbacy, he described a chamber as 'properly painted and delightfully decorated by the hand of Richard, our monk, an excellent craftsman', he knew the mural painter personally and was at least as well qualified as the critic of today to assess the relative merit of his work.[89]

Art at St Albans was a vigorous living tradition, preserved so since the late eleventh century. No such striving after excellence distinguished contemporary Bury St Edmunds.[90] Nevertheless, even at Bury there is very real satisfaction in Jocelin of Brakelond's description of energetic site clearance in the precinct: 'Behold! at the Abbot's command, the court resounds with the noise of picks and masons' tools for the demolition of the guest-house, and it is now almost all pulled down'.[91] And while Jocelin, characteristically, added a caution – 'As for its rebuilding, may the Most High provide!' – Samson of Tottington (1182–1211), about whom he wrote, would have viewed such hesitations with impatience. Abbot Samson was a man of decision, known 'to love the active life better than the contemplative . . . rarely did he approve of any man solely for his knowledge of literature, unless he were also wise in worldly affairs'. That wisdom, painfully learnt through recent experience of a less competent regime, had laid the foundations at Bury, as elsewhere, for programmes of unparalleled expansion.

Other great houses, Battle and Westminster among them, had lost ground in much the same way. But Jocelin's story is especially well told. 'At that time', wrote Jocelin about Bury in the fraught 1170s,

Abbot Hugh was grown old and his eyes waxed somewhat dim. Pious he was and kindly, a strict monk and good, but in the business of the world neither good nor wise. . . . Discipline and religion and all things pertaining to the Rule were zealously observed within the cloister; but outside all things were badly handled . . . The townships of the Abbot and the hundreds were given out to farm; the woods were destroyed, and the houses of the manors threatened to fall in ruin, and day by day all things went from bad to worse.

Samson reversed all this. He was no religious zealot: 'When he heard of any prelate that he grew faint beneath the burden of his pastoral cares and turned anchorite, he did not praise him for so doing.' The life of the spirit, as he saw very well, depended first on the economic health of the community. Hugh had been prior of Westminster before coming to Bury. And at Westminster also, during those decades, between a quarter and a third of the abbey's annual revenues had escaped the community's control. [92] Samson would have none of it. 'May I lose these eyes,' he is recorded as saying, placing his fingertips upon them, 'on that day and in that hour when I grant any hundred to be held by hereditary right'.[93] The problem at Benedictine houses was common enough; only the drama was his own.

In Samson's time, whereas the difficulties were obvious, so also were the available remedies. Inflation, in just these years, was pushing up costs and devaluing fixed rents.[94] Every monastic house, forced to re-examine its accounts, came up with a similar conclusion. Alienated lands must be restored to the demesne; the 'domination of servants' must be ended. With this in mind, the monks of Battle included a forged writ, *Servorum Dominatio*, in their cartulary. It dated to the early thirteenth century, when its purpose was obvious; yet purported to be an instruction from King William, Battle's founder, to Gausbert of Marmoutier, its first abbot. 'I have been informed,' the Conqueror was supposed to have said, 'that you have given in fee the great part of that leuga [Battle's circular *banlieu*] to your servants This I completely forbid, and so that it [the alienation] may be of no effect, I command it [to be restored] upon pain of forfeiture, lest the liberty I gave that church be destroyed by others.'[95]

There were many things wrong with this document. But the problems it addressed were very much of its period, even if Abbot Gausbert himself never knew them. Gausbert's successors had squandered Battle's estates on the purchase of services, then finding it difficult to recover what they had lost. At Bury, Abbot Samson had witnessed the same disintegration. His solution, shared with others, was to take the land back into demesne.[96] He need have looked no further than to the Cistercians for his model. By Samson's time, Cistercian home-farming on dependent granges had fully established its profitability. The white monks lost nothing in heritable fees; they gained by the higher prices of inflation. Inevitably, their prosperity cost them valuable friends. In influential court circles, towards the end of the twelfth century, Walter Map and Gerald of Wales were among those who found fault with the Cistercians. Each had a personal grievance against the monks, and neither is an accurate source. Nevertheless, they helped create an image of Cistercian avarice which, because it coincided with the experience of ordinary men, stuck with the white monks for generations. Walter Map was at Henry II's side from the 1160s; Gerald of Wales was at Court from 1184, then serving under Richard I in various offices, and dedicating a book to King John. Like Henry, Gerald favoured the Carthusians and the Grandmontines; like Richard, he accused the white monks of cupidity.[97] A century later John Pecham, archbishop of Canterbury (1279–92), remained of a similar opinion. The Cistercians, in his judgement, were the 'hardest neighbours that priest or layman could have'.[98]

Such notoriety, repellent to patrons, was extraordinarily difficult to disregard, not least because it had elements of truth. Two of the stories circulating at Court

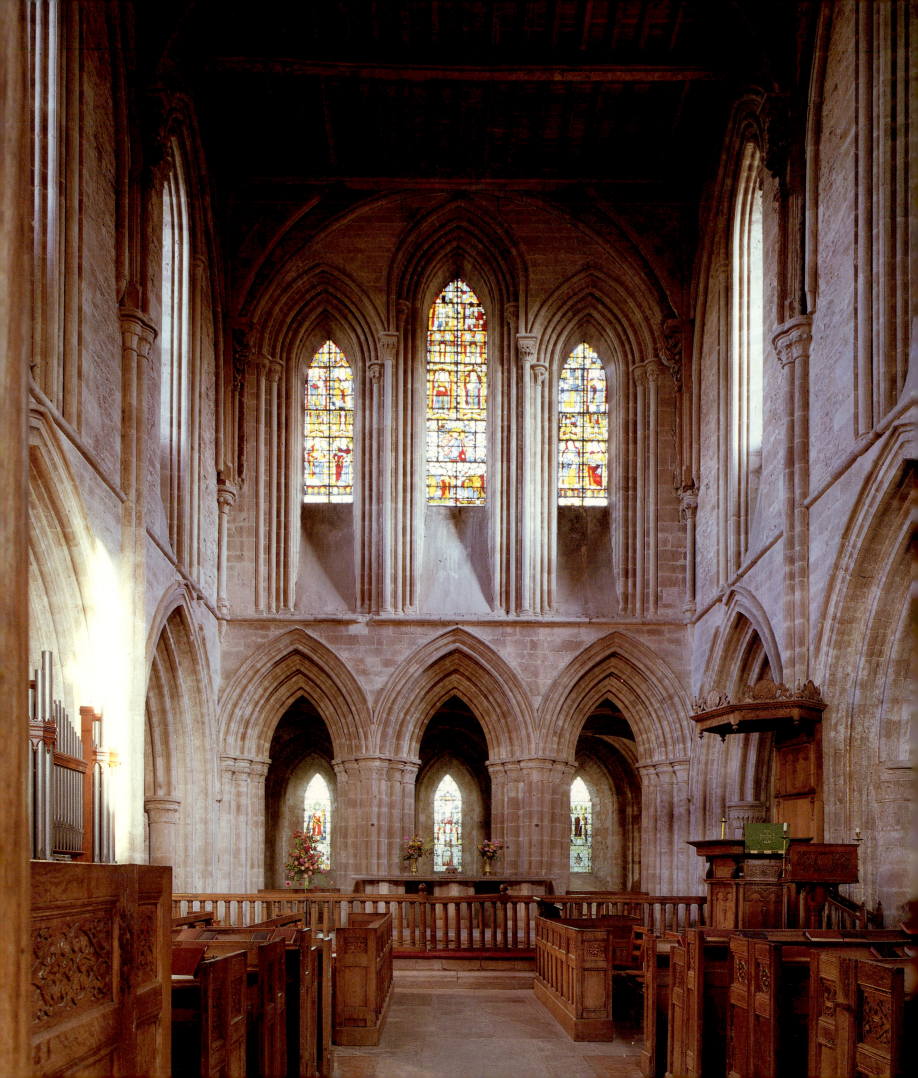

at this date concerned Cistercian communities actively engaged in new building. One was about Abbey Dore, accused of swallowing the less opulent Trescoit. The other, told by both Walter Map and Gerald of Wales, concerned the monks of Byland, alleged to have tampered with a boundary at Coxwold.[99] Neither story need have been true, but both made fair sense in their context. The new churches at Abbey Dore and at Byland were no ordinary buildings. Confronted with costs they had never met before, the monks needed every penny they could collect. Abbey Dore's fine choir was of a single period, begun simply enough in the late 1170s but replanned almost immediately on a much grander scale, complete with side aisles and vaulted ambulatory.[100] The model for Abbey Dore was the new church at Cîteaux, consecrated in 1193. And Cîteaux again, known to all abbots, was similarly the exemplar for Byland. Before 1177, while Cîteaux itself was being remodelled, Abbot Roger laid out the huge church, on its virgin site at Byland, which his successor, Philip, some twenty years later, found 'fair and great . . . as it now appears'.[101]

Philip, previously abbot of Lannoy in the diocese of Beauvais, was a Frenchman. And the great church he admired had much that was French in its makeup. This interchange of men and of styles, characteristic of the Cistercians, helped give their architecture its innovatory edge. Byland itself is no longer thought to have marked the beginning of French Gothic influence in the North. That distinction, it has been suggested, belongs rather to Kirkstead (Lincolnshire) or Furness (Lancashire), after which the style was taken up by the cathedral-builders.[102] Nevertheless, the exceptional wealth of the Order, its many abbeys under construction, and its centralization, kept it the doyen of fashion. Cistercian abbots were frequent travellers. They went to Cîteaux annually for the General Chapter. They visited Clairvaux to adore St Bernard's relics. And they were often on the road to other houses of the Order, on visitations of correction and encouragement. Plainly, they pondered what they saw. Of the first English abbots, Adam of Meaux, Alexander of Kirkstall and Robert of Newminster were all skilled builders, trained at Fountains under Bernard's Geoffrey of Ainai.[103] Roger of Byland (1142–96), in the course of his long abbacy, would have journeyed overseas many times. There he learnt to appreciate the exact proportions – aisles half the width of naves, naves half as high as they were wide – characteristic of the best architecture of the Order. It was Roger's own countryman, Abbot Baldwin of Forde, who delivered this contemporary judgement on aesthetics:

> Unity of dimension established on the principle of equality, appropriate arrangement, adaptation, and the commensurate concordance of parts is not the smallest factor of beauty. What falls short of proper measure, or exceeds it, does not possess the grace of beauty.[104]

What chiefly survives of Baldwin's Forde Abbey is a spacious vaulted chapter-house, reused from the 1650s as a chapel. It was probably built just before his time by Forde's second abbot, Robert of Pennington, but has all the 'grace of beauty' Baldwin wanted. Times, however, were changing, and a gulf separated the generations. Robert's chapter-house at Forde, although handsome and very large, was almost entirely bare of ornament. In contrast, Cistercian abbots of Baldwin's day had lost their earlier horror of decoration. Forde, we know, would be one of those abbeys accused of breaking the mould.[105] Byland in practice ignored the legislation by which St Bernard and the General Chapter had set store.

There may have been reason, in a former Savigniac house like Byland, to disregard the architectural precepts of St Bernard. Savigniacs, before their union with the Cistercians in 1147, had not been remarkable for austerity in building, and Bernard's death in 1153 had removed another impediment to change. But Byland's Savigniac allegiance was a thing of the past well before Abbot Roger

101. The Cistercians of Abbey Dore, extending their choir before 1200, had the model of the newly rebuilt Cîteaux to guide them; in contemporary white-monk churches like these, the primitive simplicity of the early fathers was set aside.

102. A costly vaulted ambulatory (seen here at the east end) surrounded the choir at Abbey Dore, as at Cîteaux.

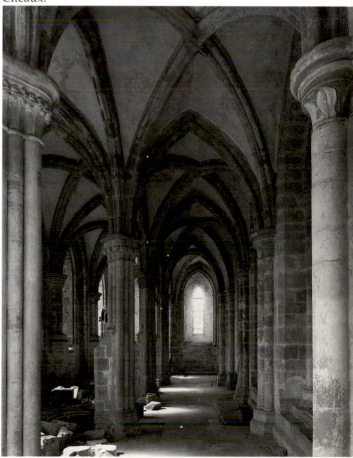

and his monks 'manfully' cleared the scrub below the Hambleton Hills, drawing off 'by long and wide ditches . . . the abundance of water from the marshes'.[106] And the new Byland buildings, on their 'ample, fitting and worthy site', had plentiful precedents already within the Order. Clairvaux III, rebuilt soon after Bernard's death to accommodate the many pilgrims at his shrine, had been enlarged at the east end with a semicircular ambulatory and with a chevet of nine radiating chapels. Pontigny's complex presbytery, remodelled from 1185, exceeded even the splendour of Savigny itself, where rebuilding had begun a decade earlier.[107] Inevitably, there remained Cistercian communities which, even at this date, preferred the primitive simplicity of the founding fathers. Prominent among them were the Irish houses, multiplying from the 1170s under Anglo-Norman patronage. And the same economical hunchback plan – the head of the presbytery sunk deep into the shoulders of the transepts – is to be found again at the Scottish Glenluce, settled in 1191–2 from Dundrennan. But it was not primarily money that determined such choices. Glenluce was well off by any standards; it could afford to build with greater style than the plan suggests, and did so, moreover, in other ways.[108] Simultaneously, Staffordshire's Croxden, although never rich, had a Savigniac connection to assert. Colonized in 1176 from Aunay-sur-Odon, Croxden's new church copied the ambulatory and apsidal chapels of its Norman mother-house, at one remove from the Savigny model.[109]

Genuinely wealthy Cistercian communities, of which there were many by this date, built with competitive gusto. Byland inspired new works at Rievaulx. While Glenluce was being planned, Dundrennan (its mother-house) was engaged in a remodelling which borrowed extensively from other northern communities, including Furness, Roche and Byland. What caused Dundrennan's rebuilding was the addition of a tower at the crossing, simultaneously being constructed at Furness. Such towers had not featured at earlier Cistercian churches. They had been expressly forbidden – 'There shall be no bell-towers of stone.' – even as late as the General Chapter of 1157. St Bernard, too, would have been contemptuous of the accompanying enrichment of Dundrennan's transepts with multi-shafted piers and ornate galleries: 'Oh, vanity of vanities! . . The walls of the church are resplendent, but its poor go in want. Its stones are adorned with gold, and its children are forsaken and want for clothes.'[110] For all that, Byland's vanities were already dominant at Dundrennan in the 1180s. Of course, Byland's new buildings, no doubt shocking to some, were known to every northern abbot of the period. But there was another link also between the houses. Dundrennan had been colonized originally from Rievaulx, in North Yorkshire, later to be Byland's nearest neighbour. Its first abbot, Sylvanus, was recalled to Rievaulx in 1167 as successor to the saintly Abbot Ailred. There he had been able to watch Byland's building progress, retiring to that abbey in 1188 and dying the next year within its walls. Sylvanus' legacy is still very much with us, plainly to be read in the 'resplendent' tiers of Dundrennan's lavish north transept.[111]

'What is the point,' St Bernard had demanded,

> of ridiculous monstrosities in the cloister where there are brethren reading – I mean those extraordinary deformed beauties and beautiful deformities? What are those lascivious apes doing, those fierce lions, monstrous centaurs, half-men, and spotted pards, what is the meaning of fighting soldiers and horn-blowing hunters?

His target, back in the 1120s, had been the excessive sculptural ornament of Cluniac cloisters. 'Good God!', he had concluded, 'If one is not ashamed of such impropriety, why not at least rue the expense?'[112] Yet within two generations at most, his shafts might have lodged nearer home. Those who still sought to restrain Cistercian building, already in retreat before 1200, had lost the battle utterly by the next century.

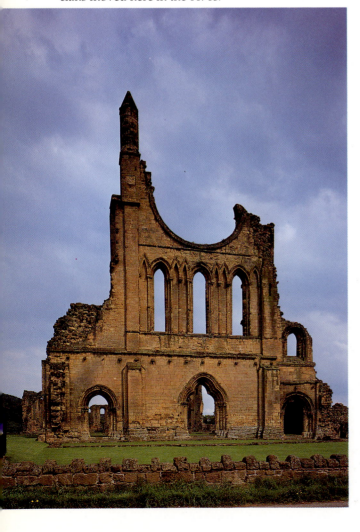

103. The west front at Byland, completing the building of a huge abbey church first begun when Cistercians moved here in the 1170s.

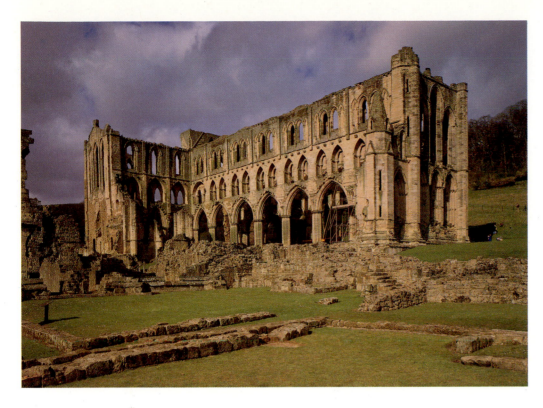

104. Rievaulx's continuing wealth in the early thirteenth century enabled its monks to rebuild their choir and presbytery (centre) on a much larger scale, adopting the new Gothic style.

Soon after 1200, at the Irish white-monk houses, a change of great significance occurred. Until that time, Cistercian ornament in Ireland had exhibited commendable restraint. Cistercian abbots, while not banning decorative sculptures altogether, had been broadly successful in resisting masons whose inbred tradition might have inclined them rather to the exoticism of a west portal like Clonfert's. That effort was abandoned in the early thirteenth century at just about the time that the Order's General Chapter, in 1213, made one of its last and most specific attacks on excessive ornament.

It is hereby forbidden by authority of the General Chapter that there be from henceforth in the Order any pictures, sculpture – save for the image of Christ our Saviour – or any variegated floors [*varietates pavimentorum*], or anything unnecessary in the way of buildings or victuals.[113]

If the abbot of Boyle was present at that assembly, neither he nor his Irish comrades paid attention. The forty capitals of Boyle's new nave, carved between 1215 and 1220, are all richly decorated with leaf patterns, grotesque animals and human figures. There are dogs, fighting cockerels, and a coiled-up snake; naked men wrestle with a lion. Dragons bite the string course at contemporary Corcomroe; a dog barks from one of the capitals at Abbeyknockmoy; birds and variegated foliage ornamented the new wash-place at Mellifont in about 1200, an exotic octagonal pavilion (plate 64).[114]

Almost all of this was confined to the native Irish houses. It was but one manifestation of a breakdown of Cistercian discipline, associated with anti-Norman sentiment, which troubled the Irish province and which led directly into the Conspiracy of Mellifont (1227). But the 'extraordinary practices of Ireland', where 'the severity of Cistercian discipline and order is observed in scarcely anything except the habit'[115], were at least partly due to white-monk wealth. There were over a hundred monks at Mellifont at the time of the Conspiracy. The lordship of Mellifont was of 51,000 acres, and the abbey's huge endowment included much else in addition.[116] Mellifont is in Louth. In County Dublin, to the south, the Church had come to hold, before the Middle Ages were out, almost half the available acreage.[117] What price then the Poor Christ of the Gospels?

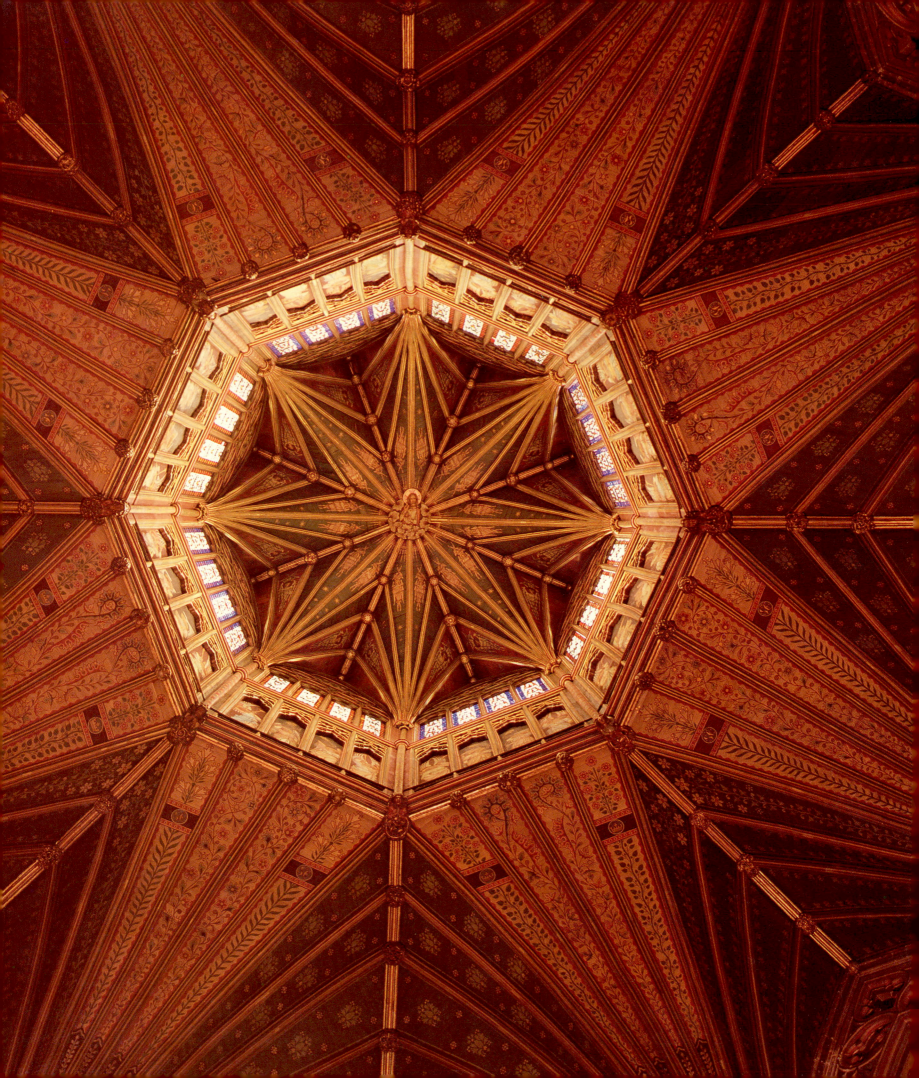

CHAPTER 4
Golden Century

The paradox of wealth is that it too often attaches to those who could well do without it. The hermit-monks of the twelfth-century Reform had taken themselves out into the countryside. They had at first wanted little, and for a time, at least, they had led exemplary lives there. But conscientious disciplinarians though they remained for many years, they returned less than their due to society. They were the victims, economically, of their own success. Having no other obvious outlets for their profits on the land, they channelled them characteristically into building. As for the cure of souls, the monks had long turned their backs on the world at large, admitting it only as a stranger. Next to the grassed-over foundations of Cistercian Kirkstead, where just one shaft of Gothic masonry stands alone, there is an especially significant survival. Kirkstead's *capella ante portas* (chapel before the gates) is a building of the 1230s, of such superior quality as to be described without hyperbole as a 'gem'.[1] Yet this lay travellers' chapel, where alone they might worship, is small and set apart, maintained at arm's length by the community.

Disengagement from society had made fair sense in the twelfth century. Contemporaries had accepted it from their monks. Later generations were less certain. Distanced by their wealth, the Cistercians could offer little to their folk. They were countrymen. In the country where they dwelt, the parochial organization was at least adequate; or had become so before the end of the twelfth century. Quite other was the condition of the expanding towns, in which the bishops had moved slowly or not at all. There were, in truth, individual exceptions. Hugh du Puiset's great collegiate church of St Cuthbert at Darlington was only one of his many building enterprises. Yet the bishop of Durham was as generous to Darlington, and as alive to new fashions there, as he had been in his Galilee Chapel. Started before the end of the century, Darlington's parish church was among the earliest pioneers of northern Gothic. It was cruciform in plan, with equal-sized transepts and a big aisled nave, more like a church built for monks.[2] In point of fact, Darlington was indeed semi-monastic. Hugh du Puiset had reorganized its priests as a collegiate body: four prebendaries under a dean. But the building was also, and more importantly, the only parish church of a new town. Darlington's full borough status dates to about 1190.[3] Its church closed the end of a big market square, in which the bishop – as lord and developer – had large interests.

Darlington, throughout the Middle Ages, never got a second church. Yet it was not as badly off as those other developing towns – Hythe and St Ives, Nantwich and King's Lynn among them – which were limited to a 'chapel of ease'. It was not that such chapels, subordinate to another church, were necessarily starved of investment; on the contrary, dependency's humiliations, brought home to local donors, might have acted as something of a spur. Hythe's magnificent thirteenth-century chancel, built during an era of great prosperity for the port, far exceeded in *nouveau riche* extravagance anything at the mother-church at Saltwood.[4] Nantwich also – so-called 'Cathedral of South Cheshire' – advanced to uncommon size in the Late Middle Ages, while neither St Ives nor St Nicholas (Lynn), both substantially rebuilt in the 1410s, were outclassed by other churches in their vicinity. Still, the griefs of subordinate status remained with them. Lynn's St Nicholas was founded as far back as the mid-twelfth century, when the bishop of Norwich, William Turbe (1147–74), developed his *nova terra* by the Tuesday

105. Alan of Walsingham's ingenious timber octagon, begun in 1328, spanning the crossing at Ely.

106. Kirkstead's *capella ante portas* (chapel before the gates), built in the 1230s for the use of lay visitors not permitted to worship in the monks' church.

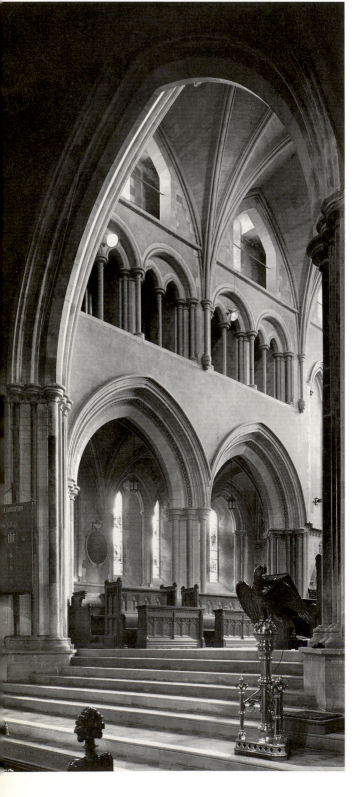

107. Hythe Church, while remaining just a chapel of Saltwood, was nevertheless given one of the grandest chancels ever built for parochial worship.

Market, north of the Saturday Market and town centre. Yet even today this great church remains no more than a chapel of the earlier St Margaret's. No baptisms were permitted at St Nicholas before 1627, nor were burials encouraged within its precinct.[5] At St Nicholas and at many such dependent chapelries, the church-yard was either small or non-existent. Like it or not, the men of medieval St Ives were required to carry their dead to the neighbouring – and much less prosper-ous – port at Lelant, further up the estuary. Market Harborough, a late twelfth-century town plantation successfully carved out of the royal manor of Great Bowden, similarly lacked a churchyard of its own. Its deceased burgesses were taken home to the village church at Bowden, to 'the rock whence [they were] hewn, and to the hole of the pit whence [they were] digged.'(Isaiah, 51:1).[6]

Anomalies of this kind, which the bishops were powerless to overcome, continued to burden urban parishes. They propped the door wide open to the friars. Clerical indifference to the towns, and to the peculiar problems they raised, placed in vivid contrast the individual mission of St Francis: a clarion call once again for evangelical poverty, preached with urgency in the human caul-dron of the market-place. Such messages had been heard before from the relig-ious, most recently from the Cistercians and their imitators. But they had been directed then at a very different audience, and where they now found their mark was in a society little known to the hermit-monks, who had indeed done their utmost to escape it. Overwhelmingly, it was to urban congregations, many of them fast-growing, that the friars were drawn. In 1221, the Dominicans (also known as 'Friars Preachers' or 'Black Friars') landed in England. They went first to Oxford, but before they had finished, had settled in over fifty boroughs. The Franciscans ('Friars Minor' or 'Grey Friars') arrived in 1224. There were Carme-lites ('White Friars') in England from the early 1240s, and Austin Friars ('Hermit Friars of St Augustine') from not much later. Not every friar agreed with another. And all lost the favour of monks and parish clergy, who came to see their rivalry as a threat. Yet they lived amongst the townspeople, recruiting directly from their number; and they shared both their thoughts and their speech. The new invasion was an unqualified success.

While the friars had their enemies in the 'vineyard' of England, their troubles began with their friends. 'As the friars grew in numbers and their virtues became known', wrote the Franciscan chronicler, Thomas of Eccleston, 'the people's regard for them increased, and they began to plan how to provide them with suitable houses.'[7] Often this worked very satisfactorily, and there remains a special magic in the Greyfriars site at Canterbury, its gardens divided by a stream. However, interpretations of what was 'suitable' differed markedly. Thomas of Eccleston tells the story of Franciscan settlement at Shrewsbury, to which the Minorites had come in the mid-1240s:

> The lord King [Henry III] gave a plot of ground at Shrewsbury to the friars, but the church was built by Richard Pride, a burgess of the town, and the other buildings by Laurence Cox. But when Brother William [of Nottingham], who was zealous for poverty, saw the stonework of the dormitory, built with devotion and skill and at great cost, he ordered it to be taken down and re-placed with cob walls.[8]

William was the fourth Franciscan minister of England, widely known for his 'zeal and sincerity'. Before him, the second minister, Albert of Pisa, had been a man of equal integrity. It was he, 'full of zeal', who 'had the stone-built cloister at Southampton demolished, although with great difficulty, because the people of the city objected.'[9] 'Brother Albert', reported Thomas of Eccleston somewhat slyly, 'once told us that we should have a real love for the Friars Preachers [the Dominicans], because they had brought many benefits to our Order, and had sometimes showed us the dangers against which we must guard in the future.'[10]

Plainly, one of those dangers, resisted only intermittently, was the temptation to build as boldly as the Preachers. If Southampton's friary lost its cloister in Albert's time, it had gained a fine stone church by 1287, consecrated with much rejoicing on the Feast of St Francis (4 October). A new chapter-house and dormitory followed shortly in 1291.[11]

Thomas of Eccleston had other things to say about the Preachers. As a Minorite, he cared little for them. Before he wrote, a 'great and scandalous strife' had arisen between the Minorites and the Preachers, the one claiming to be 'more rigorous and humble', the other 'declaring that they were instituted first, and [were] on that account more worthy'.[12] Yet Thomas, for all that, is an exceptionally reliable source.[13] And certainly what he tells us about Dominican building practice rings true:

> Once I met a well-known preacher who frankly confessed that in one place his preoccupation with erecting buildings had caused him to lose his zeal for preaching and robbed him of his former devotion. Brother John, Visitor of the Order of Preachers in England, also told Brother William of Abingdon that until he had built their house in Gloucester he had possessed excellent gifts as a preacher, and said that no one who was an eloquent preacher should be burdened by responsibilities for building. He told how this concern for begging money had so demoralized Brother William that the King of England once said, 'Brother William, your conversation was formerly so spiritual: but now the only thing that you say is, Give, give, give!' [*modo totum, quod loqueris, est, Da, da, da*].[14]

William's friary complex at Gloucester is still there. Its roofs, in church and cloister, preserve those same timbers – oaks from the royal forest of Dean, from Wenlock (Shropshire) and Gillingham (Dorset) – which Brother William's importunities once wrung from Henry III. Recognizably too, despite later mutilations, Gloucester remains a Dominican house of the initial settlement period, the only such survival in England.[15] Most important of its characteristics, equally to be found at excavated sites of the same period, is the big 'preaching nave', much more spacious than the choir, and originally of striking austerity.[16] Huge covered spaces like these were designed to accommodate the swollen audiences in the towns to which the Preachers (along with the Franciscans) felt the call. As Hubert de Romans explained: 'It should be noted that the Lord, when he sent prophets into the world, more often sent them to a city than to other smaller places.' His own Order, the Dominicans, did likewise for the following reasons:

> In cities there are more people than in other places, and therefore it is better to preach there than elsewhere, just as it is better to give alms to more than to fewer people. Again, there are more sins there. . . . Again, lesser places which lie around cities are more influenced by cities than vice versa, and therefore the good effects of preaching which takes place in the city are passed on to those places more than vice versa, therefore one should try to produce good effects by preaching in cities, in preference to other smaller places.[17]

There was another reason, not stated by Hubert, for concentrating effort in the cities. The friars were Mendicants: they lived by begging and they required the support of those larger populations from which alone they could collect sufficient alms. Securing a foothold was not always easy, and it was made more difficult by the open contempt displayed by the Mendicants for older orders: 'They look upon the Cistercian monks as clownish, harmless, half-bred, or rather ill-bred, priests; and the monks of the Black order [Benedictines] as proud epicures.'[18] Right at the start, in 1233, the Augustinian canons of Dunstable had lost two of their number, Walter and John, who 'went out without permission by a broken window and leapt over the wall of the monastery and took the habit of

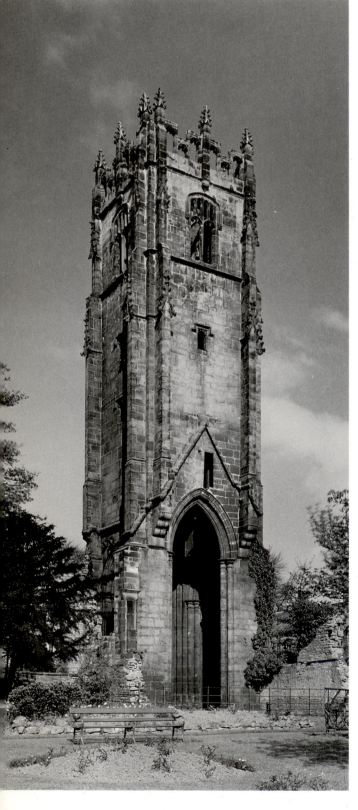

108. Urban friary buildings seldom survived the Dissolution in England, this Franciscan crossing tower at Richmond (North Yorkshire) being one of the very few exceptions.

the Friars Minor at Oxford'. Then, in 1259, the Dominicans 'by very great industry and deceit entered the vill of Dunstable against our will'. It was almost twenty years later that the prior of Dunstable 'ate with the Friars Preachers in the vill for the first time'.[19] Only 'by stealth' were the Minorites able to establish themselves at Bury St Edmunds in 1257, although both they and the Preachers had sought admission as much as two decades before. Even so, the Mendicant presence in Bury lasted only five years, after which the Minorites had to agree to leave the town, settling at Babwell outside its gates.[20]

Friary sites, in practice, frequently had this characteristic, being located well away from the town centre. At Southampton, to be sure, the Minorites were well placed. They enjoyed a prime commercial plot within the town walls, directly opposite the house of Walter le Fleming, one of their wealthiest patrons.[21] Other friaries took root in vacant buildings which might, as at Southampton, be quite central. Yet more familiar was the lot of the Dominicans of Hereford, settled on reclaimed land at Wide Marsh, outside the city walls; in Nottingham, it was on the Broad Marsh that the Franciscans were established; while all five friaries at Newcastle upon Tyne were sited on the periphery of urban settlement, only later wrapped around by the city walls.[22]

Mendicant banishment was understandable. It signified recognition of the friars' success and of the threat they posed to their competitors. Matthew Paris, at St Albans, had neither Preacher nor Minorite as neighbour. Yet he could see, as early as the 1250s, what had happened to fellow monks, and dreaded more of the same. Telling again the story of 'how the Minorite brethren forced their way into the city of St Edmunds', he recorded how

people could hardly express their astonishment that such holy men – men who had voluntarily chosen poverty for their lot – should thus, laying aside all fear of God, despising the anger of the reverend martyr [St Edmund] and of men, and heedless of the protection of privileges, violently disturb the peaceful state of that noble church [Bury], which was well known to be of great dignity and antiquity.[23]

These were the brethren, both Minorite and Preacher, who built 'dwellings which rivalled regal palaces in height. These are they who daily expose to view their inestimable treasures, in enlarging their sumptuous edifices, and erecting lofty walls, thereby impudently transgressing the limits of their original poverty, and violating the basis of their religion'. Nothing, in Matthew Paris' view, could curb the friars' greed, nor restrain them from the pilfering of others' dues:

When noblemen and rich men are on the point of death, whom they know to be possessed of great riches, they, in their love of gain, diligently urge them, to the injury and loss of the ordinary pastors, and extort confessions and hidden wills, lauding themselves and their own order only, and placing themselves before all others. So no faithful man now believes he can be saved, except he is directed by the counsels of the Preachers and Minorites. Desirous of obtaining privileges in the courts of kings and potentates, they act the parts of councillors, chamberlains, treasurers, groomsmen, and mediators for marriages; they are the executors of the papal extortions; in their sermons, they either are flatterers, or most cutting reprovers, revealers of confessions, or impudent accusers. Despising, also, the authentic orders . . . they set their own community before the rest.[24]

Highly dangerous to the 'authentic' orders, as Matthew Paris recognized, was that growing belief among 'faithful' men that only through the friars could they be saved. The spring of monastic patronage was running dry. Consider the case of just one northern county. In Yorkshire, there were no new Cistercian founda-

tions after 1151, unless Cîteaux's 'alien' cell at Scarborough (1202) is counted with them. The last Yorkshire Premonstratensian house was founded in 1198; the Gilbertines stopped multiplying from 1209; and even the Augustinians, with only one exception, ceased expansion no later than 1218. In contrast, the friars continued to settle thickly in Yorkshire as elsewhere, so that one day it would be said of their inflated community that 'a fly and a friar will fall in every dish'. Thus the Dominicans were in York from 1227, the Franciscans from 1230, the Carmelites from 1253, the Austin friars from 1272.[25] Of the Yorkshire market towns, Beverley had its Dominicans from 1240, its Franciscans from 1267. In the teeth of local Cistercian opposition, which had driven them once already from the port, the Franciscans were back in Scarborough from the late 1260s, where they joined Dominicans settled there since 1252. Pontefract had its Dominicans from 1256; Franciscans were at Richmond the following year.[26]

All this activity was urban-based. And it was for this reason especially that so few English friary buildings have survived the suppressions, when every site came up for redevelopment. In Yorkshire, only the late-medieval tower of the Franciscans of Richmond is still standing. Elsewhere – whether in England, Wales or Scotland – there is very little left of any friary building and nothing major (except at Gloucester) of the first period. In Ireland, the case is very different. It was in Ireland that the Mendicants enjoyed a late-medieval popular revival unequalled elsewhere in Britain. Then, protected by the peculiar circumstances of the Irish Reformation, Irish friars were sheltered and encouraged by their local patrons well into the seventeenth century. What resulted was exceptional survivals. Many of the most complete of these friary remains are of rural houses, founded for the most part in the fifteenth century. However, they include also some earlier churches of considerable size and importance: among them, the Minorites' Timoleague and Ardfert, Ennis and Claregalway; the Preachers' Newtownards, Athenry and Kilmallock.

By the time these churches were built, in the late thirteenth and early fourteenth centuries, most primitive restraints had been discarded. If the Irish Franciscans remembered St Francis' preference for houses 'entirely built of laths and rubble, plastered with clay', they paid it little attention. And they were similarly oblivious to St Dominic's insistence on churches and other buildings of modest size.[27] Ennis, one of the largest of this group, preserves a fine stone church unlikely to date much later than the 1280s. It has the plain rectangular plan characteristic of Franciscan churches, to which (on the south) a big transeptal chapel was later added. In 1306, a poet visited Ennis. What he found to praise – and what St Francis himself would have found less pleasing – was

> the delightful beautiful convent of Inis an Laoigh, on the fish-abounding stream, with lofty arches, white walls, sweet bells, well kept graves, homes of the noble dead: with furniture, crucifixes, illuminated missals, embroidered vestments, veils and cowls, glass windows and chalices of rare workmanship.[28]

Ennis was a burial place – 'home of the noble dead'. And it was the handsome founders' tombs at Kilmallock and Athenry which were accorded special prominence in those churches. Friary patrons of this period were usually, although not exclusively, of Anglo-Norman stock. Kilmallock and Athenry were Anglo-Norman houses; Ennis was native Irish. Together, they reflect a growing concern with urbanization which first took root in the Anglo-Norman settlement, and which was always more characteristic of the English territories. Very few of Ireland's friaries, established before 1300, were sited anywhere but in towns. And almost all those towns, thickly concentrated in the English counties, were just as new as the friaries within them.

By 1300, after a century of growth, Ireland's 'urban places' were more than 200

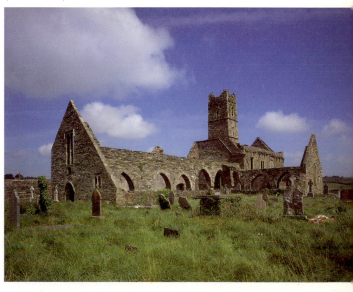

109. Franciscans settled at Timoleague (Cork) in the thirteenth century, and were still in occupation as late as 1630. Much of what is seen here, including the tower, is a rebuilding of the early sixteenth century, financed by the Minorite Bishop Courci of Ross (1494–1517).

in number, all with some claim to borough status.[29] And while many of these 'rural boroughs' were only lightly settled and others not infrequently failed, medieval Ireland, in this century in particular, was more urban than it would ever be again. A similar process had been at work in twelfth-century England (see pp. 43–4), as in contemporary Scotland and South Wales. And this, after the deliberate colonizing settlements of earlier times, was a development over-whelmingly market-led.[30] Viking Dublin had lived on loot, to which trade and industry were secondary. Its Anglo-Norman successor, the 'colonial capital city', had the castle and cathedral of a political centre, but flourished especially on its markets. Dublin's trade was both regional and overseas. The thirteenth-century city had its Shoemakers' Lane and Skinners' Row, its Cook Street and Fishmon-gers' Alley. There was a Winetavern Street for the Bordeaux trade, and a 'Roch-elistrete' (*vicus rupelli*) where the merchants of La Rochelle had their tenements. And inevitably there were the four communities of Friars Mendicant: Domini-cans from 1224, Franciscans from 1233, Carmelites from 1274, Austins from 1282 or a little earlier.[31]

These friars and their kin – flies who fell in every urban dish – signal the development of many towns. In Scotland, the friaries have left little behind them. They became the target of Protestant zealots, especially destructive in the burghs. Nevertheless, we know that Dominicans had settled Edinburgh and Glasgow before 1250, Aberdeen and Inverness, Perth, Stirling, Berwick and Ayr. There were Franciscans at thirteenth-century Berwick and Roxburgh, Hadding-ton, Dumfries and Dundee. Carmelites came to Scotland as early as the 1260s; and Trinitarians (called 'Red Friars' by the Scots) had already won a special corner there by the 1240s.[32] They came to a land in which the town was unknown before 1100, where almost all twelfth-century burghs had been initiatives of the Crown, but in which commerce was freely taking off.

The primacy of commerce in towns of this period is best seen in their market provision. The church or castle gate had ceased to be a major influence on town planning. Everywhere towns grew outwards from their market squares, from a road junction, or from a swelling in the street. When Edinburgh first developed as a market centre, it had expanded along the line of the free-standing crag on which the king felt required to perch his fortress. The castle took priority over trade. Later Scottish towns reversed this emphasis. Crail is a minor east-coast port which grew rapidly under royal patronage in the twelfth century. It had a castle of its own, above the harbour, and it was next to that castle, in its customary location, that Crail's first market-place at Nethergate was established. Yet before the century was out there was to be a second market at Crail, as important as the first, along the High Street. The burgh's plan-dominant, once the royal castle, had been transformed into its harbour and major thoroughfare.[33]

The colonization of the main roads by market traders is proof of renewed business confidence, bringing the would-be burgess out of hiding. In England, Edinburgh's equivalent was the bishop of Salisbury's fortified city at Old Sarum. Hidden behind its Iron Age ramparts, Old Sarum had seemed, even to near-contemporaries, a curious site for a cathedral city – 'a castle rather than a city, an unknown place'. By the late twelfth century, it was obviously deficient in every way. In the cathedral, the canons could barely make themselves heard above the tempest; water was short; trade was interrupted by frequent disputes as bur-gesses and garrison fell out. Re-siting the cathedral from 1220 was a bold and dramatic initiative. But it almost immediately paid off. In complete contrast to the claustrophobia of Old Sarum's ramparts, the bishop's market at New Salis-bury, first licensed in 1219, straddled an open junction of major throughways – to London and Exeter, Winchester and Southampton, Lymington, Christchurch and Poole. Early in the next century, Salisbury ranked among England's most im-portant provincial capitals. Its burgesses, 'grown wanton with fatness', had

become 'so strengthened with privileges that fame publicly proclaimed them a chosen race'.[34]

Salisbury's latter-day security was widely felt, even without the guarantees of the Church. New Salisbury, whether as cathedral city or market town, was never fully fortified. Most of its lesser contemporaries were not walled at all, as foreign visitors to England were wont to observe, puzzled by this obvious neglect. Long Melford, one of England's most extended villages, is exactly what it says it is – drawn out along the line of the Bury to Colchester road as if nothing were of more account than a market frontage. The same is true of Needham Market, on the Ipswich road. And there are market towns everywhere, among them Stony Stratford, which still offer little more than a single High Street. Stony Stratford is in Buckinghamshire, on that ancient trading artery from London to the Midlands which is now a blood infuser to Milton Keynes. Old and new – medieval borough and modern conurbation – these near-neighbours have flourished on direct access to trade for which their situation has ideally equipped them. In Stony Stratford's case, the initial market grants date to 1194, 1199 and 1200. But the settlement may have existed for a decade already, for the name Stratford first occurs in the 1180s in this locality, when there is evidence also of standard-sized house-plots, renting at either six or twelve pence.[35]

Stony Stratford's better-known namesake at Stratford-upon-Avon was a precisely contemporary urban development, of which the entrepreneur was the bishop of Worcester. Situated on an easy river crossing, Stratford remains an important junction of major throughways. It has not always had the fine stone bridge with which Hugh Clopton first equipped it in the fifteenth century. At times of flood, so Leland tells us, 'many poore folkys and othar [had] refusyd to cum to Stratford when Avon was up, or coming thithar stoode in jeoperdy of lyfe.' Nevertheless, even without such provision, the bishop's success in attracting new settlement to his estate was such that, within half a century of the borough's foundation, his tenants (in borough and manor together) had multiplied no fewer than six times.[36]

The Thursday market at Stratford was first licensed in 1196. Throughout the next century, royal licences of this kind continued to be granted or confirmed, coming to number thousands before 1300. Some part of this growth was a consequence of improved administrative efficiency. Yet it was an obvious product, too, of increasing trading volumes and of specialization, down to village level, among craftsmen.[37] Both Stratfords flourished especially on long-distance trade. But both were located also among less well situated communities which became applicants for market licences in their turn. Indeed, it is a striking fact about the great majority of the later thirteenth-century markets that they had little direct access to the major trade routes. Buckinghamshire's licensed markets, of which Stony Stratford was only the second, had risen to thirty-four by 1348, when the Black Death brought further expansion to an end. Very few of these foundations were exclusively commercial. They owed their origins rather to seigneurial initiatives, determined by the location of estates.[38]

What this meant, in effect, was that almost all the later markets – among them the great majority of subsequent failures – were out in the isolation of the villages. They were semi-paternalistic foundations, established less for profit than to meet the modest needs of the growing numbers of landless poor – labourers or lesser craftsmen who sold their skills daily for cash wages.[39] Accordingly, newly founded markets of this kind are no certain proof of increasing prosperity in the localities. And there are other suspect indicators – rising entry fines and rents – which have more to do with overcrowding and inflation.[40] Nevertheless, greater labour mobility and a steady growth in the money supply are not in doubt. Both assisted market expansion. Nine out of ten of Stratford-upon-Avon's new burgesses came from the immediate vicinity of the bishop's new town – from the

villages and tiny hamlets of Stratford's catchment area, within a day's walk (there and back) of its Thursday market.[41] Everywhere market towns cast no more than an eight-mile shadow, even a provincial capital – a Nottingham or a Leicester – recruiting from just double that radius.[42] Where market areas were both as small and as plentiful as these, profits seeped back into the remotest localities, with obvious consequences in the villages.

The new and growing emphasis on a rural cash economy helps explain contemporary improvements in housing standards, beginning very nearly at the bottom. Medieval peasant houses of this early date have left few obvious remains. Their study has been exclusively archaeological. Yet there is plentiful evidence, even so, of rising expectations, at least among those who had land. Stone in the villages – as in castle, church and town – found increasing favour as a building material. From the late thirteenth century, if not before, individual houses of the wealthier sort were linked and reorganized as farmsteads.[43] Growing disparities of wealth, shown thus on the ground, resulted from the development of locally vigorous peasant land markets, allowing the consolidation of stem family holdings at the expense of the unlucky and the feckless.[44] Typically successful engrossers of vacant plots at this date were Richard de Clyve and Thomas de Agmondesham, yardlanders of the bishop of Worcester.[45] They may stand for a whole class of prospering peasant families, recognizable as clearly in the Balles, Stalkers and Palmers of King's Ripton, the Buks and Scuts of Downham-in-the-Isle, the Mokes and Franklyns, Grays and Geres of the abbot of Ramsey's Holywell-cum-Needingworth.[46] It was Thomas Brid, second of his name and just such a one, who built a new house in 1281 for his mother, Agnes the widow. The cottage was at Halesowen, in Worcestershire. It was two bays in length – 30 feet by 14 overall – and was furnished with three doors and two windows. Agnes enjoyed the luxury of a sea-coal fire, distant though she was from the coast.[47]

Thomas Brid, as a yardlander, was comparatively well off. Not so his fellow tenant, the quarter-yardlander Ralf Ordrich, who could afford nothing better for his younger son, Richard, than a house-plot and movable hut.[48] Temporary buildings of Richard's kind have yet to be recognized in excavations. But the comfortable two-bay cottage of Mistress Agnes' retirement has many archaeological parallels. The most exact is 'house 17' (the blacksmith's house) at Goltho, in Lincolnshire, rebuilt in the late thirteenth century and abandoned about a century later. Compared with earlier houses on the same village site, all of much flimsier construction, Goltho's 'house 17' was built to last. It was 30 by 14 feet, just like Agnes' Halesowen cottage. Internally, its two rooms – one of which was heated by a hooded corner hearth – were divided by a central cross-passage.[49] Neither in dimensions nor in plan were these two houses exceptional. At both, the bay length (approximately 15 by 15 feet) corresponded to the standard measure of timber-framing. The plan was that of the typical thirteenth-century village longhouse, as excavated at Upton or Wharram Percy. There was nothing crude or temporary in peasant housing of this class. Goltho's superior timber houses, in a stoneless region, rested on life-prolonging padstones. At Upton and Wharram, substantial timber frames – two and sometimes three bays in length – were supported on drystone foundations. Paths and yards were usually cobbled.[50] At each of these villages the associated finds suggest life-styles of comfort and modest affluence. Thus the householders of Goltho treated themselves at market to enamelled harness pendants, to decorative belt-chapes, buckles, rings and spurs. Those of Upton and of Wharram bought gilded strap-ends and brooches, ornamented pottery, knives, locks and keys.[51] Coal, rare at Goltho and Upton, occurred at Wharram in many domestic contexts, some of which were certainly of this period. As at Halesowen, Wharram's coal was not local. It had had to be carted 40 miles.[52]

Substantial peasant houses, strongly built of granite, were a feature even of such remote and tiny hamlets as Hound Tor and Hutholes, on Dartmoor. And here too, taking the place of turf-walled cottages, they were clearly intended for a long life.[53] But a change in building materials, if that is all it was, proves little: there was no shortage of granite on Dartmoor. And a more certain indication of new directions in rural society is the longhouse-to-farmstead sequence of a village site like Gomeldon, one of Glastonbury's Wiltshire estates. Here, unmistakably, is material evidence of that redistribution of peasant wealth, favouring the able, which occurred simultaneously on the Ramsey manors of Holywell and King's Ripton, or on the bishop of Ely's Downham-in-the-Isle. By 1300, when Gomeldon's farmsteads took shape, the main families in such manors had come to share out office-holding between them. They collected the lord's rents, assessed his tithes, and creamed off a percentage of his profits. Gomeldon's longhouses were of the same approximate bay-size as the cottages of Goltho and Halesowen. The largest single unit at any period at Gomeldon was no longer than 40 feet within the walls. Nevertheless, what separated the village's farmsteads from its earlier individual longhouses was the courtyard plan – barn on one side, residence on another – of the new style. These yard-centred longhouses were single-storeyed still. They were crowded, cheek by jowl, on neighbouring plots. Yet they were as surely on their way to full farmhouse status as their occupants were *en route* to yeoman farmer.[54]

This clear evidence of rising status, plainly visible in the quality of peasant housing, is an important contribution to the continuing debate about what actually happened in thirteenth-century England. Too much has been made of peasant squalor.[55] Too little has been understood of the higher standard of living to which many could increasingly aspire. Again archaeology suggests some of the answers. Of the three moated enclosures at the Huntingdonshire hamlet of Wintringham, near St Neots, only one has been thoroughly investigated. But this, at the far end of the village from the former manor house, has revealed a complex and compressed building history. On the archaeological evidence, the moat was first inserted in about 1250. It surrounded a new farmhouse, and sealed with its upcast a much humbler building – a hall and chamber, with outbuildings and kitchen – which itself overlay an even simpler structure, described as a 'single-celled, quasi-aisled building'. Neither of the earlier phases, antedating the moat, had lasted more than a generation. Even the third-phase rebuilding, for all its scale, was quickly overtaken by a fourth. It was in this final episode, dating to the early fourteenth century, that a new order was introduced in courtyard planning. Hall and chamber were squarely set at one end of a rectangular court. There was a kitchen to the west and other buildings to the south and east, all on parallel alignments. Every building of Wintringham's last period before abandonment was an improvement on the structure it replaced. And so it had been on three occasions already within the space of little more than a century. Each generation, clearing the buildings of the last, had set up an establishment of higher status.[56]

Wintringham's growing wealth is abundantly confirmed by the quality of the finds from the site: a personal seal of *c*.1300, a lead ampulla brought back from a pilgrimage, a jug of curious and obscene design, a gaming-piece, six candleholders and much else. Yet it is hard to be certain about the detail of Wintringham's timber buildings, whereas there is nothing ambiguous about Old Soar, near Plaxtol, a Kentish stone manor house of the late thirteenth century. Old Soar's hall, probably timber-framed like Wintringham's, has since been lost under a Georgian farmhouse. It measured about 43 feet by 34. To the east, the stone solar block has survived intact, approximately half that in area. Warm and dry over its strongly vaulted undercroft, the great chamber at Old Soar was a spacious and well-equipped apartment. It had its own ground-floor entrance, its individual newel stair, its private garderobe and personal chapel. There was a

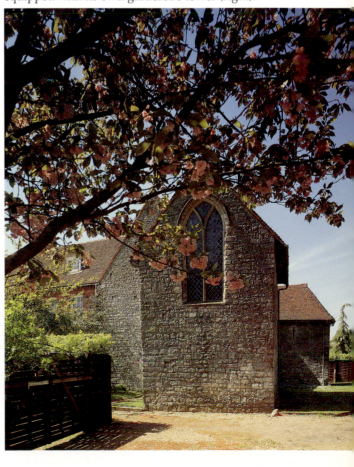

110. The solar range of *c*.1290 at Old Soar, partly hidden by an attached first-floor chapel (centre) and equipped with its own garderobe tower (right).

111. The mid-thirteenth-century great chamber at 'King John's House' (Romsey), probably one of the guest apartments of Romsey Abbey.

sidewall fireplace, now lacking its hood, and there were big shuttered windows to north and south.[57]

For its date, Old Soar is something of a rarity; there are few survivals like it. Only the solar range at Charney Bassett, one of the monks of Abingdon's stone-built manor houses, offers much of a parallel.[58] However, the remains of contemporary halls are more abundant, and many were still aisled in the old way. Such, certainly, had been the hall at Old Soar. And such again were the similarly dated halls at Harwell and Temple Balsall, at Kersey, Fyfield and Great Bricett.[59] In contrast, Wintringham's builders had managed without aisles of any kind. And what enabled them to do this was the growing sophistication of contemporary roof carpentry, promoted by active building in every quarter. Carpenters, before the century's close, had learnt to lift their aisles into the roof-space. At first, they had built their frames on conventional tie-beams, requiring the support of strong stone side walls. Then they began to use base-crucks and post-bearing hammer-beams to spread the main thrust of the roof.[60] These techniques were expensive. But they cleared the hall's floor of the encumbrance of arcades, and they made a brave show up aloft. With the tile mosaics of the same period, its ornamental ridge-tiles, finials and louvers, the new framed roofs were a token of confidence and of wealth: of an ability to live comfortably and well.[61]

Individual thirteenth-century apartments – the nuns' great chamber at Romsey (King John's House) or the sophisticated *camerae* of the military orders at Harefield and Strood Temple [62] – would be hard to match anywhere for comfort. Those luxuries still exceptional in the mid-twelfth century were coming to be routine amongst the rich. As always, the king led the way. Notorious for its splendour, Henry III's rebuilt palace at Clarendon, near Salisbury, was a show-case of all the new methods. It had costly tile-mosaic floors, among the earliest in England. Its chambers were painted with the king's favourite romances (the adventures of Alexander, the apocryphal duel of Richard and Saladin), with moralities (the Tree of Jesse, the Wheel of Fortune), or with the lives of those saints (Margaret of Antioch, Edward the Confessor) for whom Henry conceived particular affection. Clarendon's state chambers had glazed windows and wainscoted walls; their rich blue ceilings sparkled with applied gold stars; their chimneypieces were loaded with fine statuary.[63]

So little is known of Clarendon's earlier buildings that useful comparisons are impossible. But the extent and the exceptional nature of Henry III's expenditure at Clarendon is undeniable. Henry risked – and very nearly lost – everything for building. Throughout his long reign, but especially during the decades of his personal rule between 1234 and 1258, a full tithe of Henry's income was sunk in buildings, each more 'seemly', 'sumptuous' and 'beautiful' than before.[64] Henry may have viewed his extravagance as public policy: to ride like the heroes of his beloved romances 'in triumph through Persepolis'. Instead, what it brought him was permanent debt and the chronic suspicion of his barons.[65] Distrust was no barrier to emulation. Amongst those same barons, few except Simon de Montfort (castellan of Kenilworth) or Earl Gilbert (builder of Caerphilly) could match the scale of Henry's building. But all shared the same enthusiasm for military engineering, as innovatory as their circumstances would allow. This new professionalism in castle-building has attracted much attention over the years. Less frequently noticed, although equally real and very nearly as expensive, were unprecedented advances in the castle's comfort.

It is because there are earlier castles to measure them against that these buildings have particular importance. Thirteenth-century opulence is nowhere more obviously confirmed. Take Gilbert de Clare's Caerphilly. Unlike Kenilworth, which Gilbert knew well and on which he modelled his own water defences, Caerphilly was the work very largely of a single generation: of Earl Gilbert and of his widow, Countess Joan. There were special circumstances for the building

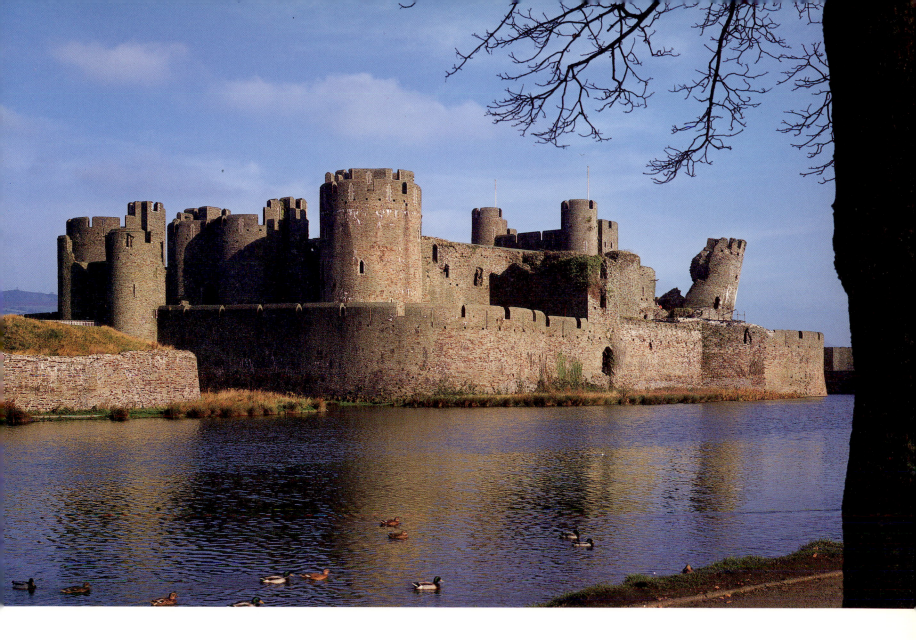

of Caerphilly, and castles on this scale were never more exceptional than in the thirteenth century, when watched with great attention by the king. Gilbert, earl of Hertford and Gloucester, was hugely wealthy: one of the richest men of his time. As lord of Glamorgan, he enjoyed the castle-building privileges of a lord of the March, while having cause to make use of them against the monarchy.[66] But Caerphilly, even so, was enormous. Begun in 1268, Caerphilly's defences anticipated the sophistication of the Edwardian fortresses of North Wales, rightly described as the 'apogee' of castle-building.[67]

Caerphilly was a castle of gatehouses. It did away with the central keep, and relied instead on a complex system of concentric defences in which moats, as well as walls, played their part. Castles of this kind owed their origins to Dover. However, it was not so much the Dover that Henry II built as the great concentric fortress which, after the siege of 1216–17, was remodelled by Hubert de Burgh. Dover in 1216 was already a very modern castle (see p. 70). But its modernity had barely rescued it from its Anglo-French besiegers, and it was the castle's gate, undermined and collapsed by Prince Louis' army, which was the obvious point of weakness in the enceinte. Hubert de Burgh was Dover's defender. He was an experienced soldier who could see very well what needed doing. Dover's rebuilding, undertaken with great dispatch, focused almost entirely on its gatehouses.

Hubert, as Henry III's chief justiciar, spent almost as much on the fortification

112. The defences of the inner ward at Gilbert de Clare's Caerphilly, with his postern (centre) and west gatehouse (left); Gilbert's main residential gatehouse (top right) rises behind the bulk of his hall.

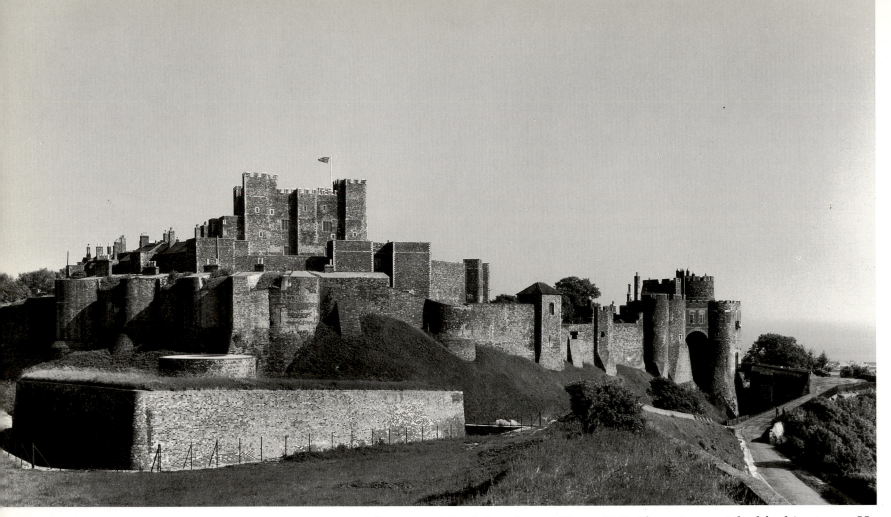

113. Hubert de Burgh's remodelling of Dover Castle, after the siege of 1216–17, closed the north gate with his three Norfolk Towers (centre), all of which have since been cut down to rampart level. He then opened another gate, Constable's Tower (right), on the west, making the gatehouse his residence.

of Dover as it had already cost Henry II. But he got a great deal for his money. He closed the vulnerable northern gate with a triad of huge towers (the Norfolk Towers), and made another opening (Constable's Tower and Gate) on the steep slope to the west, throwing his new gatehouse forward across the moat and siting his own lodgings above it. A residential gatehouse, still rare at that time, was not the only evidence of new thinking at Dover. Hubert's Fitzwilliam Gate postern, with its paired beak-shaped towers, was right up with the latest French fashions. He used the beak plan again in his Norfolk Towers, and by hugely extending the outer curtain to the cliff, made Dover a castle without peer. Certainly, by the time Hubert had finished with it, Dover was no place of last resort. Its multiple defences ensnared and then held the intruder. Its elaborate sally-ports, reached by rock-cut passages, made it as prickly as a porcupine to the besieger. Dover, once the retreat and castle-palace of Henry II and his sons, had been reborn as a weapon of aggression.[68]

When a castle like Dover went on to the offensive, the character of siege warfare changed with it. Dover itself was rarely seriously at risk after Hubert's time. Kenilworth, sheltering in 1266 behind its water-filled 'brays', was brought down only by starvation. Caerphilly never fell to an assault. But the cost of such sophistication was daunting. Edward I's North Welsh castles – Flint, Rhuddlan and Conway, Harlech, Caernarvon and Beaumaris – set new standards for all castle-builders.[69] However, the king alone could spend on this scale, and lesser men, unless assisted by the Crown, had to make what they could from fewer elements. Again Hubert de Burgh and his associates led the way. Earlier in the century, Hubert had tried out different plans at his castles at Grosmont and Skenfrith. He chose another plan altogether for the royal castle at Montgomery, placing special emphasis (as at Dover) on the gatehouse. At Pembroke and at Chepstow, Hubert's contemporaries, William Marshall and his sons, were experimenting with refortifications of their own. Each castle was the work of a

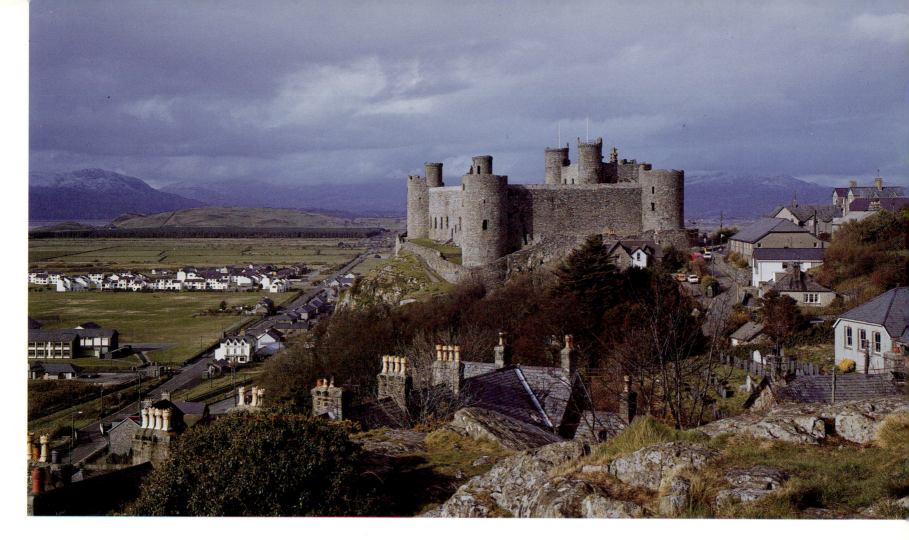

seasoned campaigner. And each was a reflection of what was latest and best, whether crafted at home or made in France.[70]

One obvious French derivative was the circular tower keep, adopted at Hubert de Burgh's Skenfrith and William Marshall's Pembroke, as at Nenagh and Dundrum in Anglo-Norman Ireland. Such towers had many advantages for the soldier, but provision of accommodation was not among them. In Ireland, the rectangular keep – Greencastle (Down), Carlingford (Louth), Athenry (Galway) – enjoyed a long life, specifically to cope with that need. In England and Wales other solutions were found, whether in the gatehouse or in the ranges of the bailey. Significantly, Hubert de Burgh's substantial hall-block at Grosmont, always the most important single element of his castle, predated by two decades the mural towers and sophisticated gatehouse of the 1220s.[71] The Marshalls' Chepstow, simultaneously, was transformed. Fitz Osbern's castle, built soon after the Conquest, had consisted of an austere palace-keep, with walled baileys along the ridge to east and west. To this, the younger Marshalls (William II Marshall and his brothers) added a second line of defence – a western barbican and an eastern lower bailey – with drum towers and a strong gatehouse in the curtain. Equally important was their work on the palace-keep itself, given bigger first-floor windows to light the great hall and a new upper chamber at the west end. Other comfortable accommodation, similarly intended for the lord's family, was provided at the south-west angle of the upper bailey, with additional lodgings in the new gatehouse and mural towers.[72] Extensive though the Marshall modernization of Chepstow had been, it was not enough for the castle's next owners. Roger Bigod III, earl of Norfolk (1270–1306), maintained Chepstow's fortifications in good order. But his contribution was essentially domestic. It was Roger Bigod who completed the second storey of fitz Osbern's already updated palace-keep; who built, in the lower bailey, a fine new hall and kitchen (with

114. Edward I's Harlech Castle, built between 1283 and 1289, was a sophisticated fortress of keep-gatehouse plan. But its dramatic setting was pure propaganda.

101

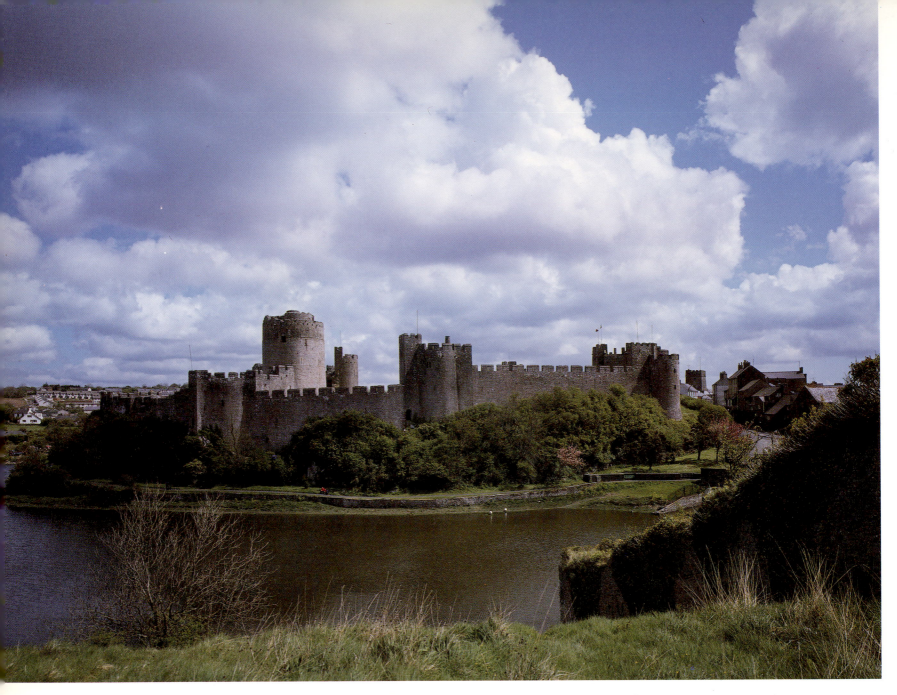

115. The drum heep (left centre) of Pembroke Castle, built soon after 1189 by William Marshall, 'a most valiant soldier of world-wide renown', still dominates the great fortress subsequently much extended by his sons.

private chambers attached); and who entirely reconstructed the south-east tower (Marten's Tower) for use as his own private residence. Chepstow, having entered the thirteenth century in the rugged clothing of a fortress, left it palatially in court dress.[73]

This neglect of military austerity in favour of greater comfort occurred wherever castles were rebuilt. One of many such programmes of domestic improvement was the addition of an extra storey to the tower at Bronllys, a lesser Marcher stronghold near Talgarth. Bronllys had a circular keep of the Skenfrith type, set on an earlier motte. It had been built by the Cliffords, comrades-in-arms of Hubert de Burgh, but (like Chepstow) was little suited to the needs of their successors. In the 1310s, while Rhys ap Hywel was lord, the tower at Bronllys was made more habitable. Bigger windows were inserted; fireplaces were rebuilt; another floor was added to the top.[74] With the same intention but on a much grander scale, the Henrician square keep at Brougham, in Westmorland, was remodelled at exactly that time. Once a free-standing tower of conventional 1170s design, it became incorporated in other buildings, almost filling the bailey, including an adjoining gatehouse ('one of the most formidable military gate-defences of the period'), a new hall, kitchen, and private lodgings. The keep itself,

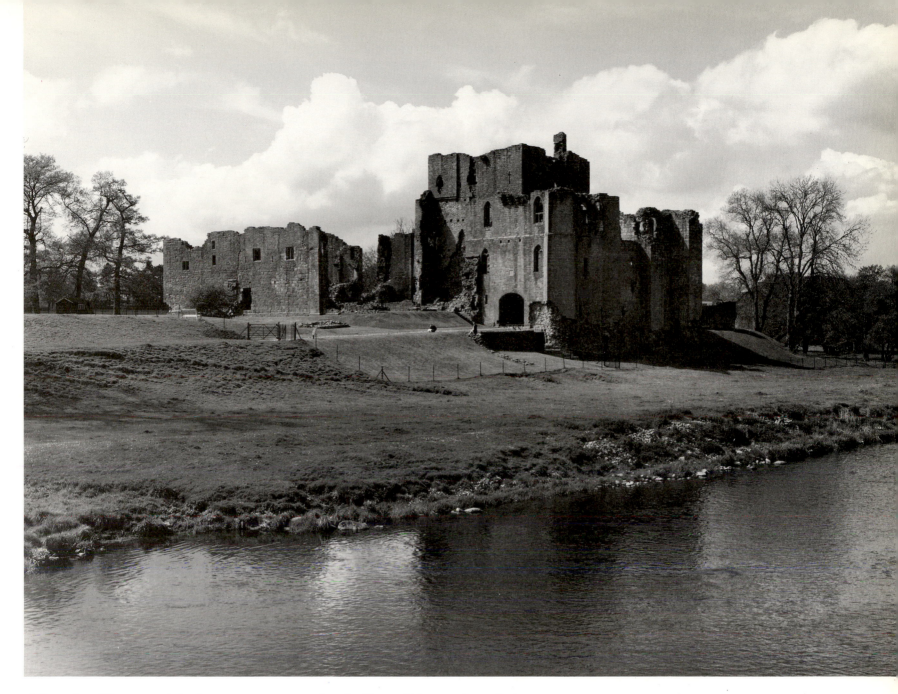

although still comparatively new, was gutted, rebuilt, and domesticated. Another storey was added, as to the keep at Bronllys, providing a fine upper chamber, octagonal in plan, complete with its own private oratory.[75]

Brougham's vaulted oratory, ingeniously fashioned out of a corner of the mural passage, is a little jewel of contemporary design. And it was this union everywhere of investment and skill which distinguished castle architecture of the period. The ingenuity was as much domestic as military. Fine upper-floor chapels were a feature again of the new accommodation at such castles as Oystermouth and Beverston. Bishop Robert's highly individual Shropshire 'castle' of the 1280s at Acton Burnell, although owing something in its plan to earlier keeps in the county, must always have seemed more like a manor house.[76] Nevertheless, the full domestication of the castle was still remote at this date, whereas military engineering, given every encouragement, would never again be as innovative. The variety of plan was enormous, from the circular Rothesay to the towered square of Liscarroll, from the polygons of Holt and Bolingbroke to the triangles of Denbigh and Caerlaverock. Yet the basic elements of each were the same. All aspired to a militarily effective gatehouse and to at least two stages of defence.

116. The modernization of Brougham Castle in *c.*1300 included the rebuilding of the gatehouse (centre) and the addition of another storey to the twelfth-century keep (behind), converting it into a comfortable residence.

117. At Oystermouth Castle, near Swansea, the upper-floor chapel in the great tower (right) is an addition of the early fourteenth century.

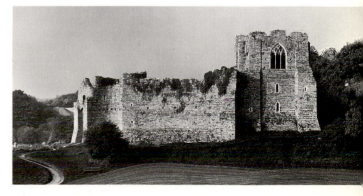

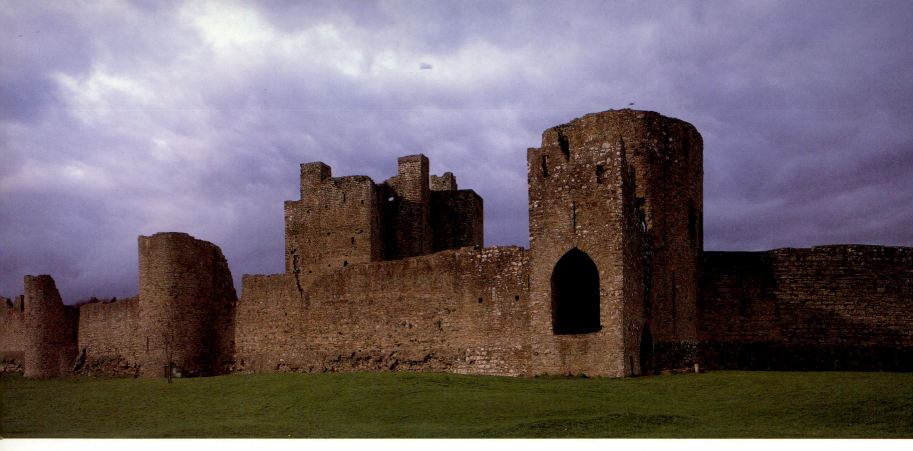

118. A sophisticated stone barbican (right) spanned the moat and protected the south gate of Trim Castle (Meath). Trim's big residential keep (centre) was probably completed in the late 1210s, followed shortly by this towered outer curtain.

119. Denbigh's great gatehouse was the focal point of a new fortress, begun with royal assistance in the late thirteenth century but then left to Earl Henry and his heirs to complete.

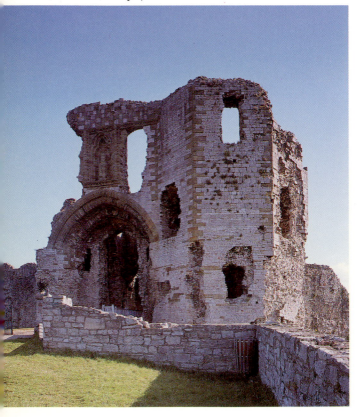

The gatehouse and its barbican, ever more ingeniously defended, attracted particular investment. Such precautions developed early at castles like Pevensey and Helmsley. Nevertheless, it is the huge elaboration of the later gatehouse complexes – at Sandal and Denbigh, Caerphilly and Caerlaverock, Kidwelly, Kildrummy and Trim – which is the most convincing evidence of high expenditure. Very few of these castles were built without a subsidy of some kind from the Crown. Denbigh certainly, when started in 1282, had both the king's money and his masons in support. But if Denbigh began with Edward I at its back, its completion then devolved on Henry de Lacy. It was Henry, earl of Lincoln (1272–1311), who built Denbigh's gatehouse: a great trinity of towers. And it was Earl Henry's heirs who ran out of money before they finished it. Edward I, similarly, left Ruthin to the Greys, Holt to the Warennes, Chirk to Roger Mortimer, and Kidwelly to Henry of Lancaster. Although plainly important at each of these works, the support of the king was not everything.[77]

Edward I's own castles, the work of professionals, were often closer to forts than to palaces. And professional also were the comital fortresses, starting at the summit with Caerphilly. John de Warenne, earl of Surrey (1240–1304), was not as wealthy as Gilbert de Clare. However, he had been a full-time soldier through most of his life; he knew France well; had travelled extensively in Germany and Spain; took a major role in the Baronial Revolt; fought in Wales and Scotland; and was still on campaign in his hoary old age, commanding a squadron at the siege of Caerlaverock (1300). What Earl John and his associates did not know about castles was not worth knowing, as Sandal and Holt both confirm. At Sandal, John de Warenne started with an existing motte and with the stone keep on which his father had begun. To these he added a barbican tower, independently ditched and with angled approach, which was one of the most formidable of its date.[78] Earl John's castle at Holt, in contrast, was built entirely from new. Pentagonal in plan, with circular towers at the angles, Holt was geometrically perfect. Only in France, or among the castles of his king, could the earl have found models for such work.[79]

That same obsessive geometry is most strikingly present in the triangular fortress at Caerlaverock. Probably built as a bridgehead castle of the English

invasion across the Solway Firth, Caerlaverock was in Scottish hands before the summer of 1300, when besieged by a large royal army. 'Caerlaverock was so strong a castle', wrote the chronicler of that time,

> that it feared no siege before the King [Edward I] came there, for it would never have had to surrender, provided that it was well supplied when the need arose with men, engines and provisions. In shape it was like a shield, for it had but three sides round it, with a tower at each corner, but one of them was a double one, so high, so long and so wide that the gate was underneath it, well made and strong, with a drawbridge and a sufficiency of other defences. And it had good walls, and good ditches filled right up to the brim with water.[80]

The writer was a poet, with the poet's licence to exaggerate, but what he sang was literally the truth. Caerlaverock and its like were the source of satisfaction at least as much to Scots as to English. Two Scottish fortresses of this class, Bothwell and Kildrummy, were neither of them entirely finished by their builders. Yet in scale, in sophistication, and in the high quality of their stonework, they were plainly up amongst the leaders. Walter of Moravia's Bothwell Castle was kite-shaped – or it would have been so, if the plan had been completed as intended. The royal fortress at Kildrummy was polygonal. Each had the *donjon*, or single strong tower, of the continuing French tradition, also seen at Edwardian Flint.[81]

Both Bothwell and Kildrummy were caught up in the Wars of Independence, neither escaping repeated sieges. However, they had anticipated the English invasion, and were not its product. Their first purpose, rather, had been the display of wealth and the public exhibition of family potency. Kildrummy's custodians, the earls of Mar, were close partners of the Scottish Crown throughout the century. The Morays of Bothwell, those 'businesslike raiders from the north', prospered particularly on a fortunate alliance which brought them Bothwell with the Olifard inheritance.[82] Another acquisitive raider, Aymer de Valence, held Bothwell briefly in the early fourteenth century as Edward I's Warden of Scotland. Aymer, whose name continues in the 'Valence Tower' at Bothwell, was created earl of Pembroke in 1307. He became by slow stages one of the richest men in England, on a level at least with the Warenne earls of Surrey, while still outstripped by both Lancaster and Gloucester.[83] Like these and others of the comital class, Aymer was a builder of castles.

Aymer's principal legacy is the castle at Goodrich, almost intact as a record of his life-style. With the one exception of a residual tower keep, Goodrich is a single-period castle. It is the purpose-built residence of a soldier and great nobleman, whose restless career of command and diplomacy kept him always at the centre of events. Aymer, as earl of Pembroke, went to war with a retinue more than a hundred strong. Even in peace, his personal following of household knights and officials can rarely have fallen below fifty.[84] Goodrich, accordingly, was a compromise. It was a soldier's castle, symmetrically planned, with corner towers elegantly spurred. It had a well-developed gatehouse and an intricate barbican: dog-legged, gated and bridged. Simultaneously, Goodrich was an apartment block, spilling over at the brim with private lodgings, for which a range of common services was provided. There was a big garrison chapel, next to the castle gate. A communal kitchen served Pembroke's hall, in addition to two other halls. Common lavatories were provided – a 'battery' of three. And throughout the castle there were individual apartments, with fireplaces, drains and garderobes of their own.[85]

The fact that Aymer's retinue was so well-housed is further valuable evidence of its quality. Certainly, it included men of rank and substance, some of them relatives and many of long service, bound by sentiment and contract to the earl.[86] Aristocratic households of this sort were forbiddingly expensive. They could not have been supported even by barons of high status without constant infusions

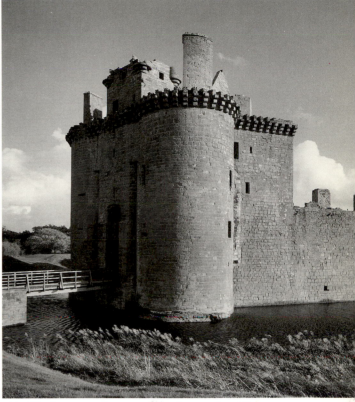

120. The keep-gatehouse at Caerlaverock, at the apex of a triangular fortress.

121. The chapel wall, between angle towers, at Kildrummy Castle, showing the high quality of the thirteenth-century masonry.

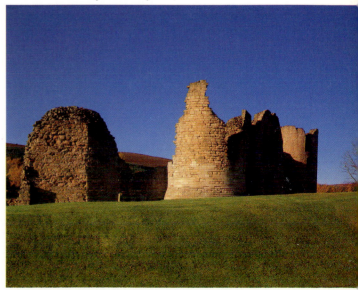

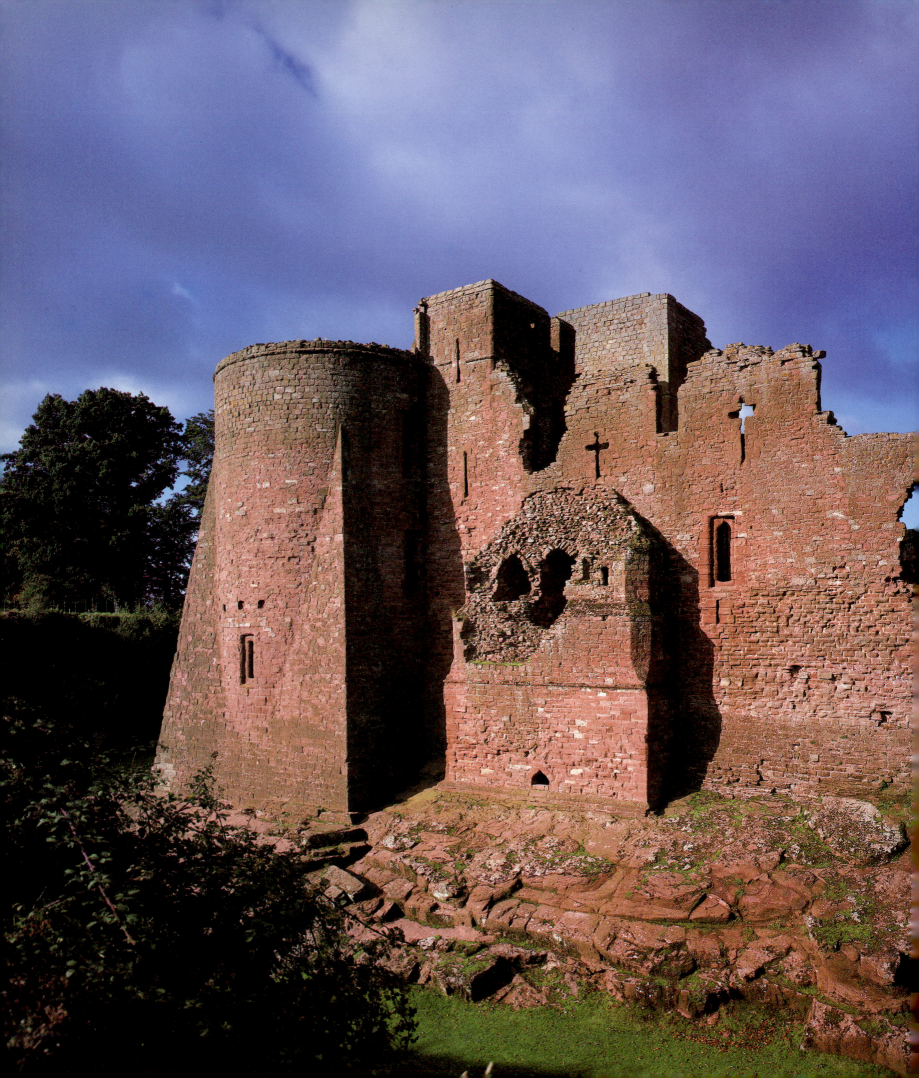

of new wealth. Aymer himself was still assembling lands in 1313, when the final elements of his inheritance came together. He was among those who profited from the suppression of the Templars in 1312, and similarly gained in 1322 from the fall of Thomas of Lancaster.[87] Contemporary families like the Bohuns, earls of Hereford, and the Mortimers, earls of March, were equally busy accumulators.[88] Yet while much of this was achieved, as in Aymer's own case, through politics or the consolidation of inheritances, there were other factors favouring the great at this time, including rising receipts on their estates. In just half a century, between 1267 and 1317, the Clares of Gloucester almost doubled their fortune. They bought out their neighbours, among them knights of their retinue, and successfully exploited their demesnes.[89] Little of this could have been achieved without the help of a myriad of officials. And both the cause and a consequence of increased activity on the demesnes was a significant expansion of the household. Caerphilly's huge scale was clearly related to the size of Earl Gilbert's *familia* – of a travelling household (knights, esquires and maids of honour) exceeding 200, and of a corps of officials, clerks and servants which multiplied that number many times.[90] When Thomas of Lancaster, wealthiest and most troublesome of Edward II's earls, built himself a castle at Dunstanburgh, in Northumberland, he shaped it to accommodate an army.

'By the size of his patrimony,' a contemporary wrote of Lancaster, 'you may assess his power.'[91] It was a patrimony concentrated chiefly in the North Midlands rather than in Northumbria. And it was from those counties in particular that Lancaster recruited a retinue sufficient to challenge the king. However, the earl used outlying Dunstanburgh as he did his other castles – Tutbury and Kenilworth, Pontefract, Melbourne and Leicester – both as residence and administrative centre. And it was his continuing lack of favour at Edward II's court which kept him at home more than most. Building, in these circumstances, was a 'social necessity', practised by Lancaster with the same deliberate purpose as he kept up an over-large household. Both were costly but inescapable exhibitions of largesse: the heaviest charges on his revenues.[92]

Dunstanburgh is a very obvious castle. It stands on a tall promontory with the sea at its back, isolated by wasteland and water. Lancaster clearly saw it as a refuge. Yet as a work of military engineering, alongside others of its time, it was a dinosaur. Dunstanburgh was a straightforward castle of enclosure. Only its huge residential gatehouse, later converted into a tower keep, had any of the sophistication of the big royal fortresses with which Lancaster and his generation were familiar.[93] Lancaster's choice of plan is significant, for it again underlines the growing importance of the late-medieval nobleman's affinity. Already, the earl's strength lay less in his castles than in his clientage. Far from recalling a primitive fortress like Richmond, with which it has sometimes been compared,

122. At Goodrich Castle, the south-east lodgings tower – two apartments over a basement – is adjoined by a three-seater garderobe turret (centre), draining directly into the moat below.

123. Thomas of Lancaster's Dunstanburgh Castle, on the Northumbrian coast, was a huge promontory fortress, large enough to hold his private army. The keep-gatehouse was Lancaster's personal residence.

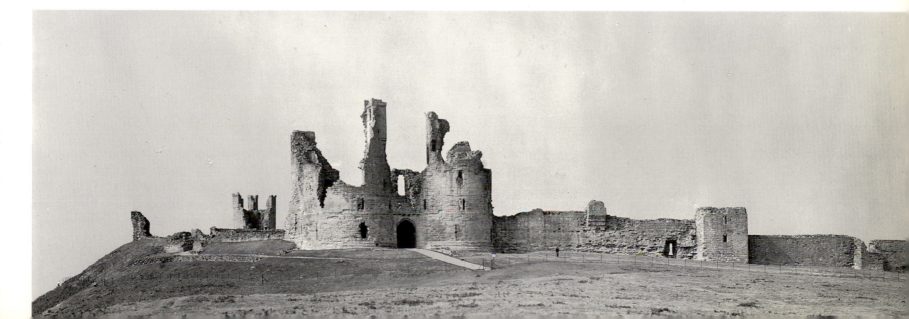

Dunstanburgh looked forward to the noble barracks of the future: the so-called 'castles of livery and maintenance'.

Dunstanburgh's enceinte, begun in 1313 and enclosing the whole headland, remained unfinished in Lancaster's lifetime. However, it was sufficiently advanced in 1322 for the earl's advisers to urge him to escape there. And some believe Lancaster was on the way to Dunstanburgh when eventually cornered at Boroughbridge. In any event, building within less than ten years on the scale achieved at Dunstanburgh would have tested even the greatest of fortunes. And Dunstanburgh accordingly, like Goodrich or Caerphilly, is again proof of exceptional resources. These resources moreover, in Lancaster's case, came almost exclusively from his manors. Lancaster's overflowing household and his many building projects were supported by expert management, even through those periods of dearth after 1314 when Dunstanburgh itself was under construction. In bad times as in good, Lancaster's officials responded energetically to his needs. They pushed up rents and exacted feudal dues to the point of provoking resistance; they invested heavily in enclosures and reclamation.[94] Many of these men were clerks in holy orders. They had learnt their skills in that most wide-ranging of schools: the patrimony of God and Holy Church.

That patrimony, undoubtedly, was guarded by accountants as professional as any soldier of the period. On 12 February 1322, just a month before Lancaster's execution, the Norman crossing tower at Ely Cathedral had collapsed: 'behold! suddenly and swiftly the bell-tower crashed down upon the choir with such a thunderous noise that one might think an earthquake had occurred'. Its almost immediate reconstruction, alongside work on the Lady Chapel only lately begun, constituted one of the most remarkable building projects of all time. Within six years, the stonework of the crossing was back in place,

> and immediately, in that year [1328], the ingenious wooden structure of the new tower, designed with great and astonishing subtlety, to be erected on the said stonework, was begun. And at very great and heavy cost – especially for the huge beams required for that structure, which had to be sought far and wide, found with much difficulty, bought at a great price, and carried to Ely by land and water, and then cut and wrought and cunningly framed for the work by subtle craftsmen, – at last, with God's help, it was brought to an honourable and long-hoped-for finish. The cost of the new tower during the twenty years that Alan of Walsingham was sacrist was £400.6.11, whereof £206.1.0 came from gifts. . . . The new choir was made in the 12th year of Edward III, A.D.1338, and the following years by Brother Richard de Saxmundham.[95]

'Of all the products of the Decorated Style,' in one recent view, 'the great programme at Ely Cathedral [Octagon, Choir, Lady Chapel and Prior Crauden's Lodgings] stands pre-eminent'.[96] In another modern assessment, Ely's Octagon and Lady Chapel rank as 'two of the most spectacular buildings of a notably splendid period in English architecture'.[97] That spectacle was obtained at 'heavy cost', much of which had to be found by the bishops. Thus it was Bishop John Hotham (1316–37) who privately funded the reconstruction of Ely's choir, built initially by Hugh of Northwold (1229–54) at scarcely believable expense: 'which work he completed in seventeen years, and on the building of this work he spent £5400.18.8'.[98] Bishop Hotham's successor, Simon Montacute, gave 'many large sums' towards the huge Lady Chapel which was Brother John of Wisbech's individual enterprise.[99] The Ely chronicler's figures are not to be taken too literally, particularly where they concern the earlier work. Nevertheless, the sums were large, and could only have been met because Ely's bishops were wealthier than they had ever been before. By 1300, according to one calculation, they were

124. Bishop John Hotham's choir at Ely Cathedral, rebuilt in the 1330s after the Norman crossing tower had collapsed with a 'thunderous noise'.

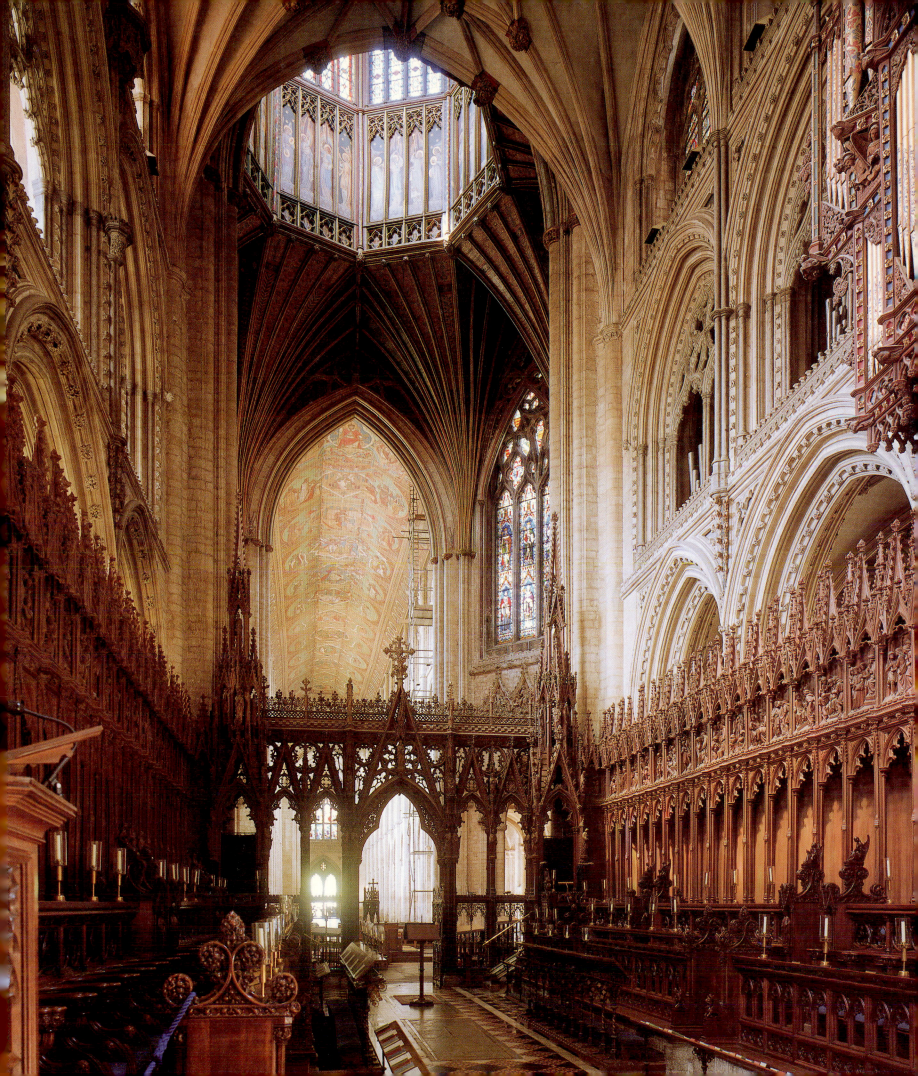

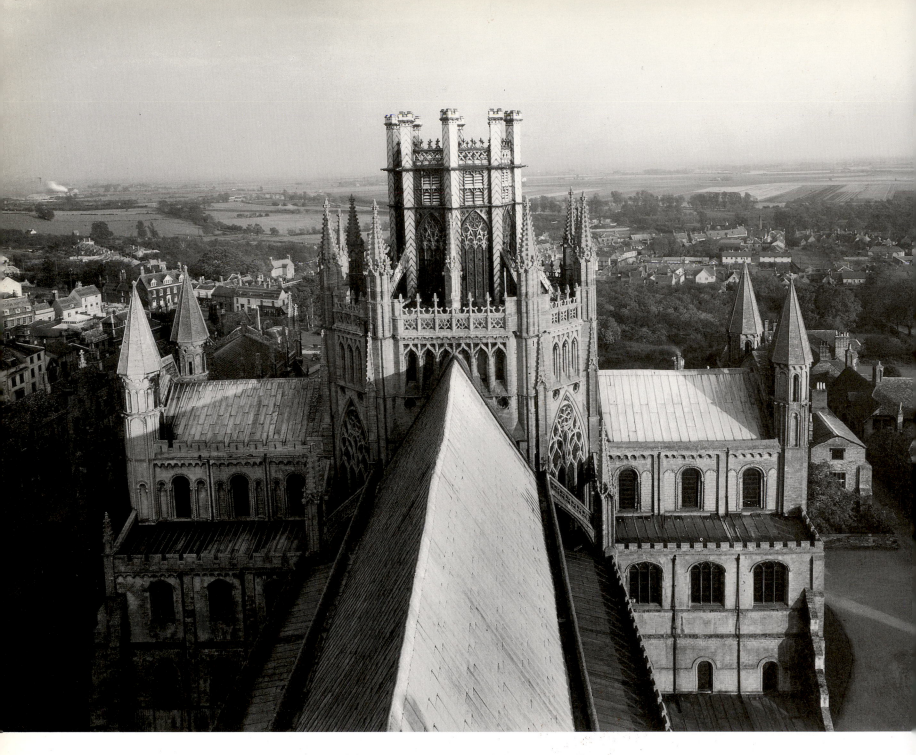

125. The Ely octagon, seen from the west tower along the ridge of the nave roof.

three times richer than the bishops of the late twelfth century. From a Domesday base in 1086, the multiplier was nearer to five.[100]

Increases of this order, although large by any standard, were not unique in the period. Take Worcester Cathedral, where a hugely ambitious rebuilding programme began under Bishop William of Blois (1218–36). William of Blois' episcopacy coincided with the start of a long period of accelerating receipts. It had followed a century of almost stagnant revenues. Yet income was to double by the late 1260s, doubling again before the end of the century, when it came to total as much as £1200.[101] Distorted by inflation, these figures have to be interpreted with caution. In some cases, especially in the calculation of direct farming receipts, the profits may be less real than they appear.[102] Yet at both Ely and Worcester, fully 60 per cent of the episcopal revenues came not from demesne produce but from rents.[103] It was this cash in hand, more plentiful by the year, which provided the support for new building. William of Blois' Lady Chapel, at the east end of

Worcester's presbytery, was closely followed by a costly scheme to replace the entire chancel of Wulfstan's Anglo-Norman cathedral, preserving only his crypt. The nave had been reached by the 1320s, during the episcopacy of Bishop Thomas Cobham (1317–27). And although work from that time was to be of a simpler character, everything undertaken by Cobham's predecessors had been distinguished by sumptuous display.[104]

If proof were still needed of a thirteenth-century boom, buildings of this kind would provide it. Two projects especially stand out. Earliest in time was the re-siting of Salisbury Cathedral, discussed for some years and begun by Richard Poore in 1220. Towards the end of the same century, the rebuilding of Exeter is notable particularly for an extraordinarily complete documentary record in the week-by-week accounting of the fabric rolls. At Salisbury, Richard Poore had been dean of the cathedral before returning there in 1217 as bishop. And it was while he was dean that he reordered the statutes of Salisbury Cathedral in his *Nova Constitutio* of 1213–14, adopted elsewhere as the 'Use of Sarum'. Salisbury, accordingly, is more than a display of the overflowing wealth of the bishop and the patrons he attracted. It is an exact contemporary record of liturgical practices, as codified by the man who laid it out.

Newly prominent in the liturgy was the daily celebration of a solemn Mass to the Virgin, becoming common practice in 'all the noble churches in England', and contemporaneously the inspiration of Worcester Cathedral's rebuilding, as of many parallel enterprises. At Salisbury, work began with an eastern Lady Chapel, dedicated in 1225 and large enough already to accommodate the entire body of cathedral clergy. It was this remarkable building, more a hall than a church, which at once set the standard for what followed. Its slender marble shafts were a deliberately chosen badge of excellence. Reused everywhere throughout the body of the cathedral, they established the quality of a huge interior which was also essentially functional. Salisbury's broad aisles and eastern ambulatory were laid out as processional spaces – for the Sunday procession, clockwise round the church, sprinkling each altar in turn with holy water; for feast days, when the procession took in cloister and precinct as well. There were breaks, again for the procession, in the continuous step-like plinth which supported the tall nave arcades. All the many altars asperged during these rituals were architecturally distinguished within the body of the building by raised floor-levels and additional ornament.[105]

Proudest of the proud monuments at Salisbury today is the splendid sepulchre – almost a shrine – of Giles of Bridport (d.1262), bishop when the cathedral was consecrated in 1258, less than a generation after work there began. In an otherwise disciplined Early English interior – as clear and as precise as Dean Richard's Use of Sarum [106] – Bridport's tomb is an exotic intrusion. It is at once richly ornate and frankly innovative: the earliest use in Salisbury of French *rayonnant* bar tracery, introduced through the king's works at Westminster.[107] Sophisticated bar tracery, the characteristic of English 'Decorated', was again freely used in the great cloister at Salisbury and in the cathedral's huge octagonal chapter-house. They are the work of Giles of Bridport's immediate successors: Walter de la Wyle (d.1271) and Robert Wickhampton (d.1284). Each had fallen under the spell of Henry III's Westminster, as heedless of the cost as the king.

These additions look expensive, and indeed they were. They were not even, when it came down to it, very useful. A secular cathedral had no need of a cloister; Salisbury's ornate chapter-house, although certainly of more purpose, was many times too spacious for its canons. But the bishops had no reason to economize. There are two gargantuan churches, of the same date as the cathedral, in the Wiltshire parishes of Potterne and Bishops Cannings, both of them episcopal manors. Each has a great tower on the crossing, a pair of big transepts, and a chancel of exceptional quality.[108] Choice personal estates like these,

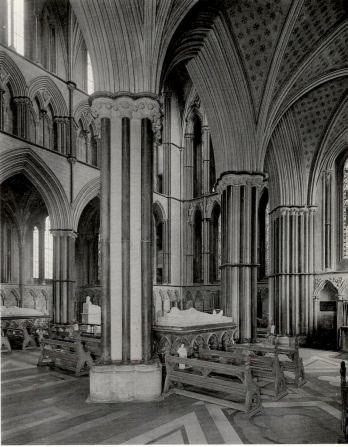

126. The rebuilding of Worcester Cathedral, financed by increasing revenues, began with William of Blois' Lady Chapel in 1224.

128. (following page) Salisbury Cathedral was built in a single programme in all but its fourteenth-century spire, beginning here at the Lady Chapel in 1220.

129. (following page) Salisbury's nave, built throughout in the Early English style, was probably ready for use by 1258, when the new cathedral was consecrated with great ceremony.

127. Personal devotion to the Virgin inspired the famous roundel in the bishop's chapel at Chichester, probably painted for Bishop Richard Wich (1245–53), canonized in 1262.

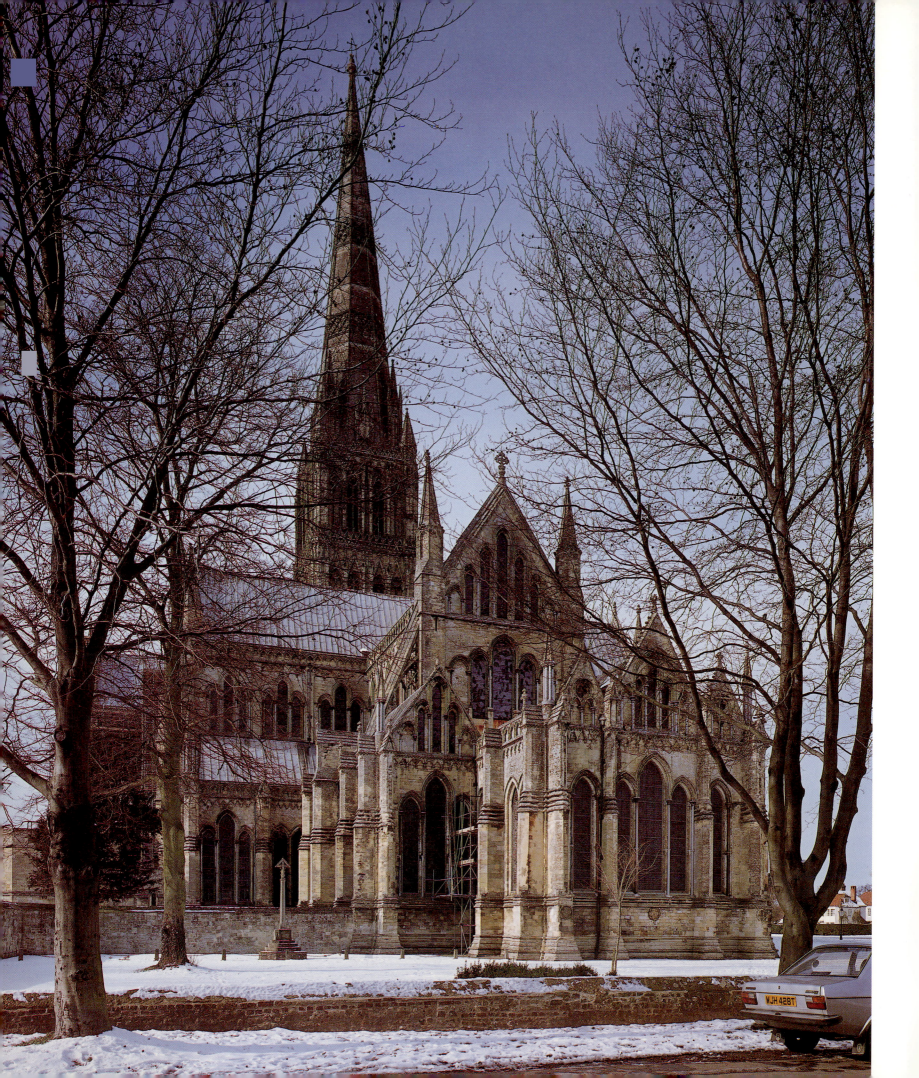

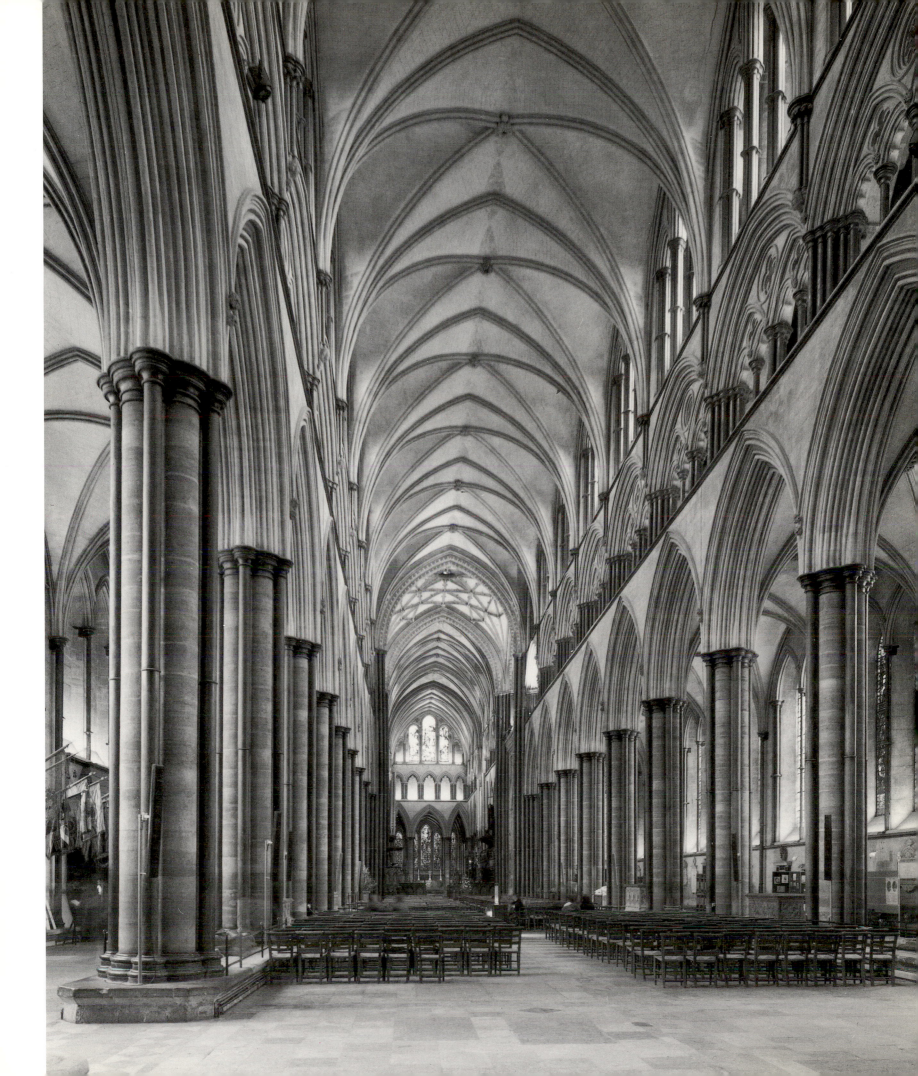

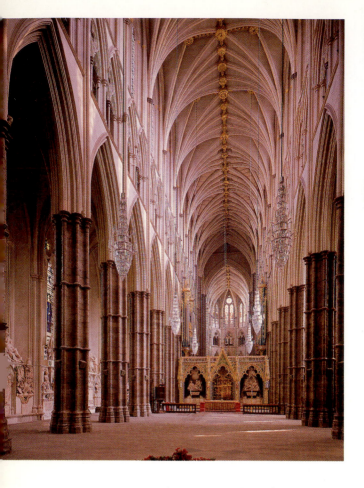

130. Henry III's ambitious rebuilding of Westminster Abbey – a major preoccupation of the king through much of his long reign – was the fount of the English Decorated style.

131. Giles of Bridport (d. 1262), was bishop of Salisbury at the time of the consecration. His monument is among the earliest examples of a provincial change to Decorated, influenced by the royal works at Westminster.

132. The great cloister at Salisbury, begun by Bishop Walter de la Wyle in *c*.1270, was a characteristic extravagance, unnecessary in a secular cathedral.

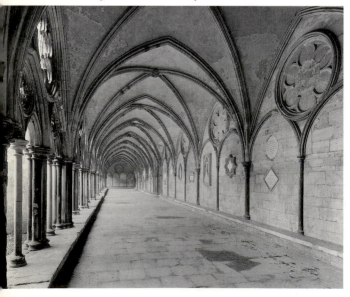

exploited increasingly successfully through the century, provided the revenues which made a builder of every bishop of the period. Whatever the cost, building held few terrors for such men. Walter de la Wyle and Robert Wickhampton turned to Decorated as if to an opiate. When most generally adopted from the 1290s to the 1340s, Decorated – costliest of English building styles – mirrored the prosperity of almost every great landowner in the last decades preceding the Black Death.

No great building project of this extravagant half-century was more consistently pursued by the bishops themselves than the remodelling of Exeter Cathedral. One of those remembered especially by contemporaries for his generosity to Exeter was Bishop Peter Quinel (1280–91), said to have met the greater part of building costs out of personal funds and to have left further subsidies in his will. In 1300, in recognition of Quinel's generosity *tam inter vivos quam in ultima voluntate*, a special obit was established in his name.[109] Yet it had been Bishop Quinel's predecessor, Bishop Walter Bronescombe (1258–80), who had started the rebuilding with a new Lady Chapel (modelled on Salisbury's) in the 1270s. And the full extent of episcopal support becomes obvious only after 1299, in the fabric rolls surviving from that date. What these record is that it was the bishops, unquestionably, who bore the brunt of the building costs. It was their regular annual subsidy, set at £124 18s 8d in the time of Thomas Bitton (1292–1307), which guaranteed continuity in the works. To this sum, the dean and chapter added half as much again in a charge against the revenues of their prebends. A similar figure, gathered in from many sources, raised the annual total to about £250. It included testamentary bequests and the alms of pilgrims, but depended chiefly on the bishop as fund-raiser: assigning Whitsuntide offerings to the fabric fund, publishing indulgences in aid of the cathedral works, and collecting subsidies from the clergy of the diocese.[110]

The concentration of the Exeter works, both in time and in patronage, might

have led in other circumstances to economies. Yet while building was in progress there from the 1270s to the 1340s, there is nothing to suggest any parsimony. It is true that Bishop Grandisson (1327–69) complained of personal poverty shortly after his elevation to the episcopacy. Yet it was in Grandisson's time that Exeter's nave was completed. And he himself had had the benefit of Bishop Stapledon's generosity in assigning 1000 marks (£666 13s 4d) to the works. Stapledon (1308–26), who was Edward II's treasurer in the 1320s, was a man of great personal wealth. It was he who commissioned Exeter's huge episcopal throne, built at his own expense in 1313–19 and rising 60 feet towards the vault.[111] Stapledon's carved oak throne, with the distinctive sixteen-shafted 'Exeter pillar' of Quinel and his successors, are Exeter's badges of excellence. They are complemented by the rich and complex carving of the cathedral's vaulting bosses, and by the multi-ordered arches of its arcades. In a single-period building otherwise no less unified than Salisbury, patterns in window traceries are varied and inventive, in a manner far removed from earlier times

133. The huge scale of Bishops Cannings Church is another demonstration of the wealth of Salisbury's thirteenth-century bishops, contemporaneously at work on their cathedral.

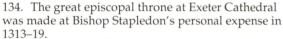

135. Multi-shafted 'Exeter pillars' in the nave of Exeter Cathedral.

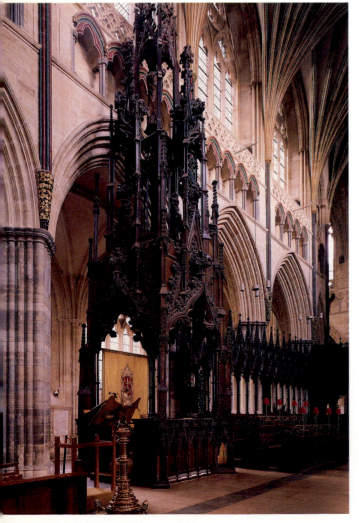

134. The great episcopal throne at Exeter Cathedral was made at Bishop Stapledon's personal expense in 1313–19.

Exeter's splendour might have been greater still but for the comparative poverty of its relics. It was not that the cathedral had unimportant relics; indeed, its collection was the finest in the region. It included (with much else) splinters of the True Cross, a finger of St Mary Magdalene, hairs from the head of the Virgin Mary, and four of St Agatha's teeth. Well into the fifteenth century, when it became the focus of the cult of Bishop Lacey (d.1455), it was still adding treasures to this assemblage.[112] But no individual relic at Exeter attracted the popular following of the Rood of Bromholm, the Holy Blood of Hailes, the Holy House at Walsingham, the uncorrupted body of St Cuthbert at Durham, or Glasgow's shrine of St Kentigern, known as Mungo. Skilful exploitation of just one such relic could transform the fortunes of its custodians. Bromholm initially was a small Cluniac community, a dependency of the Warenne priory at Castle Acre. Yet it came to enjoy great prosperity during the first half of the thirteenth century, following the monks' acquisition of a True Cross relic, formerly a treasure of the Byzantine emperors. It was in 1226 that Henry III, later a frequent visitor, first came to Bromholm. Before that, his chancellor, Richard Marsh (bishop of Durham 1217–26), had shown his devotion to the Bromholm Rood by a handsome contribution to the church. At that time, Ralph of Coggeshall tells us, 'a new and beautiful building arose' in place of its tumbledown predecessor. The priory's independence was assured.[113]

Ralph of Coggeshall was himself a monk: a Cistercian abbot in his time. He knew a profitable relic when he saw one. Yet there had been those already, well before he wrote, who recognized the dangers of such cults. Guibert de Nogent, discussing *The Relics of the Saints* a full century before, told a true story ('I was there myself at the time') about a relic of dubious worth – 'some bread which the Lord bit with his very own teeth'. His support had been called upon, as a learned bystander, to authenticate the claims of the fund-raiser. 'I must admit,' says Guibert, 'I blushed to hear it, and had I not been afraid that, in the presence of his sponsors, it would have been taken as a rebuke to them rather than the speaker, I would have had to denounce him as a forger.'[114]

Relic-collecting, both art and profession, became tainted inevitably with fraud. Thus Glastonbury's monks, ill-pleased with what they had, turned to archaeology for better fortune. First, they rediscovered the body of St Dunstan, a former abbot also claimed by Canterbury. And then, behind the curtains which screened their excavations, they came upon the coffins of King Arthur and Queen Guinevere.[115] The occasion for these researches, immensely profitable in later times, was the rebuilding after the fire of 1184. That catastrophe, it was claimed, had left earlier relics fortuitously unharmed.

> No place you can walk lacks relics of the blessed – the paving stones, the areas beside and above the high altar, the very altar itself, are full of relics. No wonder the resting place of so many saints is called a celestial sanctuary on earth! How happy are those, dear Lord, whose lives are changed for the better by this holy place! None can fail of salvation who has the favour and intercession of such saints![116]

Salvation through intercession was vigorously pursued. Reading Abbey's relic collections were so extensive, calling upon the protection of such an army of saints, that even the expert Dr London, required to catalogue them in 1538, had to confess himself defeated. With Reading's chief relic, the hand of St James the Apostle, and some other remains worth recording individually, Dr London noted: 'There be a multitude of small bones, laces, stones and arms, which would occupy four sheets of paper to make particularly an inventory of every part thereof.'[117] This multitude had been assembled over many years, as Reading's monks laboured tirelessly to keep their collections and their intercessors up to

116

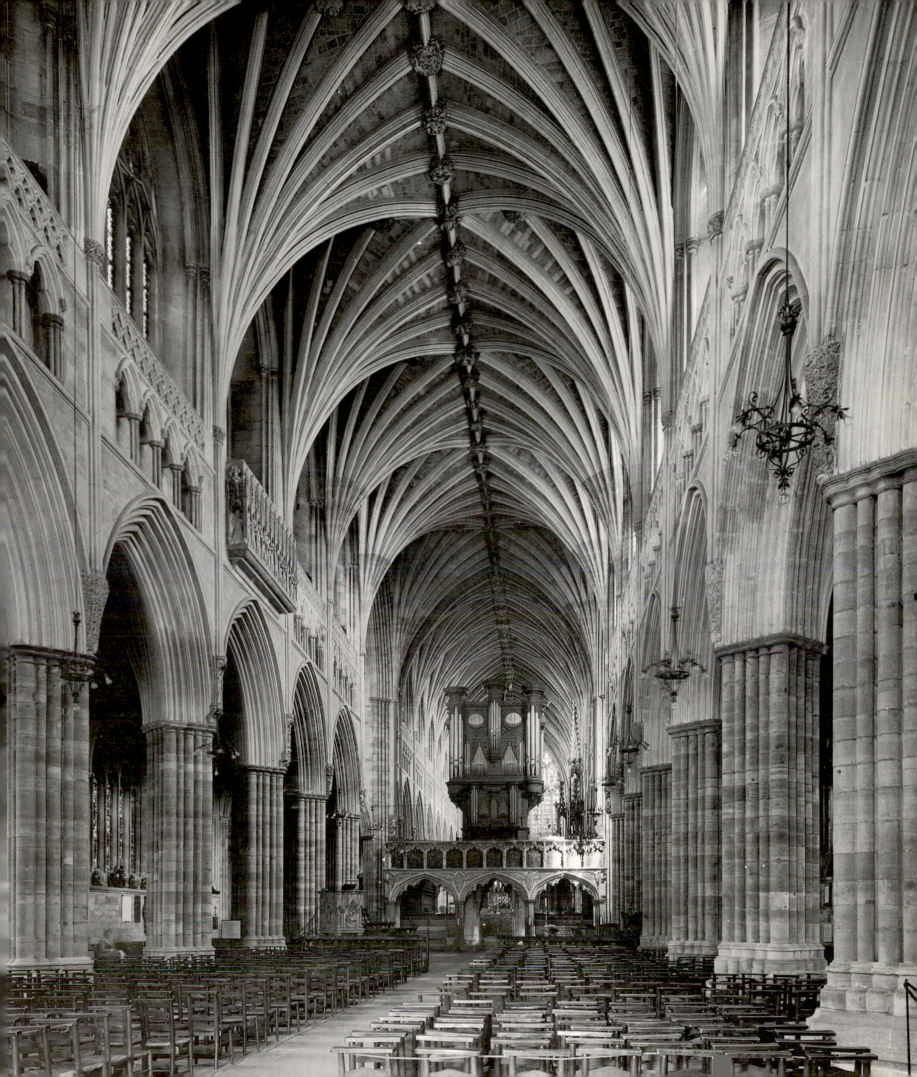

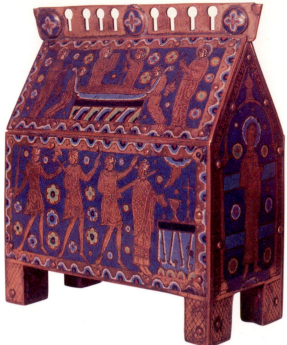

date. It included substantial relics of Becket the Martyr, also venerated at Hereford and best remembered of the post-Conquest saints.[118]

Contemporary saints like Thomas Becket (d.1170), archbishop of Canterbury, and Hugh of Avalon (d.1200), bishop of Lincoln, could confer important benefits on their communities. Canterbury's choir, burnt down by the 'just but occult judgement of God' on 5 September 1174, owed the speed, cost and scale of its immediate rebuilding to the high fashion of the murdered prelate's shrine.[119] At Lincoln Cathedral, the lavish Angel Choir, rebuilt between 1256 and 1280, became the costliest of reliquaries for St Hugh.[120] Once that holy man himself had been a notorious collector, undeterred by the grisliest of cadavers. He preserved 'with great devotion' a sinew from the arm of St Oswald (chief among Peterborough's relics) which he had drawn from the 'still bloody' flesh of the martyr. At Meulan, we are told, Hugh 'came to the shrine of St Nicasius, where, having prayed with deep devotion and made an offering of gold, he acquired a large bone, which he removed with his own hands from the head. This acquisition

136. This early thirteenth-century enamel reliquary of Thomas Becket (d. 1170) is one of the treasures of Hereford Cathedral. The archbishop's martyrdom is depicted on the front panel of the reliquary; his burial is shown on the lid.
137. The Angel Choir at Lincoln, rebuilt between 1256 and 1280 to hold the miracle-working Shrine of St Hugh's Head.
138. Abbot Roger's new presbytery, laid out on a hugely enlarged scale in the 1220s, owed much to the successful promotion of the cult of St Hilda (d. 680), Whitby's founder and patron.

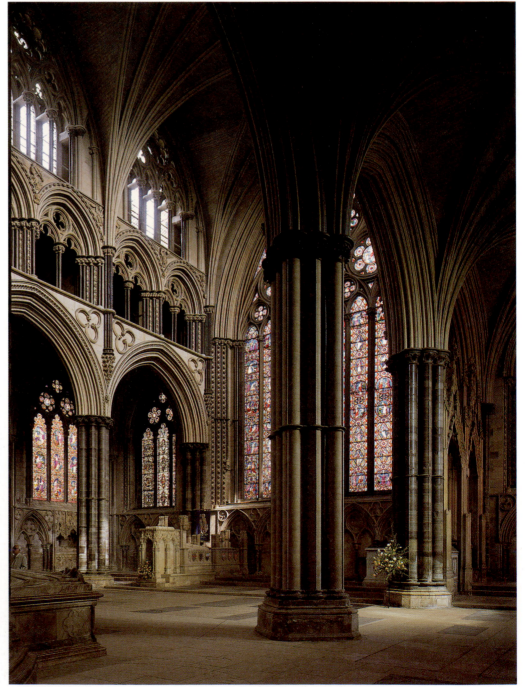

caused him immense joy.' From Fleury, he secured a tooth of St Benedict, founder of Western monasticism, which 'he frequently kissed . . . with deep devotion before having it placed in his ring'. At Fécamp, unabashed, Hugh 'extracted by biting two small fragments of the bone of the arm of the most blessed lover of Christ, Mary Magdalen'. 'What terrible profanity!', cried the abbot and his monks. 'We thought that the bishop had asked to see this holy and venerable relic for reasons of devotion, and he has stuck his teeth into it and gnawed it as if he were a dog.'[121]

Rebuildings associated with successful cults became common in thirteenth-century Britain. Lincoln's cathedral clergy, just before starting on their Angel Choir, had taken the precaution of preparing a sepulchre for their late bishop, Robert Grosseteste (1235–53), which could equally have done duty as a shrine.[122] In the event, the cult of Bishop Grosseteste was a failure. But other comparable celebrations – not necessarily of the recent dead – did much better. Lincoln's eastward extension into the Angel Choir had been modelled on Bishop North-wold's new presbytery at Ely Cathedral, accommodating the shrine of St Etheldreda (d.679). And Northwold, at Ely, may have taken his example from the slightly earlier enlargement of the east end at Whitby, rebuilt in the 1220s for St Hilda (d.680).[123] Each cult, once established, attracted the offerings of pilgrims – at Oxford, St Frideswide; at Winchester, St Swithin; at Salisbury, St Oswald; at Westminster, St Edward; at Glasgow, St Mungo; at Cashel, St Patrick; at St David's, its eponymous saint. Among the more successful of the later cults was that of Thomas Cantilupe, bishop of Hereford (1275–82), diligently promoted by his successor, Bishop Swinfield (1283–1317). A chancel window at Credenhill (Herefordshire), showing Thomas of Hereford in the company of Thomas of Canterbury (the established saint), may have been one of the elements in this promotion.[124] Certainly miracles at Cantilupe's shrine in Hereford Cathedral began just as soon as it was completed. The shrine, dating to 1287, is still there. Cantilupe had been provincial grand master of the military order of Knights Templar. Against his tomb-chest, armed Templars attend him in his sleep.[125]

Cantilupe's shrine, unlike a more conventional tomb, was given space in the comparative isolation of the north transept. Appellants were accustomed to speak their minds; they raised a public clamour to the saint. Provision had to be made for them accordingly. William of Melrose, a Cistercian abbot, is on record as being fearful of such disturbances. But his reluctance to promote St Waltheof (d.1159), his predecessor, was set aside by the community he led.[126] In the following century, Cistercian houses were just as ready as any other to exploit a relic. Hailes Abbey, in Gloucestershire, is a case in point. Founded from Beaulieu in 1246, Hailes was a late recruit to the Cistercian Order. It took time, even under the patronage of the wealthy earl of Cornwall, to settle down. Burdened with debts in the late 1260s, its fortunes suddenly improved. It was in 1270 that Edmund of Almaine, the founder's son and heir, gave the abbey a costly and re-markable relic. It was a phial of the Holy Blood of Christ, bought from the Count of Flanders in 1267 and authenticated by the Patriarch of Jerusalem. Before this relic, Margery Kempe one day would kneel, with 'loud cries and boisterous weepings'.[127] And for her and her like, the east end of the abbey church was transformed. Beyond the high altar, with outside access of its own, the Holy Blood shrine was centrally placed within a *corona* of radiating chapels. Cry as loudly as she might, and weep as boisterously as she wished, Margery Kempe left the community of Cistercians undisturbed.[128]

Hailes was a royal house and the Holy Blood a princely gift which continued to bring profit to the abbey. When Edward I, in undisguised rivalry with his uncle's Hailes and with his grandfather's Beaulieu, founded a Cistercian com-munity of his own at Vale Royal in the 1270s, he similarly turned to relics for its endowment. Edward had fought in the Holy Land before his accession, and there

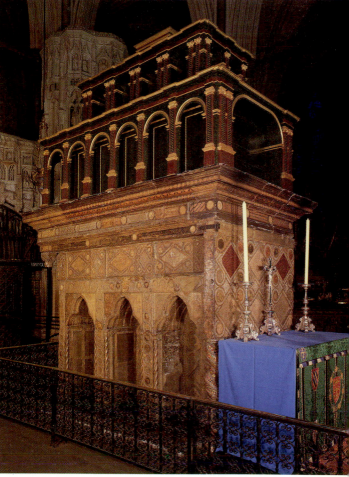

139. Henry III's personal cult of Edward the Confessor (d. 1066) was the occasion for his rebuilding of Westminster Abbey. St Edward's shrine base, which survives, was made by Peter of Rome in the expensive marble mosaic technique known as Cosmati work, shortly before Henry's death in 1272. It carried a precious casket of gold and jewels, lost at the Reformation. The present timber superstructure is a Marian substitute of 1557.

140. Bishop Thomas Cantilupe's shrine base (1287) at Hereford Cathedral, with armed Templars under the arches against the tomb-chest.

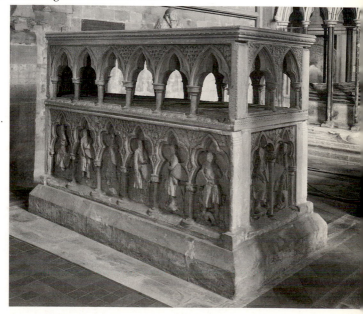

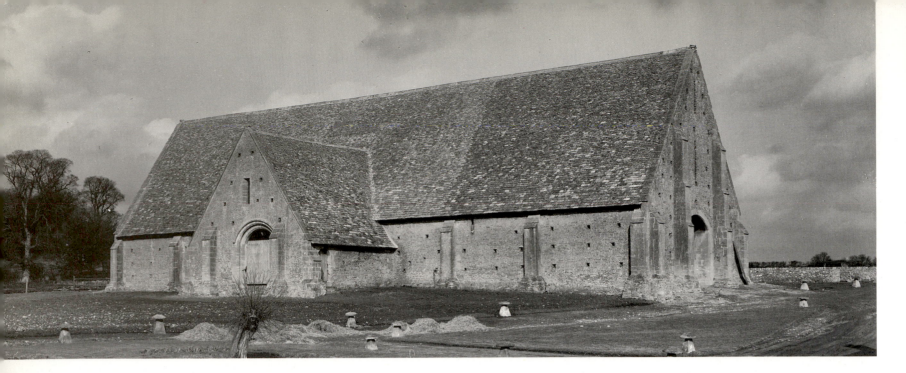

141. The stone barn at Great Coxwell (Berkshire), datable to the late thirteenth or early fourteenth centuries, was built by the Cistercians of Beaulieu, in Hampshire, to hold the produce of their distant demesnes.

came to the place where was kept the wood of the cross on which the Saviour of the world was hung; and he violently carried off with great joy a beautiful piece of it, which he brought back with him to England with much rejoicing. By virtue thereof he overcame all those who rose up against him on all sides so utterly that there was none like unto him of the kings of all the world . . . This most sacred portion of the Holy Cross he gave with great devoutness to the Abbey [Vale Royal] at its first foundation, so that it might strike terror into its persecutors and confer the gift of eternal life on those living holy lives. And besides this most precious jewel the devout King sought everywhere for relics of the saints canonically approved, and most graciously conferred them on his monastery.[129]

If Edward's fragment of the True Cross worked miracles for Vale Royal, none were recorded in its Ledger Book. Furthermore, the king soon lost interest in the works he had begun, and having set a scale of impossible grandeur, withdrew all support in 1290. In 1336, the abbot could still complain:

We have a very large church commenced by the King of England at our first foundation, but by no means finished. For at the beginning he built the stone walls, but the vaults remain to be erected together with the roof and the glass and the other ornaments. Moreover the cloister, chapter-house, dormitory, refectory and other monastic offices still remain to be built in proportion to the church; and for the accomplishment of this the revenues of our house are insufficient.[130]

Yet Vale Royal was a rich house, even by the standards of a wealthy Order, and the king's indifference was not the only reason for its difficulties. In sum, Edward's great project – 'one of the largest works of piety ever undertaken by a medieval English king'[131] – had come to fruition far too late.

What Vale Royal lacked was the continuing support of lesser patrons and the scope to develop its estates. Beaulieu, King John's foundation of 1203–4, offers a significant contrast. On Beaulieu's former estates to this day, there are two remarkable survivals. At Beaulieu-St Leonards (close to the abbey) and at Great Coxwell (on Beaulieu's Berkshire holdings), huge stone barns of formidable size and quality recall a period of exceptional prosperity.[132] Both date to the thirteenth century, and both belong to that episode of monastic high farming which, at about the time of Vale Royal's greatest difficulties, was already approaching its end. The Beaulieu barns, moreover, have their parallels. Contemporary stone

142. The interior of the nuns of Shaftesbury's barn on their Bradford-on-Avon estate.

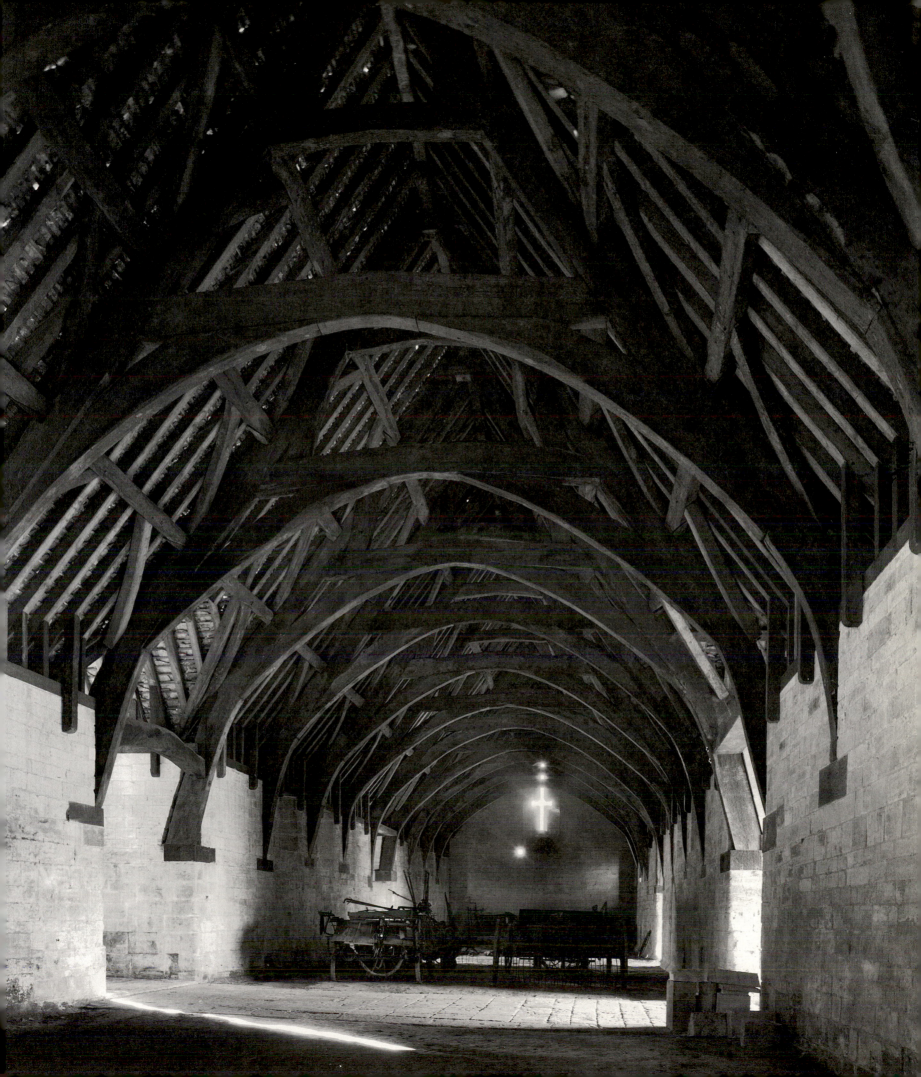

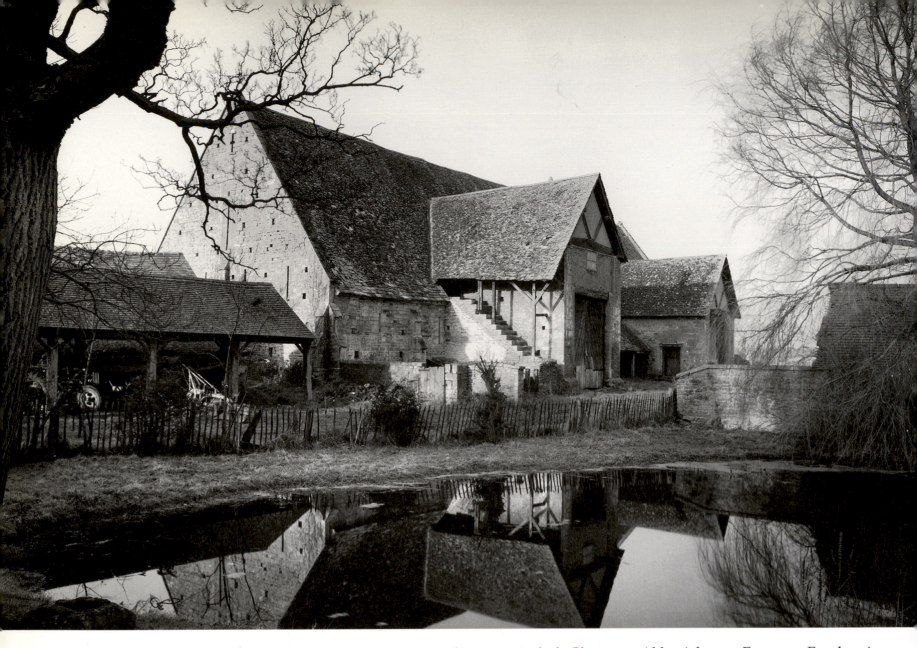

143. Bredon was an important rectorial manor of the bishops of Worcester, whose barn dates to c.1350; over the south-east porch, the custodian's chamber had its own fireplace, privy and outer stair.

barns, again of vast size, include Gloucester Abbey's barn at Frocester; Evesham's at Middle Littleton; Tewkesbury's at Stanway; the bishop of Worcester's barn at Bredon; and Shaftesbury's great barn at Bradford-on-Avon, recently shown to have been one of a pair.[133] Timber barns, too, have survived in sufficient quantity to suggest that they were once very plentiful. Leigh in Worcestershire, formerly of Pershore Abbey, is among the finest of these, datable to about 1300. Even when Leigh was built, timbers of the required size and number for a barn of this size would have been difficult to find. And the great oak crucks of the Pershore barn were evidently not chosen for their economy.[134] Similarly costly were the Templar barns at Cressing Temple (Essex), and the huge aisled barns on the Kentish demesnes of Christ Church and St Augustine's, Canterbury.[135]

Demesne barns of this kind are important material evidence of agricultural surpluses, bringing building within reach of many landowners. How those surpluses were achieved in thirteenth-century Britain has now been minutely explored.[136] They were the product of improved farming methods and more methodical accounting; of abundant cheap labour and fair weather. In the thirteenth century, as never before, income and expectations coincided. At Abingdon Abbey, little remains today of one of the wealthiest of Benedictine communities. Yet what there is includes a building of particular interest. Dating to the thirteenth century, it is of two storeys, with a single great chamber, well-lit and heated by a fireplace of its own, over a costly vaulted undercroft. This comfort-

122

able apartment, now identified as the Checker (or counting-house) of the abbey, was once the administrative focus of the community. Professional officials, more expert by the day, required to be suitably housed.[137]

Both the innovatory expertise of these monastic administrators and the real profitability of thirteenth-century demesne farming have been questioned.[138] Nevertheless, there is no denying the bulk of new building in this period, nor the accent placed everywhere on quality. One of many contemporary building projects in thirteenth-century England, exceeding in ambition even those of the previous century, was the completion of the priory church at Newstead. A new north aisle had been added to the church in about 1250. Before 1300, the work was finished off with an especially handsome west front. The front is symmetrical, with a big central window over an elegant west portal and with matching blind tracery to north and south. Approached from the west, it is as if there had been a nave and flanking aisles. Yet Newstead's church never had a south aisle, and the facade to right of centre is a dummy. However impractical and whatever the cost, the canons of Newstead put beauty first, giving priority to aesthetics.[139]

Similar priorities show up in other places. When the nuns of Caen remodelled the chancel of their Gloucestershire church at Avening, they could as easily have chosen to demolish the existing work and to start (as so often happened) over again. Instead they kept the Norman bay, adding another of identical dimensions. The vaulting, in particular, was continued with great skill, in an extension of the utmost sensitivity.[140] On a much grander scale, the spectacular strainer arches at Wells Cathedral, inserted in the 1320s to strengthen the crossing, have an elegance unrelated to engineering. Their source is almost certainly Bristol Abbey, where the bridge-like supports of the chancel-aisle vaulting, completed a decade earlier, set new standards of artistic excellence in the South.[141]

Excellence in the arts comes expensive. But projections were favourable; the mood was optimistic; there is little evidence anywhere of economy. Monks and nuns, in communities of all sizes, mortgaged their future in major works. Dunstable Priory, like many of its contemporaries, was rarely without builders on site. And it was the high cost of these, together with the king's taxes, which brought about deliberate retrenchment in the 1290s. At Michaelmas 1294, as part

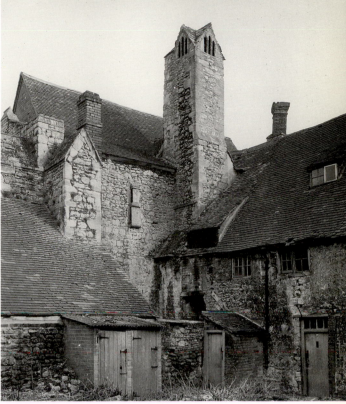

144. The Checker at Abingdon: the abbey's spacious counting-house was heated by a great fireplace which still retains its thirteenth-century chimney.

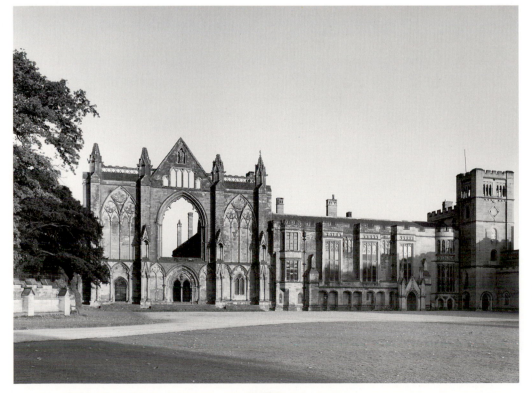

146. (following page) These strainer arches, inserted in the 1320s to strengthen the crossing at Wells Cathedral, are among the supreme aesthetic achievements of medieval church architecture.

145. So anxious were Newstead's canons to preserve the symmetry of their church-front that they built a dummy facade to the right of the central portal, false-fronting a missing south aisle.

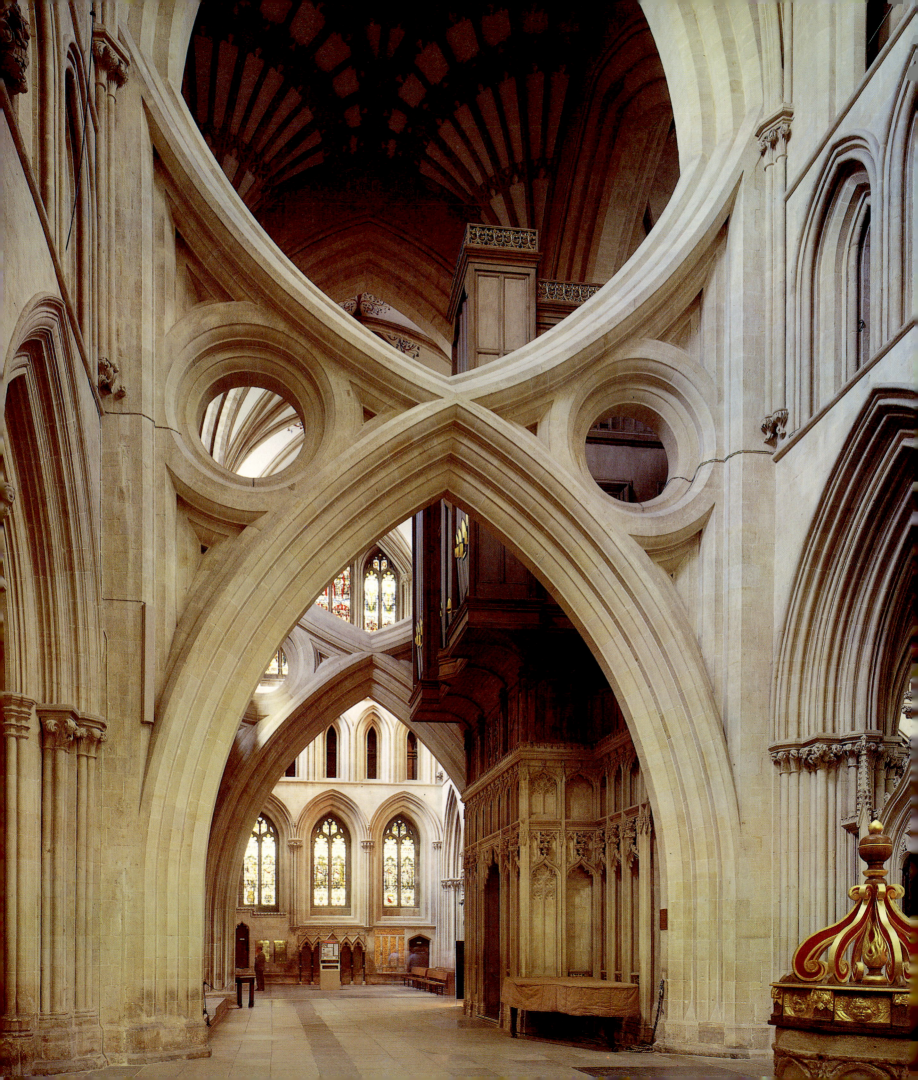

of this programme, tithes were leased, corrodies were sold, and commons were limited:

> we decided that one portion of conventual dishes of every kind should be set before two brothers. Of the other economies made at that time, as regards the number of dishes in the convent, as regards the almonry, the reception of guests, and the management of the household, you will find the particulars entered in the old book of obits [since lost].[142]

Yet Dunstable's canons never starved, and the survival record of monastic communities remained outstandingly good. True, individual religious houses, like Dunstable itself, occasionally ran into difficulties. The nuns, especially, were often muddled and in trouble, causing their advisers grave anxiety. Polsloe was a Benedictine nunnery of modest affluence, far from the poorest of its order. However, the total remodelling of Polsloe's claustral ranges, undertaken in the early fourteenth century, could not have failed to impose strains on its revenues. Bishop Stapledon of Exeter, no mean expert in such matters, proffered the most basic of advice. Bi-annual accounts were to be required from 'all your bailiffs, reeves and receivers'; the rolls of the accounts were to be kept in the common treasury 'so that they may be consulted, if need shall arise by reason of the death of a Prioress, or of the death or removal of bailiffs, receivers or reeves'; every year, the prioress was to compile and present a full statement of Polsloe's finances – 'And all these things are to be put in writing and placed in the common treasury, to the intent that it may be seen each year how your goods increase or decrease.'[143]

The nuns were not the only ones to get it wrong. The monks of Pontefract and Selby, both similarly engaged in building programmes at this time, fell deeply (if temporarily) into debt.[144] And there is no better evidence of an aborted building scheme than the ambitious remodelling of Kirkham Priory, frozen barely midway towards completion.[145] However, the stories of success outweigh the failures. It was during the thirteenth and early fourteenth centuries that the choirs, for example, of Abbey Dore and Sawley, Boxgrove and Waverley, Bayham, Carlisle, Tynemouth, Whitby, Hexham, Guisborough, St Radegund's (Cambridge) and St Mary's (York) were rebuilt; that new naves, or west fronts, were completed at Jedburgh and Bridlington, Bolton and Lanercost, Binham, Crowland and Peterborough; that fine chapter-houses were supplied at Worcester and Lincoln, Westminster and Margam, Basingwerk and Chester, Cockersand, Furness and Dundrennan; that Cambuskenneth got its tower and Easby its refectory; and that entire new abbeys were built at Beaulieu, Netley and Titchfield, Balmerino, Sweetheart and Culross, Kells, Cong and Ballintubber.

Such lists are almost infinitely extendible. They establish the strength of the contemporary building boom, and make it difficult to accept that 'bleaker interpretation' of the thirteenth-century economy, which in truth applies chiefly to the landless.[146] Inevitably there were victims of the system. And one obvious consequence of the monks' success was the turning of the tenantry against their lords. But that success is itself not in doubt. It rubbed off on others in all sorts of places, not least on the appropriated parish churches. Caen's high-quality extension of the chancel at Avening was no isolated gesture of benevolence. Parish churches everywhere were undergoing transformations, grander and costlier than before. No revolution of religious sentiment had brought this about: the parishioners had yet to take charge. The parish church, like the tithe-barn, was a material asset on which the monks saw little purpose in economizing.

The monks, as appropriators, have received a bad press. In the Later Middle Ages, squeezed by falling revenues, their neglect of parish churches became notorious.[147] Sometimes, indeed, this had been true of earlier years, causing many bishops, even before the recession, to view appropriations with mistrust.

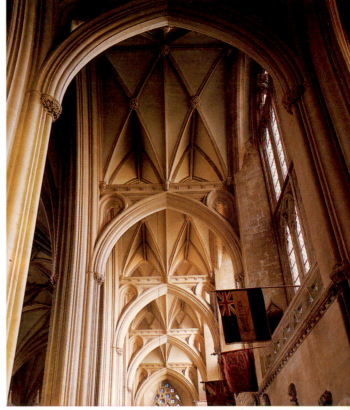

147. The source of the Wells strainer arches was probably this fine vaulting in the south chancel aisle at Bristol Abbey (now the cathedral), datable to the early fourteenth century.

148. The decagonal chapter-house at Lincoln Cathedral was one of many such polygonal chapter-houses rebuilt regardless of cost, at a time of unprecedented prosperity.

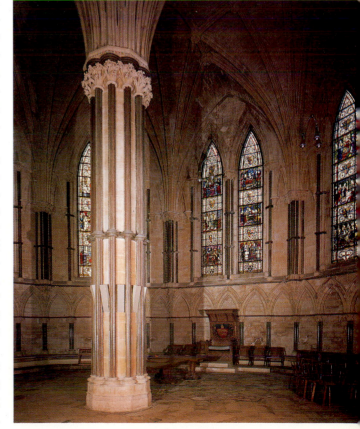

149. Easby, in North Yorkshire, although never a rich abbey, underwent an extensive rebuilding in the early fourteenth century, including this huge new refectory.

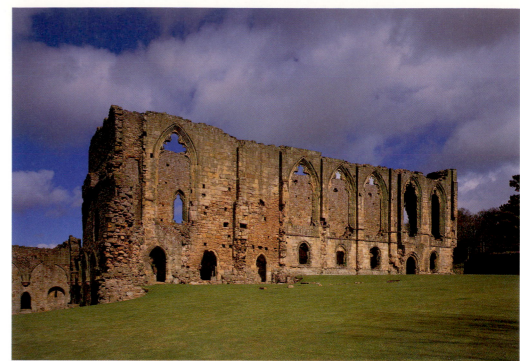

150. Sweetheart Abbey was Scotland's last Cistercian foundation, built by a wealthy widow, Devorgilla, in memory of her late husband, John Balliol (d. 1269).

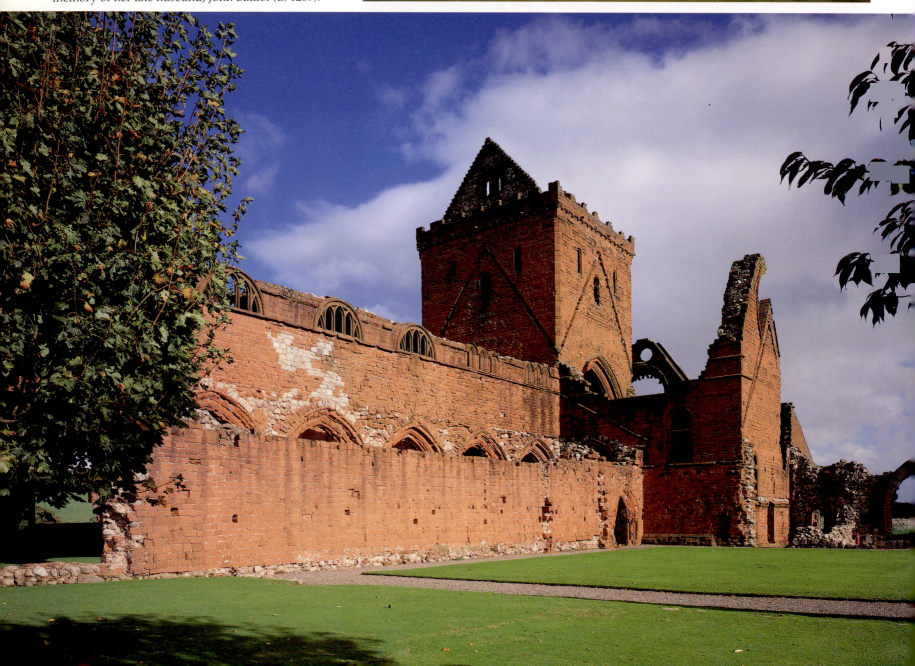

'An experience of nearly twenty-three years,' wrote Bishop Swinfield of Hereford in 1305, 'has taught me that these appropriations are fraught with so many perils and losses both to the living and the dead, especially in my diocese, wherein the greater number of the parish churches have already been appropriated . . . that I cannot now rehearse them to your Excellency [Edward I] in this present letter'.[148] Outright appropriation of a church and its revenues took more out of a parish than it gave back. Yet that practice – 'absolutely odious,' Bishop Sutton said, 'to all the prelates of the church' – had its spin-off while the monks remained in funds. By custom, repairs to the chancel were a charge on the rector; the parishioners looked after the nave. Before 1350, it was the chancels especially which were most frequently remodelled. From 1350 until the Reformation, it was the naves.

One cause of such remodellings was an increasingly sophisticated liturgy, requiring more space and better equipment in the chancel. Arcane rituals, necessarily restricted to a specialized and better educated parish clergy, began to be conducted behind screens. Probably the earliest of such screens is the fragment at Kirkstead (plate 106), a Cistercian *capella ante portas* entirely rebuilt in the 1230s. But there is another similar timber screen, no later than the mid-century, in the big contemporary chancel at Stanton Harcourt Church, in Oxfordshire. And a third screen (of stone) was an integral part of an even grander chancel reconstruction at the Kentish Westwell.[149] From the fourteenth century, no chancel would be complete without its rood screen. Nor would it be fully furnished without piscina and sedilia, without aumbries or (for many) an Easter sepulchre. Bishop Quinel of Exeter (1280–91) was prominent among those who tried to ensure that this was so. Each church of his diocese, he was careful to provide, should have at least this minimum of equipment: a stone altar and a font; an image of the patron saint and another of the Virgin Mary; a chalice and ciborium; a pyx, chrismatory and censer; candlesticks and crosses, both fixed and processional, with adequate sets of vestments and sufficient books.[150]

Quinel's statutes return repeatedly to the problems of keeping chancels in repair. And there are indeed many documented instances of neglect. But one frequently voiced criticism of the chancels of Quinel's day was less that they were tumbledown than that they were 'dark and gloomy'. Goals were shifting, and an immediate consequence of the new beliefs was that the Anglo-Norman chancel, only recently installed, was already becoming out of date. Spacious new chancels, brilliantly lit, distinguished many thirteenth-century rebuildings. They occur, for example, at Faringdon and Climping, at Cherry Hinton, Cobham and Bishops Cannings. From Bamburgh to Alconbury, Bibury to Castor, Icomb to Stoke D'Abernon, Bosham to Ripple, Pillerton Hersey to Barton-le-Clay, chancels were remodelled and re-equipped. Each of these chancels is an Early English rebuilding of high quality. When the Decorated style reached the localities at Heckington (Lincolnshire) and elsewhere, rebuilding carried on as before. Some of the most sumptuous chancels of any date in England belong to the 1320s and 1330s. There would be none to compare with them until Pugin.

A few of these chancels, among them Dilwyn in Herefordshire, are well-documented monastic rebuildings.[151] Others were the gift of individual donors, whether wealthy career clergy or local landowners. All shared the characteristics of conspicuous display, pursued with scant regard to the cost. Probably the best known of these rebuildings are the lavishly sculptured chancels at Hawton (Nottinghamshire) and Navenby (Lincolnshire), within a few miles of each other across the county boundary. Both have the usual piscina and sedilia south of the high altar, but make equivalent display on the north wall also, with Easter sepulchre, founder's tomb and vestry door. Then there are the chancels, scarcely less fine, at Audley (Cheshire) and Madley (Herefordshire), at Cliffe (Kent) and Sparsholt (Berkshire), at Great Haseley (Oxfordshire) and Chaddesley Corbett

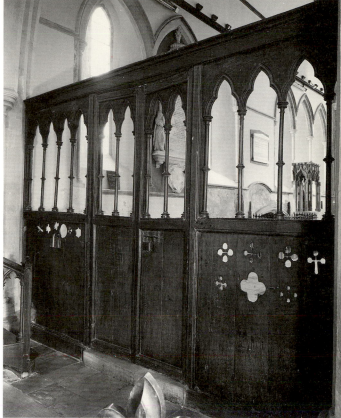

151. Stanton Harcourt's mid-thirteenth-century chancel screen is one of the earliest survivors of this type of church furnishing, increasingly common in the Late Middle Ages.

152. The thirteenth-century stone screen and vault at Westwell Church were part of an exceptionally grand chancel rebuilding.

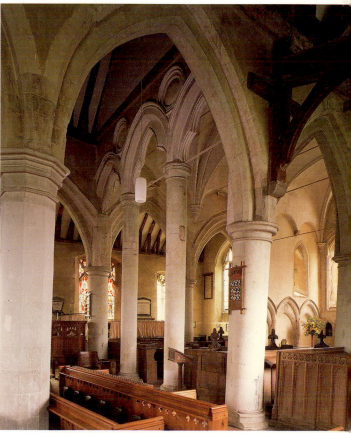

(Worcestershire), at Lawford (Essex) and many more. Of these, Lawford is the smallest. The church is remote and on its own. Yet the extravagance of Lawford's stone-carvings is particularly memorable – 'full of indomitable exuberance'.[152] Along with rich naturalistic foliage and inventive figure-carving, no two tracery patterns at Lawford are the same.

The lushness of Lawford sticks in the memory because of its comparative compression. However, its quality and exuberance have many parallels. In the same county, Maldon (All Saints) is especially notable for the richly ornate carvings of its fourteenth-century south aisle. In Leicestershire, Gaddesby's extraordinary show-front, at the west end of the south aisle, hints at its lavish interior. Both Cogges and Ducklington, neighbours in North Oxfordshire, have sumptuous extensions of the 1330s. These additions, in each case, almost certainly resulted from new chantries. But memorial foundations, important though they became, had only rarely been the cause of rebuildings. It was in the period 1250 to 1340, when population had climbed to its maximum, that Warwickshire's parish churches underwent their major expansion. Overall, as a recent study of these churches has shown, 'evidence for a rapid increase in the size of the naves and in the size and number of their aisles during the expansionist years of the

153. On Heckington's Easter sepulchre, soldiers sleep at the base as the three Maries (accompanied by an angel) attend the risen Christ. Other early fourteenth-century furnishings of this big Lincolnshire chancel include sedilia, piscina and founder's tomb.

154. The *c.*1320 south aisle of the parish church at Gaddesby shows the Decorated style at its most ornate.

thirteenth and fourteenth centuries, is as unequivocal as that for the cut-back in nave extension during the population decline of the later Middle Ages.'[153] That increase varied according to region. Existing parish churches, in Warwickshire's long-settled Feldon, absorbed the bulk of population growth in the extension of naves and their aisles. Arden, in contrast, had been colonized by new settlers, clearing the forest for their fields. Its churches were smaller than those of Feldon, but more numerous.[154]

In any one parish, special circumstances might account for a big church: a wealthy patron like the bishop of Ely at West Walton, near Wisbech, or the fleeting consequence of a port such as Hedon, on the Humber. But much depended, too, on the underlying health of the economy. West Walton, for one, is in the exceptionally fertile Norfolk Marshland.[155] Its immediate neighbours in the reclaimed silt fens included the similarly grand churches at Leverington, Walsoken and Walpole St Peter, with Whaplode and Holbeach, Gedney and Long Sutton, a little to the west in Elloe wapentake. From 1241, with the construction of the Common Dyke, Elloe's reclamation was complete. New settlements – at Whaplode Drove and Holbeach Drove, at Gedney Hill and Sutton St Edmund – brought further accretions to a siltland population already greatly swollen and enriched since 1086, when it was the uplands which enjoyed the advantage.[156] Whaplode Church, substantial enough on first building in the 1130s, was to be extended in the next generation. To the four bays of Whaplode's nave, three further bays were added just fifty years later, almost doubling the original floor area. At precisely this time, the parish church of Long Sutton was re-sited and rebuilt in stone, only to be enlarged in the following century, when its first church was encased in another. Holbeach took shape as a big urban church, entirely rebuilt in the fourteenth century. Gedney's aisles, exceptionally wide and spacious, were additions of the decades round about 1300, when the population of Elloe had reached a total not exceeded for another half-millennium.[157]

155. Whaplode's Early English tower was a costly thirteenth-century addition to a big silt-fen church rebuilt in the 1130s and extended some fifty years later.

156. Broad aisles were added to the nave at Gedney Church (Lincolnshire) in *c.*1300 to accommodate a growing congregation of wealthy fenlanders.

156. Broad aisles were added to the nave at Gedney Church (Lincolnshire) in *c.*1300 to accommodate a growing congregation of wealthy fenlanders.

157. Patrington Church, 'Queen of Holderness', is the most complete of all England's Decorated parish churches, entirely rebuilt in the early fourteenth century.

Hedon's hinterland, the plain of Holderness, was likewise a region of dense settlement.[158] Accordingly, Hedon's great church, so-called 'King of Holderness', has a matching 'Queen' at Patrington to the east, the swagger parish church of a vanished market town, once prospering under the patronage of the archbishops of York, and at its wealthiest in the early fourteenth century. Patrington is entirely of this period. It has the big chancel of its time, equipped with an Easter sepulchre (one of the best of its kind) and with other expensive furnishings, including a contemporary timber screen. Patrington's transepts were aisled; its nave was spacious; there was abundant accommodation for the townspeople.[159]

At just about the date that Patrington was rebuilt, the taxation (lay subsidy) returns of 1334 provide, for the first time, comprehensive data for a comparison of economies. Romney Marsh and its neighbouring Walland Marsh were more prosperous than they had ever been before: twice as well-off as the adjoining Kentish Weald, and the product, like Elloe and Holderness, of reclamations.[160] New Romney, in addition, was one of the Cinque Ports, as yet unaffected by river silting. Fortunate in every way, New Romney's parishioners found their church

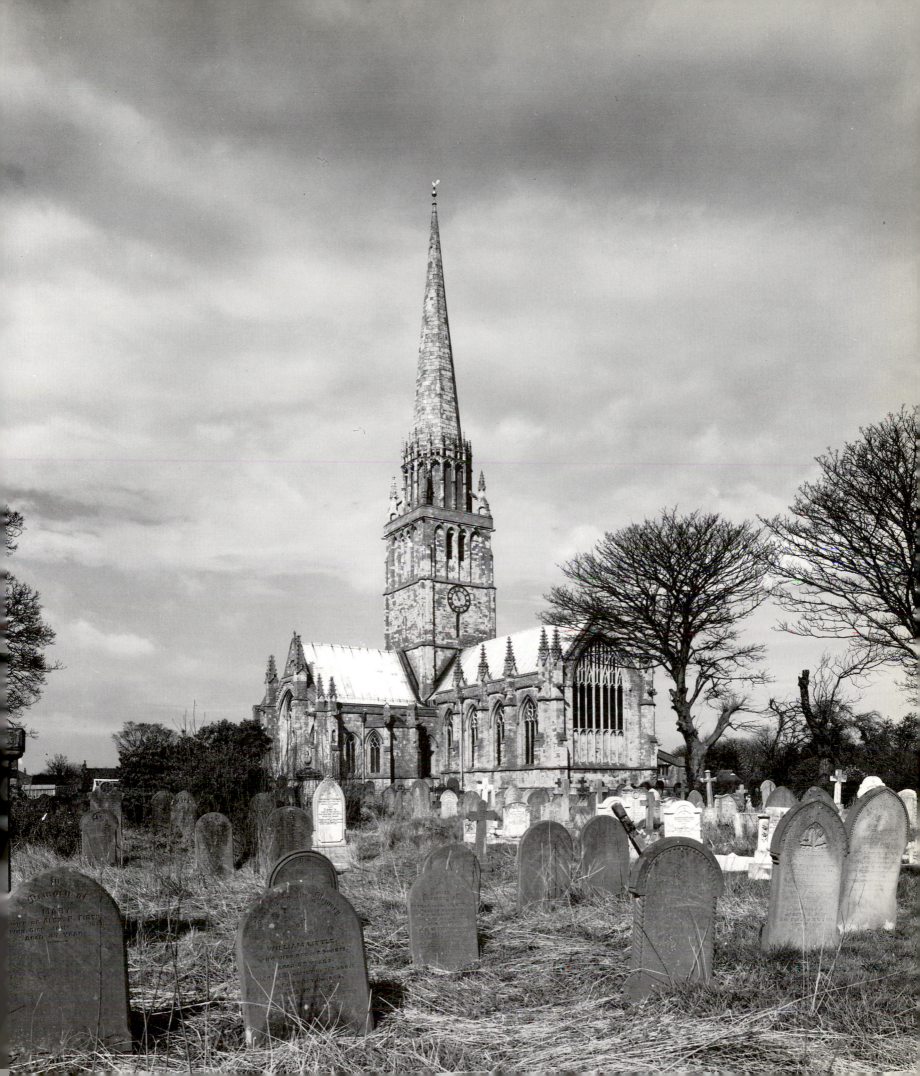

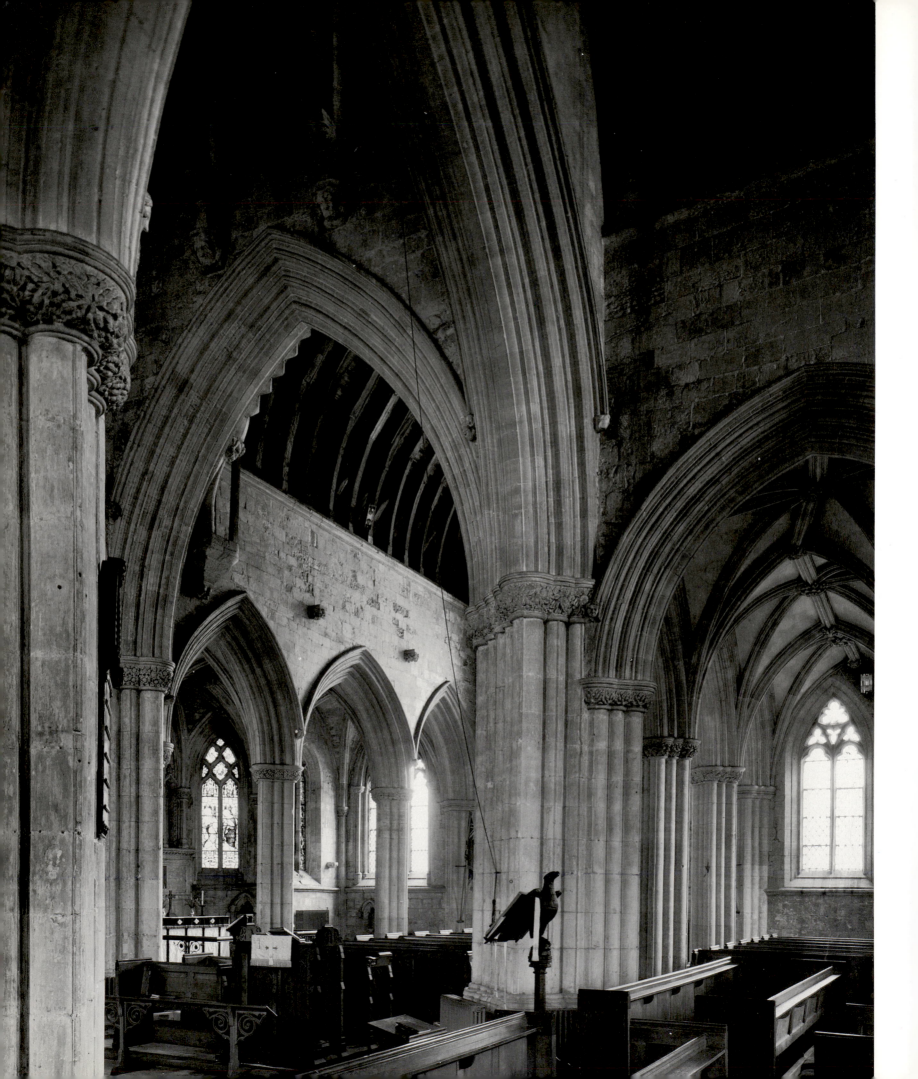

too small in the early 1300s, despite the magnificence of its twelfth-century reconstruction. They wrapped the Anglo-Norman building in a new set of aisles, hugely extending its east end.[161] In the rich surrounding marshland other churches underwent similar refashionings. Lydd is a big church, essentially of the thirteenth century, with a long nave and exceptionally broad aisles. St Mary in the Marsh, in the identical period, was equipped with a new chancel and wide nave. Ivychurch, a large building of the mid-fourteenth century, replaced another of like size. Brookland's nave, until early that century, grew steadily out towards the west.[162]

It was not only reclaimed marshlands that prospered. In 1334, a line of wealth can be drawn through England. From York in the north-east to Exeter in the south-west, it separates the relatively rich areas to the east of the line from the poor and disadvantaged to its west.[163] At this period, there were few parish churches of great consequence west of that line. To its east, in contrast, there were clusters of new churches – Ashbourne, Bakewell and Wirksworth in Derbyshire; Crick, Finedon and Kislingbury in Northamptonshire; Sleaford, Heckington and Grantham in Lincolnshire; Beeston, Hingham and Attleborough in Norfolk, with Snettisham and Cley-next-the-Sea.

One possible cause of contemporary expenditure on such churches may have been political necessity. After the Statute of Mortmain in 1279, limiting clerical investment in new estates, monastic appropriators had cash to spare, a good part of which, for some decades at least, might usefully be diverted into building.[164] No doubt a number of chancels at appropriated parish churches owed their renewal to this surplus. But the rebuilding of entire churches, equally character-istic of the period, required the cooperation of lay parishioners. A common extravagance of these times – and almost their symbol – was the addition to many churches of fine bell-towers. Earlier in the century, they had already been a feature of the great silt-fen churches at Whaplode and Long Sutton, Leverington, Walsoken and West Walton. And if few parish bell-towers ever matched West Walton's, most magnificent of this marshland assemblage, prestige steeples were everywhere in demand in the regions east of the wealth-line. Shortly before 1300, the neighbouring Huntingdon parishes of Buckworth and Alconbury were in evident tower-building competition. There was another fine steeple in the same locality at Warboys, while it was at this time also that Hallaton and Leighton Linslade acquired their steeples, that a west tower was added to Stamford (St Mary's), and that Ketton was given its lofty bell-stage.

Both Ketton and Stamford had spires added to their towers in the early fourteenth century. And it was the admonitory finger-to-heaven of churches such as these that distinguished most particularly a period of building confi-dence of which the *chef d'oeuvre* was the huge spire at Salisbury. Higham Ferrers in Northamptonshire, Grantham in Lincolnshire, Willingham in Cambridge-shire, Clifton Campville in Staffordshire, Exton and Gaddesby in Leicestershire, Repton and Ashbourne in Derbyshire – all have grand steeples of the early fourteenth century, which in context are as much prodigies as Salisbury's. Then the money ran out with the Black Death.

159. Competitive tower-building in the locality probably explains the splendour of this late thir-teenth-century steeple at Warboys Church.

158. Clustered piers and richly carved capitals were used throughout the church interior, this being a view into Patrington's south transept from the nave.

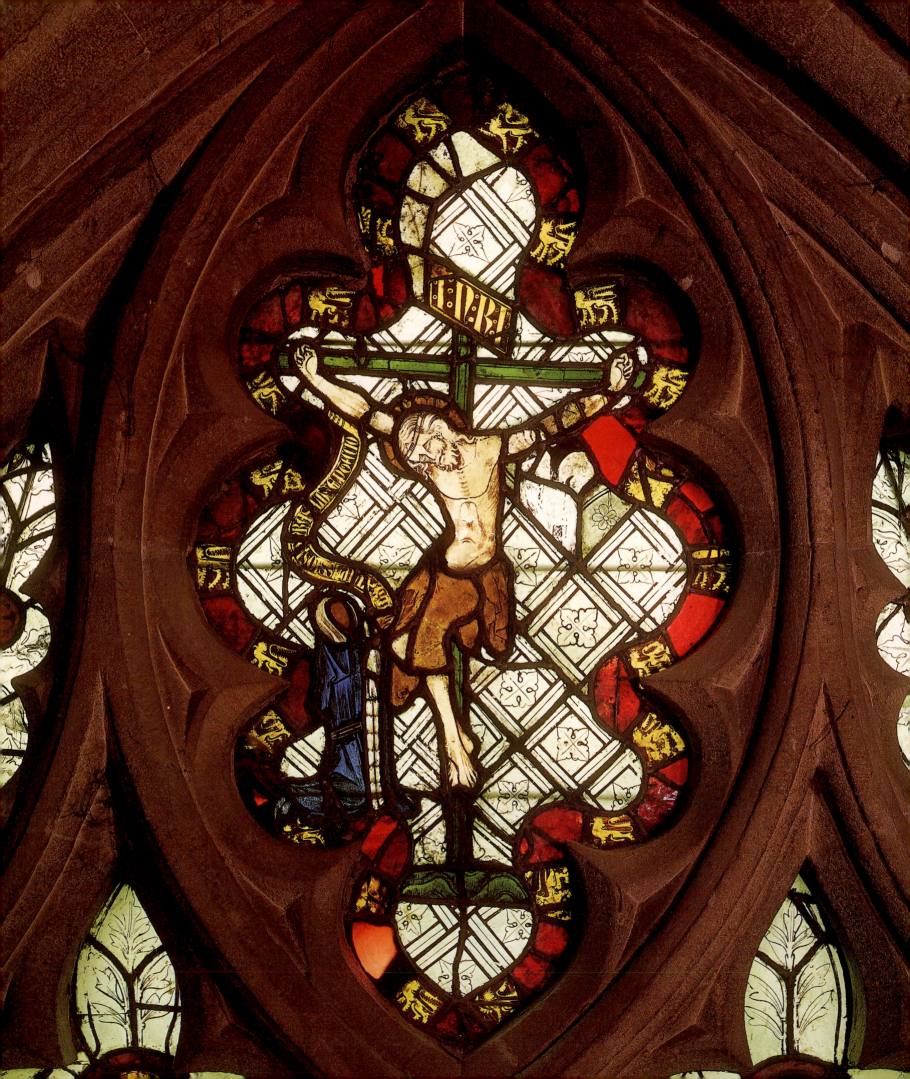

CHAPTER 5
A Rainy Country . . . Ripe with Death

The purpose of the Statute of Mortmain in 1279 had been to curb the permanent alienation of lands and other properties to the Church:

> no one at all, whether religious or anyone else, may presume to buy or sell any lands or tenements, or to receive them from anyone under the colour of gift or lease or any other title whatsoever, or to appropriate them to himself in any other way or by any device or subterfuge, so that they pass into mortmain in any way, under pain of forfeiture.[1]

The legislation was draconian, but it was not unexpected. Over the centuries, to a growing chorus of lay protest, something like a third of all lands and rents in the kingdom had come under the 'dead hand' of the Church. Furthermore, it was widely perceived that rights were being lost and that burdens were being distributed unfairly, 'for when religious houses enter upon property, they do nothing for the town, the heirs are reduced to poverty, and the city is deprived of young men for its defence in time of war'.[2] The city in question was Dublin in 1300, and already Mortmain's rigour had been compromised. From as early as 1280, the Crown had begun the new practice of licensing landed accessions to the Church. These licences are important evidence for the historian. They coincide with and document a major movement in the faith towards the endowment of masses for the dead.

Inevitably, the profile of alienations and accessions to be obtained from these licences is incomplete. Licences were not always applied for by the religious houses, and many were only partly taken up. Nevertheless, two broad tendencies stand out. First, the licences provide further evidence of that withdrawal from the land market which, after a brief recovery in the early fourteenth century, characterized religious houses of the enclosed orders. Second, they demonstrate the growing importance in that market of other institutions – the college, the parish gild, the chantry and the obit – of which the purpose was unequivocally memorial.[3] Neither the economic retreat of the religious houses nor the commemorative emphasis of their replacements were wholly new. For some time already, the enclosed orders had ceased to attract major benefactors. Memorial bargains, struck between founders and their monks, had always been a condition of early growth. But the specialized intercessory foundation was something different. Only slowly on the increase before 1300, the popularity of the personal chantry after that date is very obvious.[4] Some new circumstance unquestionably had arisen.

That circumstance was official recognition of the doctrine of Purgatory and of the Church's role in the alleviation, through prayer, of the soul's suffering. Purgatory – that 'third place' where the shriven soul had yet to be purged of remnant sin – had made slow progress to full acceptance by the Church. And it was not until 1274, at the Council of Lyons, that it won a final place in Christian doctrine. Then, within a generation, it was given added significance at the Papal Jubilee. Boniface VIII, seeking to attract pilgrims to Rome in 1300, granted all comers the plenary indulgence which had been restricted previously to crusaders. Before the end of the year, he had extended that indulgence to all who died

160. A fine early fourteenth-century *Crucifixion* in one of the window-heads of the south chancel aisle at Wells Cathedral.

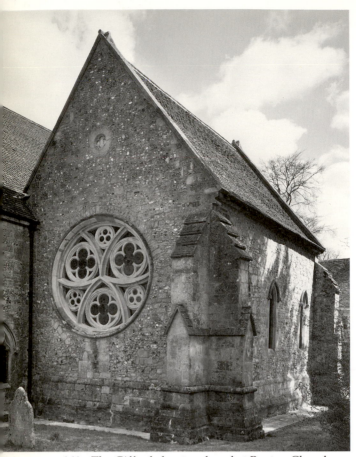

161. The Giffard chantry chapel at Boyton Church (Wiltshire), built in the 1280s at the birthplace of three brothers, two of them career clergy, for the celebration of memorial masses.

on the way to Rome, or who had made preparations for the journey.[5] The precedent of papal intervention in another remote world, liberating the departed soul from Purgatory's rigours, was of huge and slowly recognized importance. It led, in due course, to a runaway inflation of indulgences, and to popular faith in the efficacy of intercession, chiefly through the medium of the mass. 'Amongst other means of restoring fallen humanity,' affirmed one foundation document, 'the solemn celebration of masses, in which for the well-being of the living and the repose of the departed, to God most High the Father, His Son is offered, is to be judged highest in merit and of most power to draw down the mercy of God.' Compared with 'different works of piety and service of the Divine Majesty, solemn masses shine forth as Lucifer among the stars', was another contemporary assessment of their worth.[6]

Lucifer, moreover, was up for sale. Before 1300, prominent ecclesiastics were leading the way in the founding of personal chantries. Boyton, in Wiltshire, has a fine south chapel, added to the church in about 1280 and especially notable today for its inventively traceried west window, remarkable even for that period. Boyton was the birthplace of two career bishops: Walter Giffard, archbishop of York, and Godfrey Giffard, bishop of Worcester, chancellors of England in succession (1265-8). It was Walter – fat, genial and 'fond of luxury' – who obtained Boyton Church for his own estate. Then, after his death in 1279, Godfrey built the chapel in memory of them both and of their brother Alexander, the knight.[7] It was his birthplace again that Bishop Thomas Bitton of Exeter (1292-1307) chose for the costly chantry chapel which he added to Bitton Church in the late 1290s.[8] And the same would be the case with William of Yaxley, abbot of Thorney, whose heart burial of 1293 is preserved at Yaxley Church, and who was probably responsible before his death for much of that church's reconstruction.[9]

Within decades, the fashion was taken up by the laity. Of course, much earlier there had been individual lay chantries, among them the chantry at Wymondham (Norfolk), said to have been founded in 1174 by William d'Aubigny, earl of Arundel, for the soul of Thomas Becket and his own.[10] Noseley, in Leicestershire, was another early foundation: a private chapel elevated to college status in 1274 and very grandly rebuilt at that date.[11] However, the great majority of new chantries, both ecclesiastical and lay, belonged to the period after 1300, clustering especially in the 1330s and 1340s, shortly before the Black Death. They include the Achard chantry at Sparsholt (Berkshire), founded by Sir Robert in 1335 at the Corpus Christi altar at the parish church.[12] There is the impressive Moreby chantry chapel at Stillingfleet (East Yorkshire), founded in 1336 by the priest, Nicholas de Moreby, for the souls of Sir Robert (his brother), of William (his father) and Agnes (his mother), and endowed in that year with parish lands.[13] There is Bishop John Stratford's chantry of 1331 at the parish church of Holy Trinity, Stratford-upon-Avon, situated in the south aisle he had rebuilt especially for that purpose, and later made collegiate by further gifts.[14] At Cogges, in Oxfordshire, the richly decorated north chapel was added in the 1340s by John Lord Grey, probably as a chantry for Lady Margaret, his mother, whose high-quality cenotaph it still houses.[15] The former chancel at Spilsby became the Willoughby Chapel of that Lincolnshire parish church, endowed by Robert Lord Willoughby (d.1348) for his kin and successors, and the occasion for a major rebuilding.[16] The showy south transepts of Northborough (Northamptonshire) and Minchinhampton (Gloucestershire), with the north transept of Winterbourn Bassett (Wiltshire): each owed its rebuilding to a personal chantry established in the last decades before the plague.[17]

These were major initiatives, requiring considerable investment. At Stratford-upon-Avon, both Bishop John Stratford (d.1348) and his brother Bishop Robert (d.1362), loyal sons of the town, gave bountifully to the collegiate church of their foundation.[18] Spilsby too became a collegiate church, with an establishment of a

master and twelve priests. The works at Northborough, halted by the Black Death, were to have been the beginning of an entire Delamere rebuilding, at least as lavish as Lord Willoughby's work at Spilsby, although now little more than an isolated fragment, just a flavour of the family's first intentions.[19] At Winterbourne Bassett, the Despenser rebuilding was diminutive by comparison with either Spilsby or Northborough. Nevertheless, it included both neatly finished chancel and new north aisle, with the family's mortuary chapel in the linking transept.

The collegiate chantry, permanently manned and sufficiently endowed, was the best that money could buy. It could also be dauntingly expensive. Surviving buildings are one means of assessing the degree of investment required. Among them, for example, is the big collegiate church at Ottery St Mary, east of Exeter, rebuilt by Bishop John Grandisson after 1337, following its purchase from the dean and chapter of Rouen. The Norman canons, who had held Ottery since the Conquest, demanded a high price for the estate, 'unreasonable and exorbitant' in Grandisson's view, having regard to the little revenue they extracted from it. However, Rouen had held the manor of Ottery as well as the church, and it was this which became the kernel of the bishop's endowment, helping to support a collegiate body no fewer than forty strong – eight canons and eight vicars, with chaplains, clerks and choristers, and with a master of grammar for the boys. It was to accommodate this great clerical establishment that Grandisson rebuilt Ottery Church, placing special emphasis on an aisled choir with ambulatory, to which a cathedral-style Lady Chapel was then attached. Ottery's parochial nave, refashioned at the same date, was small in proportion to the choir. Yet this too was commandeered for the burial of Grandisson's relatives, most prominently Sir Otho, his brother.[20]

162. The collegiate church at Ottery St Mary, rebuilt at the expense of John Grandisson, bishop of Exeter (1327–69), as a chantry for his relatives and himself.

137

163. The late thirteenth-century effigy at Dorchester Abbey of a knight in 'active repose'.

165. (right) Detail of the head of the Dorchester knight.

164. The effigy of William de Valence (d. 1296) at Westminster Abbey: a rare survival of engraved and enamelled copperplate clothing on an oak figure.

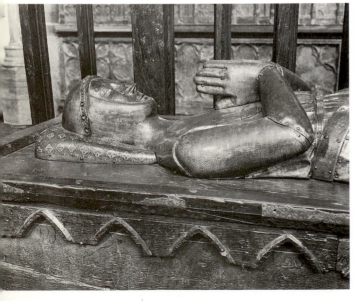

It is the big choirs of these collegiate chantries which most often distinguish them from other churches. One such is the choir of Cotterstock Church (Northamptonshire), made collegiate in 1338–9 by John Giffard, a former rector of Cotterstock and royal official. It entirely overshadows the earlier nave of the little parish church, and was provided for the use of the provost, twelve priests and two clerks of Giffard's new foundation – 'lettered, of honest report, chaste, sober and quiet, abstaining altogether from junketings, drunkenness, wanton ways, strife and brawling, and all such things as detract from and confound the devotion proper to so high a service'. That service was minutely prescribed. Cotterstock's clergy, living in common and observing a semi-monastic regime, met daily in their church for the canonical offices. They sang masses for John Giffard and for the royal family he served, and were to remember their souls after death.[21] Exactly this commemorative role was assigned to those priests who Sir John de Heslerton established at Lowthorpe (East Yorkshire) in 1333, building them a big chancel, more spacious than the nave, for the purpose.[22] A third church, at Astley (Warwickshire), was the grandest of the three. What survives at Astley today is the choir of Sir Thomas Astley's college of 1343, now the nave of the present parish church. Astley's fourteenth-century furnishings are exceptionally intact, with eighteen contemporary choir-stalls still in use, complete with their painted stall-backs, canopies, and misericords. The stalls have been re-sited at the east end of the former choir, losing six of their number in the move. Once twenty-four, they had seated a community of priests, clerks and choristers at least as large as Cotterstock's.[23]

Astley's church was originally cruciform, with a central steeple over the crossing, fully furnished with transepts. Subsequently, this would be the plan of many of the greater collegiate churches, to be recognized already at such pre-plague English churches as Sir William Trussell's Shottesbrooke (Berkshire) of 1337, and later establishing a standard for the aristocratic chantries of mid-fifteenth-century Scotland.[24] Like everything else about such foundations, the cruciform plan was expensive. But the transepts provided sites for additional altars, and the crossing became a favourite place for tombs. These massed family sepulchres, in the final event, were the cause and justification of the collegiate chantries, and were invariably given prominence in their buildings. The personal monument, as never before in Britain, had invaded the interior of parish churches.

It is to this period especially – to the late thirteenth century and to the early fourteenth – that the liveliest effigies and the finest brasses belong. They are not alone in excellence, for this was the time also of the flowering of the English 'court' style in the illuminated Lisle and Queen Mary psalters, in the painted retables of Thornham Parva and of Westminster, in the glass at Wells and Eaton Bishop and in the murals at South Newington, in the floor-tiles of Chertsey and of Tring. Characteristically, these arts are distinguished by refinement and invention: a combination as likely to occur in memorial sculptures as in the capitals, bosses and window traceries of the Decorated churches which contained them. Only comparatively rarely has English art attained international stature. But it got there unquestionably in the anonymous knight effigy at Dorchester (Oxfordshire), straining to rise from his tomb.[25] And this sculpture, dating to the late thirteenth century, stood at the beginning of a generation of experiment which, while it never created anything of that quality again, resulted in many striking images.

Most memorable of these is the Penshurst shallow-relief carving of a woman in anguished prayer, locked in her coffin by the restraining arms of a delicate foliated cross.[26] Similar 'windows' in stone coffin lids, exposing a head or half the body, occur at Cherry Hinton (Cambridgeshire), at Valle Crucis (Denbigh) and at Appleby (Westmorland), the happiest of these conceits being the grave slab of

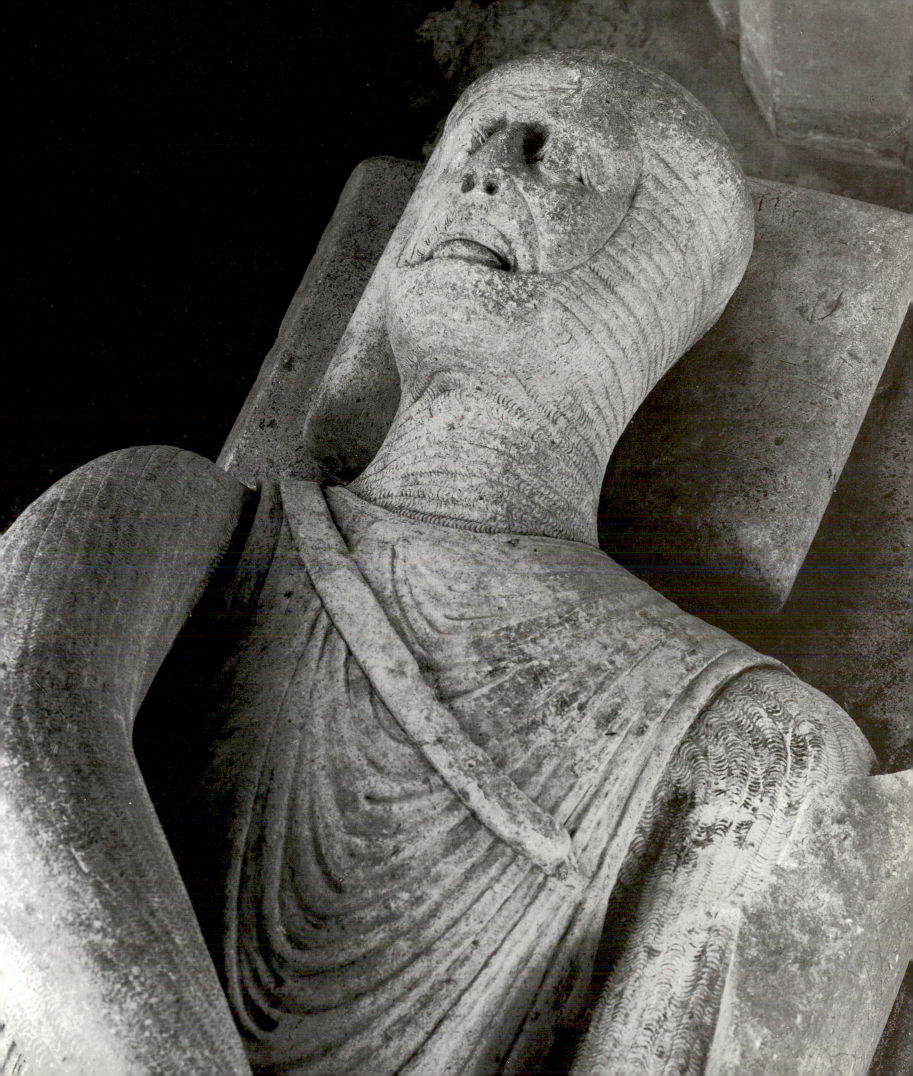

167. A Templar effigy, hand on sword, in the Temple Church (London).

Yveyt at Sleaford (Lincolnshire), where Yveyt's head, hands and feet are shown through openings in the coffin lid, accompanied by the Norman French inscription: 'You who pass by, pray for the soul of Yveyt, the wife of William de Rauceby, on whose soul may God have mercy.'[27] In the same original and inventive tradition are the paired effigies under blanket-like coverings at the Lincolnshire parish churches of Careby and South Stoke, and the elaborate anthropomorphic coffin lids at Bredon (Worcestershire) and Lowthorpe (East Yorkshire), each making use of that sprouting Tree imagery which at Dorchester again, in the Tree of Jesse window, inspired a sculptural *tour de force* almost as remarkable as the Dorchester Knight.

Above all, it is by contemporary knight effigies, carved fully in the round, that the restless energy of the period is best conveyed. They have their hands on their swords, which are sometimes partly drawn. Their legs are tensely crossed, as for the duel. It is a tradition which goes back to the mid-thirteenth century: to the fine series of Templar effigies at the Temple Church in London, and to the Salisbury memorial of William Longespée, the crusader, killed in action against the Mamelouks in 1250, when he is reported to have said in the face of death: 'Please God, my father's son will not flee for any Saracen. I would rather die well than live ill.' It was just such tales of heroism, dramatized by foreign wars, which inspired notable feats of imagination in the sculptors. At two Norfolk churches, Reepham and Ingham, Sir Roger de Kerdiston (d.1337) and Sir Oliver de Ingham (d.1344) toss on the pebble beds of their battlefields. A knight at Great Haseley (Oxfordshire) holds his sword in his right hand, while still grasping its empty scabbard with his left. At Aldworth, in Berkshire, Sir Philip de la Beche, amongst his noble kin, reclines lightly on his elbow as though dozing.[28]

166. Thirteenth-century knight effigies in the nave floor of the Temple Church.

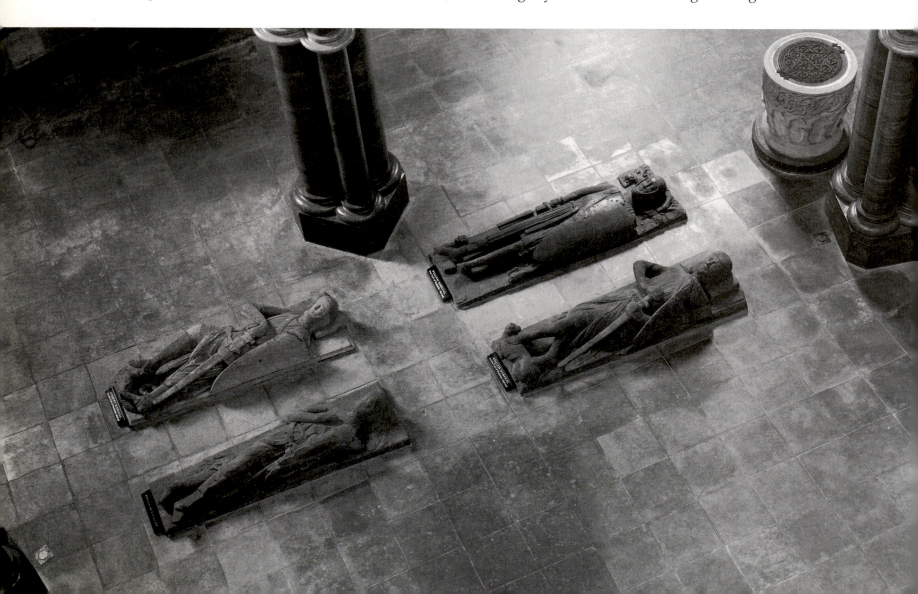

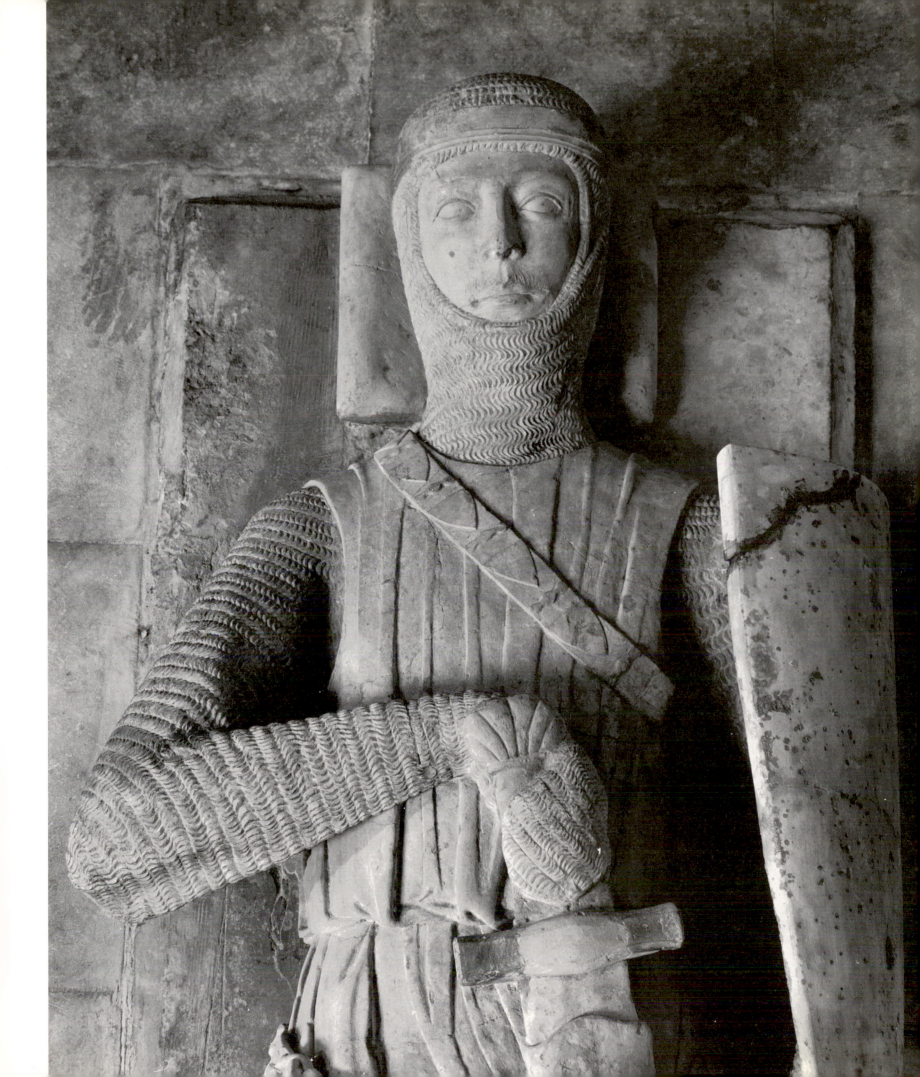

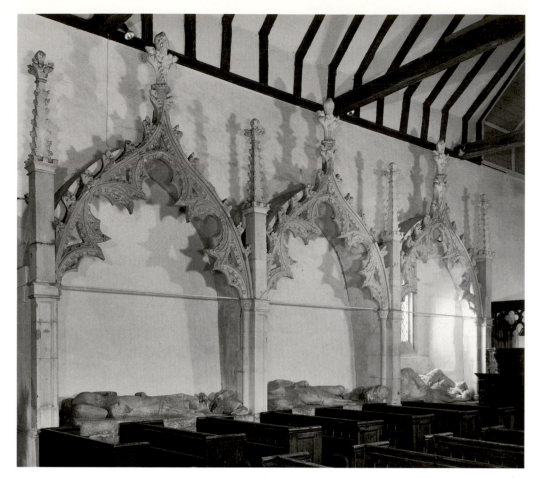

168. Early fourteenth-century canopied monuments of the de la Beche family, against the north wall of the nave at Aldworth Church; there are three similar monuments in the south aisle.

169. The canopied monument at Winchelsea Church of Edward I's admiral, Gervase Alard (d.1310).

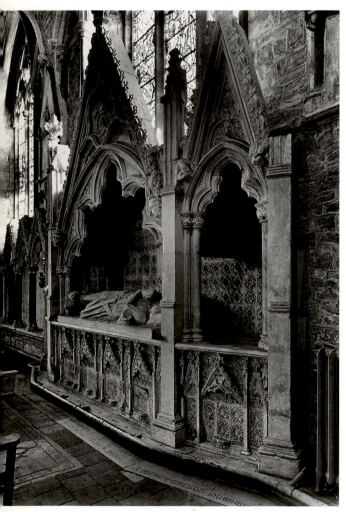

The Aldworth effigies, all of the early fourteenth century, are a particularly memorable assemblage. They lie under grandly sculptured canopies, like the contemporary effigies at Winchelsea (Sussex), equally distinguished by their realism. At Aldworth, realism is most obvious in the folding robe of Joan de la Beche, Sir Philip's daughter. At Winchelsea, it found expression in such naturalistic touches as belts which spill over the tomb-chests. Herefordshire, a county of sculptors, saw the style culminate in the Pauncefoot monument at Ledbury and in the tomb of Blanche Mortimer at Much Marcle. At both, an illusion of reality is fostered by drapery which flows over the tomb-chest and down its side.[29]

Less illusionistic, but of as high quality as these sculptures, are the brasses of the period, far superior to anything that came later. Two of the best brasses ever made were those of Margaret de Camoys at Trotton (Sussex) and of her contemporary Joan de Cobham at Cobham (Kent), both of about 1310. Especially fine again are the full-length knight brasses to Sir William de Setvans (c.1322) at Chartham (Kent) and to Sir Robert de Bures (c.1331) at Acton (Suffolk). Comparing one with another, it is the earlier of the two side-by-side Sir John d'Abernon brasses at Stoke d'Abernon Church, in Surrey, which is unquestionably the finer composition.[30]

What kept this art alive was continuing confidence and great wealth. It thrived on the success of the mighty landowners. What then caused it to sicken was a retreat of patronage, confirmed but not initiated by plague. The fate of New Winchelsea, Edward I's entrepreneurial substitute for an older port overwhelmed by the fury of the sea, tells it all. New Winchelsea today is a ghost town. Its big parish church, guardian of finely sculptured cenotaphs and realistic effigies, survives only as far as the crossing. Many of its intended house-plots, laid out on their secure hilltop site in 1283, within a spacious and optimistic grid of streets, were only briefly settled, if at all. Low-lying Old Winchelsea had been

battered by repeated storms – the first in 1250, the last in 1287–8 – each more damaging than the last. They were the opening salvos of a serious and prolonged climatic collapse, heralded by coastal inundations. Old Winchelsea was lost to a 'rainy country'. New Winchelsea fell victim to war and plague in a century 'ripe with death'.[31]

The direct consequences of climatic deterioration in medieval Britain are controversial and difficult to measure. But the deterioration itself, as a Europe-wide phenomenon, is not disputed. It began, as at Winchelsea, with a series of mighty storms, swamping coastal Holland, Denmark and North Germany.[32] At Pevensey, to the west of Winchelsea, recently reclaimed marshlands were flooded. The dried-out fens of Cambridgeshire became awash once again. On the north coast of Kent, the monks of Christ Church (Canterbury) recorded heavy losses on their manors. Parts of Holderness, in south-east Yorkshire, were swallowed irrecoverably by the tide.[33] All this was bad enough. However, it was then overtaken by the onset everywhere of cooler and wetter summers, especially catastrophic in the sodden harvest seasons of 1315–16 and in the widespread dearth which ensued.[34] Neither the Great Famine of 1316–17 nor the livestock murrains of 1315–21 (sheep in 1315–17, cattle in 1319–21) were experienced in every region with equal force.[35] Yet what distinguished the new regime was its permanence. The reliably golden summers of the previous two centuries were over. In Northern Europe, cultivation of the vine remains among the most sensitive of agricultural frontiers. Investment in new vineyards, still widely made in Midland England during the first decade of the fourteenth century, was abandoned soon afterwards. It has not, even now, been resumed.[36]

The deteriorating climate is reflected also in a contemporary retreat from the margin. On Dartmoor, high on the granite uplands, medieval hamlets have never been resettled since their desertion in the early fourteenth century.[37] Similarly at Ibstone, in the south-west Chilterns, the land rises to over 700 feet. And there, as on Dartmoor, the abandonment of peasant tenements on this Merton College manor had begun as early as 1295.[38] The South Yorkshire Pennines are another representative highland zone. Settlement on the Pennine grits and sandstones had intensified in the twelfth and thirteenth centuries. For the first and last time in the region's history, large areas had been brought under the plough. Yet before the 1340s and unconnected with plague, there was to be a dramatic retreat of cultivation. In Silkstone and Penistone, Hoyland, Royston and Sheffield, great tracts of former arable lay waste. In just half a century, from the still prosperous 1290s, the taxable wealth of many of these communities had fallen by between a half and a third.[39]

Medieval tax assessments are frequently suspect, and these Yorkshire figures – derived from the Taxation of Pope Nicholas of 1291 and from Edward III's Inquisitions of the Ninth of 1342 – are scarcely better than most. But comparisons between them are still valuable. The jurors of 1342 worked directly from the 1291 clerical assessment. In recording their own estimates of wealth in the localities, they were required to explain any discrepancy. Time and again, in accounting for lower valuations in many parts of England, they noted arable abandoned and waste. Coastal inundations had been one of the major reasons for this loss. In Sussex alone, over 3500 acres had been flooded. However, the bulk of reported waste was in the upland regions – in the North Riding of Yorkshire, in the Chilterns north of London, and in Shropshire west of the River Severn. As the jurors related, bad weather had destroyed their crops; seed corn was everywhere in short supply; the soil was exhausted; tenements lay in ruins for want of husbandmen (*derelicta pro defectu inhabitantum*).[40]

None of this had been the work of a moment. For some, the decades before the Black Death were 'fortunate years'; for others – and perhaps for most – they were quite the reverse.[41] Lacking new investment or more advanced technology, the

land could support just so many. On the margins especially – on thin upland soils or waterlogged clays – its profitability was quickly eroded. Hence the apparent paradox of a teeming land, overcrowded with people, in which tenements increasingly lay vacant. In 1342 it was the poverty of the tenants rather than the sterility of the soil which was blamed for untilled arable in Buckinghamshire.[42] Almost half a century before, abandoned holdings on the bishop of Worcester's manors at Alvechurch (Worcestershire) and Tredington (Warwickshire) were the consequence of tenant failure, even then, to make a living off the land and meet the rent.[43]

When Alvechurch and Tredington lost their tenants, in or just before 1299, the population of Britain may have peaked already, to stay at that level until the plague. At Havering certainly, and on other Essex manors, land values were falling from 1300, implying some reduction in tenant pressure.[44] However, another possible reason for lower receipts at Havering was a decline in the yield from its arable. Only the best of soils could have supported the combination, characteristic of Essex farming in the early fourteenth century, of over-cropping and inadequate manuring. The county's typical three-course regime – wheat, oats and fallow in rotation – kept the land in production for two years out of three, allowing it only one to recuperate. Farming at this level of intensity, spread over land of varying quality, was unsustainable. At Robert Bourchier's manor of Tolleshunt, later known as Bourchier Hall, there was a falling off in harvest yields from the 1330s, followed by near failure at mid-century. In 1351, shortly after the Black Death, the yield of oats on the Bourchier demesne was 2.4 of seed sown; wheat returned only 1:1, barely recovering its seed. Over the same two decades, the manor's arable acreage almost halved.[45]

While the Bourchier figures are especially shocking, they accord broadly with the secular trend. True, there were better farmers in other regions, achieving yields that were significantly higher.[46] Nevertheless where, as on the Winchester estates, manors of many different types and qualities appear together in the records, there is overall evidence of falling production, much of it attributable to infertility.[47] In particular, this was the case at the less profitable margin, on those hills and in those forests formerly colonized by enclosers. There was no money to be made now in upland ploughing or woodland clearance. Land values fell as agricultural frontiers closed. Arable was abandoned; landowner capital was withdrawn; another door was shut upon the folk.[48]

Those folk, of whom Britain was full to bursting by the early fourteenth century, had had more than their share of deprivations. Even if population had indeed reached its maximum by 1300 – and much of the new evidence suggests the contrary[49] – overcrowding was everywhere endemic. Holdings became smaller as the land filled up; the peasant land market quickened; the disintegration of free tenements became customary.[50] In the Third World today, identical conditions obtain in which 'labour is so plentiful that its marginal productivity is negligible, or nil, or even negative'.[51] Then as now, labour lost its price. As men and their families were driven destitute from the land, society paid the penalty in violence.

At least some of this violence was between the villagers themselves: the strong closing ranks against the weak. But feelings of social outrage were mounting also at this period, to find outlets in a new literature of protest. Contemporary poems like the 'Outlaw's Song of Trailbaston' of about 1305, the 'Poem on the Evil Times of Edward II' (1307–27), the 'Song of the Husbandman' and the 'Song against the King's Taxes', both of about 1340, voiced urgent grievances which ranged from laments about the weather to forthright attacks on royal taxation, on corrupt courts and imperfect justice, and on the privileges and the avarice of the rich. 'Our rye is rotted and rotten in the straw on account of the bad weather', sang the Husbandman. 'To seek silver for the king, I sold my seed, wherefore my land lies

144

fallow and learns to sleep.'[52] 'I will teach them [the judges] the game of Trailbaston,' the Outlaw joined in, 'and I will break their back and rump, their arms and legs, and it would be right.... You who are indicted, I advise you, come to me, to the green forest ... where there is no annoyance but only wild animals and beautiful shade; for the common law is too uncertain.'[53] Like the Husbandman's grumble about the weather, the Outlaw's complaint about the 'game of Trailbaston' was entirely topical. Trailbaston first occurs in 1305, being the issue of general commissions to hear and determine (*oyer* and *terminer*) reported felonies. It was the Crown's response to repeated breaches of the peace and to a common perception of gathering violence, on track for a crescendo of disorder.[54]

The idiom, the perception, the remedy and its causes were all new. Poems of social protest had been known before. But they had had none of the immediacy of this literature.[55] As for perceived truths, Edward I's Statute of Winchester (1285) had begun with the premise that 'from day to day, robberies, murders, burnings are more often committed than heretofore'. Remedies had been proposed, yet only fifteen years later the belief would be repeated that 'there are more evildoers in the land than formerly, and robberies, burnings and murders are committed without number, and the peace is less well kept because the statute that the king caused to be made recently at Winchester has not been kept.' It was the Outlaw's verdict on the injustices of Trailbaston that 'If God does not prevent it, I believe war will flare up.'[56]

Trailbaston's failures were perhaps inevitable. However, they had less to do initially with the venality of the king's justices than with a sudden conjuncture of economic problems, experienced most acutely by the poor. After a century of price stability, the cost of foodstuffs doubled between 1305 and 1310. Prices again rose steeply in the famine years. They seesawed erratically during the next two decades, then collapsed absolutely – bringing ruin and destitution to cultivators on the margin – in the acute monetary deflation of the late 1330s and early 1340s.[57] Shortage of coined money was a prime cause of the deflation. And it, in its turn, had a great deal to do with the spiralling costs of professional armies, of fortress-building, and of other war expenditure.[58] No region escaped the royal purveyors. No settlement, however small and impoverished, was immune from the king's taxation – for the first time, a regular charge. 'There is a desperate shortage of cash among the people', ran a report of 1338–9. 'At market the buyers are so few that a man can do no business, although he may have cloth or corn, pigs or sheep to sell, because so many are destitute.'[59] In his comunication to the Irish sheriffs in 1311, Edward II frankly admitted the real costs of his father's campaigning. So much of Ireland's revenues had been diverted to the Scottish wars 'that the residue of our money of the issues of our land of Ireland remaining for a long time past is not sufficient for keeping the peace there'. Profiting from this weakness, 'divers Irish of our land of Ireland, our felons and rebels, both because of this same lack of money and their customary pugnacity ... [are] day by day perpetrating burnings, homicides, robberies, and other innumerable and intolerable transgressions.'[60]

Especially intolerable – and much closer to the centre of government – were the sufferings in 1327 of John de Bannebury, farmer of the tithes of Hackney (Middlesex). 'If he [John] wished to avoid damage and save his life', blustered that villainous pair, Brothers Muf and Cuf, he was to deliver his receipts within the week to Brother Puf, their 'abbot', or see Hackney's parsonage put to the torch. Their claims were as false as their robes. Nevertheless it was Brother Muf's own kinsmen, Robert and Richard de Baldock, who were granted a commission of oyer and terminer by the king, following their fabrication of trumped-up countercharges. The Baldocks 'sent their letters to all the people in the county warning that none should be so foolish as to be against them'. They procured

justices 'who wore their robes and took their fees'. They set armed men in pursuit of John de Bannebury, and put him in fear of his life. If this were royal justice and these its executives, small wonder that the Outlaw took to the Forest, in flight from Trailbaston's evil 'game'.[61]

There are many reasons for believing that violent crime increased in these decades. Certainly, there was a sharp rise regionally in recorded felonies during the Great Famine of 1315–17.[62] But although violence and destitution were clearly linked, the most dangerous villainy – organized crime – was only occasionally the work of the poor. Outlawry, chosen as much as enforced, had all the makings of a cherished way of life. The call of the green forest, 'where the jay flies and the nightingale always sings without ceasing', had been heard and attended well before the days of Robin Hood. If Robin himself was a make-believe hero of the 1330s, his exploits were those of the historical Folvilles and Coterels – gentry and parish clergy – the leaders of criminal gangs.[63] It was these well-born bandits, with their patrons and maintainers in the aristocracy, who recruited from the vagabonds of an overcrowded land ill-served by traditional methods of peace-keeping. The village tithing system and the local watch barely functioned by the late thirteenth century. There were no more county eyres after 1294. Before that time, the rise in vagrancy, whether perceived or real, had begun to show up clearly in the records. Vagrant crime in Essex doubled as a proportion of reported cases between the eyres of 1272 and 1285. In Bedfordshire two years later, at the eyre of 1287, distrust of the vagabond had become so intense that almost every crime reported to the royal justices was blamed either on a vagrant or a stranger.[64]

Hardly less worrying was the related problem of maintaining manorial discipline. Conflict, formerly rare, became a frequent occurrence on the manors. Each side had exaggerated expectations. It was an abbot of Burton who in 1280, savouring his triumph, told his villeins that they owned nothing of Mickleover but their bellies. Yet he himself had been sorely provoked: challenged by a claim to ancient demesne of the Crown which, had it been successful, would have freed his villeins and wrecked his lordship.[65] Other claims to ancient demesne, souring relations between abbot and tenant, began at Titchfield (Hampshire) in 1271 and at King's Ripton (Huntingdonshire) in 1275. They were fought with vigour over a long period. And they arose in each case from a landowner's desire to multiply labour services and from his villeins' determination to diminish them.[66]

The King's Ripton dispute was with the abbot and convent of Ramsey. It was not the only local violence to disturb the monks' calm, for Ramsey itself was one of two vills – Cistercian-held Sawtry was the other – heading the list of reported homicides at the Huntingdonshire Eyre of 1286 and at its Ramsey banlieu follow-up.[67] This concentration of violence in Huntingdonshire's monastic vills is unlikely to have been mere coincidence. The collective memory of a religious community is long; it favours the implacably litigious. At Halesowen, in Worcestershire, the abbot and canons of a rich Premonstratensian community locked themselves in conflict with the men of their vill in litigation persisting through two centuries. Again the argument concerned ancient demesne. Again both sides went to court and took to violence. By 1273, with the worst still to come, all hope of peaceful coexistence had been abandoned. The abbot appealed for royal licence to fortify his house, fearful of the fury of his tenants.[68]

Halesowen was not unique in its predicament. It was cattle-rustlers from Deeping, across the Fen, who caused the monks of Spalding in 1333 to strengthen and crenellate their precinct wall.[69] At St Augustine's (Canterbury), the massive Fyndon Gate, rebuilt between 1300 and 1309, only just predated a serious rising of tenants in 1317–18, the sequel to rent strikes and other mischief. Six hundred men of Minster, in the chronicler's estimate,

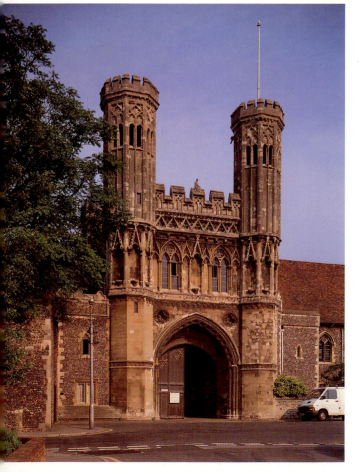

170. The Great Gate at St Augustine's (Canterbury), rebuilt with great display by Abbot Thomas Fyndon in 1300–9.

having gathered to themselves a still greater number of malefactors, approaching the manors of the abbot at Minster and Salmstone in hostile fashion with bows, arrows, swords and sticks, several times besieged them and made sundry attacks thereon, and placed fire, which they had brought with them, against the doors to burn down those manors.

Thieves, rogues and arsonists were abroad. Many, as was reported of the rioters at Minster market, 'had nothing to lose'. They included returned soldiers, not to be put off by a manor's hedge or ditch, nor to refrain from 'tumult and excessive shouting' at the abbot's court.[70] From 1294, pardons had been granted for service in the royal armies, emptying the king's gaols with brutal and predictable effect. Homicides and outlaws, purged by war, came back from campaign to make mayhem.[71]

One of the more ribald tales told of these years concerned the public humiliation of the dean of Ospringe, paraded through Selling back-to-front on his horse, then ending arse-up in a sewer.[72] Frightened by such stories and by the undisguised hostility of the mob, the wealthy clergy looked to their defence. It was Bishop Bek of Durham (1284–1311), a great builder all his days, who fortified the episcopal residences at Bishop Auckland and at Eltham, while making himself a private castle at Somerton, in Lincolnshire, modelled on contemporary royal works. Henry Gower, bishop of St David's (1328–47), added parapets and

171. The crenellated parapets (centre) on the bishop's palace at St David's were added by Bishop Henry Gower (1328–47).

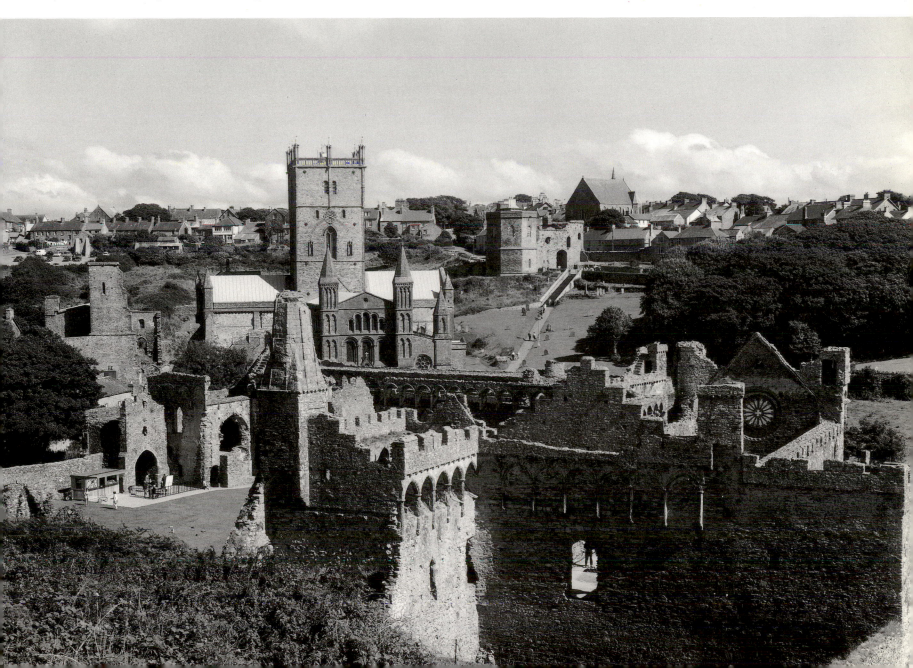

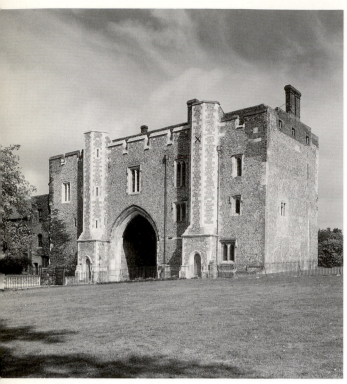

172. Abbot Thomas de la Mare's fortress-like mid-fourteenth-century gatehouse at St Albans.

174. (right) The moat and gatehouse of the bishop's palace next to the cathedral at Wells, fortified by Ralph of Shrewsbury in 1340.

173. The new abbey gatehouse at Bury St Edmunds, built following the riots of 1327, was equipped with a portcullis and with arrow-loops concealed behind the statuary.

wall-walks to his country residence at Lamphey, doing the same for his palace next to the cathedral. In 1340, for 'the security and quiet of the canons and ministers resident there', Bishop Ralph of Bath and Wells (1329–63) obtained a royal licence 'to build a wall round the churchyard and the precinct of the houses of him and the canons [of Wells], and to crenellate and make towers in such a wall'.[73] What he created for himself, in palace wall and moat, was one of the most complete episcopal defensive systems ever built.

There was good reason for taking such precautions. Bishop Ralph himself had been in dispute with the citizenry of Wells. And there were many ecclesiastical corporations, up and down the land, which had experienced similar difficults with their neighbours. Few would have been ignorant of the recent savage riots at St Albans and Bury St Edmunds, two of the richest and most prominent of the monastic boroughs. Under cover of Edward II's deposition and murder in 1326–7, the townspeople had risen against their lords, besieging and plundering both abbeys.[74] Neither revolt was successful. But a new unease accompanied dealings between monastic lords and their burgesses, one product being greater reliance on precinct walls. St Albans' huge gatehouse, rebuilt by Abbot Thomas de la Mare in the mid-fourteenth century, has the turrets and the bulk of a fortress.[75] At Bury St Edmunds, the two surviving gatehouses of the west precinct wall offer a significant contrast. Of these, the earlier – tall, belfry-like and unprotected – is confident work of the abbey's finest period, not later than the second quarter of the twelfth century. The second postdates the 1327 riots and is a building of entirely different character. Superficially unmilitary, it has arrow-loops concealed behind the statuary of the facade and a portcullis for rapid sealing of the entrance.[76]

Thomas de la Mare, builder of the St Albans gate, had been prior of Tynemouth (1340–9) before promotion to his abbacy. And it was probably there that he learnt the practice of systematic fortification, for Tynemouth (a dependency of St Albans since 1089) was already more a castle than a priory. In 1296, right at the beginning of the long agony of the Anglo-Scottish wars, the monks of Tynemouth had obtained a licence to enclose and crenellate their precinct. The decision cost them dear. With a garrison to maintain and with constant demands for hospitality, they were brought to the brink of bankruptcy many times. Nevertheless, their tall promontory site, washed on three sides by the ocean, was readily defensible from the start. Before 1346, when the English victory at Neville's Cross brought the worst of the fighting to an end, Tynemouth was accounted one of the strongest fortresses in the North, and there was a keep-gatehouse still to come in the 1390s.[77]

At Tynemouth, the enemy was plain to see. At other religious houses, while the perception of violence was genuine enough, it might arise out of many different causes. One motive for wall-building had always been innocent self-advertisement: the instinct to put on a brave show.[78] But there was a price to be paid also for those sharp business practices to which communities of religious were always prone. It may be that few sank as low as the greedy canons of Haughmond, usurious mortgagees of their starving peasant neighbours during the Great Famine of 1315–16.[79] Yet many had been busy accumulators for generations before the Famine, trailing resentment and human tragedy in their wake. Among those especially active in the contemporary land market were the Conqueror's monks of Battle. Through the thirteenth century, Battle Abbey had bought out the holdings of lesser landowners in the locality, and had tightened its grip on its burgesses.[80] Battle's new gatehouse, built when these accumulations were substantially complete, had two roles. It was in 1338, as French pirates roamed the Channel, that Battle obtained its licence to crenellate. Accordingly the gatehouse, with its portcullis defences, may be seen as a response to coastal raids. A second purpose, though, was more permanent. Huge in bulk, crenel-

175. The inner face of the great gatehouse at Battle, erected soon after 1338, when Alan of Ketling obtained a licence to crenellate his abbey.

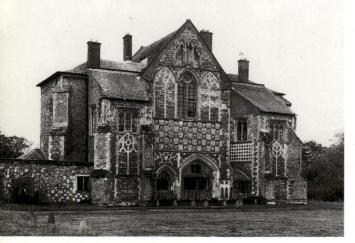

176. The big residential gatehouse of the Augustinian canons of Butley was built in the 1320s. The five tiers of heraldry, over the entrance, claim the patronage and protection of the great.

lated and spectacularly turreted, the monks' gatehouse dominated and over-awed the little market-place at Battle, making a statement unequivocally about lordship.[81]

Such statements drew added authority from noble patronage. Great arrays of sculptured heraldry ornament monastic gatehouses of the period. At Butley Priory, in Suffolk, the most extravagant of these, there are no less than five tiers of shields above the entrance. They invoke the protection of the good and the great, from the Holy Roman Emperor to the kings of France and England, from the mightiest baronial families to that East Anglian nobility with which the canons believed themselves in symbiosis.[82] Butley's gatehouse was as big as Battle's. It made its point as obviously through size. Certainly there was a monumentality in contemporary gatehouses at Worksop and Tor, Whalley and Bolton, which had not been present in the buildings they replaced. From this time forward, whatever their location, monks and canons of the possessioner orders hid behind facades of public strength. Maxstoke Priory, almost the last of the major Augustinian communities to be established in England, was newly founded in 1337. Located at the heart of Midland England, with the castle of its noble founder just across the fields, Maxstoke was as secure as might be from Frank or Scot. Even so, its canons sought the protection of a high precinct wall and of big gatehouses, both an inner and an outer. Strongly built in stone, these defences are still largely intact.[83]

At Maxstoke, castle and priory were direct contemporaries. Each owed its origin to the elevation of a local landowner, William de Clinton, to the newly re-established earldom of Huntingdon, vacant since 1237. Edward III simultaneously made three other promotions to the earldoms of Salisbury, Suffolk and Northampton, purposing to reverse that 'serious decline in names, honours and ranks of dignity' which he believed had contributed to disorder.[84] The new earl's castle was a creature of its times. It was a fortified manor house which, although larger than most (as comital rank demanded), was in no way a threat to Edward's peace. Like other such 'castles of law and order', whether built for a baron or a bishop, Maxstoke's defences included a water-filled moat, a stone curtain, a residential gatehouse, and a strong tower exclusive to the lord.[85] In late-medieval England these were to be the elements of all personal fortresses, for as long as they continued to be built. At such houses 'thieves must knock ere they enter'. What was defined by their enclosures was private space.

Viewed professionally as a castle, the moated manor house fails every test. And this has been the cause of some confusion. Moated enclosures of all sizes and strengths became common from the late thirteenth century. Frequently found even on the smaller farms and homesteads, moats peaked in number before the Black Death, recognizably a phenomenon of the period.[86] In Ireland, certainly, these moats have been seen as defensive.[87] In England, too often, they have been accounted status symbols, unrelated to the problems of their day. 'Prestige', one historian roundly declares, was 'the prime mover' in contemporary fortification.[88] 'In moated homesteads,' claims another, 'we surely see the physical expression of the social ambitions of a particular group . . . a phenomenon best explained in terms of social aspiration and fashion.'[89] The moats of Cambridgeshire, asserts a third, 'seem to have been a relatively short-lived fashionable ideal constructed around houses for prestige purposes by local lords and farmers, directly imitating their social superiors'.[90] Much of this, evidently, is nonsense. It takes little account of that collapse of public order by which men of property felt threatened on every side.

Take the case of Aydon, a medium-sized manor house in Northumberland. Aydon, just north of Corbridge, was sited uncomfortably close to one of the principal Scottish routes to the south. Its troubles, consequently, were a degree worse than most, although not unrepresentative in kind. In the early 1290s, when

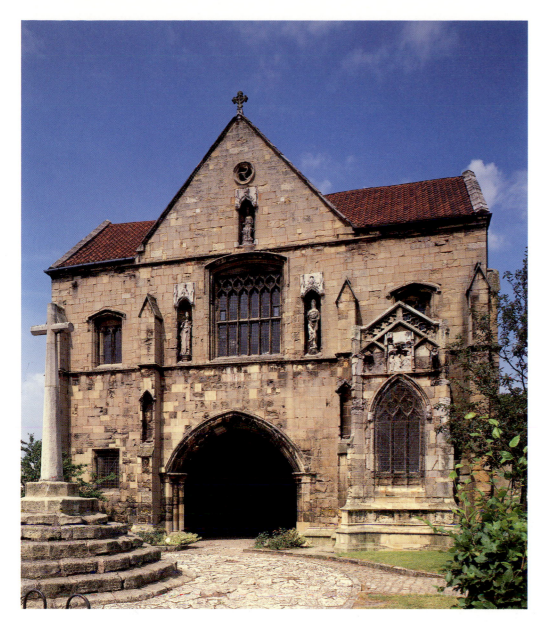

177. Worksop Priory's fourteenth-century gatehouse, although large and imposing, is still thoroughly domestic in character.

178. In contrast, the contemporary gatehouse at Tor Abbey (Devonshire) is unmistakably defensive, built to arm this coastal community against seaborne pirate raids.

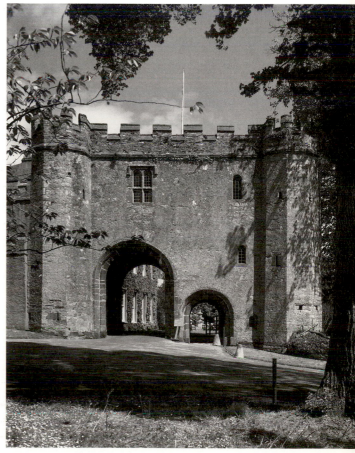

bought at high cost by Hugh de Reymes, an Ipswich merchant, Aydon had seemed entirely secure. Work on a new house was in progress by 1296, and Robert, Hugh's heir, had moved north. But what had appeared a good investment before the Scottish Wars, rapidly turned into a disaster. There were Scottish raiders at Corbridge in 1296 and 1297. Aydon itself, in 1315, was surrendered to the Scots without a fight. In between, the Reymes family manor house, initially undefended and equipped with every comfort, had taken on the lineaments of a fortalice. Robert obtained his licence to crenellate Aydon in 1305. It was probably following this that a parapet was added to Robert's courtyard wall, and that battlements encircled his hall roof. Both, certainly, were afterthoughts, not anticipated when work there began. Another major revision was the addition before 1315 of a big fortified outer enclosure – a 'wall of stone and lime' – strengthening those quarters on the north and west unprotected by the slope to Cor Burn. Nothing availed Aydon's defenders. When the house was again taken in 1317, to be robbed and plundered by local rebels, the cup of Robert's miseries overflowed. A listing of his Northumbrian revenues, on his death some six years later, showed them to have been reduced almost to nothing.[91]

Robert and his heirs, it might now appear, would have been better advised to stay at home. Yet there was little enough security even at Ipswich. Violence at Bury, a Suffolk urban community with special problems of its own, erupted in

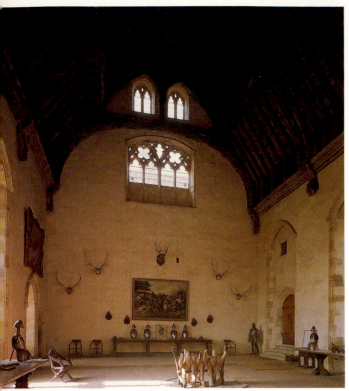

179. Sir John de Pulteney's great hall at Penshurst (Kent) was the principal public apartment of a big rural manor house, built without defences in the 1340s.

180. Lawrence of Ludlow's polygonal defensive tower (left) at Stokesay Castle was added to his hall and chamber in the 1290s.

1327. Just over the county border in Essex, contemporary Colchester was repeatedly held to ransom by John Fitzwalter and his gang, who laid full siege to it on more than one occasion.[92] If time and place still favoured the merchant prince, permitting Sir John de Pulteney the luxury of his undefended manor house at Penshurst, others would have learnt a grimmer lesson. Sir John (d.1349) was a Londoner. Penshurst, which remained unfortified until 1392, was in Kent.[93] When, in the 1290s, Lawrence of Ludlow rebuilt Stokesay, his view of the situation had been different. Lawrence, like Sir John, was a successful merchant, called upon for loans by the king. Both were confident of royal favour and protection. But there the resemblances ceased. Lawrence's home was in western Shropshire, exposed to the violence of the March. He had no choice but to look to his defence. The great tower at Stokesay, licensed in 1291, was a personal stronghold: a huge and costly polygon, sophisticated in plan, cut off from the enclosure by a drawbrige. A tall stone curtain and a water-filled moat surrounded and protected Stokesay's court.[94] Only in Lawrence's private tower is there any hint of those major developments in military architecture just then being put in practice in North Wales. Yet Stokesay, for all that, was a very modern building, combining domestic comfort with a defensive posture more than adequate to deter an intruder.

It is in Stokesay 'Castle', and in others like it, that the temperature of the times is best taken. It was seldom possible, as disorder grew, to do without defences of any kind. Yet the taste for domestic comfort was growing also, and these buildings – like the castles of the king and his higher feudality – continued as residences at least as much as fortresses. Acton Burnell, just up the road from Stokesay, has similarly become known as a 'castle'. But Acton, in point of fact, was a defensible manor house, built at his birthplace by Bishop Robert Burnell (d.1292) as a country retreat and private residence. Burnell, the busy royal chancellor, gave high priority to the quality and the privacy of his own quarters. Defence, while not ignored, was next in line. Acton today is a puzzle only if awarded marks for being the castle it never was.[95]

Acton Burnell was a very individual building: in no sense a model for its times. But the chancellor's concern for personal privacy was familiar in his day, as was the emphasis he placed on its protection. Many country houses, through two

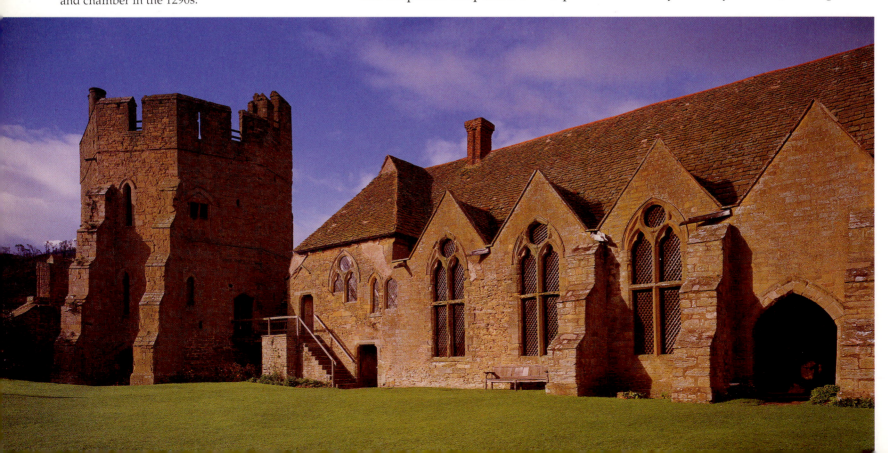

centuries since the Conquest, had survived with only token defences. By 1300, this had ceased to be the case. Among the better equipped manor houses of English-held Wales was Weobley, in coastal Glamorgan. It had a spacious first-floor hall, over the kitchen, with ranges of comfortable private accommodation, well supplied with fireplaces and garderobes. Although in no obvious danger from the Welsh, Weobley (like many others) was fortified at this period – its little courtyard oppressively enclosed.[96] The same was increasingly true of the North. Important undefended manor houses like Spofforth and Markenfield, well south of the March, had been walled and moated before 1310, without thought of protection against the Scots.[97] The English defeat at Bannockburn in 1314 changed the rules. By the time that a Scottish army, four years later, washed unchecked through the West Riding of Yorkshire, both Spofforth and Markenfield had defences of their own, although provided against another sort of enemy.[98]

It was general disorder, rather than any specific threat, which accounted for the great majority of contemporary defence works. No Scot caused the fortification in 1312 of John de Handlo's moated manor house at Boarstall (Buckinghamshire).[99] Fears of local unrest similarly explain the moating of Broughton (Oxfordshire) at about this time; the provision of strong residential towers, adjoining the halls, at Longthorpe (Northamptonshire) and Halloughton (Nottinghamshire); the defence by tower and portcullis of the manor house at Clevedon (Somerset); and the protection by corner towers of Woodsford 'Castle' (Dorset), licensed in 1335.[100] Such traditions, once established, held firm. Water-filled moats and showy military-style gatehouses continued to be thought appropriate for late fifteenth-century gentry residences like Baconsthorpe Castle and Oxburgh Hall.[101] Then, when moats went out of fashion, the frontispiece gatehouse enjoyed a further century of favour. Yet these defences had begun in deadly earnest. Their setting was a society starved of law. They became redundant only after plague.

That redundancy, of course, was not immediate. Penshurst is only one of many examples of late fourteenth-century fortifications, some of which (like the great gatehouse at Thornton Abbey) had direct associations with the Peasants' Revolt of 1381. But the cause of that unrest was relative affluence, whereas earlier

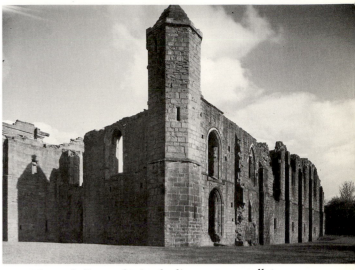

181. Henry de Percy obtained a licence to crenellate his Yorkshire manor house at Spofforth in 1308. The big solar block, with its stair turret (centre), was added to an existing thirteenth-century hall (right) at that date.

182. Robert Burnell, chancellor of England (1274–92) and bishop of Bath and Wells, built this crenellated manor house next to the parish church at Acton Burnell, his Shropshire birthplace.

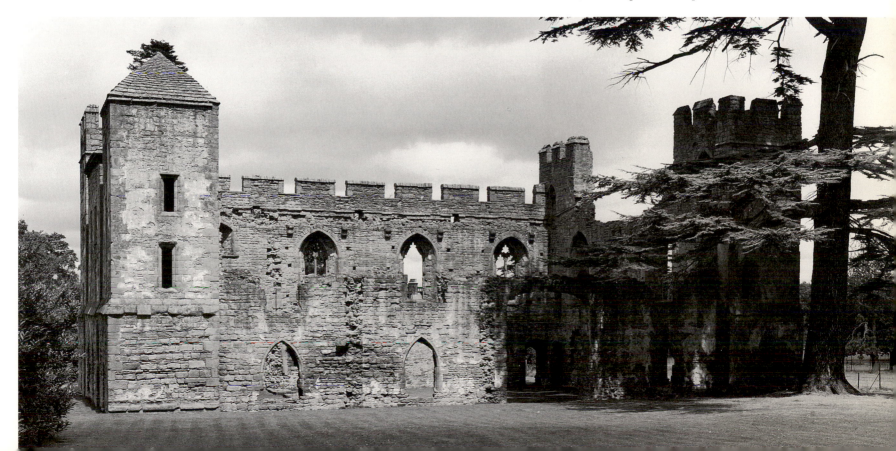

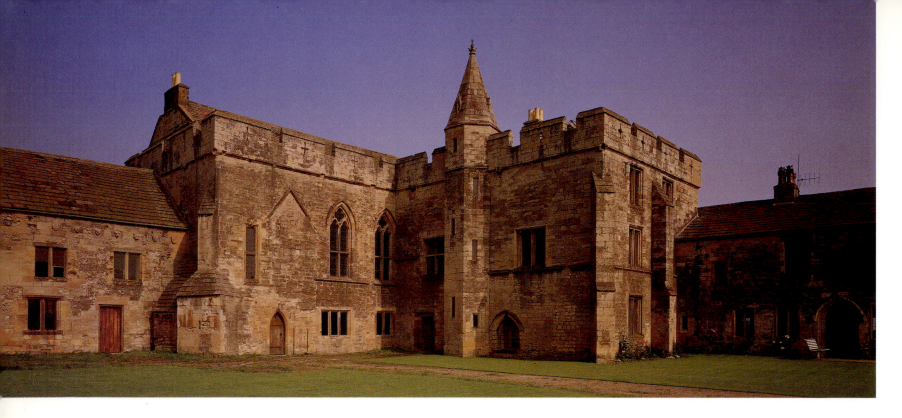

183. Licence to crenellate Markenfield, in West Yorkshire, was granted in 1301, and it is probable that the moat and curtain wall date from that time. The fourteenth-century domestic quarters in the north-east corner of Markenfield's enclosed court included a first-floor hall (left) over a kitchen, with a big solar, private chapel, and contemporary stair turret in the attached range.

184. A strong residential tower, now chiefly known for the contemporary wall-paintings in the Great Chamber, was added in c.1300 to the existing manor house at Longthorpe, near Peterborough.

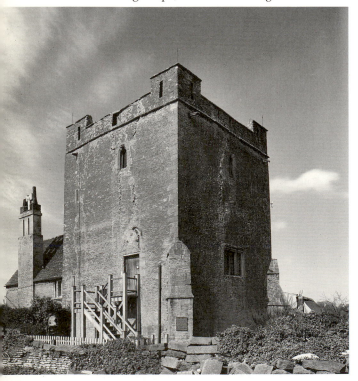

it had been hopeless destitution. In pre-plague Britain, the great and unresolvable evil was overcrowding. Already, famine and disease had operated more than once to cut back surplus population. Yet the probability had remained of population recovery, whatever the degree of any loss.[102] Landowners repeatedly, while surprised by every crisis, nevertheless pulled themselves successfully from each trough.[103] The Black Death, accordingly, was all the more significant because the solution it provided was once and always.

One immediate consequence, still visible today, was a halt in contemporary building programmes. At no time had building been more voluptuous or extravagant than in the immediate pre-plague decades. The froth was blown off it by the Black Death. Tideswell Church, in Derbyshire, was one of the exceptions. Shortly after 1350, work re-started there again on a scale still grander than before. Yet even at Tideswell there was a noticeable pause in 1349, followed by a change in direction.[104] At Ashbourne, to the south, a similar programme of reconstruction, slowed dramatically by the plague, never subsequently recovered its momentum. Ashbourne remains one of Derbyshire's great parish churches. It has a fine pre-plague steeple over the crossing, big transepts, a spacious congregation-packing nave, and broad south aisle. But the nave at Ashbourne was never vaulted, and a north aisle, although projected, was never built. Both were overtaken by the pestilence.[105]

There was a new vicar at Ashbourne in 1349, very probably succeeding a plague victim. In that year too, Wolstan de Bransford, bishop of Worcester, died of the plague, and the rebuilding of his cathedral was interrupted.[106] Many of Worcestershire's parish clergy are known to have perished with their bishop. In Bransford's diocese, there were 217 new institutions to benefices in 1349, compared with only 14 in the previous year.[107] Inevitably, the mortalities which halted the cathedral works, similarly brought pause to the parishes. The same was true all over the country. One obvious casualty was Northborough Church, in Northamptonshire, in course of rebuilding as a family mausoleum when stopped short by the plague at the south transept.[108] In Leicestershire, lop-sided Medbourne was another probable victim of the pestilence, with only its south aisle and south transept complete.[109] There never would be a southern equivalent of the lush north aisle finished in 1335 at Suffolk's Kersey.[110] Only the big chancel of half-complete Cley-next-the-Sea (Norfolk) was in use after 1349; all the rest

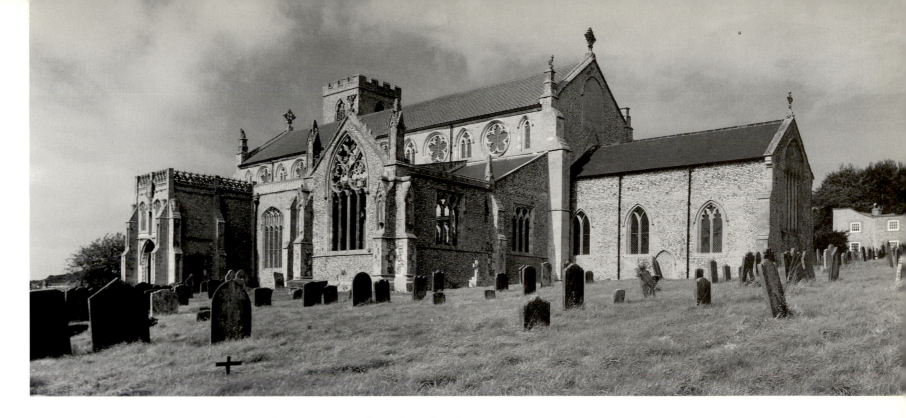

of the building – transepts, aisles and nave – stayed roofless for three generations.[111] At Ashwell (Hertfordshire), on the north wall of the church tower, a famous inscription recalls even now that 'wretched, fierce, violent' pestilence after which only 'the dregs of the populace live to tell the tale'. 'Death is like a shadow,' warned another graffito at Gamlingay (Cambridgeshire), 'which always follows the body.'[112]

The woes of the times were felt most keenly by those ill-accustomed to suffering. Busy estate managers like the Benedictines of Battle had continued to build actively right up to the Black Death. Yet by 1351, the plague had cost them permanently some 20 per cent of their revenues, and that was not the limit of their losses.[113] Durham Priory, similarly, suffered a collapse of receipts, particularly in spiritualities, or tithes. [114] At Selby, it was the Black Death unquestionably which persuaded the abbey to move without further hesitation into leasing.[115] Only a few years before, Selby's monks had spent lavishly on a grand new choir, at least as magnificent as their nave. After the 1340s, although still ready to invest in their domestic comforts, they added nothing of any substance to their church. Both Battle and Durham reacted similarly.[116]

One last oasis in the Possessioners' desert was Edward III's foundation, next to the Tower of London, of a new Cistercian community at St Mary Graces. The initial circumstances of the foundation were Edward's recent victory over the French at Crécy in 1346, and his escape from shipwreck the following year. It was a thoroughly traditional Plantagenet initiative, with exact precedents at Hailes (1246) and Vale Royal (1274). However, the plague's intervention in 1348-9 added a third cause to the rest. The Cistercians of St Mary Graces, from their settlement in 1350, remembered especially the king's late confessor, Thomas Bradwardine, archbishop of Canterbury and *doctor profundus* : the Black Death's most elevated victim.[117]

Of the older-established orders, only one other London community was directly consequent on the plague, and that was a house of Carthusians. Characteristically, it was to recluses like the Carthusians and to a mixed assemblage of friars and chantry priests– full-time guardians of the soul – that benefactors of the period turned most readily. Edward III himself gave more generously to his College of St George, in the castle at Windsor, than he ever did to the Cistercians. And even the London Charterhouse, founded in 1371 after many

185. It was probably the Black Death of 1348–9 which halted an exceptionally grand rebuilding of the parish church at Cley-next-the-Sea. Building was resumed only in the fifteenth century, when the bulk of the church was roofed and a new porch was built on the southern show-front. In the sixteenth century, as the port's trade declined, both transepts were walled off and abandoned.

186. Abbot Lytlington's massive bell-tower, at the west end of the parochial aisle at Crowland, was one of the final products of a rebuilding programme halted at the Black Death and resumed again only in the early fifteenth century.

187. Edward II's monument in Gloucester Cathedral. The king's murder at Berkeley Castle on 21 September 1327, and subsequent burial here at Gloucester, was the beginning of a hugely successful popular cult, financing a great programme of rebuilding.

delays, began in 1348 as a secular college and plague burial ground. John of Reading, a monk of Westminster, watched these new developments with dismay. Writing after 1361, following the second major onset of the plague, John saw 'all the wealth of this world' left behind by the dead, and greed around him everywhere. 'This Mammon of iniquity,' the Benedictine wrote,

is thought to have hurt the religious most of all; but it dealt the mendicant orders a mortal wound. For these latter found so much superfluous wealth flowing to them from their confessions and the legacies of their penitents, that they would scarcely deign to receive the offerings of the faithful. Without more ado, little heeding their profession and their rule, which consist in mendicant poverty, they gathered from all sides superfluous equipment for their rooms, their tables and their horses, being tempted thereto by the devil.[118]

John of Reading was no unprejudiced witness. Only a few years before, certainly influencing his judgement, Westminster had lost the patronage of Isabella of France (d.1358), the queen-dowager and a very wealthy lady. Isabella had been 'seduced' by her Mendicant confessors to alter her will, and was later buried in the Franciscan churchyard at Newgate.[119] But if John's conclusion that 'the friars always spoil their penitents' is not to be taken too seriously, there is the ring of truth in what he had to say about a contemporary florescence in friary building. The great Dominican church at Norwich, cathedral-like in its proportions, is a rare but significant survival. Begun on a fresh site in 1327 and still new when John of Reading wrote, the friary church was destroyed by fire in 1413, only to be almost immediately rebuilt. There was no lack of local patrons, both citizen and gentry, to support its reconstruction on that scale.[120]

Few, if any, of the great Possessioner houses could have commanded equal loyalty by this date. Yet they had rarely so needed their friends. Every landowner's prosperity had been undermined by the recent 'death of men'. Village communities had been loosened at their roots. When all twelve of Merton College's villeins at Cuxham died in 1349, others flocked to replace them. But the new men were most unlike the old. They wanted more in wages, and gave less in labour. They were turbulent, disobedient and ill-disciplined.[121] Conflict between the 'haves' and the 'have nots' of village society had already troubled pre-plague England.[122] After the Black Death, as mortalities relieved the pressure of these inter-group frictions, the survivors turned collectively on their lords. With so many new faces in every community, old loyalties counted for nothing. In 1348–9, fully 70 per cent of Crowland's tenants at Oakington died of the plague or other causes; 57 per cent at Cottenham; and 48 per cent at Dry Drayton.[123] In the same years, the Premonstratensians of Titchfield lost 305 of their 515 tenants; another 92 perishing in 1361–2, when the plague made its second visitation.[124] It was John of Reading's estimate, having lived through both pandemics, that 'barely a tenth part of the people survived, the great majority having been carried away by the plague'.[125] His figures were as inflated as his loathing of the friars, but the shock they still recall was very real.

Demoralized by loss, monastic builders interrupted their work or gave up cherished programmes altogether. At Worcester Cathedral Priory, the halt in nave construction lasted several decades, sufficient to embrace a change of master mason and the adoption of a new style of building. Other grand enterprises, like the nave at Bristol Abbey, were never carried through to completion.[126] Luckier contemporary programmes included Gloucester Abbey, birthplace of English Perpendicular. And there were big building schemes starting up again, before the end of the century, at major churches like Canterbury and Winchester. Even the monks of Crowland, by the 1410s, had regained their nerve sufficiently to embark on a remodelling of their church.[127] But the stock response everywhere had been to halt work abruptly, with little hope, at many houses, of

a resumption. Neither the Gilbertines of Mattersey nor the Benedictines of Milton ever fully rebuilt the churches they had lost in the fires of 1279 and 1309 respectively.[128] Littleshall's enlarged choir, laid out at this time, never rose above its foundations.[129] At Kirkham, the over-ambitious replanning of another Augustinian house was to stall permanently by the mid-century, if not before.[130] Back in 1301, in happier days, the wealthy nuns and canons of St Gilbert's Sempringham had begun a new church of 'marvellous greatness'. But this 'most costly undertaking' had faltered already by 1317, far exceeding available resources. In the 1390s, Sempringham's huge church remained unfinished: a prominent reminder of landowner indigence and of the times' continuing 'malignity'.[131]

Such high visibility, when their fortunes had soured, did the monks and their allies little service. In direct and humiliating contrast to Bristol Abbey's failure, the reconstruction of St Mary Redcliffe, the canons' near neighbour, began again no later than the 1370s.[132] This 'fairest, goodliest, and most famous parish church in England' was at least as grand as any abbey. It was hugely enriched by Bristol's merchant community, most prominently the ship-owner, William Canynges (d.1474). Canynges lies buried at St Mary Redcliffe, of which he personally financed the re-roofing. He has two memorials: the earlier shared with his wife, Joanna, who died before him in 1467; the later to himself as a priest of Westbury, the secular college he then joined.[133] Like the citizens of Norwich, patrons of the Mendicants, the men of Bristol turned their backs on the Possessioners.

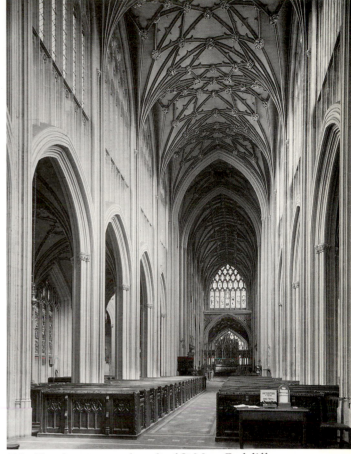

188. The clerestory and vault of St Mary Redcliffe (Bristol) are a Perpendicular rebuilding of *c*.1450, financed by William Canynges, the ship-owner.

189. Effigies of William Canynges and of Joanna, his wife, in the south transept of their parish church at St Mary Redcliffe.

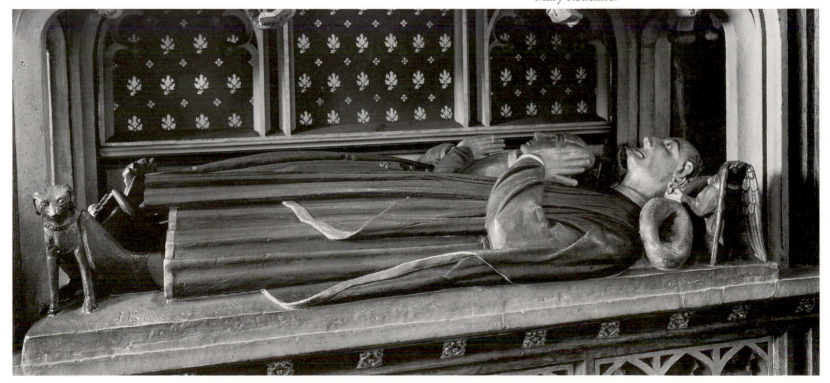

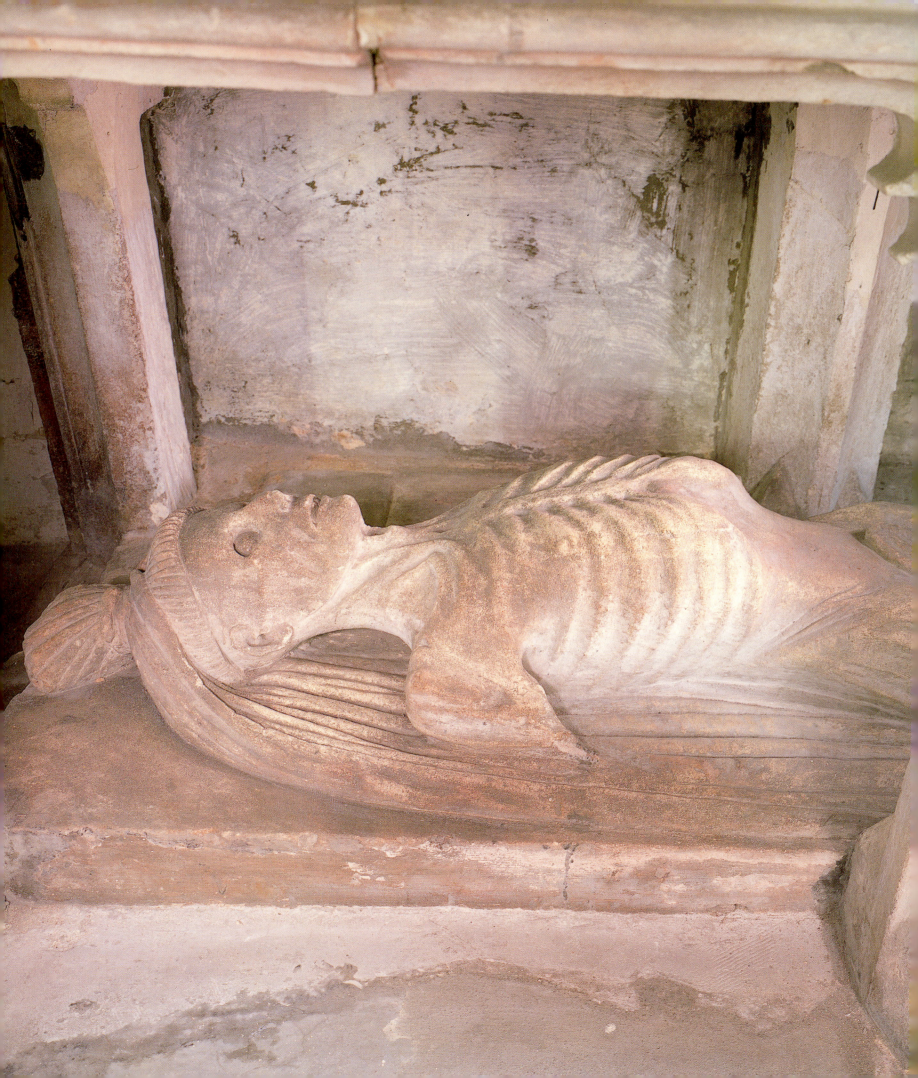

CHAPTER 6
Learning to Live with Death

Death cast a long shadow after 1349. At Easter that year, St Albans lost its abbot, its prior, sub-prior and forty-six monks, all within a matter of days. The next month, in May, the abbot and twenty-six monks of Westminster died. The community at Llanthony Secunda, in Gloucestershire, was reduced by two-thirds. At Meaux, in Yorkshire, the loss was as much as four-fifths. At Wothorpe, in Northamptonshire, only one nun survived, and the priory shortly afterwards closed down.[1] These are shocking statistics. But they are made much worse by the apparent permanence, even at the larger houses, of such reductions. The obituary lists of Christ Church (Canterbury) provide an exceptional run of evidence for the period. Christ Church lost only four of its number in the Black Death. Then in the second visitation of the plague, between 9 June and 4 October 1361, twenty-five monks were carried off. That third of the community lost in 1361 was never fully made up. From 1395, when the obituary lists resume after a prolonged gap, there were successive mortality crises at the cathedral priory at intervals of rarely more than four years. Tuberculosis, sweating sickness, the plague and dropsy were all big killers at Canterbury. Far from improving in the fifteenth century, the life expectations of these comfortably-off monks deteriorated significantly throughout the period.[2]

Nothing suggests that the Canterbury figures are exceptional. If anything, mortalities at the cathedral priory are likely to have been below average. 'We are left in no doubt,' it has rightly been said, 'that by almost any standards of comparison the monks were exceedingly well fed, clothed and sheltered, and that they benefited from levels of sanitation, hygiene and medical care which were wholly exceptional for the times.'[3] In practice, these circumstances offered little protection, and the high mortalities experienced at Canterbury continued right through into the early sixteenth century. Over the country as a whole, there is as yet no agreement among demographic historians about when sustained recovery first began. Even the full extent of the late-medieval population collapse is still unknown. What is certain is that the crisis was severe and prolonged, and that the population of England in the late fifteenth century was scarcely larger than it had been in the twelfth.[4]

If any still doubt the profound effect on society of this 'golden age of bacteria'[5], they need only pay attention to its art. It is true that the popular morality painting, *The Three Living and the Three Dead* , often associated with the plague, was already current in England in the decades before the Black Death. Telling of an encounter between three young huntsmen and the cadavers they will shortly become, it occurs among the moralities at Longthorpe Tower (Northamptonshire), generally dated to the 1320s or 1330s. There are contemporary versions of the identical theme at three (and probably more) parish churches: Widford (Oxfordshire), Hurstbourne Tarrant (Hampshire), and Wensley (North Yorkshire).[6] Even before this time, the simple message of the Wensley mural – 'As we are now, so shall thee be' – is to be found on the late twelfth-century Bishop Jocelin slab at Salisbury Cathedral and on a similarly dated grave-cover at Monk Sherborne.[7] Nevertheless, mortality reminders multiply appreciably after the Black Death, when they may become, as at Peakirk, much more terrible.

190. The cadaver effigy of Sir John Golafre (d. 1442) at Fyfield Church; on the bier above, the same knight lies fully clad in plate armour.

191. At Peakirk Church, slugs and worms cascade from the cadavers in this mid-fourteenth-century Northamptonshire rendering of the legend of *The Three Living and the Three Dead.*

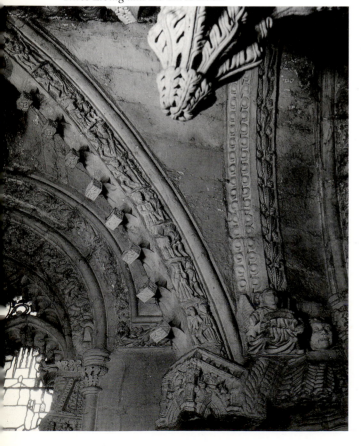

192. *Dance of Death* sculptures on a vault rib (centre) of William Sinclair's ambulatory at Rosslyn Chapel; another subject chosen at Rosslyn in *c.*1450 was *The Three Living and the Three Dead.*

In this Northamptonshire version of the familiar 'warning picture', only two of the Three Dead are preserved. They are infested with moths and with other symbols of corruption; they drip with slugs and worms.[8]

Other *Three Living and Three Dead* paintings of the post-plague period might appear, on the face of it, more light-hearted. There is something quite merry about the Wickhampton (Norfolk) painting, probably the best preserved of its kind. Here a boy and a hare carry on the chase, as three fashionably dressed young hunters, one with a hawk on his wrist, encounter three cadavers in the forest. At Lutterworth (Leicestershire), in a common version of the tale, the hunters are rendered as three kings.[9] But the choice of such opposites was deliberate. Death's most shocking quality was its capricious sweep; it cut down youth in its freshness and regality in its pride; it paid no respect to rank or wealth. 'Away, while I flee', cries the king at Belton, reining round his horse before the Dead. There was nowhere, it is certain, for him to go.[10]

Still more obviously a response both to plague and social protest was that related morality, the *Dance of Death*. No rendering of the *Dance* is known in Britain before the fifteenth century. It was only occasionally to be found after the Reformation. What it provided for its own period was a reassuring message of injustice remedied by Death. The *Dance*, above all, was a leveller. Rosslyn Chapel, south of Edinburgh, is a rich repository of contemporary beliefs and values. Its luscious mid-fifteenth-century sculptures, commissioned by the literate and wealthy William Sinclair, earl of Orkney, include a *Dance of Death* in which high-stepping cadavers lead off a king and a cardinal, a bishop, an abbot and a knight. They take lowlier folk also: a ploughman, a carpenter, and a gardener. But though 'both high and lough shal go on dethis daunce', it was the former who departed with greater sorrow. 'My gaze is on my enemy', sang the Welsh priest-poet, Dafydd Trefor of Anglesey,

> the thief of man leading to the dance; mirthlessly leading the pope, and throwing him corrupted to his grave; drawing the emperor from his father's tower, and pulling his highness under you. You do not respect barons or king after wine You take the proud man gravewards, and honour goes the same way. You summoned each in his rank to the graveyard In every guise you appear, there is no power to shun you.[11]

There is a painted glass panel at St Andrew's Church (Norwich) on which Death, on a chess-board, leads off a mitred bishop, visibly flinching at his touch. At the former priory church at Hexham, the victims are a pope and an emperor, a cardinal and a king. At Newark, a dancing skeleton points to the grave as a richly dressed youth, moving puppet-like to the same rhythm, fumbles for a bribe to forestall him.[12] The image was powerful and long-lasting. Over a century later, in the early 1600s, the *Dance of Death* reappears on a carved chimneypiece at Yorkshire's Burton Agnes.[13] At South Dalton Church, in the same county, a marble cadaver, typically late-medieval, underlies the Baroque effigy of Sir John Hotham (d.1689). [14] But there is no reason for thinking that because *memento mori* warnings lasted so long, they lacked any earlier significance. Of the many cadaver effigies of late-medieval England, none is more terrible than the Golafre monument at Fyfield. Sir John Golafre died in 1442. He lies in full armour on a crenellated bier, with his cadaver immediately below him. Golafre's body is wasted; his eyes are deep hollows; his head is thrown back as though caught in a spasm; his mouth gapes horribly in a rictus.[15] The Fyfield sculptor, inept in other ways, knew Death with all the ease of a familiar.

It was Death's habitual presence, whether in threat or actuality, which gave meaning, form and relevance to this art. Cadaver effigies like Golafre's at Fyfield are encountered for the first time in this period. While sometimes merely grisly and macabre, they can yet make that point about the transience of wealth which

opens the modern burial service even now. The John Baret (d.1467) cadaver monument at St Mary's, Bury St Edmunds, carries this familiar inscription: 'With your good prayers I pray you help me / For like as I am, so shall ye all be.'[16] Baret lies in the great Perpendicular church to which he and his wealthy fellow burgesses, John Nottingham (the porches) and Jankyn Smith (the chancel chapels), each made a major contribution. They were all prominent drapers and rentiers of Bury. They were members of Bury's pugnacious Alderman's Gild which united in resistance to the Abbey. Some founded gilds of their own. Jankin Smith's gild was 'The Sweet Man Jesus'. Richly endowed as a collegiate body, the gild's sole purpose was the daily celebration of memorial masses for the souls of Jankin Smith and his kin.[17]

Civic pomp, pride and ritual featured largely in commemorative activity of this kind. Jankin Smith, after securing his soul, left most of his great fortune to Bury's town gild, to be administered for the general good of the community. Both John Nottingham and John Baret were major benefactors of Bury, and it was William Baret, nephew of John, who rebuilt St James's Church (now the cathedral at Bury) after the fire of 1465.[18] Arguably, it was less from morbid anxiety than 'as befits an alderman' and 'according to the custom of the town', that equivalent burgesses at Kingston upon Hull poured wealth and devotion into Holy Trinity, to make it the greatest urban church in the land.[19] Such civic purposes have a momentum of their own, and panic may be difficult to sustain. 'Whan that the month of May / Is comen, and that I here the foules synge, / And that the floures gynnen for to sprynge, / Farewel my bok, and my devocioun', sang Geoffrey Chaucer, as men died all around him of the plague.[20] But Chaucer's own relatives, his son and his granddaughter, behaved differently. Ewelme, in Oxfordshire – almshouse, church and school – is the most perfect of family memorials. The manor, the home of Thomas Chaucer, Geoffrey's son, was obtained through his wife, Matilda Burghersh. Thomas (d.1434) and Matilda (d.1436) lie in fine style at Ewelme Church, their tomb-chest resplendent with family heraldry. Shortly before, the church had been rebuilt by their daughter, Alice, following her marriage to William de la Pole, earl of Suffolk. William, raised to duke in 1448, was murdered two years later. His duchess survived him another quarter-century, and it is her monument that dominates the building. It is an enormous sepulchre in which Alice, stern-faced and coroneted, with the Garter emblem on her arm, reposes amid a company of angels. Below, barely glimpsed through the tracery of her tomb-chest, Alice's wasted cadaver lies hideous and naked, only partly covered by its shroud.[21]

'Here I am given to worms', Ralph Hamsterley of Oddington had his brass inscribed, 'and thus I try to show that, as I am laid here, so all honour is laid down.' His shroud indeed crawls with the creatures.[22] Oddington, like Ewelme, is in Oxfordshire. At the other Oddington, not far away in Gloucestershire, a mighty late fourteenth-century Doom, on the north wall of the nave, swamps the church interior with its warnings.[23] At Tewkesbury, in the same county, the fifteenth-century cadaver on the Wakeman cenotaph is infested by snakes or worms, a toad, a spider and a mouse.[24] 'Wake I or sleep, eat or drink, / When I on my last end do think, / For great fear my soul do shrink; / *Timor mortis conturbat me* [The dread of death do trouble me].'[25]

If little could be done about the dread of death, at least Purgatory's pains might be alleviated. Holme Church (Nottinghamshire) is an almost complete late fifteenth-century rebuilding. It is not a large church by the standards of its day. But it is the work of one man, John Barton the clothier, and his purposes are stamped upon it still. 'Pray for the soul of John Barton of Holme, merchant of the Staple of Calais, Builder of this Church', ran the inscription in Holme's big east window. Barton died in 1491. Before that time, he had remodelled Holme's nave, built a new south aisle, and considerably improved the existing chancel. South

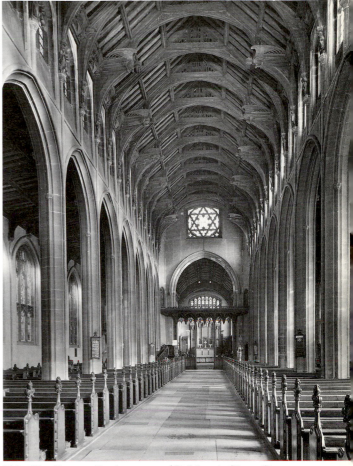

193. The Perpendicular nave of St Mary's (Bury St Edmunds), particularly noted for its fine hammer-beam roof, to which many of the borough's gildsmen contributed.

194. A fifteenth-century cadaver effigy, infested by worms and other creatures, on the Wakeman cenotaph at Tewkesbury Abbey.

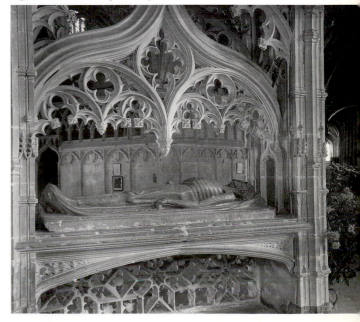

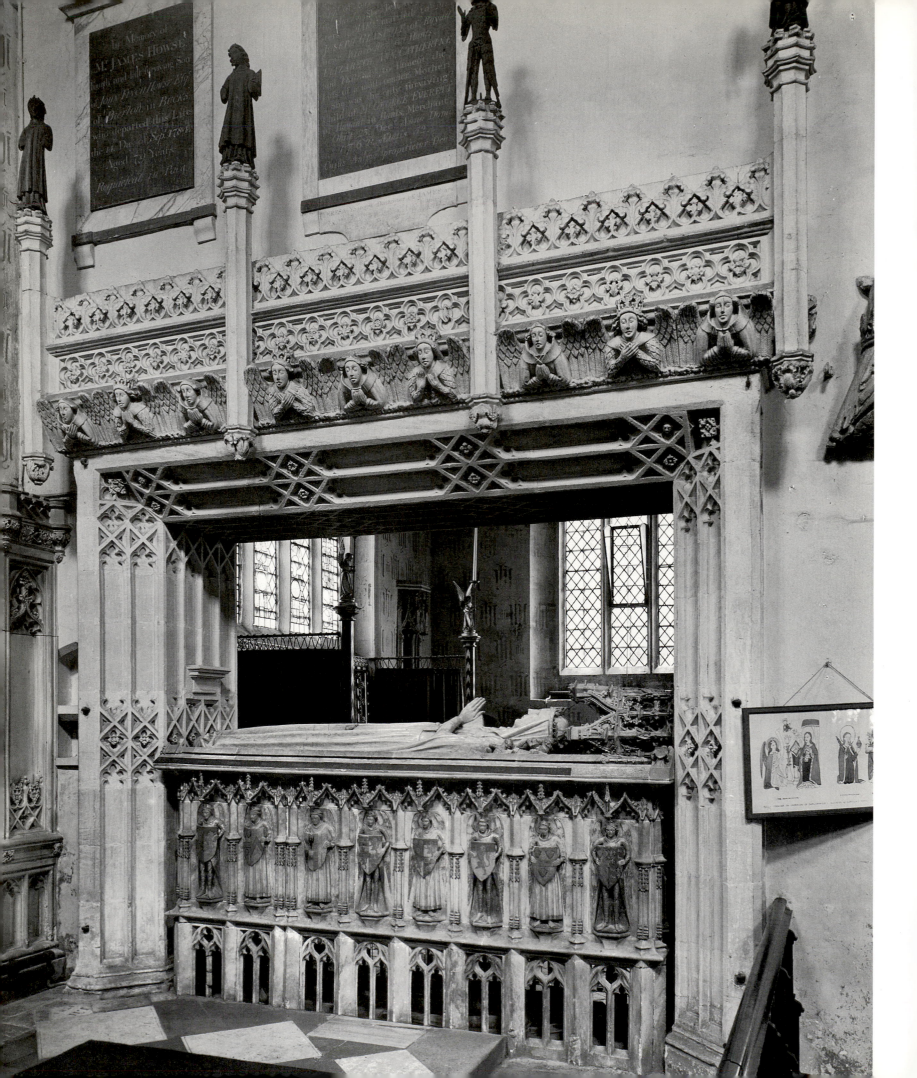

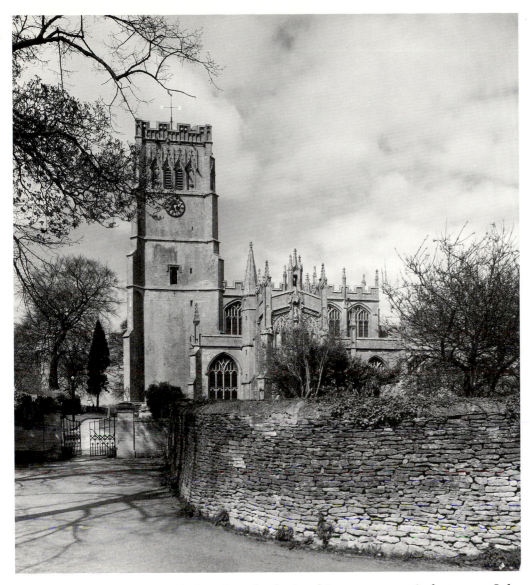

of the chancel, Barton added a chapel, placing his monument in between. John and Isabella Barton, man and wife, lie richly clothed in effigy on their tomb-chest. Below, a single cadaver has its mouth agape, as if screaming for a last gulp of air. Barton's monument carries a second inscription: 'Pity me, you at least my friends, for the hand of the Lord has touched me.' A third inscription, once in a window of Barton's house, spoke eloquently of the man and his period: 'I thank God and ever shall. / 'Tis the sheepe hath payed for all.'[26]

The sheep were paying for much else. Holme is sited just to the north of Newark, where Barton did most of his business. There, at Newark Church, it was the sale of wool and of a flock of sheep which financed the building of Meyring's Chantry in about 1500. On the near-contemporary Markham Chantry, it was wool sales again which filled the purse of that unfortunate young man who treads the *danse macabre* to this day. In those years too, Newark Church was undergoing its transformation. The work that had begun there before the Black Death had got no further than the reconstruction of the south aisle. Then building resumed again in the mid-fifteenth century, beginning with the north aisle and the nave. A big aisled chancel was added at Newark in the 1490s. Shortly afterwards, prodigiously glazed transepts were attached to the church, and a major refurnishing was undertaken.[27]

Newark, like Holme, is a 'wool church', owing its rebuilding to this trade. It has many equivalents, up and down the country, from Cullompton (Devon) to Dedham (Essex), from Northleach (Gloucestershire) to Salle (Norfolk), from

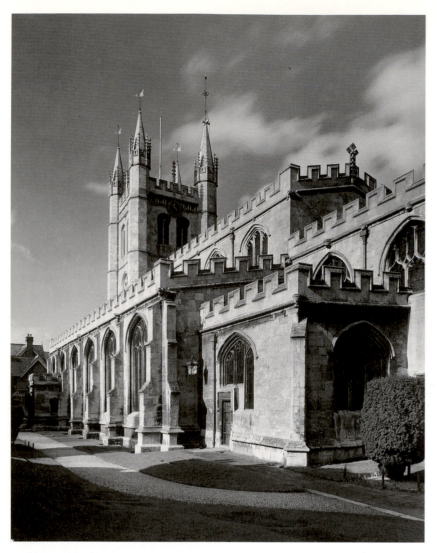

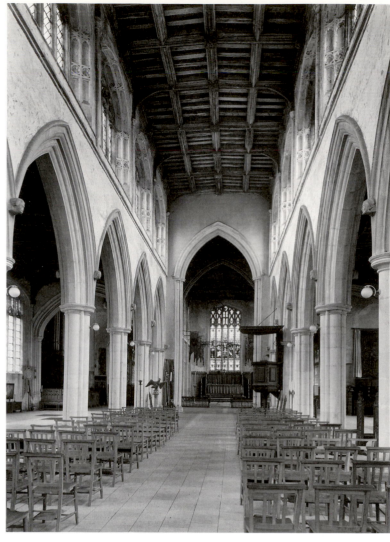

Hitchin (Hertfordshire) to Steeple Ashton (Wiltshire), with Berkshire's Newbury, Somerset's Yeovil, Oxfordshire's Chipping Norton, and many others. At Ludlow (Shropshire), it was the wealthy gild of palmers who rebuilt their parish church; at Thaxted (Essex), it was the master cutlers. Ludlow's palmers, richly attired, are still to be seen on a window of their church, feasting grandly in the company of their fellows. On another window, the so-called 'Golden Window', generally acknowledged to be Ludlow's best, a merchant of substance kneels in prayer, under a splendid *Annunciation*. John Parys died in 1449. 'Katherine his wife', the inscription runs, 'caused [this window] to be made.'[28]

Ludlow's rebuilding was an exhibition of wealth. And great churches like Ludlow, like Thaxted or like Newark, have sometimes been seen as evidence of prosperity in the Late Middle Ages, contrary to those who might have argued the reverse.[29] However, wealth on its own is seldom the best explanation of these programmes. Cloth and tin, both expanding trades at the time, have been invoked to explain continued church-building in Devon and Cornwall through the worst of the mid-fifteenth-century recession.[30] But other regions, less favoured than the south-west, nevertheless saw rebuildings throughout the period. And the great majority of church reconstructions, far from being a record of widely shared prosperity, were individual thank-offerings for good fortune in the past or purely personal insurances for the future. At John Barton's Holme, it was the sheep which 'payed for all'. At Fairford in Gloucestershire, the rich clothier, John Tame of Cirencester, built himself a church in the 1490s which, in its glazing

especially, was as sophisticated and costly a private memorial as anything undertaken by the king. His inscription tells us why: 'For Jesus love pray for me / I may not pray, nowe pray ye / with a pater noster and an ave / that my paynys relessyd may be.'[31]

A century earlier, Walter Skirlaw, bishop of Durham (1388–1406), donated a new church to his Yorkshire birthplace, the village of Skirlaugh in the East Riding. It is a charming building of uniform date and superior quality, but what it principally resembles is a college chapel. Bishop Walter was a prominent member of the career clergy. He was a royal chancery clerk and keeper of the privy seal; a widely travelled diplomat; an Oxford man who never ceased to be grateful for that beginning. What he built for himself at Skirlaugh was a very personal affair: less a parish church for the benefit of the community than a chantry for the comfort of his soul.[32]

The ambition was common enough. However, it was likely to be dependent on uncommon resources, and few achieved it entirely on their own. Individual circumstances might change. At Norfolk's Shelton, for example, a major rebuilding of the parish church came to a halt in 1487 on the death of Sir Ralph Shelton, its 'founder'. Ralph left clear instructions in his will that year to complete the work he had begun. But the chancel was skimped, the nave roof left unmade, and even

197. (far left) Newbury Church, in Berkshire, was entirely rebuilt in the early sixteenth century, principally at the expense of a single wealthy clothier, John Smallwood ('Jack of Newbury'). 'Of your charity, pray for the soul for John Smallwood . . . [and of] Alice his wife', urges their brass.
198. (left) The Cutlers Gild at Thaxted financed many improvements at the parish church of this little Essex town, including the sixteenth-century clerestory and nave roof.
199. (lower left) Detail of the costly stonework on the crossing tower at Fairford Church, rebuilt by John Tame (d.1500) and by Sir Edmund Tame (d.1534), his son.

200. Fairford Church (Gloucestorshire).

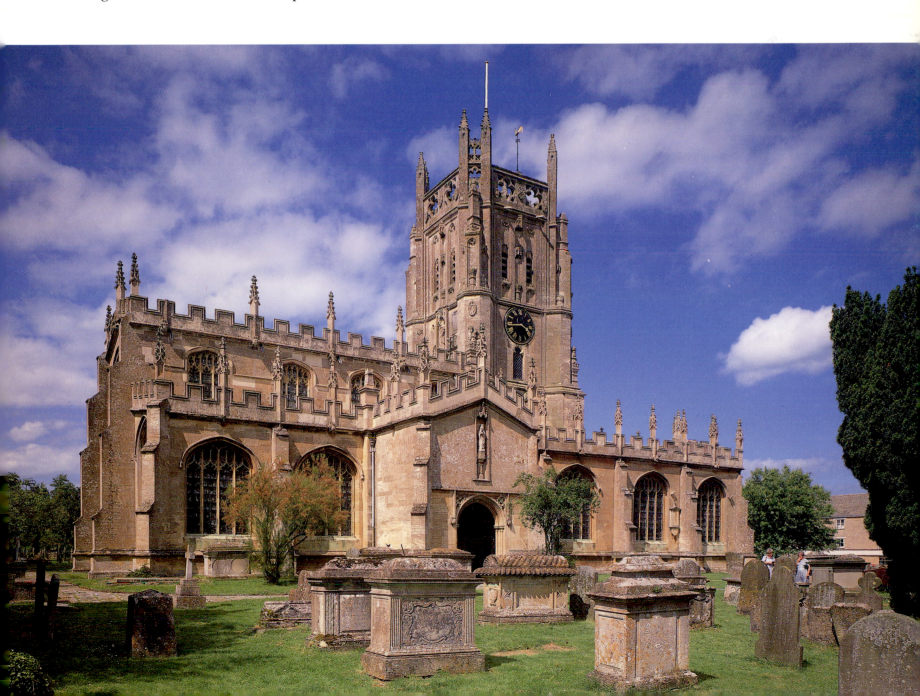

201. Etchingham Church's austere arcades may reflect the declining estate revenues, towards the end of his life, of Sir William de Etchingham (d. 1389), its rebuilder.

203. (right) On rebuilding the chancel at Norbury Church, in Derbyshire, the fitz Herberts filled its windows with their heraldry. The great east window, restored in 1973–83, has heraldic circles at the head and saints below, including fitz Herbert of Norbury (centre) over Edward the Confessor and other saints. The side windows have yet to be restored.

202. The spire of Bridgwater Church, built in 1367, was financed by parish collections, bequests, and other gifts.

Sir Ralph's tomb remained unfinished.[33] Etchingham Church, in Sussex, was an earlier project which similarly shows evidence of economy. In the 1360s, when Sir William de Etchingham began work on a new church, his personal finances looked secure. But by the end of the next decade, with some distance still to go, the receipts from his estates were shrinking fast. Etchingham has an austerity uncharacteristic of its period, probably reflecting this recession. Yet William got his value all the same. Before his death in 1389, he had commissioned a brass which he installed in the chancel floor, next to the altar. The brass records, at its head: 'This William caused this church to be rebuilt anew.' At its foot, another inscription calls upon passers-by to pray for the knight, for of earth he was made and to earth he has most certainly reverted: 'May God have pity on my soul.'[34]

Etchingham was an investment, increasingly sought by its day, in the once and future glory of a clan. In Etchingham's chancel windows, the arms of Sir William once kept company with those of England's premier earls and royal dukes.[35] Similarly at Norbury Church, in Derbyshire, where a complete heraldic scheme still survives in the fitz Herberts' chancel, the lords and patrons from the castle next door share windows with the noblest in the land.[36] There is little evidence in such programmes of economy. Nor was cost-paring characteristic, even with congregations much reduced, of the many church refurbishments of the period. A good deal could be achieved by common action, and parishioners everywhere raised funds collectively – much as they do today – under the inspiration of ambitious churchwardens. One such collection was made in 1367 for the spire of Bridgwater Church, in Somerset. Another financed the rebuilding of Bodmin Church (Cornwall) in 1469–72. While individually wealthy parishioners gave more generously than the rest, it was the cooperative endeavour of entire communities which brought these large-scale projects to fruition.

Bridgwater's spire of 1367 – 'exceedingly elegant . . . tall, fine and sheer' [37] – has since been much repaired and rebuilt. Nevertheless, it still stands today as originally intended: an ornament to the borough and to its neighbourhood. Some fifty years earlier, a new bell at Bridgwater had been financed out of parish collections, fully a tenth of its metal 'received from gifts as in jars, plates, basins, ewers, chattels, mortars of brass and mill [pots]'. [38] And when the spire itself was under construction in the summer of 1367, the same resources were drawn upon again. Thus the greater part of the spire-funding was secured within the borough, in general collections from each ward. Other contributions came in similarly from the adjoining villages. Some money was willed to the project and received through executors. A little more came in from individual gifts: Thomas Somer gave 20s, William Mostard and John Possebury gave 6s 8d each, John Lange donated half a crown.[39]

As many as 460 'voluntarie' donors were listed individually in the rebuilding accounts of Bodmin Church (1469–72). In addition, some gave their labour and surplus building materials – timber, lime and stone. Others contributed animals for later sale – two lambs, a goose and a cow. Most gave money, whether in person or by the group – from the 'maidens' of Fore Street, 6s; from the 'parish people', 19s; from the 'poor commons' as agreed, 'obolus [halfpenny] a man'. Bodmin's numerous parish gilds were especially prominent in the collections, no fewer than thirty-five of them making grants to the rebuilding. Almost all these associations were religious fraternities: cooperative chantries, usually of friends and neighbours, with no necessary connection with a trade. However, Bodmin's skinners and glovers (gildsmen of St Petroc) contributed as a craft, as did its smiths (SS. Dunstan and Eloy), its shoe-makers (St Anian), its millers (St Martin), and its tailors and drapers (St John Baptist).[40]

Cooperative fund-raising of this sort, in which all played their part, brought almost any ambition within reach. Boston, in Lincolnshire, had once been a great port. It prospered still in 1309, when the much-enlarged scale of a new church at

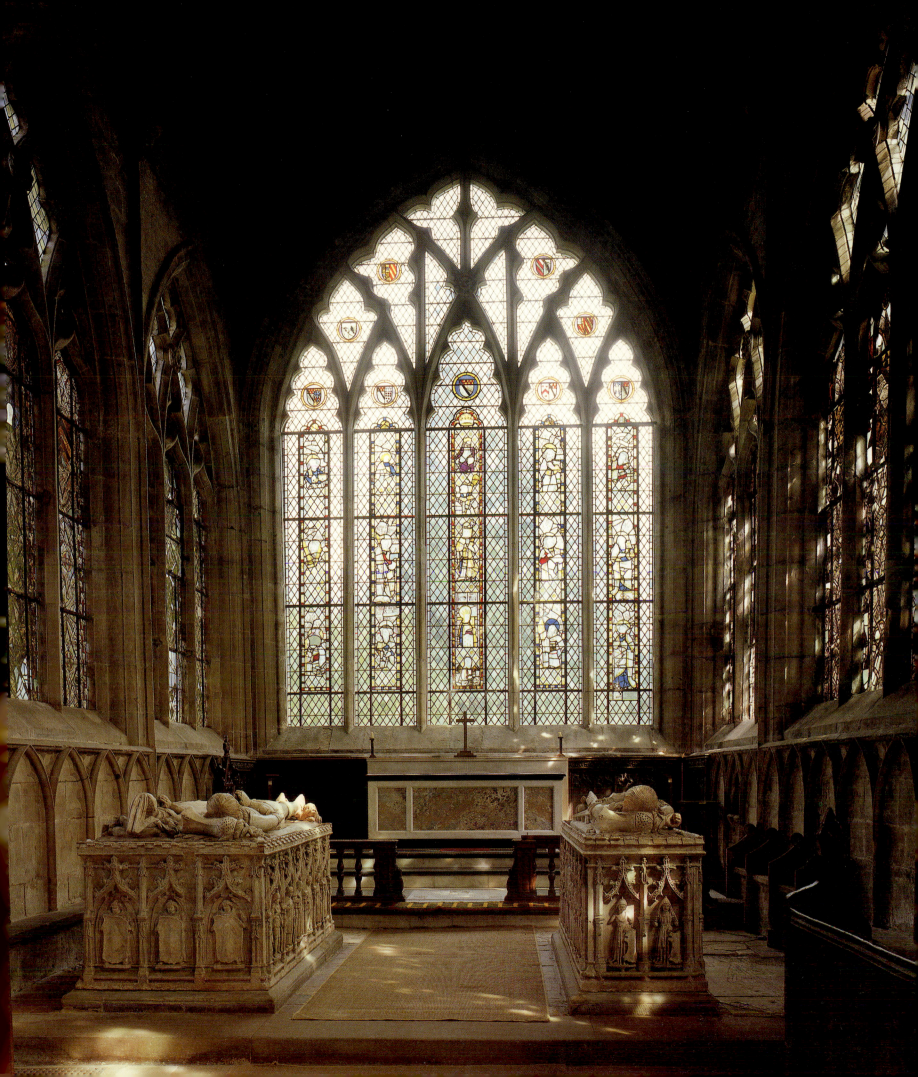

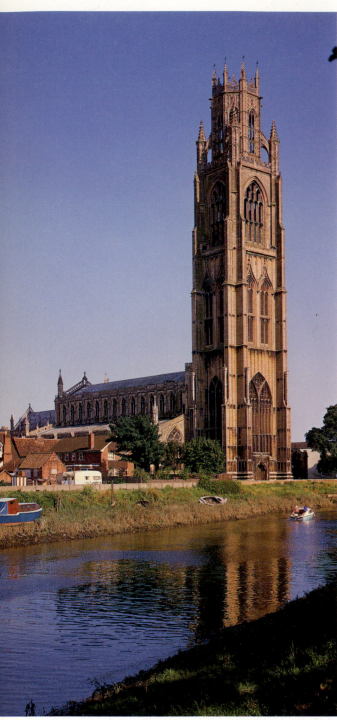

204. Boston's fifteenth-century Stump, dwarfing an already large church, was one of the prodigy towers of late-medieval Europe, and a landmark for many miles around.

St Botolph's was first determined. However, within a few decades of the onset of the Black Death, Boston's economy had collapsed absolutely, as catastrophically as any in the kingdom.[41] The consequences at its parish church are hard to see. 'Across the Washes . . . stands Boston', wrote William Stukeley in 1707:

> Tis remarkable for its beautiful Church and Steeple which is reckoned the highest tower in Europe . . . All the Country through there are very fine Churches . . . but this overlooks them all, like a proud Dame sensible of her beauty and scorning the meaner Crowd about her.[42]

Stukeley was mistaken about Boston's European rivals; there were some towers (very few) which were taller. But Boston's so-called 'Stump' was indeed a prodigy, raised by successive stages through the fifteenth century as 'hubris gripped the Bostonians'.[43] Heading this major cooperative effort were Boston's parish fraternities. And figuring among them prominently were the gildsmen of Corpus Christi, whose central purpose was the service of the dying.

At King's Lynn also, the Corpus Christi Gild was a major patron and landowner in the borough, receiving rents from its warehouses and other premises. The gild had a hall of its own, where it met to feast on Corpus Christi Day (the Thursday after Trinity Sunday). It maintained altars and chaplains at the churches of Lynn, and helped meet occasional expenses of the corporation.[44] Unequivocally, the gild was a product of the Black Death:

> During the great pestilence which was at Lynn in 1349, in which the greater part of the people of that town died, three men seeing that the venerated Sacrament of the Body of Christ was being carried through the town with only a single candle of poor wax burning in front of It, whereas two torches of the best wax are hardly sufficient, thought it so improper that they ordained certain lights for It when carried by night or by day in the visitation of the sick . . . and designed this devotion to last for the period of their lives. Others seeing their devotion offered to join them and thirteen of them drew up their ordinances.[45]

Some of the gild ordinances of Lynn have been preserved to this day, including those of the Gild of St Thomas, established in 1376 'for to maintain and find, before a certain image of St Thomas, in the church of St Nicholas of the foresaid town of Lynn, one candle of two pounds of wax, for to burn in service time every festival day in the year'. All gildsmen, it was prescribed, should go in procession to St Nicholas' Church on 7 July (the Translation of St Thomas), 'fairly and honestly arrayed'. At that mass, 'all the brothers and sisters shall offer a halfpenny, in the worship of God and of St Thomas'. The gild agreed to find a large candle – 'of 16 pounds of wax' – to burn at the Easter sepulchre. Gild members were to attend the dirges (offices of the dead) of their deceased associates; they were to offer a halfpenny on such occasions, and would in turn have the benefit of thirty memorial masses, sung at the cost of the fraternity. All would assist a colleague in distress, whether 'through loss on the sea, or through fire or any manner other', as far as in each of them lay.[46]

Gild funds accumulated in entry fees – five shillings, in the case of the Gild of St Thomas – and in fines for non-attendance at gild functions. And it was seldom long before the post-plague fraternities of a community like Lynn took up the refurbishment of the borough's churches. Within a generation of the founding of Lynn's St Thomas Gild, its associated church of St Nicholas had been entirely rebuilt in all but the steeple. The new gild, no doubt, was prominent in the work, and there were other gildsmen active in the same cause. Among these were the brethren of the 'Great Gild' of Lynn (the Trinity Gild), who maintained four chaplains at St Nicholas' Church, in addition to six others at St Margaret's Priory (where they had their gild chapel), and another three at St James'.[47] Huge

establishments of this kind found parallels elsewhere, and usually coincided with rebuildings. The palmers of Ludlow, dedicated gildsmen of St John the Evangelist, maintained a warden, seven priests, four 'singing men', two deacons, six choristers and a porter. 'There is but one church in the town,' reported John Leland of Ludlow in 1540, 'but that is very fayr and large and richly adorned and taken for the fayrest in all these quarters. The church has been much advanced by a brotherhood therein, founded in the name of St John the Evangelist'.[48]

Other great urban churches closely associated with rich brotherhoods were Coventry's St Michael's and Holy Trinity. At St Michael's, the smiths and the cutlers, the girdlers and the drapers, the dyers, cappers, cardmakers and mercers, all had altars of their own. Trades were represented at Holy Trinity also, among them the tanners and the butchers. But more important than these was the wealthy Trinity Gild, product of the post-plague merger of three major gilds: St Mary (the Gild Merchant), St Katherine, and St John.[49] Both St Michael's and Holy Trinity are big Perpendicular churches, extensively rebuilt from the late fourteenth century with the help of the brethren who maintained chapels there. In addition, the Trinity Gild at Coventry built itself a Gildhall of such quality and substance that it has been continuously in service ever since. Trinity's Gildhall of St Mary was rebuilt in the mid-1390s. It had a spacious common hall, with a lavishly panelled roof and with large windows, expensively glazed. There was a council chamber and a treasury, a vaulted undercroft, stores and a kitchen. The richly carved throne of the Master of Trinity Gild recalls the honour and the dignity of that office. It was a dignity to which royalty itself paid due regard. Under the north window of St Mary's Hall, a specially commissioned *Assumption* tapestry recalls the visit to Coventry in 1500 of Henry VII and Elizabeth of York. It shows their majesties at prayer, with the Virgin between them, and with a company of Apostles in attendance. St Katherine and St John Baptist survey the scene from above, as if welcoming the royal couple to gild membership.[50]

Few gilds aspired to recruitment at this level. Yet it was certainly far from unknown. Two dukes, three earls, and the king and queen were included in the devotions of St Barbara (London), founded in the early sixteenth century.[51] And there were other brotherhoods also, among them Boston's Corpus Christi Gild and the Great Gild of Lynn, which had memberships of similar distinction. Noble brethren like these expected no benefit from the social insurance of the gilds. Not for them the promise of the Coventry Gild Merchant that 'if any man or woman of the gild . . . has, by mishap and not by any fault of his own, fallen into poverty, the gild shall lend him a sum of money, to trade and make gains with, for one year or two, as they think well, without taking anything for the loan.'[52] Nor were the gilds' charitable functions, usually quite restricted, of any lasting interest to an aristocracy which had other means of giving of its own.[53] What attracted high-born membership was that provision, once again, for the future comfort of the soul which had been the motive for association from the start. 'First', began the Coventry statutes,

> the bretheren and sisteren of the gild shall find as many chaplains as the means of the gild can well afford; and shall enlarge or lessen the number of chaplains according to the more or less flourishing state of the gild . . . and they shall read, pray, and chaunt, for the welfare of holy church, for our lord the King, the Queen, Archbishops, Bishops, and other prelates and clergy of the realm, for dukes and duchesses, earls and countesses, barons and baronesses, and all other good men, and for the commonalty of the realm of England, and for all the bretheren and sisteren of the gild, and for all the good-doers to them. . . . [and] when any brother or sister of the gild dies, each of the chaplains shall chaunt for his soul, by his name, for a whole year next following.[54]

It was the steady accumulation of responsibilities of this kind, of new

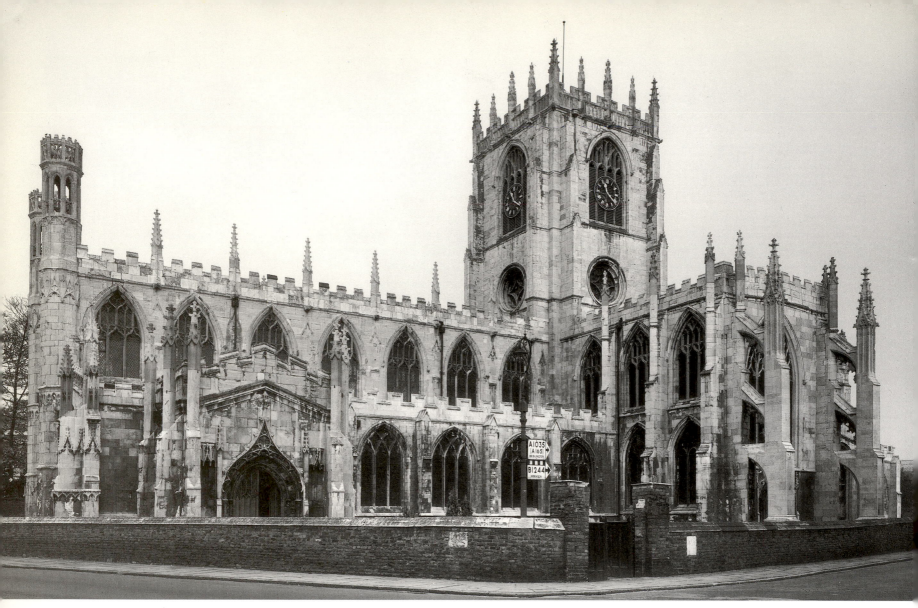

205. St Mary's Church was rebuilt as a cooperative effort of Beverley's townspeople within a decade of the collapse of the tower in 1520.

chaplaincies and of dedicated altars, which gave momentum to campaigns of church refurbishment. Even those gilds which had begun with no such purpose developed into expert fund-raisers as time passed. When, in 1520, the crossing tower at St Mary's (Beverley) collapsed, the townsmen and their gilds rallied instantly. Within barely a decade, the tower had risen more splendidly than before. Even quicker was the rebuilding of the damaged nave, completed by 1524. It was the musicians of Beverley, an inscription records, who met the whole cost of the nave's north-east pier; they are carved in comic miniature on its capital. A Beverley merchant, John Crossley, gave 'two pillars and a half'; the good wives of Beverley 'gave two pillars – God reward them'.[55]

God's reward was as much the object of those gildsmen of Roughton who had come together specifically in the late fourteenth century to renew the defective furnishings of their parish church. The initiator of Roughton's gild was Nicholas of Worstead.[56] And at just that time also, the parish church at Worstead, Nicholas' birthplace, was undergoing a reconstruction of its own. Worstead housed a wealthy clothier community. Its church, of which the nave was rebuilt in 1379 and the chancel remodelled a century later, is still one of the grandest in Norfolk. Some of its original furnishings survive. Worstead's fine west screen, dated 1501, was provided out of the funds of the 'batchelors' light, that God preserve, with all the benefactors of the same now and ever'. The rood screen, of 1512, was given by John Alblaster and his wife. Earlier legacies to the church had paid for a font cover in 1461 (William Eche), had helped repair the nave roof in 1480 (William Crosby), had met the cost of 'marble' paving in the south chapel

two years later (Robert Camonde), and had bought a new bell in 1493 (Roger Blome).[57]

Such piecemeal financing supported the building programmes at many East Anglian churches, through a century and more of remodellings. Parish collections assisted such works; there were plays and other fund-raising events in the churchyard; manor-court fines, in some areas at least, were assigned in half to the fabric.[58] However, what chiefly gave confidence to the churchwardens of the time was the steady accumulation of gifts and legacies, together with the reasonable expectation of many more. Sometimes these gifts were conditional. When, in 1509, John Dikke gave generously 'to the making of a new aisle in [New] Buckenham Church, £20 for the stonework and £10 for the timberwork', he made it a condition 'that the same work be ended and performed within this year'.[59] At Heydon in 1460, John Barker's 20 marks towards the building of the west tower was given only 'if the parishioners put a hand to it with a will'.[60] At St Stephen's (Norwich), as the Reformation took hold, a new urgency is to be heard in the bequests: £10 to the 'performing and full finishing of the clerestories' (Robert Green, 1540); 20 marks to the 'new making' of the church and £6 13s 4d to the new steeple, provided both were 'done in seven years' (Thomas Godsalve, 1542); £10 to the rebuilding 'within seven years' (Thomas Capps, 1545); £13 6s 8d to the rebuilding of church and steeple, on condition that the south aisle was rebuilt like the north, and that 'they begin in seven years', or the sum would be reduced to 10 marks (Edward Robinson, 1545).[61]

There is the date 1550 over St Stephen's west door and another of 1601 on the tower. And it was towers especially that required major funding and that encouraged competition between the parishes. Many church towers, as at St Stephen's itself, constituted the final element of costly and elaborate reconstructions. They were the last-born, the Benjamins, of extended building projects. They attracted particular expenditure. It was in the late 1530s that Wisbech's tower was finished, triumphantly ornamented with patronal heraldry and with pre-Reformation religious imagery. Somerset's noblest steeple, the prodigy at Taunton, was built between 1488 and 1514. That 'most perfect of Perpendicular steeples' at Louth, in north-east Lincolnshire, dates to 1501–15.[62]

Panelled from top to bottom in the most expensive flint flushwork, Eye's west tower is one of the finest in Suffolk. And it was at Eye in 1470 that more than £40 was raised in just one year, 'partly with the plough, partly in church ales, but chiefly of the frank and devout hearts of the people'.[63] That same generosity, straight from the heart, supported many similar enterprises. Over fifty bequests, beginning in 1501, helped finance the building of the huge detached belfry – the new 'stepill or clocher' – at East Dereham (Norfolk). Another fifty legacies, concentrated especially in the 1460s and 1470s, assisted the construction of the parish belfry at Wymondham, so monumental as to dominate the entire church. The tower was a gesture of lay defiance, directed against the monks who shared the building. It completed the reconstruction of the parochial nave, and followed an altercation between the Benedictines and their parishioners, which had left them woundingly divided. There are now two towers at Wymondham. The smaller is on the crossing, and was rebuilt as a belfry in the 1390s, exclusively for the use of the monks. It was the bells which caused the trouble. Desiring access to bells of their own, Wymondham's parishioners took their complaint to the courts. It took them half a century to get what they wanted. But in 1445, following a reconciliation, they were granted the site for their steeple. Two years later, in 1447, they obtained start-up finance from a sympathetic local landowner. Over the next half-century, their common endeavour was to outclass the monks absolutely.[64]

Special circumstances accounted for the rivalry at Wymondham. But the spirit of competition was more general. In Suffolk today, with less than five miles to

206. The Perpendicular steeple at Louth, built between 1501 and 1515.

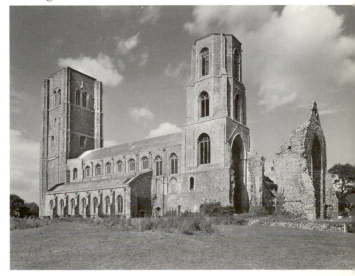

207. Wymondham's mid-fifteenth-century bell-tower (left) was built by the parishioners to hold their own bells, in open rivalry with the monks' belfry on the crossing.

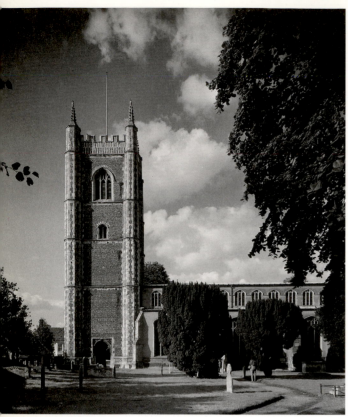

208. The huge west tower at Dedham Church was almost complete in 1519, when Stephen Denton left £100 to pay for battlements.

209. Unable to complete the tower they began in 1525 in competition with neighbouring Dedham, the parishioners of East Bergholt built themselves this timber bell-cage in the churchyard.

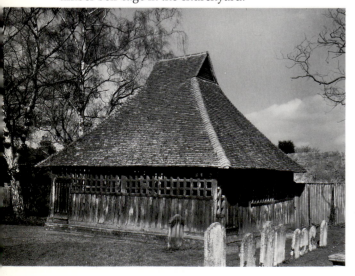

separate them, there are three very similar church towers. One is at Brandeston; another at Framsden; the third (and last-built) is at Helmingham. Dated 18 February 1488, the contract for Helmingham's steeple has been preserved. It records the parish's agreement with a Norfolk tower-builder, Thomas Aldrych, a native of North Lopham:

> [Thomas] with God's grace shall make, or do to be made, at the west end of the church of Helmingham aforesaid, a sufficient new steeple of 60 foot of height, after the breadth, wideness and thickness of the steeple of Framsden, with a black wall wrought of flint, and as many tables [stages] as the steeple of Framsden hath, so [provided] that it be made after the fashion of the steeple of Bramston [Brandeston], the west door, the lower west window, and with a place one each side of the said window for to set in an image, and with all the other windows and buttresses of the said steeple after the fashion of the steeple of Bramston aforesaid.[65]

Aldrych had agreed to continue building above 60 feet if the parishioners would pay him accordingly – ten shillings for every extra foot. And this, very probably, is what they decided to do, for Helmingham's tower is just a little higher than the neighbouring models to which its builder otherwise adhered. At North Lopham, Thomas Aldrych's own birthplace, there is at least some suggestion of a similar final push to the campaign. The last bequest to tower-building at North Lopham Church is dated 1503. Already, the programme had continued for two decades. Then, as work neared its end, John Wade bequeathed another 26s 8d, to 'edify' Lopham's steeple. It was 'to make two feet on behalf of myself and my deceased brother', at much the same additional cost as at Helmingham.[66]

Without doubt, one of the most substantial individual contributions ever made to tower-building was Stephen Denton's legacy, in 1519, of £100 'for the battlyment of the steeple' at Dedham.[67] The battlements and pinnacles of this great Essex tower are indeed exceptional. And, of course, they stung Dedham's nearest neighbours into rivalry. Just across the county border, in southern Suffolk, East Bergholt was another prosperous clothier town, also engaged at that time in church-rebuilding. By 1525 East Bergholt's nave was complete, and it was then that work began on the new tower. As projected, East Bergholt's tower was to have been at least as grand as Dedham's steeple, but it never got beyond the first stage. Cut off short at the stump, it found a temporary substitute in a timber-framed bell-cage which is still, most exceptionally, in place. East Bergholt's churchyard bell-cage now houses a famous chime of bells. Gabriel, the earliest, dates to about 1450. It carries the inscription 'Hecce Gabreelis . . . [in translation] Here sounds this bell of faithful Gabriel'. The next oldest bell was cast in 1601. 'Sum Rosa . . . My name is Mary', runs its maker's boast, 'for my tone I am known as the Rose of the World.'[68]

East Bergholt's failure to complete its tower is sometimes said to have followed the disgrace and death in 1530 of the Ipswich-born Cardinal Wolsey, thought to have been a patron of the rebuilding. But small-town Essex was especially exposed at this time to the eloquence of Protestant divines. And it is just as likely that East Bergholt's failed tower, like St Osyth's unfinished chancel, can be attributed to a freezing over of the old beliefs. It is not that single-donor towers, even at this scale, are unknown. There is the big tower at Great Ponton (Lincolnshire), built by Anthony Ellis, merchant of the Calais Staple, in the 1520s.[69] In 1482, it was a Nottinghamshire landowner, Sir Thomas Molyneux, who financed the substantial west tower of Hawton.[70] Lavenham, in Suffolk, owed its monumental west tower to a wealthy clothier, Thomas Spring III (d.1523), and to John de Vere, earl of Oxford (d.1513).[71] And at Cricklade, in Wiltshire, the great crossing tower still carries the heraldry of the Hungerford

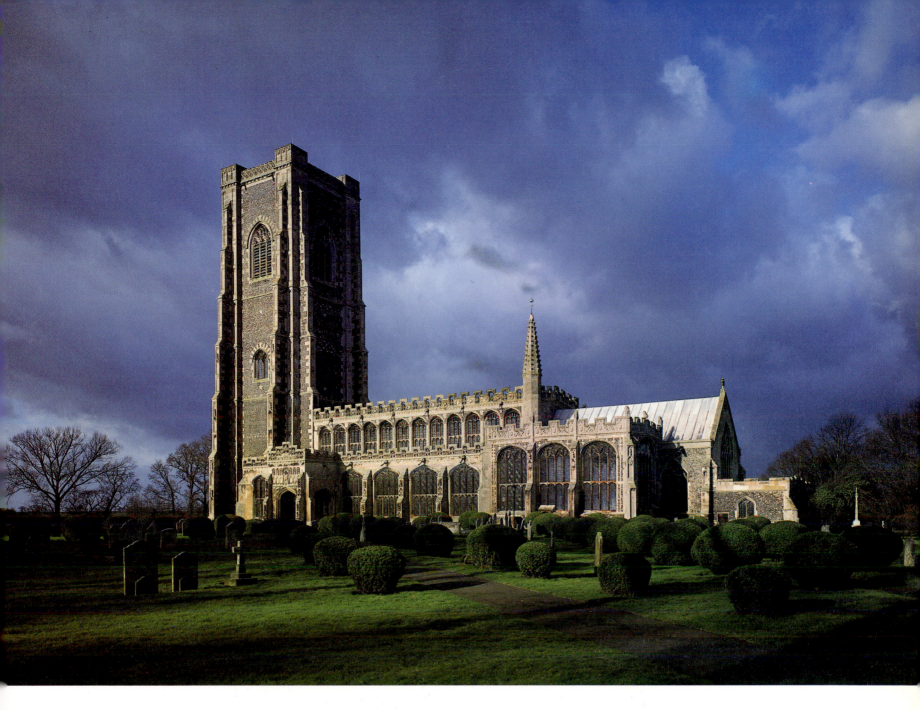

family and of John Dudley (d.1553), duke of Northumberland.[72] But individual donors, in almost every case, were just the pump-primers. It was the parishioners as a body, of their 'frank and devout hearts', who kept the building funds in balance until completion.

Nowhere is this leadership and its local effect more obvious than in John Botright's rebuilding of Swaffham Church. Botright – doctor of divinity, master of Corpus Christi Cambridge (from 1443) and chaplain to Henry VI (from 1447) – was rector of Swaffham, a big Norfolk parish, from 1435 to 1474. He was an absentee incumbent for much of that time. But he was a local man, a native of Swaffham. And he began to take more interest from 1454, when his career was already well established. Botright's *Black Book of Swaffham*, begun in that year, was intended to help remedy past abuses. It opened with a terrier of church lands, compiled on Holy Cross Day (14 September) 1454. Church goods had been stolen or had otherwise gone missing, and the *Black Book*, accordingly, included full inventories, complete with valuations, of the service books, plate and vestments of Swaffham Church. The book ended with a third section – Botright likens it picturesquely to the third deck of Noah's Ark – which attempted a

210. Lavenham is one of the great Perpendicular parish churches of cloth-making Suffolk. Its west tower, begun in the 1480s, was completed with the help of Thomas Spring, the clothier, and of John de Vere, sixteenth earl of Oxford.

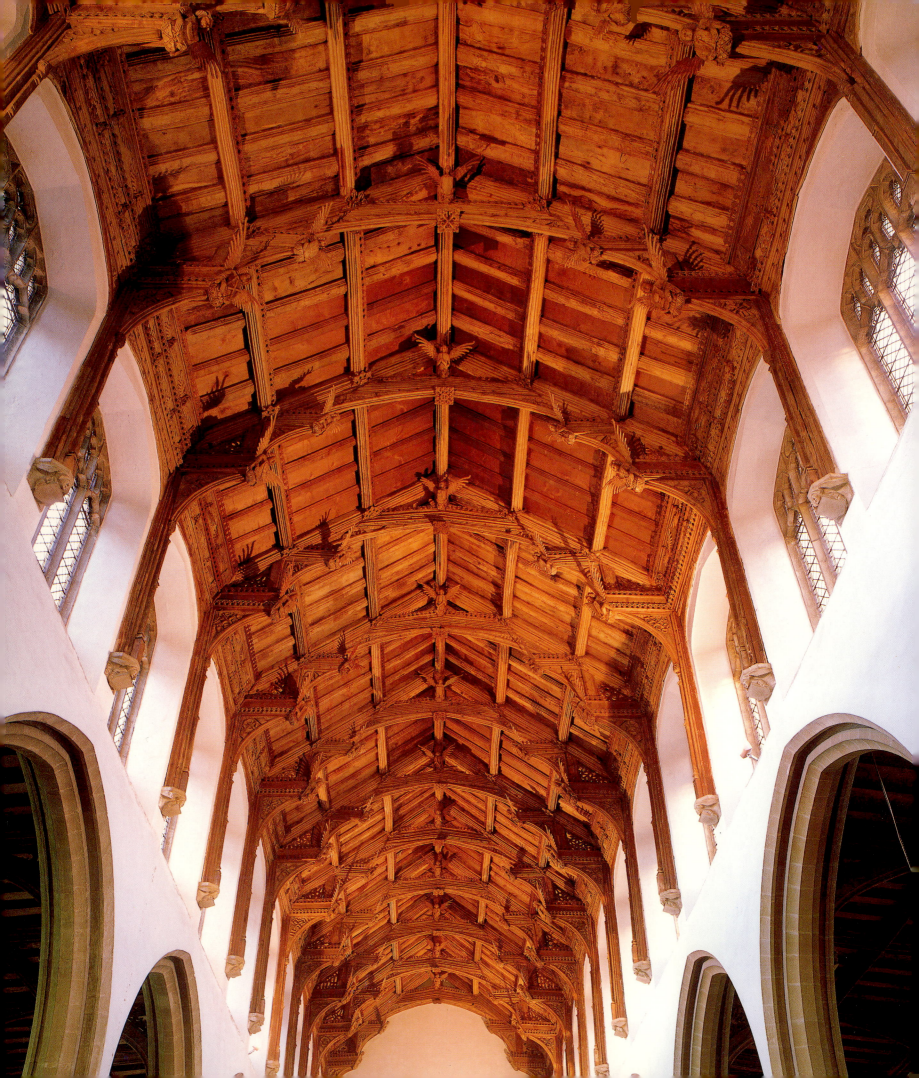

resolution of parish accounts, listing debts some already 'xiij years behind'.[73] Shortly after Botright's death, a Bede Roll was added to the *Black Book*, recording the many contributions to the rebuilding and refurnishing of his church. It begins with this memorandum:

> Be it remembered that on the day of Pentecost [Whit-Sunday] it is customary to say the Office of the Dead for the Benefactors of the Church of Swaffham, with the Mass of Requiem . . . on the morrow after the High Mass of the day. After which Mass of Requiem there should be said three prayers . . . Be it noted that when these prayers are said for the soul of 'thy priest', it means for the soul of Master John Botright, doctor of divinity and rector of this church, who lies buried before the image of St Peter.[74]

Among the debts Botright listed in the third part of his *Book* had been money already 'proffered' by fifty-two parishioners for the re-making of Swaffham's steeple and its bells. Two generations would come and go in the parish before the steeple was eventually complete. However, other works began almost immediately in the 1450s, starting that long process of total substitution which so many parish churches underwent. Most generous of Botright's donors was his own churchwarden, John Chapman, the 'Pedlar of Swaffham'. John is represented four times on surviving pairs of bench-ends at Swaffham Church: twice as a poor pedlar humping his pack, and twice as a wealthy merchant in his shop. On the first pair his companion is a devoted hound; on the second he is joined by Catherine, his spouse, both fingering rosaries in their piety. That piety took a practical turn. It was John and Catherine Chapman who built Swaffham's north aisle; who paved it and glazed it; and who furnished it throughout with new benches. They contributed, in addition, the very large sum of £120 to the long-delayed completion of Swaffham's steeple.[75]

Other generous donors to the works at Swaffham were Simon Blake (d.1489) and Jane, his wife, founders of a chantry in the Lady Chapel. Together, they spent 'in paving with marble of the cross alley before the chancel door, in repairing of the organs broken with the falling of the church, glazing of a window in the clerestory, and in finding of a freemason to the making of the church by the space of a year, and in money given to the making of the new steeple, £40.'[76] Fellow parishioners, rich and poor, contributed as much as they were able. John Bury, 'sometime here parson', gave money for the choir-stalls and 'ceiled the chancel'; Robert Payn, along with much else, gave twenty tons of high quality building-stone for the steeple; John and Catherine Payn 'made' the little chapel of Corpus Christi and gave forty chaldrons of lime to the tower; the Taylors provided handsomely for the roofing of the nave, which the Langmans then furnished with benches; the Plummers restored the Trinity Chapel; the Coos 'did make the roof of the porch'. Through half a century and more, such gifts and legacies, many substantial, enabled work to continue on the rebuilding. First to be finished was the chancel at Swaffham, completed before Botright's death in 1474. Sixty years later, the bells were in place, and the steeple had been raised to its battlements.[77]

John Botright rests where it all began, near the altar of the church he rebuilt. There is nothing especially displayful about Botright's tomb: a canopied sepulchre in the north wall of the chancel. But it carries shields and badges in the manner of its day: in his case, the bogus heraldry of a scholar. Three boats and three augers (the emblems of a shipwright) make a rebus, or visual pun, on Botright's name. There are chalices and wafers to represent his priesthood, and the triangle of the Trinity for his faith.[78] In the chancel at Fishlake, a West Yorkshire church, these clerical badges – chalice, patten and missal – reappear on the monument of Richard Marshall (d.1505), 'vicar of this church of good fame . . . in whose time this chancel and vestry bildite was'. But they are accompanied

211. The double hammerbeam roof at Swaffham is the chief glory of a major parish-church rebuilding led by John Botright (d. 1474), the rector.

on Fishlake's tower by more authentic heraldry: the rose and crown of Edward IV (1461–83) and the falcon and fetterlock of the Yorkists. Priest and king, in reward for their investment, besought that 'infinite pity' of Almighty God by which they might 'everlastingly enjoy' His deity.[79]

Fishlake's west tower has no rival in the immediate locality. It does honour to its builder even now. But it was in the personal monument, still more than in such buildings, that opportunities arose for display. Fishlake itself is not rich in monuments, only the priest's being of note. Elsewhere, one late-medieval cenotaph elbows out another, in exhibitions of egregious self-importance. Gone was the primitive vigour of the earlier tomb sculptures – of the London Templar effigies, of the Salisbury Longespée monument, and of the restless Dorchester knight. Repose and a new opulence took its place. At Norbury, in Derbyshire, a cross-legged knight lies with his shield on his arm and his hand on his sword, in the old active posture of the warrior. The effigy, although crude, is simple and direct, and was probably the monument of Sir Henry fitz Herbert, rebuilder in 1305 of the adjoining manor house. The contrast with Norbury's later memorials is complete. Two of the most notable of these monuments are the tomb-chests and effigies of Sir Nicholas fitz Herbert (d.1473) and Sir Ralph (d.1483), his son. They are of alabaster, quarried in Derbyshire and carved by local craftsmen. Their quality is almost Burgundian. On each, lost inscriptions once told of fitz Herbert dignities and of the many children of Norbury's lordly patrons. Of

212. The alabaster effigies of Sir Ralph fitz Herbert (d. 1483) and Elizabeth, his wife, in the chancel at Norbury (Derbyshire).

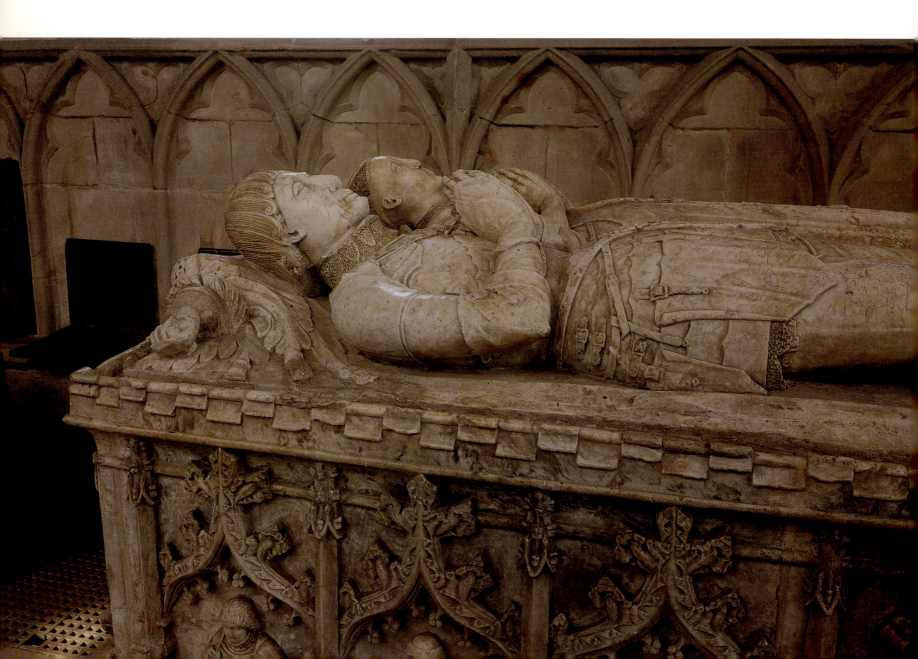

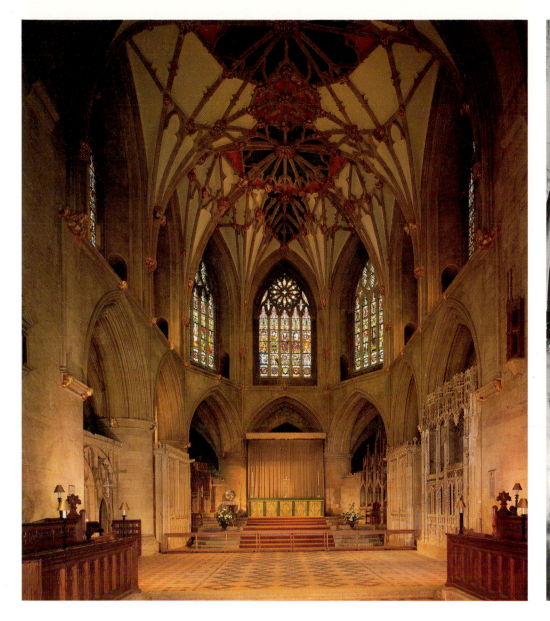

Nicholas, it was claimed: 'This church [the nave and aisles] he made of his own expense / In the joy of Heaven be his recompense.' The inscription to Ralph began with the reminder: 'The dart of death no man may flee.'[80]

By the 1490s, when both tombs were made, a nobleman knew well how he must rest. Sir Nicholas and Sir Ralph, on their crenellated biers, lie flecked by the tints of the fine heraldic glass for which Norbury's great chancel is also known. They wear full armour, as had their ancestor Sir Henry. Yet they appear quite untarnished by the wars. Chivalric conventions in tomb sculpture, fully formed at Norbury, outlasted their relevance by many years. But they had not always been as meaningless as they became. Some of the earliest and the finest of the new-style memorials were to men who had indeed won their repose. Tewkesbury Abbey, in particular, collected such monuments from the outset of the Hundred Years War. Tewkesbury's patron was the great Clare and Despenser heiress, Eleanor de Clare. It was she who rebuilt the monks' presbytery in the 1340s as a mausoleum for the menfolk of her clan. Prominent among these was Edward le Despenser, buried at Tewkesbury in 1375. Edward had fought at Poitiers alongside the Black Prince. He was one of Edward III's first Garter Knights. Remembered for his bravery, his courtesy, and his success with the ladies, Edward kneels in handsome effigy, facing the high altar, on the roof of his private chantry chapel.[81]

213. The presbytery at Tewkesbury Abbey, with its fine commemorative glass and closely packed aristocratic memorials of the Hundred Years War period, was rebuilt in the 1340s by the heiress Eleanor de Clare, sister of Gilbert de Clare (killed at Bannockburn in 1314) and widow of Hugh le Despenser the Younger (executed for treason in 1326).

214. The chantry chapel at Tewkesbury of Edward le Despenser (d. 1375), 'much beloved of ladies', hero of Poitiers and knight of the Garter.

215. Reginald Lord Cobham (d. 1446) was the rebuilder of Lingfield Church, which he made collegiate in 1431. His monument, centrally placed in the chancel at Lingfield, is one of the best examples of the genre.

217. (right) Sir Hugh Calveley, a successful war captain, rebuilt Bunbury Church (Cheshire) after 1386, following the foundation there of his collegiate chantry.

216. The effigy of Edward, Prince of Wales (d. 1376), called the Black Prince, at Canterbury Cathedral.

The Anglo-French wars, like the Crusades of earlier times, fired the imagination of tomb sculptors. Also buried at Tewkesbury was Guy de Brien, Edward III's standard-bearer at Crécy. And it was that battling generation of Crécy (1346) and Poitiers (1356) that set the pattern for all later memorials. Reginald Lord Cobham of Sterborough (d.1361) was a hero of both those encounters. Like Edward le Despenser and Guy de Brien, he was one of the original Garter Knights. At Lingfield, in Surrey, Reginald's armoured effigy carries the Garter of his order, with the shields of his knight-companions against the tomb-chest. It was another Reginald, the third Lord Cobham (d.1446), who fought at Agincourt in 1415 and who re-founded Lingfield Church as a college. He lies in proud effigy in the chancel there, on a table-tomb enriched with family heraldry.[82]

Companions-at-arms made common cause in determining a death-style for their class. At Canterbury, there is the tomb-chest and effigy of the Black Prince himself, complete with funeral achievements – helm and crest, gauntlets, scabbard and *gipon* (coat armour).[83] Other veterans of Crécy and Poitiers, Thomas Lord Berkeley (d.1361) and Maurice (d.1368), have left fine chivalric monuments at Berkeley Church and at Bristol Cathedral respectively.[84] John Lord Neville (d.1388) and Sir John Marmion (d.1387) both served in the armies of John of Gaunt – duke of Lancaster, brother of the Black Prince, and uncle of Richard II. Neville, builder of Raby Castle in County Durham, left a richly sculptured table-tomb at Durham Cathedral, crenellated, and with heraldry and weepers.[85] Marmion died in the duke's cause in Spain, but was brought home for burial in Yorkshire. At West Tanfield Church, next to his castle gate, he shares a monument with Elizabeth, his widow. Their paired effigies are protected by a crenellated iron hearse, still furnished with its original candle prickets.[86]

Such military references were deliberate. At the beginning, they were meaningful as well. None can doubt the profession of Sir Hugh Calveley (d.1393) of Bunbury, a freebooting captain of the Hundred Years War and knight-companion of Sir John Chandos and Sir Robert Knolles. Calveley, who is buried in the chancel of Bunbury Church, used the profits of his raiding parties – the notorious *chevauchées* – to re-found his parish church as a college. On a fine architectural tomb-chest, behind the spikes of an iron grille, Calveley reposes in full armour. His head rests on a tilting helm, his feet on a miniature lion.[87] Calveley is shown in death as he was in life. But the style, for the most part, was convention. From the 1350s, for the rest of the Middle Ages, it was shared by the Despenser lords of Tewkesbury, the Cobhams of Lingfield, the Willoughbys of Spilsby, the Greenes of Lowick, the Nevilles of Staindrop, the Redmaynes of Harewood, the Vernons of Tong, the Bardolphs of Dennington, and many more.[88] The same tradition was still current at Goudhurst in the 1530s. And much later, in Civil War Cheshire, it surfaced again in the effigy of Sir Philip Mainwaring (d.1647) of Over Peover. Philip was lord of the manor and a former captain of the Cheshire Light Horse. His parish church was in the grounds of the Mainwaring manor house, and it was there that Philip's widow built a chapel for his remains, 'amazingly pure in its classicity'. Philip shares a Roman-style sarcophagus with Lady Ellen. But whereas Ellen is dressed in the fashion of her time, Philip wears the armour of his Late Gothic ancestors, Sir Randle and Sir John, both also buried in that church.[89]

Many of these memorials – not least the last – were of the very highest quality. But none were as assertive as the huge sandstone monument of Thomas Lord Morley (d.1453) of Hingham. Morley was of an old and wealthy Norfolk family which had become even richer on his marriage to Lady Isobel, daughter of the then earl of Suffolk.[90] Isobel outlived her husband by many years, and it was she who commissioned his monument. Morley had fought at Agincourt in 1415. His grandfather, another Thomas (d.1416), was captain-general of the English forces in France. Robert, second Lord Morley (d.1360), had commanded the English

fleet at Sluys in 1340 and was at Crécy in 1346. The Morley monument at Hingham, rising the full height of the north chancel wall, exudes dynastic pride. Prominent everywhere is the heraldry of the Morleys and their associates. Against the back wall are Isobel's ten children, continuators of the line, figuring as weepers above the tomb-chest. To the sides and on the superstructure are the family's patron saints: St George and St Michael, SS John Baptist and Evangelist, St Margaret, St Mary Magdalene, and St Katherine. A seated Christ, presiding over all, bestows His benevolence on the assemblage.[91]

One Scottish near-equivalent of the Morley tomb is the big Douglas monument at Lincluden (Dumfries). Lincluden, formerly a community of Benedictine nuns, had been extensively rebuilt after 1389 on its conversion to a secular college. In the north chancel wall, the contemporary memorial to Princess Margaret, wife of the fourth earl and daughter of King Robert III, celebrates an alliance of particular importance to the Douglases. With appropriate heraldry on the tomb-chest – of Douglas and of Stewart, of Drummond (for Margaret's mother) and of Moray (for Joanna, her mother-in-law) – the association of the families is made plain.[92] In war and by marriage, the Douglas earls had made their ascent to the most important offices in the land. It had been the third earl, Archibald 'the Grim', re-founder of Lincluden, who had acquired Bothwell Castle through marriage to the Moray heiress, Joanna. Other Douglas castles were Sir Archibald's Threave Castle (Galloway) and Hermitage (Borders), with a fourth Douglas stronghold on the coast east of Edinburgh, riding the cliff at Tantallon. William the first earl (d.1384), builder of Tantallon, fought on the French side at Poitiers.

218. The alabaster effigies of William Lord Bardolph (d. 1441) and Joan (d. 1447), his wife, in the Bardolph Chapel at Dennington Church, in Suffolk. Sir William, who fought at Agincourt in 1415, was a Garter Knight – he wears the Garter below his left knee. He founded his chantry at Dennington in 1437.

219. At Goudhurst (Kent), these high-quality wood and painted gesso effigies of the iron-master Sir Alexander Culpeper (d. 1537) and his wife continue the late-medieval tradition.

220. The wall-monument in the chancel at Lincluden of Princess Margaret (d. 1451), daughter of King Robert III and widow of Archibald (d. 1424), earl of Douglas and duke of Touraine.

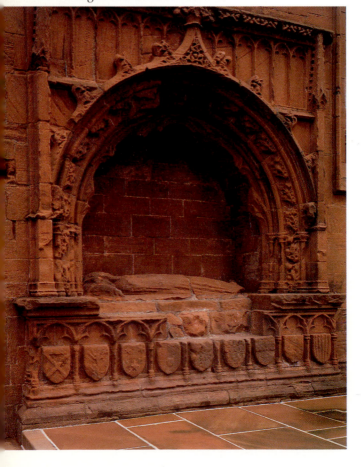

Archibald the third earl (d.1400), was present at Poitiers also. Margaret's husband, Archibald 'the Tyneman' (the Loser), fourth Douglas earl (d.1424), was repeatedly in France, to be rewarded for his services with the duchy of Touraine just before his death at Verneuil.

Those wars which had boosted the Douglases and their kind also gave direction to castle-building. There are clear Anglo-French influences at each of the four Douglas fortresses. Yet none was an exact copy of what the earls had seen abroad. And what they reflect is the growth through these decades, under pressure of war, of a vigorous international chivalry. Sovereigns everywhere took the lead. From 1350, Edward III's rebuilding of the royal fortress at Windsor was a costly exercise in public relations. So too was David II's reconstruction of Edinburgh Castle after 1356, and the simultaneous transformation – by John II and Charles V – of the former Valois hunting-lodge at Vincennes. Karlstein, near Prague, became the imperial fortress-palace of Charles of Bohemia; Avignon, of the papacy in exile. For a time at least, so one contemporary reported, 'almost all the masons and carpenters throughout the whole of England were brought to that building [Windsor Castle], so that hardly anyone could have any good mason or carpenter, except in secret, on account of the king's prohibition'.[93]

As if that were not enough, the association of Edward III's works with a new chivalric order captured the attention of his aristocracy. Edward's Order of the Garter, instituted at Windsor in 1348, was only the second such foundation to become permanent. Secular orders of chivalry – as distinct from the semi-monastic crusading orders of the twelfth century – had been launched in Castile with Alfonso XI's Order of the Band (c. 1330). Three years after Edward III's Garter foundation, John II of France instituted his own Order of the Star (1351). Charles of Bohemia's Order of the Golden Buckle followed in 1355.[94] These brotherhoods required huge establishments. On a scale far exceeding any English castle till that date, Edward rebuilt Windsor for the crowd.[95]

Fully as important as the accommodation they provided was the high visibility of such fortresses. Windsor itself is prominently placed, on a site ideally suited to display. Edinburgh and Stirling, the major Stewart castles, are even more conspicuous on their rocks. Of the four Douglas strongholds, Threave and Hermitage rise respectively from a marsh and a shaven moor; Tantallon (on its cliff-top) and Bothwell (on its bluff) are each given presence by added towers.[96] Better preserved than Tantallon, which it otherwise closely parallels, is Thomas Beauchamp's east facade at Warwick Castle. Beauchamp (of Warwick) and Douglas (of Tantallon) fought in the opposing armies at Poitiers. Beauchamp had been the companion of Edward III since youth, and Douglas likewise knew the English court well, spending much time there in diplomacy. The castles of these men reflect what they had learnt, whether in France or at Windsor. Huge residential gatehouses and prominent corner towers ornament the show-fronts of both fortresses. But at neither do the defences continue on that scale, each facade being less a barrier than a stage-set.[97]

It was this self-conscious sense of theatre in contemporary chivalry which gave context to the 'first great flowering of English domestic architecture' coincident with the Hundred Years War.[98] Frequently, it was the war itself which furnished the means. Thomas Beauchamp, earl of Warwick (1329–69), was at Crécy as well as at Poitiers. He was marshal of England from 1344, and took part in almost every French campaign. There is no surviving record of his total profits. Yet from Poitiers alone, Earl Thomas collected the ransoms of two wealthy priests, the archbishop of Sens and the bishop of Le Mans.[99] And it was the windfall of Poitiers, it is usually thought, which financed the rebuilding of Warwick's show-front.[100] Magnates like Earl Thomas and his immediate heirs – Earl Thomas II Beauchamp (1370-1401) and Earl Richard (1403–39) – created the myth in which they themselves in due course played a role. Thomas I Beauchamp,

221. Windsor Castle, headquarters of the new Order of the Garter, was extensively rebuilt by Edward III (1327–77) in one of the costliest building campaigns ever undertaken by an English king.

Edward III's companion at Crécy, was a founding Garter knight. He knew, and was perhaps part, of the king's earlier initiative (also at Windsor) for the re-institution of the Arthurian Round Table. Warwick Castle was the product of preoccupations of this kind, as was Windsor and a fortress like Tantallon. Of the two corner towers of Warwick's east facade, the earliest (Caesar's Tower) was probably begun soon after Poitiers. The second (Guy's Tower) may not have been finished before the 1390s. Tall and ornamental, and with small defensive purpose, each tower invokes a hero in the company of whom a Beauchamp might have felt himself at ease.[101]

During Edward III's reign, and while the war went well, magnate self-esteem was much inflated. The king did all he could to keep it so. Wealthy though he was, Thomas Beauchamp enjoyed a royal pension of a thousand marks a year from as early as 1347.[102] And it was subsidies like this, along with profitable marriage alliances and the receipts of war and office, which enabled the post-plague aristocracy, for half a century at least, to aspire to new levels of affluence.[103] If rents were already falling, as indeed some were, disposable wealth was

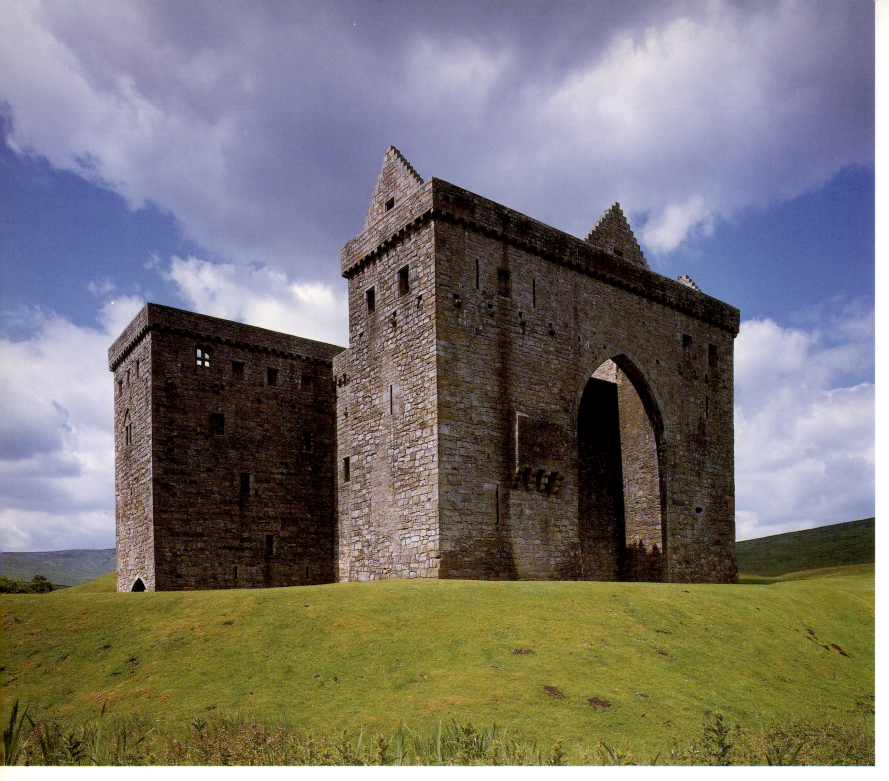

222. The Douglas earls rebuilt their frontier fortress at Hermitage in c.1400, adding new towers at the angles.

unaffected. The bounty of France filled the gap. When the Cheshire knights, Hugh Calveley, John Norbury and David Hulgreve first went to the French wars, they were the penniless younger sons of minor gentry. They returned in the 1380s with money to invest, entering the local land market as major purchasers.[104] 'Dispendiousness' – the wasteful extravagance of the French nobility on life- and death-styles appropriate to their class – was partly learnt by such men during their years abroad.[105] But they were not lacking in models of their own. In the 1350s and 1360s, supported by a temporary boom in receipts from the wool customs, Edward III had never been richer. He spent some of his new surpluses on the war in France. But much was diverted also to more domestic purposes, especially to the enhancement of his life-style.[106] It was in the late 1350s that the king 'caused many excellent buildings in the castle of Windsor to be thrown down, and others more beautiful and sumptuous to be set up'.

Edward was 'assiduous and eager in the construction of buildings: in many parts of his kingdom he completed buildings most excellent in craftsmanship, most elegant in design, most beautiful in location and in cost of great value'.[107]

Edward III, unlike his grandfather, was no fortress-builder. Windsor, when complete, was always less a castle than a palace. Similarly, Edward's expenditure on his favourite country houses – on Eltham and Havering, King's Langley and Sheen – focused almost exclusively on the royal apartments and on the improvement of the quarters of his household.[108] However, there was one castle especially, at Queenborough on the Isle of Sheppey, which he evidently took to his heart. Last of the royal castles to be built entirely from new, Queenborough was also (after Windsor) the most expensive. It is not difficult to see why Edward lavished money on it. Queenborough was demolished in the mid-seventeenth century; all that remains is a low mound. However, the castle is known to have been a perfect circle in plan, with a big central rotunda for the king's hall and chambers, surrounded by a moated outer curtain. This huge royal tower-house of innovatory design stood tall above the flats of the broad Thames estuary, bidding hostile ships to keep their distance.[109]

While Queenborough was under construction in the 1360s, Edward was a frequent visitor to the site. He came there from Hadleigh, on the far side of the estuary, which he was also remodelling at that time. Hadleigh was a big thirteenth-century fortress to which Edward made characteristic additions. As was his usual practice, he rebuilt the royal apartments, siting them splendidly on the very edge of the bluff, with views across the estuary towards Queenborough. On the east curtain facing the sea – where the French, as they sailed up-river, would see them first – he built two big drum towers to make a show-front. Hadleigh's twin towers are a landmark still. They remind us of the importance Edward placed on propaganda, and of contemporary priorities in castle-building.[110]

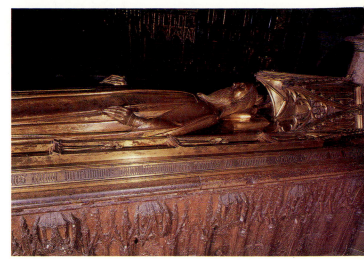

223. Edward III, shown here in realistic effigy at Westminster Abbey, died old and crazed on 21 June 1377.

224. All the emphasis in Warwick Castle's show-front, begun after Poitiers (1356), is on height. In addition to a massive central gatehouse, with big projecting barbican, the Beauchamp earls built tall residential corner towers, of which Caesar's Tower (left) was the earlier. The twelve-sided Guy's Tower (right) was still under construction in the 1390s.

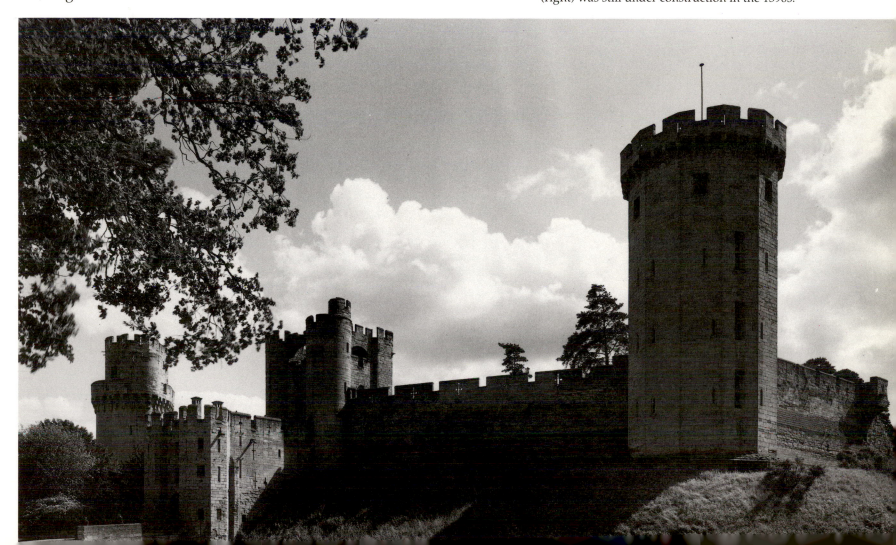

Hadleigh was a sham. But it was scarcely more unreal than many other 'cardboard' castles – than Archbishop Courtenay's Saltwood or the archdeacon of Canterbury's Lympne, than Sir John de la Mare's Nunney or Sir Richard Abberbury's Donnington, or than that slice of purest theatre at Amberley. William Reade, who fortified Amberley in the early 1380s, was a scholar-bishop – a mathematician, historian, and astronomer. Before coming to Chichester in 1369, he had spent most of his life as a teacher. But the French wars began again in that year. There were repeated invasion alarms along the Sussex coast, threatening the episcopal manors. Amberley was only eight miles from the sea, and it was probably the successful French and Castilian raids of 1377 which persuaded the bishop to apply that same December for a licence to crenellate his manor house. If the purpose of Reade's additions was his protection alone, something went fearfully amiss. His new defensive curtain was overlooked on the east by the tower of the adjoining parish church. Only the north face of the castle, benefiting from the slope, was strongly fortified. On the west, Amberley's curtain was a straight unbuttressed wall. The bishop's show-front to the south, facing the road, had just one feature of importance in its central gatehouse.[111]

Such fortifications are not be taken too seriously. They always had another purpose than defence. At Lympne, along the coast, the archdeacon of Canterbury's fortified manor house was located impressively on a cliff-top. It made a brave show towards the sea. Yet Lympne's defences (like those of Amberley) were

225. Bishop Reade's southern show-front at Amberley Castle, built in the late 1370s, had only this central gatehouse to give its strength.

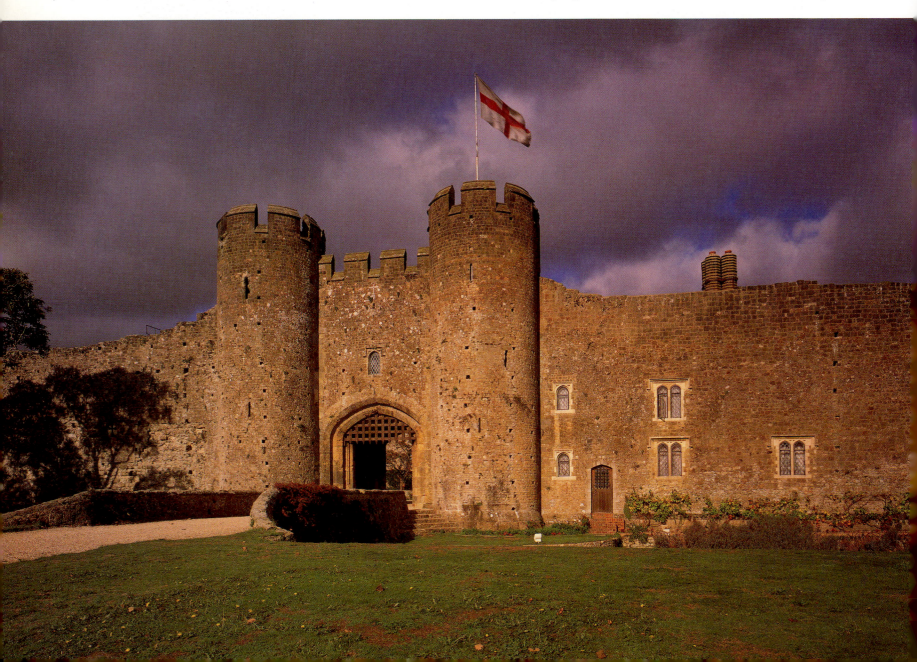

closely overlooked by an adjoining church-tower, and were scarcely more substantial than the bishop's.[112] Archbishop Courtenay's gatehouse at Saltwood, rebuilt in the 1380s in fine aggressive style, was again sited principally for effect.[113] Like its parallel at Abberbury's Donnington, the Saltwood gatehouse was chiefly residential. Both towers commanded fine views.[114]

The token defences of Amberley, Lympne and Saltwood had to do with their placing by the coast. However, Donnington is in Berkshire, well away from all danger. It was next to the main Newbury–Oxford road, but was no more under threat than was Sir John de la Mare's Nunney, hidden away safely in rural Somerset. The buildings, in each case, were social frames. In his youth, Richard Abberbury of Donnington had served in France with the Black Prince. He was later appointed guardian of the Prince's heir, and continued to hold office in the royal household after Richard II's accession in 1377. Today, only his gatehouse survives intact. But Donnington still stood when William Camden, the antiquary, visited Newbury in the 1580s. Camden found it 'a small but very neat castle, seated on the banks of a woody hill, having a fair prospect and windows in all sides very lightsome'. A particularly handsome window, over the gate, lit Abberbury's personal chamber. He can be pictured there, sitting at his window, contemplating the traffic and reeling in his memories of the wars.[115]

Donnington, behind its gatehouse, was of unique horseshoe plan. It belonged to an era of innovatory castle-building instanced already by Queenborough. Edward III, it has sometimes been suggested, found his example for Queenborough in Bellver. And this association of his castle with a circular Majorcan fortress of 1309–14 has caused it to be viewed as the 'perfect fulfilment' of the Edwardian plan, 'for in no other castle in medieval England is the concentric principle worked out with such uncompromising logic'.[116] That expertise at Queenborough was genuine enough. But the line of succession is less clear. Edward III and his knights were professional soldiers, well able to have views of their own. If they remembered the great castles of Edwardian Wales, that memory had been overlain by more recent exposure to a huge variety of new models on the Continent. John Lord Cobham's heavily machicolated gatehouse at Cooling, on the north Kentish coast, is unmistakably French in inspiration. The same is true of the machicolated angle tower at Roger Ashburnham's Scotney, while the water defences both at Scotney and at nearby Bodiam are again probable borrowings from the Continent. Sir John de la Mare's Nunney, clearly influenced by his campaigns, resembles the tower-houses of south-west France – of English-held Guyenne and the Auvergne. Both John Lord Lovel's Wardour (Wiltshire) and Earl Henry Percy's Warkworth (Northumberland) are more readily paralleled in northern France than anywhere closer to home.[117]

These castles broke with the Edwardian tradition in another important particular. They gave accommodation priority over defence. Even Sir Edward Dalyngrigge's Bodiam, licensed in 1385 specifically for the 'defence of the adjacent country and resistance to our enemies', was notable chiefly for the many comfortable lodgings with which its gatehouses and angle towers were tightly packed.[118] Bodiam's four corner towers were still Edwardian-style drums. But if their circular plan was stronger than the square, it was not as well suited to new requirements. Dirleton, in East Lothian, was a late-medieval remodelling of an earlier Scottish castle, badly damaged in the Wars of Independence. Just before those Wars, Dirleton had been rebuilt at considerable expense, with prominent round towers at the angles. Yet little of this 'Edwardian' work was preserved. In Dirleton's restoration after the Wars, its Halyburton lords built a new great hall and adjoining great chamber, with a chapel and a kitchen, all housed in a rectangular eastern range. They created a show-front on the south face of the castle by rebuilding the gatehouse with a projecting forework, and by consolidating the adjoining western tower. Two other early towers – big late

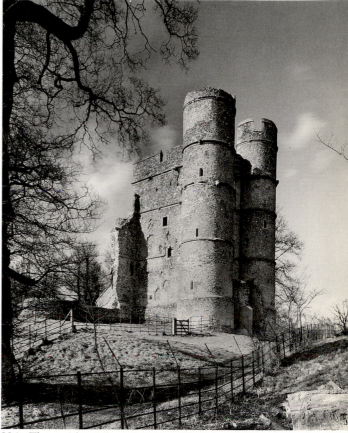

226. The residential gatehouse at Donnington Castle, added in *c*.1386, included Sir Richard Abberbury's great chamber over the gate passage.

227. The one surviving corner-tower of Roger Ashburnham's Scotney Castle, built in the late 1370s.

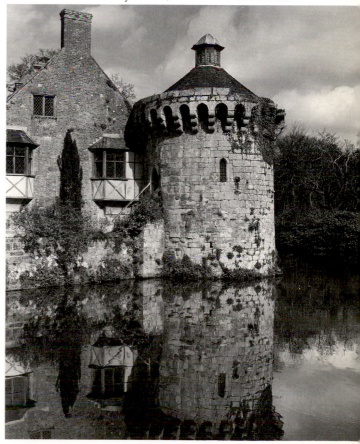

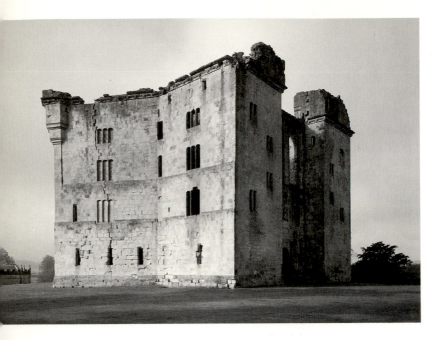

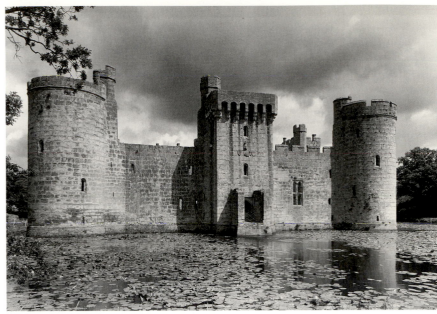

228. John Lord Lovel obtained his licence to fortify Wardour in 1393. What he built was a hexagonal tower-house in the contemporary French manner, for which there are no English parallels.

229. Sir Edward Dalyngrigge's Bodiam Castle, built in the late 1380s, was more military in plan than Lord Lovel's Wardour, but was nevertheless largely residential.

230. Dirleton Castle's show-front, remodelled after the Scottish Wars of Independence, kept the late thirteenth-century drum towers to the west of the main gate, but replaced them on the east with a rectangular lodging range, built to accommodate the Halyburtons' hall and chamber.

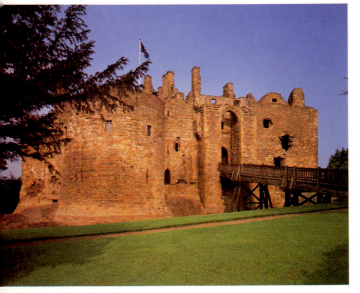

thirteenth-century drums on the east – were abandoned and reduced to their foundations. They provided a base for the overlying lodging range more conveniently rebuilt on the square.[119]

Sometimes, as at John of Gaunt's Dunstanburgh or the contemporary gatehouse at Carlisle, improved defence and new accommodation went together. In 1380, when Lancaster ordered the reconstruction of his castle at Dunstanburgh, he was just a few months away from the widespread tenant rebellions and attacks on his property which accompanied the Great Revolt of 1381. Two years earlier, it had probably been Lancaster again who had commissioned the new gatehouse at Carlisle. Both fortresses were strengthened as a result of these works, and both would be successful shortly afterwards in turning aside invading Scots. Nevertheless, it was the new lodgings in each case which had received as much attention as the defences. At Dunstanburgh, John of Gaunt converted Thomas of Lancaster's huge gatehouse, newly built in the 1310s, into a personal residence. He erected another gatehouse next to the first, blocked the original entrance passage, and made a substantial tower-house for himself of what remained.[120] Carlisle's new gatehouse, begun in 1378, was intended from the start as a multi-purpose building, housing the offices and the accommodation of the sheriff. John Lewyn, the supervising mason at Carlisle, had worked on the castles at Bamburgh and Durham, and knew his business well. Carlisle's defences at ground level were formidable. They included a barbican and flanking tower; a long entrance passage closed by two gates and a portcullis; guardrooms on each side; and a prison. In contrast, the first floor was entirely domestic. 'Above the gate,' Lewyn's instructions ran, 'there will be a hall thirty feet long and twenty feet broad, with a wooden partition-wall [a screen]. And the kitchen [in the flanking tower] will have two suitable stone fireplaces, and in the room behind the dais [the sheriff's chamber] there will be a fireplace and a privy, with window-lights, shutters and entrances suitable for all the rooms.'[121]

Carlisle's gatehouse suite was exceptionally self-contained, for castle apartments of this date rarely included a private kitchen. However, there was nothing unusual about the separation of quarters at Carlisle, and it was the deliberate seclusion of the personal chamber which had increasingly to be respected by castle planners. When John of Gaunt rebuilt Dunstanburgh, and when he spent even greater sums on his more important palaces at Kenilworth, Pontefract and the Savoy, his purpose was to accommodate the great 'company of annuitants' which no man of quality could be without.[122] One of Lancaster's

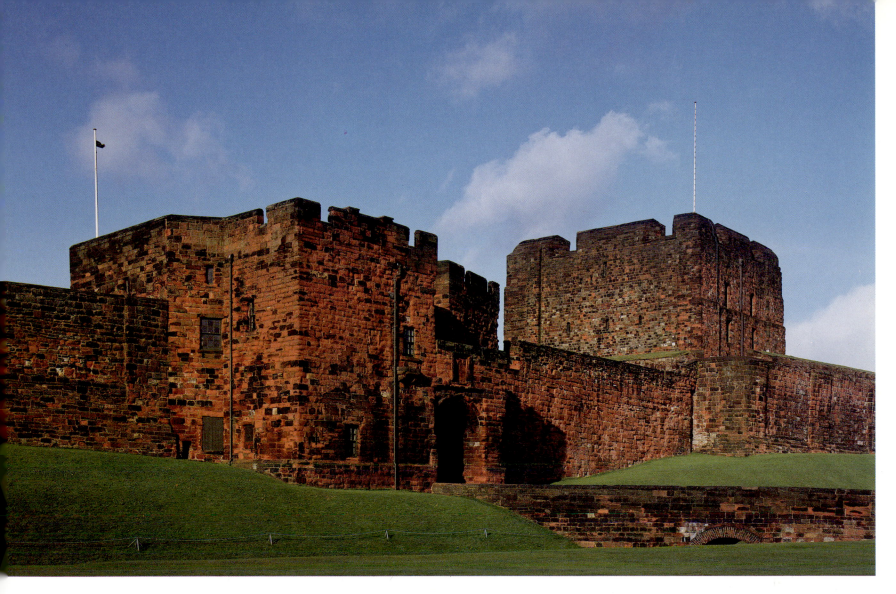

choice companions, prominent in that 'core of highly rewarded knights conspicuous for their courtly and chivalric skills', was Sir John Marmion, later to be buried in fine military pomp at West Tanfield (see p. 178). Marmion was a native Yorkshireman, the duke's lieutenant in a troubled region which continued to cause him much concern. It was landowners of Marmion's rank and substance who, when they joined their patron at any of his fortresses, required to be adequately housed.

How this might be done was a matter of some delicacy, for there was rank as well as numbers to be considered. Near-identical sets of lodgings occur at some lordly residences: at the Nevilles' Middleham (North Yorkshire), with up to 24 separate lodgings; at John Lord Lovel's Wardour (Wiltshire), with perhaps 26; at John Holand's Dartington (Devon), with as many as 40 or 50.[123] But there were other castles also, among them Hylton and Bolton, in which the apartments were deliberately graded. Hylton (Co. Durham) was a big residential gatehouse-tower, built for Sir William Hylton in about 1400. Although smaller than Bolton, it was nevertheless equipped with a variety of lodgings: a chamber for the chaplain; another for the butler; a third (rather grander) for the steward, and so on.[124] At Bolton (North Yorkshire), Richard Lord Scrope's purpose-built castle of the 1380s, the accommodation was layered like a cake. Bolton, at least in part, was the work of John Lewyn, mason of the gatehouse at Carlisle. Even more than Carlisle, it was dictated by the quarters it had to hold. Thus Lewyn and his employer adopted a simple quadrangular plan, with few of the defensive subtleties of an Edwardian fortress, but with space in abundance for graded lodgings. From Scrope's own suite in the west range at Bolton to the chambers

231. Carlisle's gatehouse (centre), built in 1378–82, included the sheriff's lodgings (hall, kitchen, chamber and privy) on the first floor. Like the much earlier Anglo-Norman keep on the right, it was subsequently modified to carry artillery.

232. Richard Lord Scrope's Bolton Castle was purpose-built in the 1380s to accommodate the former treasurer's great household. Scrope had his personal quarters in this west range; his hall was in the north range (left); each of the corner towers was stacked high with private apartments.

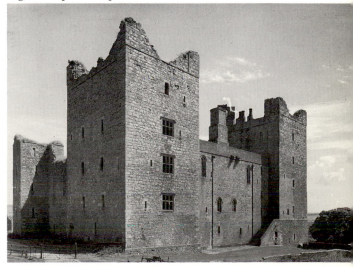

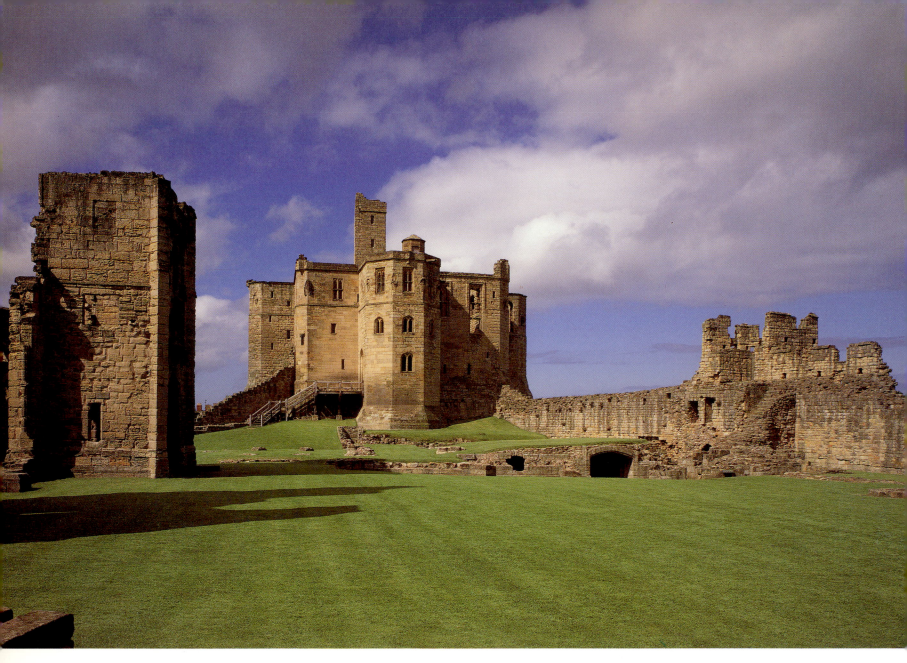

233. Henry Percy's late fourteenth-century tower-house at Warkworth was built on a former motte. His collegiate church, which may never have been completed, crossed the bailey in front of the tower. On the tower's far side, a great sculptured Percy Lion challenged the Scots.

of his bailiffs by the gate, provision was made for eight separate households, each with hall and chamber, and for at least another dozen individual lodgings, suitable for minor officials and lesser guests. Lewyn's indenture of 1378 specifies that every chamber for which he was contracted should be fitted with a fireplace and a privy.[125]

Scrope was a soldier of considerable experience who had fought since early youth both in France and in Scotland, rarely missing a campaign. He could have chosen to arm Bolton to the teeth. Yet he gave priority instead to the over-large household in which a man of his rank found recognition. Scrope's father, Sir Henry (d.1336), had founded the family fortune on a successful career in the law. Scrope himself, raised to the baronage in 1371, combined profitable military service with office at court, first as treasurer and then chancellor of England. For ambitious men of the North like the Scropes of Bolton and their cousins, the Yorkshire Scropes of Masham, these anxious times gave plentiful opportunities for advancement.[126] From the mid-1290s, the Northern Marches had become permanently unsettled. To restrain the Scots, the Crown had no choice but to encourage the emergence of powerful new coteries of frontier lords who, along with the Scropes, would include both the Percies and the Nevilles.

The Nevilles had been at Raby (Co. Durham) since the thirteenth century, and were relatively long-established in the North. But the Percies were a Yorkshire

188

family, like the Scropes of Masham. And it was the Wars of Independence which gave them that first entry to the Northumberland lands which they would convert very quickly into a power-base. The bishop of Durham's Alnwick was purchased by Henry first Lord Percy in 1309 out of the profits of his Scottish campaigns. It was Henry II Percy who acquired the fortress at Warkworth in 1332, with other former Clavering estates. The promotion in 1377 of Henry IV Percy to the revived earldom of Northumberland placed the family interests on a new footing. It was Earl Henry who laid hands on the Lucy inheritance, and who exploited the continuing difficulties of the Anglo-Scottish lords to add the Atholl estates and the Comyn lands in Tynedale to what his grandfather had already acquired from the earls of Dunbar. In less than a century, the Percies trebled their returns. They became the leading landowners in both Northumberland and Cumberland, and the greatest territorial power in the Marches. 'Too much puffed up', as one contemporary saw them, the Percies risked all in rebellion. But even Hotspur's defeat at Shrewsbury in 1403, and the further débâcle of the revolt of 1405, were not enough permanently to unseat them. Restored to their estates by Henry V, the Percies returned to their fortresses.[127]

What they had begun at those fortresses already, and what their successors of the fifteenth century finished off, was indeed cause for some family satisfaction. Alnwick has been much remodelled by later dukes of Northumberland, and is now chiefly remarkable for its scale.[128] But Warkworth's neglect from the late sixteenth century has preserved many of the elements of the huge chivalric fortress laid out initially for Earl Henry. Like Scrope of Bolton, Henry Percy had fought in France as a young man. He was a knight of the Garter and understood – at least as well as Edward III, his patron – the political importance of keeping state. Warkworth was Earl Henry's principal residence. The huge tower-house on the motte and the big collegiate church in the bailey below were the emblems of his style in life and death.

Warkworth's tower-house was probably completed by Henry's grandson, the second Percy earl. The church, almost certainly, was never finished. However, the intentions of the first earl are plain enough. Henry was a creature of his times. His tower-house, like the contemporary palaces of Charles of Anjou, carries a great heraldic panel – a rampant Percy Lion – on its northern face, overlooking the town, where the Scots would have seen it on their approach.[129] Externally, the tower is stark and bare, although pierced above basement level by many windows. Internally, its fierceness at once gives way to the superior demands of courtly living. On the first and second floors, seemingly thick external walls are honeycombed with passages and chambers. The great hall, the kitchen and the chapel's sanctuary rise through two stages. A central lantern, or light well, ventilates the basement. There are sophisticated arrangements for the collection of rainwater and the voiding of privies. Individual suites and lodgings are skilfully intermeshed, packing even the look-out tower, in which three single-chamber apartments are superimposed.[130]

The ingenuity of Warkworth, its apartment-like quality, and at least a measure of its pomp, were present in every major fortress of the North. John de Neville's Raby, like the Percies' Alnwick, has been much rebuilt since his time. But its multi-towered profile, its machicolated gate-turrets with their stone armoured figures, its ceremonial great hall and huge louvered kitchen, all commemorate the rise of another Marcher family, promoted by the Crown towards the end of the century to counterbalance Percy power in the locality.[131] John Lord Neville obtained his licence to refortify Raby in 1378. It was in that same year that Scrope commissioned Bolton, and just a little later that the rebuilding began of the related Yorkshire castles at Wressle (1380) and Sheriff Hutton (1382). At none of these buildings, despite the menace of the Scots, was defence the most important

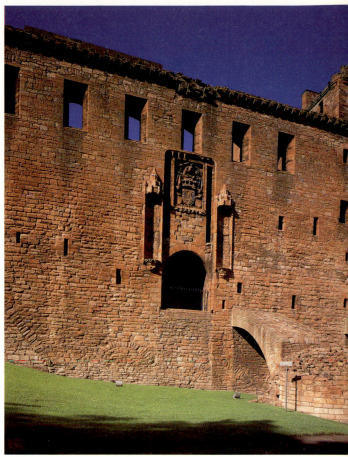

234. James I's fine heraldic panel, over the main gate of his new palace at Linlithgow (begun in 1425), was Scotland's own assertion of dynastic pride.

235. The south range of Wressle Castle is all that now remains of Thomas Percy's little-known Yorkshire fortress-palace, built in the 1380s.

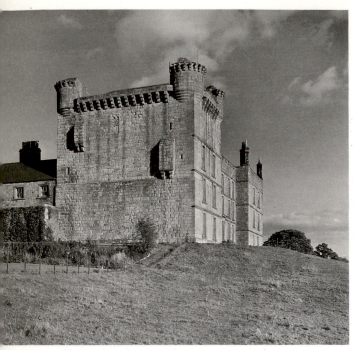

236. A late fourteenth-century tower-house at Chipchase, in Northumberland, has since been incorporated in a Jacobean mansion. On this intact western face, the corbelled-out garderobes are original, as are the corner-turrets (bartisans) and the prominent machicolations on the wall-head.

238. (right) This south-east tower and residential range at Bothwell Castle were built by the Douglas earls in the late fourteenth and early fifteenth centuries; the Douglas hall was in the east range (right) at

237. The gatehouse tower at Doune, built in the 1390s, was Albany's personal residence, one of its elements being a comfortable private hall. In the north range (right), the castle's great hall adjoined a second big tower, with a well-fitted kitchen and buttery under guest lodgings.

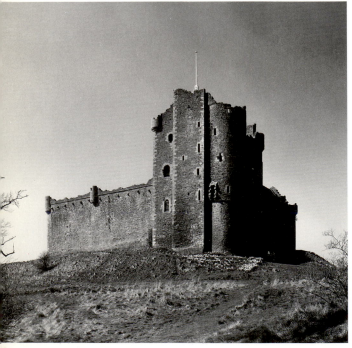

consideration. Wressle was the work of Thomas Percy, younger brother of Earl Henry and himself promoted earl of Worcester in 1397 for services to Richard II. Percy was a famous soldier, a knight of the Garter like John de Neville and Earl Henry, and the companion-at-arms of such legendary war-captains as Sir Robert Knollys, Sir John Arundel and Sir Hugh Calveley. Yet Percy did no more to fortify Wressle than did Scrope to protect Bolton, or Neville to strengthen Raby and Sheriff Hutton. Wressle shares the domestic four-square courtyard plan, ideal for the accommodation of a numerous retinue, of Treasurer Scrope's Bolton and of John de Neville's almost identical Sheriff Hutton. It was expensively built of the finest-quality masonry. It had large window openings in every facade, and was tightly packed, as were the other two fortresses, with individual suites and private lodgings. When John Leland came to Wressle in the 1530s, the castle (of which only the south range now survives) was still in perfect condition. Leland found Wressle 'all of very fair and great squared stone', seeming 'newly made' on first inspection. 'In the castle be only five towers,' the king's antiquary went on, 'one at each corner, almost of like bigness. The gatehouse is the fifth, having five lodgings in height, three of the other towers have four heights in lodgings: the fourth containeth the buttery, pantry, pastery, lardery, and kitchen. The hall and the great chambers be fair, and so is the chapel and the closets.'[132]

Thomas Percy had five towers at Wressle. Lesser men – at Harewood (West Yorkshire), and at such contemporary Northumberland strongholds as Edlingham, Chipchase and Belsay – might have to rest content with only one. However, the tower-house in each case was the lord's personal residence, as revealed by the quality of its fittings. At Harewood, the least known and most neglected of these buildings, the Redmaynes' overgrown hall preserves its high-table fireplace and elaborate canopied buffet. At Edlingham, there are remains of fine vaulting in the hall and of a bold chimneypiece carried forward on caryatids. Chipchase, enriched externally with prominent machicolations, has three floors of chambers over a vaulted basement – the great hall and chapel on the second storey, and another private hall and kitchen on the third. At Belsay, the Middleton tower-house had three principal storeys only. But its hall was enriched with painted heraldry, and its integral stair turret served another six levels of family bedchambers, ascending (as at Warkworth) into a look-out.[133]

There were a number of refinements at English buildings of this kind which were still relatively unfamiliar in contemporary Scotland. One was the almost universal use of stone in fortifications; another, the emphasis on the tower itself; a third, the progressive amelioration of aristocratic lodgings – the individual chamber with its fireplace and privy, the public hall and the integrated kitchen.[134] Scots who had served in the wars in France, or who were familiar with court life at Windsor or Vincennes, were influential in introducing the new values. When Bothwell Castle, on the Clyde, was rebuilt for Archibald 'the Grim' and for his son, Archibald II Douglas, duke of Touraine (d.1424), they made characteristic improvements to its accommodation. The Douglas earls repaired Bothwell's ruined keep, but left unfinished the Edwardian northern defences of Walter de Moravia's earlier fortress. They added a new show-front to Bothwell, with towers on the east; built a great hall there and a big first-floor chapel; and extended the range of lodgings on the south. They had already built lavishly at Threave.[135]

Where, in particular, a new model was established was in the castle of the Regent Albany at Doune. Robert Stewart, earl of Fife and duke of Albany, was the younger brother of King Robert III. For thirty-two years, from 1388 until his death in 1420, a combination of circumstances, including his brother's illness and his nephew's captivity in England, made Albany the ruler of Scotland. Doune was purpose-built. It was never fully finished, and was clearly intended to include other ranges against the curtain to the west and to the south. Nevertheless,

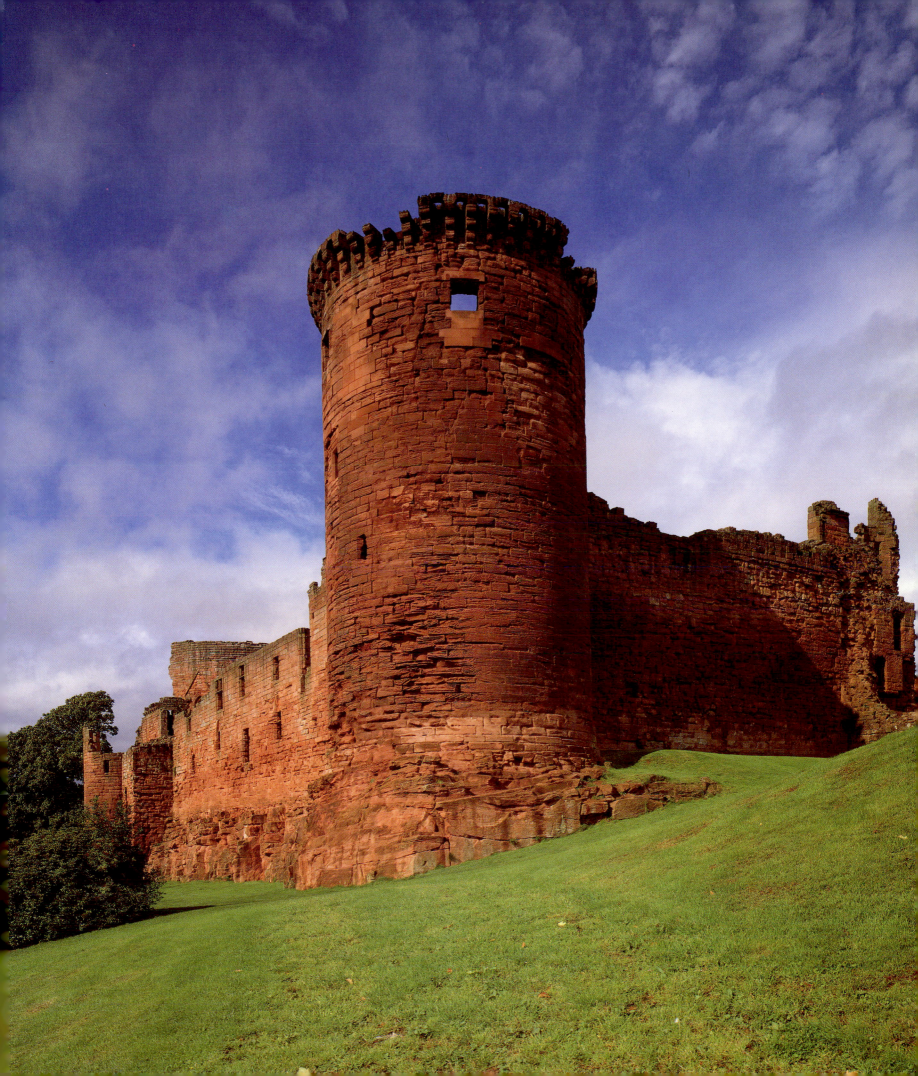

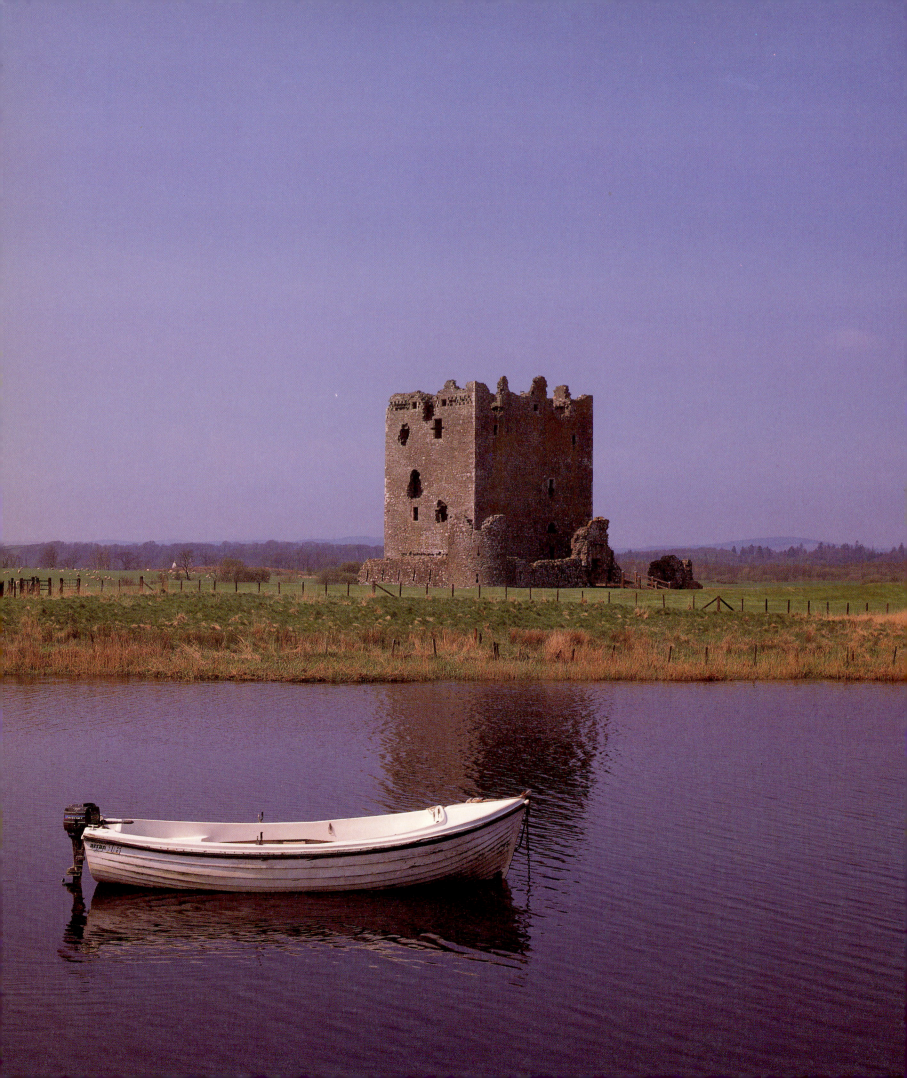

it incorporated all the accommodation essential for Albany's household, and set a standard for the many who paid suit to him. Doune was a stone castle of rich and costly build. It had two tall towers, one of which – the gate-tower – Albany reserved as his own. There were three halls at Doune, two of them private, and there were many individual chambers and separate lodgings. In Albany's personal hall, on the first floor of the gatehouse, there was a handsome double fireplace. Next to it, there was a smaller private chamber and latrine. Fireplaces and privies were provided throughout the building. The integrated kitchen, joined to the great hall by a servery with wide hatches, was spacious and well equipped. Above it, a big guest chamber had two attached sleeping closets, hugging the chimney-breast and warmed by the cooking fires below.[136]

Few remember the amiable but unlucky Roger Walden. 'Better versed in things of the camp and the world than of the church and the study', Walden was secretary to Richard II from 1393 and treasurer from 1395. Briefly, between 1397 and 1399, he was archbishop of Canterbury in place of the banished Thomas Arundel. One of the projects for which, during Richard's final tyranny, Walden assumed responsibility, was the rebuilding in 1396–9 of the royal accommodation at Portchester Castle. Portchester's coastal situation, with its back to the sea, made it a potential refuge and escape-hatch.[137] The castle was already well protected by ancient walls. Furthermore, its defences had only recently been strengthened by the building of a great tower (Assheton's Tower) and by a second reinforcement of the barbican. Walden, accordingly, ignored further defence and concentrated exclusively on the accommodation. In just three years, the inner bailey at Portchester was transformed. Comfortable apartments, at first-floor level, were erected against the south and west curtains. Only the kitchen, at the east end of the south range, rose the full height of the building. Service rooms on two levels gave on to the hall beyond, approached formally from the court by porch and stair. In the attached west range, the archbishop's chamber was particularly spacious and well lit. It had a smaller bedchamber on the south, and opened to the north-east into another sizeable apartment, with access to an earlier chapel in the keep. Under these apartments there were individual lodgings, each with its door on the court. There were lodgings again in the north and east ranges, in the gatehouse, and in the new Assheton's Tower.[138]

Roger Walden's 'palace' at Portchester, cramped though it was by existing walls, was an elegant solution to the contemporary problem of how to make an old fortress habitable. Plainly, the archbishop was not prepared to live uncomfortably at Portchester. But neither was he ready wholly to abandon defence, and it is a significant characteristic of Walden's remodelling of Portchester that none of his new apartments had outer windows. Other prominent churchmen of his time, building castles on the same coast, had been much less cautious than the archbishop (see pp. 184–5). Yet they too shared his taste for 'sumptuous' living, and found it likewise in the frame of mighty buildings. It was this fashionable ostentation, too potent to resist, which made such 'proud good-for-nothings' of the clergy.

239. At Threave, in Kirkcudbright, Archibald the Grim's big residential tower is still accessible only by water. Built in the late fourteenth century, Threave was one of the earliest and the largest of Scotland's aristocratic tower-houses, with a basement store and mezzanine kitchen, under another three floors of accommodation – great hall, family bedchambers, and barrack-room.

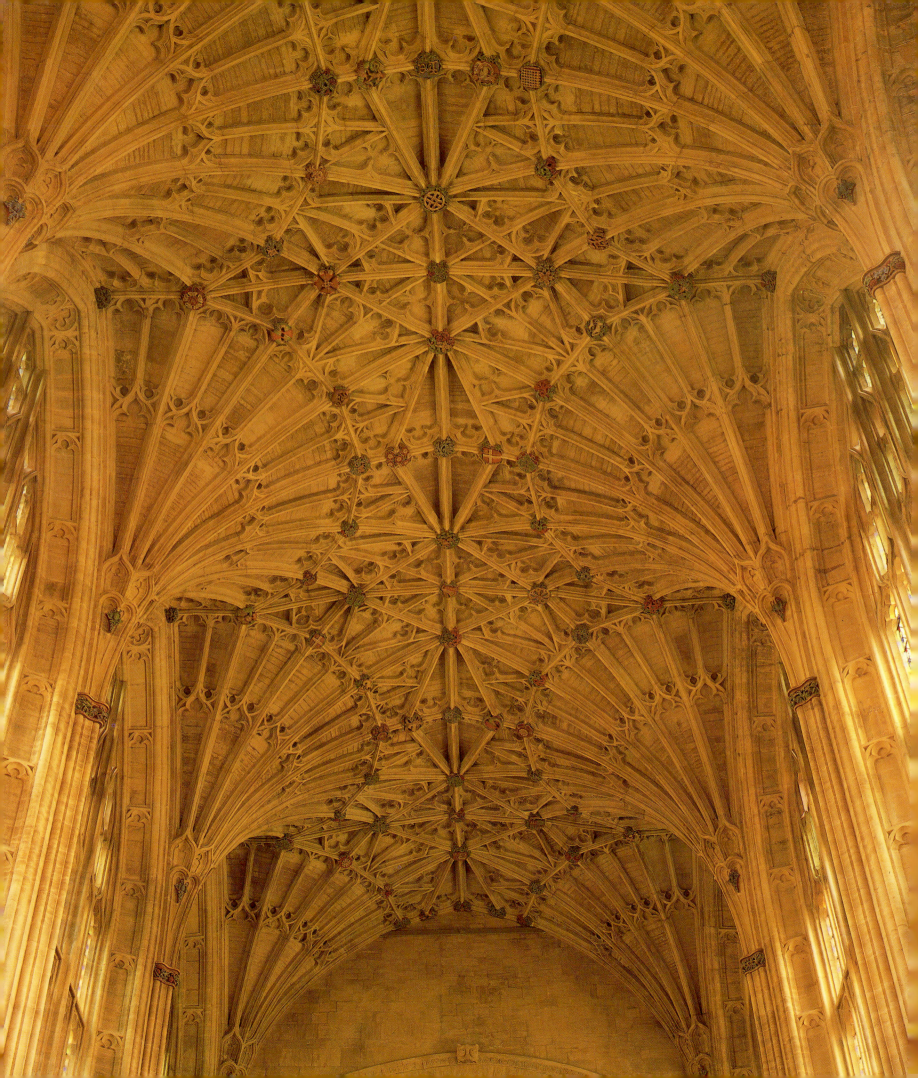

CHAPTER 7
Caim's Castles

Lollard criticism of the Church would not have attracted the attention that it did without the pressures of a costly war in France. It was John Wyclif who complained of the 'many proud good-for-nothings . . . endowed with temporal and worldly lordships and great revenues'.[1] And it was John of Gaunt among others, with many of his knights, who heard the siren call of disendowment.

Gaunt was unwilling to support Wyclif to the limit of his more adventurous heresies, eventually distancing himself from the great doctor on those matters. However, there was nothing exceptional in the objections already voiced – not just among the Lollards – to excessive temporal wealth in the Church. 'This day,' the fourth-century angel had exclaimed when Bishop Silvester of Rome received Constantine's apocryphal Donation, 'has venom been shed into the Church'. Wyclif, challenging the pope's temporal dominion, used this legend repeatedly in his writings. But he was just one of a great company of preachers and polemicists who, on better scriptural authority, had long urged apostolic poverty on their congregations.[2] On Wyclif's death in 1384, his disendowment proposals lived on after him. Lollards, after Wyclif, called the material church 'Caim's Castle', using the hostile acrostic – C for Carmelites, A for Austins, J for Jacobites (Dominicans), and M for Minorites (Franciscans) – first shaped by the doctor himself. They believed, reported Bishop Buckingham in 1393,

> that it suffices every Christian to serve God's commandments in his chamber or to worship God secretly in the field, without paying heed to public prayers in a material building . . . neither is the material church building held among them as holy church, but rather every such materially built house is called by them 'caym' castle.[3]

John Buckingham, bishop of Lincoln, spoke of ordinary folk – of Anna Palmer, the Northampton anchoress, and of the six Lollards of her coven in the borough.[4] Such humble dissidents posed little threat to Church or State. But the same could not be said of the so-called Lollard Knights – of Sir Lewis Clifford and Sir Richard Sturry, of Sir Thomas Latimer and Sir William Nevill, of Sir John Clanvow, Sir John Montagu and Sir John Cheyne. Richard II's court, it has been shown, was the seven's 'common ground'; all were career-soldiers, retained by great lords; and four were knights of Richard's Chamber.[5] Their presence at court, so close to the king, had a material effect on royal policy.

Lollard influence continued under the Lancastrians. Richard II's reported prediction that Henry of Bolingbroke would destroy the Church, contained at least a particle of truth. It was Bolingbroke's son, Henry V, who attracted most attention as a church reformer – a 'celestial warrior' (*celestis miles*), hammer of the Benedictines as well as smiter of both heretic and Frenchman.[6] But earlier than this, the Lollard Disendowment Bill of 1410 had come before Henry IV's Parliament. The Bill was no more than a paper scheme which may never have received formal notice. It dealt in Mickey Mouse numbers. However, its programme was specific, seeming to give reality to those other hypothetical redistributions of resources on which preachers had been musing since the 1370s. Lollard confiscations from the Church – from their enemies, the bishops, and from the black-monk houses – were intended to benefit three areas. First, national defence would profit by the promotion of fifteen earls and by the support of another 1500 knights and 6200 squires. Then, poverty would be relieved by the provision of 100 new almshouses. Lastly, the secular clergy's

240. The expensive fifteenth-century clerestory and fan vault of the nave at Sherborne Abbey.

quality would be enhanced by the endowment of universities, fifteen in all, and by the financing of 15,000 priests and clerks. 'And therefore,' the bill concluded,

all the true commons desire ... that these worldly clerks, bishops, abbots, and priors, who are such worldly lords, be put to live by their spiritualities; for they ... do not do the office of true curates as prelates should, nor do they help the poor commons with their lordships as true secular lords should, nor do they live in penance nor in bodily travail as true religious should, by means of their [temporal] possessions. But of every estate they take joy and ease and put from them the labour, and take profits that should come to true men.[7]

Political Lollardy got no further than this. After the collapse of Sir John Oldcastle's revolt on 9 January 1414 , even the Lollard gentry took cover. But Lollardy was not the only new thinking to be current at this time, and the Church came under pressure from many quarters. The monasteries, in particular, had laid themselves open to the accusations of both reformers and xenophobes. Again it was the war in France that was to blame. Since 1294, when Gascony had been lost, 'alien' priories of suspect allegiance had been the victims of repeated confiscations. Cut off from their mother-houses by the war on land and sea, they had increasingly become the prey of well-placed neighbours – of prominent officials and influential men at court, among them the seven Lollard Knights.[8] In 1378 all French monks were expelled from England. Many subsequently returned, and the expulsions of 1378 were perhaps always more an episode than a watershed.[9] Nevertheless, another general eviction followed in 1404, and Henry V took little persuading, just ten years later, to make these banishments permanent. 'If a final peace should be made,' the Commons pointed out to the king,

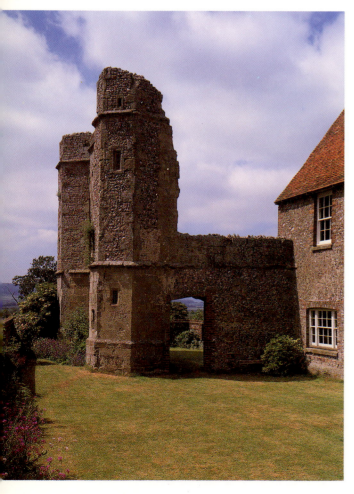

241. Isolated and unsupervised, the small French communities at the alien priories went their own way. At Grestain's Wilmington (Sussex), a fine first-floor hall, of which this is the turreted south facade, was added to the priory buildings in the fourteenth century.

and all the possessions of the alien priories existing in England should be restored to the chief houses of religion overseas, to which such possessions belong, damage and loss would come to your said realm ... by reason of the great farms and levies of money which from year to year are daily rendered from the same possessions to the chief houses abovesaid, to the great impoverishment of the same your realm in this matter, which God forbid.[10]

If xenophobia and greed inspired the confiscations of 1414, there was also real concern for religion. Fully conventual alien priories were no more at risk of undue corruption of morals than any other communities of monks. Many – like Boxgrove and Folkestone, Spalding, St Neots and Horsham St Faith – had already severed all links with their French mother-houses, to take shelter in denizen status. However, much the greater part of French investment in English lands had been not in priories of that scale at all, but in non-conventual estate centres and parish churches (see pp. 11–18). Far from home as they were, these holdings had posed administrative problems from the start. War had multiplied the difficulties many times, and the inability of the French houses to meet their responsibilities had given rise to justified reproach. Permanent appropriation, in the circumstances, made good sense, 'to the intent that divine service in the places aforesaid shall be more duly made by Englishmen in time to come, which have not been made before now by Frenchmen'.[11]

Neglect of the cure of souls was one of the commonest complaints about the aliens. Another was their freedom from supervision and the consequent self-indulgence of their life-styles. Wilmington, in Sussex, was the premier estate centre of the Norman monks of Grestain, who had held lands and the church there since the Conquest. Grestain's investment in the parish church was always modest. However, its adjoining 'priory' at Wilmington was a substantial building, comparable in every way to a lay manor house. In the fourteenth century, when Wilmington's hall was rebuilt, only the prior and his companion were in

196

residence. They must have rattled around such huge quarters, in the priory's latter days, like coins in an empty collecting box.[12]

It was this topsy-turvy world, ranking privilege routinely above obligation, which increasingly enraged the reformers. Walter Brystowe, last prior of Wilmington, enjoyed all the luxuries of a warm and well-lit hall, a solar and an oratory of his own. These were comforts barely consonant with the life of religion, yet had come to be widely expected. The easeful existence of senior monks like Walter Brystowe gave ammunition to their more active accusers. When he scolded the English Benedictines in 1421, Henry V was himself in the prime of life: still in his mid-thirties, vigorous, impatient and battle-hardened. First, he pointed his finger at 'the fathers and heads of houses, whose acts and lives are to be an example to their subjects'. They must spend more time with the monks in their charge, and lie less often at their manor houses; they must keep full accounts, and stop treating the assets of the community as their own; 'also let the costly and excessively scandalous cavalcades of the abbots be moderated, as well in the varied and irregular array of servants as in the adornment of the horses'. Personal property, Henry reminded the black-monk abbots, 'is an execrable and detestable sin, which creeps upwards and poisons simple conventuals greatly in these days'. Monks, accordingly, were not to handle money but were to draw what they needed 'in goods entirely'. They must have no articles of value – silver cups or fine books – in their keeping. 'Because there are great excesses in monks' frocks', uniformity of dress was to be insisted on from this time, and 'that bright cloth of Worcester, which is accounted more military than monastic, should be entirely forbidden to all'. Meat diets might continue, for 'whereas the eating of meat is forbidden to monks . . . the infirmity of present day monks and long and established observance has weighed against this rule'. But all monks must keep refectory in the company of their fellows, and were not to remove their meals to private chambers.[13]

Henry was right to warn his Benedictines of the creeping poison of private property. They answered him, of course, as though nothing whatever were the matter.[14] But potentially corrupting distributions of pocket-money (the *peculium*) were indeed on the increase at many of the larger black-monk houses by this date.[15] And those 'private or separate cells or rooms', which Henry had identified as a major abuse, were more common than they had ever been before. St Benedict, in the sixth century, had counselled his monks: 'If it be possible, let them all sleep in one place'.[16] And Bishop Alnwick of Lincoln, even as late as 1442, might continue to insist that the Cistercian nuns of Catesby should 'live in common, eating and drinking in one house, sleeping in one house, praying and serving God in one oratory, leaving utterly all private hidles [hiding-places], chambers and singular households, by the which have come and grown great hurt and peril of souls'.[17] But few religious communities in late-medieval Britain could have taken such injunctions very seriously. It was those same nuns of Catesby, once corrected by William Alnwick, whose private 'sells in the Dorter' were sold off at 6s 8d each at the Dissolution.[18] At Durham, the great dormitory had been rebuilt in 1398–1404, to become the model for many similar partitionings:

> every Mouncke having a litle chamber of wainscott verie close severall by them selves & ther wyndowes towardes the cloyster, every wyndowe servinge for one Chambre by reasoune the particion betwixt every chamber was close wainscotted one from an other, and in every of there wyndowes a deske to supporte there bookes for there studdie; In the weste syde of the said dorter was the like chambers & in like sort placed with there wyndowes, and desks towardes the fermery & the water, the chambers beinge all well bourded under foute.

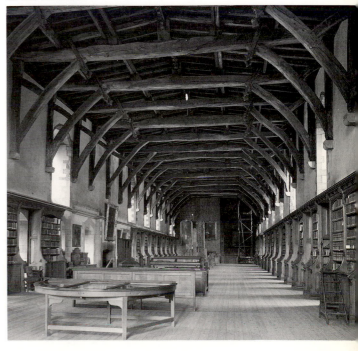

242. The great dormitory at Durham Cathedral Priory was rebuilt in 1398–1404. It was fitted at that time with individual cubicles, each monk having his desk in the window.

244. Cleeve Abbey's sixteenth-century gatehouse carries Abbot Dovell's welcoming inscription at the far end. On this south face, the equivalent panel over the gate arch reads 'DOVEL'.

243. The first-floor refectory at Cleeve Abbey, as rebuilt in the fifteenth century on a new alignment and at a more congenial scale.

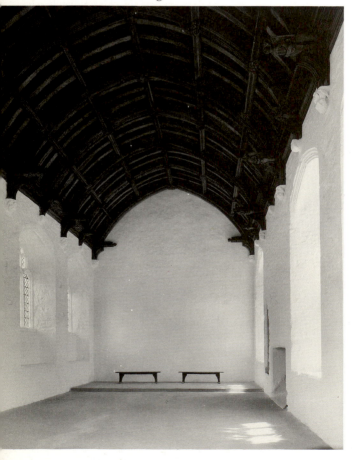

Even novices at Durham, usually housed together, had each 'his chamber severall by him selfe'.[19]

'Private hidles, chambers and singular households' appealed with a peculiar and unquenchable force to those sworn to a life led in common. The black-monk abbots in 1421 had defended the right to privacy of their senior men. And Brother William Ingram, penitentiary at Canterbury Cathedral Priory from 1511, no doubt felt entitled to the personal chamber and south-facing garden which were among the rewards of his office. Ingram, who had made his profession in 1483, was almost fifty at the time of his promotion. His income, drawn from many sources in the priory, kept him comfortably in select food and wines. He bought furnishings and other goods; had a servant of his own; and sometimes hired a cook for the parties he arranged in his chamber.[20] Before 1536, when their priory was dissolved and their goods exhaustively listed, each of the ladies at Minster in Sheppey had been assigned a personal chamber in the dormitory. All had featherbeds in their rooms, with bolsters and pillows, coverlets, blankets and sheets. Some had firepans, and most had other items of private property. Agnes Davy had 'browghte with her' painted hangings for her chamber, a carved wainscot cupboard, and a 'cofer of ashe' for her things. Agnes Brown collected silver – a goblet and a maser, another 'lytill pece of silver' and a spoon. These were included in the list, much the longest in the inventory, of 'stuff given her [Dame Agnes] by her frends'.[21]

Minster in Sheppey was an Augustinian house. But while the Rule of St Augustine was more liberal than most, its relaxations were increasingly shared. Cleeve Abbey, in northern Somerset, and Valle Crucis, near Llangollen, were both Cistercian communities. They had begun austerely as houses of traditional plan. Yet when rebuilt towards the end of the fifteenth century, each was significantly transformed. At neither was there need to provide for lay brethren who had long ceased to be recruited by the order. Accordingly, one major modification at Cleeve was the reuse of the west range to accommodate the abbot and his guests. Another was the insertion of new windows in the dormitory and its division into two rows of cubicles. The south range, simultaneously, was reconstructed. The old north–south refectory, built for a much larger community, had begun to seem too cavernous. It was demolished to give way to a smaller and more comfortable first-floor hall, parallel to the cloister, where the abbot and convent could entertain their friends, keeping the table for which they were famous.[22]

The monks of Cleeve, in their latter days, were defended by Thomas Arundell as men 'of very honest life and conversation'. But it was their hospitality, above all, that would be missed. Even this, though, had had its darker side. There is a welcoming inscription above Abbot Dovell's gate at Cleeve which reads: 'Gate be open, shut to no honest person.'[23] The sentiment is generous and wholly appropriate. But it had been employed too often to excuse lavish building, encouraging life-styles which might be scandalously relaxed. Well-known offenders in this regard, owing their notoriety to grateful songsters, were William Dovell's brother-abbots in distant Wales. At Valle Crucis, a wealthy house, Abbot Dafydd ab Ieuan's 'full-stocked tables ever groan[ed] with wine and meat'. Even little Strata Marcella, during Dafydd ab Owain's abbacy (1485–95), was richly supplied with venison and wild game, with sea fish and with every kind of fruit. The abbot's cups flowed over with exotic wines, worthy (sang the bard) of Prester John.[24]

Dafydd ab Ieuan (1480–1503), that incomparable host, was also a mighty builder at Valle Crucis. He contributed especially to the abbey church: 'a noble fabric for God, His Cruciform House'.[25] But, more significantly, he reorganized his quarters. The community at Valle Crucis had been much diminished. As at Cleeve, its lay brethren had departed. Their nave had been walled off and their

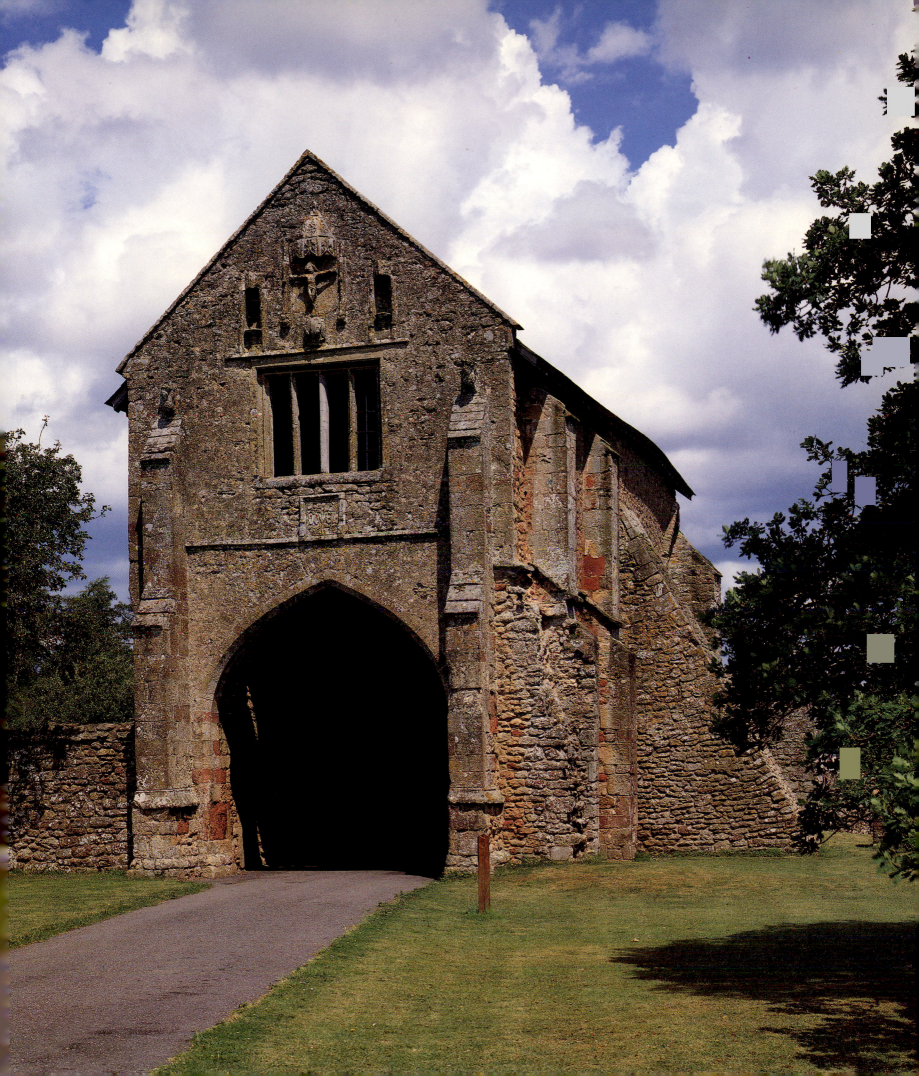

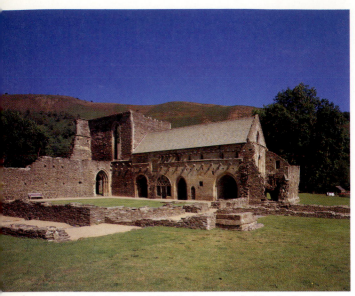

245. In the Late Middle Ages, probably during the abbacy of Dafydd ab Ieuan (1480–1503), the east range at Valle Crucis was remodelled extensively to provide apartments for the abbot and his guests.

246. Under Cleeve's new refectory, on the south side of the cloister, were two self-contained corrodians' apartments. It was in one of these that Edward Walker purchased a life interest in 1535, shortly before the community dispersed.

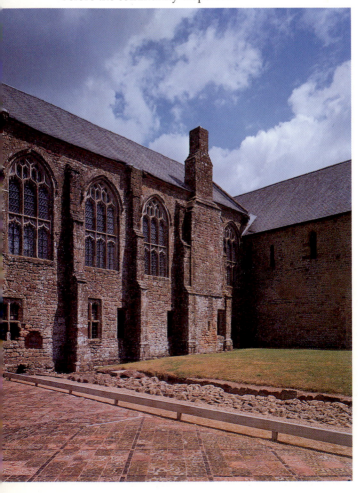

former dormitory and frater, in the abandoned west range, were available for conversion to other uses. Even choir-monks were thin on the ground. In 1535, there were only six monks in residence at Valle Crucis. And although this was about average for a Welsh Cistercian community of that date, it nevertheless fell far short of St Bernard's statutory minimum – twelve monks and an abbot – which only Tintern had managed to preserve.[26] Falling numbers encouraged a replanning. The east range at Valle Crucis was still in good repair, and Abbot Dafydd took it for himself. Dafydd made his hall over the chapter-house, at the north end of the monks' dormitory, with his chamber at its north-east corner, against the transept. The rest of the dormitory, for about half its length, was divided into apartments for his guests.[27] Valle Crucis Abbey, with its monks in individual lodgings, probably in the west range, and its abbot rehoused in the east, had become thoroughly secularized. It was a manor house in which religion, although still fitfully alive, could all too easily be overlooked. Brother Richard Whitford, who knew Wales well, was saddened by what he saw of such conversions. He remarked how the Welsh monks do 'eat and drink and feed out of due time or due place and such meats or drinks as be prohibit and forbidden … And do delight and take pleasure in secular company and there keep dalliance in clattering and talking, hearing and telling of tales'.[28]

The merry-making was general, but few saw it as entirely reprehensible. Nobody gave better value than the rich monks of Durham, whose hospitality was reputed not 'inferior to any place in Ingland, both for the goodnes of ther diete, the sweete & daintie furneture of there Lodgings, & generally all things necessarie for travveillers'. Durham's 'famous house of hospitallitie called the geste haule' was

a goodly brave place much like unto the body of a church with verey fair pillers supporting yt on ether syde and in the mydest of the haule a most large Range for the fyer. The chambers & lodginges belonging to yt weare most swetly keept, and so richly furnyshed that they weare not unpleasant to ly in, especially one chamber called the Kyng's chamber deservinge that name, in that the king him selfe myght verie well haue lyne in yt for the princelynes therof.[29]

There was no King's Chamber at Ulverscroft Priory, in Charnwood Forest. But this tiny Leicestershire community of Austin canons was even more dependent than the monks of Durham on hospitality for its pleasure and its profit. Ulverscroft stood 'in a waste ground, very solitary' where 'there is no good toune, nor scant a village'. Its canons were great handymen, of whom it would be said at the Dissolution that 'there was not one religious person there but that they can and doth use either embroidering, writing books with very fair hand, making their own garments, carving, painting, or engraving'.[30] However, the community also depended on travellers' contributions, and it was probably as its guesthouse that the west range was rebuilt in the Late Middle Ages, when the prior's lodgings were removed to the east.[31]

Indeed, there were very few religious communities, before the Suppression, which had never functioned in some measure as hotels. Some had used their gatehouses for this purpose. And it was in the commodious (and still surviving) gatehouse at Minster in Sheppey, over the gate-passage, that the canonesses once offered their priests and other visitors the particular comforts of the Confessor's Chamber: a 'good featherbed', a 'good bolster', a 'good counterpane', and a 'great joined chair of wainscot'. There was a second lodging (called the Steward's Chamber) in Minster's gatehouse, to which again a smaller bedchamber was attached.[32] At Darley Abbey (Derbyshire), when suppressed in 1538, there were several such guest suites in the precinct. There was the Low Chamber, the Second Chamber, the Great Chamber and the Mayfield Chamber: all comfortably

furnished with featherbeds and hangings, bolsters, blankets and coverlets. Only the Glass Chamber and the Servants' Chamber (in which there were four beds) had no 'inner chamber' adjoining.[33]

There is a terrace of late-medieval lodgings at Crossraguel (Ayr) – each with its chamber, partitioned bedspace, and privy – which can only have been intended for the pensioners, or 'corrodians', that few abbeys of the period could do without.[34] Many such pensioners were imposed on the religious houses by patrons too powerful to resist. They seldom brought the benefits of short-term visitors and could result in a costly haemorrhage of resources. But grants of corrodies were also frequently self-imposed. They mortgaged the future, but might be the only possible response to an immediate fund-raising crisis. Always rare among the Mendicants, who had little enough at any time to give away, corrodians occurred towards the end of the fourteenth century at the Carmelite friary at King's Lynn. In 1363, the friary church had been struck by lightning and burnt down. Those who contributed to its rebuilding included Alan and Alice Smith, who together donated 100 marks to the cause. When granted a corrody in 1368, they were the first of no fewer than five lay households to be established within the friary precinct over the next decade. All had their separate lodgings, and one at least – the Ellingham household – had a purpose-built dwelling of its own.[35]

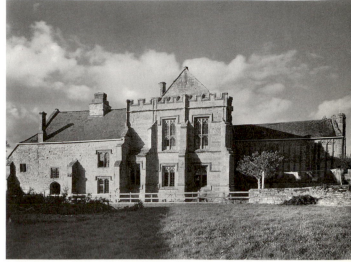

247. It was Abbot Broke (1505–22) who rebuilt the superior's lodgings at Muchelney Abbey. His own chamber was on the first floor (centre), with two large windows facing south.

The Ellingham house at Lynn, erected for Hugh and Cecilia in 1377, had a hall and two chambers (upper and lower), a pantry and larder at the lower end of the hall, and another chamber above. It had a kitchen and private garden, and could be entered independently from the street.[36] Few corrodians, even at the greater houses, got as much for their money as this. But all bought themselves an arrangement which, like the annuity of today, carried some of the added spice of speculation. Alan and Alice Smith, corrodians of Lynn, may have stayed there for as long as thirty years. If so, the Carmelites got much the worst of the deal. However, the risks and the rewards of transactions of this kind were evenly divided. One pensioner who came off less well than the Smiths was Edward Walker ('gentleman') at Cleeve Abbey. In 1535, failing to read the times correctly, Walker put down £27 for a life interest in one of the two pensioners' apartments still to be found under the abbey's fifteenth-century refectory. Walker got two rooms – using the bedchamber for his servant – and a privy. He was entitled to fodder for his horses, wood for his fires, bread and ale at his 'pleasure and demand', and 'sufficient and holsome meat and drinke' to keep him for the rest of his days. On Cleeve's suppression in 1536, he had enjoyed these for scarcely a year.[37]

248. The fireplace in Abbot Broke's chamber at Muchelney.

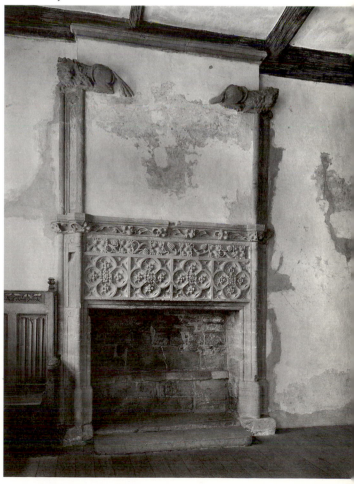

Over that short span, Walker had dined with the abbot in the fine new hall just up the stairs from his apartment. And the English abbots, no less than the Welsh, were known to eat very well.[38] If it now seems a little shocking that fully two-thirds of the receipts of Whalley (Lancashire), another Cistercian house, were spent in the 1520s on food and wine, contemporaries would have found it less extraordinary.[39] There is nothing in the building evidence to contradict such figures. Whalley, like Cleeve, had been the scene of much recent building activity. Furthermore, the great bulk of that expenditure, from the early fifteenth century, had been devoted to the improvement of accommodation.[40] It was the abbot's lodgings at Whalley, east of the former dormitory, which were preserved by Richard Assheton after the Dissolution, when Whalley's church and its claustral ranges were demolished. Like other superiors' lodgings – like those of Neath (Glamorgan), Arbroath (Angus), Milton (Dorset), Norton (Cheshire), Watton (Yorkshire), Muchelney (Somerset), Castle Acre (Norfolk), St Osyth's (Essex), Repton (Derbyshire) and many more – the abbot's quarters at Whalley were newly built.[41] The finest of these remodellings was the great lodging range lately erected by Prior Singer (1486–1521) at Much Wenlock. This Shropshire

201

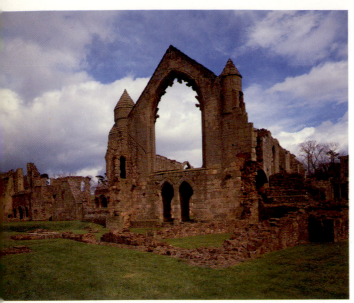

249. The abbot's hall at Haughmond, grandly rebuilt in the early fourteenth century, gave the fortunate canons of this rich Augustinian house a place to eat and entertain in style and splendour.

250. A new kitchen was included in the general rebuilding of the abbot's quarters at Glastonbury, begun by John de Breynton (1334–42); it had four great corner-fireplaces, their flues uniting in the single central chimney.

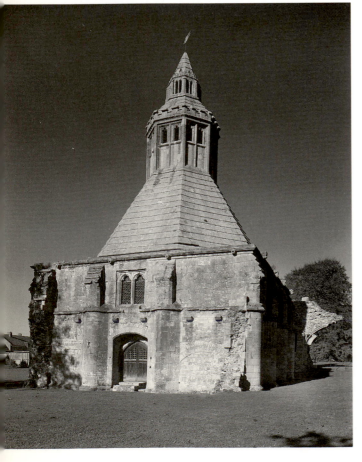

house was an old and wealthy Cluniac community, and Richard Singer himself was a very grand personage in the county. His fine new quarters, faced on the west with a glazed corridor on two levels, included a big private hall and adjoining great chamber, with individual apartments for the more favoured of his guests.[42] Shortly after Singer's death, the community he had governed was rebuked for its lax standards – for its drinking, its card-playing and its gossip after compline, for the fine clothes and many servants of the monks.[43] And it was just such behaviour that was recalled outside the walls by those who had begun to contemplate reform. Thomas Starkey's *Dialogue between Pole and Lupset* (c. 1530) was a political text, not primarily concerned with church reform. Nevertheless, among the views Starkey attributed to his patron, Reginald Pole (later Mary's archbishop and cardinal), was the belief that all abbots and priors should be re-elected every four years and should 'lyve among hys bretherne, & not to tryumph in theyr chamberys as they dow'. Such behaviour, in Starkey's view, had provoked envy in the cloister and caused huge expense, 'for to hys tabul resortyth the idul cumpany dwellyng about hym'. Regular re-election 'surely schold be a grete reformatyon in the monasterys of englond'.[44]

Starkey was positive, even in his day, that 'I wold not that thes relygyouse men wyth theyr monasterys schold utturly be take away, but only some gud reformatyon to be had to them'.[45] However, the concentration of so many 'religious men' on their personal comfort had done their image permanent harm. Nowhere can this concentration have been more obvious at the time than at Haughmond, another Shropshire house. The community at Haughmond, while not as rich as Wenlock's, had always been well off.[46] When other religious houses, affected by stagnant rents, held back from further investment, Haughmond's canons built as they pleased. It is this freedom which makes their choices significant. First, they reduced the size of their abbey church, depriving it of much of its nave. Then they demolished the redundant west range, keeping only its high outer wall. Both the chapter-house and abbot's lodgings were still much in use. To these, accordingly, they added fashionable bay windows and other creature comforts, including wainscot, full glazing, and panelled ceilings.[47] All this was work of 1500 or later. But Haughmond's domestication had begun almost two centuries before. A fine new hall, markedly grander than the canons' existing refectory, was built at Haughmond in the early fourteenth century, in the south court next to the abbot's lodgings. Hall and refectory shared a kitchen, and it was in 1332, just after this kitchen's completion, that the abbot of Haughmond drew up a new set of ordinances. As before, both fuel and the basic foodstuffs – flour, cheese and butter, peas and other vegetables for pottage – were to be bought out of the common fund. Fresh fish still came from the abbey fisheries. But meat was another and more recent charge, and this was to be purchased from the revenues (specially assigned) of two appropriated parish churches, to which would be added an annual allowance of twenty pigs from the piggery at Haughmond's gates.[48]

Haughmond's new hall is sometimes identified as the canons' infirmary. However, it has few of the characteristics of the traditional infirmary, and functioned more probably both as guest-hall and misericord – a place where meat-eating was permitted. In St Benedict's day, the 'flesh of four-footed animals' had been expressly forbidden to all monks, saving only 'the sick who are very weak'.[49] But exceptions were so numerous by the time the hall was built that the rule had, in practice, been set aside. In 1336, Pope Benedict XII bowed to the inevitable. He allowed the healthy to eat meat along with the sick, while insisting still, so far as he was able, on some continuing formal presence in the refectory.[50] From this time, specially constructed misericords multiplied everywhere at the religious houses. Keeping full refectory became a thing of the past, limited to feast days and to other celebrations.

Of the seven Yorkshire houses of Cistercian allegiance, only Meaux (which has yet to be excavated) shows no clear evidence of these changes. At Fountains, there was a large fifteenth-century misericord, bridging the River Skell, between the abbot's lodgings and the infirmary. At Byland, a contemporary misericord and substantial meat kitchen were sited south-east of the refectory. At Jervaulx, there was a meat kitchen east of the dormitory, associated with the late-medieval abbot's lodgings. The big abbots' kitchens at Roche and at Rievaulx also probably served that purpose in their time.[51] It was the monks' refectory at Kirkstall, as at many of the lesser houses, which was rebuilt afresh in the fifteenth century. Kirkstall was in cattle country. Its monks were stockmen and became, like the Benedictines of Battle in similar circumstances, substantial consumers of their own beef. To this end, they built themselves a meat kitchen and divided their refectory, introducing a new floor to make two chambers. They cut new windows at both levels and blocked the old. In place of the former reading pulpit – sad reflection of the times! – they permitted themselves the luxury of a chimney.[52]

251. The vault and central louver of the great kitchen at Durham Cathedral Priory, rebuilt in 1366–70.

Small communities of religious, not always requiring a misericord of their own, often made alterations of this kind. Ivychurch, in Wiltshire, was an Augustinian house which had suffered badly in the Black Death (when it lost all but one of its canons) but which had recovered its fortunes by the late fifteenth century through the acquisition of former alien estates. In the 1480s, Ivychurch's canons celebrated their good fortune by smartening up their refectory. They gave it a new roof and modernized the windows, again substituting a fireplace for the pulpit.[53] At Bushmead (Bedfordshire), at much the same time, another community of Augustinians floored over the refectory, put in new windows, and built a chimney to replace the open hearth.[54] Two Cistercian communities, Forde (Dorset) and Croxden (Staffordshire), chose very different solutions. Forde was a wealthy house, about as rich as Kirkstall. It re-roofed its refectory in the fifteenth century, introduced a new floor, and put in new windows at the same time.[55] Croxden, once prosperous, had fallen in this period on harder times. There were only six monks at Croxden in 1381. The community recovered somewhat before its suppression in 1538, but had economized before that on an over-large refectory, cutting it to a third of its length.[56]

252. Another intact late fourteenth-century kitchen has survived at the Oxfordshire manor house of Stanton Harcourt.

There was a new fireplace in the cross-wall of Croxden's trimmed refectory, which suggests that not all these alterations were unwelcome. In point of fact, life at the religious houses had never been more convivial than it was in these last sunset days. Thus the fortunate monks of Glastonbury – wealthiest (after Westminster) of the black-monk houses – fed mightily on the roasts from their huge abbot's kitchen, newly-built in the later fourteenth century.[57] There was a similar great kitchen at Durham Cathedral Priory, rebuilt in 1366–70 by the master mason John Lewyn, later architect of Bolton Castle and Carlisle. It cooked roasts and other dishes for the brethren in the 'Loft', surely the most companionable of misericords. There,

the mounckes [of Durham] dyd all dyne together at one table, in a place called the lofte, which was in the west end of the fratree above the seller, the Subprior dyd alwaies sitt att the upper end of the table as cheeffe, and theye had there meat served from the great kitching, the said great kitchinge servinge both the prior and all the whole covent.[58]

Durham's monks had other comforts. Their frater was 'finely wainscotted' and painted above with a 'goodly fair great picture of our Saviour Christ and the blessed Virgin Mary and St John'. In the Loft 'where all the Monkes did dine & sup in ... every Monke had his Mazer [cup] severally by himself that he did drink in ... and all the said Mazers were all largely and finely edged about with silver, and double guilt with gold'. After dinner, the monks went to their separate carrells [studies] in the north cloister alley, 'all fynely wainscotted', and 'there

253. The cloister and first-floor refectory of Durham's rest-house at Finchale Priory. In the Late Middle Ages, Finchale's refectory was subdivided, when holidaying monks took their meals in the prior's house.

254. The Perpendicular nave of Canterbury Cathedral, rebuilt by Prior Thomas Chillenden (1390–1411).

studied upon there books, every one in his carrell all the after none unto evensong tyme'. Senior monks and officials had fires in their chambers. The rereдorter, 'called the privies', was a 'most decent place' where 'every seate and particion was of wainscott close of either syde verie decent, so that one of them could not see one another, when they weare in that place'.[59]

Warm and well-fed, the monks who slept off their dinners in Durham's great cloister enjoyed even the benefits of private health-care. The cloister itself was newly rebuilt in the fifteenth century, and had probably – as was the practice at many houses by this date – been glazed against the chill northern airs.[60] When its rituals became oppressive and relief seemed due, Durham's monks could escape to their own rest-home. Finchale Priory, attractively sited a little down-river on the Wear, had been the hermitage of St Godric, the sailor-saint. It was inherited by Durham on Godric's death in 1170, and was in use by the priory from the mid-fourteenth century as a holiday resort for its monks. Finchale kept the church and the small attached cloister of a functioning monastic community. But its remains are still dominated by the fine suite of lodgings – a hall and great chamber, a chapel and study – rebuilt for the prior in the fourteenth century and shared, at least in part, by his monks. They came to Finchale in rotation, in parties of four, for visits of as long as three weeks. Their day-chamber, which was heated, was described at the time as the *camera ludencium* – the 'Player Chamber'.[61]

Finchale's convalescent monks were allowed walks in the fields, where they might 'religiously and honestly' take the air. And it was for this purpose specifically – to 'breathe the clear air' – that Walter Reynolds, archbishop of Canterbury (1313–27), gave the monks of Christ Church his country place at Caldicote, to which they might resort after blood-letting. [62] Towards the end of the Middle Ages, it was the custom at Christ Church for the older monks to be allowed their individual chambers in the cathedral's infirmary, which they might furnish comfortably with their own goods.[63] Senior men like these had been excluded in 1422 from the canons' infirmary at St Frideswide's (Oxford), when Bishop Fleming required that 'no canon henceforward have any separate or private chamber assigned to him in the infirmary, unless he be broken down by so great sickness, old age and ill-health, that he must have the refreshment which he necessarily ought to have in a chamber of his own'.[64] But Fleming himself, just the previous year, had outlined what was usually expected. At Huntingdon, in 1421, he ordained that

> two of the best lodgings in the infirmary, with fireplaces and latrines, be kept completely ready and in fair condition for canons in ill health, to whom, during the time of their infirmity, better, richer and more delicate meats beyond the general commons of the house, shall be supplied out of the common goods of the house, whereby they may be the better restored, and also doctors and medicines, so that with the help of God they may the more quickly recover health.[65]

Separate lodgings of this kind, each with its fireplace, have been identified in the infirmary of the Yorkshire priory at Monk Bretton, where they are additions of the fifteenth century. And the divided infirmary, at Monk Bretton as elsewhere, was as characteristic an improvement of the Late Middle Ages as the remodelled prior's apartment and enlarged guesthouse.[66] All these accustomed ameliorations of lodgings were to be found again at Yorkshire's greatest monastic complex at Fountains Abbey. The abbot's lodgings at Fountains, already improved many times, were substantially enlarged and rebuilt by Abbot Huby (1495–1526). Both guesthouses at Fountains were modified in the later Middle Ages, when subdivided and re-equipped with new chimneys. The abbey's huge infirmary, at first of open plan, was subsequently partitioned into separate cells or lodgings, furnished with their fireplaces and latrines.[67] Similar partitioning at Tintern,

204

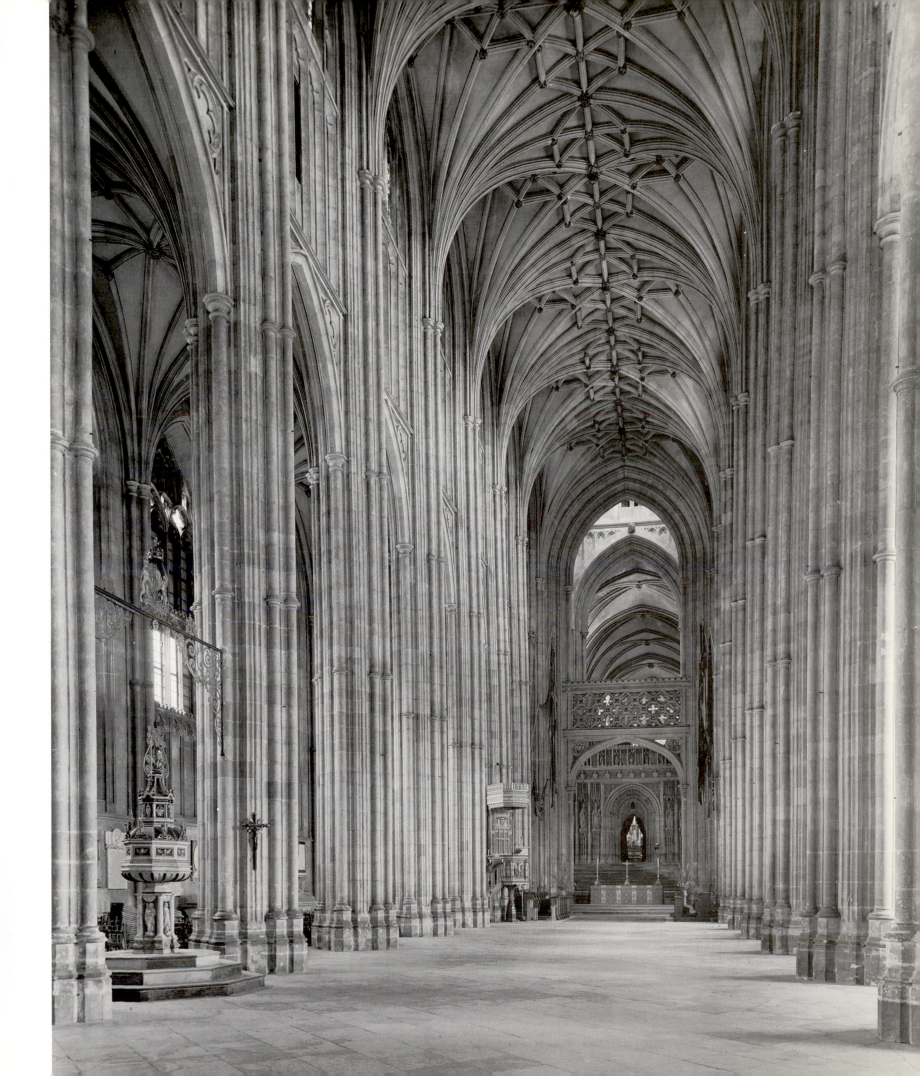

carried out in stone, was obviously intended to be permanent. Each little 'ward' in Tintern's infirmary had a fireplace of its own, with individual lockers in the wall.[68]

The greatly improved lodgings of the monastic clergy are some proof of their continuing prosperity. And it was certainly the case that individual communities, even as late as this, found the resources for major building programmes. There was Canterbury's huge nave, rebuilt by Prior Chillenden (1390–1411) – 'the greatest Builder of a Prior that ever was in Christes Churche'. There was that other big nave at St Swithin's (Winchester), begun by Bishop Edington (1346–66) and completed by William of Wykeham (1366–1404). Fire halted the rebuilding of Sherborne in 1437. Yet Abbot Ramsam (1475–1504) found it possible to resume work on the church in a style no less costly than before. Melrose Abbey, after the English raid of 1385, was rebuilt by the Scots with vast display. And neither Gloucester nor Glastonbury, in the Late Middle Ages, would ever stop building for very long.[69] But put all these together, and there is still nothing to equal the huge creative effort of the twelfth and thirteenth centuries in which monks of every order had engaged. Money was not the only problem. When the Mendicants were still building *plura et grandia* in the 1480s, the much wealthier Cistercians had become – so one of their number complained at the time – a public laughing-stock. After fifty years of cooperative but misdirected effort, they had yet to complete their Oxford college.[70]

Those passers-by at Oxford – 'great men among them' – who had mocked Cistercian efforts at St Bernard's, were partly moved by their dislike of the Possessioners. The alienation was general and (in the long term) very dangerous. Nevertheless most religious houses in fifteenth-century Britain would have seen poverty as the more immediate threat. Some of the bigger and better endowed communities had diversified successfully since the Black Death. They had become stockmen, enclosing arable for pasture, and had invested surplus funds in urban tenements.[71] Even at times like these, a specially able administrator like Prior Thomas Chillenden of Canterbury could turn the moment to his community's advantage. Chillenden, who had been treasurer of Christ Church before becoming prior in 1390, disposed of the priory demesnes within five years of his election, using the capital thus unlocked to finance building.[72] Other monks, less courageous or well-briefed, moved more circumspectly. There was wisdom, necessarily, in a slower pace of change, but there was also much costly hesitation.[73] Westminster's wealthy monks, insulated against bad times by their huge endowments, became more inward-looking every day. They began losing control of their estates from the 1360s, and by the 1420s, in common with the great majority of landowners like themselves, had withdrawn almost totally from direct farming.[74] These new policies did little to help their public image. As rentiers, Westminster's monks were 'not benevolent, but ineffectual'. They failed even to collect the rents at first agreed, losing the respect and the cooperation of their tenants. In Westminster's last years, its historian concludes, 'it can hardly be doubted that the main profits of husbandry on its demesnes were appropriated, not by the monks themselves, but by their lessees.'[75]

The community at Westminster could absorb its losses. Other Possessioner houses suffered more severely, and a few went under altogether. Small communities were generally the more vulnerable, but their size could sometimes be a help. A quiet life and lack of exposure kept them from the sight of greedy laymen. Furthermore, a relatively minor house of canons like Owston (Leicestershire) – always a rentier – might weather the reverses of the later Middle Ages rather better than a committed demesne farmer like Leicester Abbey.[76] But great and small, religious communities throughout Britain at this time found themselves raiding their reserves. There was nowhere to turn for new money. Unlike the lay nobility, monastic landowners had nothing to gain by war

206

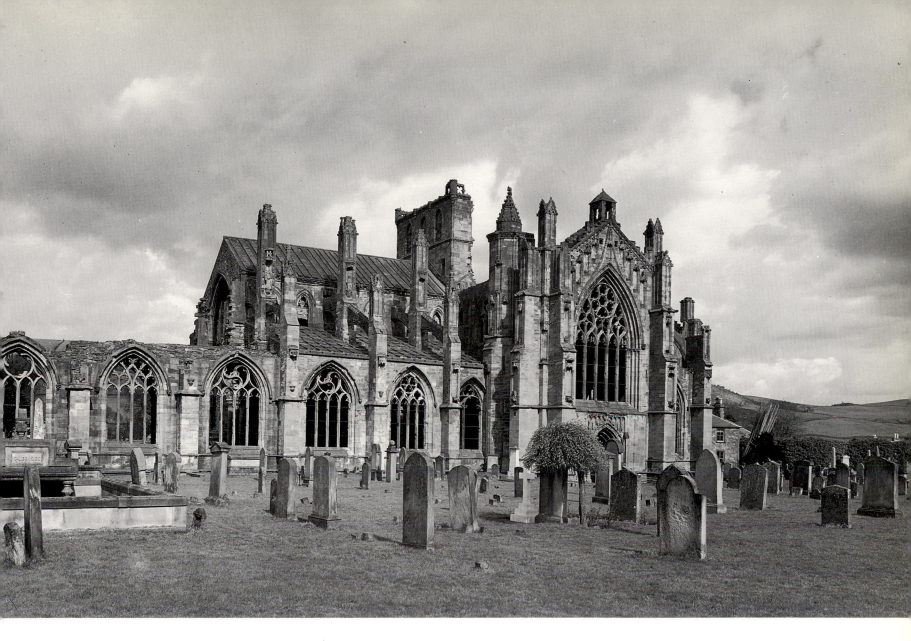

service. They had no prospect of reward in royal office, nor the hope of a marriage alliance. 'Few modern corporations', it has been remarked of Durham Priory, 'whether industrial, ecclesiastical or educational, could conceivably contemplate with equanimity the prospect of a permanently fixed income. Yet this was essentially the situation of late medieval English monasteries over a period as long and sometimes longer than 200 years.'[77]

Durham, like Westminster, survived comfortably on its endowments, even while adjusting, both in rents and spiritualities, to a much lower level of income.[78] In contrast, the fate of a smaller and less well-governed community is well illustrated by Selborne Priory, in Hampshire. Selborne's canons had begun complaining of their poverty as early as 1297. But their problems really dated to the 1350s and 1360s, in 'the present pestilence and scarcity of the times'. Through the rest of the century, the priory was repeatedly in difficulties over its failure to pay papal procurations. Selborne was probably better off than it liked to admit, for its canons were to be reproached in 1387 for luxury in dress, in particular 'the affectation of appearing like beaux with garments edged with costly furs, with fringed gloves, and silken girdles trimmed with gold and silver'. But its income was insufficient for such refinements. By the mid-fifteenth century, 'for their great necessity', the canons were heavily mortgaged. There were just four canons in residence in 1463, each attended by his servant. Twenty years later, Thomas Ashford – seventy-two years old and calling himself 'prior' – was alone. He had

255. The rebuilding of Melrose Abbey, after the English raid of 1385, was carried out with little evidence of economy.

allowed Selborne's buildings to fall into disrepair. They were 'ruinous' and practically deserted.[79]

Echoing spaces and over-large buildings were among the priory's problems. In better days, when the king had come to Selborne several times, there had been a community of seventeen or more.[80] All this, by 1484, was remote history. Selborne was caught in a familiar trap. It needed new recruits, but had nothing with which to attract them. The problem, present everywhere in the monastic church, was openly acknowledged by the hierarchy.[81] Closures like that of Selborne were debated carefully, and efforts were made to limit damage. Selborne's estates, in 1484, were reassigned to the endowment of Bishop William Waynflete's new Oxford college at Magdalen.[82] In the 1460s and 1470s, Charley Priory (Leicestershire) was absorbed by the neighbouring Ulverscroft; Chetwode (Buckinghamshire) by Notley in the same county; Wormegay (Norfolk) by the larger Pentney; and Great Massingham by the canons of West Acre.[83] When the Benedictine monks of Ely, in 1446–9, took control of Mullicourt (Norfolk) and Spinney (Cambridgeshire), they did so because

> the fruits thereof had been so diminished by pestilences, barrenness and the negligence of the priors and other misfortunes that they were insufficient for the support of the priors, convents, and rectors, wherefore it was feared that they might come to profane uses and their possessions fall into the hands of laymen.[84]

'Profane use' of church property was still rare enough. Yet it could happen where a patron was especially well-connected, as was the case at Grafton Regis, in Northamptonshire. Grafton was a small Augustinian hermitage, or priory cell, in which the Woodville family had a long-standing interest. It was a Woodville patron (Thomas) who bequeathed Grafton Regis to St James (Northampton) in 1434; and another Woodville (Anthony) who, shortly afterwards, took it back again. Anthony, second Earl Rivers, was not a man to be meddled with. He was the brother of Elizabeth, Edward IV's queen, and spent much of his life in court circles. Grafton, abandoned and neglected, had collapsed, like little Wormegay, 'quasi in terra'. Rivers laid down his new manor house across the former cloister, sealing its foundations with the upcast.[85]

If several of the smaller houses failed in this way, the huge majority continued to keep going. They survived less on their merits than on a life-raft of conservatism and inertia. Wormegay's collapse in 1468 was blamed on every sort of natural disaster: on plague and on fire, on drought and (in the same breath) on floods and on the cost of digging ditches.[86] Nothing was said at Wormegay of a failure in discipline or of trouble with the priory's tenants. Yet it was this last, in particular, that worried the greater landowners, unable to find cultivators for their estates. Peasant discontent had caused anxiety before, in the overcrowded pre-plague decades. After the Black Death it took a fresh turn as tenants, in short supply, tasted their new freedom to withdraw. By the mid-fifteenth century, on the Crowland Abbey manors, the peasant land market had slumped catastrophically. There was no competition, even on formerly sought-after demesnes, for the many messuages left vacant and decayed; rents were still falling; unpaid debts were unlikely to be recovered.[87] That same problem of long-term debt, eventually written off, worried the wealthy monks of Ramsey. They had plenty to cushion them, but experienced, nevertheless, 'the deepest and most prolonged depression in manorial revenues' their house had ever seen.[88]

Both Crowland and Ramsey adjusted to their situation by cutting numbers. Other houses, Battle and Bolton among them, did the same; and the survivors lived very well.[89] But it was a selfish strategy, tolerating waste. And it gave little thought to the morrow. In 1536, the drafters of Henry VIII's first Act of

Suppression would have abundant cause at the 'little and small abbeys' to accuse their governors that they did 'spoil, destroy, consume, and utterly waste as well their churches, monasteries, priories, principal houses, farms, granges, lands, tenements, and hereditaments, as the ornaments of their churches and their goods and chattels to the high displeasure of Almighty God, slander of good religion, and to the great infamy of the King's Highness and the realm if redress should not be had thereof'.[90] They had indeed sold the family silver.

As for the greater abbeys – 'enormously rich . . . more like baronial palaces than religious houses'[91] – they had long found it hard to keep themselves that way, and had collected many enemies along the line. The problem, above all, was fixed receipts. Marmaduke Huby, abbot of Fountains (1495–1526), was as creative a builder as Prior Chillenden a century before. However, when Huby took office, rents on the Fountains estates had remained unchanged for many decades, and the abbot's only possible strategy in the financing of his works was the exaction of every penny of feudal dues.[92] That purpose again, at actively-building Haughmond, was probably the reason for the canons' unrelenting collection of anachronistic feudal heriots: the best beast of the deceased tenant for the landowner.[93] And sales of manumissions – purchases of their freedom by the abbot's bondmen, or *nativi* – never entirely died out on the monastic estates, despite their increasing irrelevance.[94]

Impositions of this kind were all the more disturbing because they were so obviously out of date. They were accompanied by other grave vexations. Some of these resulted from the old and bad practice of sharing a church between laymen and religious. And it was riots provoked by this always sensitive relationship which caused the burning in 1378 of Hatfield Broad Oak and of Sherborne in 1437.[95] But more damaging overall was that erosion of good will between the monks and their tenants which was a consequence of the struggle to make ends meet. The men of God, as landowners, were no more sensitive to tenant hardship than any layman. 'In all those parts of the realm', wrote Thomas More in his *Utopia* (1516),

> where the finest and therefore costliest wool is produced, there are noblemen, gentlemen, and even some abbots, though otherwise holy men, who are not satisfied with the annual revenues and profits which their predecessors used to derive from their estates. They are not content, by leading an idle and sumptuous life, to do no good to their country; they must also do it positive harm. They leave no ground to be tilled; they enclose every bit of land for pasture; they pull down houses and destroy towns, leaving only the church to pen the sheep in.[96]

'Your sheep begin now,' said Hythlodaeus to the Cardinal, 'to be so greedy and wild that they devour human beings themselves and devastate and depopulate fields, houses and towns.' More's narrator told only the last episode of the story. When, back in the late fourteenth century, the Abbot of Osney had harassed his tenants at Brookend (Oxfordshire) to maintain their cottages and other buildings in good repair, his intention had been rather to keep them on the land than to drive them off it.[97] But the end-product of such bullying was depopulation. Brookend, along with many similar settlements on the less fertile margins, was deserted by the mid-fifteenth century. It had lost men steadily to the wealthier surrounding villages, leaving few for the sheep to devour. Whether the abbot willed it or not, his tenants at Brookend had abandoned their homes – 'men and women, husbands and wives, orphans and widows, parents with little children' – so that 'one insatiable glutton and accursed plague of his native land may join field to field and surround many thousand acres with one fence'.[98]

Brookend's eventual demise was at least in part self-inflicted. And not every monastic landowner was a glutton. There is a surviving agreement, dated 14

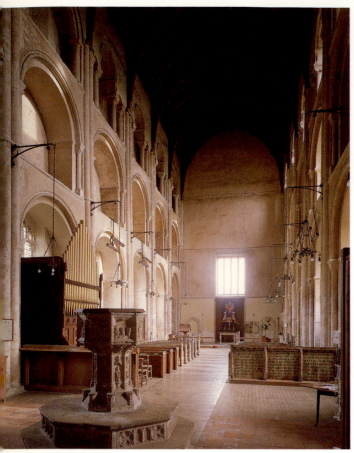

256. Binham Priory's shared church became the cause of dispute between the monks and their Norfolk parishioners. At the Dissolution in 1539, Binham's parochial nave was kept intact when the rest of the church (from the pulpitum east) was abandoned.

257. The residential gatehouse of the rich Augustinian canons of Thornton Abbey, rebuilt in the 1380s as a semi-military work following the Great Revolt of 1381.

September 1432, which resolved conflicts of interest between the prior of Binham and his tenants, and which seems, on the face of it, very fair. Entry fines were renegotiated; rights of common (where applicable) were redefined; duties 'in making and repairing the common streets and the King's highways' were clearly stated. Sharing the priory church between monks and parishioners had created major difficulties in the past. It was agreed, accordingly, that 'they, the said tenants and parishioners, all and singular, and their heirs, living in the future in the Town of Binham, may sing or cause to be sung their own divine services in the Parish Church when and as often as they please'. The parishioners might have a bell of their own to summon them to divine service, 'provided always that the bell shall not be rung at any time to the prejudice or derogation of the office of the Sacrist of the Priory'. They might process with the monks on the principal festivals, but 'round the Churchyard of the Church and not round the Conventual Cloisters of the Priory'.[99]

Reasonable though it appears, the Binham agreement hides conflict. It had been reached in the context of a very recent dispute, and had followed a long history of tenant discontent, which included the burning of the priory records in the Revolt of 1381 and the forcible enfranchisement (soon reversed) of its villeins. In 1431, just the year before the final concord, Bishop Alnwick of Norwich, 'a very great man', had come to Binham, only to find himself cold-shouldered by the monks. The parishioners had seized their opportunity with some skill. They had run to the bishop with honeyed words. 'Venerable Lord and noble pastor,' they had exclaimed prophetically,

if the bells had belonged to *us*, we should have rung a solemn peal for your reverence with the greatest joy; if *we* had had vestments, we should have come in procession and not in this rustic garb; if the Church had been *ours*, we should have escorted you to the Holy of Holies Some time, by the grace of God, we shall see the day and the hour when we shall be able to receive your lordship more honourably.[100]

That time, owing to a misjudgement of the 'somewhat uncouth prior', came almost immediately at Binham. And there was always a mixture of good and bad, open-handedness and extortion, charity and ill-grace, present in the monks' dealings with their tenantry. Certainly, one image of Furness Abbey – notably generous to its tenants in the apportionment of free dinners, of bread and of beer, of manure for their fields, of alms for their elderly, and of schooling for their young – is hard to reconcile with another of the same community's enclosing Abbot Bankes who came to Sellergarth on 16 December 1516 'with more than 22 of his monks and people . . . in riotous manner assembled'. It was Bankes who, that same winter, 'pulled down the whole town called Sellergarth, in Furness, wherein there were 52 tenements and tenants, with all their households . . . and has laid the third part of the said town to several pasture to his own use.'[101] Truly, 'good that was gotten in many a day, may slip away', as the proverb warns, 'in short time.'[102]

It was the Pestilence, at many abbeys, which began the trouble. If the abbot of Ramsey's tenants had been captious and homicidal even before the Black Death, they became much worse in the decades that followed it. Nor had circumstances remained unchanged in other respects, for the criminal elements in the post-plague years were not the poor and the desperate – the landless men of no account – but the abbey's former allies in the villages.[103] People of substance, in town and country – craftsmen, jurors, and manorial officials – headed the Great Revolt of 1381.[104] They were markedly more dangerous than any rebel leadership of the past, and provoked a swifter reaction in the monks. In 1382, immediately after the rebellion, the abbot of Thornton (Lincolnshire) obtained a licence to crenellate 'the new house over and about the gate' of his abbey. Like other

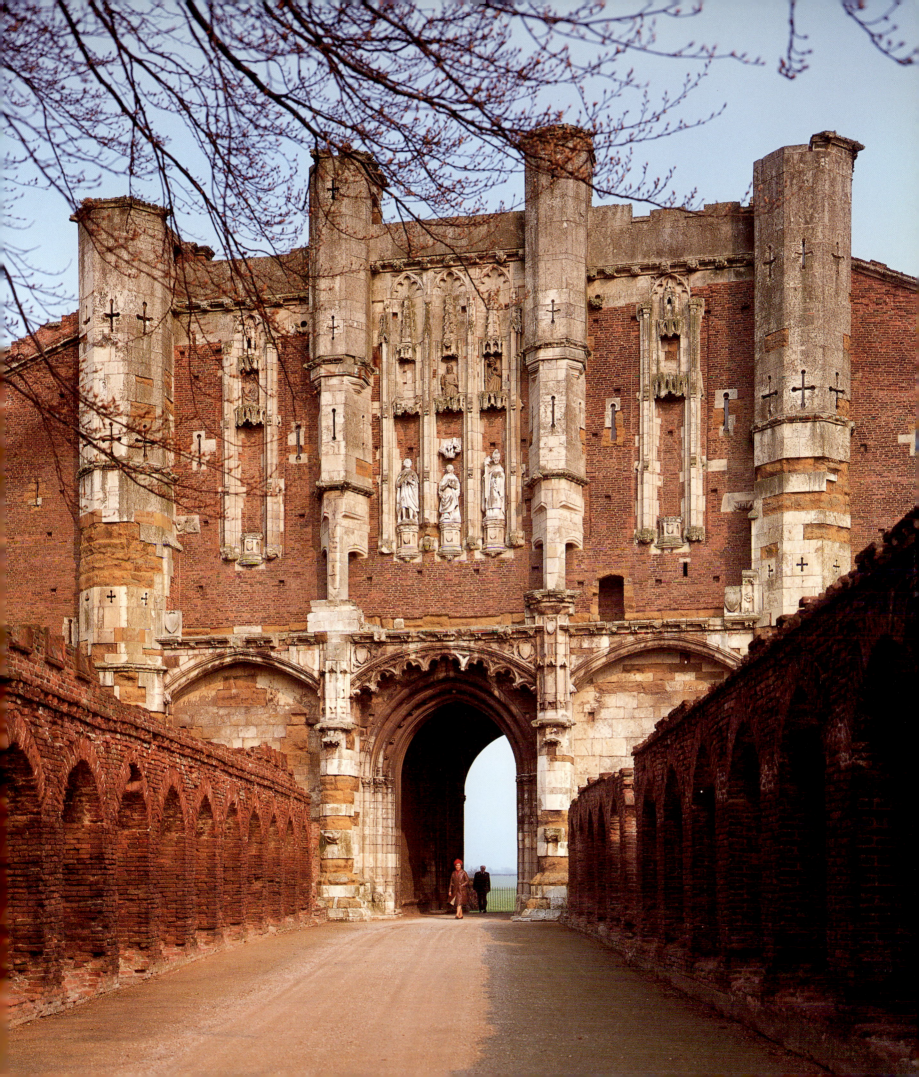

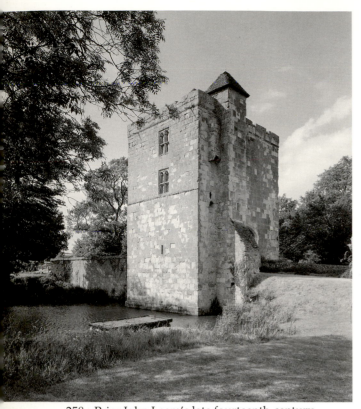

monastic gatehouses of the period, Thornton's 'new house' was primarily residential. But while there was an element of make-believe in the stone figures on its parapets – 'men with swords, shields, poll-axes, etc., in their hands looking downwards', so that 'the battlements . . . seemed to be covered with armed men' – the rest of Thornton's fortifications were no sham. The new gatehouse bristled with fire-points. There were arrow-loops at all levels, reached by purpose-built galleries. There was a portcullis so tall that it needed to be raised from a chamber on the second floor. Enclosing the abbey court, there was a substantial precinct wall. In front of the gate, there was a moat.[105]

There was nothing unusual in a big gatehouse or a precinct wall. Every monastery, by this period, would have had one. However, Thornton was near the coast, just south of the Humber, and another likely reason for the abbey's improved defences was the growing risk at that time of sea-borne raids. Fear of French pirates, on the notoriously exposed Sussex littoral, was certainly one cause of Michelham's fortification during the priorate of the energetic John Leem (1376–1415). Prior Leem, like his neighbour Abbot Hamo of Battle, was an active commissioner for coastal defence. In addition, he had been receiver of rents for John of Gaunt at Pevensey (1377–82), attracting some of the odium in which the great duke was held by the rebels of 1381. Soon afterwards, Michelham Priory was fortified. Its buildings were enclosed within a wide water-filled moat. A tall stone gatehouse guarded the only bridge, comfortably furnished on the upper floors with spacious lodgings.[106]

Other monastic sites of this period at which defences have been preserved include Brecon (Brecknock), St Andrews (Fife), Crossraguel (Ayr), Lindisfarne (Northumberland), Lanercost (Cumberland), and Tavistock (South Devon). Even small and poor communities like Ulverscroft (Leicestershire) and Hulne (Northumberland) could somehow find the means, in the Late Middle Ages, to surround themselves with fortifications of some substance. [107] However, there is nothing to compare, at any of these sites, with the huge defensive effort of the Irish Possessioner houses, trapped in a web of disorder. If the Irish Cistercians, as is now sometimes said, experienced a renewal in the fifteenth century, they showed it strangely in the planning of their churches. Of two white-monk

258. Prior John Leem's late fourteenth-century gatehouse at Michelham, seen here from the inner bank of the moat, was his community's response to coastal piracy and tenant unrest.

259. At Cistercian Monasteranenagh (Limerick), in the Late Middle Ages, the church was much reduced by walling off (centre) the bulk of the nave; both north and south transepts were abandoned at the same time, leaving only a simple rectangular choir.

260. Both Crossraguel's gatehouse (right) and the abbot's tower-house (centre) are additions of the early sixteenth century.

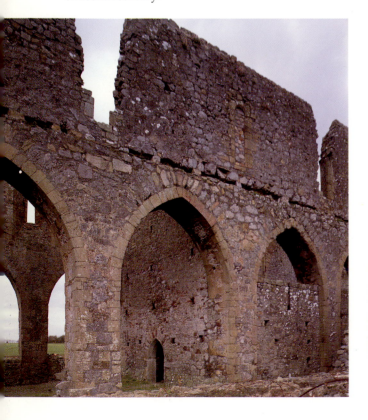

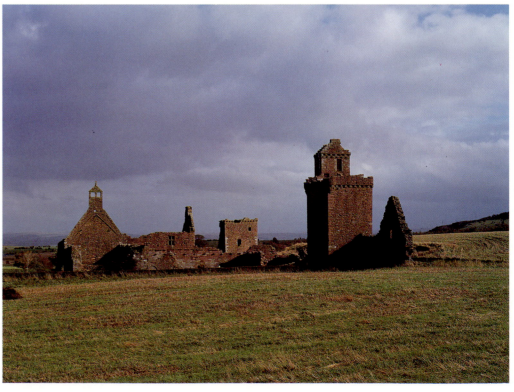

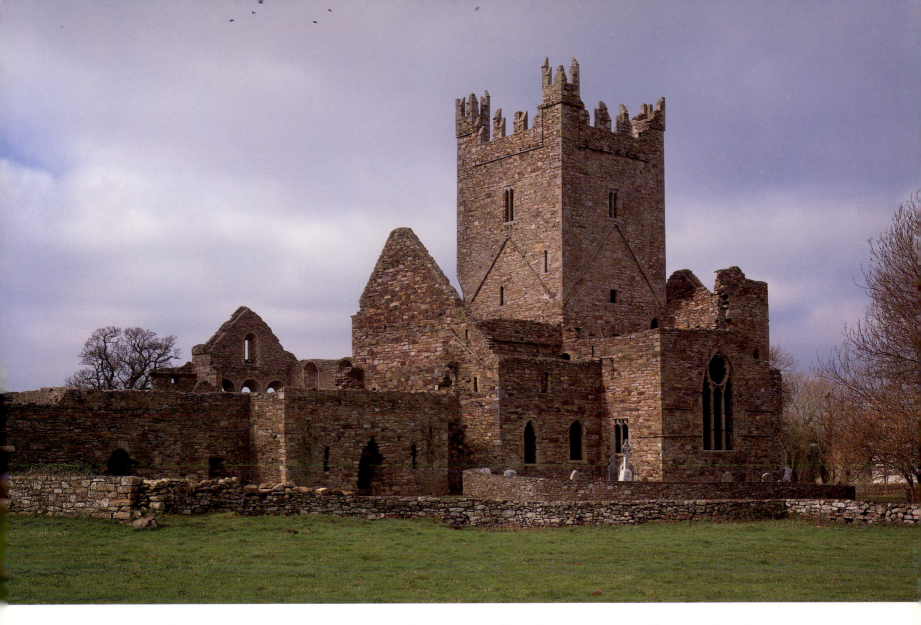

churches in Tipperary, rebuilt at this time, one was at Holycross (guardian of a famous relic), the other at Kilcooly (destroyed by 'armed men' in the 1440s). Neither community spared expense on the rebuilding. But each also took the opportunity to modify its church, introducing new lodgings over the vaults and raising a watchtower on the crossing. What had once, in better days, been the House of God alone, came to double as residence and fortress.[108]

Holycross, supported by its pilgrims, maintained a big church. But the new church at Kilcooly, shorn of its aisles, was much smaller than the old. And there were other Irish white-monk churches – among them Inch (Down), Knockmoy (Galway), and Monasteranenagh (Limerick) – which lost both nave and transepts at this period.[109] It was not just falling recruitment, or even chronic poverty, which brought about such shrinkages in monastic churches. Jerpoint (Kilkenny), the mother-house of Kilcooly, was no upstart abbey. It was one of medieval Ireland's wealthiest religious communities, yet chose in the fifteenth century to demolish its south aisle, and to build a big fortress-tower above the crossing.[110] Neither the Cistercians of Bective nor the Benedictines of Fore could hold out eventually against major reductions in church and cloister to accommodate the new-style defences. At Bective (Meath), in the fifteenth century, both the west and south ranges were entirely rebuilt on a much smaller scale; the east range was cut short; a great tower-house was erected at the south-west angle of the cloister, and another at the west end of the church.[111] Big tower-houses, similarly, were built at Fore (Westmeath) in the 1420s. One of these, south of the choir,

261. Jerpoint Abbey's big fifteenth-century tower, over the crossing, has the same fortress-like quality found again at many other Irish Cistercian towers of the same period.

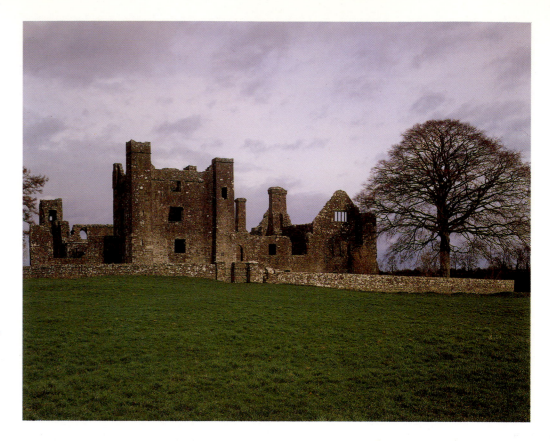

262. A strong tower-house (left centre) was added to Cistercian Bective (Meath) in the fifteenth century, when the church and claustral buildings were much cut down. In the 1540s, after the monks had gone, Thomas Agard converted the former abbey into a mansion, of which the Tudor gable (right) is a survival.

263. The fortification of Fore Priory (Westmeath) in the 1420s included the addition of a tower-house (right) – probably the prior's residence – to the south of the choir, with another tower filling the west end of the nave.

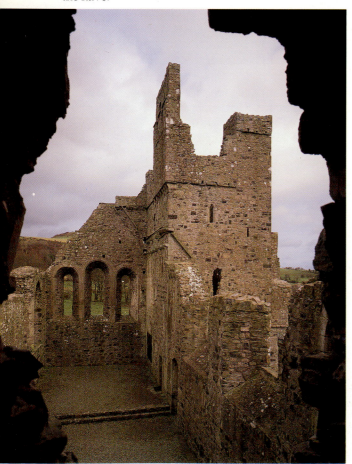

probably held the prior's lodgings. A second tower was built into the other end of the church, taking up the former western bay. Both towers had openings into the church itself, with comfortable apartments on the two upper levels, each with a garderobe of its own.[112]

Fore, like Bective, lost part of its cloister in the rebuilding. It was less a religious house in its latter years than a Marcher fortress, 'very necessary for the defence of the country against the attacks of the wild Irish upon the king's subjects and the protection of them and the goods and chattels of the inhabitants at any time of disturbance'.[113] When the Pale was at its smallest and English government most weak, both Fore Priory and Bective Abbey were at risk. But their situation, even so, was not as dangerous as that of some of the more distant Possessioner houses, marooned among the enemies of the crown. Kells Priory, in Kilkenny, was one of these. It was an Augustinian house of Anglo-Norman foundation, comfortably endowed in the late twelfth century and grown rich under the protection of the fitz Roberts. Things began to go wrong at the priory in the early fourteenth century, when its last fitz Robert patron died. The Kells lordship, in the charge of absentees, could do little to control the local gentry. Kells was burnt for the first time in 1327. It suffered particularly in the disorders of 1445–6, when James fitz Gerald, earl of Desmond, and his Irish allies 'brinte, wastede, and destruede syxty and syxtene of townes [in Kilkenny] and brande and brake xvi chyrches and robede hem of har catel and godes that may nought be numbred'. Among the signatories of this document was Prior Thomas of Kells. And it was Thomas and his successors who fortified Kells Priory, enclosing it with a towered curtain of such ambitious extent that it took in an area of fully five acres, being the largest such enceinte in medieval Ireland.[114]

No fewer than six big tower-houses line the walls at Kells. At Athassel Priory (Tipperary), attacked and burnt by 'certain nobles' in 1447, there was only one major tower at the gate.[115] Nevertheless, Athassel's fortified enclosure, which probably post-dates the attack, was almost as large as that of Kells. And as neither priory had access to new resources at this period, the decision by both

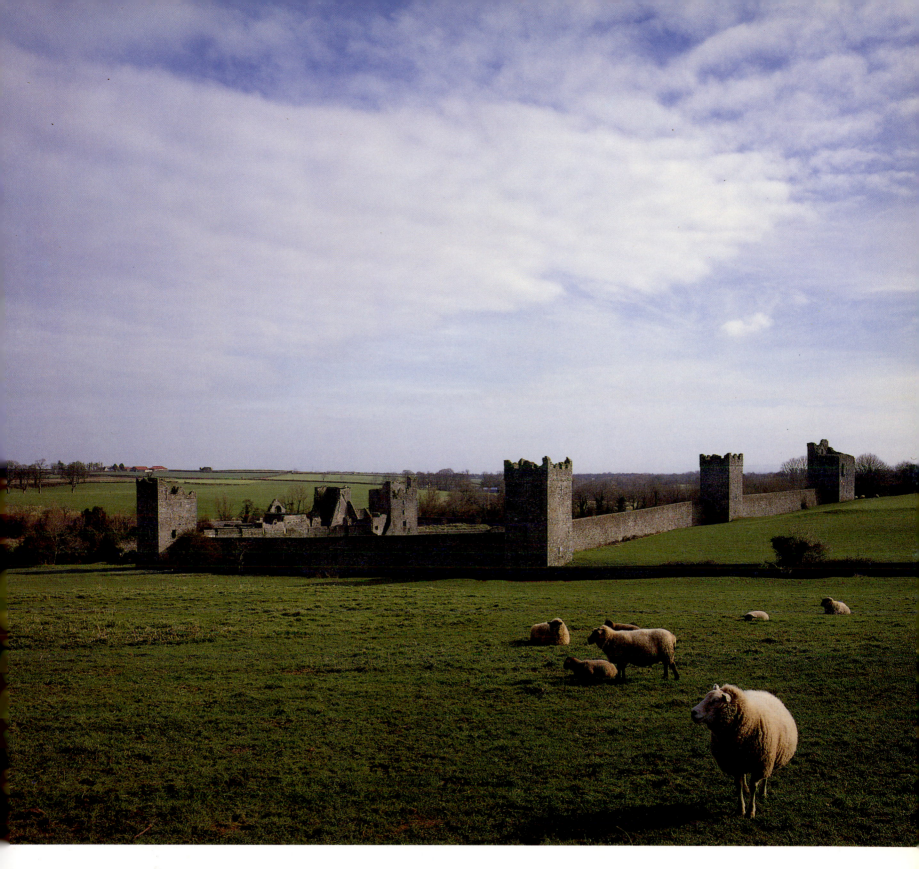

communities to build defences on such a scale must have depended on the passing on of costs. In practice, the price of security at the Irish Possessioner houses was the exploitation of what became known as 'coign and livery'. As developed most oppressively in fifteenth-century Ireland, the system paid the wages of private armies. It gave the lord his licence to billet workmen on his tenants, and encouraged him in the demand of carrying services. Inevitably, it was fiercely resented. Still, in 1537, the Butler earls of Ormond were milking Kilkenny in this way, where:

264. The tall towered curtain of the Augustinian canons of Kells Priory (Kilkenny) is a well-preserved example of fifteenth-century monastic defences.

215

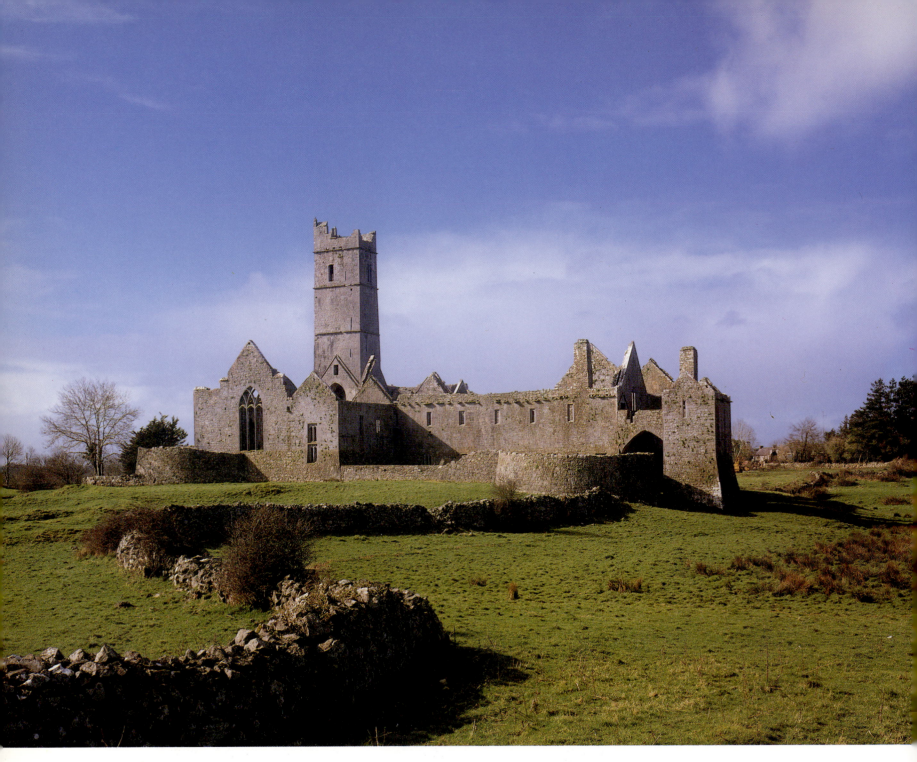

265. The Observant Franciscan friary at Quin (Clare), founded in 1433, rises from the remains of a thirteenth-century fortress; two circular tower-bases, one under the friars' dormitory (right centre), the other under the south-east angle of their chancel (left), show clearly in this view of Quin from the east.

all the inhibytauntes of the saide countye of Kylkenny ben chargeid by the saide erlle [Piers Butler] to gyve mete, drynke, lodgeing and wageis unto all artyfycers and laborers which the saide erlle shalle by hymselff or his officers retayne for any his byldeinges untill the clere fynysheing of the same buyldeinges; and also compelleith the said inhibytauntes to carye and bryng with ther garrons or ploughorsseis all maner stuff or caryages for the said buyldeinges necessary or requysit at all tymes, withoute any recompence or payment made unto the said inhibytauntes therfor.[116]

Sharing out the costs, the monks of Fore and the canons of Athassel built ambitiously. Kells Priory and Bective Abbey were transformed. But coign and livery, widely deplored as an abuse, completed the alienation of the Possessioners. The contrast with the Irish Mendicants was absolute. There is a Franciscan friary at Quin (Clare), founded in 1433, which has preserved its buildings almost intact. Surviving friary complexes are no rarity in Ireland. However, what is exceptional

216

about Quin is that it straddles the foundations of an Anglo-Norman fortress, reusing the line of the former castle's outer walls, but otherwise borrowing nothing from their strength. Quin's lack of defences and apparent immunity from attack put the embattled Possessioners in their place. Like other Franciscan communities – like the equally complete but more exposed estuarine friaries at Moyne and Rosserk in County Mayo – Quin depended for its survival not on force alone, but on the superior reputation of its brethren.[117]

Quin was a native Irish house, founded by Macon Macnamara. Moyne and Rosserk, both 'lately built' in the 1460s, each had some link with the reforming Observants, favoured by contemporary Irish patrons. In important regards, the Observants in Ireland rose on the back of Gaelic patriotism. But whereas support for the friars – for reforming branches of the Austins and Dominicans, as well as for those of the Franciscans – was always at its strongest in the Gaelic West, it was never exclusively native Irish. When the Observants settled in Ireland in the fifteenth century, they found friends there of many persuasions. It was immigrant Scots who founded Tertiary communities at Glenarm, Inver and Bonamargy, in Antrim. Slane, in Meath, was the initiative of an Englishman, Christopher Fleming. And if the substantial surviving remains at Kilcrea (Cork), Muckross (Kerry) and Kilconnell (Galway) are all of Gaelic Irish communities, the similarly well-preserved Limerick Franciscan houses at Askeaton and Adare owed their origins to the Anglo-Irish aristocracy.[118] What these new and costly buildings confirm in Irish spirituality is a major religious renewal. Excluding the Possessioners, left behind by the times, it was largely Mendicant led.

This was much less the case in late-medieval England, to which the Observants came only very tardily.[119] True, the Mendicants in England had powerful friends. From the mid-fourteenth century, wealthy and pious ladies like Mary de St Pol at Denny (Cambridgeshire) and Elizabeth de Clare at Walsingham (Norfolk) had chosen Minorite communities for special favour.[120] But neither Mary nor Elizabeth, who were also founders of Cambridge colleges (Pembroke and Clare), limited their largesse to the Franciscans. They were among the pioneers of a lay piety both rich and many-stranded, deeply private and afflicted by false starts. Denny itself, Mary de St Pol's foundation, had had a long and chequered history before she got there. It began life briefly as a Benedictine community, dependent on the cathedral priory at Ely. Then the Templars owned Denny for over a century, but lost it on their suppression in 1308, when it came for a short period to the Hospitallers. In 1324, the Crown took Denny back again, to grant it almost immediately to Mary de St Pol, recently widowed countess of Pembroke. It was Mary who, in 1339, began the transfer of Franciscan nuns there from Waterbeach. The move was complete by 1351, and Mary herself, in her later years, spent much time in the community. She was buried at Denny in 1377, and had long treated the abbey as private property. It was for the great lady's exclusive use that the former Templar chapel was adapted and enlarged as private lodgings. The nuns were given a new church of their own, immediately east of the old. Their cloister was tucked away to the north of that building, out of earshot of the countess and her household.[121]

Denny, as Mary left it, was a personal memorial. And this quest for something private, if necessary through several stages, became very general in the period. One of the more interesting conversions – from parish church, to collegiate chantry, to priory of Bonshommes – occurred at Edington, a Wiltshire parish. Edington is a big church, 'so varied in its skyline and so freely embattled that it looks like a fortified mansion'.[122] It is of one period only, completed within a decade of 1351, at the point of transition between Decorated and Perpendicular. It was commissioned and paid for by William of Edington, bishop of Winchester (1346–66), the epitome of the successful civil servant.

William was already a wealthy man by 1351. He had been treasurer of England

266. The great church at Edington was built at the expense of William of Edington, bishop of Winchester (1346–66), and entrusted to a community of Bonshommes.

268. The Fitzalan Chapel at Arundel, packed with family memorials, was the former choir of a collegiate chantry, founded by Earl Richard in 1380 on the site of a dependent priory of Séez Abbey.

267. In 1389, Archibald the Grim expelled the nuns of Lincluden to establish his Douglas collegiate chantry and almshouse in their place; shown here are the choir (right) and south transept (centre) of the earl's new church.

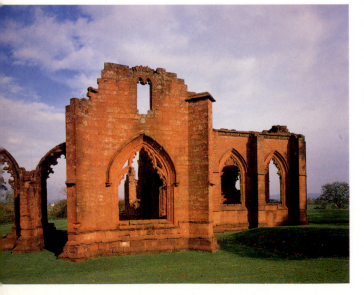

since 1344 – 'For two years a treasurer, twenty winters after may live a lord's life, as lewd men tell.'[123] – and was still on his way up in the royal service. What he first intended at his birthplace was a comparatively modest perpetual chantry, served by a warden and three chaplains. The very next year, he doubled the number of chaplains. And in 1358, following his promotion in 1356 to the chancellorship, he imposed a complete change of direction. Since 1347, Bishop William had been a member of the Black Prince's council. The Prince, it is known, came to harbour a special affection for the Bonshommes of Ashridge (Hertfordshire), founded in 1283 by his ancestor, Edmund of Cornwall, and later re-endowed by himself. Probably at his urging, William of Edington turned to the English Bonshommes for recruits. The move was expensive, requiring major additions to the endowment. Nevertheless, there were good practical reasons for the change. William's decision was taken, he said, 'in order to free the chaplains from the cares and obligations of the secular life'. He sheltered them further by the appointment of two secular priests 'who shall serve the parishioners in the nave of the church and administer the sacraments to them while the brethren are occupied in celebrating the divine office'. And he charged his new community with what would be, for ever after, its chief purpose: 'At every mass,' he ordained,

> the brethren shall remember the founder [Bishop William himself], King Edward [III] or the then sovereign, Edward, prince of Wales [the Black Prince], the king's son, Robert [Wyvil], bishop of Salisbury, the then bishops of Salisbury and Winchester, and John, the founder's brother … After the death of the founder, the brethren shall first remember the founder, his father and mother [Roger and Amice], the people mentioned above, the benefactors of the church, Adam [Orleton], formerly bishop of Winchester [William's patron], Gilbert de Middleton, formerly archdeacon of Northampton [and official of the court of Canterbury], any others as seems fitting, and finally the souls of all the faithful departed. When the mass is finished each celebrant shall say 'May Almighty God preserve William our founder' during the founder's life, and after his death 'May the souls of William our founder and of all the faithful departed, through the mercy of God, rest in peace'. They shall do the same every day after grace and the canonical hours.[124]

There was to be only one other attempt at a Bonshommes foundation in medieval Britain. And that, at Ruthin in 1478, was unsuccessful.[125] But Ruthin was already a college, and what inspired its re-foundation by Edmund Lord Grey, earl of Kent (1465–90), was the almost unlimited potential of dedicated communities like these for the perpetual celebration of soul-masses. The Irish chose Mendicants to remember them. English and Scottish grandees of the same period increasingly put their faith in colleges. None of this was good news for the Possessioners. At Lincluden (Kirkcudbright) in 1389, a Benedictine community – the only nunnery of its order in medieval Scotland – was suppressed at the petition of Archibald, earl of Douglas, for conversion into a secular college.[126] Ten years before, the Benedictines of Séez had allowed themselves to be persuaded by Richard fitz Alan, earl of Arundel (1376–97), to give up their priory for his chantry. In 1379, only Séez's prior was in residence at Arundel. The earl replaced him with a full-scale community – 'humbly offered to the Divine Majesty as a trivial memorial of our devotion' – of a master and twelve chaplains, two deacons, two sub-deacons, two acolytes, and four choristers.[127]

Arundel was a man of strong and sincere religious convictions. And when he directed, some years before his death, that there should be no unnecessary extravagance (bobaunce) at his funeral, he probably meant what he said.[128] He was not alone in holding views of this kind, for Bishop Philip Repingdon of Lincoln (d.1424), a well-known rooter-out of heresies, would nevertheless return to the

218

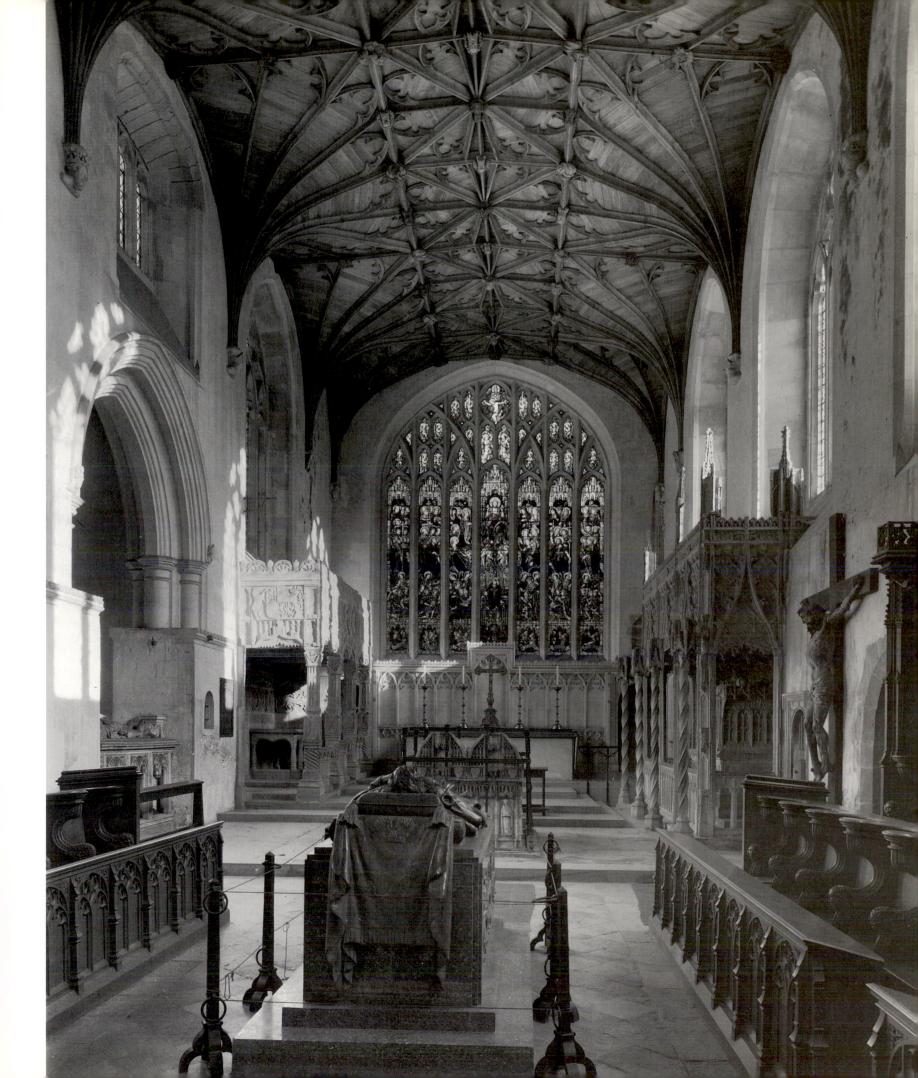

Lollard principles of his youth in the demand that his 'fetid body unworthy of human honour' should be interred 'just beyond the threshold of the porch of St Margaret's parish church on the north side of the same church under the clear and open firmament of heaven, not in church or monastery, for I find myself unworthy for this'.[129] But the bishop, in point of fact, was buried in his cathedral. And the vast majority of his noble contemporaries would have dismissed such misgivings as an irrelevance. Bernard Ezi II, sire d'Albret, set something of a record in 1358 in the purchase of 100,000 masses for his soul's redemption. Yet his was only the most extravagant of many such memorial provisions in late-medieval France.[130] And in England also, the purchase of requiem masses in multiples of a thousand became widely expected of a nobleman. Richard Beauchamp, earl of Warwick (d.1439), and Richard Plantagenet, duke of York (d.1460), were two of the kingdom's wealthiest magnates. Warwick's unwelcome legacy to his heirs was a trust which, for over forty years, employed the receipts of thirty manors essentially for the benefit of his soul. The earl began with the provision of 5000 soul-masses, but directed the bulk of his money into a longer-term project for the building of an expensive chantry at Warwick Church.[131] Richard of York was one of those who suffered as an heir. His inherited obligation was to complete the church at Fotheringhay (Northamptonshire) founded by his uncle, Duke Edward. It was in 1433, nearly twenty years after Edward of York's death, that Duke Richard reached agreement with his uncle's feoffees, and eventually came into his own. Edward had run himself deeply into debt, not least in providing for his soul. Richard undertook to complete the great church of which Edward had built only the choir. But it was Edward who was remembered as Fotheringhay's founder. Nightly round Edward's tomb the college gathered – all thirteen fellows, eight clerks, and thirteen choristers – to chant the *De Profundis* after compline.[132]

Edward died at Agincourt in 1415, where he was one of Henry V's captains. And Henry, too, made provision for his death as carefully as he mounted his campaigns. 'No one else in medieval England', it has been said of him recently, 'ever thought it necessary to invest so heavily in the purchase of paradise.'[133] As patron of both Bridgettines and Carthusians, Henry had England's most respected spiritual advocates at his call. But this, even so, was not sufficient. Providing for the short term as well as for the long, Henry planned an instant barrage of memorial masses, saturating Heaven with his requiems. Within a year of his decease, he provided in 1421, 20,000 masses must be sung for his soul – 3000 in honour of the Holy Trinity, another 5000 for the Five Joys of Mary, 1200 for the Twelve Apostles, 900 for the Nine Orders of Angels, 300 for the Three Patriarchs, 15 masses daily for the Five Wounds of Christ, and the balance in favour of All Saints.[134]

Half that number satisfied Cardinal Beaufort (d.1447), Henry's uncle. But Beaufort, like the king, had other investments. And neither the cardinal nor his nephew would ever have questioned the belief that 'the founders of sacred places are most faithfully commended by the prayers and intercessions of the same before all the other benefactors and enjoy the same intercessions almost as first fruits for ever'.[135] It was Henry VI, most fecklessly ambitious founder of them all, who said this. His great works of piety at Eton (1440) and King's College (1441) entirely overshadowed Cardinal Beaufort's. Yet there is something especially appealing about Beaufort's 'Almshouse of Noble Poverty' at St Cross (Winchester), rebuilt at the cardinal's expense in the mid-1440s, and still the refuge and retreat of distressed gentlefolk. St Cross's most impressive survival today is the long west range of individual bedesmen's lodgings, four to a staircase, complete with garderobe towers (on the outer wall) and contemporary chimneys. The common hall of Beaufort's almshouse has also been preserved, as has its kitchen, its formal gatehouse, and master's lodgings.[136] At Beaufort's St

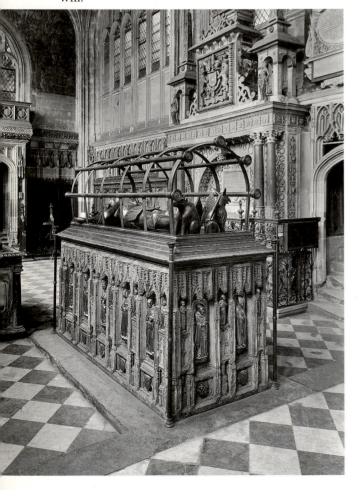

269. The tomb-chest and effigy of Richard Beauchamp, earl of Warwick (d. 1439), centrally placed in the costly chantry chapel added to Warwick Church in accordance with the terms of Beauchamp's will.

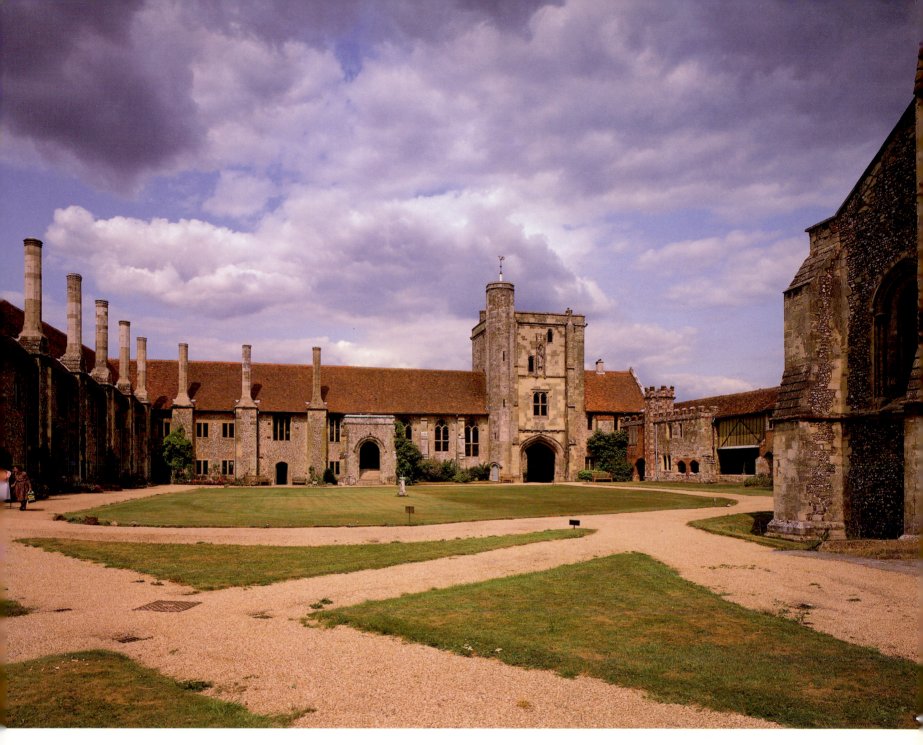

270. Cardinal Beaufort rebuilt St Cross Hospital (Winchester) in the 1440s as an Almshouse of Noble Poverty; he provided his bedesmen with individual lodgings (left) and with a common hall next to the great gatehouse.

Cross, as at William de la Pole's contemporary Ewelme (Oxfordshire), founded in 1437, the emphasis lay on the dignity of the individual bedesman and on his entitlement to a chamber of his own. All the inmates of Ewelme, the duke of Suffolk provided, should have 'a certeyn place by them self . . . that is to sayng, a lityl howse, a celle or a chamber with a chemeney and other necessarys in the same, in the whiche any of them may by hym self ete and drynke and rest.' They still do.[137]

It is chance which has kept the two almshouses essentially intact. But the post-Suppression almshouse was modelled on such as these, and they continue to make sense even now. The same is true of the academic college, simultaneously taking shape at the universities. The purpose of such colleges, in fifteenth-century Oxford and Cambridge, was less the advancement of learning at either university than the celebration of soul-masses for the founder. Archbishop Chichele's 'poor and indigent scholars' at All Souls (Oxford) were bound by their statutes:

221

272. William of Wykeham's academic buildings at New College (Oxford), begun in 1379, came to include a bell-tower (left) and cemetery cloister of *c*.1400, partly hiding the west wall of his chapel.

not so much to ply therein the various sciences and faculties, as with all devotion to pray for the souls of glorious memory of Henry V, lately King of England and France . . . the lord Thomas, Duke of Clarence, and other lords and lieges of the realm of England whom the havoc of that warfare between the two said realms [England and France] has drenched with the bowl of bitter death.[138]

But this common memorial purpose was also a major determinant of the standard college plan which has been repeated with minor variants ever since. The earliest academic colleges, especially those at Cambridge, had used existing churches as their chapels. They had resembled secular manor houses rather than religious institutions, with the great hall across the court from the main gate. In the Late Middle Ages, the purpose-built chapel became as necessary an element of the college's equipment as its hall and kitchen, its gatehouse, its quadrangle and scholars' sets.

All these were represented at New College (Oxford), founded by William of Wykeham in 1379 and the model for Henry Chichele's All Souls. New College was the first academic college at either university to be built to one unified plan. And the distinguishing characteristic of William of Wykeham's scheme – used again at his Winchester co-foundation in 1382, and then in Oxford at Chichele's All Souls (1448) and Waynflete's Magdalen (1458) – was the sharing of a single range by hall and chapel, built at one time and end-to-end. A concerted

271. The bedesmen's court and cloister, with the church tower behind, of William de la Pole's almshouse at Ewelme, founded in 1437.

223

274. The great quadrangle and cloister of Bishop Waynflete's Magdalen College (Oxford). As at New College, Waynflete's hall (left) and chapel (right) were placed end-to-end in the same range. Both were in use by 1480.

programme of this kind required major investment. Nothing like it was attempted at Cambridge before Henry VI, in 1443, began to reconsider what he wanted for King's College. Even so, Henry's projects were too lavish to be realized. The chapel at King's, begun in Henry's youth, remained unfinished at his deposition in 1461; at Eton College (Buckinghamshire), only the choir of Henry's huge projected chapel was ever built. [139] William of Wykeham's long experience as the surveyor of royal works had served him better. He had been elected bishop of Winchester, on Edward III's intervention, in 1367. And his thoughts had soon turned to commemoration. New College Chapel, begun in 1380, was in use just six years later. It was one of the biggest college chapels ever built in Oxford, and has the individual cross-plan, with transverse ante-chapel, first developed at that university at Merton. Much of Wykeham's glass still survives in the ante-chapel, including the big inscription across the base of each window: '*Orate p. Willmo Wykham epo. Wynton. fundatore istius Collegii* ' (Pray for William of Wykeman, bishop of Winchester, founder of this College).[140] The message is more a boast than a reminder.

New College owed everything to one man's beneficence. And it was the size of personal fortunes, in late-medieval Britain, which determined the scale of the new foundations. The collegiate chantry, dedicated to a family's interest, was the best that a rich man could do. It was deservedly popular at that level. There is a cluster of fine buildings, in the Lothians close to Edinburgh, which includes the

273. The choir of William of Wykeham's chapel at New College; behind the altar, his first-floor hall continued the same range.

225

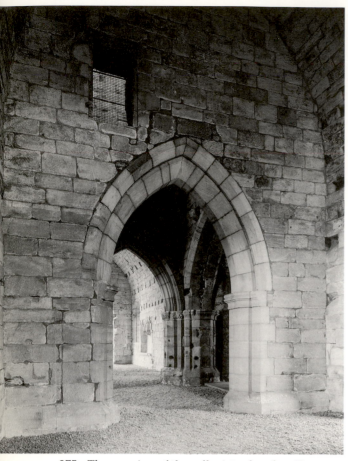

275. The crossing of the collegiate church at Dunglass, founded by Sir Alexander Home in 1443.

276. The collegiate church at Crichton was founded by Sir William Crichton in 1449.

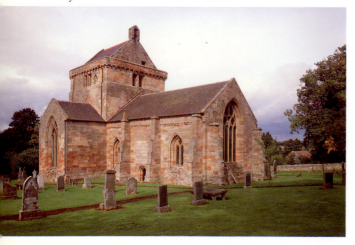

surviving churches of four secular colleges – Dunglass (1443), Crichton (1449), Rosslyn (1450), and Seton (1492) – all of them the foundations of wealthy noblemen.[141] Some eleven of these colleges were founded in Scotland during the second half of the fifteenth century; another thirteen between 1500 and the Reformation.[142] Fifteenth-century Ireland, in contrast, remained relatively free of such foundations, preferring the intercession of the Mendicants. But England's collegiate chantries, already on the increase before the Black Death, continued to multiply after it. Characteristic of this investment was its lack of common policy, each patron attending to his own. There are well-equipped collegiate churches at Wingfield (1362) and Bunbury (1386), Irthlingborough (1388) and Attleborough (1405), Staindrop (1408), Tong (1410), Higham Ferrers (1422), Lingfield (1431), Tattershall (1440), Rotherham (1483), and many more. Some of these, like Suffolk's unspoilt Denston (1475), preserve the chaplains' stalls and other furnishings intact. Others, notably Cobham (1362) and Manchester (1421), have kept complete ranges of collegiate buildings.[143] None of these belonged to an order of any kind. They were the work of individuals, both laymen and priests, and were as different as their founders from each other.

Given preferences such as these, the older-established monastic orders had little to anticipate in new endowment. They lost out almost totally on the spoils of the alien priories after 1414, and although sometimes able to profit from mergers between communities, too often failed even on those. The fault was not exclusively their own. They belonged ineluctably to an older culture which they could neither amend nor reject. When, amongst their number, the Carthusians alone enjoyed a popular revival in the half-century following the Black Death, what recommended that order to the bulk of its patrons was not superior 'monkery' as once understood, but the quality of the monks' lives as quasi-hermits.[144] One other monastic 'family' – the Order of the Most Holy Saviour, commonly known as Bridgettines – similarly enjoyed the favour of the Lancastrians and their associates during the crucial decades of the alien suppressions. The Lancastrian discovery of the Bridgettines of Vadstena (Sweden) followed in the wake of a royal marriage between Philippa, youngest daughter of Henry IV, and King Eric of Denmark and Sweden. The nuns of Vadstena impressed their English visitors, offering everything that was novel and good. The order was young; it recruited chiefly from ladies of noble birth; it had a fashionable concern both for popular preaching and for that visionary mysticism for which its foundress, Bridget of Sweden (d.1373), was best known. Along with the Carthusians and the Celestines – a strict eremitical order founded by St Celestine (d.1296) of Monte Morrone – the Bridgettines were a natural choice for the third of the penitential foundations required of Henry IV after the judicial murder of Archbishop Scrope.[145]

Richard le Scrope, archbishop of York, was executed on 8 June 1405 for his supposed complicity in the Percy Rebellion. And ten years later, Henry V met the conditions of his father's exoneration by founding two religious houses, Sheen (Carthusian) and Syon (Bridgettine), just down-river from his palace at Richmond. 'Five hundred poor,' Shakespeare makes Henry declare before Agincourt, 'I have in yearly pay, / Who twice a day their withered hands hold up / Toward heaven, to pardon blood: and I have built / Two chantries, where the sad and solemn priests / Sing still for Richard's soul. More will I do.'[146] Henry won his battle, but did no more. The Celestines of Paris never got their new house. Syon remained companionless, as no other Bridgettine community took root in medieval England. And Sheen, while the largest and best-endowed of its order's nine English houses – six of them post-plague foundations – was the last Carthusian priory of the revival.

Henry V's monastic renewal was skin-deep. It owed everything, in reality, to disendowment: to that enforced suppression of the alien houses in 1414 which,

with long-term consequences, fatally breached the inviolability of church lands. Syon and Sheen, on opposite banks of the Thames, were the principal beneficiaries of this plunder. It was Syon's portion, along with much else, to get the valuable alien estates at Lancaster and Loders, at Atherington and Otterton, at Throwley, Sidmouth, and St Michael's Mount. Sheen received Carisbrooke and Hayling, Lewisham, Wareham and Ware. With few and unimportant exceptions, the only other religious communities to extract much benefit from the suppressions were either new Carthusian houses or collegiate chantries. Coventry's new Charterhouse got Ecclesfield and Swavesey; the Vernon college at Tong got Lapley; Axholme, another recent Charterhouse, was granted Monks Kirby; William of Wykeham's Winchester College received Andover; St Stephen's (Westminster) got Frampton; the Yorkist Fotheringhay College got Newent; London's great Charterhouse shared Ogbourne St George with the royal colleges at Windsor and King's (Cambridge).[147]

Valuable estates like these were the glittering prizes. For a struggling Possessioner house like the Augustinian Ivychurch in Wiltshire, they could make all the difference between a situation of prosperity or collapse.[148] But Ivychurch's acquisition of Saint-Wandrille's former cell at Upavon was the exception. Such rewards usually went to better-placed houses, by virtue of either their reputation or their friends. One example was that partitioning, between three high-profile establishments, of Bec-Hellouin's rich Ogbourne St George. Another was the conversion of Bec's lesser priory and estate centre at Stoke-by-Clare (Suffolk) into the collegiate chantry of Edmund Mortimer, earl of March (d.1425). Mortimer was Stoke's patron. And it became his argument that the former Anglo-Saxon college, replaced in the 1090s by Gilbert de Clare's French-speaking monks, should be reinstated as a secular establishment. Aelfric's college of seven prebends, dating back to the reign of Edward the Confessor, was re-founded by Earl Edmund in 1415. It had the same basic organization, with a dean and six prebendaries, supported now in their memorial work by eight vicars, four clerks, and five choristers.[149]

By an accident of inheritance, Mortimer's death in 1425 brought the entire March patrimony, including Stoke-by-Clare, to Richard Plantagenet, duke of York. It was Richard and his duchess, Cecily, who used some of this new wealth to complete their own college buildings at Fotheringhay. And Stoke, like Fotheringhay itself, became an important Yorkist chantry. There was little left over in such arrangements for the Possessioners. Back in the summer of 1415, drafting his will at the start of the Agincourt campaign, Edward of York (founder of Fotheringhay) had already shown what he thought of the monks. Duke Edward left his body for burial at Fotheringhay College. He ordered 1000 soul-masses, but prescribed that these should be purchased not from the big communities but from 'the poorest religious who can be found' – from the Carthusians of Witham and Hinton, Beauvale and Coventry, and from the Mendicants of London and of Stamford. The duke's church plate and furnishings were to go to the masters and fellows of his new college. Henry V – 'mon tres soverain seignour le Roy' – was to receive Edward's best sword and dagger. Other comrades-at-arms were remembered individually with gifts of valuables, of cash, or of armour – the duke's habergeon (coat of mail) to Philip Beauchamp; his brigandines (body armour) to Thomas Beauchamp; another suit of brigandines ('mes nouvelles brigandiers de rouge velvet') to Sir John Popham, with his helmet ('mon bassinet qe je port') and his best war-horse ('mon meillour chival'). Nothing whatever was assigned to the Possessioners.[150]

Inevitably Duke Edward, when he made these dispositions, had war very much on his mind. He dictated his will at Harfleur, in the heat and dust of the siege. At Agincourt, two months later, he was England's highest-born casualty. In any other circumstances, a nobleman of his position might have been expected

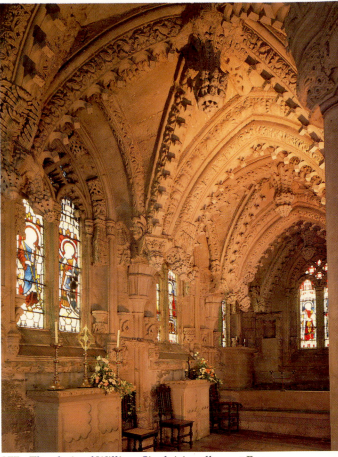

277. The choir of William Sinclair's college at Rosslyn, founded in 1450, was the only part of the earl's church to be completed. This is a detail of the extravagant and inventive carving in the ambulatory.

278. The effigies at Tong Church, in Shropshire, of Sir Richard Vernon (d. 1451) and Benedicta, his wife. Sir Richard, speaker of the House of Commons and treasurer of Calais, was the nephew and heir of Sir Fulke Pembruge (d. 1409), whose widow Elizabeth (d.1446) re-founded Tong as a collegiate chantry in his memory. The parish church, almost completely rebuilt after 1410, became subsequently filled with Vernon monuments.

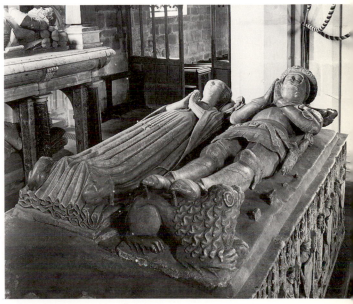

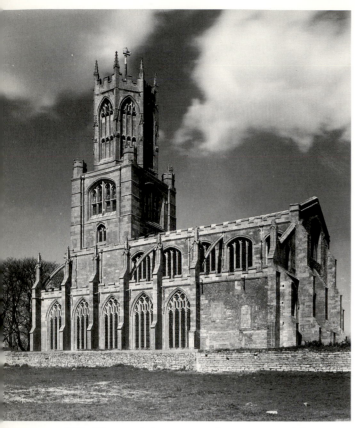

279. The surviving nave and west tower of the Yorkist collegiate church at Fotheringhay, founded by Duke Edward in 1411 and completed by his nephew Duke Richard (d. 1460). Fotheringhay's choir and domestic buildings were demolished after the suppression of the college in 1548.

to give more generously to the monks. But conventions undoubtedly were changing. Edward's heir was Richard Plantagenet (d.1460). And it was Richard's widow Cecily who, during the rest of her long life, became a leading figure of that close-knit group which brought the Flemish *devotio moderna* to England. For nine years after Duke Richard's death, Cecily continued to live mainly at Fotheringhay. One of her works of piety during that time was the glazing of the collegiate church. In Cecily's windows at Fotheringhay – recorded in 1719 but since lost – there was the figure of Archbishop Richard le Scrope, martyred cult hero of the Yorkists. Scrope was never canonized. Yet he appeared in the company of more authentic martyrs – St Alban, St Blaise and St Clement. Other particular favourites of the duchess, similarly rewarded in her glass, were St George and St John Baptist (both with strong English followings), St Erasmus of Formiae (patron of sailors and sick children), and the still fashionable St Bridget of Sweden.[151]

The political upheaval of 1461, when Henry VI was deposed and Edward Plantagenet (Cecily's son) usurped his throne, was a major setback for some Lancastrian foundations, among them Henry's Eton and King's College. But the new Yorkist ruler, probably under his mother's influence, took the Bridgettine nuns of Syon to his bosom. Edward IV was later recognized as Syon's second founder. His mother was remembered in the nuns' Easter obit 'for alle frendis and benefactours, and specialli for the duke Richard and Cecillie his spouse, parenters unto kynge Edward'.[152] It was the Bridgettines' reputation for contemplative piety that continued to bring them much support. Their library, along with that of the Carthusians of Sheen, became one of the great storehouses of English mysticism.[153] In it, the writings of Walter Hilton figured prominently. Hilton's best known work, still read today, was his manual on the early stages of the mystical life, entitled *The Scale of Perfection*. But it was another of Hilton's treatises, on the *Contemplative and Active Life*, which made especially favourite reading in Cecily's household. Hilton's message was peculiarly appropriate. A person in high authority must expect to have worldly commitments. But assiduous prayer and meditation, if not taken to excess, could bring rich spiritual rewards even so. Hilton for the layman, as Benedict for the monk, won his following by preaching the possible.[154]

Another book often read at Cecily's table was her copy of *The Revelations of St Bridget*. There was a second copy of Bridget's *Revelations* at the Carthusian house at Sheen, and at least two others at Syon.[155] Cecily, in her latter years, left her castle at Fotheringhay to live closer to these two spiritual power-houses. And it was from Sheen and Syon, under patronage such as hers, that the writings of the Continental mystics permeated England. A recluse at Sheen, John Dygoun, was the first in England to make a copy of Thomas à Kempis' *Imitation of Christ*. Another early copy of the *Imitation* was Robert Bale's of 1469, in which Yorkist propaganda, praising Cecily's son, was included.[156] Other Carthusian communities, even the most remote, spread the word. It was Nicholas Love, prior of Mount Grace in northern Yorkshire, who translated the third great text (after the *Scale* and the *Imitation*) of the English movement – the pseudo-Bonaventuran *Meditationes Vitae Christi* (*Mirror of the Blessed Life of Jesus Christ*).[157] And it is at Mount Grace even now, more than anywhere else, that it is still possible to recapture some remnant flavour of the best of late-medieval English spirituality. Thomas à Kempis writes 'about living an interior life', 'on the love of one's cell', and 'on the love of solitude and of silence'. Those, exactly, were the priorities of the builders of Mount Grace.

Much of Mount Grace survives intact: it is the only English Charterhouse to have done so. And what is at once obvious in the Great Cloister there, is the complete separation, one from another, of the brethren's individual *domunculae* – their cells and gardens. It was in the small library of Mount Grace that the only remaining contemporary copy of the *Book of Margery Kempe* was preserved.

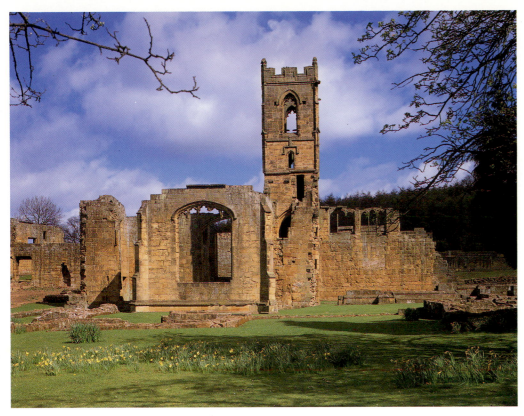

280. The Carthusian priory church at Mount Grace, in North Yorkshire, where God visited Richard Methley 'in power'.

Margery was an English visionary, in the same tradition as those mainstream mystics – the Blessed Matilda of Hackeborn, St Catherine of Siena, or St Bridget of Sweden – venerated by Cecily of York.[158] She was a devotee of St Bridget, and could sob as loudly as her model, the Blessed Dorothea of Montau, at every recollection of Christ's Passion. The interested and tolerant brethren of Mount Grace found parallels for her ecstasies in those of their own Richard Methley.[159] However, the 'boisterous' weeping of such as Margery had no place in the silence of the cloister. Mount Grace's church was small, barely adequate for the community. Its refectory was diminutive and seldom used. Each hermit-monk kept to the cell where, in uninterrupted solitude and private meditation, he could bare heart and soul unto the Lord. 'Christ is ready to come to you', promised Thomas à Kempis, 'but you must make room, deep in your heart, to entertain him as he deserves; it is for the inward eye, all the splendour and beauty of him; deep in your heart is where he likes to be.'[160]

One day at Mount Grace, after mass in the little church, Brother Methley felt the immanence of the Lord:

God visited me in power, and I yearned with love so as almost to give up the ghost Then did I forget all pain and fear and deliberate thought of any thing, and even of the Creator First I oft commended my soul to God, saying: 'Into thy hands,' either in words or (as I think rather) in spirit. But as the pain of love grew more powerful I could scarce have any thought at all, forming within my spirit these words: 'Love! Love! Love!' And at last, ceasing from this, I deemed that I would wholly yield up my soul, singing, rather than crying, in spirit through joy: 'Ah! Ah! Ah!'[161]

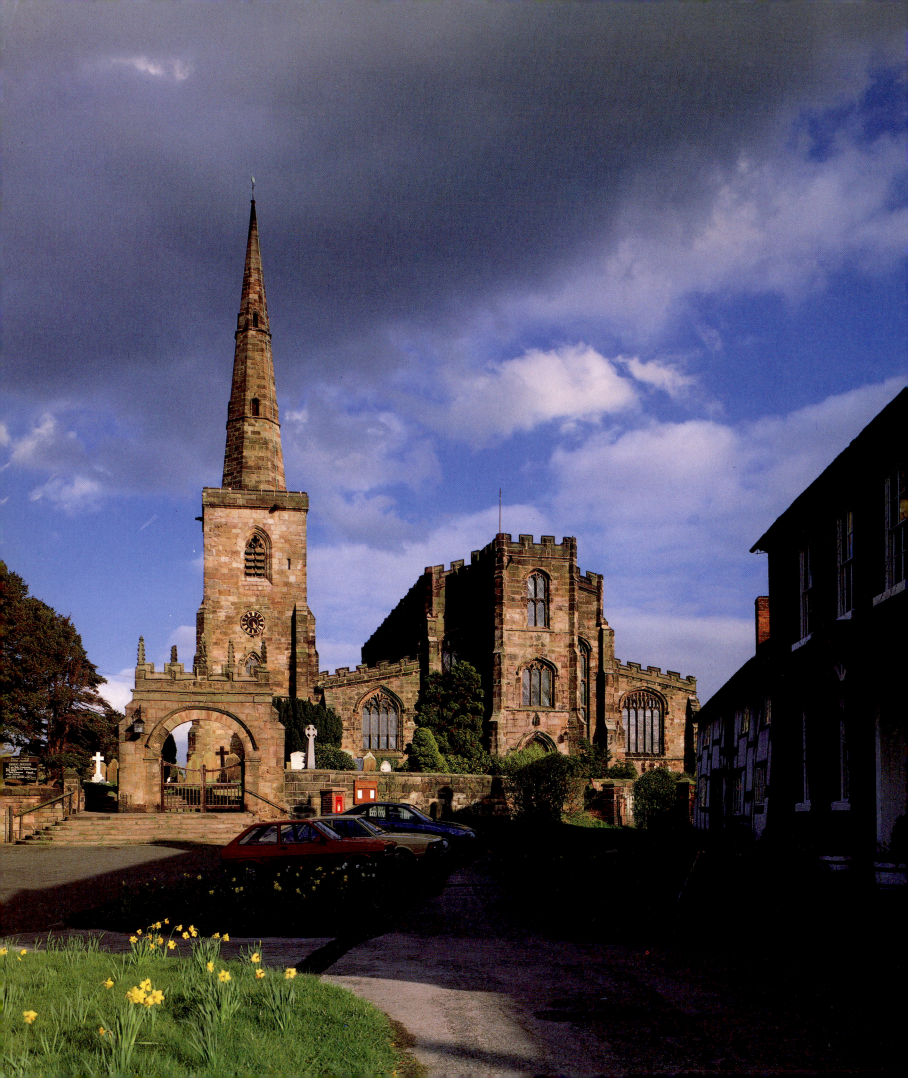

CHAPTER 8
God's Plenty

The private vision of Richard Methley, the Carthusian, was individual and exclusive. Margery Kempe was a 'creature' of the folk. There were many, she tells us, who laughed at her. But she discovered her own personal *Imitation* in public contempt and, in spite of it all, kept her friends. Our Lord had told Margery: 'Daughter, I say to you that I want you to wear white clothes and no other colour, for you shall dress according to my will.' Margery, mother of fourteen, was a matron. 'Ah, dear Lord', she had reasonably responded, 'If I go around dressed differently from how other chaste women dress, I fear people will slander me. They will say I am a hypocrite and ridicule me.' Implacably, 'Yes, daughter', had come the reply, 'the more ridicule that you have for love of me, the more you please me.'[1]

It was one way, certainly, to find the Lord, and other pious ladies – Catherine of Siena, Dorothea of Prussia, Angela of Foligno, and many more – had taken the same path before Margery.[2] But what was most particular about the devout women (*mulieres sanctae*) of this period was that they invited their humiliations not – as had once been the case – in the seclusion of the cloister, but in the parish church, in the street, and in the home.[3] Margery was a native of the port of King's Lynn (Norfolk). Like Norwich at the same period, Lynn was a lively centre of religious innovation, stimulated by overseas trade.[4] There was a Benedictine priory church (St Margaret's) at Lynn, with a huge parochial nave. Other big churches in the town included the parochial 'chapels' of St Nicholas (just then being rebuilt) and St James. All four orders of friars had houses at Lynn. There were two ancient hospitals – St John Baptist and St Mary Magdalen – and sixty or more religious gilds and fraternities, still on the increase in the early fifteenth century when Margery departed on her pilgrimages.[5]

One of Lynn's friaries, the Grey Friars in St James' End, has left a tall tower – an octagon on the crossing – built during Margery's lifetime. Just across the road was the church of St James (now lost), where Margery encountered the hostility of a visiting Franciscan, 'a holy man and a good preacher', usually identified as William Melton.[6] 'I wish this woman were out of the church,' exclaimed Melton, losing patience with the weeping creature, 'she is annoying people [with her shrieks].' He never changed his mind, and refused to have Margery in his congregation. Yet she, advised by her confessor to attend another church while he preached,

> felt so much sorrow that she did not know what she could do, for she was excluded from the sermon, which was to her the highest comfort on earth when she could hear it, and equally, the contrary was to her the greatest pain on earth, when she could not hear it. When she was alone by herself in one church, and he preached to people in another, she had as loud and as astonishing cries as when she was amongst people.[7]

Other preachers, who knew Margery better, were more tolerant. And her appetite for sermons was, in any event, hardly different from that of the great majority of her fellow townspeople. Preachers were much in demand. The big nave of St Margaret's (Lynn) was one of their many stations in the town. Another was the churchyard of St James, next to the Grey Friars, where Melton took the opportunity of a name-day sermon to preach 'a great deal against the said creature [Margery], not mentioning her name, but so conveying his thoughts

281. When Astbury Church, in Cheshire, was rebuilt in the fifteenth century, the earlier aisles (north and south) were left intact, a new clerestory soaring through the middle. Astbury's steeple (left) was a recent rebuilding of the late fourteenth century.

282. The refurnishing as preaching spaces of many fifteenth-century parish churches usually included the provision of complete sets of benches. Here a carved bench-end from Brent Knoll Church, in Somerset, depicts *The Hanging of Reynard the Fox*.

284. (right) A pulpit of *c*.1500, carved with saints under gables held by angels, at Trull Church, in Somerset. Other contemporary church furnishings still in use at Trull include carved screens and a good set of benches.

283. The figure of *Hypocrisy* (praying with open eyes) on a bench-end at Blythburgh, in Suffolk. Other warning figures on the Blythburgh benches include *Avarice* (on his money chest), *Gluttony* (with a large belly), and *Sloth* (in bed).

that people well understood that he meant her'.[8] A third was the church of St Nicholas, in Newland, rebuilt in fine style in the 1410s to furnish uninterrupted preaching space. Huge windows lit the interior of St Nicholas. Pews were fitted to seat the congregation, each bench-end handsomely carved.[9]

Near Lynn at the Wiggenhalls (St Mary and St Germans), at Harpley and Beeston (between Lynn and Norwich), and at Salle and Great Walsingham (to the north), are some of the most complete remaining sets of late-medieval carved benches. There are others of comparable quality in the Suffolk churches of Wingfield and Blythburgh, Southwold and Hesset, Dennington, Lackenheath and Earl Soham. There is a fine fifteenth-century pulpit at Salle and another at Southwold. And there are other contemporary pulpits all over the country – at Bodmin and Launceston (Cornwall), Halberton, Witheridge and Dartmouth (Devon), Bridgwater, Long Sutton and Trull (Somerset), Dean and Elstow (Bedfordshire), Oundle and Fotheringhay (Northamptonshire), North Cerney,

Cirencester and Northleach (Gloucestershire), Haslingfield (Cambridgeshire), Nantwich (Cheshire), Tattershall (Lincolnshire), Edlesborough (Buckinghamshire), Arundel (Sussex), Lutterworth (Leicestershire), and so on.

Such catalogues make heavy reading. Nevertheless, they establish the point that pews and pulpits, by the Late Middle Ages, had become the standard furniture of parish churches. Preaching, on one level, was instructional. On another, it was inspirational as well. All parish priests, since the late thirteenth century, had been required to teach their congregations the Six Points: the Sacraments, the Fourteen Articles of Faith, the Ten Commandments, the Seven Works of Mercy, the Seven Virtues, and the Seven Vices.[10] Chiefly, it was for the visiting preacher to develop other topics – 'the Council of Christ, Virtuous Patience, Temptation, the Charter of Heaven, the Horse and Armour of Heaven, the Love and Desire of Jesus, Of True Meekness, the Effect of Will, Of Active and Contemplative Life, the Mirror of Chastity'.[11] All these were treated in the *Poor Caitif*, a manual much used by Lollard preachers. For the parish clergy likewise, John Mirk's popular *Manuale Sacerdotis* (Instructions for Parish Priests) included advice on 'How thou shalt thy parish preach, / And what ye needeth them to teach'. It began with a warning about the priest's own behaviour: 'For little is worth thy preaching, / If thou be of evil living.'[12] 'Do as the priest says, but not as he does', is one of the oldest of English-language proverbs.

For preachers everywhere, a favourite sermon aid was the big painted *Doom*, or *Last Judgement* scene, often found over the chancel arch of parish churches. Particularly fine examples of these *Dooms* have survived in the big preaching naves of St Thomas (Salisbury) and Holy Trinity (Coventry), but smaller country churches like South Leigh and Wenhaston also had them. Their message was at once a threat and a deliverance. 'Where,' demanded the Dominican, John Bromyard, probably pointing at such a *Doom*,

> are the evil princes of the world, the kings, earls and other lords of estates, who lived with pride and with great circumstance and equipage, who used to keep many hounds and a numerous and evil retinue, who possessed great palaces, many manors and broad lands with large rents, who nourished their own bodies in delicacies and the pleasures of gluttony and lust, who ruled their subjects harshly and cruelly to obtain the aforesaid luxuries, and fleeced

285. A stone pulpit of early sixteenth-century date at Witheridge Church, in North Devon.

287. (right) Detail of the *Weighing of the Souls* from an early sixteenth-century *Doom* at Wenhaston Church, in Suffolk.

286. At South Leigh Church, in Oxfordshire, a big fifteenth-century *Last Judgement*, over the chancel arch, spreads to the nave walls on each side; on the south wall (right) is a contemporary *St Michael Weighing the Souls*, with the Virgin standing next to him as intercessor. Both paintings were restored in 1872.

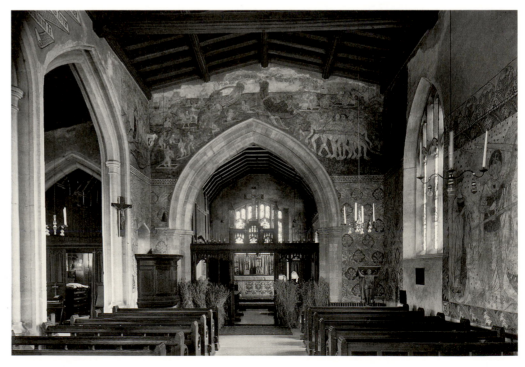

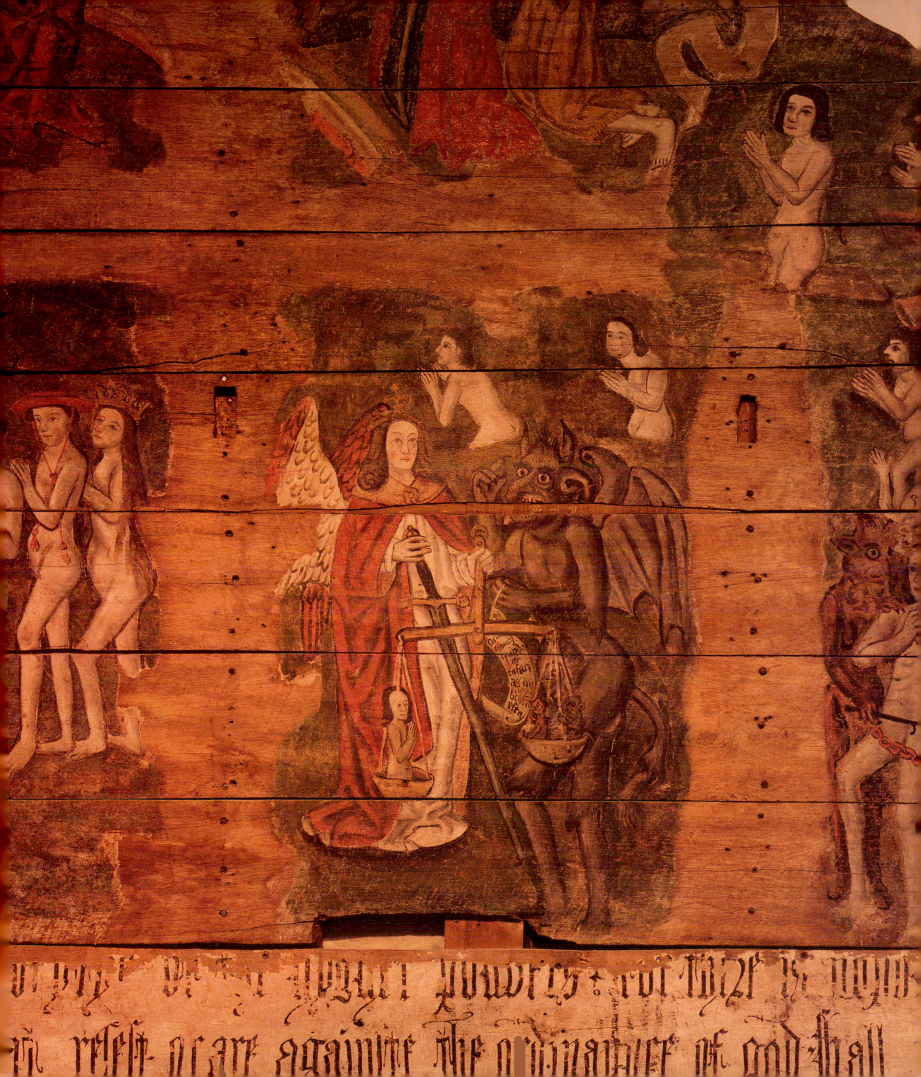

289. Astbury's huge internal space, as in many Perpendicular parish churches of the late fifteenth century, was divided only by a rood-screen.

them? . . . Where again are the usurers [*uncomfortable shifting on the benches*], who used to make a penny out of a farthing, and from eleven pence make twelve, and out of a peck of wheat or its value make two or three pecks; the false merchants [*another wriggle*], who knew how to deceive a man to his face? . . . You will find that, of all their riches, their delicacies and the rest, they have nothing; and the worms, as you will see [*Bromyard points again*], have their bodies.[13]

Then comes the reassurance all have waited for. 'The righteous poor,' promises the Franciscan, Nicholas Bozon,

will stand up against the cruel rich at the Day of Judgement, and will accuse them of their works and severity on earth. 'Ha! ha!, will say the others, horribly frightened, 'these are the folk formerly in contempt. See now how honoured they are among the sons of God! What are riches and pomp worth to us now who are abased!' . . . At the Day of Judgement the simple folk [*a ripple of delight*] will be exalted for their good deeds, and the haughty abased for their pride.[14]

Congregations loved what they heard. The parish church was their theatre; the pulpit, their stage; the visiting preacher, their principal player. One noted peripatetic preacher was Nicholas Philip, a Franciscan, who left a sermon diary on his death. Philip preached at Oxford and Newcastle in the 1430s, at Lichfield, King's Lynn, and Melton Mowbray.[15] Only at Melton, of the five towns on his circuit, would he have found no friary church of his order. But Melton's parish church – 'the stateliest and most impressive of all churches in Leicestershire' – provided him with everything he needed. It was cruciform in plan, with a broad nave and big aisled transepts, giving plenty of space for a numerous congregation and entirely dwarfing the rector's chancel. Yet even this was not enough for Melton's townspeople. Towards the end of the fifteenth century, they re-roofed their church, inserting a prodigy clerestory. Melton's wall-of-glass clerestory wraps the church about, like a ribbon on a *bonbonnière*.[16]

Clerestories were not all for show. Sermon audiences, seated for long hours in the body of the nave, wanted to see their preachers as well as hear them. Parishioners welcomed better lighting for the many other uses of their churches – for elections and assemblies, for inquests and audits; as courts, as schools, and as warehouses.[17] There are many immediate parallels to Melton Mowbray, among them Gedney and Sleaford, big Decorated churches in southern Lincolnshire, re-equipped before 1500 with splendid clerestories.[18] However, the most thrilling of these rebuildings is undoubtedly Astbury (Cheshire), where the entire core of a fourteenth-century church has been removed and replaced, the new Perpendicular arcade and its great crowning clerestory rising ship-like through the earlier aisles.[19]

Rebuildings like Astbury's were especially disruptive, but were none the less popular with wealthy donors. The Perpendicular clerestory at Martock Church (Somerset) carries the arms of local gentry – the Poulets, the Beauforts, and the Widcombes.[20] It was the Smyths who gave a clerestory to Cavendish Church (Suffolk); the Peytons who contributed the 'uncommonly big and tall clerestory' to Isleham Church (Cambridgeshire); Warden James Stanley (1485–1506) who built the fine clerestory at collegiate Manchester; Archbishop Rotherham of York (1480–1500) who put a new clerestory on Laxton Church (Nottinghamshire); Sir Robert Wingfield (d.1480) who completed the clerestory at East Harling (Norfolk); and John Ashfield, a wealthy wool-merchant, who built the lantern-like clerestory on the nave at Chipping Norton (Oxfordshire), among the most splendid of Cotswold wool churches.[21] In another famous wool church, at Long Melford (Suffolk), individual contributions were carefully recorded in an

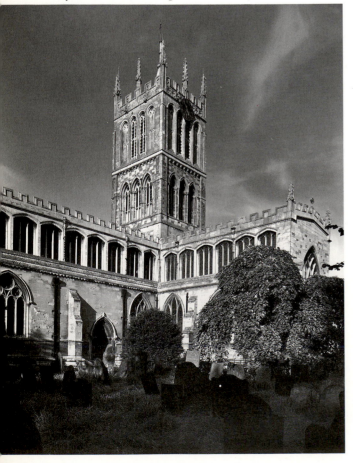

288. The late fifteenth-century re-roofing of the nave and transepts at Melton Mowbray was accompanied by the insertion of a grand clerestory.

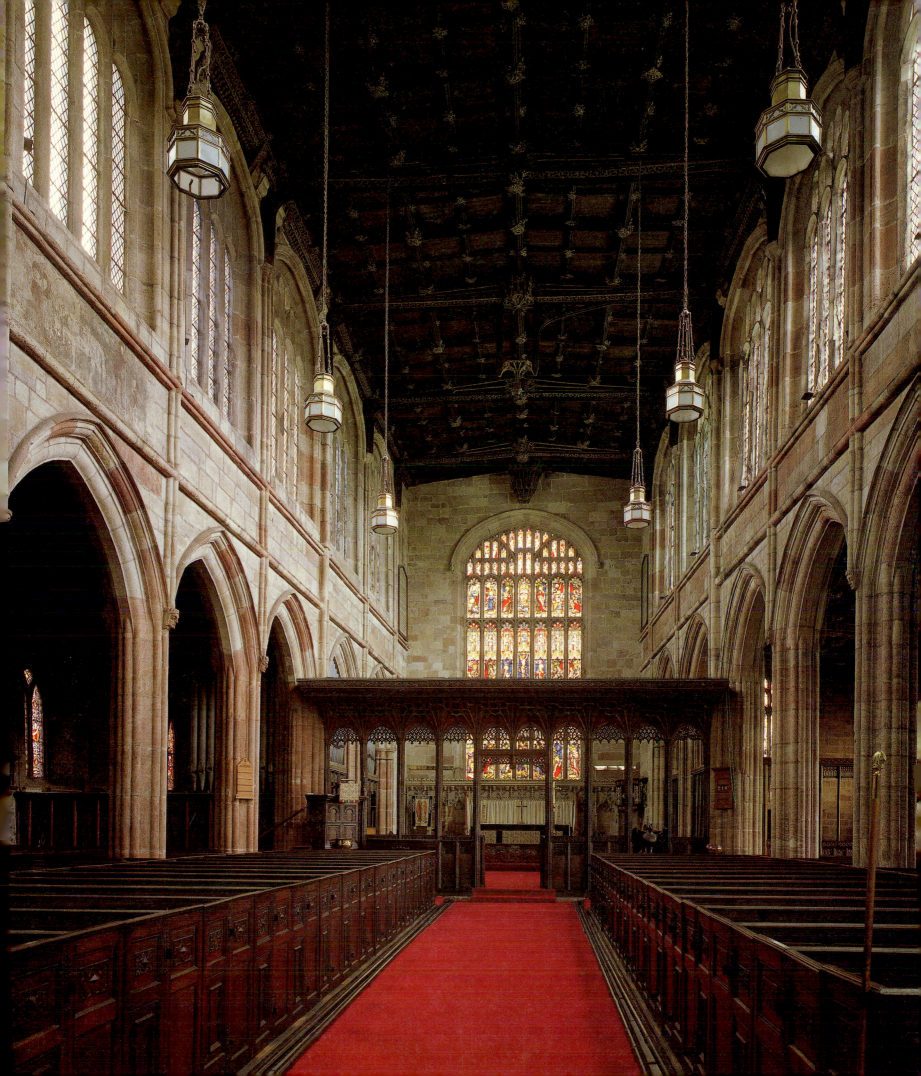

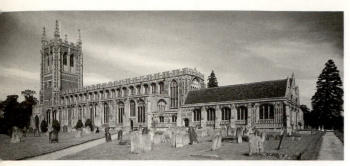

290. Long Melford Church was rebuilt and extended by John Clopton and other wealthy parishioners towards the end of the fifteenth century.

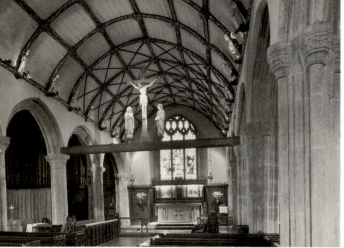

291. The chancel and fifteenth-century wagon roof of St Ives Church, in Cornwall.

292. This south parclose screen, at Dennington Church (Suffolk), dates to the mid-fifteenth century; the balustraded loft, a rare survival, was repainted in 1843.

exceptionally complete set of inscriptions. Most generous of Long Melford's benefactors was John Clopton (d.1497), clothier and new 'founder' of the church. Others who featured on the Melford inscriptions included Robert and Marion Sparrow, Thomas and Mabel Cooper, John and Alice Pie, Thomas and Joan Ellis, Roger Moriell, John Keche, and Giles Dent ('late parson of Melford'). 'Pray for the soul of [Giles Dent and all the others]' was the optimistic and unvarying refrain.[22]

With the clerestories went new roofs, of which Martock and Manchester, Isleham, East Harling and Long Melford preserve some of the finest. Those were all big churches. But even minor buildings of the Late Middle Ages could be treated to roofs of great magnificence. The little parish church at Earl Stonham (Suffolk) received a hammerbeam roof, on a contemporary clerestory, of outstanding decorative quality.[23] At Needham Market in the same county, no bigger than Earl Stonham, there is an extraordinary roof structure of the 1460s or 1470s which incorporates a clerestory of its own. Needham Market's *chef d'oeuvre* – the most exciting roof in England – is said to have been commissioned by Bishop Grey of Ely.[24] But it was parish fraternities, all over the country, which chiefly raised the money for such purposes. Those other celebrated masterpieces of East Anglian roof-carpentry – at Suffolk's Eye and Woolpit, Mildenhall and Dennington, Blythburgh and Framlingham; at Cambridgeshire's March and Willingham, Burwell and Soham; at Norfolk's Ringland, Wymondham and Salle – were the product of collective piety in the parishes. It was Cornish men and women – the humbler sort of parishioner – who funded the handsome wagon roofs at St Ives and St Neot, Fowey and Lanreath, Golant and Mawgan-in-Meneage; gildsmen of Somerset who met the cost of the fine roofs at Evercreech and Long Sutton, Bruton, Somerton and Isle Abbots; Welsh farmers of Brecknock who commissioned the barrel ceilings at Llanfilo and Partrishow, and who hired the best wood-carvers available at the time for the rood screens at each of these small churches.[25]

Works of this kind benefited the parishes. They clearly assisted that 'laud and loving of Almighty God and the augmenting of Divine Service' to which many gifts were ostensibly directed.[26] Nevertheless, their purpose was overwhelmingly memorial. The prayer-invoking inscriptions on the Long Melford nave and clerestory are repeated on every kind of church furnishing. The great screen and loft at Attleborough (Norfolk) solicits prayers for the souls of Richard and Margaret Hart, for Peter and Isabelle Martin, and for Thomas Cove, rector (1424–46).[27] Another fine screen at Felmersham (Bedfordshire) carries the same petition for the souls of Richard and Annette King.[28] There is an 'orate pro' inscription on the pulpit at Burnham Norton (Norfolk), given by John and Katherine Goldale in 1450.[29] And there are identical 'pray for' inscriptions on contemporary glass at St Neot (Cornwall), and at Bledington and North Cerney (Gloucestershire); on the brass eagle lecterns at Oxborough (Norfolk) and Merton College (Oxford); and on the Perpendicular fonts at Earl Soham (Suffolk), Walsoken (Norfolk), and St Mary's Beverley (East Yorkshire).[30] On the nave roof at Isleham (Cambridgeshire), completing a programme of works, there is the customary demand for recognition:

> Pray for the good prosperity of Christopher Peyton and Elizabeth his wife, and for the souls of Thomas Peyton esquire and Margaret his wife, father and mother of the said Christopher Peyton, and for the souls of all the ancestors of the said Christopher Peyton, which did make this roof in the year of our Lord MCCCCLXXXXV [1495], being the Xth year of King Henry VII.[31]

Donor portraits, with or without accompanying inscriptions, are routine at many parish churches. Or a rebus may be used in their place – the *golden well* of Bishop Goldwell of Norwich (1473–99), peppering the east window of his chantry at Great Chart (Kent); or the *shell-on-a-barrel* of Sir Ralph Shelton

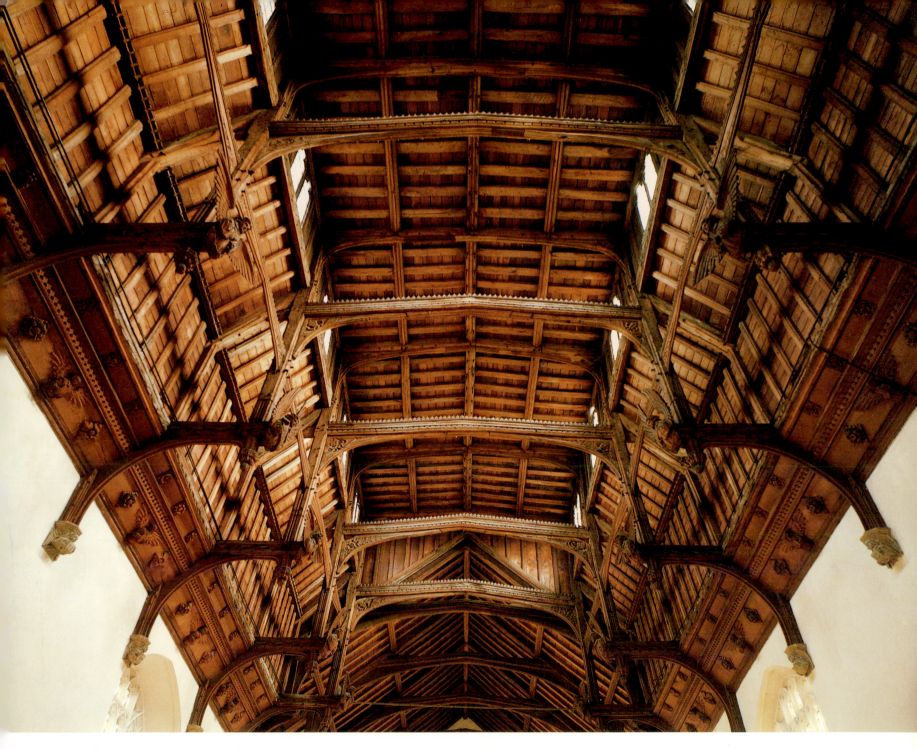

293. This late fifteenth-century nave roof at Needham Market is the acknowledged masterpiece of contemporary roof carpentry.

(d.1487), repeated in the windows of the church he rebuilt on the family estate at Shelton (Norfolk).[32] Very occasionally, some allusion may be made to the new beliefs. At Crowcombe Church (Somerset), on a fifteenth-century font, donors kneel in the presence of Christ (showing His wounds) and of St Anne (teaching the Virgin to read).[33] These were fashionable cults, reminiscent of the Netherlands *devotio moderna*. But they apper out of place in a small country church, remote from the clamour of the city. Where such devotions were more genuinely welcome was in a big urban community like Norwich. There is a huge civic church on Norwich market – St Peter Mancroft – which was entirely rebuilt between 1430 and 1455 at the cost of devout citizens and parishioners. St Peter's has a big display tower, ornate and expensive. Its tall eight-bay arcade carries a wall-of-glass clerestory and a fine hammerbeam roof, creating a vast preaching space. The Seven Sacrament font, given to St Peter's in 1463 by a rich Norwich grocer, John Cawston, commemorates that modish devotion.[34] The cult of St Anne, favoured in England after Richard II's marriage to Anne of Bohemia in

239

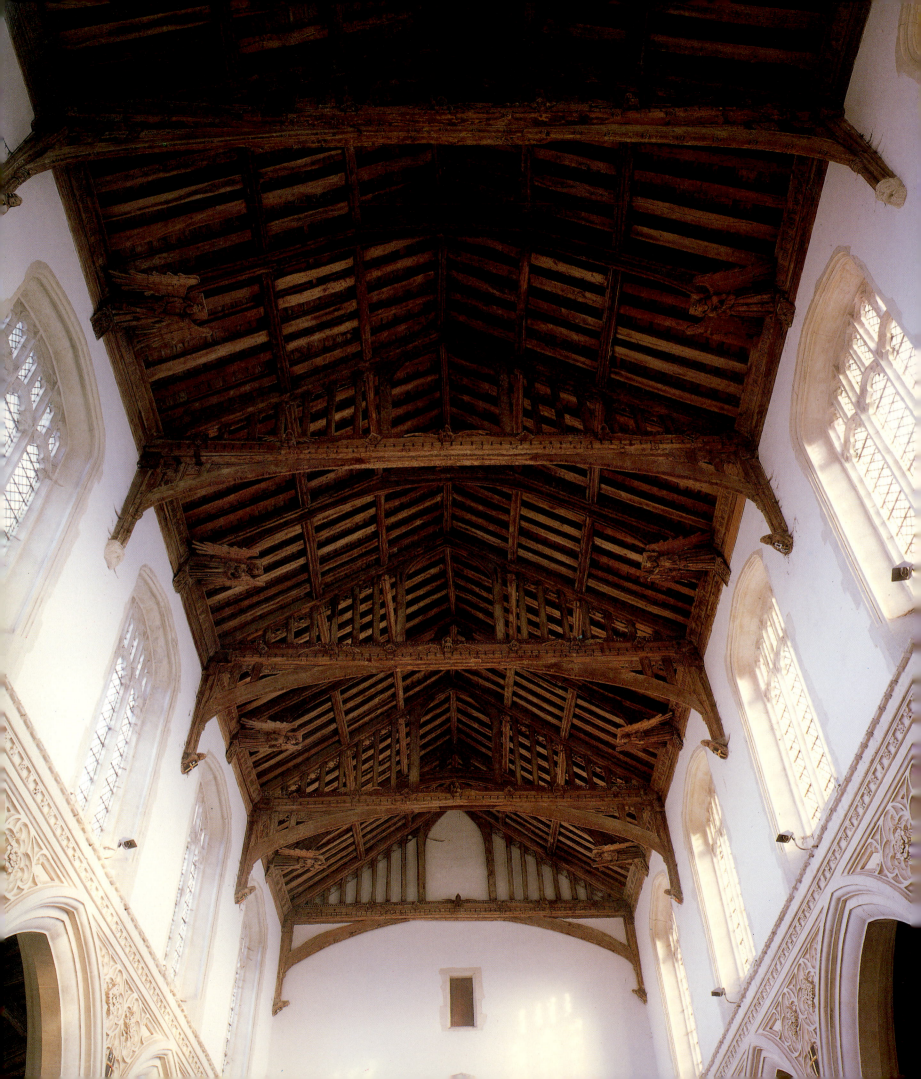

294. Isleham's nave roof was built in 1495 at the expense of Christopher and Elizabeth Peyton, and still carries their 'Pray for . . .' inscription.

295. The church of St Peter Mancroft (Norwich) was rebuilt by its parishioners between 1430 and 1455.

296. The preaching nave at the civic church of St Peter Mancroft.

1382, inspired its own confraternity – one of three in the city – at St Peter's. Another confraternity, dedicated to the Mass of the Name of Jesus, reflected the growing popularity of a newly flourishing cult, propagated by St Bernardino of Siena (d.1444). Norwich testators, from the 1490s, bought votive masses of the Five Wounds of Christ.[35]

Yet Norwich was hardly typical of the whole country. The city was the home of Julian of Norwich, author of the *Revelations of Divine Love*. It supported more mystics and hermits, anchorites and Flemish-style *beguinages* (households of devout laywomen) than any other English city of its period.[36] More usual by far was the case of Hull, where even the close proximity of a Carthusian community did little to tarnish burgess orthodoxy. Hull, like Lynn and Norwich, had strong overseas connections. And these must account for an early reference, in John Fitlyng's will of 1434, to the Five Wounds of Christ.[37] However, Fitlyng's up-to-date beliefs and accompanying bonfire of death's vanities – his executors must eschew vainglory and 'do only what was necessary for the praise of God' – were not widely shared amongst his fellows. No Hull testator ever matched the 4000 instant requiems of William Setman (d.1429), a former mayor of Norwich.[38] Nevertheless, all made payments for memorial masses a priority in their wills, following that with provision for their parish churches. When Hull's testators left money to their huge 'chapel' of Holy Trinity, their clear intention was to support and embellish a favourite sepulchre. Of the 300 or so burgesses whose preferences are known, over 200 opted to be buried within Holy Trinity; 64 preferred St Mary's, the other parochial chapel in the town; 24 were satisfied with churchyard burial; nine favoured the Austin friars; and only four (two each) chose to rest with the Carmelites and the Carthusians.[39]

In just the same way, the contemporary country gentry voted with their cadavers for the parish churches. In Hull's own county, 90 of a sample of 148 late-medieval Yorkshire testators chose burial in their local parish churches, another eleven selecting churches in York itself. One, Dame Joan Ingleby, gave her mortal remains to the Carthusians of Mount Grace, asking that the brothers 'should have my soul especially recommended in their prayers'.[40] Gloucestershire

gentry, over the period 1200–1500, likewise turned their backs on the monks: 77 of the 97 knights whose place of burial is known opted instead for the parish churches.[41] In a sample of 200 Kentish wills, datable between 1422 and 1529, 76 per cent of knights chose to rest in their own parish churches, as did 96 per cent of esquires and 92 per cent of gentlemen. Less than one per cent remained loyal to the Possessioners.[42]

The parish churches and their fabrics were the immediate beneficiaries of such dispositions. In bequests alone, Hull's deceased burgesses contributed over £800 to the building funds of Holy Trinity and St Mary.[43] And Holy Trinity in consequence, the senior of the two 'chapels', grew to be one of the great parish churches of medieval England. Gentry families, where it suited them to do so, adopted individual parish churches as their own. Nettlestead Church (Kent), burial-place of the Pympes, was glazed at the expense of Reginald Pympe (d.1438), who lived in the manor house next door. Another of the family, John Pympe (d.1496), gave Nettlestead its rood-screen and built its south porch; leaded the church roof and tiled the floor; raised the steeple, and furnished the altars with vaulted canopies.[44] At Flamborough Church (East Yorkshire), Sir Marmaduke Constable's improvements to the family resting-place in 1376 included paving the chancel floor; he also bought marble for the monuments of his grandfather and his mother, and ('when the time shall come') for his own.[45] The Constables went on living at Flamborough, and it was a later Sir Marmaduke, 'called the Little', who composed the well-known epitaph at Flamborough Church. Sir Marmaduke Constable (d.1518) was an old warrior whose last heroic encounter – 'nothing heeding his age'– was with the Scots at Flodden Field in 1513. He was also a rhymester of some skill. Marmaduke's 26-line inscription tells the story of his campaigns. 'But now', the old man muses, 'all these triumphs are passed and set on side',

> For all worldly joys they will not long endure.
> They are soon passed, and away doth glide,
> And who that putteth his trust in them, I call him most unsure;
> For when Death striketh, he spareth no creature,
> Nor giveth no warning, but taketh them by one and one.
> And now he [the poet] abideth God's mercy, and hath no other succour,
> for as ye see him here, he lieth under this stone.
> I pray you, my kinsmen, lovers, and friends all,
> To pray to our Lord Jesus to have mercy on my soul.[46]

Sir Marmaduke Constable – 'by King Edward [IV] chosen Captain there [at Berwick] first of any one' – was representative of a class which, in late-medieval Britain, egregiously privatized religion. Its sepulchres filled the chancels of many parish churches; its family pews nudged the pulpits in the naves; its private chapels and oratories, in the seclusion of family manor houses, disregarded old conventions of public worship. The Late Middle Ages can show no individual sepulchre as exclusive and grandiose as Sir Robert Montgomerie's Skelmorlie Aisle (1636), at Largs in Ayrshire; no serried monuments as flamboyant or closely packed as the Elizabethan Spencer tombs at Great Brington; no private pews or 'closetts' to compare in any way with the two post-1600 Norreys 'bird-cage' pews at Rycote Chapel, or with the Shirley Pew at Breedon-on-the-Hill.[47] But the feeling of separation is already there. When men of 'gentle' birth scented, for the first time, a plebeian vulgarity in religion – when they mocked its ancient ceremonies and drew their curtains on them – the door to Reformation was shoved ajar.[48]

Rycote itself, before its grand refurnishing by Francis Norreys, earl of Berkshire (d.1623), was the private chantry chapel of Oxfordshire gentry, standing church-like in the grounds of their manor house. Consecrated in 1449, it had been

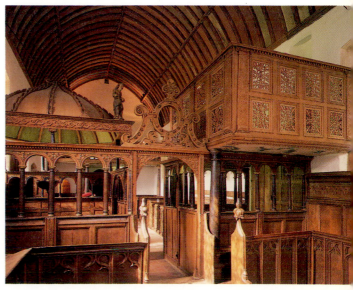

297. The personal chantry chapel of Richard Quatremains (d. 1477), next to his Oxfordshire manor house at Rycote.

298. The 'bird-cage' pews and other Jacobean furnishings of Rycote Chapel, installed by Francis Norreys, earl of Berkshire (d. 1623).

founded by Richard Quatremains (d.1477) and Sybil, his wife, who nevertheless chose burial at neighbouring Thame. Quatremains was not a man to take chances. Shortly before the end of a long and politically charmed life, during which he enjoyed the favour of both Lancastrians and Yorkists, Quatremains confirmed the Rycote chantry in two manors. Much earlier, he had been the founder in 1447 of the Gild of St Christopher at Thame, to which many local notables subscribed. 'O certain death', ran his epitaph at Thame, 'that now hast overthrown / Richard Quatremains Esquire and Sybil his wife that lie here now full low / . . . That founded in the Church of Thame a Chantry vi poor men and a fraternity: / In the worship of Saint Christopher to be relieved in perpetuity. / They that of their alms for their Souls a paternoster and Ave devoutly will Say / of holy father [the Pope] is granted they pardon of days forty always. / …Upon their Souls Jesus have mercy Amen.'[49]

One of Richard Quatremains' earlier business associates, before the dynastic upset of 1461, was the Lancastrian admiral, Ralph Boteler of Sudeley. And Boteler, the successful sailor – like Quatremains, the wealthy politician – also built himself, in effect, a private church.[50] Boteler's chapel, next to his new castle at Sudeley, was bigger than most. However, the tradition of chapel-building was very general by Boteler's time, accommodating the Lord in every household. It

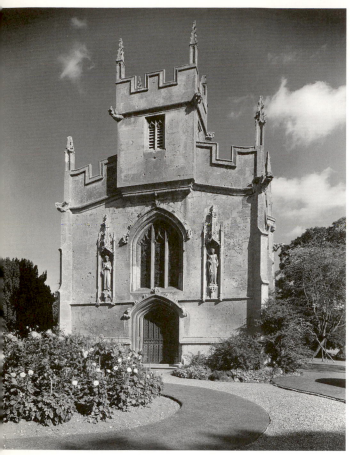

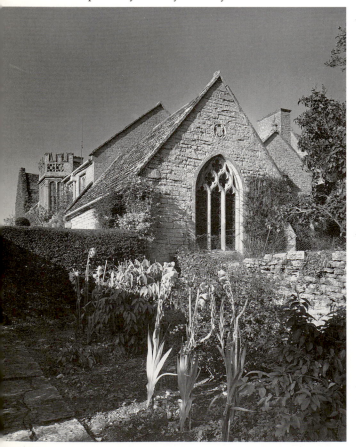

299. Ralph Boteler's mid-fifteenth-century chapel at Sudeley Castle was the size of a small parish church.
300. The private chapel (centre), originally free-standing and next to the manor house at Lytes Cary, was probably built by Peter Lyte in 1343.

was not simple convenience that put Him there. Sir Robert Harcourt's big private chapel at Stanton Harcourt (Oxfordshire) was just over the wall from what had already been set apart as the family church. Sir Robert himself (d.1471) lies buried in that church, surrounded by the sepulchres of his kin.[51] Other contemporary family oratories, in great houses within a stone's throw of the parish church, included the Lovell chapel at Minster Lovell and the Hastings chapel at Ashby de la Zouch.[52] Families like these took Christ captive. It was by His presence among them that a special relationship was formed, justifying their holdings of broad acres.[53]

From early in the fourteenth century, a big domestic chapel had been included in most major remodellings. John de Broughton's chapel at Broughton Castle (Oxfordshire) was one of the earliest of these, licensed in 1331. Like the lavish mid-century Berkeley chapels at Berkeley and Beverston, in Gloucestershire, Broughton's chapel was one element in a general modernization of the family's living quarters, supplied regardless of the neighbouring parish church.[54] Other contemporary building programmes in more remote places – Stonor, in the Oxfordshire Chilterns; Ightham Mote, in Kent; Lytes Cary, in Somerset – similarly included personal chapels.[55] And when a wealthy young couple like the Yardes of Bradley (Devonshire) decided to set up house together in the early fifteenth century, it was natural enough that, within a few years, they should furnish their new establishment with a chapel of its own, while contributing generously at the same time to their parish church.[56]

Such private chapels, in late-medieval Britain, might be conspicuously big and well equipped. Bothwell Castle (Lanark), as refurbished by the Douglas earls, included a large first-floor chapel next to the hall. And the royal chapel at Linlithgow (West Lothian) was given equal prominence, with access from the great hall, in the grand new palace of the Stewarts.[57] Important late fourteenth-century castles like the Cliffords' Brougham (Westmorland), extended at this date, and Treasurer Scrope's new four-square fortress at Bolton (North Yorkshire), acquired big private chapels as of right.[58] Similarly, a large and church-like chapel completes the show-front of Hampton Court (Herefordshire), built for Sir Rowland Lenthall in the 1430s. Although other private chapels were seldom quite as prominent, they nevertheless featured at many gentry manor houses of the period – at Cotehele (Cornwall) and at Compton (Devon); at Bramall (Cheshire); at Smithills and at Samlesbury (Lancashire).[59] One of the last and most magnificent of these pre-Reformation personal oratories was Sir William Sandys' chapel at The Vyne. Sandys' spacious chapel, in his fashionable Hampshire manor house, still preserves the expensive and high-quality Netherlandish glass which shows him at his most assiduous as a courtier. Below a big *Cruci-fixion*, in the east central window, is the kneeling figure of Henry VIII, robed in the splendour of his regality. Behind him (to the left) kneels Margaret of Scotland, the king's sister. In front (to the right) is Catherine of Aragon, the wife he was shortly to discard.[60]

The Vyne, in many ways, was an innovatory building. It included a long panelled gallery of the 1520s, which was among the earliest of its kind in Northern Europe. But Sandys' private chapel was nothing new. Like other chapels of its kind, it reveals again that withdrawal from public life which was coming to characterize the aristocracy. Understandable though it was, this distancing was not widely liked. Bishop Grosseteste of Lincoln, back in the 1240s, had counselled: 'Forbid dinners and suppers outside the hall in hiding-places and in chambers, because much waste results from this and no honour to lord or lady.' Rather,

let your freemen and guests be seated [in the hall] at tables on either side together, as far as possible, not here four, there three . . . and you yourself be seated at all times in the middle of the high table, that your presence as lord

or lady is made manifest to all, and that you may see plainly on either side all the service and all the faults.[61]

Making lordship manifest still had its value in the Late Middle Ages, and the companionship of the hall was not yet dead. Nevertheless, the more fastidious personal habits of the late-medieval nobility caused many of these obligations to seem burdensome. There is a famous passage in William Langland's *Piers Plowman* in which the poet laments:

> Desolate is the hall each day in the week
> Where neither lord nor lady delights to sit.
> Now has each rich man a rule to eat by himself
> In a privy parlour, because of poor men,
> Or in a chamber with a chimney and leave the chief hall
> That was made for meals and men to eat in.[62]

Langland wrote from the heart. He was a contemporary of the social conflicts of the 1370s and 1380s – of labour shortages and rent strikes, riots and the Great Revolt of 1381 – which were driving class divisions ever deeper.

Building styles reinforced these distinctions. Come what may, the king's servants were required to keep hall – to 'come to the hall and sit there, upon pain of losing their wages for six days'. But Edward IV, whose household ordinance this was, customarily dined apart in his chamber.[63] And the lord's removal from hall to great chamber, from great chamber to privy chamber, and from privy chamber to bedchamber, had begun a good while before. It was not until the turn of the sixteenth and seventeenth centuries that the real revolution took place in household planning, when the common hall went into terminal decline. However, the typical great house of the Late Middle Ages – like the monastery of the same period – was already an aggregate of private spaces: each carefully protected by its own front door, as mutually exclusive as a modern block of flats.

How such a house might most conveniently be arranged was defined in the *Dyetary* of Andrew Boorde (d.1549). Boorde was a physician, a one-time Carthusian and an indefatigable traveller, who knew his subject well. His *Dyetary*, published in 1542, began with four chapters on house-building, of which the fourth 'doth show under what manner and fashion a man should build his house or mansion, in eschewing things that shorten man's life.' Boorde gives counsel on foundations – 'upon a gravelly ground mixed with clay'; and on prospects – east and west, for 'the south wind doth corrupt and doth make evil vapours'. He then advises:

> Make the hall under such a fashion that the parlour be annexed to the head of the hall. And the buttery and pantry be at the lower end of the hall, the cellar under the pantry, set somewhat abase; the kitchen set somewhat abase from the buttery and pantry, coming with an entry by the wall of the buttery, the pastry-house and the larder-house annexed to the kitchen. Then divide the lodgings by the circuit of the quadrangular court, and let the gatehouse be opposite or against the hall door (not directly) but the hall door standing abase, and the gatehouse in the middle of the front entrance into the place: let the privy chamber be annexed to the state chamber, with other chambers necessary for the building, so that many of the chambers may have a prospect into the chapel. If there be an outer court made, make it quadrangular, with houses of easements, and but one stable for horses of pleasure.

Next, Boorde turns to what, as a physician, he knew best. 'See no filth nor dung be within the court, nor cast at the back-side,' he counsels, 'but see the dung to be carried far from the mansion.' For the same reason, the other stables, with the dairy – 'if any be kept' – and the slaughter-house, 'should be elongated the space

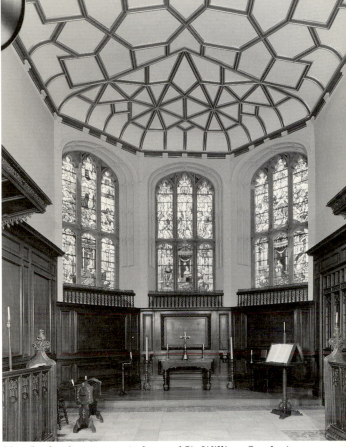

301. In the three east windows of Sir William Sandys' chapel at The Vyne, Henry VIII kneels below a *Crucifixion* (centre), accompanied by kneeling royal ladies (Catherine of Aragon and Margaret of Scotland) to right and left.

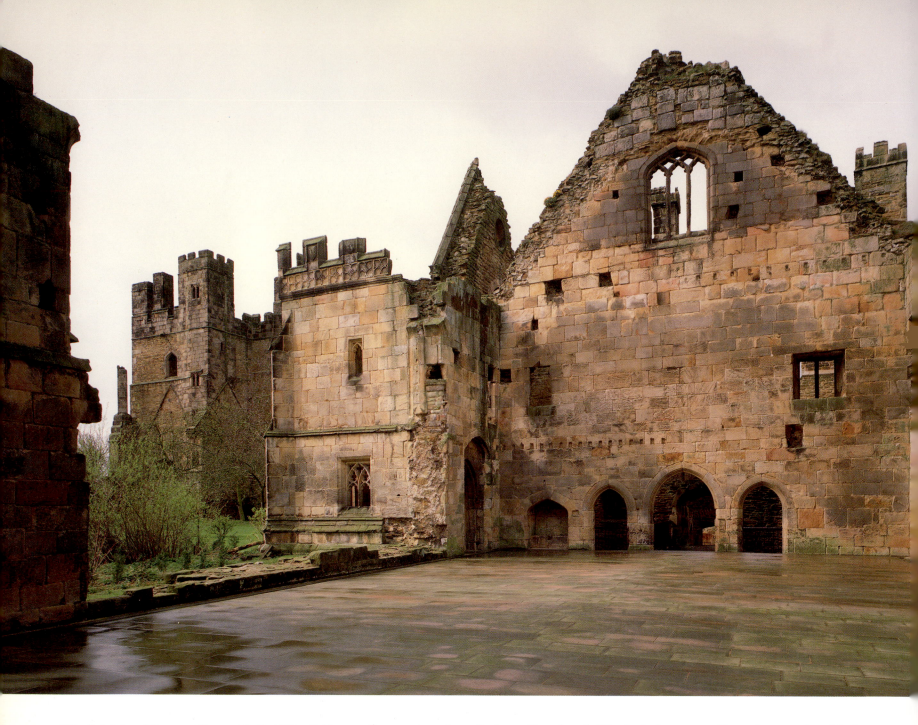

302. Ralph Lord Cromwell's great hall at Wingfield Manor was the main public apartment of a huge country palace, built in 1439–50. Cromwell's audience chamber and private lodgings were at the lower end of the hall, above the three service doors (right). His High Tower can be seen across the inner court (now a garden) on the left.

of a quarter of a mile from the place'. The bakehouse and brewhouse should also be kept at a distance. And

when all the mansion is edified and built, if there be a moat made about it, there should some fresh spring come to it; and divers times the moat ought to be scoured, and kept clean from mud and weeds. And in no wise let not the filth of the kitchen descend into the moat. Furthermore, it is a commodious and pleasant thing to a mansion to have an orchard of sundry fruits; but it is more commodious to have a fair garden replete with herbs of aromatic and redolent savours.

In that garden, there might be 'a pool or two for fish, if the pools be kept clean'; a park, stocked with deer and rabbits, is a 'necessary' thing, as is a dovecot. A pair of archery butts 'is a decent thing about a mansion'; while for a great man, 'necessary it is for to pass his time with bowls in an alley.' When all is finished, 'there must be a fire kept continually for a space to dry up the contagious moistures of the walls, and the savour of lime and sand. And after that a man may

246

lie and dwell in the said mansion without taking any inconvenience of sickness.'[64]

What Boorde was describing was not something extraordinary – a largely fictional ideal – but the typical courtyard house of late-medieval England. So comfortable were these houses that, since that time, many have remained continuously in use. But there is a price to be paid for long life. Baddesley Clinton (Warwickshire), for example, is a better record today of sixteenth-century antiquarianism than of the taste of any earlier generation. Both Lytes Cary (Somerset) and Great Chalfield (Wiltshire) have been considerably extended and rebuilt. And Oxburgh Hall (Norfolk), with the exception only of its fifteenth-century show-front, is almost wholly Victorian.[65] However, there is one surviving manor house, on the grandest of scales, which has escaped almost unaltered through the centuries. South Wingfield (Derbyshire), built for Ralph Lord Cromwell between 1439 and 1450, was the more conventionally planned of the treasurer's two principal country seats. The other was the spectacular Tattershall Castle, in Lincolnshire. Both were financed out of a decade at the Treasury, beginning in 1433.[66]

No English treasurer of Cromwell's time expected to lose money in that office. Most, including Cromwell himself, made great fortunes out of it. However, it was not a popular role, and Cromwell inevitably had his enemies. At Tattershall, it was a neighbour, William Tailboys, and his hireling 'slaughterladdes', who threatened the treasurer with kidnap and murder; at South Wingfield, there were the disappointed Pierpoint claimants to cause anxiety.[67] Nevertheless, Cromwell died peacefully in his bed. And what was notable about his houses was their defenceless state, even when the habiliments, as at Tattershall, were military. In practice, the treasurer's best security lay not in his walls, but in the numbers and the vigilance of his household. All about Cromwell were his beholden councillors – his lawyers, his knights, and his bureaucrats. At Wingfield alone, his companions and servants totalled over a hundred. As friend and foe discovered in fifteenth-century England, there was more to be gained by manipulation of the law, than by any act of mayhem or misrule.[68]

Wingfield accordingly was a country house, not a fortress. It anticipated Andrew Boorde's ideal. It had two great courts, or quadrangles, each with its own gatehouse. There was a big common hall, opposite the inner gatehouse, with a buttery and a pantry 'at the lower end', and a kitchen 'set somewhat abase'. Lodgings filled the ranges on every side. All this was standard form. What was different about Wingfield was the scale of Cromwell's manor house, and the huge additional provision for his guests. Cromwell himself had a big audience chamber over the buttery, next to the lower end of the great hall. And it was here too, somewhat exceptionally, that he had his lodgings centrally placed. Household servants were accommodated in the dormitory ranges of the outer court. Family and guests had their lodgings in the inner court – twelve in the west range and another twelve in the cross range (six on each side of the gatehouse), with especially grand apartments for Cromwell's more important visitors in the upper three storeys of the tower.[69]

It was the High Tower especially that distinguished South Wingfield as the residence-in-chief of a wealthy nobleman. Every major establishment had to have one. But the tower was no more military than the communal hall or kitchen, each catering more directly for the household. At Tattershall, Cromwell's tower – the 'great tower called le Dongeon' – was the lord's personal solar-block and private residence. Linked to the common hall in the bailey, it housed the treasurer's parlour on the ground floor, his private hall on the next, his audience chamber on the second floor, and his bedchamber under the roof. All these apartments, even the parlour at ground level, had big windows. They had great chimneypieces, handsomely carved, on which Cromwell's badge of office – his treasurer's purse – was prominent alongside his family heraldry. In the flat

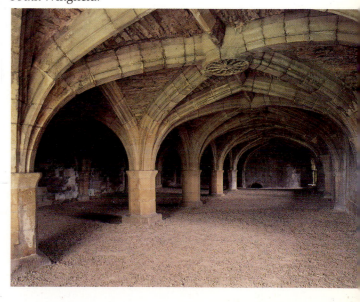

303. The vaulted undercroft below Cromwell's hall at South Wingfield.

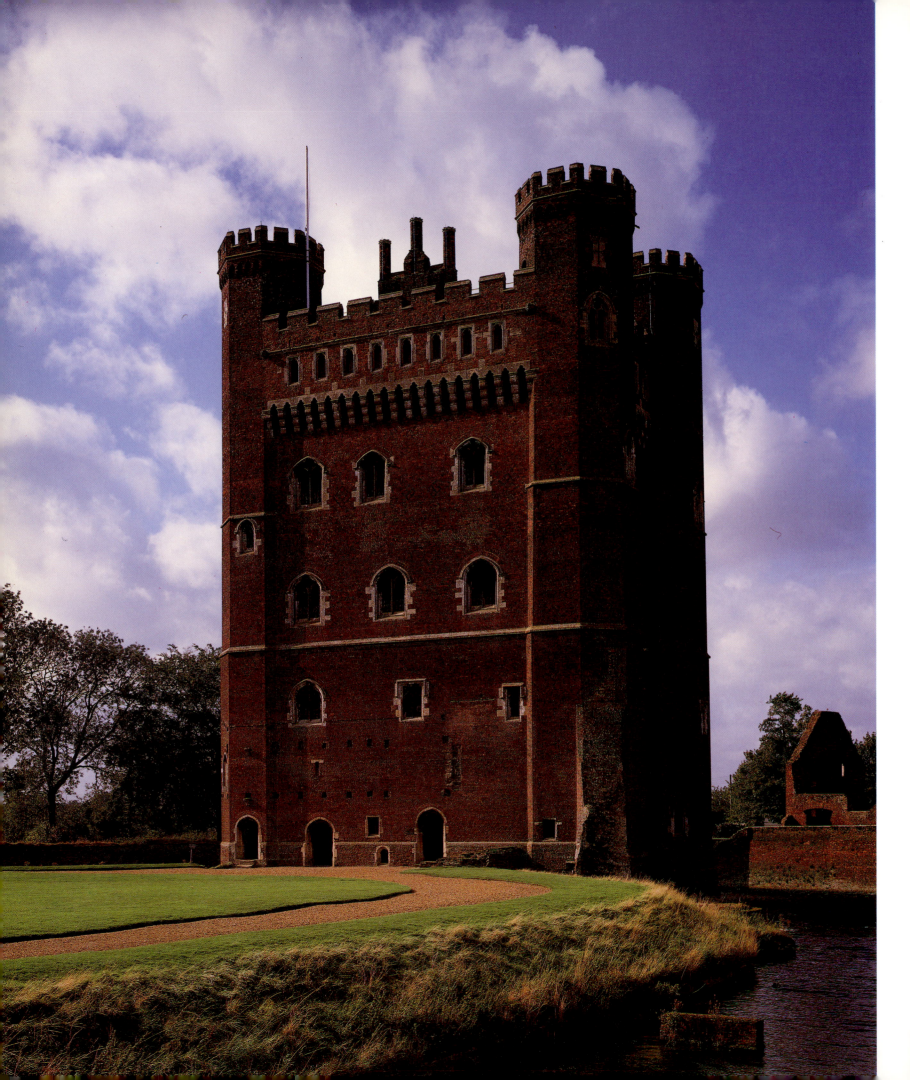

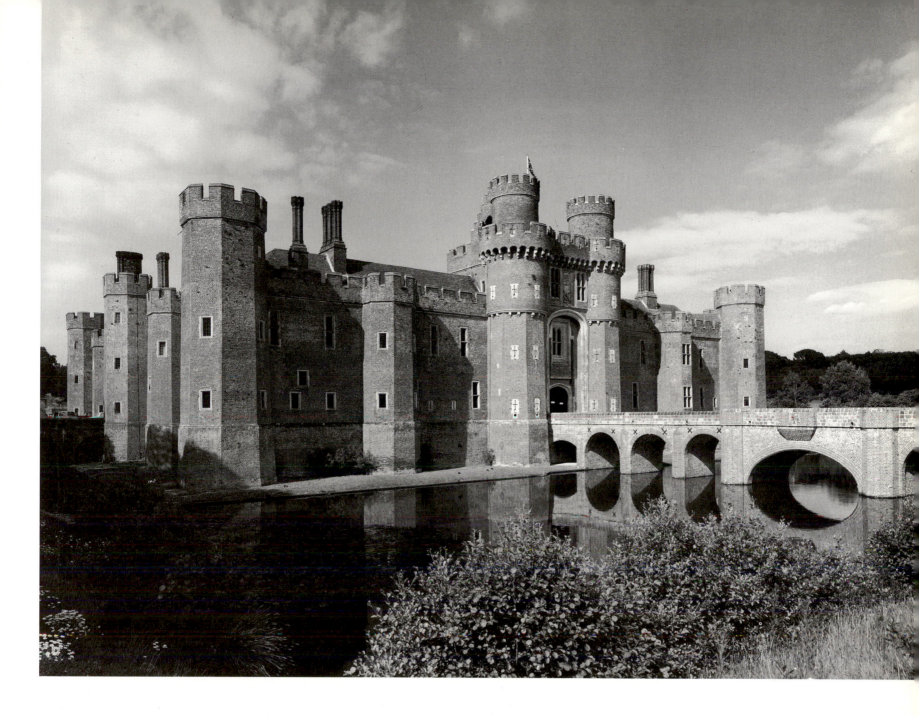

Lincolnshire countryside, Cromwell's tower stood proud, invoking the admiration of his contemporaries.[70]

Tattershall's Great Tower is in Netherlands-style brick, specially made in Cromwell's kilns by 'Baldwin Dutchman'.[71] It was a new material, only just winning wider acceptance in fifteenth-century England, and was still an attention-drawing novelty. Another novelty at Tattershall was the tower's machicolated fighting galleries, also a direct borrowing from the Continent. Cromwell no doubt learnt the technique while campaigning in France after Agincourt. At home, he felt secure enough to misapply it. Warlike and professional though they seemed from afar, Tattershall's wall-head galleries were not continuous. They broke at the angle-turrets, interrupting the rush of the defenders and leaving each corner uncovered. Their purpose, very obviously, was display.[72]

That same apparent neglect of the finer points of defence reappears at Raglan Castle, in Monmouth. Raglan was the most military of a new category of fortress-mansion – including Ralph Boteler's Sudeley (Gloucestershire), Roger Fiennes' Herstmonceux (Sussex), John Montgomery's Faulkbourne (Essex), John Fastolf's Caister (Norfolk), and Andrew Ogard's Rye (Hertfordshire) – built by Cromwell's

305. Sir Roger Fiennes' symmetrically planned Herstmonceux, brick-built like Cromwell's Tattershall in the new fashion of the 1440s, was more a country mansion than a fortress.

304. The Great Tower at Tattershall was built as a private residence for Treasurer Cromwell between 1432 and 1448.

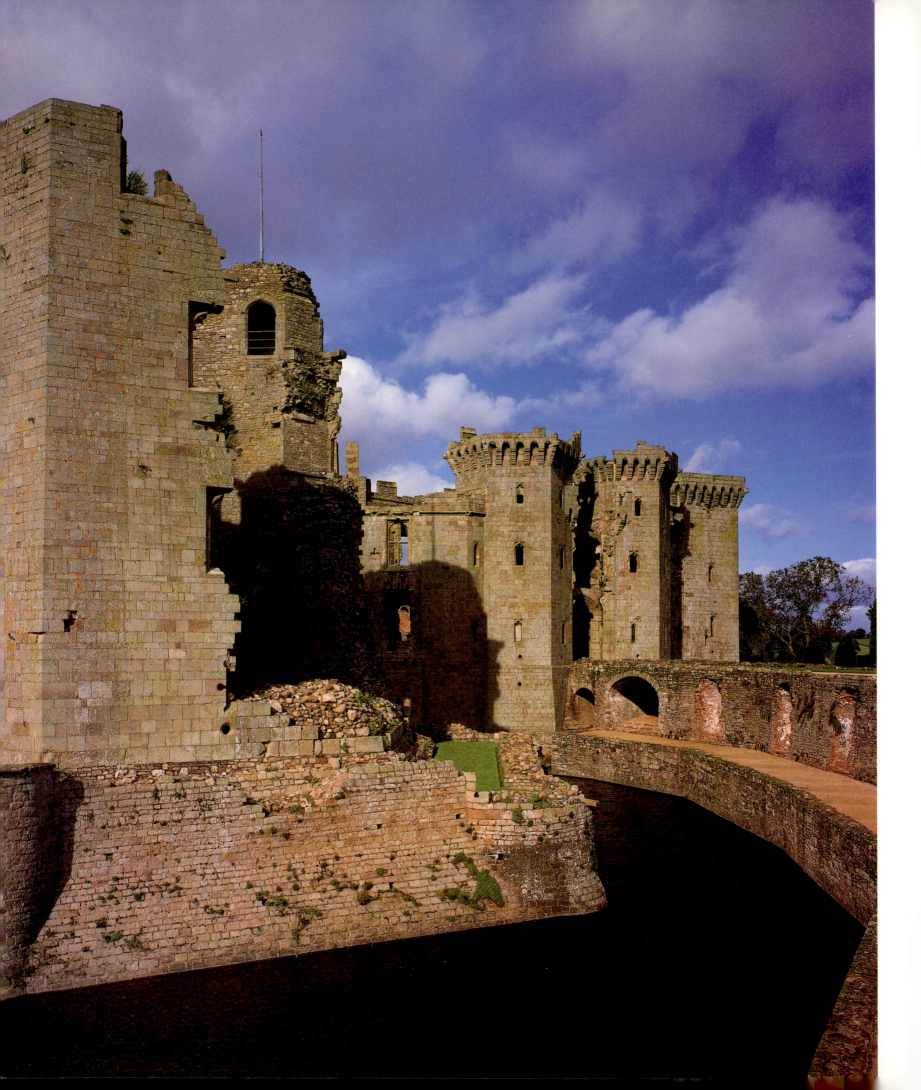

former companions-at-arms. Sir William ap Thomas, builder of Raglan's 'Yellow Tower of Gwent', had fought (like Cromwell) at Agincourt. His free-standing tower keep, influenced by Breton models, is a clear recollection of those times. However, the elaborate French drawbridge with which ap Thomas furnished his tower was already too cumbersome for his son. William Lord Herbert continued to build grandly at Raglan. But he removed his father's timberwork and rebuilt the bridge in stone. Circling the keep with a new apron wall, Herbert obscured ap Thomas' gunloops. The loops he himself provided in Raglan's great gatehouse and its north-west kitchen tower were among the least effective ever built.[73]

William Lord Herbert, briefly earl of Pembroke (1468–9), was a casualty of the Wars of the Roses. After his defeat at Edgecote on 26 July 1469, he was executed at Northampton the next day. That very summer, John Paston was besieged by the duke of Norfolk at Fastolf's Caister – 'St Bartholomew's [24 August] was a cruel day,' recalled Fastolf's former secretary, William Worcestre, 'with guns [fired] at the castle; the siege lasted for 5 weeks and 3 days'.[74] And those were the times again when John Heydon (d.1480), another Norfolk landowner and an enemy of the Pastons, felt so threatened by the malice of his county neighbours that he fortified Baconsthorpe against them.[75] But if fortifications, on such evidence, still retained some value, their principal utility was as a warning. John Gilbert's embattled road-facing facade at Compton Castle, added to his Devonshire manor house as late as 1520, was a record of intent – the contemporary equivalent of a wall-mounted burglar alarm – unsupported by genuine defences.[76] To the same end, the Bedingfelds of Oxburgh (Norfolk) turned their manor house to the road, decking it with false machicolations.[77] Fifteenth-century Cotehele (Cornwall), with its squat but sturdy gatehouse and its high precinct wall, was particularly well equipped to stand a siege. Yet when that gallant Cornishman, Richard Edgcumbe, was brought to bay at Cotehele late in 1483, in the aftermath of Buckingham's rebellion, he thought it more prudent to slip away quietly than to risk making a bonfire of his home.[78]

306. The polygonal tower keep (left) and great gatehouse (right) of the still military mid-fifteenth-century Herbert fortress at Raglan.

307. Built at huge expense in the 1430s, Sir John Fastolf's brick castle at Caister, near the Norfolk coast, was another of the fortified mansions built by re-turned soldiers, enriched by the plunder of France.

308. This fierce show-front at Compton Castle (Devonshire) is an early sixteenth-century addition, antiquarian rather than military in intent.

309. The fifteenth-century gatehouse facade of Sir Richard Edgcumbe's Cornish manor house at Cotehele.

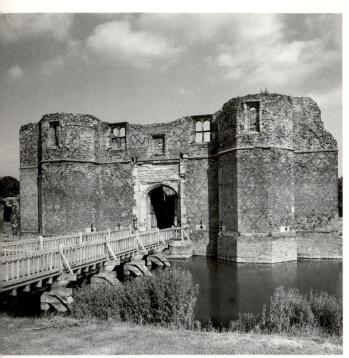

310. The gatehouse at Kirby Muxloe, left unfinished on William Lord Hastings' execution in 1483.

311. Bunratty Castle (Clare) was one of the largest of the individual tower-houses of mid-fifteenth-century Ireland.

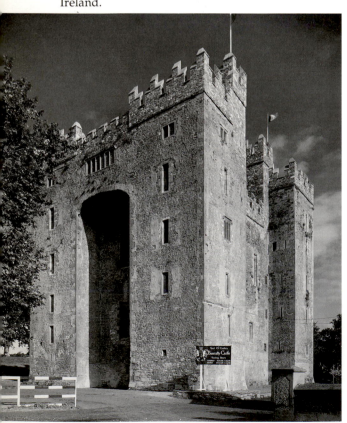

Old habits die hard. William Lord Hastings' new tower-house at Ashby de la Zouch (Leicestershire), built in the 1470s for one of England's most successful politicians, might have been somewhere else entirely – in the Scottish Highlands, perhaps; or in the March; or in Ireland, along the Gaelic rim. It had a portcullis at the entrance (raised from the lord's kitchen), a windowless basement, and a water supply all of its own.[79] At Kirby Muxloe, next to Leicester, it was Hastings again who commissioned a new mansion to replace his family home, which would have been the nearest English equivalent, had it ever been completed, to a private artillery fortress like Rambures.[80] However, the surviving building accounts of Kirby Muxloe, interrupted by Hastings' execution on 14 June 1483 and ceasing altogether shortly afterwards, make one particularly significant omission. Kirby is never called a castle (*castrum*) in these accounts; it is a manor (*manerium*) or a place (*placea*).[81]

Kirby Muxloe, like the Hastings Tower at Ashby, was always more a celebration than an insurance. Before Richard of Gloucester's protectorship in the spring of 1483, Hastings had nothing to fear. He had been the loyal friend and counsellor of Edward IV (d. 9 April 1483); a commander at Barnet in 1471, when Edward had won back his throne; and a principal negotiator of the Treaty of Picquigny in 1475, which ended the Hundred Years War. He was a pensioner of two crowns, of England and of France, and was among his generation's richest men. These honours put their mark on Hastings' buildings. At Ashby, expensive panelled tracery enriched the Hastings Tower; there were ornamental angle-turrets and deep machicolations, carved window-heads and great display of heraldry. Kirby Muxloe, too, had a rare and handsome symmetry, exceptional in English building as early as the 1480s, and undoubtedly intended to be admired. Anthony 'Docheman' made Kirby's bricks, just as Baldwin, his countryman, had made Tattershall's. There were other obvious links between the buildings. John Cowper, Hastings' master mason at Kirby, had earlier learnt his trade at Cromwell's Tattershall. Both castles made display their first priority. Of the many circular gunports which pierced Kirby's facade, the majority were both decorative and 'well arranged'.[82] But some, required for balance, were less well placed. Opening on to opposite faces of Hastings' towers, they gave his fortress the capacity to self-destruct.[83]

Contradictions of this kind, which can hardly have passed unnoticed, raise doubts about the purpose of Hastings' building. True, there were still genuine fortresses in fifteenth-century Britain – the Stewarts' Edinburgh and Stirling, in central Scotland; Ireland's Blarney and Bunratty, Askeaton and the multi-towered Cahir. But English castles were not generally among them. Last of the private castles to be raised in England was Edward Stafford, duke of Buckingham's Thornbury, in western Gloucestershire. And Thornbury, for all the duke's ambitions and his predilection for private armies, was really just a palace in martial dress. Like Kirby, Thornbury was never finished. On 17 May 1521, Duke Edward's execution brought a halt to it. No other great nobleman, in Tudor or later England, ever presumed to build like Buckingham again. However, there is little to show that even Duke Edward saw Thornbury primarily as a stronghold. He was not of the court circle which, under the influence of Cardinal Wolsey and of the king himself, experimented with architecture as with a toy. Buckingham's preferred reading, in his less serious moments, was tales of chivalry and of heroic derring-do.[84] Nevertheless, he did have works on architecture among the books in his collection, and the complex full-height bays of Thornbury's privy-garden front were among the most 'curious' and displayful ever built. Over the inner gate at Thornbury, half-finished on Buckingham's death, another such oriel was intended. Below was the portcullis, the gunports and crosslet loopholes; above, a geometric oriel like the big trefoiled bay over the entrance of Sir Thomas Kytson's Hengrave Hall. Duke Edward in Gloucestershire, smouldering in the

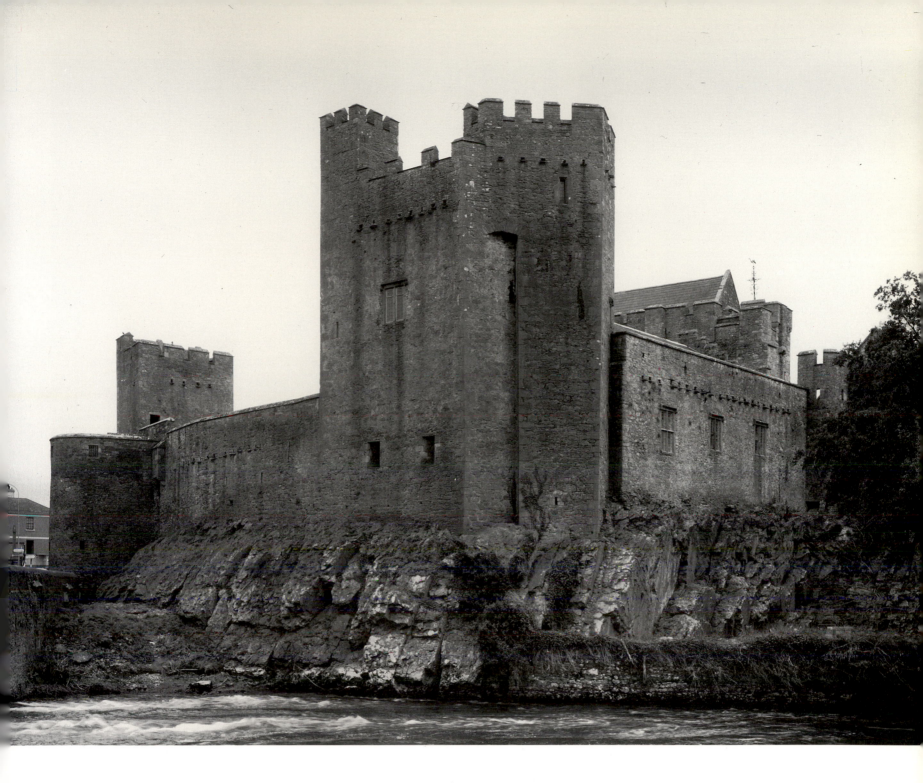

312. This assemblage of fifteenth-century tower-houses at Cahir, in Kilkenny, still makes a formidable fortress.

West, was hardly more aggressive in the buildings he proposed, than a London merchant in the Suffolk mansion of his retirement.[85]

Buckingham's strength was his huge personal following in the South-West. It was his downfall also, for Henry VIII never forgot the second duke's rebellion against Richard III, and always anticipated a repeat. Duke Edward did little to disabuse him. Although less numerous than the retinues of Duke Humphrey (d.1460) and Duke Henry (d.1483), Duke Edward's permanent following, in the year of his execution, totalled 148 – or half as many again as the already large retinue with which Ralph Lord Cromwell had surrounded himself at his 'manor-place' at Wingfield.[86] All had to be accommodated at Thornbury Castle, for the most part in the lodgings of the great outer court which was as extensive and well provided as the Green Court at Eltham, rebuilt for Henry VII. That other requirement of a magnate's public life-style, the big common hall, has survived

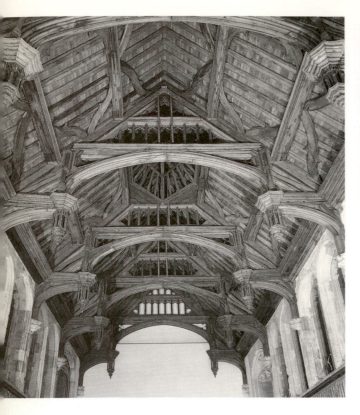

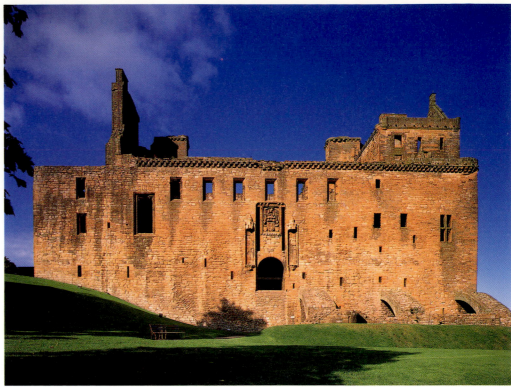

313. The great hammerbeam roof of Edward IV's hall at Eltham Palace, in south London.

314. James I's great hall of chivalry at Linlithgow ran almost the entire length of the east range of his palace, at first-floor level over the gate.

316. (right) Sir Thomas Burgh's timber-framed hall, in his town-house at Gainsborough, may predate the fire of 1470, after which the kitchen (beyond the triple service doors at the far end) was rebuilt in brick.

315. A big bay window (centre) lit Burgh's high table at Gainsborough; the octagonal corner tower (left) was a post-1470 addition to his private apartments.

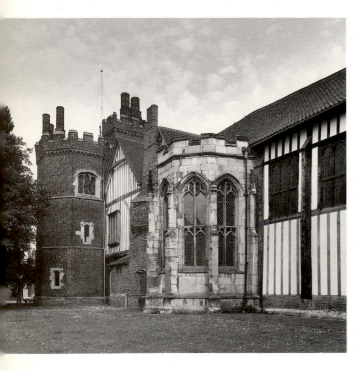

at Eltham Palace, with a Scottish equivalent at Linlithgow. Eltham's hall, finished in 1480, was the work of Edward IV. It was of brick, faced with ashlars; it had a line of big windows along its whole length, with a tall full-height bay at the dais end; its great hammerbeam roof, expensively moulded, was a masterpiece of contemporary carpentry.[87]

Eltham lacks its lodgings; Thornbury, its hall; neither has kept its great kitchen. Yet each of these has been preserved at Gainsborough Old Hall, the new urban mansion of a successful royal servant and enduring Lincolnshire politician, who built it to celebrate his ascent. Sir Thomas Burgh (d.1496) was a household official of Edward IV and a leading Yorkist. Knighted first by Edward IV in 1462, he was made a Garter knight by Richard III for his part in the suppression of Buckingham's rebellion in 1483, then raised to the peerage in 1487, shortly after Henry VII's usurpation.[88] Only the gatehouse range at Gainsborough is now missing. What remains is the essential accommodation of a building of its class – the great hall and kitchen, complete with service rooms; the lord's east solar range, with personal tower attached; and the west range (across the court) of household lodgings. Burgh's common hall, with a stone bay at the dais end, is a very grand apartment. But the most unusual feature of Burgh's great house is the kitchen he built to feed his household. Late-medieval kitchens are themselves no great rarity. They have survived at Haddon and Raby, at Stanton Harcourt (plate 252) and Canford, at South Wingfield and Ashby de la Zouch. But whereas the kitchen at Haddon is more authentically furnished, and the others all have special features of their own, only Gainsborough's kitchen preserves its staff quarters – three small chambers in the corners of the kitchen, each with its sleeping space above. Over the adjoining buttery, between the kitchen and the hall, another two big chambers may also have been assigned to household servants.[89]

Burgh's hall is timber-framed. It is the earliest part of his manor house, and probably predates a violent incident of 1470, when Lancastrians put a torch to the rest. Everything else is of brick, including the kitchen and an octagonal tower at the north-east corner of Burgh's solar, which carried an additional three

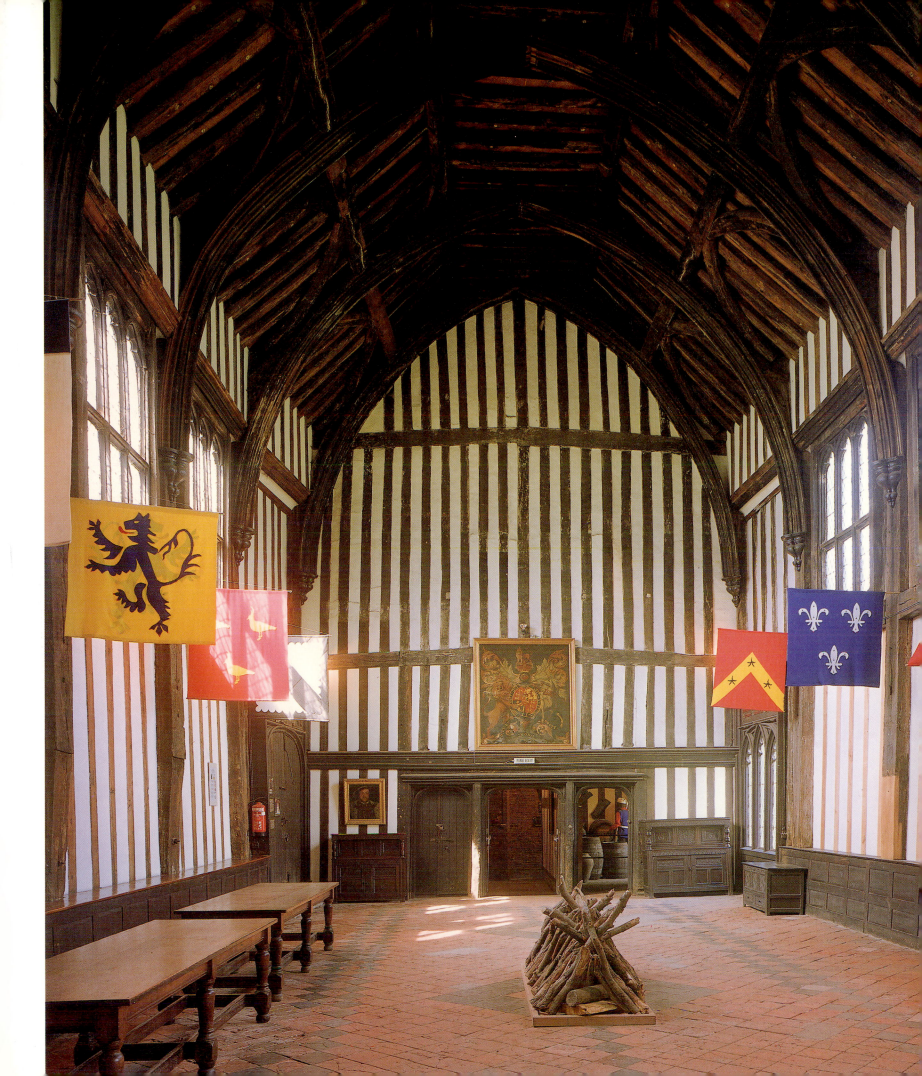

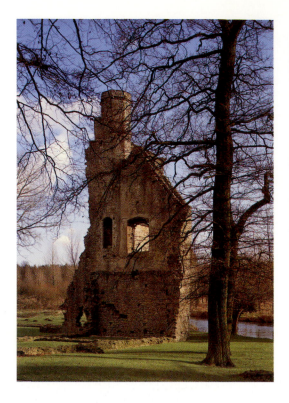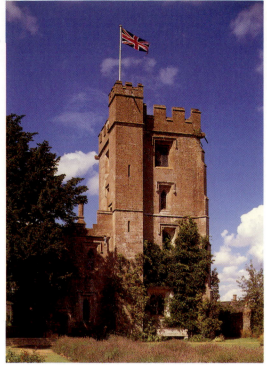

317. Lord Lovell's viewpoint tower at Minster Lovell rises behind the gable of the west range of his manor house, to which it was added in the late fifteenth century.

318. The viewpoint tower at Stanton Harcourt, built for Sir Robert Harcourt in the 1460s, had a particularly handsome chamber at the top, under the crenellated parapet, with a big private chapel at ground level.

319. Sir John Croft's brick gatehouse at West Stow Hall (Suffolk) was built in the 1520s.

320. In the great hall of John Norreys' mid-fifteenth-century Berkshire manor house at Ockwells, the contemporary heraldic glass (right) established Sir John's Lancastrian connections.

apartments. The tower was strongly built. It was embattled as though for the wars. But its machicolations were false, like those of Oxburgh; its spiral stair was left-handed, of little value in defence; its chambers each had fireplaces and private garderobes.[90] Other contemporary residential towers survive at Oxfordshire's Minster Lovell and Stanton Harcourt. Minster's tower, probably built for Francis Lord Lovell (d.1487), was sited attractively by the river. It was of four storeys, of which the upper two made a single apartment, reached by its own private stair. A big oriel window, lighting the topmost chamber, faced south across the river towards the view.[91] Sir Robert Harcourt's tower at Stanton Harcourt was finished off with another such viewpoint. Built in the 1460s, Harcourt's tower had a private chapel on the ground floor and three storeys of chambers above.[92]

Stanton Harcourt, which has kept a substantial part of its embattled precinct wall, still has a fortified appearance. But Sir Robert's tower, like the great brick tower-house of the bishops of Lincoln at Buckden Palace, adjoins an earlier church tower. And both tower and precinct wall, at each of these houses, were there chiefly to make points about status. Bishop Thomas Rotherham, who began Buckden's rebuilding before his elevation to the archbishopric of York in 1480, was chancellor of England under Edward IV. Like his colleague William Lord Hastings at Kirby Muxloe and Ashby de la Zouch, Rotherham got pleasure and fulfilment out of building. Buckden's great tower was probably modelled on Cromwell's tower at Tattershall, also an inspiration for Hastings' Kirby Muxloe.[93] All three buildings were of brick, chosen for its warmth and for its 'sumptuous' effects, as at Caister and Herstmonceux, Rye and Gainsborough, or at Sir William Oldhall's costly mansion at Hunsdon (Hertfordshire), probably the grandest of them all.[94] Brick continued a firm favourite with the great and the good – Prior Overton at Repton, Bishop Waynflete at Farnham, Archdeacon Pykenham at Hadleigh, Cardinal Morton at Hatfield, Margaret Pole at Warblington, Henry Lord Marney at Layer Marney, Sir John Cutte at Horham, Sir Henry Fermor at East Barsham, Sir John Crofts at West Stow, Sir John Russell at Chenies, Sir William Compton at Compton Wynyates, the Bedingfelds at Oxburgh, the Norths at Kirtling, the Tollemaches at Helmingham, and the Mannocks at

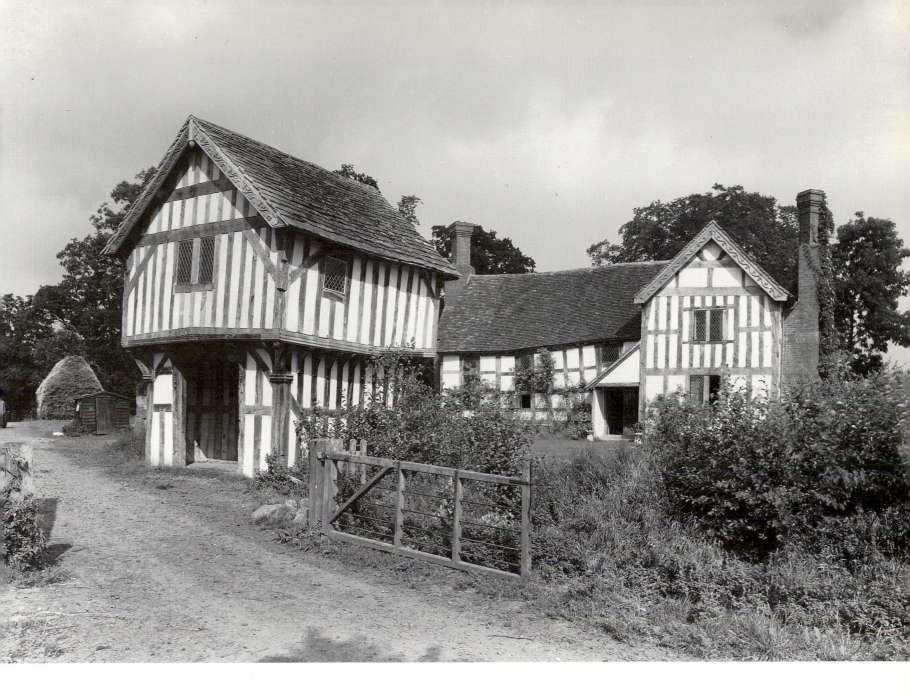

321. At Lower Brockhampton, a fifteenth-century gatehouse (left) spans an earlier moat, making a formal entry to the Rowdens' manor house.

Giffords Hall – who combined spectacle with convenience in their dwellings.

Many of these houses had nominal fortifications – a gatehouse, a moat, or a strong tower. But the East Barsham gatehouse, the Oxburgh moat, and the Compton Wynyates tower were markers only, helping to define private space. At comfortable fifteenth-century manor houses like Ockwells (Berkshire) and Lower Brockhampton (Herefordshire), the chambered-over gatehouses which framed their formal entries had as much defensive logic as churchyard lych-gates. This downgrading of defences was not simply a reflection of lower status. True, the Rowdens of Lower Brockhampton were a local farming family, of no higher account than lesser gentry.[95] But Ockwells was the purpose-built home of an important man, Sir John Norreys (d.1466), whose other house at Yattendon, further west in the same county, had been embattled in 1448. Norreys left Ockwells almost entirely unprotected – a prodigious display of expensive timber-framing, of glass and of brickwork: the best that money could buy.[96]

Norreys was a successful household official, promoted master of the wardrobe to Henry VI in 1447. Ockwells, his new manor house, was next to Windsor, and Norreys clearly built it to entertain friends from Court and as a base for his political ambitions. He furnished it centrally with a big common hall, lit by a

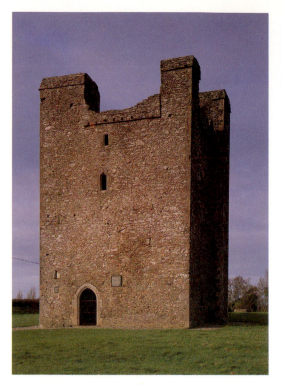
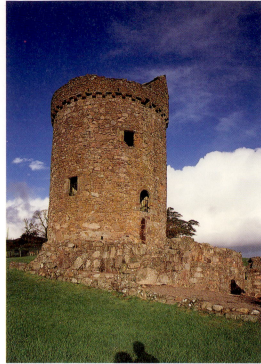
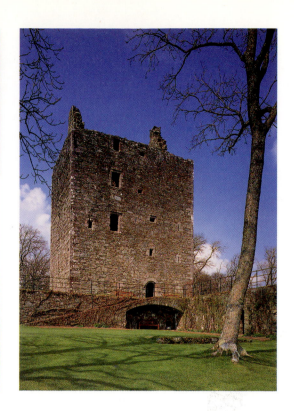

322. The tower at Roodstown (Louth) was one of many such tower-houses in fifteenth-century Ireland, usually accompanied by a fortified enclosure, or bawn. It had a hall on the first floor, over a store, and bedchambers on the two floors above. A circular stair, left of the entrance, rose the full height of the building.

323. Orchardton, in Kirkcudbright, is a rare example of a circular tower-house, again of four storeys, thought to have been built in the mid-fifteenth century by John Carnys, the laird.

324. Nothing on the outside of the late fifteenth-century tower-house at Cardoness gives any indication of the range and comfort of the apartments within.

325. A big fireplace, carved buffet and wall-cupboards in the hall of the McCullochs' tower at Cardoness.

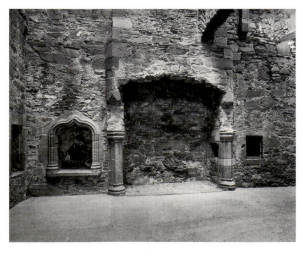

great spread of windows. In those windows, most exceptionally, the original heraldic glass has been preserved, flattering to both Norreys and his guests. With the master of the wardrobe's distaff badge and his motto 'Feythfully Serve', are the arms of Henry VI and of Margaret of Anjou, together with those – Beauchamp and Beaufort, de la Pole and Butler, Wenlock, Bulstrode and Lacon – of former colleagues and Lancastrian adherents.[97]

There is nothing reticent about Ockwells. This big undefended manor house of late-medieval England is as plain a declaration of the rank and affluence of its builder as any contemporary Marcher tower-house. The two are not as far apart as they appear. At first glance, the McCullochs of Cardoness Castle (Kirkcudbright), the Audleys of Audley's Castle (Down), and the Heskeths of Rufford Hall (Lancashire), might seem to have had little in common. Their houses certainly look very different. But they were all of gentry status, and all required the same standard elements of family accommodation, whether stacked on different levels or on the flat. In Ulster, Audley's Castle was the smallest of these buildings: a simple gentleman's tower-house, with a hall on the first floor and chamber above, each with its garderobe attached. Next to the tower was a walled enclosure – a bawn – which held the stables, stores and workshops of the farm.[98]

Audley's Castle is representative of a whole class of Irish tower-houses, of which in the Late Middle Ages there were many hundreds. A number of these towers, among them Roodstown (Louth) and the elegant Ballynahow (Tipperary), had at least one further storey of private chambers. A few, including Cormac MacCarthy's Blarney Castle (Cork) and Macon Macnamara's Bunratty Castle (Clare), were multi-chambered and of complex design.[99] In contemporary Scotland, this sophistication was again present at towers like Orchardton or Cardoness, in Kirkcudbright. Built in the late fifteenth century, when there was still danger of English seaborne raids across the Solway Firth, Cardoness' outer face was forbiddingly plain and austere. Yet the tower was comfortably furnished internally with window seats and wall-cupboards, with fireplaces at all levels, with garderobes, and with an elegant newel stair. On six storeys, starting with basement and entresol, Cardoness' principal apartments – its hall and its great chamber – were on the second and third floors respectively. Each of these rooms

was provided with a stately sidewall fireplace. Over these again, there were two additional levels of family bedchambers, one of them a sixth-floor attic.[100]

In 1498, a Spanish ambassador remarked of Scotland that 'the houses are good, all built of hewn stone and provided with excellent doors, glass windows, and a great number of chimneys'.[101] The comment is unexpected in a visitor from the South, but what he said was not far short of the truth. While both the Scots and the Irish remained conservatively attached to tower-building – in some cases, long after such precautions were strictly necessary – they saw no reason to go without modern comforts. Abundant mural fireplaces were among the most frequent of these improvements. At Cardoness, even the attic floor had its fireplace in the gable wall. A still grander tower at Borthwick (Midlothian), built for Sir William Borthwick in the 1430s, had at least twelve mural fireplaces to heat its many chambers, necessitating the provision of six chimney-stacks. [102] In Borthwick's second-floor hall – 'the grandest medieval hall in Scotland' – the great chimney-hood is especially memorable. It is the Scottish equivalent, along with the carved stone buffet for the display of family plate (also found at Borthwick), of the fancy timberwork of an English hall like Rufford.

Built for the Heskeths of North Lancashire in the second half of the fifteenth century, Rufford abandons every customary restraint. It is a carpenter's fantasy, in which the most eye-catching of the surviving furnishings is a great movable screen at the hall's service end, carved with uninhibited exuberance. The Heskeths' screen is over the top: typically *nouveau riche* and wholly tasteless. Nevertheless, it was essential equipment of an apartment of this kind, the representative furnishings of which are listed in full in a contemporary Latin–English vocabulary. With other vocabulary lists of house and farm equipment – the contents of chamber and kitchen, bakehouse, brewhouse, and farmyard buildings – schoolboys learnt the Latin names of the everyday furnishings with which they were familiar in the hall (*Nomina instrumentorum aule*): 'a board, a trestle, a bench cover, a dorsal [chair-back cover], a mat, a table dormant [permanent], a basin, a wash-basin, a fire, a hearth, a brand, a yule-log, an andiron, a long settle, a chair, a pair of tongs, a bench, a stool, a cushion, wood for the fire, a pair of bellows, a screen'.[103]

Rufford had all of these, and much more. It had the tall bay window – 'with double storey clear lights and embattled' – specified in building contracts of the day.[104] It had a hammerbeam roof, lavishly carved and as grand as the hall roof at Weare Giffard (North Devon) or of the abbot's new hall at Milton (Dorset).[105] Abbot Middleton's hall at Milton had its carved screen also. But though movable, it was more architectural than Rufford's and less flamboyant, there being a better match locally in the screen at Samlesbury, another North Lancashire manor house.[106] On both the Rufford and the Samlesbury screens, the decoration is of a lushness characteristic of the North, found again on the choir-stalls at Carlisle.[107] And there is another parallel with church furnishings in the dais canopy at Rufford – like a canopy of honour above a rood screen. Seldom seen in the South, dais canopies occur relatively frequently in northern halls, even at those of comparatively low status. There was one, for example, at the very grand Ordsall Hall (Salford), in South Lancashire. But others which survive (or have left traces) include Horbury Hall and Lees Hall, Bolton Hall, White Hall and Woodhouse Farm, each a West Yorkshire farmhouse of lesser gentry.[108]

At Lees Hall, the dais canopy is especially well preserved.[109] Rufford's canopy is similarly intact. But both have lost the heraldry with which they were probably once painted, and which survives today only at Cheshire's Adlington. The Leghs of Adlington were an old-established Cheshire family, prominent in the government of their county. They married well, having an earl and an archbishop among their kin. And when, in the early sixteenth century, Thomas Legh (d.1519) built his new hall, every prize must have seemed within his grasp. His apartment

was appropriately magnificent. It was nearly as tall as it was long; its roof was of hammerbeams, richly carved and embattled; its spere-truss – a pair of stout posts supporting a single tie-beam at the service end of the hall – and screen (now lost) were as splendid. At the squire's dais end, a five-tiered heraldic canopy is datable by inscription to 1505, although the painted arms of its many panels are Elizabethan.[110]

Such egregious displays of heraldry, especially prominent in the hall, were characteristic of both the fifteenth and the sixteenth centuries. But it was not just the armigerous classes who built halls. Neither the Nettletons of Lees Hall (Yorkshire) nor the Rowdens of Lower Brockhampton (Herefordshire) had any initial claim to aristocracy. In just the same way, there were many successful farming families in the Welsh border counties, with easy access to English markets, whose policy of land purchase at every opportunity raised them insensibly into the gentry. 'He who buys land with good privilege, becomes a gentleman in his district', observed Lewys Glyn Cothi to the constable of New Radnor; 'he who sells land alongside the houses soon fails.'[111]

There were opportunities in plenty, in fifteenth-century Wales, for just this sort of gentry advancement. The builders of the fine halls of north-east Wales were office-holders for the most part – agents of great absentee landowners. They knew something of the world of the aristocrats they represented, and were well placed to take advantage of the local land-market.[112] Wales is no country of introverted tower-houses. Even in the long shadow of Owain Glyn Dwr's rebellion, such fortifications were practically unknown. Instead, what developed was a characteristically spacious but open and undefended farmhouse, remarkable for the quality of its carpentry. Three architectural pointers to the gentry life-style – the dais canopy, the aisle-truss (or spere-truss), and the hammerbeam roof – concentrate in the rich Marcher counties.[113] They occur in well-built halls, open to the roof, usually of two bays or more. Conservative farmhouses of this kind, unlike the Scottish tower-house, could do without the luxury of sidewall fireplaces. The open hearth was still the focus of hospitality. At Pennarth Fawr, in south Caprnarron, a central hearth was retained – and the roof filled with smoke – until as late as the early sixteenth century. But Madog ap Howel ap Madog's fine new hall, built in the 1450s, was not without assertions of social status. The carved and moulded spere-truss had no structural function in Madog's building. It framed a movable screen, and was there, like the dais canopy, for added grandeur.[114]

Pennarth Fawr was not a large building. However, it repeated almost exactly the characteristics of such greater Welsh halls as William Gruffydd's Cochwillan, built for Caernarvonshire's high sheriff, or Plas Cadwgan and Plasnewydd, both in Denbigh.[115] This same retention of the hall, appropriately scaled down, was just as true of English farmhouses of the period. There are particularly well-known clusters of yeoman houses of superior quality in the Pennine Calder Valley and the Kentish Weald. The 'Pennine Aisled Hall' and the 'Wealden Open-Hall House' were the best of the house-types developed in those regions, and both were of a very high standard.[116] However, improvements were more general than this. From the 1350s, in the wake of the Black Death, land-holding and agricultural production had taken a new direction, concentrating in fewer and better capitalized units. The peasant consolidators of vacant plots at Leighton Buzzard or Halesowen, at Barcheston, at Goldicote or Stoke Fleming, were men of growing substance and self-esteem.[117] Such men ate better than they had ever eaten before; they dressed with more care; they invested, routinely, in bigger houses.[118] Some, like the iron-masters of Kent Water (Cowden) or the clothiers of the Upper Calder Valley, were as wealthy as the gentry and lived as comfortably. But they were yeomen still, and the differences meant less all the time.[119] What

326. The Heskeths' timber-framed hall at Rufford, in North Lancashire, dates to the second half of the fifteenth century. At the lower end of the hall, a highly carved movable screen partly blocks off the service passage.

327. The rich hammerbeam roof of the hall at Weare Giffard is datable to the late fifteenth century.

328. The Little House, fronting on the market square at Lavenham, is typical of good-quality burgess housing of the late fifteenth century, with a full-height hall between chamber blocks.

329. At Singleton's Weald and Downland Open Air Museum, this fifteenth-century Wealden house from Chiddingstone (Kent) has been re-erected and fully restored. As in other houses of its type, a central hall (open to the roof) separates two chamber blocks, of which the nearest is an addition of c.1500.

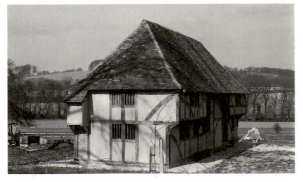

both classes required was more accommodation, characteristically obtained by multiplying private chambers while keeping the hall in between. In every region, the answer was the H-plan house of two equal-sized cross-wings, closing each end of the hall. One such house was Woodsome Hall, in Farnley Tyas (West Yorkshire), built in the early sixteenth century for the Kayes. In Arthur Kaye's time, there were already three family parlours in Woodsome's cross-wings – the Low Parlour, the Dining Parlour, and the Upper Parlour. After John Kaye succeeded his father in 1574, he added another two chambers, partitioning his former chapel 'for lakk of Rowme'.[120]

John Kaye's improvements at Woodsome were made at a time when the open hall was increasingly vulnerable. Many halls of his period were divided and floored over – a chamber above, and a hall below – when new chimneys and framed staircases were inserted. However, for hundreds of years until just the previous generation, the open hall had remained the centre of most households. It had come in all varieties and sizes. At the top of the range, among Wealden houses, there was both the single-bay hall of the Old Shop at Bignor and the more usual two-bay halls of Synyards at Otham, of the Parsonage at Headcorn, of the Pilgrims' Rest at Battle, of Old Bell Farm at Harrietsham, or of Bayleaf at

Chiddingstone (now dismantled and re-erected at Singleton).[121] Elsewhere, open halls featured in much humbler dwellings – in the cruck-built cottages of the South Midlands and Surrey–Hampshire border; behind each of the twenty-four shops of a speculative terrace at Tewkesbury; in the box-frames of Herefordshire and Shropshire.[122] Few of these smaller hall-houses were gentry built. They were the dwellings of yeomen and of small-town burgesses, grown prosperous on the back of the pestilence.

There is an opulence in the domestic architecture of post-plague England which is hard to reconcile with current theories of economic collapse. As one historian (who believes in that collapse) has recently observed: 'If buildings alone provided evidence for the changing fortunes of the inhabitants of fifteenth-century towns, we would have to conclude that they were passing through a period of unparalleled prosperity.'[123] But buildings are *not* the only evidence, as of course he knew, and the story of consumer preferences is much more complicated. Late fifteenth-century Coventry, it has been argued, was in deepening recession: 'desolate' as never before. Yet its burgesses could still find new money for their great gildhall and parish churches, while the extraordinarily lavish timberwork of the early sixteenth-century Ford's Hospital is among the most

330. The *Angel and Royal* at Grantham still preserves its late fifteenth-century stone facade.

331. Jettied upper floors were added to the *George* (Norton St Philip) in *c*.1500 to improve the accommodation at this big late fourteenth-century village inn.

332. At Glastonbury, the *George and Pilgrims* owes its expensive stone panelling to Abbot Selwood (1456–93).

spectacular in the land.[124] There is good-quality housing at Coventry too, now assembled in the terraces of Spon Street. And each of these Spon Street dwellings – even the humblest – came furnished with its hall and private parlour.[125] Some predate the crisis. But together they testify to a rise in expectations from which there was no turning back.

Coventry was not alone in its troubles.[126] All provincial centres were losing ground to London, especially in the luxury trades. And even the smaller markets, in late-medieval England, were meeting fresh competition from the inns.[127] Among those who benefited from the new trading conditions was a Londoner, Thomas Walle, who came back to his native Grundisburgh in the evening of his life, to rest in the fellowship of his kin. Walle's London house has gone, and there is not much today – an over-restored terrace at Staple Inn (High Holborn) and the finely carved facade of Sir Paul Pindar's house of *c*.1600, now in the collections of the Victoria & Albert Museum – to suggest what it might have been like. However, what Walle built himself in rural Suffolk in the 1520s was a house which looks designed for a tiny urban plot: the sort of place in which a townsman could be happy. Jettied on two levels, Walle's house stands brave and tall in its big surrounding garden, rising naked from the ground like a spear of asparagus or the summer bloom of a single Jersey lily.[128]

Walle was a rich salter. Both his house at Grundisburgh and the adjoining parish church – which he also rebuilt in the 1520s – carry his salt-cellar emblem. Other commercial people who did well in his period were the innkeepers – the hosts of the *Angel and Royal* at Grantham and the *George and Pilgrims* at Glastonbury, of the *New Inn* at Gloucester and the *George* at Winchcombe, of the *Round House* at Evesham and the *George* at Norton St Philip.[129] Each of these great inns, during Thomas Walle's lifetime, was extensively improved and rebuilt. Yet only one of these establishments was in a major provincial centre, and Norton St Philip,

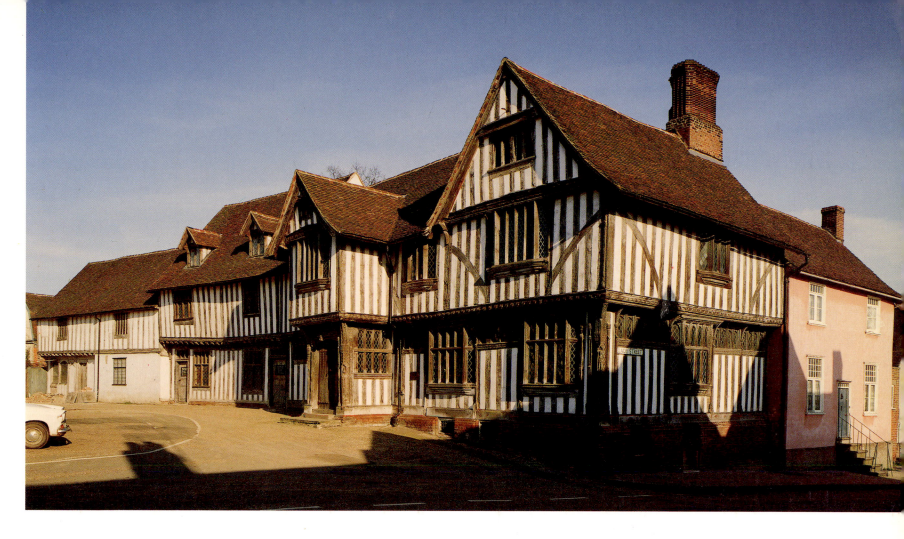

although the long-term venue of an ancient fair, can at no time have been more than a big village.[130]

By and large, it is the continuing vitality of the medium-sized market towns, of the lesser manufacturing centres, and of the bigger English villages, which principally supports another view of the Late Middle Ages as 'a period of spaciousness and promise in the history of England's provincial towns' – the very opposite of general decline.[131] However, that spaciousness, though present, was often plague-induced. And the promise was never universal. Against the comfort and prosperity of a little manufacturing town like Thaxted (Essex), must be set the slow and irreversible descent of an ancient city like Winchester – 'in a manifestly decayed condition [in the early sixteenth century] and perhaps a third the size it had been four hundred years before'.[132] But there is no doubting Thaxted's success. Its cutlers' knives and shears paid, in the fifteenth century, for the fine new gildhall at the top of the broad market street. Continuing profits in that trade assisted the rebuilding of Thaxted's outsize parish church, and enabled individual gildsmen to furnish their houses with elaborate timber overhangs and swagger oriels.[133]

In Essex again, Paycocke's House at Coggeshall is probably the best known of all late-medieval English townhouses. Purpose-built in c.1500 for a family of wealthy clothiers, graziers and butchers, Paycocke's is a very modern building. It has already lost the medieval full-height hall, floored over to provide an upper parlour. Externally its facade, though still richly displayful, is distinguished by a new and careful symmetry.[134] Other late-medieval merchant houses – the De Vere House at Lavenham and the Porch House at Potterne – are as ornate as Paycocke's. And there are many simpler buildings – including the Corner Shop at Ludlow, the houses and shops of Butcher Row in Shrewsbury, and the misnamed 'King John's Hunting Lodge' at Axbridge – which are at least as

333. Lavenham's Corpus Christi Gildhall dates to the 1520s, when the clothiers of this little Suffolk town were still prosperous.

334. The Cutlers' Gildhall at Thaxted was built in the late fifteenth century, as were the three adjoining timber-framed houses (right) on the lane leading up to the parish church.

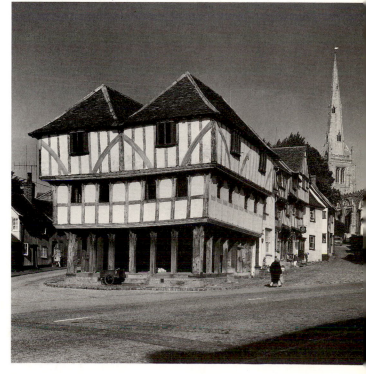

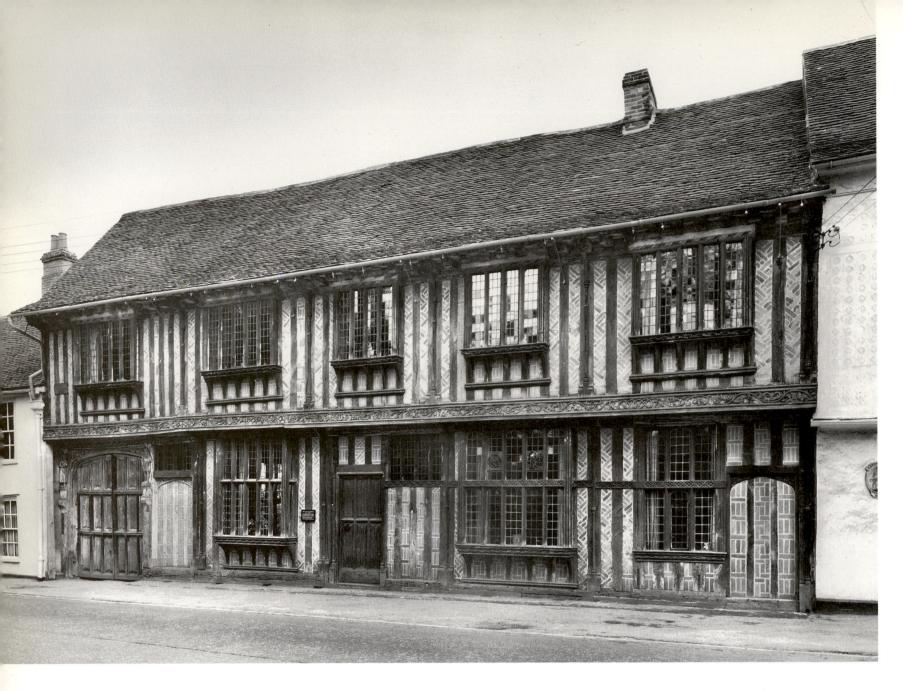

335. Paycocke's House, in Coggeshall, was built in c.1500, with exceptional display, for a wealthy local family of grazier-butchers.

comfortable internally, room for room.[135] Yet none have the grace of Paycocke's oriel-hung facade, nor look forward with such assurance to the future.

For England's wealth-producers like the Paycocke clothiers of Coggeshall, that future was brightening daily. We know of other Essex villages, among them those in Havering, which prospered hugely from the settlement of rich Londoners.[136] And while there were always successful entrepreneurs still able to make their way at the older provincial centres – at Exeter, at King's Lynn, or at Norwich[137] – many more now spread out thinly through the better farming lands, and through regions already famous for their cloth. Such men, in Tudor England, had learnt to live their lives in surroundings of great comfort and high quality. 'Not long ago', reported that 'admirable sweet scholar', the Dutchman Levinus Lemnius,

travelling into that flourishing Island, partly to see the fashions of that wealthy Country, with men of fame and worthiness so bruited and renowned, and partly to visit William Lemnius, in whose company and well-doing I greatly rejoice (as a father cannot but do) . . . I saw and noted many things able to ravish and allure any man in the world, with desire to travel and see that so noble a country. . . . [There] every Gentleman and other worthy person showed unto

266

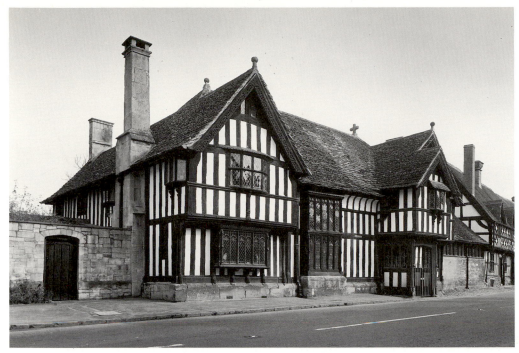

336. The Porch House at Potterne (Wiltshire) is a big late fifteenth-century merchant house, with a central full-height hall.

337. Smallhythe Place (Kent) is one of the many comfortable houses of Early Tudor England which continue to be cherished even now.

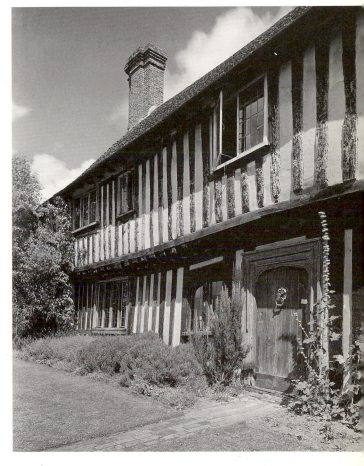

me (being a stranger born and one that had never been there before) all points of most friendly courtesy; and taking me first by the hand, lovingly embraced and bade me right heartily welcome. . . . And besides this, the neat cleanliness, the exquisite fineness, the pleasant and delightful furniture in every point for household, wonderfully rejoiced me; their chambers and parlours strewn over with sweet herbs refreshed me; their nosegays finely intermingled with sundry sorts of fragrant flowers in their bedchambers and privy rooms, with comfortable smell cheered me up and entirely delighted all my senses.[138]

Lemnius wrote in 1561, and there were other things – 'touching their populous and great haunted cities, the fruitfulness of their ground and soil, their lively springs and mighty rivers, their great herds and flocks of cattle, their mysteries and art of weaving and clothmaking, their skilfulness in shooting' – about which, regrettably, the old physician found it 'needless here to discourse'. However, anybody today who penetrates the English countryside – who goes to Pembridge, Ledbury or Weobley (Herefordshire), to Clare, Kersey, Hadleigh or Long Melford (Suffolk), to Burford (Oxfordshire), to Saffron Walden (Essex), to Lacock (Wiltshire), or to Henley-in-Arden (Warwickshire) – will have no difficulty in seeking what he meant. At each of these small havens there are men and women now, living like their predecessors in the late-medieval houses which still afford them such continuous satisfaction.

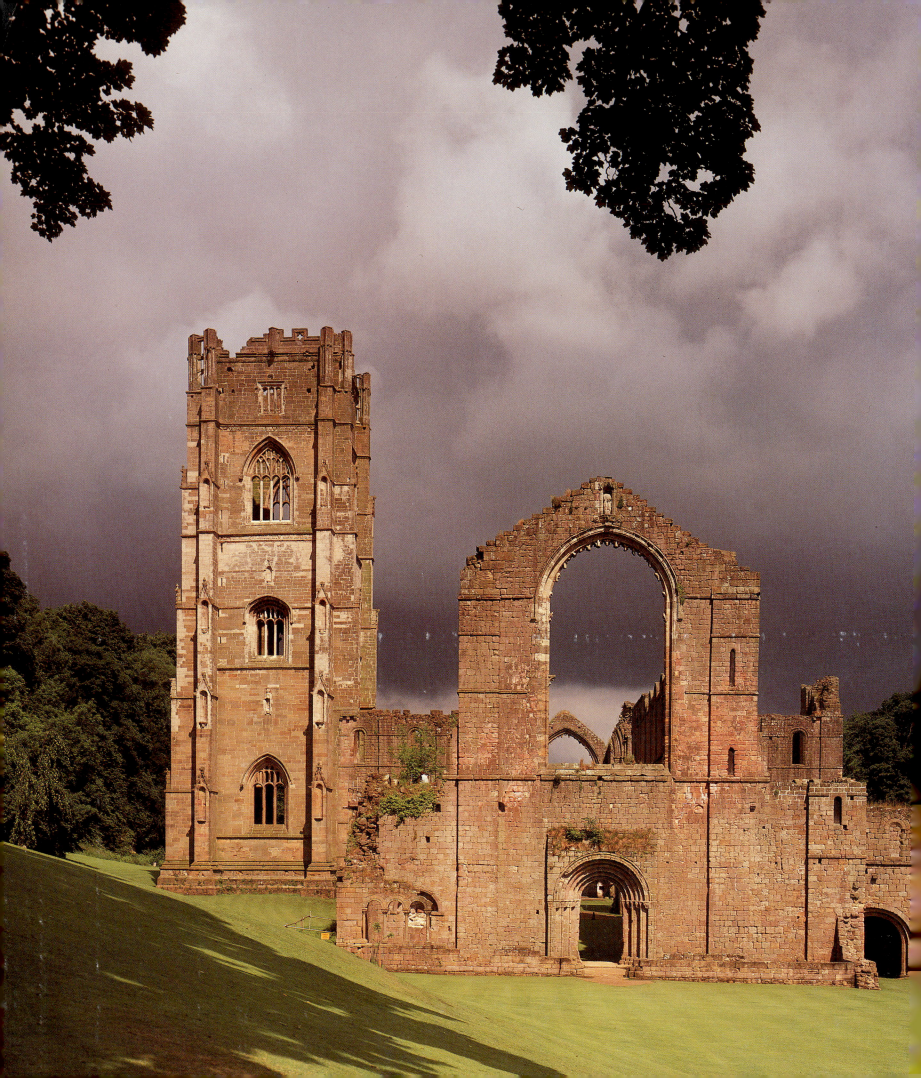

CHAPTER 9
An Habitation of Dragons and a Court for Owls

It may be that full recovery in late fifteenth-century England remained, for the great majority, an illusion. Not everybody moved forward with the ruthless speed of the enclosing Spencers of Althorp, or had the luck of the coal-owning Willoughbys of Wollaton.[1] Indeed, the revival of those years probably looked more complete – even to those who lived with it – than it really was, exaggerated by recent catastrophes. Widespread murrains of sheep and cattle had caused serious hardship throughout the 1430s. Then, at the mid-century, England's wool sales on the Continent had collapsed. The murrain went away, and the market eventually recovered. Nevertheless, receipts on many manors were no higher in 1500 – and were often much less – than they had been at the beginning of the century.[2] Furthermore, the major population recovery which alone could provide a solution for Britain's economic ills showed little sign of taking place before the 1500s.[3] From that time forward, great landowners everywhere – the Possessioners among them – were again well placed to grow rich. Rents improved; prices rose; wages steadied or fell. Cushioned by higher revenues, the monks began, for the first time for many years, to think again constructively about the future. But the sands were running out for their communities. At even the best-conducted of the religious houses – at mighty Glastonbury, attempting self-renewal in the 1530s – 'thorns shall come up in her palaces, nettles and brambles in the fortresses thereof: and it shall be an habitation of dragons, and a court for owls.'[4]

In reality, the potential for renewal within the monastic church was always much greater than it might have suited its critics to acknowledge. Cistercian communities, left alone with their sheep, included some of the sleepiest in the land. They were notorious for their isolation and lack of scholarship. Yet it was the monks of Hailes, cheerfully acceptant of Margery Kempe's reproaches for their 'many great oaths and horrible', who took corrective visitation very seriously.[5] And it was Margery Kempe's contemporary, Thomas Burton of Meaux, who (as one of the few Cistercians ever to lift a pen) wrote some of the best history of his generation. As early as this, in the opening decades of the fifteenth century, there is already a refreshing Renaissance curiosity in what he wrote. Burton knew the worth of original documents, and had made it his business to recover them: 'some which had been exposed to the rain, and others put aside for the fire'. Like any good historian, having 'abridged their great length and illuminated their obscurities ... finally I have combined the total results into this one volume [*Chronica Monasterii de Melsa*] with the greatest care'. Other monastic chroniclers, he knew, had been less scrupulous. But no one, Burton tells us, 'who finds anything in what follows, which he did not know before, should think I invented it: let him rest assured that I have only included what I have found written in other works, or in a variety of documents, or have heard from reliable witnesses, or have myself seen.'[6]

Only brambles grow at Meaux today. But Burton's clear intelligence is with us still, and it is not the only evidence of high quality. Inevitably, there were failures: especially in outlying areas and at smaller houses. But even these may reveal, in the disappointments of contemporaries, a lively concern to do better. One

338. The great tower on the north transept at Fountains Abbey was one of the many building projects successfully completed during Marmaduke Huby's long and productive abbacy (1495–1526).

hopeful reformer was the Scot, Thomas Fassington, whose mission had been 'to reconstruct our [Cistercian] order, which had virtually disappeared as a result of destruction, and of secular encroachment by savage wolves who covet milk and wool, and seek their own interests rather than those of Jesus Christ'. By 1517 he had suffered enough, and 'now being convinced that he can achieve nothing amongst this depraved and perverse nation [of Scotland], he would rather lead a more holy and useful life at Cîteaux than live amongst such ostriches'.[7]

It was Marmaduke Huby, abbot of Fountains for more than thirty years, who wrote thus to Cîteaux for his friend. And Huby himself – that 'golden and unbreakable column in his zeal for the Order' – stood high even by the standards of other notable reformers, among them Bishop Redman of Ely. For both Huby (the Cistercian monk) and Redman (the Premonstratensian canon) the reforming instinct was essentially practical. In Fountains' great library, Richard Rolle's *Prick of Conscience* stands out as a curiosity; it was probably only there because Rolle, the recluse of Hampole, was a Yorkshireman.[8] No Cistercian community, whether Fountains or any other, had a copy of Thomas à Kempis' *Imitation of Christ* in its collections.[9] But the *Imitation* was not to be found in black-monk libraries either, nor even in those of the Mendicants. And if 'devotional torpor' was indeed what they all shared, it was also the considered response of many moderate men to what they saw as religious hysteria. Liberal and humane, intellectually drawn to the middle ground, they were confident of their own ability to reform. 'In all Huby's extensive correspondence,' it has been usefully pointed out,

> and whatever the difficulties which confronted him, there is no hint of self-deception, no touch of desperation or despair, no stoic confrontation with destiny. Rather, it is a busy correspondence, instinct with optimism and a sense of achievement, and with an eye to the future. If he and his confreres insisted continually on the need for reform, they were equally insistent that they could accomplish it.[10]

This confidence delivered new buildings. Once again, as in the past, cloisters 'resounded with the noise of picks and masons' tools'.[11] It was Abbot Huby who revived the Cistercian initiative at Oxford, finding books and other equipment for St Bernard's College, and gathering funds from his brother abbots towards completion.[12] Huby built vigorously at Fountains too, where the great tower is his personal memorial. Taking his text from Timothy – '*Regi autem . . .* Now unto the King eternal, immortal, invisible, the only wise God, be honour and glory for ever and ever' – he only stopped work on the embellishment of his abbey to turn his attention to its granges.[13] Bishop Richard Redman (d.1505), conjointly abbot of Shap, similarly gave a lead to the Premonstratensians. As Visitor of the English province of the Order from 1459, Redman laboured tirelessly for over forty years to correct and improve his community. He worked both by admonition and example. Durford Abbey, in Sussex, was not a rich house. It may never have had the resources to rebuild the ruined cloister which Redman noted there in 1494. However, Durford in those years was recruiting more successfully than it had done for decades, drawing comfort and support from the bishop.[14] In remote and rain-swept Westmorland, on the barren moor at Shap, Redman showed what he could do back at home. His great west tower at Shap, like Huby's contemporary tower at Fountains, is testimony to the growing confidence of his generation.[15]

In that generation, the outstanding figure was Richard Bere, abbot of Glastonbury (1493–1524) – 'good, honest, virtuous, wise and discreet, as well as a grave man, and for those virtues esteemed in as great reputation as few in England at that time of his coat and calling were better accounted of'.[16] Bere was an intellectual: 'a man of strict monastic obedience, much given to the godly virtue of abstinence', who had nevertheless travelled widely, had conversed

with Pope Julius II (patron extraordinary of the arts), and was later a correspondent of Erasmus.[17] Under Bere's direction, Glastonbury became again a major centre of pilgrimage, associated in particular with the Holy Grail and the cult of St Joseph of Arimathea. Partly as a result of that cult, the study of history revived at Glastonbury, where the younger monks chose their names in religion from notable figures of the past: among them a Gildas and a Bede, an Arthur and an Athelstan, a Dunstan and an Oswald, a Basil and an Ambrose, a Ceolfrith, a Neot and an Arimathea. If there were no other evidence of renewal at Glastonbury, these names alone would suggest it. But it was more than a fixation with Glastonbury's potent legend which gripped the community in Bere's time. Bere himself was an Oxford scholar; and so increasingly were his monks. While smaller houses in the locality struggled to maintain themselves, recruiting only with great difficulty, Glastonbury under Bere – and under Richard Whiting, his successor – continued to add to its numbers.[18] One reason for this popularity was its wealth. Glastonbury's annual revenues, totalling more than £3000, were second only to those of royal Westminster. Its monks were the fortunate recipients of generous cash doles. Its abbots lived like princes. Even after meeting the fixed costs of a huge establishment of this kind, there was a cornucopia left over for building.

In Bere's abbacy especially, building was given high priority. Not long afterwards, during the 1530s, John Leland visited Glastonbury. As was his custom, he recorded the building works of earlier abbots, including the energetic but feuding John Chinnock (1375–1420) – rebuilder of the cloister, the dormitory and the refectory. However, he gave most of his attention to Richard Bere, whose contributions were still fresh when he got there:

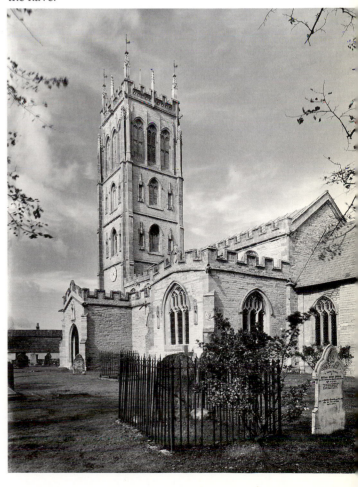

339. At Weston Zoyland, the initials of Abbot Richard Bere (1493–1524) establish Glastonbury's role in the rebuilding of this big Somerset church; they occur on the south chapel (centre) and on one of the benches in the nave.

> Richard Bere abbot built the new lodging by the great chamber called the king's lodging in the gallery. Bere built the new lodgings for secular priests and clerks of Our Lady. Abbot Bere built Edgar's Chapel at the east end of the church: but Abbot Whiting performed some part of it. Bere arched [buttressed] on both sides the east part of the church that began to cast out. . . . Bere made the vault of the steeple in the transept, and under[neath] two arches [strainers] like St Andrew's Cross, else it had fallen. Bere made a rich altar of silver and gilt: and set it before the high altar. Bere, coming from his embassy out of Italy [1503–4], made a chapel of Our Lady of Loretto, joining to the north side of the body of the church. He made the chapel of the Sepulchre in the south end of the nave whereby he is buried *sub plano marmore* in the south aisle of the body of the church. He made an almshouse in the north part of the abbey for seven or ten poor women, with a chapel. He made also the manor place at Sharpham in the park at two miles by west from Glastonbury: it was before a poor lodge.[19]

Even that was not all. At least two of Glastonbury's appropriated churches – the church of St Benedict in Glastonbury itself, and the splendid St Mary at Weston Zoyland – were extensively rebuilt during Bere's abbacy. In the High Street, next to the abbey precinct, the court-house (Tribunal) was re-faced in Bere's time. Both the *George and Pilgrims* (also in the High Street) and the parish church at Meare (adjoining the abbey's fishery) had been rebuilt by Bere's predecessor, Abbot Selwood.[20]

Bere's pocket was deep. However, his monks were not just living off their capital. There is a huge barn at Doulting, east of Glastonbury, which is datable no earlier than the fifteenth century. It is matched by another great barn at Tisbury (Wiltshire), on one of the manors of the ancient nunnery at Shaftesbury.[21] Both barns were built in a century better known for its retrenchment on the demesnes. And together they suggest a quality of estate management at the religious houses certainly higher than is usually allowed them. There is other

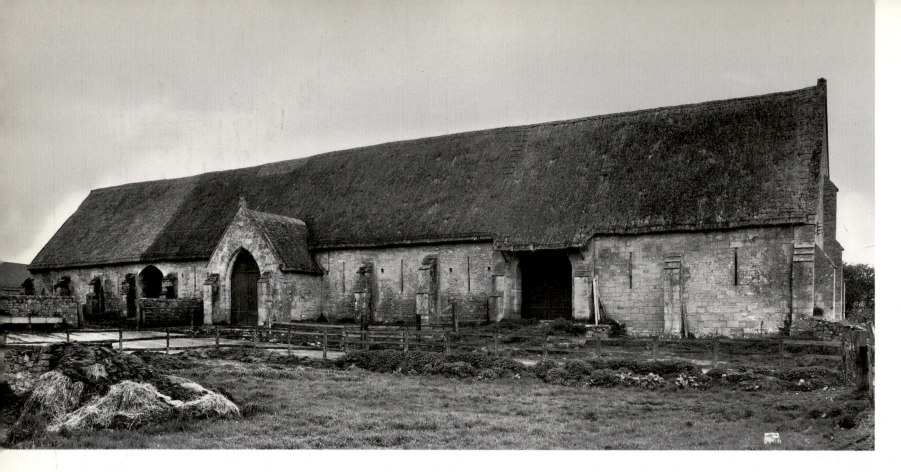

340. Shaftesbury's fifteenth-century barn at Tisbury, in Wiltshire, was one of the largest ever built. Much of the rest of the nuns' grange at Place Farm was rebuilt at the same time, including the surviving farmhouse and two gatehouses.

341. Evesham's lavishly panelled bell-tower was completed during the abbacy of Clement Lichfield (1514–38), shortly before the suppression of his community.

evidence of efficiency and concern. It was the good practice, for example, of the canons of Owston (Leicestershire) – all eleven, with their abbot – to supervise the annual sheep-shearing on their pastures. At Launde, in the same county, Prior John Lancaster assumed personal charge of his priory's flocks, and himself negotiated the disposal of its wool-clip.[22] This busy engagement in everyday affairs, frequently shared by the entire fellowship of the greater houses, enhanced the quality of life there. Of some twenty-two monks at Selby Abbey in the 1530s, fully half held major office in the community. There was the bursar, the kitchener and the pittancer; the sacrist, the almoner and the precentor; the keeper of the spirituality of Snaith (a priory cell), and the four other keepers – of the guest-house and the infirmary, the refectory and the altar of the Blessed Mary in Selby's choir. Other recorded offices at Selby, some of which had come together by this date, included the posts of prior, sub-prior and third prior; of prior at Snaith; of keeper of the fabric; of chaplain to the abbot and keeper of the bishop's chantry; of granger, extern cellarer and keeper of the store-room; of chamberlain, succentor and sub-sacrist.[23]

Thus contentedly employed, monks upheld each other more cheerfully in devotional routines alleviated by mutual tolerance and good companionship. 'He who avoids extremes does best', advised the Erasmian scholar, Robert Joseph of Evesham, addressing his friend, Brother Athelstan of Glastonbury. 'Slip between each extreme; you will pass safest by the middle road.'[24] It was counsel which would have appealed to Abbot Huby or Bishop Redman. For it was just this moderation which, in a community of religious, created the climate for useful works. 'Up, then! Drop Scotus,' Joseph urged John Neot, another Glastonbury friend, 'take up your bowls and be off to the green; you will bring back a bushel of health as well as a sixpence or two. If you don't feel like bowls, go fishing.'[25] Relaxed and self-assured, it was Joseph and his fellow monks who found the funds for the 'right sumptuous and high square tower of stone in the cemetery of Evesham'; it was Prior William Selling (1472–94), another noted humanist, who joined Archbishop Morton in building the great crossing-tower ('Bell Harry') at Canterbury Cathedral; and it was a third scholar-antiquary,

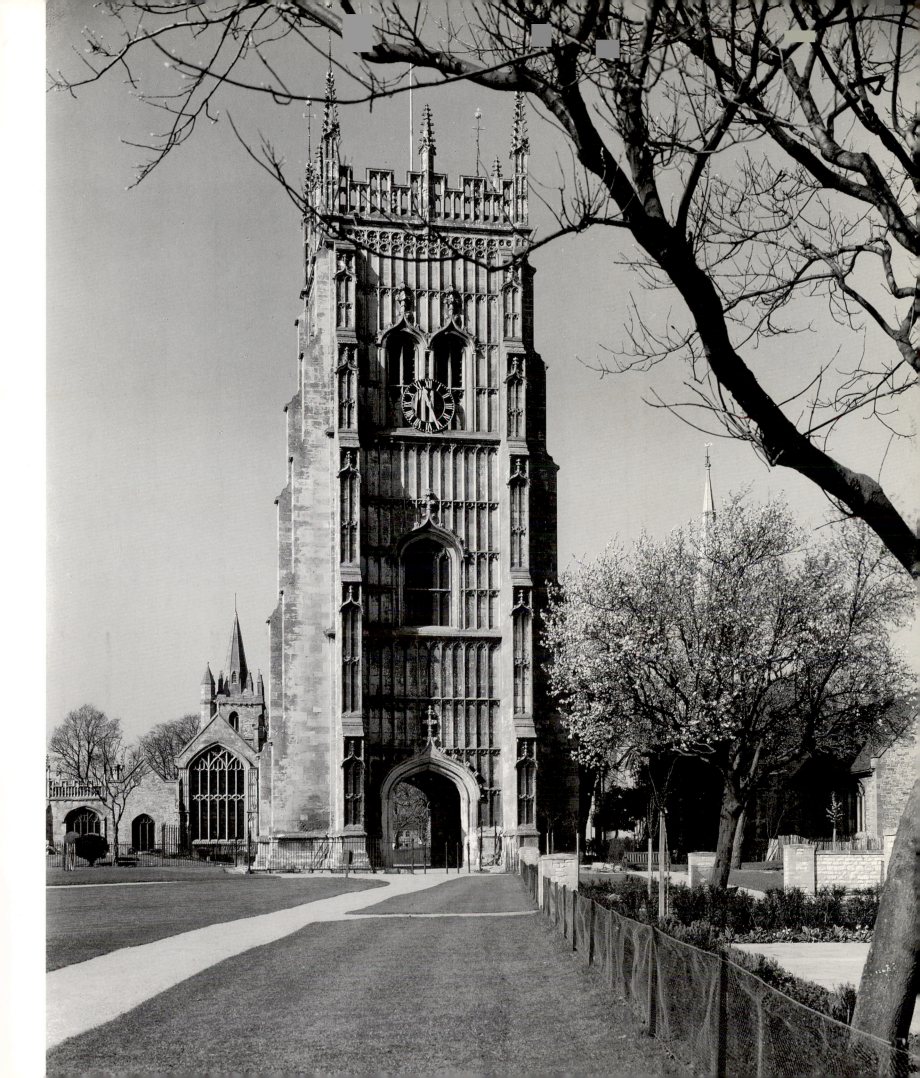

Abbot Richard Kidderminster of Winchcombe (1488–1527), under whose direction 'the cloister at Winchcombe . . . had all the appearance of a young university', and who (Leland tells us) 'did great cost of the church, and enclosed the abbey towards the town with a main stone wall'.[26]

'Surely,' wrote Francis Bacon after the monks had gone, 'a man shall see the noblest works and foundations have proceeded from childless men, which have sought to express the images of their minds, where those of their bodies have failed.'[27] And the celibate churchman, the epitome of these, had always built notoriously 'for his pleasure'.[28] Nevertheless, there was purpose as well as gratification in such work. None can now say whether Richard Mone, last prior of Bolton, built first for himself or for God. Mone's huge west tower at Bolton, which he never finished, was clearly commemorative from the start – 'In the year of our Lord MVCXX [1520],' runs the prominent inscription, 'R[ichard Mone] began this foundation, on whose soul God have mercy, Amen.'[29] Yet the quality of Mone's masonry was exceptionally high: far higher than it need have been for utility. And there are other indications also of an acceptable discipline in Mone's community, distinguished by good recruitment and lack of scandal.[30]

In truth, there was everything to be gained by continued building, wherever there were resources to support it. Poverty-stricken Ulverscroft, deep in Charnwood Forest (Leicestershire), would yet be described in 1536 as 'much of it within this three years new set up and built'.[31] And if even little Ulverscroft could achieve as much, others better-placed could do more. Obsessive builders of the period included Abbot Vintoner at St Osyth's, Abbot Dovell at Cleeve, Abbot Chard at Forde, Prior Singer at Much Wenlock, Abbot King at Thame, and Abbot Broke at Muchelney. The hospitable churchmen of late-medieval Wales – Abbot Franklin at Neath (and afterwards at Margam), Abbot Rhys at Strata Florida, Abbot Dafydd and Abbot Siôn at Valle Crucis – were famous builders as well as fine hosts.[32] It was Abbot Dennis at Holy Cross and Abbot Philip at Kilcooly who re-started the building programmes which, in late-medieval Ireland, have been seen as evidence of Cistercian renewal.[33] And so busy were the abbots and bishops of fifteenth-century Scotland – at Melrose and Jedburgh, Balmerino and Arbroath, Dunkeld and Aberdeen, Elgin, Glasgow and Crossraguel – that they fashioned between them a new national style, part-Flemish and part-French, but unique to Scotland in a sub-Romanesque pasticcio of cylindrical piers and round-headed arches, of nail-head and dog-tooth ornament. 'An inferior architecture', one of its premier students has observed: 'the fag-end of the international medieval tradition'.[34]

Abbots who built thus were not above criticism. Yet all could see plainly that the enemy within was less hyper-activity than inertia. What Colet believed to be the 'Way of Cain' could, after all, have its uses. In 1511, in his Convocation sermon, Dean Colet had urged another path:

> Let be rehearsed also to my lords these monks, canons, and religious men, the laws that command them to go the strait way that leadeth unto heaven, leaving the broad way of the world; that commandeth them not to turmoil themselves in business, neither secular nor other . . . [for] *Woe unto them which have gone the way of Cain. They are foul and beastly, feasting in their meats.* [Epistle of Jude][35]

However, ten years later, when Cardinal Wolsey tried to bring about reform, the answer of the black-monk abbots was '*non possumus*' (we can't). If every monk, they argued, had to follow the Carthusian Rule – or the Bridgettine or Franciscan Observant – recruitment at their houses would dry up.[36] Colet's 'vain babbling', his 'feasts and banqueting', 'sports and plays', 'hunting and hawking', had their part to play in monastic regimes forever haunted by the demon accidie. The affliction was as old as monasticism itself. As diagnosed by Cassian (d.435), this 'weariness of the heart . . . especially trying to solitaries', caused 'dislike of the

342. Aberdeen Cathedral's early fifteenth-century nave has the plain cylindrical piers typical of Scottish ecclesiastical architecture of that period.

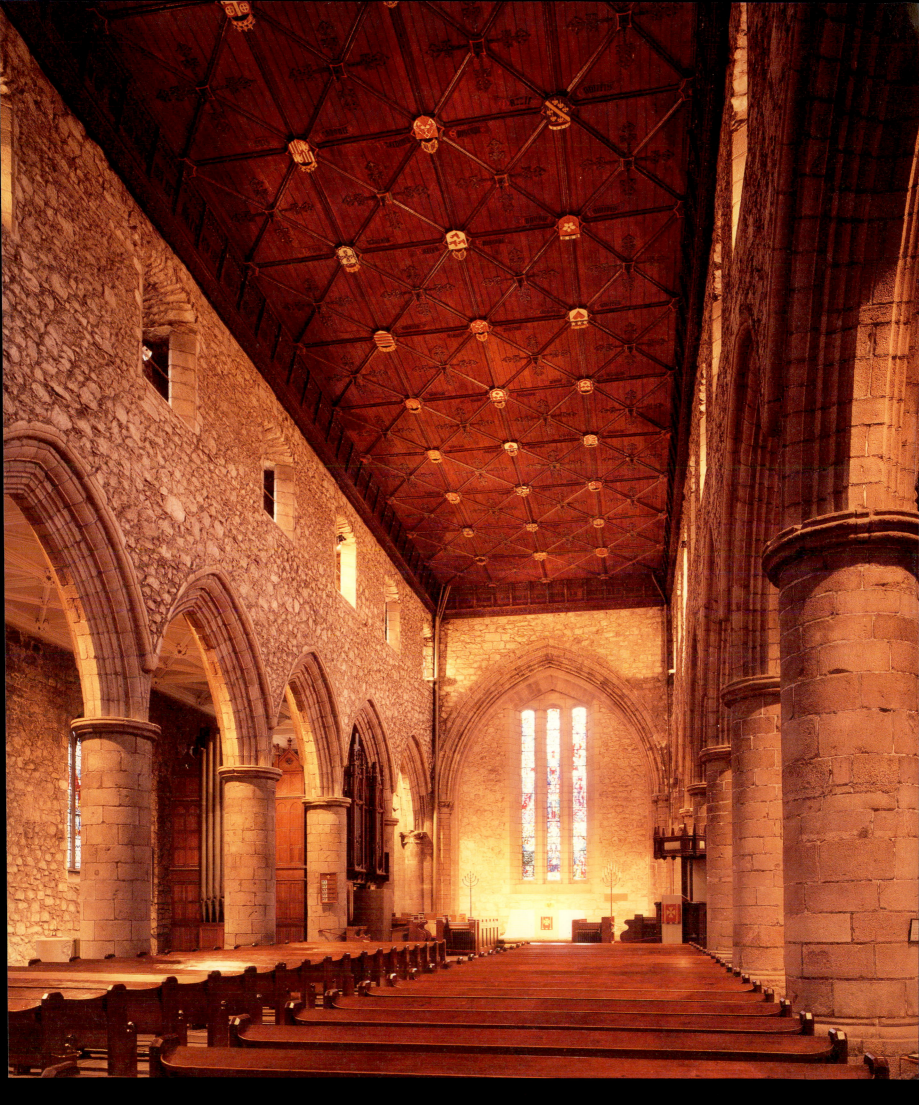

343. Henry VII's Lady Chapel, at the east end of Westminster Abbey, was begun in 1503. It became the grandest of all royal chantry chapels when both the king and his mother, Margaret Beaufort, were buried there.

345. (right) The fan vault of Henry VII's Chapel at Westminster.

344. The effigies of Henry VII (d. 1509) and Elizabeth of York (d. 1503) on their Renaissance tomb-chest at Westminster Abbey, designed by Pietro Torrigiano and made between 1512 and 1518.

place, disgust with the cell, and disdain and contempt of the brethren'. But whereas the earliest Christian writers had understood accidie to be a kind of mental exhaustion, brought about by excessive spiritual endeavour, later critics of the monks were more accustomed to identify it with sloth.[37] 'Busyness' was their remedy for such a condition. And nowhere was this 'busyness' more readily achieved than in the habitual confusion of the building site.

During Colet's time – and in that of his vituperative contemporary, Simon Fish – John Islip was abbot of Westminster (1500–32). Islip, the 'good old father', is portrayed on his obituary roll as surrounded by the flowers of his many virtues – a pansy for hope, a pink for faith, a rose for charity, a marigold for prudence, a daisy for temperance, a violet for counsel, a corn-cockle for wisdom, a lily for piety, a gillyflower for constancy, and so on.[38] But the picture, of course, is incomplete. 'If the abbot of Westminster,' Fish pointed out, 'should sing every day as many masses for his founders as he is bound to do by his foundation, a thousand monks were too few.'[39] Instead, there were forty-six monks at Westminster during Islip's abbacy, and building was what their superior spent his money on. Small wonder that Margaret Beaufort (d.1509), who had at first proposed to leave her fortune to Westminster, eventually assigned it to scholarship at Cambridge. Yet Margaret, for all that, remained loyal to the tradition of burial at Westminster, where her body was to lie 'in such convenable place as we in our life, or our executors after our decease, shall provide for the same within the Chapel of Our Lady, which is now begun by the said our most dear son [Henry VII]'.[40] Margaret sleeps there still – 'while the world shall endure' – in all the lush magnificence of the huge east chapel erected by Abbot Islip and her son. Her tomb-chest and effigy, like that of Henry himself, is one of the premier Renaissance monuments of all England.[41]

There is another Renaissance monument, at Bodmin Church in Cornwall, which is plainly modelled on Pietro Torrigiano's tomb of Henry.[42] And Prior Vivian's classical cenotaph of 1533, even in this distant place, is just one of many flags to the new thinking. The usual Renaissance devices – nudes and Mediterranean foliage – occur at the head of Abbot Vintoner's big bay window at St Osyth's (Essex). There is acanthus on the carved oak panels from Arbroath (Angus), commissioned by Abbot (later Cardinal) David Beaton. Female figures and winged putti, griffins, mermen and sphynxes, fill the friezes on the facade of Abbot Chard's new lodgings at Forde (Dorset). Arabesques and roundels, naked putti and classical urns, decorate the parlour at Thame (Oxfordshire) of the time-serving scholar-pluralist, Abbot King.[43] Robert King was a survivor. His patron, John Longland, bishop of Lincoln (1521–47), was chancellor of Oxford. And King himself became, following the suppression of Thame Abbey, the first incumbent of the new bishopric of Oxford. Among his friends and close associates – those who caroused with him at Thame – were some of the most prominent of Henry VIII's commissioners for the Suppression: John Tregonwell and William Fermor, John Williams and the notorious Dr London.[44] Erasmians all, they entertained humanism and dismissed the monks, each pursuing his particular advantage.

It was Erasmus who had once said: 'The monastic life should not be equated with the virtuous life; it is just one type of life that may be either advantageous or not according to the individual's dispositions of mind and body. I would no more persuade you to it than I would dissuade you from it.'[45] Such talk appealed to intelligent men, and had become increasingly difficult to resist. At Wells Cathedral today, there is a stone pulpit of the 1540s which is an outward and visible sign of just this kind of liberal thinking. Given to the cathedral by a former royal official and diplomatist, Bishop William Knight (d.1547), the Wells pulpit is of 'solid, monumental and very plain Italian Renaissance forms, handled without any hesitation and without any hankering after prettiness . . . one of the

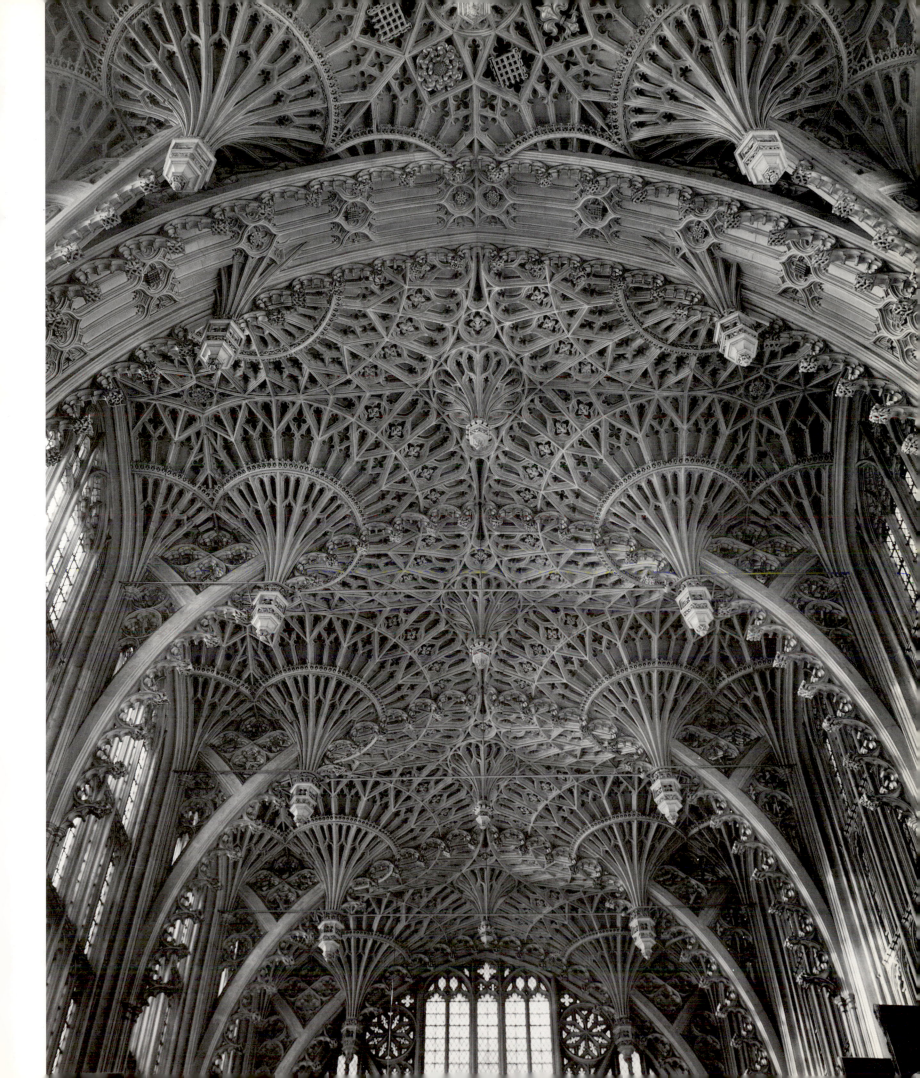

346. The purely classical pulpit at Wells Cathedral, given by Bishop William Knight (1541–7).

347. Giovanni da Maiano's terracotta portrait bust of the Emperor Nero, commissioned (with seven others) in 1521 for Cardinal Wolsey's new palace at Hampton Court.

348. The tomb-chest (with later effigies) of Thomas Howard, duke of Norfolk (1524–54); prepared for Thetford Priory in the late 1530s, it was removed after 1540 to Framlingham Church.

349 Sir John Thynne was a member of the Lord Protector Somerset's circle; Thynne's symmetrical south front at Longleat, while no earlier than the 1570s, was influenced by Somerset House.

earliest attempts in England at a serious understanding of the Renaissance'.[46]

If understanding at this level was always patchy in the North, William Knight was not alone in exhibiting it. Giovanni da Maiano's terracotta portrait roundels, at Wolsey's Hampton Court, would not have disgraced either Francis I's Fontainebleau or the Vatican.[47] There is high-quality Renaissance carving, probably of French or Flemish origin, on Henry VIII's pulpitum at King's College Chapel (Cambridge).[48] Thomas Weaver's entirely classical Easter sepulchre at Tarrant Hinton (Dorset) is no later than the early 1530s; and it is to that decade again that Thomas II Howard's tomb-chest at Framlingham (Suffolk), with its fine Early Renaissance display of scallop-shell niches and baluster shafts, is now attributed.[49] Thus inclined by his Fench marriages and by his travels in foreign parts, James V of Scotland employed the best French craftsmen on the embellishment and renewal of his four palaces – on the royal lodgings at Holyrood, on the fountain at Linlithgow, on the courtyard elevations at Falkland, and on the facades and interior fittings of his compact palace at Stirling – 'the most impressive pioneer Early Renaissance essays in the British Isles'.[50]

Briefly at the mid-century, England underwent a classical revival of extraordinary sensitivity, usually associated with Edward Seymour, duke of Somerset (d.1552), and his circle. It was this which inspired Sharington's banqueting tower and belvedere at Lacock Abbey; which accounts for Northumberland's Mediterranean-style loggia at Dudley Castle; and which caused Sir John Thynne to build his house at Longleat as he did.[51] In the parish churches, it explains the exact classical monuments of William Sharington at Lacock (1553) and Gregory Cromwell at Launde (1551), of Sir Richard Brydges at Ludgershall (1558) and Sir Robert Dormer at Wing (1552) – 'the finest monument of its date in England and of an unparalleled purity of Renaissance elements'.[52] But Somerset's circle was always small, and its values were too refined to travel far. More important in every way was the general reception of the new learning which had begun before that date, admitting the Renaissance to the provinces.

Some conservatives stood like rocks against the tide. There is no hint of the Renaissance in the Grace and Butler armoured effigies at Kilkenny Cathedral, dating to the mid-sixteenth century. Nothing classical infects the ornament of Walter Smith's tomb-chest at Totnes (1555). No pilaster or pediment, medallion or urn, features on the Nevill monument at Staindrop (1564) to the fifth earl of Westmorland, or on the contemporary Ferrers cenotaph at Baddesley Clinton.[53] Otherwise traditional monuments like Sir William Sydney's tomb at Penshurst (1553) or Sir Robert Broke's at Claverley (1558) may carry just a suggestion of the new style. But the Oxford monument of the one-time humanist and former abbot of Thame, Robert King (d.1557), was 'still entirely without Renaissance mo-

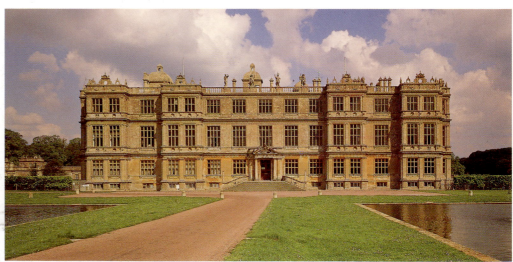

tifs'.[54] Not everybody moved as cautiously. There are two Frowyk monuments, in the parish church at South Mimms (Hertfordshire), which are separated by no more than thirteen years. The Frowyks were wealthy Londoners, father and son, and their monuments are very similar in many ways. Nevertheless, when the younger Henry Frowyk died before his father in 1527, his canopied tomb-chest was still wholly Gothic. Shortly afterwards, the Renaissance came to South Mimms. Henry Frowyk the Elder's monument, datable to 1540, uses classical mouldings as a cornice. Its corner-posts are balusters, bulbous and foliated, like the legs of a Victorian concert grand.[55]

In a very short time, these fashions were to triumph absolutely. But they had already won a wide measure of acceptance. On Sir Ralph Egerton's screen at Bunbury (Cheshire), painted in 1527, there are dolphins and graceful arabesques.[56] Dolphins crown the facade of Sir Henry Marney's gatehouse-tower at Layer Marney (Essex), while the sybils and naked putti of Sir Edmund Tame's window-glass at Rendcomb (Gloucestershire) belong likewise to the early 1520s.[57] Classical buildings furnish a backdrop for the big pre-Reformation painting of *The Adoration of the Magi* at St Mary de Crypt (Gloucester).[58] Renaissance and Gothic motifs are juxtaposed on Margaret Pole's great chantry at Christchurch Priory (Dorset); there are pilasters and classical foliage on the north aisle screen at Warmington (Northamptonshire), and putti, medallions and profile heads on the parclose screens of Lincolnshire's Theddlethorpe All Saints.[59]

Nowhere was the Early Renaissance received more comprehensively than in the terracotta monuments of East Anglia. There are just a few of these great tombs, probably of Flemish origin, and all datable to around 1530. Nothing like them was ever built again. Nevertheless, rarities though they were, what they establish in English society of the early 1530s is a new willingness among patrons to adopt wholesale every device and motif of the Renaissance. Little except their wealth could have associated the Marneys of Layer Marney with the Bedingfelds of Oxborough; Roger Appleyard of Braconash with Sir Edward Eckingham of Barsham; the Norwich grocer, Robert Jannys, with Elisha Ferrars, last abbot of Wymondham. Yet each took to the new classicism with scarce a backward glance, commissioning an expensive monument so tightly packed with urns, with mermaids and putti, capitals, pediments and acanthus scrolls, as to leave room for no other kind of ornament.[60]

What had brought them to that point was better schooling. Dean Colet's condemnation of the pre-Reformation clergy in 1511 was less than fair, for the Church was not as bad as he made out.[61] In particular, it had led the way in education. Colet himself, as re-founder of St Paul's School (London), continued the long tradition of the late-medieval episcopate, sponsors of an 'educational revolution'. After William of Wykeham (d.1404), the most committed educationalist of fifteenth-century England was another bishop of Winchester, William Waynflete (d.1486), the quintessential 'schoolmaster bishop'.[62] Waynflete was headmaster (*magister informator*) of Winchester College in the 1430s; he was provost of Eton from 1442. On his elevation to Winchester in 1447, he at once launched new initiatives of his own. Waynflete was the founder in 1448 of Magdalen College (Oxford). He later provided it with a local feeder-school (Magdalen College School), and built another grammar school at Wainfleet All Saints, still the principal medieval monument of his birthplace.[63] Other bishops did likewise. Archbishop Chichele's major project was All Souls (Oxford), of which he was co-founder with the king. But he had been an earlier benefactor also of his home town at Higham Ferrers, to which he gave the grammar school of 1422 – a smartly crenellated little building at the church door.[64] Thomas Rotherham, archbishop of York (1480–1500), similarly built a grammar school at his Yorkshire birthplace, while giving liberally to both Oxford and Cambridge. Edmund Lacey of Exeter (1420–55) assisted Exeter College (Oxford); John

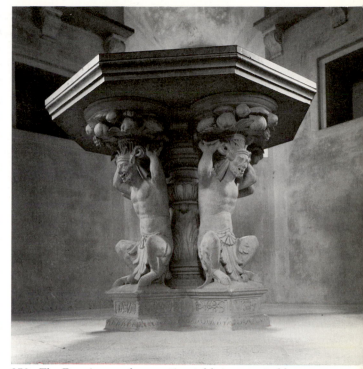

350. The Renaissance banqueting table, supported by fruit-bearing fauns, in the lower chamber of Sir William Sharington's belvedere at Lacock Abbey, datable to *c*.1550.

351. Gregory Cromwell's Renaissance wall-monument of 1551 is in the private chapel at Launde, formerly the chancel of an Augustinian priory church. Launde Priory was among the religious houses acquired by Thomas Cromwell in 1538 and inherited by Gregory, his son.

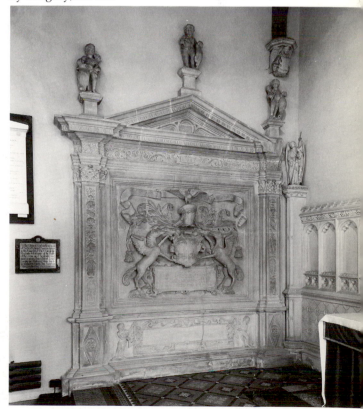

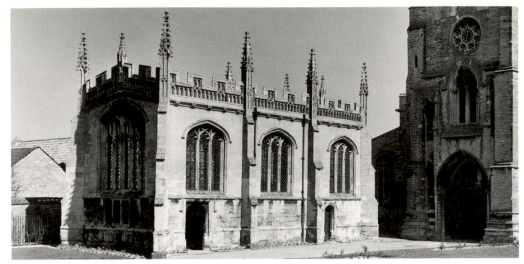

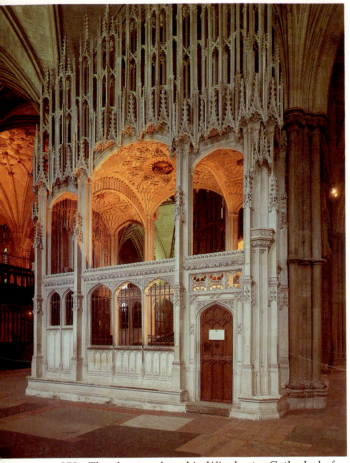

352. The chantry chapel in Winchester Cathedral of Bishop William Waynflete (1447–86), one of England's greatest educational benefactors.

353. Henry Chichele's grammar school at Higham Ferrers was founded in 1422. The archbishop's other benefactions to his home town included a collegiate chantry and an almshouse.

354. Many of England's bishops contributed to the building costs of Oxford's mid-fifteenth-century Divinity School; their monograms, arms, rebuses and mottos are prominently displayed on its vault-bosses.

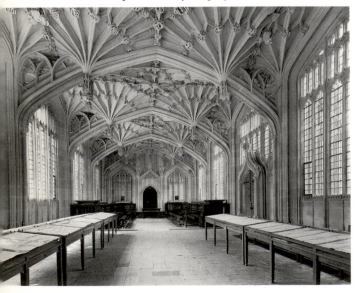

Carpenter of Worcester (1444–76) supported Oriel College (Oxford); William Smith of Lincoln (1495–1514) co-founded Brasenose College (Oxford), with the help of a pious lawyer, Sir Richard Sutton.[65] 'There never was a prelate so good to us as you have been', Oxford told Bishop Beauchamp of Salisbury in 1481, addressing one of the less memorable of its benefactors: 'You promised us the sun, and you have given us the moon also.'[66]

So indeed it must have seemed as the two universities, in the golden summer of their expansion, harvested the surplus wealth of the episcopacy. On the vault-bosses of Oxford's fifteenth-century Divinity School, to which Richard Beauchamp of Salisbury (1450–81) subscribed, are the devices and mottos of his contemporaries and associates – of Thomas Kempe of London (1450–89) and John Russell of Lincoln (1480–94), of Thomas Bourgchier of Canterbury (1454–86) and Walter Lyhert of Norwich (1446–72), of John Arundel of Chichester (1459–77), of William Waynflete of Winchester (1447–86), of Peter Courtenay of Exeter (1478–87), and many more. '*Kemp me fieri fecit*', runs one proud inscription; 'God save my lord of London', runs another.[67]

The work on the Divinity School was of the highest quality. Its educational purpose was exemplary. But, as men said, 'it is no liberality to rob Peter and enrich Paul . . . it were none alms but great sin'.[68] The bishops overrode all objections. Waynflete's Magdalen College (Oxford) was greatly enriched in 1457 by the bishop's gift of the ancient hospital of St John Baptist; in 1484, not long before his death, Waynflete gave Magdalen the depopulated Selborne Priory (Hampshire) in addition.[69] There was only one canon resident at Selborne at the time. And it was a similar collapse at St Radegund's (Cambridge), where the nuns 'are reduced to two in number, one of whom is professed elsewhere and the other is an infant', which enabled John Alcock, bishop of Ely (1486–1500), to close that once-rich nunnery, 'reduced to poverty and decay by reason of the dissolute conduct and incontinence of the prioress and nuns, on account of their vicinity to the University of Cambridge'. In 1496–7, with help from the Crown, he founded

a college in its stead for one master, six fellows and a certain number of scholars to be instructed in grammar, to pray and celebrate divine service for the king [Henry VII], his queen Elizabeth, his mother Margaret [Beaufort], his son Arthur prince of Wales, and his second son the duke of York [later Henry VIII], his other children, the bishop of Ely, and for the soul of the king's father Edmund [Tudor] earl of Richmond.[70]

There is a monastic cloister still at Alcock's Jesus College; a first-floor hall which was once the nuns' refectory; a chapel which was formerly their church.[71] There was logic, plain to see, in such conversions.

355. Bishop Alcock's Jesus College (Cambridge) reused the church and cloister of the Benedictine nunnery at St Radegund's, suppressed for this purpose in 1496.

356. The gatehouse, with Tudor heraldry, of St John's College (Cambridge), founded by Margaret Beaufort in 1509 in place of the dissolved hospital of St John the Evangelist.

One of those engaged in the early years and fortunes of Jesus College was Margaret Beaufort, countess of Richmond. Margaret contributed to the new buildings at Jesus, and was the patron of Dr Jubbes, the first Master.[72] As Alcock had done, she looked to the revenues of decayed religious houses to help her with foundations of her own. Assembling the endowment for Christ's College (Cambridge), she bought Creake Abbey from the Crown in 1507, to which it had fallen the previous year on the death of the last canon and reigning abbot.[73] Before 1509, she had made her arrangements for St John's. 'Be it remembered,' Margaret provided,

> that it was also the last will of the said princess to dissolve the hospital of St John [the Evangelist] in Cambridge, and to alter and to found thereof a college of secular persons; that is to say, a master and fifty scholars, with divers servants; and new to build the said college, and sufficiently to endow the same, with lands and tenements, after the manner and form of other colleges in

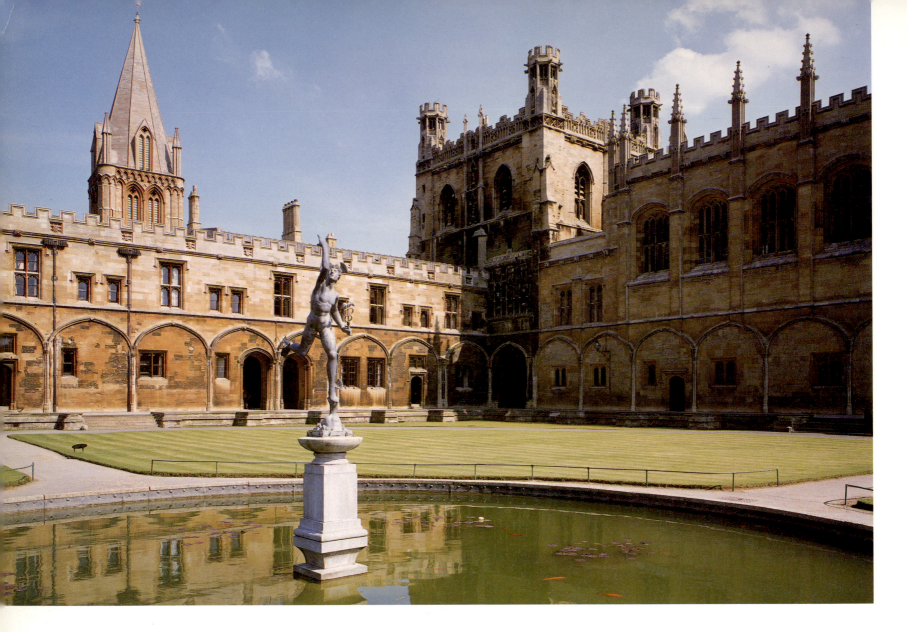

357. The great cloister of Cardinal College (Oxford) was never finished; but Wolsey's south range (right), including his first-floor hall, was among the buildings completed before his fall.

358. The hall of Wolsey's college (now Christ Church), built between 1524 and 1529.

Cambridge; and to furnish the same, as well in the chapel, library, pantry, and kitchen, with books and all other things necessary for the same.[74]

In July 1509, when suppressed on the petition of Margaret's executors, St John's Hospital was 'in a most impoverished and dilapidated condition'; it was ripe for reformation or for closure.[75] On similar grounds, it was the supposed irregularities at some thirty communities where, Wolsey claimed, 'neither God was served nor religion kept', that enabled the cardinal to pick them off, one by one, in the 1520s.[76] But not all Wolsey's victims were such obvious candidates for dissolution as Tiptree Priory (Essex), with only two canons in residence, or Pynham Priory (Sussex), with just one. Bayham Abbey (Sussex), where there was vigorous resistance to suppression, was a well-off Premonstratensian community.[77] At Oxford, the even richer Augustinians of St Frideswide's Priory, guardians of a famous shrine, were expelled by Wolsey in 1524 to make room for his Cardinal College. That college is now Christ Church, left half-finished by Wolsey; St Frideswide's great priory church, narrowly saved from demolition by the cardinal's disgrace, was elevated in 1546 to cathedral.[78] Both Wolsey's Oxford college and its intended feeder-school at Ipswich were conceived on the grandest of scales. At Ipswich – Wolsey's birthplace – chantry, school and almshouse were combined. The resulting college, founded in 1528 and suppressed just two years later, was to have had a dean and twelve fellows; eight clerks and eight choristers; thirteen bedesmen; a master, two ushers, and fifty

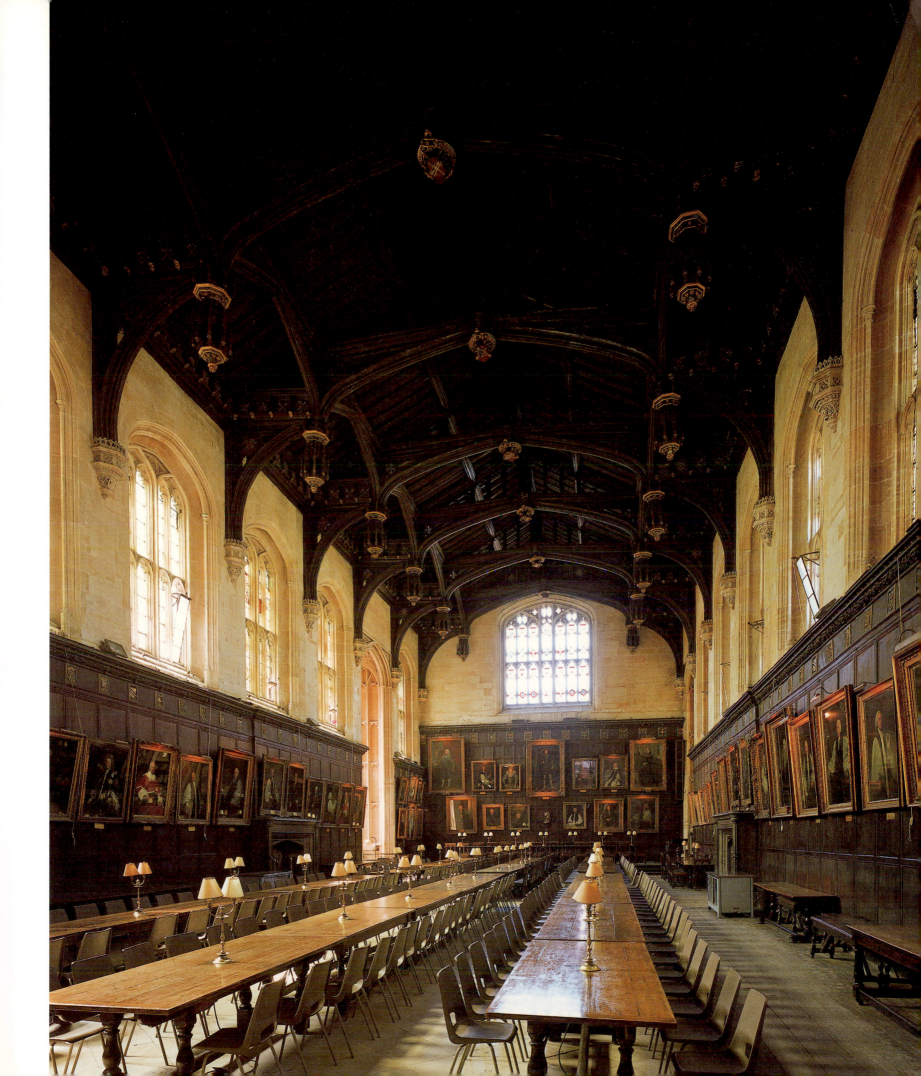

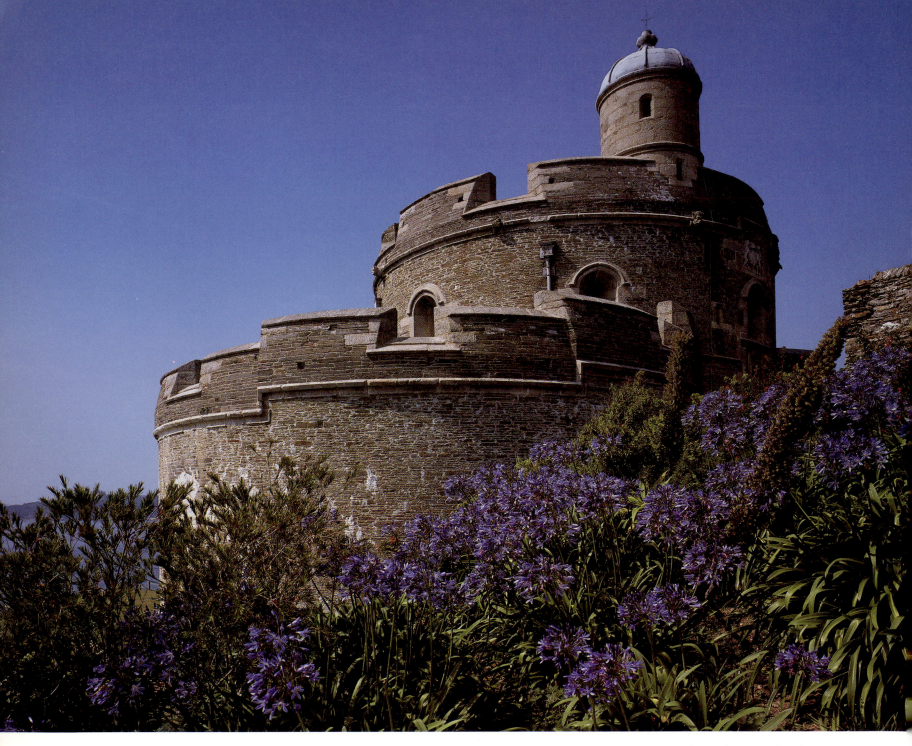

359. Henry VIII's geometrically planned artillery fort at St Mawes, overlooking the Fal estuary, was built in the early 1540s, after the threat of invasion was already over.

scholars.[79] Funding these great enterprises, on which Wolsey set his heart, was the real occasion for his multiple suppressions.

It was Wolsey's suppressions, clearly seen for what they were, which gave the lead to other plunderers of church property. By 1536, when the smaller houses were dissolved, there was no lack of new proposals for their future. 'I trust now to see,' wrote Thomas Starkey to the king, 'all such superfluous riches, which among them that bare the name of spiritual [the monks] nourished nothing but idleness and vice, to be converted and turned by your gracious goodness to the increase of all virtue and honesty'.[80] Starkey meant more schools. And so indeed might Henry VIII himself have thought, before distracted by his troubles overseas. In 1532, after the briefest of suppressions, he had re-founded Wolsey's Cardinal College. Four years later, with much new patronage at his disposal, he had re-populated Franciscan friaries, formerly Observant; had saved the Gilbertine houses (even the smallest) from premature suppression; and had re-founded Augustinian Bisham (Berkshire) and Cistercian Stixwould (Lincoln-

shire) as new Benedictine and Premonstratensian communities.[81] But then, in mid-1538, just as the first of the greater houses began to surrender to his commissioners, Henry's diplomatic system of continental checks and balances collapsed. Unable to play off France against the Empire, and confronted by his two long-term rivals in coalition, Henry's thoughts turned immediately to defence. It was into the sands of an unprofitable foreign war that the spoils of the Dissolution quickly drained. And it was the rubble of suppressed abbeys which built those coastal 'blockhouses, bulwarks, walls, castles and fortresses' so beloved by the king and his advisers. 'Lord,' an admirer told Henry in 1539, 'how may all Englishmen rejoice that your grace neither spareth to visit with your own eye the ruinous places of the sea coasts, by which our enemies might suddenly invade us, neither letteth to work with your own hands, continually managing tools, continually inventing new sorts of weapons, new kinds of ships, of guns, of armour'.[82] Henry – 'heavy with sickness, age and corpulences of the body' – reached hungrily for these distractions as though for oxygen.

The king's military engineering, learnt many years before, was badly out-of-date when he began. His new coastal fortresses were expensive, ill-conceived, and 'retardataire'.[83] They were to be almost immediately superseded. Nevertheless, the huge scale of the royal works, and their fine geometric balance, added mightily to Henry's reputation. Deal, begun in 1539, was the largest of these buildings. With other Kentish castles on the most threatened length of coast, it was completed in little more than a year. But it was the much smaller St Mawes, on the Fal estuary in Cornwall, which was certainly the most elegant of Henry's works. St Mawes, completed in 1543–5 when the danger was long past, was a perfect drawing-board castle – a composition of interlocking circles. It carried self-congratulatory Latin inscriptions. 'Henry,' one of these promised, 'thy honour and praises will remain for ever'; 'Honour Henry the Eighth, most excellent King of England, France and Ireland', demanded another; then, remembering the infant Edward, duke of Cornwall and future king – 'Let fortunate Cornwall rejoice that Edward is now her Duke', and 'May Edward resemble his father in fame and deeds'.[84]

It was John Leland, the king's librarian and antiquary, who composed the St Mawes inscriptions. Leland knew his castles well, for he had been journeying already for almost a decade, recording the defences of the realm. During that time, between 1536 and 1540, he had watched the surrender and demolition of the monastic houses. But even before the devastation of those 'bare ruin'd choirs', the medieval landscape had become spotted with decay. Appleby (Westmorland) was a 'ruinous castle wherein the prisoners be kept'; Baginton (Warwickshire) was 'now desolated'; Chilham (Kent) was 'now almost down'; Dursley (Gloucestershire) 'fell to decay and is clean taken down'; of Elmley (Worcestershire) 'there standith now but one tower'; and so through the letters of the alphabet.[85] Exceptionally, some castles had survived better than the rest. But they had done so, usually, as lordly residences, having little further purpose in defence. Thus Yorkist Fotheringhay (Northamptonshire) was still 'fair and meetly strong with double ditches and hath a keep very ancient and strong. There be very fair lodgings in the castle. And as I heard, Catherine of Spain [Aragon] did great costs in late time of refreshing it.'[86] Of the Nevills' Sheriff Hutton (Yorkshire), Leland could report – 'the stately stair up to the hall is very magnificent, and so is the hall itself, and all the residue of the house: in so much that I saw no house in the North so like a princely lodging ... This castle was well maintained by reason that the late duke of Norfolk [Thomas Howard] lay there ten years, and since the duke of Richmond [Henry fitz Roy].'[87] At royal Kenilworth (Warwickshire), 'King Henry VIII did of late years great cost in repairing the castle of Kenilworth. Among these reparations, the pretty banqueting house of timber, that stood thereby in the Mere, and bore the name of

360. A carved escutcheon (once painted with the royal arms), over the keep door at St Mawes, faces the forward gun platform. Tritons hold Latin inscriptions which read (in translation): 'May the soul live for ever of Henry VIII who had this made in the 34th year [1542–3] of his reign.'

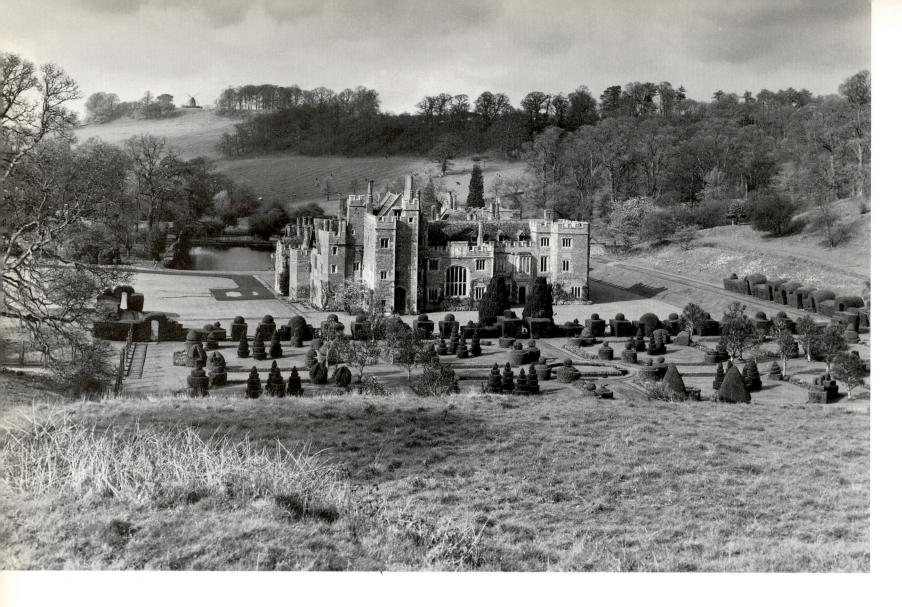

361. Sir William Compton (d. 1528), building his country mansion at Compton Wynyates in Warwickshire, had little to fear from local violence; his corner tower (left) was no more than a token defence.

Pleasance, was taken down, and part of it set up in the base court at Kenilworth Castle.'[88]

In 1524–6, when Henry moved the banqueting house at Kenilworth, he spent nearly £500 on the old fortress.[89] But 'the only Phoenix of his time for fine and curious masonry' had hardly started. By purchase and exchange, attainder and escheat, Henry added swiftly to his stock of royal residences, of which he had assembled more than fifty before his death.[90] Already in 1534, Thomas Cromwell was complaining 'what a great charge it is to his highness to continue his buildings in so many places at once . . . if [only] his grace would spare for one year, how profitable it would be to him'.[91] Yet Henry, the very next year, acquired Chobham, Hackney and Petworth; in 1536, he collected Chelsea and Suffolk Place, Durham House, Mortlake and Hyde; in 1537, Otford, Knole and Oatlands; in 1538, Hatfield and West Horsley; in 1539, Beddington, Halnaker and Tyttenhanger. Still in the 1540s, taking his pick of the religious houses and their principal estates – Ashridge and Dartford, Dunstable and Guildford, Reading and Syon, St Albans, Rochester and many more – Henry made no end to his collecting.[92]

The king's mania was increased by competition. Henry built as compulsively as Francis I – but with less taste. It was on 22 April 1538, exactly thirty years from his accession, that Henry began 'Nonnesuche', the most ingenious and displayful of all his palaces. Little is known in detail of the works at Nonsuch, which was demolished in 1682. Yet it was clearly Henry's intention to outshine contemporary Fontainebleau, his source both of craftsmen and ideas.[93] Nonsuch, towered

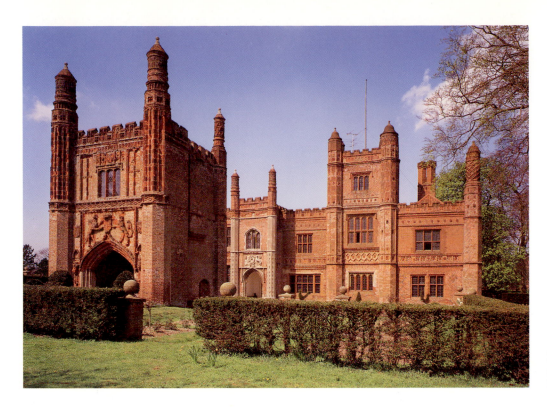

362. The gatehouse (left) and main show-front (right) of Sir Henry Fermor's East Barsham Manor, built in the 1520s.

and pinnacled, was hung splendidly with carved and gilded slate. It celebrated history, myth and legend in *stucco duro*. Guarded by Scipio and Hercules, by Socrates and the Thirty-One Caesars, Henry lay protected by a shield of stucco statuary – 'by the doyens of arts and virtues, and the avenging goddesses ... by the feats of Hercules and the tender care of the gods, that he may act always in affairs without danger, and rest with dignity'.[94]

In Henry's time, protected by 'long peace and quietness within the realm', others slept equally secure. There were already huge wall-of-glass windows in the gatehouse at Coughton Court (Warwickshire), built in the 1510s for the Throckmortons.[95] Sir Henry Marney's contemporary gatehouse at Layer Marney (Essex) had multiple windows at every level.[96] The strong corner tower at Compton Wynyates (Warwickshire) had nothing to do with a personal insecurity which Sir William Compton, 'chief Gentleman of the Bed-Chamber ... [and] more attentive to his profit, than public affairs', in all probability never felt.[97] 'What say you,' asked the knight in Sir Thomas Smith's *Discourse of the Common-weal of this Realm of England* (1549), 'by our buildings that we have here in England of late days, far more excessive than at any time heretofore? Does not that impoverish the realm and cause men to keep less house[hold]s?' No, was the doctor's considered reply: 'I say that all these things be tokens of ornaments of peace ... It [excessive building] does not impoverish the realm at all, for all the expense of buildings for the most part is spent among ourselves and among our neighbours and countrymen as among carpenters, masons, and labourers'. The real enemy, as he saw it, was adulteration of the coinage – the Great Debasement of 1542–51.[98]

363. The south facade and garden front of Sir Richard Weston's Sutton Place, dating to the late 1520s, was as unprotected as any modern house.

The 'Old Coppernose' coins of the final years of Henry's reign were a clear indictment of his wars and his extravagance. But those wars had been fought away from English soil – in Scotland, in Ireland, or on the Continent. And the castle, accordingly, became redundant in Tudor England, in favour of the undefended country house. John Gilbert's military facade at Compton Castle (plate 308) was the exception.[99] Yet even Gilbert's fortifications were a show-front only. And there was nothing, for example, at Sir John Cutte's Horham Hall (Essex), at Sir Henry Fermor's East Barsham Manor (Norfolk), at Sir William

287

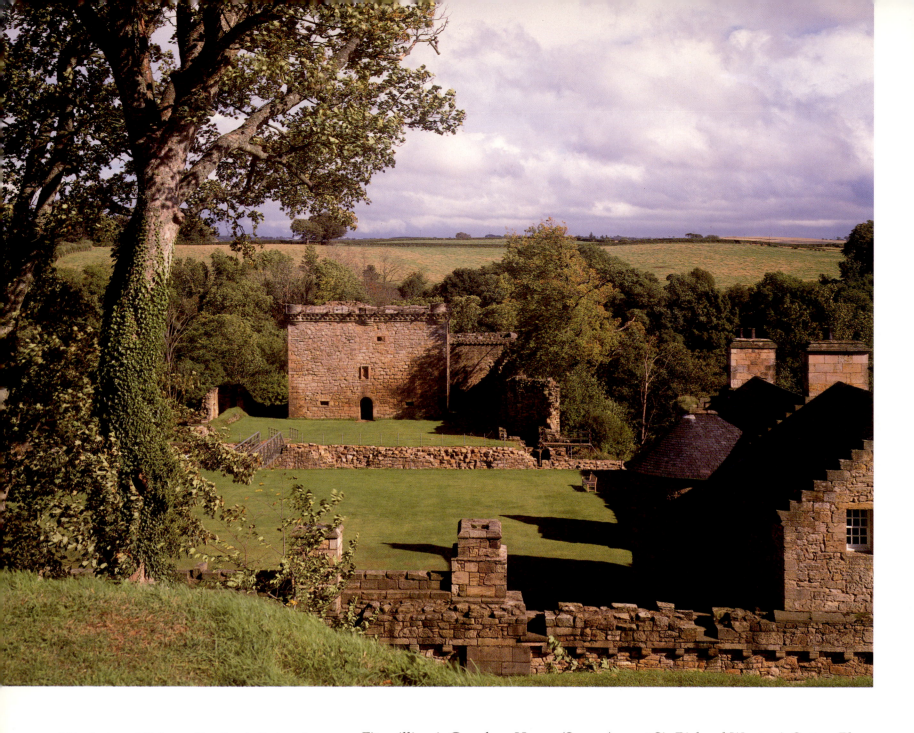

364. A view of Sir James Hamilton's Craignethan Castle, from the higher ground immediately to the west. When first built in the 1530s, Hamilton's tower-house (centre) was protected by a tall rampart shield, fronted by a vertical-sided ditch.

Fitzwilliam's Cowdray House (Sussex), or at Sir Richard Weston's Sutton Place (Surrey), which made any special provision for defence.[100] Certainly no Henrician courtier, however assured of royal favour, ever built a private castle to compare in strength or guile with Sir James Hamilton's artillery fortress at Craignethan (Lanark). And Craignethan's innovatory defences – its big rampart shield, its vertical-sided ditch, and its loopholed *caponier* (cross-moat artillery gallery) of the 1530s – were not allowed again by a Stewart monarch.[101] Hamilton's successors built modest Z-plan castles at Claypotts and Elcho, Earlshall, Castle Menzies and Glenbuchat. They were satisfied with fortified mansions at Rowallan, Maclellan's Castle and Tolquhon. At Greenknowe Tower and Drum Coltram, Scotstarvit and Carsluith, they continued building tower-houses as of old.[102] All these, too, would lose their purpose after 1603, in the wake of the Union of the Crowns. Among the last of Scotland's greater private fortresses was the huge castle at Fyvie (Aberdeen), built for Alexander Seton, first earl of Dunfermline (d.1622). But Seton was a man of peace, of whom it would be said (even by an enemy) that he 'above all things studied to

288

maintain peace and quietness'. And he has left us this inscription at Pinkie House (Musselburgh), commemorating the building of his pleasance:

> For himself, for his descendants, for all civilized men, Alexander Seton, lover of mankind and civilization, founded, built and adorned his house and gardens and these suburban buildings. Here is nothing warlike, even for defence; no ditch, no rampart. But for the kind welcome and hospitable entertainment of guests a fountain of pure water, lawns, ponds and aviaries.[103]

Another such pleasure ground, at Edzell Castle (Angus), was made for Sir David Lindsay in 1604. It was a walled space – like Stafford's earlier pleasance at Thornbury Castle (Gloucestershire), 'a goodly garden to walk in, closed with high walls embattled'.[104] Lindsay had a banqueting house at one corner of his garden; a fully equipped bath-house at the other. He promenaded in the crystal light of the Seven Planetary Deities and of the Seven Liberal Arts, of Justice and Prudence, Fortitude and Temperance, Faith, Hope and Charity: all present in the sculptures on his walls.[105] Even in troubled Ireland, where the castle lasted

365. At Ormond Castle, in Tipperary, Thomas Bulter's Elizabethan mansion (left), dating to the late 1560s, fronts a mid-fifteenth-century fortress.

366. The earliest part of Crichton Castle is the fourteenth-century tower-house (centre); the gables and chimneys of Francis Stewart's late sixteenth-century palace range are on the right.

367. The Italianate facade of Francis Stewart's range at Crichton has an open pillared loggia at courtyard level with exaggerated diamond-faceting above.

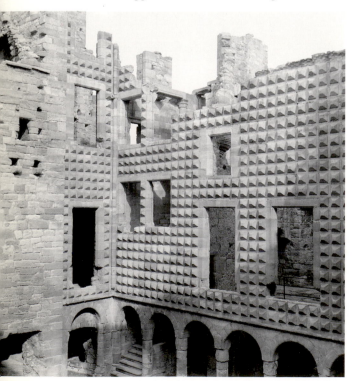

longest, some felt they could anticipate a better future. Tower-houses multiplied in Tudor and Stuart Ireland, from Roodstown (plate 332) to Ballynahow, Ballynacarriga to Ballygalley, Ross Castle to Kirkistown and Two-Mile Borris. There were big defended mansions, loopholed for musketry, at Mallow and Kanturk, Castle Caulfield, Burncourt and Portumna. Stockades, fortified farmhouses and campaign forts – Mountjoy and Benburb, Tully and Monea, Parke's Castle and Dalway's Bawn – supported the Protestant plantations.[106] Nevertheless Justice and Equity, flanking busts of Queen Elizabeth, feature repeatedly in the great stucco frieze of Thomas Butler's Long Gallery at Ormond Castle (Tipperary). Ormond, built in the late 1560s, is a gabled mansion in the open, undefended English style, learnt in long attendance at Elizabeth's court. With its many mullioned windows and pleasant garden setting, Ormond celebrates the virtues of good order. Only Butler's backing castle is still Irish.[107]

Earl Thomas kept the family castle with good reason. Troubled by the hostility of the fitz Gerald Desmond earls, he spent most of his long life in war and feud. But he probably also felt what others knew instinctively: the challenge and sweet allure of ancient stones. Inevitably, there were those who, fearful of old ways, demanded a clean break with the past. 'How then,' asked the born-again jurist Henry Barrow,

> do they [the parish churches] still stand in their old idolatrous shapes, with their ancient appurtenances, with their courts, cells, aisles, chancel, bells, etc.? Can these remain and all idolatrous shapes and relics be purged from them? Which are so inseparably inherent unto the whole building, as it can never be cleansed of this fretting leprosy, until it be desolate, laid on heaps, as their younger sisters, the abbeys and monasteries are?[108]

But Barrow was hanged for his beliefs on 6 April 1593. And the majority of his

368. Lulworth Castle was built for Thomas Howard in c.1608. It repeats the plan – but little else – of an Edwardian angle-towered fortress of the late thirteenth century.

369. Sir Charles Cavendish's 'Little Castle' at Bolsover (Derbyshire), on which work began in 1612, was a deliberate harking back to the Middle Ages.

370. Gothic vaults and a Renaissance fireplace in the Pillar Chamber of Bolsover's 'keep'.

371. Sir John Perrot made a stylish residence for himself in 1588–92 out of the late thirteenth-century Carew Castle, in South Wales.

fellow countrymen reacted as did their queen, welcoming the preservation of old churches and other buildings: 'for that we be moved for our honour and for memory to be preserved of antiquity that such monuments be rather saved than taken away'.[109] If ancient ruins, in the medieval gloaming, had ever inspired 'horror and grisly dread', they had plainly ceased to do so before 1600. Hidden away in the narrow court of Francis Stewart's Crichton Castle (Midlothian) is the most remarkable Renaissance monument of all Scotland. It is a Mannerist palace range of the mid-1580s, with the exaggerated diamond-faceting found on southern buildings of its date, in particular the Palazzo dei Diamanti (1582) in Ferrara. It has a handsome pillared loggia and geometric stair. Stewart, who had just returned from the Continent, built an Italianate facade which was modishly urban, as if intended for the public spaces of a *piazza*. Yet Crichton was in the remote countryside, alone and antique: a trysting-place for dragons and for owls.[110]

It was Edmund Spenser (d.1599), prophet of the new chivalry, who mused at Verulamium (St Albans) on the 'High towers, fair temples, goodly theatres, / Strong walls, rich porches, princely palaces, / Large streets, brave houses, sacred sepulchres, / Sure gates, sweet gardens, stately galleries', now fallen to 'weeds

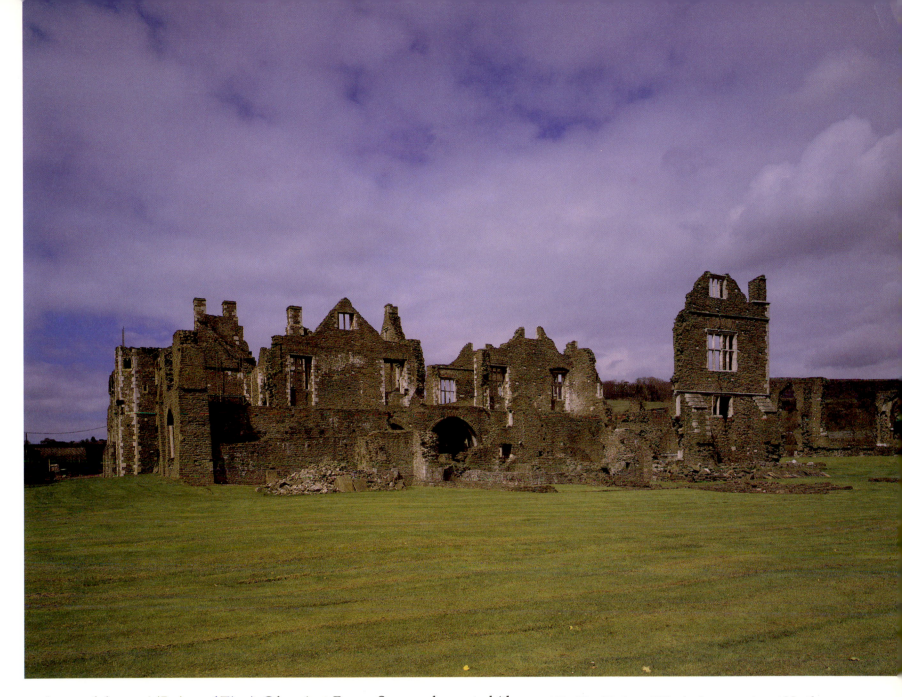

and wasteful grass' (*Ruines of Time*). Of ancient Rome, Spenser lamented 'these haughty heaps, these palaces of old, / These walls, these arcs [arches], these baths, these temples high' (*Ruines of Rome*).[111] And it was the widely shared experience of ruins of every kind which gave instant form and substance to a cult. That cult was largely literary. However, it found expression also in a rash of pseudo-fortresses – at Sir Thomas Gorges' Longford Castle (Wiltshire) and Viscount Bindon's Lulworth Castle (Dorset); at Sir John Trevor's Plas-teg (Flintshire) and Sir Thomas Morgan's Ruperra (Glamorgan); at the keep, or 'Little Castle', at Bolsover (Derbyshire), designed by Robert Smythson for Sir Charles Cavendish in 1612 and the most fancifully Spenserian of them all.[112]

Central to the success of Edmund Spenser's *Faerie Queene* was a general predisposition to nostalgia. Aristocratic builders everywhere felt drawn to a fine ruin, whether of a castle, a monastery, or a church. Thus the Cliffords of Skipton, as early as 1535, chose the cramped Conduit Court of their ageing Yorkshire fortress as the site for a fine new suite of lodgings.[113] In the 1540s, Sir John Byron's conversion of the suppressed priory at Newstead (Nottinghamshire) preserved both the canons' cloister and their church-front (plate 145).[114] Thomas Lord D'Arcy's archaizing viewpoint tower, in the former grounds of St Osyth's

372. The Herberts' Elizabethan mansion at Neath Abbey was a late sixteenth-century rebuilding of the former abbot's lodgings, reusing stone and other materials from the adjoining ruins.

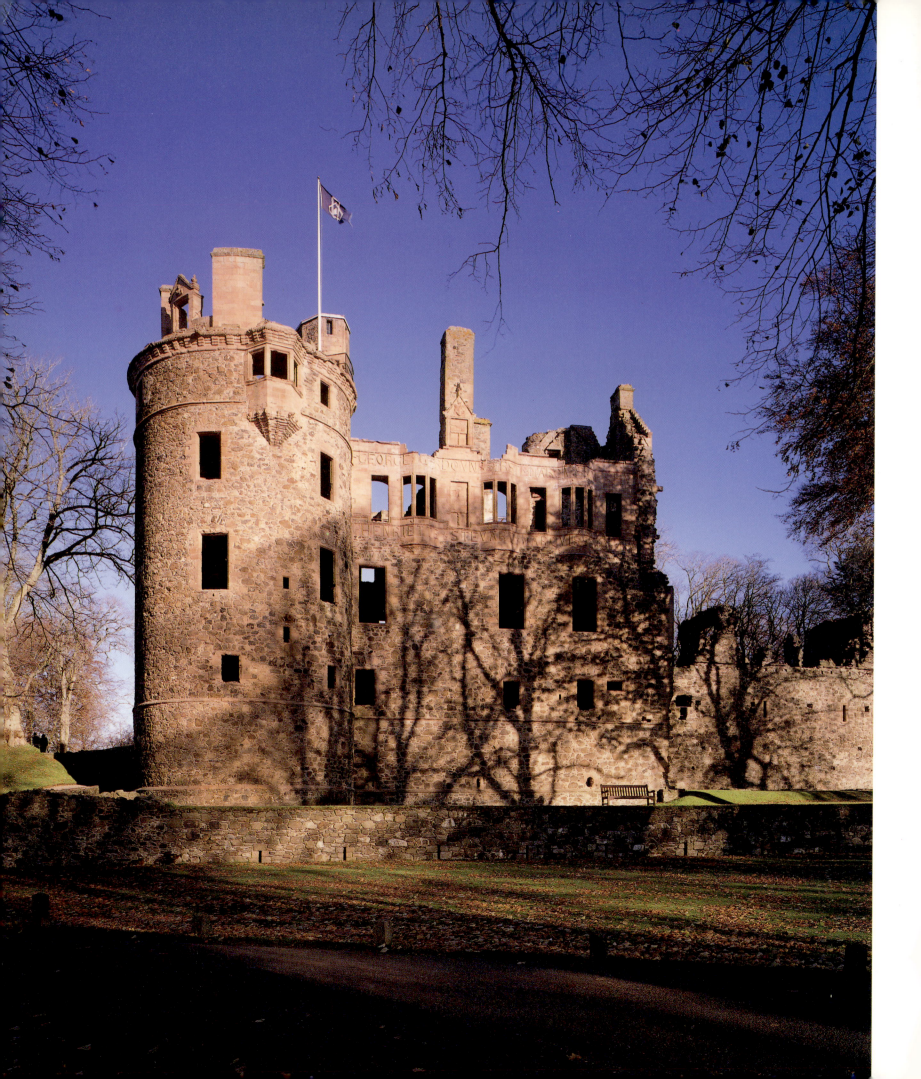

Abbey (Essex), belongs to the following decade.[115] In the mid-century, the Colcoughs made a mansion of the abbey church at Tintern (Wexford), and it was in the 1550s again that Richard Fiennes, rather than rebuild elsewhere, undertook expensive modernizations at Broughton Castle (Oxfordshire), raising the hall range to accommodate more lodgings, and cheering his new interiors with smart French plasterwork.[116] Before the end of the century, an impressive ruin was more likely to attract new building than to repel it. In this way, Sir John Perrot built at Carew Castle (Pembrokeshire) and Sir John Herbert at Neath Abbey (Glamorgan), Sir Robert Corbet at Moreton Corbet Castle (Shropshire) and Sir Edward Seymour at Berry Pomeroy Castle (Devon), each adding a large new mansion to what was there.[117]

Conservative work, continuing the Gothic tradition, remained long the scholars' choice at Oxbridge colleges.[118] At the parish churches, the appeal of medieval building styles was never lost.[119] However, the return to the past was nowhere made more consciously than in Robert Maxwell's rebuilding of old Caerlaverock. Maxwell chose Caerlaverock not for its strength but for its legend. Within this great Edwardian fortress on Solway Firth, once the most powerful of its kind, he located the 'dainty fabrick' of a miniature Renaissance palace – as neat, exact and playful as any doll's house.[120] Maxwell built for the debate and delectation of his more sophisticated friends, as appreciative of a splendid castle as himself. In 1634, when Caerlaverock was restored, that appreciation was already part of their culture. One of the last scenes of John Webster's *The Duchess of Malfi* (1612) is set among the ruins of an 'ancient Abbey'. Here, reflects Antonio,

> in this open court,
> Which now lies naked to the injuries
> Of stormy weather, some men lie interr'd
> Lov'd the church so well, and gave so largely to't,
> They thought it should have canopi'd their bones
> Till doomsday.

In his own final hour, Antonio offers their tortured spirits some consolation. He tells Delio, his friend:

> I do love these ancient ruins:
> We never tread upon them, but we set
> Our foot upon some reverend history.[121]

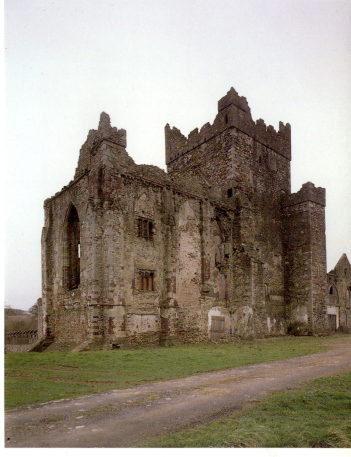

373. At Huntly in Aberdeenshire, George Gordon, first marquess of Huntly (d. 1636), restored his family's twice-pillaged castle rather than build on a new site elsewhere; among Gordon's improvements and additions to Huntly in 1602–6 were the elegant French-style oriels of the south front.

374. The Colcloughs' makeshift conversion into a family residence of the Cistercian church at Tintern (Wexford) was undertaken within a generation of the suppression of 1536.

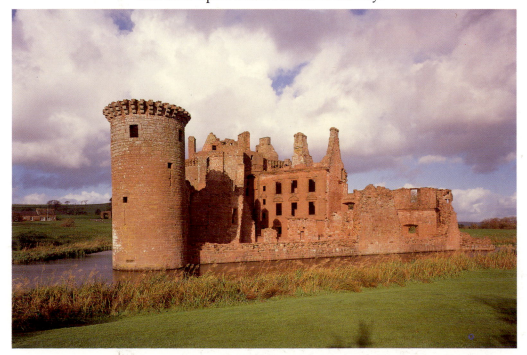

375. The Renaissance palace range (centre) was Robert Maxwell's incongruous addition to the great triangular fortress at Caerlaverock, otherwise little changed since the siege of 1300. Maxwell's range is dated 1634.

Glossary

Advowson the patronage of a church; the right of presentation to a benefice.

Aisle the part of a church, on either side of nave or chancel, usually separated off by an arcade.

Alien priory a religious establishment, not always conventual, owing obedience to a mother-house outside Britain.

Ambulatory the walking-place, or aisle, round the east end of a church, behind the high altar.

Appropriation the formal transfer to a monastic house of the lands, tithes and other receipts of a parish church, usually conditional on the appointment of a vicar.

Apse the semicircular termination of a chancel, chapel or chapter-house at its eastern end.

Arcade a line of columns supporting arches, as in **nave arcade**

Arrouaisian a contemplative branch (like the Victorines) of the Augustinian 'family' of canons.

Asperge to sprinkle, as in 'asperging the altar', with holy water.

Assarter one who clears and encloses untilled land for cultivation.

Attainder the forfeiture, following a treason or felony, of lands and rights.

Augustinian communities of priests, also known as Austin canons, who adopted the Rule of St Augustine; first officially recognized during the second half of the eleventh century.

Aumbry a locker or cupboard, usually in the north chancel wall, for the safe-keeping of service-books and sacramental vessels.

Austin Friars originally congregations of hermits, brought together in 1256 as the Hermit Friars of St Augustine.

Bailey the defended outer court of a castle.

Banlieu the area controlled by a monastic house, as in the *banlieu* of Battle Abbey.

Barbican an outer defensive work, sometimes taking the form of a gated bridge or ramp, before the entrance of a castle.

Bartisan a battlemented turret projecting at roof-level from the corner of a tower-house.

Bastion an earthwork or walled projection from the line of an artillery fortification, intended to provide flanking fire.

Bawn a walled and fortified enclosure, attached to a tower-house.

Bay the division of a building, as marked by a unit of roof-vaulting etc.

Bedesman the inmate of an almshouse, offering prayers for the soul of his benefactor.

Benedictine the oldest of the monastic orders, also known as 'black monks', observing the sixth-century Rule of St Benedict and first brought under a collective discipline by Benedict of Aniane in 817.

Blind arcade the decorative treatment of a wall by setting blank arches against it.

Bonshommes priest brethren, under a rector, established at only two English houses (Ashridge and Edington) and following the Rule of St Augustine.

Bridgettine a double order of nuns, with resident monks as their spiritual advisers, founded by Bridget of Sweden in the mid-fourteenth century and introduced to England by Henry V in 1415.

Burgess the inhabitant of a borough, entitled to burghal privileges.

Burh an Anglo-Saxon fortified town or other major defended place not necessarily urban.

Canon (regular canon) a priest living in a community under a common rule, usually that of St Augustine.

Capella ante portas the chapel by the gate of a Cistercian house, provided for the use of travellers and other visitors denied entry to the monks' church.

Carmelite originally the mid-twelfth-century Order of Our Lady of Mount Carmel; reorganized as friars ('white friars') in the thirteenth century.

Carthusian a contemplative order of hermit monks, bound to silence, founded by St Bruno in 1084 at La Grande Chartreuse, near Grenoble.

Cartulary a book, or register, of charters.

Castellan the governor of a castle.

Cenotaph a sepulchral monument.

Chancel the eastern part of a church, reserved to the clergy, separated from the nave by a screen.

Chantry a chapel or altar endowed by its founder to support memorial masses in his name.

Chapter-house the chamber, usually centrally placed in the east claustral range of a monastic house, where the community met daily to conduct business and to receive instruction, including the reading of a chapter of the rule.

Charterhouse a house of Carthusian monks.

Chevet an ambulatory with radiating chapels at the east end of a major church.

Choir the part of a church, equipped with stalls, where the community gathered to sing mass.

Chrismatory a small box or other vessel, usually of metal, for keeping the holy oil.

Ciborium a chalice-shaped vessel, with a lid, for the consecrated bread (the reserved Host).

Cistercian reformed Benedictines, also known as 'white monks', established at Cîteaux by Robert of Molesme in 1098 and later greatly increased under the leadership of Bernard of Clairvaux (d.1153).

Clerestory the upper part of the main walls of a church, above the line of the aisle roofs, pierced by windows to light the interior.

Cloister a covered exercise and study space, usually to the south of a monastic church.

Cluniac Benedictine monks of the 'family' of Cluny (Burgundy), founded in 909, and always headed by the abbot of Cluny.

Coign and livery hospitality exacted by Irish lords from their tenants to maintain armed followers.

Comital classes those of (or equivalent to) the rank of a count or an earl.

Conventual of (or belonging to) a religious house.

Corbel a stone or timber projection from the face of a wall, intended to support a beam or gallery.

Corona the crown of radiating chapels sometimes found at the east end of a major church.

Corrody (corrodian) a pension or agreed maintenance in food, clothing and lodging, usually obtained by the individual corrodian in return for a gift of money or land.

Crenellate to furnish with battlements, as in **licence to crenellate**; in effect, to fortify.

Crocket an ornamental leaf-like projection on a gable or pinnacle.

Crosslet loophole an arrow-slit in the form of a cross.

Crossing that part of a cruciform church where the nave, chancel and transepts intersect.

Crucks curved timbers supporting the ridge beam of a roof.

Crypt the chamber, usually below ground and under the east end of a church, where relics were commonly housed and displayed.

Curtain the wall, usually free-standing and equipped with interval or angle towers, which enclosed a castle courtyard.

Custumal a book of customs.

Demesne land kept in hand by its owner and not leased out to another.

Denizen native, not foreign; as in **denizen status**.

Dominican an order of friars, also known as the Friars Preachers or 'black friars', founded by St Dominic (d. 1221).

Dormitory (dorter) the common sleeping-chamber of the monks.

Drum tower a circular tower, usually a mural tower of some kind or (more rarely) a keep.

Easter sepulchre a cupboard or tomb recess on the north wall of the chancel, carved with scenes of the Burial and Resurrection of Christ.

Enceinte a fortified enclosure.

Escheat the reversion of a fief to the lord on the death without heir of his tenant.

Escutcheon a coat of arms on a sculptured shield.

Eucharist the Communion, or Sacrament of the Lord's Supper.

Eyre a circuit court held by itinerant justices.

Farm the annual payment due for an estate; a town's annual tax.

Feoffee a person invested with a fief (enfeoffed).

Feretory a shrine constructed to house important relics.

Fief an estate held in return for homage and service; a feudal benefice.

Finial a carved ornament at the top of a pinnacle or gable.

Flushwork flint and dressed stone, contrasted with each other to make patterns.

Fontevraldine a double order of nuns and monks, headed by the abbess of Fontevrault, founded by Robert d'Arbrissel in 1100.

Forebuilding a covered stair, sometimes including a chapel on its upper storey, protecting the first-floor entrance of a tower keep.

Fortalice a small fort or castle.

Franciscan an order of friars, also known as the Friars Minor or 'grey friars', founded by Francis of Assisi in 1209 and vowed to corporate poverty.

Frater a monastic refectory or eating-place.

Friar a member of one of the Mendicant orders (the chief of these being the Franciscans, the Dominicans, the Carmelites and the Austin Friars), vowed to corporate poverty.

Garderobe a privy or lavatory.

Gilbertine a community of nuns, observing the Cistercian discipline, founded by Gilbert of Sempringham in c. 1131; later reorganized as a double order of nuns and canons.

Gild a fellowship, or confraternity, formed for the mutual benefit of its members; some gilds were trade associations, but many more functioned as cooperative chantries associated with a local parish church.

Grandmontine an order of hermit monks, founded at Grandmont by Stephen of Muret (d. 1124) and dedicated to extreme austerity, poverty and silence.

Hammerbeams horizontal brackets at the top of a wall, supporting the arched braces of a **hammerbeam roof**.

Heriot the best beast or chattel of a deceased tenant, owed to the lord.

Hospitallers a military order, also known as Knights of the Order of the Hospital of St John of Jerusalem, dedicated to the provision of hospitality for pilgrims, to the care of the sick, and to the protection of the Holy Land; founded in the early twelfth century.

Infirmary a building assigned to the care of the sick.

Interval tower a mural tower; one of a number of towers set along the length of a curtain wall.

Jetty projecting floor joists in a timber-framed building, supporting an overhang.

Justiciar the principal political and judicial officer of Anglo-Norman and Angevin England, as in **chief justiciar**.

Keep the principal tower, usually residential, of a castle.

Lavatorium the monks' wash-place, in the cloister next to the refectory door.

Lay brother a man, usually illiterate and of lower social status than a monk, who had nevertheless taken the vows of the order and was employed by the community on manual work.

Loggia an arcade open at one side to catch the sun.

Louver a ventilator in the roof of a hall or kitchen, provided to get rid of the smoke.

Machicolation an opening in the floor of a projecting parapet or fighting gallery, through which missiles could be rained on an attacker.

Mendicants friars vowed to poverty and bound by their rule to maintain themselves by begging.

Messuage a dwelling-house with attached court or yard.

Minorites the Friars Minor (Franciscans).

Misericord the chamber in a monastery where meat, otherwise not permitted by the rule, might be eaten.

Mortmain 'dead hand'; lands described as held in mortmain included the inalienable property of the Church.

Motte a castle mound, characteristically shaped like an upturned basin and usually furnished with an outer court or bailey: hence **motte and bailey**.

Mullion the vertical bar between the lights of a window.

Narthex the vestibule, also known as a **Galilee**, at the west end of a major church, sometimes taking the form of a porch.

Nave the body of a church, used for worship by the parishioners.

Newel stair a circular stair winding round a newel, or central pillar.

Obedientiary an official in a monastic community, charged with a particular 'obedience' or duty.

Obit a memorial mass celebrated annually on the mind-day of a deceased person, usually the anniversary of his death.

Observants friars of the Franciscan order advocating (from the later fourteenth century) a return to the primitive Rule of St Francis.

Oriel a projecting upper window, supported on corbels.

Oyer and terminer as in the 'commissions of oyer and terminer', empowering royal justices to hear and determine criminal indictments.

Parclose screen a screen shutting off a chapel or chancel aisle.

Pentice a covered way or gallery.

Pier a pillar supporting an arch.

Piscina a basin provided in the south chancel wall for the washing of the chalice and for the priest's ablutions.

Pittancer the official charged with the distribution of monastic allowances or doles.

Portcullis a heavy timber grating designed to close off an entrance passage, sliding vertically in grooves cut on either side to receive it.

Portmanmoot a meeting of the burgesses (**portmen**) appointed to administer the affairs of a borough.

Possessioner an endowed religious community (as in **Possessioner houses**); the word was commonly applied to the older orders – the Benedictines, Cistercians, Augustinians and others – to distinguish them from advocates of evangelical poverty like the Mendicants.

Postern the side or lesser gate of a castle.

Prebend the revenues granted to a cleric (**prebendary**) as his stipend.

Precentor a monk or canon who leads the singing in the choir.

Premonstratensian an order of canons, also known as 'white canons', founded in 1120 by St Norbert.

Presbytery the eastern arm of a major church, east of the choir, containing the high altar.

Priory cell a dependent priory, having three or four monks, usually functioning also as an estate-centre.

Pulpitum a partition or screen, often of stone, separating the monks' choir from the nave.

Pyx a vessel, usually a box, for holding the consecrated bread.

Rebus a pictorial badge signifying the name of an individual.

Reeve the bailiff or steward of an estate; also applied to minor officials like the **barn-reeve**.

Refectory the common eating-place, also known as the **frater**, of the monks.

Reliquary a box or other container for relics.

Reredorter a building, at the far end of the dormitory from the church, housing the monks' latrines.

Reredos a screen, often carved and painted, behind the high altar.

Retable an altar-piece; a painting or a frame holding sculptures, fixed to the back of an altar.

Rib vault a vault in which diagonal ribs support the vault spaces between.

Ringwork a defensive bank and ditch, circular or oval in plan, surrounding a hall or other buildings.

Rood the great cross, or crucifix, placed on the rood-beam in a chancel arch, over the **rood-screen**.

Savigniac a colony of hermits founded at Savigny in 1105 by Vitalis of Mortain and later developed as an order of monks; merged with the Cistercians in 1147.

Screens passage the entrance passage, crossing the lower end of the hall, between the service doors and hall screen.

Sedilia the seats (usually three) of the priest, deacon and subdeacon; in the south chancel wall, west of the piscina.

Shell-keep a tower made by circling the top of a castle mound with a stone curtain wall.

Solar a private chamber, reserved for the lord and his family, at the dais end of the hall.

Spere-truss an arch formed of piers supporting a tie-beam at the service end of a timber-framed hall.

Spiritualities properties and revenues obtained in return for spiritual services.

Stalls the seats, often carved and canopied, in the choir.

Strainer arch an arch between two piers (or walls), inserted to relieve pressure and prevent bulging.

Succentor the chanter in a monastic or cathedral choir, who takes up the chant following the precentor.

Templars a military order, also known as the Poor Knights of Christ and the Temple of Solomon, founded by Hugh de Payens in 1118 for the protection of pilgrims in the Holy Land.

Temporalities the material possessions and revenues of a religious house.

Terrier a register of lands and rents.

Thegn a freeman, or member of the Anglo-Saxon lesser nobility, holding his land by military service.

Tironensian an order of monks founded at Tiron by Bernard (d.1117) and much influenced by the contemporary Cistercians.

Tithe a tax, payable to the rector, of the tenth part of all agrarian produce.

Transepts the two arms, north and south, of a cruciform church.

Triforium the arcade, usually purely decorative, between the nave (or chancel) arcade and the clerestory.

Undercroft a chamber, frequently vaulted, underlying an important apartment like a dormitory, refectory or chapel.

Victorine Augustinian canons of St Victor (Paris), known in the twelfth century for the superior quality of their scholarship and observance.

Vill a territorial division comprising houses and their lands; a township.

Villein a peasant holding his lands by bond-service (in **villeinage**).

Wall-walk the passage or fighting platform behind the parapet of a tower or curtain wall.

Wapentake an administrative division, equivalent to a hundred, of an English county.

Ward the court or bailey of a castle.

Warming-house the common chamber, also known as the **calefactory**, where the monks might warm themselves at the fire.

Weeper a sculptured mourning figure against the side of a tomb-chest.

Abbreviations

Ant. J.	*Antiquaries Journal*
Arch.	Archaeology, archaeological
Arch. J.	*Archaeological Journal*
Assoc.	Association
Brit.	British
Bull.	Bulletin
Bull. Inst. Hist. Res.	*Bulletin of the Institute of Historical Research*
Cal. Pat. Rolls	*Calendar of the Patent Rolls*
Coll.	Collections
E.H.R.	*English Historical Review*
Ec.H.R.	*Economic History Review*
Geog.	Geography
H., Hist.	History, historical
Inst.	Institute
J.	Journal
J. Brit. Arch. Assoc.	*Journal of the British Archaeological Association*
J. Eccl. H.	*Journal of Ecclesiastical History*
Mag.	Magazine
Med. Arch.	*Medieval Archaeology*
Nat.	Natural
Proc.	Proceedings
R.	Review
RAI	Royal Archaeological Institute
RCHM	Royal Commission on Historical Monuments
Soc.	Society
Stud.	Studies
T., Trans	Transactions
T.R.H.S	*Transactions of the Royal Historical Society*
VCH	*Victoria History of the Counties of England*

Note: Individual volumes in Nikolaus Pevsner's *The Buildings of England* series are given thus: *Berkshire*, 1966; *Dorset*, 1972 etc.

Where no author is named in a National Trust or other guide, I have adopted the form: *Rufford Old Hall, Lancashire*, 1983 etc. The date in each case is of the publication used, which may not always be the current edition.

Notes

Chapter 1
Conquest and Aftermath

1 Goscelin's narrative is quoted by Humphrey Woods, 'The completion of the abbey church of Saint Peter, Saint Paul and Saint Augustine, Canterbury, by the Abbots Wido and Hugh of Fleury', in *Medieval Art and Architecture at Canterbury before 1220*, British Archaeological Association, 1982, p.121.

2 Antonia Gransden, 'Cultural transition at Worcester in the Anglo-Norman period', in *Medieval Art and Architecture at Worcester Cathedral*, British Archaeological Association, 1978, p.10.

3 Henry Thomas Riley (ed.), *Gesta Abbatum Monasterii Sancti Albani a Thoma Walsingham*, Rolls Series, 1867, i:62.

4 John Scott (ed.), *The Early History of Glastonbury*, 1981, pp.156–9.

5 Arnold William Klukas, 'The architectural implications of the *Decreta Lanfranci*', in *Anglo-Norman Studies VI* (ed. R. Allen Brown), 1984, pp.136–71.

6 Ibid., pp.161–3.

7 Derek Phillips, *Excavations at York Minster. Volume II. The Cathedral of Archbishop Thomas of Bayeux*, RCHM, 1985, p.7.

8 Christopher Wilson, 'Abbot Serlo's church at Gloucester (1089–1100): its place in Romanesque architecture', in *Medieval Art and Architecture at Gloucester and Tewkesbury*, British Archaeological Association, 1985, pp.52–83.

9 Richard Gem, 'The Romanesque cathedral of Winchester: patron and design in the eleventh century', in *Medieval Art and Architecture at Winchester Cathedral*, British Archaeological Association, 1983, pp.1–12.

10 Ibid., passim.

11 Christopher Wilson, op. cit., p.73; and for Normandy influence in general, see Eric Fernie, 'The effect of the Conquest on Norman architectural patronage', in *Anglo-Norman Studies IX* (ed. R. Allen Brown), 1987, pp.71–85.

12 David C. Douglas and George W. Greenaway (eds), *English Historical Documents 1042–1189*, 1953, pp.606–7.

13 Marjorie Chibnall, *Anglo-Norman England 1066–1166*, 1986, p.39.

14 David Bates, 'The building of a great church: the abbey of St Peter's, Gloucester, and its early Norman benefactors', *Trans Bristol and Gloucestershire Arch. Soc.*, 102(1984), pp.129–32.

15 Quoted by Marjorie Chibnall, op. cit., p.216.

16 Antonia Gransden, *Historical Writing in England c.550–c.1307*, 1974, pp.166–85.

17 David Bates, op. cit., pp.130–1.

18 John Clifford Perks, *Chepstow Castle*, 1967; also the same author's 'The architectural history of Chepstow Castle during the Middle Ages', *Trans Bristol and Gloucestershire Arch. Soc.*, 67(1946–8), pp.307–46; and Jeremy K. Knight, *Chepstow Castle*, 1986.

19 The Castle Acre sequence is admirably described and illustrated by J.G. Coad and A.D.F. Streeten, 'Excavations at Castle Acre Castle, Norfolk, 1972–77. Country house and castle of the Norman earls of Surrey', *Arch. J.*, 139(1982), pp.138–301. A possible parallel, recently suggested, is the lower stage of the keep at Portchester, as built for William Mauduit I in the late eleventh century (Barry Cunliffe and Julian Munby, *Excavations at Portchester Castle. Volume IV: Medieval, the Inner Bailey*, Reports of the Research Committee of the Society of Antiquaries of London 43, 1985, pp.74–6.

20 Quoted by R. Allen Brown, *English Castles*, 1976 (3rd edn), p.40, at the start of a characteristically forthright defence of the thesis that the castle arrived only with the Normans.

21 Antonia Gransden, op. cit., pp.151–65.

22 Christopher J. Tabraham, 'Norman settlement in Galloway: recent fieldwork in the Stewartry', in *Studies in Scottish Antiquity presented to Stewart Cruden* (ed. David J. Breeze), 1984, pp.114–17.

23 R. Allen Brown, op. cit., pp.22–39.

24 Guy Beresford, *Goltho. The Development of an Early Medieval Manor c.850–1150*, 1987. A less certain parallel is Sulgrave, for which unfinished pre-Conquest defences have been claimed (Brian K. Davison, 'Excavations at Sulgrave, Northamptonshire, 1960–76', *Arch J.*, 134(1977), pp.105–14).

25 Guy Beresford, op. cit., pp.85–110.

26 For the important and long-continuing excavations at Hen Domen, see Philip Barker and Robert Higham, *Hen Domen, Montgomery. A Timber Castle on the English–Welsh Border*, Royal Archaeological Institute, 1982.

27 The ramparts were previously thought to be Roman, but see Russell Chamberlin, *Carisbrooke Castle*, 1985.

28 Brian K. Davison, 'Castle Neroche: an abandoned Norman fortress in South Somerset', *Somerset Arch. and Nat. Hist.*, 116(1972), pp.16–58.

29 *Med. Arch.*, 13(1969), pp.258–9; 23(1979), p.263.

30 S.E. Rigold, 'Eynsford Castle and its excavation', *Arch. Cantiana*, 86(1971), pp.109–71.

31 Ibid., p.140 (conjectural reconstructions).

32 R.J. Ivens, 'Deddington Castle, Oxfordshire, and the Norman honour of Odo of Bayeux', *Oxoniensia*, 49(1984), pp.101–19.

33 For a recent useful discussion of Bramber, otherwise little recorded, see K.J. Barton and E.W. Holden, 'Excavations at Bramber Castle, Sussex, 1966–67', *Arch. J.*, 134(1977), pp.11–79.

34 Colin Flight and A.C. Harrison, 'Rochester Castle, 1976', *Arch. Cantiana*, 94(1978), pp.27–60.

35 H.M. Colvin (ed.), *The History of the King's Works*, 1963, i:29–32, and R. Allen Brown and P.E. Curnow, *Tower of London*, 1984, passim; also R. Allen Brown, 'Some observations on the Tower of London', *Arch. J.*, 136(1979), pp.99–108, and P.J. Drury, 'Aspects of the origins and development of Colchester Castle', ibid., 139(1982), pp.302–419.

36 John Blair and John M. Steane, 'Investigations at Cogges, Oxfordshire, 1978–81: the priory and parish church', *Oxoniensia*, 47(1982), pp.47–8.

37 Marjorie Chibnall, *The World of Orderic Vitalis*, 1984, p.47.

38 Ibid., pp.49–50.

39 John Blair and John M. Steane, op. cit., p.44; for patrons' claims in general, see Emma Mason, 'Timeo barones et donas ferentes', *Studies in Church History*, 15(1978), pp.61–75.

40 Donald Matthew, *The Norman Monasteries and their English Possessions*, 1962, pp.30–1.

41 Ibid., pp.33–4; also Rose Graham, 'Four alien priories in Monmouthshire', *J. Brit. Arch. Assoc.*, 35(1929), pp.102–3.

42 W. Budgen, 'Wilmington Priory: historical notes', *Sussex Arch. Coll.*, 69(1928), pp.30–1.

43 John Blair and Barry McKay, 'Investigations at Tackley Church, Oxfordshire, 1981–4: the Anglo-Saxon and Romanesque phases', *Oxoniensia*, 50(1985), p.26.

44 A.J. Taylor, 'The alien priory of Minster Lovell', ibid., 2(1937), p.103; H.E. Salter (ed.), *Newington Longeville Charters*, Oxfordshire Record Series 3, 1921, pp.xii–xiii.

45 C.A. Ralegh Radford, 'The church of St Peter, Wootton Wawen', *Arch. J.*, 136(1979), pp.76–89.

46 *VCH Warwickshire*, ii:133–5.

47 Donald Matthew, op. cit., pp.38–41.

48 John Blair and Barry McKay, op. cit., pp.28, 44–5.

49 A.J. Taylor, op. cit., pp.103–4; also Donald Matthew, op. cit., p.58.

50 Donald Matthew, op. cit., p.66.

51 J.S. Brewer (ed.), *Giraldi Cambrensis Opera. Speculum Ecclesiae*, iv:33–7.

52 John Blair and John M. Steane, op. cit., p.53.

53 H.E. Salter, op. cit., p.xvi.

54 Donald Matthew, op. cit., pp.29, 43, 52, 62, 66.

55 Marjorie Morgan, *The English Lands of the Abbey of Bec*, 1968, p.39.

56 Ibid., p.12.

57 Brian Golding, 'The coming of the Cluniacs', in *Anglo-Norman Studies III* (ed. R. Allen Brown), 1981, pp.65–77.

58 W.G. Thomas, 'Monkton Priory Church', *Arch. J.*, 119(1962), pp.344–5.

59 *VCH Staffordshire*, iii:331–40.

60 *VCH Lancashire*, ii:167–73.

61 David Knowles, *The Monastic Order in England*, 1966 (2nd edn), pp.134–6.

62 For a plan and brief description, see *Arch. J.*, 124(1967), pp.253–4.

63 Donald Matthew, op. cit., pp.45–6; *Sussex*, 1965, pp.114–18.

64 *VCH Hampshire*, iv:231, 235–7.

65 *Sussex*, 1965, p.337.

66 Ibid., pp.276–81, 285–7.

67 *Gloucestershire. The Cotswolds*, 1970, p.316 and plate 21: *VCH Gloucestershire*, xi:162–4, 201–4.

68 Eleanor Searle (ed.), *The Chronicle of Battle Abbey*, 1980, pp.36–7.

69 Ibid., pp.42–5.

70 Ibid., pp.50–3.

71 Ibid., pp.36–7.

72 David Knowles, op. cit., p.149.

73 Frank Barlow, 'William I's relations with Cluny', *J. Eccl. H.*, 32(1981), pp.131–41.

74 Eleanor Searle, op. cit., pp.46–7.

75 For comparative plans, see my own *The Abbeys and Priories of Medieval England*, 1984, p.10. For the Cluny III of Abbots Hugh and Peter the Venerable, see Wolfgang Braunfels, *Monasteries of Western Europe. The Architecture of the Orders*, 1972, pp.58–63.

76 F.J.E. Raby and P.K. Baillie Reynolds, *Castle Acre Priory*, 1952; C. Vincent Bellamy, *Pontefract Priory Excavations 1957–1961*, Publications of the Thoresby Society 49, 1965; F.J.E. Raby and P.K. Baillie Reynolds, *Thetford Priory*, 1979; Rose Graham, *The History of the Alien Priory of Wenlock*, 1965.

77 Brian Golding, op. cit., p.77.

78 David Knowles, op. cit., p.153.

79 Arnold William Klukas, op. cit., p.139.

80 B. Dodwell, 'The foundation of Norwich Cathedral', *T.R.H.S.*, 7(1957), p.9.

81 Edward Miller, *The Abbey and Bishopric of Ely*, 1951, pp.25, 67.

82 Edmund King, *Peterborough Abbey 1086–1310*, 1973, p.13.

83 Sandra Raban, *The Estates of Thorney and Crowland*, 1977, pp.24–5.

84 Barbara Harvey, *Westminster Abbey and its Estates in the Middle Ages*, 1977, pp.26–8.

85 Antonia Gransden, "Baldwin, abbot of Bury St Edmunds, 1065–1097", in *Anglo-Norman Studies IV* (ed. R. Allen Brown), 1982, pp.65–76.

86 B. Dodwell, op. cit., pp.14–17.

87 For a recent account of Wulfsin's cathedral, rebuilt by Bishop Aelfwold II (1045–58) with much emphasis on the proper housing of Wulfsin's relics, see J.H.P. Gibb and R.D.H. Gem, 'The Anglo-Saxon cathedral at Sherborne', *Arch. J.*, 132(1975), pp.71–110.

88 David Knowles, op. cit., p.130.

89 Bertram Colgrave and R.A.B. Mynors (eds), *Bede's Ecclesiastical History of the English People*, 1969, pp.409, 439.

90 David Knowles, op. cit., pp.166–8; M.G. Snape, 'Documentary evidence for the building of Durham Cathedral and its monastic buildings', in *Medieval Art and Architecture at Durham Cathedral*, British Archaeological Association, 1980, pp.21–2.

91 For a particularly vivid and enthusiastic description of Durham Cathedral, see Nikolaus Pevsner's *County Durham*, 1953, pp.77–110.

92 Geoffrey Webb, *Architecture in Britain. The Middle Ages*, 1956, pp.37–9; Eric Fernie, 'The spiral piers of Durham Cathedral', in *Medieval Art and Architecture at Durham Cathedral*, 1980, pp.49–58.

93 R.B. Dobson, *Durham Priory 1400–1450*, 1973, p.25

94 H.M. Taylor, *Anglo-Saxon Architecture*, 1978, iii:1014–17; and see also Martin Biddle, 'Archaeology, architecture, and the cults of saints in Anglo-Saxon England', *The Anglo-Saxon Church. Papers on History, Architecture and Archaeology in Honour of Dr. H.M. Taylor* (eds L.A.S. Butler and R.K. Morris), Council for British Archaeology Research Report 60, 1986, pp.1–31, and David Rollason, 'The shrines of saints in later Anglo-Saxon England: distribution and significance', ibid., pp.32–43; for a new and full study of Repton, see H.M. Taylor, 'St Wystan's Church, Repton, Derbyshire. A reconstruction essay', *Arch. J.*, 144(1987), pp.205–45. Norman regard for Anglo-Saxon saints, as against the more usually quoted scepticism, is strongly argued by S.J. Ridyard, '*Condigna veneratio*: post-Conquest attitudes to the saints of the Anglo-Saxons', in *Anglo-Norman Studies IX* (ed. R. Allen Brown), 1987, pp.179–206.

95 Rose Graham, 'The priory of La Charité-sur-Loire and the monastery of Bermondsey', in the same author's *English Ecclesiastical Studies*, 1929, pp.91–124.

Chapter 2
New Directions

1 William Dugdale, *Monasticon Anglicanum* (eds John Caley, Sir Henry Ellis and the Rev. Bulkeley Bandinel), 1846, v:12.

2 Brian Golding, 'The coming of the Cluniacs', in *Anglo-Norman Studies III* (ed. R. Allen Brown), 1981, p.72.

3 Giles Constable, *Monastic Tithes from their Origins to the Twelfth Century*, 1964, p.110.

4 B.W. Kissan, "An early list of London properties", *Trans London & Middx Arch. Soc.*, 8(1938), pp.57–69.

5 David C. Douglas (ed.), *The Domesday Monachorum of Christ Church Canterbury*, Royal Historical Society, 1944, pp.8–13, 78–9.

6 These churches, with others, are discussed by C.A. Ralegh Radford, 'Pre-Conquest minster churches', *Arch. J.*, 130(1973), pp.120–40.

7 H.M. Taylor, 'Deerhurst, Odda's Chapel', ibid., 122(1965), pp.233–5; and the same author's *Anglo-Saxon Architecture*, 1978, iii:738–9.

8 *North-East Norfolk and Norwich*, 1962, p.303.

9 Graham Cadnam *et al.*, *Raunds-Furnells. A Revised Chronology*, 1983; Andy Boddington, 'Raunds, Northamptonshire: analysis of a country churchyard', *World Archaeology*, 18(1987), pp.411–25.

10 Derek Keene, *Survey of Medieval Winchester* (Winchester Studies 2), 1985, pp.106–33.

11 James Campbell, 'Norwich', in *The Atlas of Historic Towns. Volume 2* (ed. M.D. Lobel), 1975, p.3.

12 Nigel Baker, 'Churches, parishes and early medieval topography', in *Medieval Worcester. An Archaeological Framework* (ed. M.O.H. Carver), Worcester Archaeological Society 7, 1980, p.31.

13 William Urry, *Canterbury under the Angevin Kings*, 1967, pp.210–11; Christopher Brooke and Gillian Keir, *London 800–1216: The Shaping of a City*, 1975, pp.122–48; and see also J. Campbell, 'The church in Anglo-Saxon towns', *Studies in Church History*, 16(1979), pp.119–35.

14 For some examples, see Peter R.V. Marsden, 'Archaeological finds in the city of London, 1963–4', *Trans London & Middx Arch. Soc.*, 21(1967), pp.217–19; W.F. Grimes, *The Excavation of Roman and Medieval London*, 1968, pp.182–209.

15 Martin Biddle, 'Excavations at Winchester, 1971. Tenth and final interim report: part II', *Ant. J.*, 55(1975), pp.312–20; B.J.J. Gilmour and D.A. Stocker, *St. Mark's Church and Cemetery*, Trust for Lincolnshire Archaeology, *The Archaeology of Lincoln, Volume XIII–I*, 1986, particularly pp.17–19; J.P. Roberts and Malcolm Atkin, 'St Benedict's Church (Site 157N)', in *Excavations in Norwich 1971–1978* (ed. Alan Carter), East Anglian Archaeology, *Report No. 15*, 1982, pp.11–29; J.R. Magilton, *The Church of St Helen-on-the-Walls, Aldwark*, York Archaeological Trust, *The Archaeology of York 10/1*, 1980.

16 *Med. Arch.*, 30(1986), pp.178–80 and plate XII; also *Current Archaeology*, 106(1987), pp.340–4.

17 William Urry, op. cit., pp.209–10.

18 Derek Keene, op. cit., pp.116–17, 126–8; Martin Biddle, op. et loc. cit.; also 'Excavations at Winchester, 1970. Ninth interim report', *Ant. J.*, 52(1972), pp.104–7, 111–15.

19 Stewart Cruden, *St Andrews Cathedral*, 1950, pp.5–7.

20 For a recent summary of the archaeological evidence, see Bridget Cherry, 'Ecclesiastical architecture', in *The Archaeology of Anglo-Saxon England* (ed. David M. Wilson), 1976, pp.151–200.

21 Donald Matthew, *The Medieval European Community*, 1977, p.212. For a cautious discussion of the English evidence, see Richard Gem, 'The English parish church in the 11th and early 12th centuries: a Great Rebuilding?', in *Minsters and Parish Churches. The Local Church in Transition 950–1200* (ed. John Blair), 1988, pp.21–30; good regional studies in the same volume include C.J. Bond's 'Church and parish in Norman Worcestershire' (pp.119–58) and Neil Batcock's 'The

parish church in Norfolk in the 11th and 12th centuries' (pp.179–90).

22 William Dugdale, op. et loc. cit.

23 For a good description of the church, with plan, see *VCH Warwickshire*, vi:236–9.

24 Dorothy M. Owen, *Church and Society in Medieval Lincolnshire*, 1971, p.5.

25 David C. Douglas, op. cit., p.78; *North East and East Kent*, 1983, pp.435–7 and plate 19.

26 *Buckinghamshire*, 1960, pp.242–3.

27 For these Germanic roots, see *Derbyshire*, 1953, p.181, and *Essex*, 1965, p.258.

28 N. Drinkwater, 'Hereford Cathedral: the bishop's chapel of St Katherine and St Mary Magdalene', *Trans Woolhope Naturalists' Field Club*, 35(1955–7), pp.256–60.

29 *An Inventory of Archaeological Sites and Churches in Northampton*, RCHM, 1985, p.47.

30 Ibid., pp.57–9, plates 13–15.

31 *North East and East Kent*, 1983, pp.133–5, 414–15.

32 *RCHM Herefordshire 1 – South-West*, 1931, pp.156–60.

33 *English Romanesque Art 1066–1200* (catalogue of the 1984 Hayward Gallery exhibition), p.178 and plate 139.

34 David Park, 'The 'Lewes Group' of wall paintings in Sussex', in *Anglo-Norman Studies VI* (ed. R. Allen Brown), 1984, pp.201–37; and see also Clive Rouse and Audrey Baker, 'The early wall paintings in Coombes Church, Sussex, and their iconography', *Arch. J.*, 136(1979), pp.218–28, and Audrey Baker, 'The wall paintings in the church of St John the Baptist, Clayton', *Sussex Arch. Coll.*, 108(1970), pp.58–81. For a re-dating of these paintings, not wholly convincing in my view, which places them in the immediate Conquest decades if not earlier, see R.R. Milner-Gullard, 'The problem of the early Sussex frescoes', *Southern History*, 7(1985), pp.25–54.

35 Sally P.J. Harvey, 'The extent and profitability of demesne agriculture in England in the later eleventh century', in *Social Relations and Ideas. Essays in honour of R.H. Hilton* (eds T.H. Aston, P.R. Coss, Christopher Dyer and Joan Thirsk), 1983, pp.45–72.

36 The words are those of Orderic Vitalis, giving Sir Richard Southern the theme for his much-quoted analysis, 'King Henry I', reprinted in *Medieval Humanism and Other Studies*, 1970, pp.206–33. For another more recent treatment, standing on Southern's shoulders, see C. Warren Hollister, 'Henry I and the invisible transformation of medieval England', in *Studies in Medieval History presented to R.H.C. Davies* (eds Henry Mayr-Harting and R.I. Moore), 1985, pp.119–31.

37 A.R. Bridbury, 'The farming out of manors', *Ec.H.R.*, 31(1978), pp.503–20; but see also Professor Postan's testy reply (ibid., pp.521–5).

38 K.J. Barton and E.W. Holden, 'Excavations at Bramber Castle, Sussex, 1966–67', *Arch. J.*, 134(1977), pp.11–79; J.G. Coad and A.D.F. Streeten, 'Excavations at Castle Acre Castle, Norfolk, 1972–77', *Arch. J.*, 139(1982), pp.138–301. For evidence of the over-hasty conversion of Lewes, resulting in collapse due to subsidence, see B. Wilcox, 'Timber reinforcement in medieval castles', *Chateau-Gaillard V*, 1972, p.194.

39 R. Allen Brown, *Rochester Castle*, 1969.

40 W. Douglas Simpson, *Castles in England and Wales*, 1969, pp. 58–61; *Hedingham Castle*, 1983.

41 Richard Southern, op. cit., pp.220–1.

42 This contemporary assessment is quoted by R. Allen Brown, in *Castle Rising*, 1978, p.13.

43 H.M. Colvin (ed.), *The History of the Kings Works*, 1963, i.38–9.

44 R. Allen Brown, op. cit. (1978), passim.

45 J.H. Williams, M. Shaw and V. Denham, *Middle Saxon Palaces at Northampton*, Northampton Development Corporation Archaeological Monograph 4, 1985; M.D. Lobel (ed.), *The Atlas of Historic Towns. Volume 2*, 1975 (for Bristol and Norwich).

46 M.D. Lobel, op. cit., p.8 (Norwich).

47 Ibid., pp.3–6 (Bristol); David Walker, *Bristol in the Early Middle Ages*, Bristol Historical Association, 1971.

48 Christopher Brooke and Gillian Keir, op. cit., p.113.

49 Ibid., p.115.

50 C. Warren Hollister, 'London's first charter of liberties: is it genuine?', *J. Medieval History*, 6(1980), pp.289–306. Professor Hollister's conclusion is that the charter was indeed issued by Henry I and was neither a forgery nor a later charter of Stephen's.

51 Susan Reynolds, *An Introduction to the History of English Medieval Towns*, 1977, pp.104–7.

52 *An Inventory of Archaeological Sites and Churches in Northampton*, RCHM, 1985, p.48; John H. Williams, 'The forty men of Northampton's first custumal and the development of borough government in late twelfth century Northampton', *Northamptonshire Past & Present*, 7(1986–7), pp.215–33.

53 Colin Platt, *Medieval Southampton. The Port and Trading Community. A.D. 1000–1600*, 1973, p.20.

54 H.W. Gidden (ed.), *The Charters of the Borough of Southampton*, Southampton Record Society, 1909, pp.2–5.

55 G.H. Martin, *The Early Court Rolls of the Borough of Ipswich*, 1954, pp.21–4; Colin Platt, *The English Medieval Town*, 1976, p.130.

56 Colin Platt, op. cit. (1976), pp.130–1.

57 R.H.C. Davis, 'An Oxford charter of 1191 and the beginnings of municipal freedom', *Oxoniensia*, 33(1968), pp.53–65.

58 Ibid., p.65.

59 *An Inventory of the Historical Monuments in the City of Oxford*, RCHM, 1939, pp.159–61.

60 For a brief general discussion followed by examples, see Hilary L. Turner, *Town Defences in England and Wales*, 1970, pp.23–5 and passim.

61 Colin Platt, op. cit. (1976), pp.57–9.

62 Colin Platt, op. cit. (1973), pp.36–43.

63 Maurice Beresford, *New Towns of the Middle Ages*, 1967, in particular chapter 11 (The Chronology of Town Plantation in England); Bryan E. Coates, 'The origin and distribution of markets and fairs in medieval Derbyshire', *Derbyshire Arch. J.*, 85(1965), pp.92–111; D.M. Palliser and A.C. Pinnock, "The markets of medieval Staffordshire", *North Staffordshire J. Field Studies*, 11(1971), pp.49–59; D.M. Palliser, 'The boroughs of medieval Staffordshire', ibid., 12(1972), pp.63–73.

64 P.D.A. Harvey, 'Banbury', in *Historic Towns. Volume I* (ed. M.D. Lobel), 1969, p.4; *VCH Gloucestershire*, vi:142–65.

65 D.M. Palliser, op. cit., p.71.

66 B.P. Hindle, *The Study of Medieval Town Plans with Special Reference to South Shropshire*, University of Salford: discussion papers in Geography 14, 1981, pp.19–23.

67 For a recent account of the most important of these, see Martin Biddle, *Wolvesey. The Old Bishop's Palace, Winchester*, 1986.

68 A.G. Dyson, 'The monastic patronage of Bishop Alexander of Lincoln', *J. Eccl. H.*, 26(1975), pp.1–24.

69 B.R. Kemp (ed.), *Reading Abbey Cartularies I*, Camden Fourth Series 31, 1986, pp.13–19.

70 For the circumstances which permitted an ambitious rebuilding after the fire of 1116, see Edmund King's *Peterborough Abbey 1086–1310. A Study in the Land Market*, 1973, passim.

71 B.R. Kemp, op. cit., p.18; the quotations are from Benedict's Rule, translated by Justin McCann, *The Rule of St Benedict*, 1972, pp.85, 119.

72 A.G. Dyson, op. cit., p.11; and for the Arrouaisians in England, making somewhat less of Alexander's role at Dorchester, see also J.C. Dickinson, 'English regular canons and the Continent in the twelfth century', *T.R.H.S.*, 1(1951), particularly pp.82–3.

73 David Crouch, *The Beaumont Twins. The Roots and Branches of Power in the Twelfth Century*, 1986, pp.196–7, 200–1.

74 Ibid., p.198.

75 A recent much-needed discussion of these monastic origins may be found in Henrietta Leyser's *Hermits and the New Monasticism. A Study of Religious Communities in Western Europe, 1000–1150*, 1984.

76 J.C. Dickinson, *The Origins of the Austin Canons and their Introduction into England*, 1950, p.99.

77 David Crouch, op. cit., pp.198–9.

78 A.G. Dyson, op. cit., p.3.

79 David Crouch, op. cit., p.199 (note 16); Jane Herbert, 'The transformation of hermitages into Augustinian priories in twelfth-century England', in *Monks, Hermits and the Ascetic Tradition* (ed. W.J. Sheils), *Studies in Church History*, 22(1985), p.143.

80 Colin Platt, *Medieval Britain from the Air*, 1984, pp.159–60.

81 H. Mayr-Harting, 'Functions of a twelfth-century recluse', *History*, 60(1975), p.345.

82 David C. Douglas and George W. Greenaway (eds), *English Historical Documents 1042–1189*, 1953, p.697.

83 Jane Herbert, op. cit., p.138; for Grafton Regis, see my *Medieval England. A Social History and Archaeology from the Conquest to 1600 AD*, 1978, p.160 and fig. 108.

84 The site of Walsingham's Holy House was excavated in 1961 and is described by Charles Green and A.B. Whittingham, 'Excavations at Walsingham Priory, Norfolk, 1961', *Arch. J.*, 125(1968), pp.225–90.

85 H. Mayr-Harting, op. cit., p.349.

86 B.R. Kemp, 'Monastic possession of parish churches in England in the twelfth century', *J. Eccl. H.*, 31(1980), p.146.

87 As in the case of Henry VII's gifts to Westminster Abbey in support of his chantry chapel (Barbara Harvey, *Westminster Abbey and its Estates in the Middle Ages*, 1977, pp.402–12).

88 B.R. Kemp, op. cit., p.143; *Gloucestershire. The Cotswolds*, 1970, p.370.

89 W.A. Pantin, 'Notley Abbey', *Oxoniensia*, 6(1941), pp.23–4.

90 R.H. Hilton, *The Economic Development of some Leicestershire Estates in the 14th and 15th Centuries*, 1947, p.109.

91 Sandra Raban, *The Estates of Thorney and Crowland*, 1977, pp.81–7.

92 B.R. Kemp, op. cit., p.138.

93 David M. Robinson, *The Geography of Augustinian Settlement in Medieval England and Wales*, British Archaeological Reports, 1980, pp.25–6 and fig. 3.

94 J.C. Dickinson, op. cit. (1950), pp.108–31.

95 Quoted by David Hugh Farmer, *The Oxford Dictionary of Saints*, 1978, p.262.

96 William Aldis Wright (ed.), *The Metrical Chronicle of Robert of Gloucester*, part 2, Rolls Series, 1887, p.641.

97 G.W.S. Barrow, 'Scottish rulers and the religious orders 1070–1153', *T.R.H.S.*, 3(1953), pp.82–3; J.C. Dickinson, op. cit. (1950), pp.120–1.

98 G.W.S. Barrow, op. cit., p.84; Ian B. Cowan and David E. Easson, *Medieval Religious Houses. Scotland*, 1976 (2nd edn), pp.96, 211–12.

99 Quoted (from a fifteenth-century source) by G.W.S. Barrow, *Kingship and Unity. Scotland 1000–1306*, 1981, p.33; for the parishes, see Ian B. Cowan, "The development of the parochial system in medieval Scotland", *Scottish H.R.*, 40(1961), pp.43–55.

100 G.W.S. Barrow, op. cit., (1953), pp.86–7.

101 Ibid, pp.89–96.

102 Quoted by Janet Burton, 'The foundation of the British Cistercian houses', in *Cistercian Art and Architecture in the British Isles* (eds Christopher Norton and David Park), 1986, p.26; and see also Christopher Holdsworth, 'St Bernard and England', in *Anglo-Norman Studies VIII* (ed. R. Allen Brown), 1986, pp.138–53.

103 David C. Douglas and George W. Greenaway (eds), *English Historical Documents 1042–1189*, 1953, p.692.

104 R. Gilyard-Beer, *Fountains Abbey*, 1970, p.5; for accounts of the break-away movement, see Denis Bethell, 'The foundation of Fountains Abbey and the state of St Mary's York in 1132', *J. Eccl. H.*, 17(1966), pp.11–27, and L.G.D. Baker, 'The foundation of Fountains Abbey', *Northern History*, 4(1969), pp.29–43.

105 Janet Burton and Roger Stalley, 'Tables of Cistercian affiliations', in Christopher Norton and David Park, op. cit., p.397.

106 For useful discussions of Cistercian founders and patrons of the first phase, see Janet Burton, op. cit., passim, and Bennett D. Hill, *English Cistercian Monasteries and their Patrons in the Twelfth Century*, 1968.

107 Quoted by Christopher Brooke, 'St Bernard, the patrons and monastic planning', in Christopher Norton and David Park, op. cit., pp.21–2.

108 R. Gilyard-Beer and Glyn Coppack, 'Excavations at Fountains Abbey, North Yorkshire, 1979–80: the early development of the monastery', *Archaeologia*, 108(1986), pp.147–88; and see also R. Gilyard-Beer, 'Fountains Abbey: the early buildings, 1132–50', *Arch. J.*, 125(1968), pp.313–19.

109 The words are those of Walter Daniel, Ailred's contemporary and biographer, quoted by David Knowles, *The Monastic Order in England*, 1963 (2nd edn), p.259.

110 Janet Burton, op. cit., p.33; Peter Fergusson, "The first architecture of the Cistercians in England and the work of Abbot Adam of Meaux", *J. Brit. Arch. Assoc.*, 136(1983), p.79; also the same author's *Architecture of Solitude. Cistercian Abbeys in Twelfth-Century England*, 1984, p.19.

111 Roger Stalley, *The Cistercian Monasteries of Ireland. An Account of the History, Art and Architecture of the White Monks in Ireland from 1142 to 1540*, 1987, pp.11–16, 56–61; also the same author's 'The architecture of the Cistercian churches of Ireland, 1142–1272', in Christopher Norton and David Park, op. cit., pp.120–4.

112 Roger Stalley, op. cit. (1987), pp.13–14.

113 The words are those of Stephen Lexington, abbot of Stanley, who carried out a visitation of the Irish Cistercian houses in 1228, quoted by Roger Stalley, op. cit. (1987), p.9. Master Stephen, a former student at Paris and teacher at Oxford, had left Oxford to join the Cistercians of Quarr in 1221. He was the leading intellectual of his generation in the Order, becoming abbot of Savigny in 1229 and of Clairvaux in 1243.

114 Ibid., pp.16–20.

115 Each of these houses was either planned by

David I or actually founded by him (Ian B. Cowan and David E. Easson, op. cit., pp.72–9).

116 David H. Williams, *The Welsh Cistercians*, 1984, i:3–7.

Chapter 3
Twelfth-Century Renaissance

1 For a translation of Gervase of Canterbury's account of the rebuilding, see L.F. Salzman, *Building in England down to 1540*, 1967 (2nd edn), pp.369–75.

2 Christopher Wilson, 'The Cistercians as 'missionaries of Gothic' in Northern England', in *Cistercian Art and Architecture in the British Isles* (eds Christopher Norton and David Park), 1986, pp.86–116; also Peter Fergusson, *Architecture of Solitude. Cistercian Abbeys in Twelfth-Century England*, 1984, passim; and see also the final pages of this chapter.

3 For a good description of the abbey church, with plan, see *Hampshire and the Isle of Wight*, 1967, pp.477–85.

4 *North East and East Kent*, 1983, pp.293–4.

5 Herbert Bloch, 'The new fascination with Ancient Rome', in *Renaissance and Renewal in the Twelfth Century* (eds Robert L. Benson and Giles Constable), 1985, p.631.

6 H.M. Colvin (ed.), *The History of the King's Works*, 1963, ii:1013–16.

7 David Park, 'The wall paintings of the Holy Sepulchre Chapel', in *Medieval Art and Architecture at Winchester Cathedral*, British Archaeological Association, 1983, pp.38–62; K. Flynn, 'Romanesque wall-painting in the cathedral church of Christ Church, Canterbury', *Archaeologia Cantiana*, 95(1979), pp.185–95; *Gloucestershire. The Vale and the Forest of Dean*, 1970, pp.278–80.

8 For a good description of Climping, with illustrations, see *Sussex*, 1965, pp.189–91.

9 *Hampshire and the Isle of Wight*, 1967, pp.199–200, 706–11.

10 R. Allen Brown, *Dover Castle*, 1985, p.32; for the best recent description of the mid-century water supply system at Canterbury Cathedral Priory, mapped in 1153–61, see R.A. Skelton and P.D.A. Harvey (eds), *Local Maps and Plans for Medieval England*, 1986, pp.43–58.

11 *Leicestershire and Rutland*, 1960, pp.316–17.

12 One surviving oak pier is still to be seen in the hall at Farnham, though very little else has been preserved (*Surrey*, 1971, p.233). For other timber halls of the period, see John Blair, 'The 12th-century Bishop's Palace at Hereford', *Med. Arch.*, 31(1987), pp.59–72, and N.W. Alcock and R.J. Buckley, 'Leicester Castle: the great hall', ibid., pp.73–9. A comparatively recent list of aisled halls was published by Kathleen Sandall, 'Aisled halls in England and Wales', *Vernacular Architecture*, 6(1975), pp.19–27.

13 H.M. Colvin, op. cit., i:44–7.

14 For the hall, formerly a hospital, see *Bedfordshire*, 1968, pp.332–4 and plate 17.

15 *Hampshire and the Isle of Wight*, 1967, pp.642–3.

16 For a useful general discussion of the 'upper hall house' of this period, see P.A. Faulkner, 'Domestic planning from the twelfth to the fourteenth centuries', reprinted in *Studies in Medieval Domestic Architecture* (ed. M.J. Swanton), 1975, pp.85–97.

17 There is a good systematic account of Manorbier in D.J. Cathcart King and J. Clifford Perks, 'Manorbier Castle', *Arch. Cambrensis*, 119(1970),

pp.83–118; for Burton Agnes, see Margaret Wood, *Burton Agnes Old Manor House*, 1981.

18 For the best discussion, with plans, of the Southampton buildings, see P.A. Faulkner, 'The surviving medieval buildings', in *Excavations in Medieval Southampton 1953–1969* (eds Colin Platt and Richard Coleman-Smith), 1975, pp.56–124.

19 H.T. Riley (ed.) *Munimenta Gildhallae Londoniensis*, i:328–9. For Henry fitz Ailwin, London's long-lasting mayor, see Christopher Brooke and Gillian Keir, *London 800–1216: the Shaping of a City*, 1975, passim.

20 For Tickhill's plan, set alongside Conisbrough, Odiham and Chilham, see R. Allen Brown, *English Castles*, 1976, pp.84–5; H.M. Colvin, op. cit., ii:844–5.

21 R. Allen Brown, 'Framlingham Castle and Bigod 1154–1216', *Proc. Suffolk Inst. Arch.*, 25(1949–52), pp.127–48.

22 R. Allen Brown, *Orford Castle*, 1964; other useful evidence of the high quality of the Orford works has been the recent identification there of late twelfth-century glazed and patterned floor-tiles, among the first of their kind in this country (P.J. Drury and E.C. Norton, 'Twelfth-century floor- and roof-tiles at Orford Castle', *Proc. Suffolk Inst. Arch.*, 36:1(1985), pp.1–7.

23 Colin Platt, *The Castle in Medieval England and Wales*, 1982, pp.33–9.

24 B.H.StJ. O'Neil and P.R. White, *Peveril Castle*, 1979; H.M. Colvin op. cit., ii:776–7.

25 W. Douglas Simpson, *Brough Castle*, 1982; H.M. Colvin, op. cit., ii:582.

26 For a sketch section of South Mimms, see my *Medieval England*, 1978, p.12; 'Motte substructures' are discussed in a brief note by M.W. Thompson (*Med. Arch.*, 5(1961), pp.305–6).

27 For these, see E.M. Jope and R.I. Threlfall, 'The twelfth-century castle at Ascot Doilly, Oxfordshire: its history and excavation', *Ant. J.*, 39(1959), pp.219–73; S.E. Rigold, 'Totnes Castle. Recent Excavations by the Ancient Monuments Department, Ministry of Works', *Report and Trans Devonshire Assoc.*, 86(1954), pp.228–56; M.W. Thompson, 'Recent excavations in the keep of Farnham Castle, Surrey', *Med Arch.*, 4(1960), pp.81–94; Nicholas Reynolds, 'Investigations in the Observatory Tower, Lincoln Castle', ibid., 19(1975), pp.201–5; T.C.M. and A. Brewster, 'Tote Copse Castle, Aldingbourne, Sussex', *Sussex Arch. Coll.*, 107(1969), pp.141–79; S.R. Bassett, *Saffron Walden: Excavations and Research 1972–80*, CBA Research Report 45, 1982, p.16.

28 There is some dispute about the date of the keep at Guildford, which may be considerably earlier than the *c*. 1170 date given in *Surrey*, 1971, p.275; H.M. Colvin, op. cit., ii:658–9.

29 M.W. Thompson, *Farnham Castle Keep*, 1961, pp.4, 15–16 and plan.

30 C.A. Ralegh Radford, *Goodrich Castle*, 1958; and the same author's *White Castle*, 1962.

31 M.W. Thompson, *Conisbrough Castle*, 1977.

32 R. Allen Brown, op. cit. (1976), p.92; Colin Platt, op. cit. (1982), p.49.

33 R. Allen Brown, op. cit. (1949–52), pp.140–1; F.J.E. Raby and P.K. Baillie Reynolds, *Framlingham Castle*, 1959.

34 H.M. Colvin, op. cit., ii:630–2; R. Allen Brown, *Dover Castle*, 1984, pp.6–11.

35 For the castle policy of Henry II and his sons, see the two related papers by R. Allen Brown, 'Royal castle-building in England, 1154–1216', *E.H.R.*, 70(1955), pp.353–98, and 'A list of castles, 1154–1216', ibid., 74(1959), pp.249–80.

36 Borough-founding is discussed in Chapter 2; for planned villages, see the work of Brian Roberts,

especially his *Village Plans* (1982) and his chapter on 'Village Forms' in *Rural Settlement in Britain* (1977).

37 For a useful dating of the adoption of demesne farming, disputed only in detail since that time, see P.D.A. Harvey, 'The pipe rolls and the adoption of demesne farming in England', *Ec.H.R.*, 27(1974), pp.345–59.

38 H.M. Colvin, *The White Canons in England*, 1951, especially pp.29–39; and see my own *The Abbeys and Priories of Medieval England*, 1984, pp.59–61.

39 Richard Mortimer, 'Religious and secular motives for some English monastic foundations', *Studies in Church History*, 15(1978), pp.77–85.

40 Ibid., p.81; also the same author's 'The family of Rannulf de Glanville', *Bull. Inst. Hist. Res.*, 54(1981), p.12.

41 H.M. Colvin and R. Gilyard-Beer, *Shap Abbey*, 1963.

42 J. Beverley Smith and B.H.StJ. O'Neil, *Talley Abbey*, 1967.

43 H.M. Colvin, op. cit. (1951), p.31.

44 G.W.S. Barrow, 'Scottish rulers and the religious orders, 1070–1153', *T.R.H.S.*, 3(1953), pp.94–6.

45 Aubrey Gwynn and R. Neville Hadcock, *Medieval Religious Houses. Ireland*, 1970, pp.149–51; and see also, for the Irish Augustinians in general, C.A. Empey, 'The sacred and the secular: the Augustinian priory of Kells in Ossory, 1193–1541', *Irish Hist. Stud.*, 24(1984), pp.131–51.

46 Quoted (from the *Magna vita sancti Hugonis*) by Elizabeth M. Hallam, 'Henry II, Richard I and the order of Grandmont', *J. Medieval History*, 1(1975), p.167; Elizabeth Hallam very properly emphasizes the political advantage obtained by Henry II from his support of the Grandmontines among others.

47 *VCH Shropshire*, ii:62–9.

48 H.M. Colvin, op. cit. (1963), i:88–9; Elizabeth M. Hallam, 'Henry II as a founder of monasteries', *J. Eccl. H.*, 28(1977), pp.124–5; for the pre-Angevin church at Waltham, see E.C. Fernie, 'The Romanesque church of Waltham Abbey', *J. Brit. Arch. Assoc.*, 138(1985), pp.48–78.

49 H.M. Colvin, op. cit. (1963), i:88–9; Elizabeth M. Hallam, op. cit. (1977), pp.117–18; the existing church at Amesbury, although of considerable size, is not now thought to have been the nuns' church, itself sited some distance to the north (*Churches of South-East Wiltshire*, RCHM, 1987, pp.233–5).

50 Quoted by Christopher Brooke, *Monasteries of the World*, 1974, p.84; for the English Carthusians, see David Knowles, *The Monastic Order in England*, 1966 (2nd edn), pp.380–7.

51 Rose Graham and A.W. Clapham, 'The Order of Grandmont and its houses in England', *Archaeologia*, 75(1924–5), p.163.

52 Ibid., pp.162–3.

53 Elizabeth M. Hallam, op. cit. (1975), pp.170–1.

54 Rose Graham and A.W. Clapham, op. cit., p.162.

55 A.B.E. Clark, *Brinkburn Priory*, 1982.

56 Christopher Harper-Bill, 'Church and society in twelfth-century Suffolk: the charter evidence', *Proc. Suffolk Inst. Arch.*, 35(1984), p.205.

57 S.E. Rigold, *Bayham Abbey*, 1974; H.M. Colvin, op. cit. (1951), pp.109–118.

58 G.W.S. Barrow, op. cit., p.94.

59 Aubrey Gwynn and R. Neville Hadcock, op. cit., pp.146–200.

60 J.C. Dickinson, 'The origins of St Augustine's, Bristol', in *Essays in Bristol and Gloucestershire History* (eds Patrick McGrath and John Cannon), 1976, pp.109–26; also the same author's 'English regular canons and the Continent in the twelfth century', *T.R.H.S.*, 1(1951), pp.71–89.

61 Edmund King, *Peterborough Abbey 1086–1310*, 1973, p.13.
62 *Bedfordshire*, 1968, p.307.
63 Edmund King, op. cit., especially chapter 4 (The colonisation of Northamptonshire).
64 Quoted by H.C. Darby, *The Medieval Fenland*, 1974 (2nd edn), p.52.
65 From an eighth-century life of St Guthlac, a hermit here, quoted by Sandra Raban, *The Estates of Thorney and Crowland*, 1977, p.47.
66 H.E. Hallam, *Settlement and Society. A Study of the Early Agrarian History of South Lincolnshire*, 1965, p.200.
67 Sandra Raban, op. cit., pp.34–40.
68 Ibid., p.54.
69 *Lincolnshire*, 1964, p.504.
70 C.A.R. Radford, 'Glastonbury Abbey before 1184: interim report on the excavations, 1908–64', in *Medieval Art and Architecture at Wells and Glastonbury*, British Archaeological Association, 1981, pp.110–34.
71 Ibid., p.125.
72 *South and West Somerset*, 1958, p.173.
73 *Wiltshire*, 1963, pp.288–93.
74 P.J. Helm, 'The Somerset Levels in the Middle Ages (1086–1539)', *J. Brit. Arch. Assoc.*, 12(1949), pp.37–52.
75 *VCH Somerset*, iii:43–4.
76 Eleanor Searle, *Lordship and Community. Battle Abbey and its Banlieu 1066–1538*, 1974, pp.45–6.
77 Ibid., pp.57–9, 66–7.
78 Eleanor Searle (ed.), *The Chronicle of Battle Abbey*, 1980, pp.96–9.
79 Eleanor Searle, op. cit. (1974), p.67.
80 J.N. Hare, *Battle Abbey. The Eastern Range and the Excavations of 1978–80*, 1985, pp. 25–35 (The Great Rebuilding).
81 Eleanor Searle, op. cit. (1974), p.133.
82 R. Gilyard-Beer, *Gisborough Priory*, 1984, pp.6–7.
83 *Powys*, 1979, pp.283–93.
84 C.A. Ralegh Radford, *Ewenny Priory*, 1952. For the fortification of monastic precincts, usually no earlier than the fourteenth century, see my *The Abbeys and Priories of Medieval England*, 1984, pp.188–92.
85 L.F. Salzman, *Building in England down to 1540*, 1967 (2nd edn), pp.367–8.
86 *County Durham*, 1953, pp.53–4, 87–8, 99–100.
87 L.F. Salzman, op. cit., pp.376–7.
88 Ibid., pp.378–80.
89 Ibid., p.381.
90 For the contrast between the houses, see Brian Golding, 'Wealth and artistic patronage at twelfth-century St Albans', in *Art and Patronage in the English Romanesque* (eds Sarah Macready and F.H. Thompson), 1986, p.113.
91 H.E. Butler (ed.), *The Chronicle of Jocelin of Brakeland*, 1949, p.96.
92 Barbara Harvey, *Westminster Abbey and its Estates in the Middle Ages*, 1977, p.82.
93 H.E. Butler, op. cit., pp.58–9.
94 P.D.A. Harvey, 'The English inflation of 1180–1220', *Past & Present*, 61(1973), pp.3–30.
95 Eleanor Searle, op. cit. (1974), pp.104–5.
96 P.D.A. Harvey, op. cit. (1974), pp.345–59.
97 David Knowles, op. cit., chapter XXXIX (The critics of the monks: Gerald of Wales, Walter Map and the satirists); Antonia Gransden, *Historical Writing in England, c.550–c.1307*, 1974, pp.221–2, 242–6.
98 For this and other references, see my *The Monastic Grange in Medieval England*, 1969, pp.92–3, where a somewhat different view is taken of Cistercian land clearances and depopulations, both of which roused criticism in their time.
99 David Knowles, op. cit., pp.671, 676.

100 *Herefordshire*, 1963, pp.57–62.
101 Charles Peers, *Byland Abbey*, 1952, p.4; *Yorkshire. The North Riding*, 1966, pp.94–101.
102 Christopher Wilson, 'The Cistercians as 'missionaries of Gothic' in Northern England', in *Cistercian Art and Architecture in the British Isles* (eds Christopher Norton and David Park), 1986, pp.86–116; and see also the opening of this chapter.
103 Peter Fergusson, 'The first architecture of the Cistercians in England and the work of Abbot Adam of Meaux', *J. Brit. Arch. Assoc.*, 136(1983), pp.82–3.
104 Quoted by Peter Fergusson in his *Architecture of Solitude. Cistercian Abbeys in Twelfth-Century England* 1984, p.105.
105 Ibid., p.107.
106 Charles Peers, op. et loc. cit.
107 For Clairvaux and its derivatives, see M.-A. Dimier, 'Origine des déambulatoires à chapelles rayonnants non saillantes', *Bulletin Monumental*, 110(1957), pp.23–33.
108 Ian B. Cowan and David E. Easson, *Medieval Religious Houses. Scotland*, 1976 (2nd edn), p.75; Peter Fergusson, 'The late twelfth-century rebuilding at Dundrennan Abbey', *Ant. J.*, 53(1973), p.243.
109 P.K. Baillie Reynolds, *Croxden Abbey*, 1946.
110 Wolfgang Braunfels, *Monasteries of Western Europe. The Architecture of the Orders*, 1972, p.242.
111 Peter Fergusson, op. cit. (1973), pp.241–3.
112 Wolfgang Braunfels, op. et loc. cit.
113 Ibid., p.243.
114 Roger Stalley, *The Cistercian Monasteries of Ireland*, 1987, pp.171, 180–9.
115 Ibid., p.18.
116 Aubrey Gwynn and R. Neville Hadcock, op. cit., p.140.
117 Jocelyn Otway-Ruthven, 'The medieval church lands of County Dublin', in *Medieval Studies presented to Aubrey Gwynn, S.J.* (eds J.A. Watt, J.B. Morrall and F.X. Martin), 1971, pp.54–73.

Chapter 4
Golden Century

1 *Lincolnshire*, 1964, p.287; there is another good example of such provision at Merevale (Warwickshire), similarly preserved as a parish church.
2 Jane A. Cunningham, 'Hugh of Le Puiset and the Church of St Cuthbert, Darlington', in *Medieval Art and Architecture at Durham Cathedral*, British Archaeological Association, 1977, pp.163–9.
3 Peter A.G. Clack, 'The origins and growth of Darlington', in *The Medieval Town in Britain* (ed. Philip Riden), Cardiff Papers in Local History 1, 1980, pp.67–84.
4 *North East and East Kent*, 1984, pp.358–60.
5 *North West and South Norfolk*, 1962, pp.220–6.
6 Both reference and image are from W.G. Hoskins, 'The origin and rise of Market Harborough', in the same author's *Provincial England*, 1963, p.58.
7 Leo Sherley-Price (trans.), *The Coming of the Franciscans. Thomas of Eccleston's De Adventu Fratrum Minorum in Angliam*, 1964, p.15; for the Latin text, see A.G. Little (ed.), *Fratris Thomae vulgo dicti de Eccleston. Tractatus de Adventu Fratrum Minorum in Angliam*, 1951, p.20.
8 Leo Sherley-Price, op. cit., p.17.
9 Ibid., p.62.
10 Ibid., p.63.
11 Colin Platt, *Medieval Southampton. The Port and Trading Community, A.D. 1000–1600*, 1973, p.64.

12 Harry Rothwell (ed.), *English Historical Documents 1189–1327*, 1975, p.685; the passage is from Matthew Paris.
13 Antonia Gransden, *Historical Writing in England c.550–c.1307*, 1974, p.489.
14 Leo Sherley-Price, op. cit., p.39; A.G. Little, op. cit., p.46.
15 Only at Norwich are there standing buildings of comparable importance, but these are of the fifteenth century.
16 B.M. Morley, *Blackfriars, Gloucester*, 1979; George Lambrick and Humphrey Woods, 'Excavations on the second site of the Dominican priory, Oxford', *Oxoniensia*, 41(1976), pp.168–231; George Lambrick, 'Further excavations on the second site of the Dominican priory, Oxford', ibid., 50(1985), pp.138–99; *Med. Arch.*, 30(1986), pp.170–1 (Newcastle Blackfriars, with plan); for a useful recent survey of the archaeological evidence, see Lawrence Butler, 'The houses of the Mendicant Orders in Britain: recent archaeological work', in *Archaeological Papers from York Presented to M.W. Barley* (eds P.V. Addyman and V.E. Black), 1984, pp.123–36.
17 D.L. D'Avray, *The Preaching of the Friars. Sermons Diffused from Paris before 1300*, 1985, p.31.
18 Harry Rothwell, op. cit., p.686.
19 Ibid., pp.686–7.
20 Antonia Gransden (ed.), *The Chronicle of Bury St Edmunds 1212–1301*, 1964, pp.9–10, 22, 27–8.
21 Colin Platt, op. et loc. cit.
22 Lawrence Butler, op. cit., p.123, and the same author's 'Excavations at Black Friars, Hereford, 1958', *Trans Woolhope Naturalists' Field Club*, 36(1958–60), p.337; Barbara Harbottle, 'Excavations at the Carmelite friary, Newcastle upon Tyne, 1965 and 1967', *Arch. Aeliana*, 46(1968), p.167.
23 Harry Rothwell, op. cit., p.118.
24 Ibid., pp.685–6.
25 Colin Platt, *Yorkshire Abbeys*, 1988.
26 The dates (from David Knowles and R. Neville Hadcock, *Medieval Religious Houses. England and Wales*, 1953) are approximate; for Bishop Grosseteste's attempt to resolve the Franciscans' difficulties at Scarborough, see Harry Rothwell, op. cit., p.684.
27 Leo Sherley-Price, op. cit., p.38; Art Cosgrove (ed.), *A New History of Ireland. II. Medieval Ireland 1169–1534*, 1987, p.751.
28 The McGrath description is as quoted in the site leaflet, *Ennis Abbey* (Ennis Development Society).
29 Art Cosgrove, op. cit., p.238.
30 For this general point about the English towns, see R.H. Britnell, 'English markets and royal administration before 1200', *Ec.H.R.*, 31(1978), p.196; and see also R.H. Hilton, 'Medieval market towns and simple commodity production', *Past & Present*, 109(1985), pp.3–23.
31 J.A. Watt, 'Dublin in the thirteenth century: the making of a colonial capital city', in *Thirteenth Century England I. Proceedings of the Newcastle upon Tyne Conference 1985* (eds P.R. Coss and S.D. Lloyd), 1986, p.154.
32 Archibald A.M. Duncan, *Scotland. The Making of the Kingdom*, 1975, p.307; and Ian B. Cowan and David E. Easson, *Medieval Religious Houses. Scotland*, 1976 (2nd edn), passim.
33 Ronald G. Cant, *Historic Crail*, 1976; discussed and illustrated in my *Medieval Britain from the Air*, 1984, pp.107–9. For further comments on Scottish markets and their influence on town plans, see G.W.S. Barrow, *Kingship and Unity. Scotland 1000–1306*, 1981, pp.88–90; Archibald A.M. Duncan, op. cit., pp.472–3; and William Mackay

Mackenzie, *The Scottish Burghs*, 1949, pp.55–61.

34 K.H. Rogers, 'Salisbury', in *Historic Towns. Volume I* (ed. M.D. Lobel), 1969, pp.1, 3-4, 7.

35 R.H. Britnell, 'The origins of Stony Stratford', *Records of Buckingham*, 20(1975–8), pp.451–3.

36 E.M. Carus-Wilson, 'The first half-century of the borough of Stratford-upon-Avon', *Ec.H.R.*, 18(1965), pp.46–63.

37 R.H. Britnell, 'The proliferation of markets in England, 1200–1349', *Ec.H.R.*, 34(1981), pp.209–21; for a recent comment on these later markets, see David Postles, 'Markets for rural produce in Oxfordshire, 1086–1350', *Midland History*, 12(1987), pp.14–26.

38 Michael Reed, 'Markets and fairs in medieval Buckinghamshire', *Records of Buckingham*, 20(1975–8), pp.563–85.

39 R.H. Britnell, op. cit. (1981), pp.220–1; and see also the same author's 'Essex markets before 1350', *Essex Arch. and Hist.*, 12(1980), pp.15–21.

40 A.R. Bridbury, 'Thirteenth-century prices and the money supply', *Agric.H.R.*, 33(1985), pp.1–21.

41 E.M. Carus-Wilson, op. cit., pp.52–5.

42 Peter McClure, 'Patterns of migration in the late Middle Ages: the evidence of English place-name surnames', *Ec.H.R.*, 32(1979), pp.175–7.

43 For a general discussion of some of the earlier evidence, see my *Medieval England*, 1978, pp.40–2, 105–8.

44 For standard rural buildings in twelfth-century England and for the development of a peasant land market, influencing these, see P.D.A. Harvey (ed.), *The Peasant Land Market in Medieval England*, 1984, pp.7–28 and passim.

45 Christopher Dyer, *Lords and Peasants in a Changing Society. The Estates of the Bishopric of Worcester 680–1540*, 1980, pp.110–11.

46 Anne DeWindt, 'Peasant power structures in fourteenth-century King's Ripton', *Mediaeval Studies*, 38(1976), pp.247–8; M. Clare Coleman, *Downham-in-the-Isle. A Study of an Ecclesiastical Manor in the Thirteenth and Fourteenth Centuries*, 1984, p.7; Edwin Brezette DeWindt, *Land and People in Holywell-cum-Needingworth*, 1972, pp.98–9.

47 Zvi Razi, *Life, Marriage and Death in a Medieval Parish. Economy, Society and Demography in Halesowen 1270–1400*, 1980, p.87.

48 Op. et loc. cit.

49 Guy Beresford, *The Medieval Clay-land Village: Excavations at Goltho and Barton Blount*, 1975, p.26.

50 R.H. Hilton and P.A. Rahtz, 'Upton, Gloucestershire, 1959–1964', *Trans Bristol and Gloucestershire Arch. Soc.*, 85(1966), pp.70–146; P.A. Rahtz, 'Upton, Gloucestershire, 1964–1968. Second Report', ibid., 88(1969), pp.74–126; J.G. Hurst (ed.), *Wharram. A Study of Settlement on the Yorkshire Wolds*, 1979, passim.

51 Guy Beresford, op. cit., pp.79–96; R.H. Hilton and P.A. Rahtz, op. cit., pp.111–13; J.G. Hurst, op. cit., pp.74–132.

52 J.G. Hurst, op. cit., pp.133–4.

53 Guy Beresford, 'Three deserted medieval settlements on Dartmoor: a report on the late E. Marie Minter's excavations', *Med. Arch.*, 23(1979), pp.98–158; for some questioning of the Houndtor dates and evidence of turf-walled houses, see D. Austin, 'Dartmoor and the upland village of the South-West of England', in *Medieval Villages. A Review of Current Work* (ed. Della Hooke), 1985, pp.71–9 and D. Austin and M.J.C. Walker, 'A new landscape context for Houndtor, Devon', *Med. Arch.*, 29(1985), pp.147–52; and for a reply reiterating the original conclusions, see Guy Beresford, 'Three deserted medieval settlements on Dartmoor. A comment on David Austin's Reinterpretations', ibid., 32(1988), pp.175–83.

54 John Musty and David Algar, 'Excavations at the deserted medieval village of Gomeldon, near Salisbury', *Wiltshire Arch. and Nat. Hist. Mag.*, 80(1986), especially pp.144–8.

55 The case for a rethink has been argued persuasively by Christopher Dyer, best qualified to know, in 'English peasant buildings in the Later Middle Ages (1200–1500)', *Med. Arch.*, 30(1986), pp.19–45.

56 Guy Beresford, 'Excavation of a moated house at Wintringham in Huntingdonshire', *Arch. J.*, 134(1977), pp.194–286.

57 Margaret Wood, *Old Soar*, 1978.

58 For this, with references, see my *The Monastic Grange in Medieval England*, 1969, pp.197–8.

59 J.M. Fletcher, 'The bishop of Winchester's medieval manor-house at Harwell, Berkshire, and its relevance to the evolution of timber-framed aisled halls', *Arch. J.*, 136(1979), pp.173–92; N.W. Alcock, 'The hall of the Knights Templar at Temple Balsall, W. Midlands', *Med. Arch.*, 26(1982), pp.155–8; C.A. Hewett, "Aisled timber halls and related buildings, chiefly in Essex', *Trans Ancient Monuments Soc.*, 21(1976), pp.46–9. And see also J.T. Smith, 'Medieval aisled halls and their derivatives', *Arch. J.*, 112(1955), pp.76–94.

60 J.T. Smith, 'Medieval roofs: a classification', *Arch. J.*, 115(1958), especially pp.121–3; and see also the summary on 'Roofing' in R.W. Brunskill's *Timber Building in Britain*, 1985, pp.60–74.

61 For further discussion of these improvements, see my *Medieval England*, 1978, pp.53–7.

62 S.E. Rigold, 'Two *Camerae* of the military orders. Strood Temple, Kent, and Harefield, Middlesex', *Arch. J.*, 122(1965), pp.86–132; King John's House has yet to be published.

63 H.M. Colvin (ed.), *The History of the King's Works*, 1963, ii:912–16; T.B. James and A.M. Robinson, *Clarendon Palace. The History and Archaeology of a Medieval Palace and Hunting Lodge near Salisbury, Wiltshire*, 1988, pp.8–31, 139–47.

64 The words are Henry's own (H.M. Colvin, op. cit., i:94, 109).

65 Robert C. Stacey, *Politics, Policy and Finance under Henry III, 1216–1245*, 1987, pp.239–43; D.A. Carpenter, 'King, magnates, and society: the personal rule of King Henry III, 1234–1258', *Speculum*, 60(1985), pp.39–70.

66 Michael Altschul, *A Baronial Family in Medieval England: the Clares, 1217–1314*, 1965, pp.201–6, 268–80.

67 C.N. Johns, *Caerphilly Castle*, 1978; the word 'apogee' is Allen Brown's, who includes Caerphilly under this label but dates the work somewhat later than does Johns (*English Castles*, 1976 (3rd edn), pp.114–5).

68 The best account of Dover remains Allen Brown's *Dover Castle*, 1985; but see also my own illustrated guide to *Dover Castle*, 1988.

69 H.M. Colvin, op. cit., i:406–7, ii:1027–35.

70 Jeremy K. Knight, 'The road to Harlech: aspects of some early thirteenth–century Welsh castles', in *Castles in Wales and the Marches* (eds John R. Kenyon and Richard Avent), 1987, pp.75–88.

71 J.K. Knight, *Grosmont Castle*, 1980.

72 Jeremy K. Knight, *Chepstow Castle*, 1986, pp.6–10.

73 Ibid., pp.10–12.

74 J. Beverley Smith and Jeremy K. Knight, *Bronllys Castle*, 1981.

75 John Charlton, *Brougham Castle*, 1961.

76 Jeffrey West, 'Acton Burnell Castle, Shropshire', in *Collectanea Historica. Essays in Memory of Stuart Rigold* (ed. Alec Detsicas), 1981, pp.85–92.

77 L.A.S. Butler, *Denbigh Castle, Town Walls and Friary*, 1976, p.11; for a recent comment on the role (usually understated) of the Marcher lords in castle-building, see R.R. Davies, *Conquest, Coexistence and Change in Wales 1063–1415*, 1987, pp.280–2.

78 Philip Mayes and Lawrence Butler, *Sandal Castle Excavations 1964–1973*, 1983, especially pp.3–4, 38–9, 47–8.

79 Lawrence Butler, 'Holt Castle, John de Warenne and Chastellion', in *Castles in Wales and the Marches* (eds John R. Kenyon and Richard Avent), 1987, pp.105–24.

80 B.H.StJ. O'Neil and C.J. Tabraham, *Caerlaverock Castle*, 1982, p.5.

81 W. Douglas Simpson, *Kildrummy and Glenbuchet Castles*, 1978; W. Douglas Simpson, *Bothwell Castle*, 1978.

82 Archibald A.M. Duncan, *Scotland. The Making of the Kingdom*, 1975, pp.440–1.

83 J.R.S. Phillips, *Aymer de Valence, Earl of Pembroke 1307–1324*, 1972, p.243.

84 Ibid., p.254.

85 P.A. Faulkner, 'Castle planning in the fourteenth century', *Arch. J.*, 120(1963), pp.221–5.

86 J.R.S. Phillips, op. cit., pp.252–68.

87 Ibid., p.242 and passim.

88 G.A. Holmes, *The Estates of the Higher Nobility in Fourteenth-Century England*, 1957, pp.9–25.

89 Michael Altschul, op. cit., pp.201–40.

90 Ibid., p.236.

91 J.R. Maddicott, *Thomas of Lancaster, 1307–1322. A Study in the Reign of Edward II*, 1970, p.9.

92 Ibid., pp.25–7.

93 C.H. Hunter Blair and H.L. Honeyman, *Dunstanburgh Castle*, 1982.

94 J.R. Maddicott, op. cit., p.31 and passim.

95 L.F. Salzman, *Building in England down to 1540*, 1967 (2nd edn), p.390.

96 Philip Lindley, 'The fourteenth-century architectural programme at Ely Cathedral', in *England in the Fourteenth Century. Proceedings of the 1985 Harlaxton Symposium* (ed. W.M. Ormrod), 1986, p.119.

97 Nicola Coldstream, 'Ely Cathedral: the fourteenth-century work', in *Medieval Art and Architecture at Ely Cathedral*, British Archaeological Association, 1979, p.28.

98 L.F. Salzman, op. cit., p.386.

99 Ibid., pp.393–4; for these works, see also F.R. Chapman (ed.), *Sacrist Rolls of Ely*, 2 vols, 1907, passim.

100 Edward Miller, *The Abbey and Bishopric of Ely*, 1951, p.95.

101 Christopher Dyer, op. cit. (1980), p.55.

102 A.R. Bridbury, 'Thirteenth-century prices and the money supply', *Agric.H.R.*, 33(1985), pp.1–21.

103 Christopher Dyer, op. cit. (1980), p.74; Edward Miller, op. cit., p.82.

104 *Worcestershire*, 1968, pp.302–4.

105 Peter Draper, 'Architecture and liturgy', in *Age of Chivalry. Art in Plantagenet England 1200–1400* (eds Jonathan Alexander and Paul Binski), 1987, pp.83–8.

106 Ibid., p.88.

107 *Wiltshire*, 1963, p.372.

108 Ibid., pp.100–3, 331–2.

109 Audrey M. Erskine (ed.), *The Accounts of the Fabric of Exeter Cathedral, 1279–1353. Part 1: 1279–1326*, Devon and Cornwall Record Society 24, 1981, p.xiii.

110 Ibid., *Part 2: 1328–1353*, 1983, pp.ix–xiii.

111 Ibid., p.xxx. For a recent general account of the building process at Exeter, see Nicolas Orme's *Exeter Cathedral as it was 1050–1550*, 1986, pp.10–20.

112 Nicolas Orme, op. cit., p.83; U.M. Radford, 'The wax images found in Exeter Cathedral', *Ant. J.*, 29(1949), pp.164–8.

113 Francis Wormald, 'The Rood of Bromholm', *J. Warburg Inst.*, 1(1937–8), pp.31–45.

114 Colin Morris, 'A critique of popular religion: Guibert of Nogent on *The Relics of the Saints*', *Studies in Church History*, 8(1972), p.56.

115 Antonia Gransden, 'The growth of the Glastonbury traditions and legends in the twelfth century', *J.Eccl.H.*, 27(1976), pp.337–58; for the account of the rediscovery of St Dunstan's relics, see John Scott (ed.), *The Early History of Glastonbury. An Edition, Translation and Study of William of Malmesbury's De Antiquitate Glastonie Ecclesie*, 1981, pp.73–9.

116 Antonia Gransden, op. cit., p.349.

117 C.H. Williams (ed.), *English Historical Documents 1485–1558*, 1967, pp.785–6.

118 Denis Bethell, 'The making of a twelfth-century relic collection', *Studies in Church History*, 8(1972), p.68.

119 Frank Barlow, *Thomas Becket*, 1986, pp.264–70 (for the cult); L.F. Salzman, op. cit., p.369 (for the fire).

120 Mary Dean, 'The Angel Choir and its local influence', in *Medieval Art and Architecture at Lincoln Cathedral*, British Archaeological Association, 1986, pp.90–101; and Virginia Glenn, 'The sculpture of the Angel Choir at Lincoln', ibid., pp.102–8.

121 Decima L. Douie and David Hugh Farmer (eds), *Magna Vita Sancti Hugonis. The Life of St Hugh of Lincoln*, 1985, ii:169–70.

122 D.A. Stocker, 'The tomb and shrine of Bishop Grosseteste in Lincoln Cathedral', in *England in the Thirteenth Century* (ed. W.M. Ormrod), 1985, pp.143–8.

123 Peter Draper, 'Bishop Northwold and the cult of Saint Etheldreda', in *Medieval Art and Architecture at Ely Cathedral*, British Archaeological Association, 1979, pp.8–27.

124 Jonathan Alexander and Paul Binski, op. cit., 1987, p.212.

125 Ronald C. Finucane, *Miracles and Pilgrims. Popular Beliefs in Medieval England*, 1977, chapter 10 (The changing fortunes of a curative shrine: St Thomas Cantilupe); Nicola Coldstream, 'English Decorated shrine bases', *J. Brit. Arch. Assoc.*, 129(1976), p.18 and plate VIIB.

126 J.S. Richardson and Marguerite Wood, *Melrose Abbey*, 1949, p.22.

127 W. Butler-Bowdon (ed.), *The Book of Margery Kempe 1436*, 1936, p.163.

128 J.G. Coad, *Hailes Abbey*, 1970.

129 John Brownbill (ed.), *The Ledger-Book of Vale Royal Abbey*, Lancashire and Cheshire Record Society 68, 1914, p.9.

130 H.M. Colvin, op. cit., i:253.

131 Ibid., p.257.

132 Walter Horn and Ernest Born, *The Barns of the Abbey of Beaulieu at its Granges of Great Coxwell and Beaulieu-St Leonards*, 1965; Professor Horn's suggested dates are before 1250, but a recent dendrochronological date for the Great Coxwell barn has placed it at a more believable 1300–1310 (J.M. Fletcher and M.C. Tapper, 'Medieval artefacts and structures dated by dendrochronology', *Med. Arch.*, 28(1984), p.129).

133 *Med. Arch.*, 28(1984), pp.246–7. Additional stone barns include those of Buckland and Torre, in each case next to the abbey buildings.

134 Leigh's full-scale restoration has begun recently, with state funding (*English Heritage News*, 12(1987)).

135 Cecil A. Hewett, 'Structural carpentry in medie-

val Essex', *Med. Arch.*, 6–7(1962–3), pp.241–6; J.M. Fletcher and M.C. Tapper, op. et loc. cit.; S.E. Rigold, 'Some major Kentish timber barns', *Arch. Cantiana*, 81(1966), pp.1–30.

136 On agricultural surpluses and increasing productivity on the land, see especially Bruce Campbell's 'The diffusion of vetches in medieval England', *Ec.H.R.*, 41(1988), pp.193–208 and the works – some of the most important of which are Campbell's own – cited there in the bibliography; for accounting and record-keeping, see M.T. Clanchy, *From Memory to Written Record. England 1066–1307*, 1979, passim.

137 Gabrielle Lambrick, 'Abingdon Abbey administration', *J.Eccl.H.*, 17(1966), pp.159–83.

138 A.R. Bridbury, 'The farming out of manors', *Ec.H.R.*, 31(1978), pp.503–20; and the same author's 'Thirteenth-century prices and the money supply', *Agric.H.R.*, 33(1985), pp.1–21.

139 *Nottinghamshire*, 1951, pp.115–16.

140 *Gloucestershire. The Cotswolds*, 1970, p.93.

141 *North Somerset and Bristol*, 1958, pp.375–6 and plate 22; both Gloucester Abbey's flying arches and the Wells-like strainers at Salisbury Cathedral can similarly be traced back to Bristol.

142 Harry Rothwell, op. cit., p.773.

143 Eileen Power, *Medieval English Nunneries c.1275 to 1535*, 1922, p.219; for the building evidence, see *Med. Arch.*, 23(1979), pp.250–1.

144 C. Vincent Bellamy, *Pontefract Priory Excavations 1957–1961*, Thoresby Society Publications 49, 1962–4, pp.xv, 9–12; G.S. Haslop, 'The abbot of Selby's financial statement for the year ending Michaelmas 1338', *Yorks Arch. J.*, 44(1972), pp.159–69.

145 Charles Peers, *Kirkham Priory*, 1946.

146 For a characteristically intelligent yet provocative discussion of this interpretation, see A.R. Bridbury, op. cit. (1985), passim. But for what just one man could do to turn an estate round in this century, see Robert C. Stacey, 'Agricultural investment and the management of the royal demesne manors, 1236–1240', *J. Economic History*, 46(1986), pp.919–34.

147 Colin Platt, *The Parish Churches of Medieval England*, 1981, pp.97–8.

148 G.G. Coulton, *Five Centuries of Religion*, 1936, iii:173; quoted in my *Parish Churches*, with other similar material, p.74.

149 *North East and East Kent*, 1983, pp.493–4.

150 F.M. Powicke and C.R. Cheney (eds), *Councils and Synods, with other Documents relating to the English Church, A.D. 1205–1313*, 1964, pp.1005–8.

151 In 1305, Wormsley Priory is recorded in a dispute as having 'built the chancel new' at Dilwyn (*Herefordshire*, 1963, p.111).

152 *Essex*, 1965, p.260.

153 L.J. Proudfoot, 'The extension of parish churches in medieval Warwickshire', *J. Hist. Geog.*, 9(1983), p.235.

154 Ibid., pp.236–41.

155 R.J. Silvester, 'West Walton: the development of a siltland parish', *Norfolk Arch.*, 39:2(1985), pp.101–17.

156 H.C. Darby, *The Changing Fenland*, 1983, pp.13–16; but see R.J. Silvester, op. cit., p.112.

157 H.E. Hallam, 'Population density in medieval Fenland', *Ec.H.R.*, 14(1961–2), p.76.

158 D.J. Siddle, 'The rural economy of medieval Holderness', *Agric.H.R.*, 15(1967), pp.40–5.

159 *Yorkshire. York and the East Riding*, 1978, pp.322–4.

160 H.A. Hanley and C.W. Chalklin, 'The Kent lay subsidy of 1334/5', in *Kent Records. Documents Illustrative of Medieval Kentish Society* (ed. F.R.H. Du Boulay), 1964, pp.65–6; R.E. Glasscock, 'The distribution of lay wealth in Kent, Surrey, and

Sussex, in the early fourteenth century', *Arch. Cantiana*, 80(1965), pp.63–5.

161 *West Kent and the Weald*, 1969, pp.415–16.

162 Ibid., pp.186–8, 333–4, 375–6, 483.

163 Robin E. Glasscock (ed.), *The Lay Subsidy of 1334*, British Academy Records of Social and Economic History 11, 1975, p.xxviii.

164 Mavis Mate, 'Property investment by Canterbury Cathedral Priory 1250–1400', *J. Brit. Studies*, 23:2(1984), p.12; though acquisitions picked up again in the early fourteenth century, very few licences were obtained in the two decades following the statute of 1279, even by those Fenland houses – Spalding, Crowland and Thorney – previously very active in the land market (Sandra Raban, *Mortmain Legislation and the English Church 1279–1500*, 1982, pp.155–6); for the Statute of Mortmain (1279), see F.M. Powicke and C.R. Cheney, op. cit., 1964, pp.864–5.

Chapter 5
A Rainy Country . . . Ripe with Death

1 Sandra Raban, *Mortmain Legislation and the English Church 1279–1500*, 1982, p.1.

2 Ibid., pp.5–6.

3 Ibid., pp.168–9.

4 Alan Kreider, *English Chantries. The Road to Dissolution*, 1979, pp.72, 74–5.

5 Jacques Le Goff, *La naissance du Purgatoire*, 1981 (translated by Arthur Goldhammer, *The Birth of Purgatory*, 1984), pp.442–3.

6 K.L. Wood-Legh, *Perpetual Chantries in Britain*, 1965, p.306.

7 *Wiltshire*, 1963, p.114 and plate 19.

8 *Gloucestershire. The Vale and the Forest of Dean*, 1970, pp.109–10.

9 *Bedfordshire*, 1968, pp.369–71.

10 *North West and South Norfolk*, 1962, p.397; a fourteenth-century chapel still marks the spot.

11 *Leicestershire and Rutland*, 1960, p.202.

12 *VCH Berkshire*, iv:318.

13 *Yorkshire. York and the East Riding*, 1972, p.351 (and notice in church); *VCH Yorkshire East Riding*, iii:110–11.

14 *Warwickshire*, 1966, p.412; John Stratford was bishop of Winchester (1323–33) before his translation to Canterbury.

15 John Blair and John M. Steane, 'Investigations at Cogges, Oxfordshire, 1978–81: the priory and parish church', *Oxoniensia*, 47(1982), pp.91, 94–5, and plate 34.

16 *Lincolnshire*, 1964, p.373 and church guide.

17 *Bedfordshire*, 1968, pp.296–7 (Northborough); *Gloucestershire. The Cotswolds*, 1970, pp.316–17; *Wiltshire*, 1963, pp.523–4.

18 Robert Stratford became bishop of Chichester (1337–62); the brothers were chancellors of England in turn.

19 Just up the road, the Delamere manor house of the 1330s survives almost intact as further proof of the family's affluence during that decade.

20 John A. Witham, *The Church of St Mary of Ottery*, 1979.

21 G.H. Cook, *English Collegiate Churches of the Middle Ages*, 1959, pp.116–7.

22 *Yorkshire. York and the East Riding*, 1972, p.308.

23 *Warwickshire*, 1966, pp.74–5.

24 *Berkshire*, 1966, pp.216–17; examples of the plan in fifteenth-century Scotland are Seton, Crichton and Dunglass, all in Lothian.

25 For a full discussion of this important effigy, finally settling for a late thirteenth-century date,

see Philip J. Lankester, 'A military effigy in Dorchester Abbey, Oxon.', *Oxoniensia*, 52(1987), pp.145–72.

26 *West Kent and the Weald*, 1969, p.435 and plate 19.

27 *Lincolnshire*, 1964, p.636.

28 *Berkshire*, 1966, p.64. Sir Philip is identified as such in the church guide. For the entire tradition, see H.A. Tummers, *Early Secular Effigies in England. The Thirteenth Century*, 1980, passim. There is some dispute at Reepham as to whether the monument is to Sir Roger de Kerdiston (d.1337) or Sir William (d.1361); for the latter, see Jonathan Alexander and Paul Binski (eds), *Age of Chivalry. Art in Plantagenet England 1200–1400*, 1987, pp.248–9.

29 Brian Kemp, *English Church Monuments*, 1980, p.22; *Herefordshire*, 1963, pp.217–18, 260–1.

30 Jonathan Alexander and Paul Binski, op. cit., pp.250, 293–5.

31 The words, borrowed from Baudelaire's *Les Fleurs du Mal* LXXVII, were used there with quite a different meaning; for a useful account of Winchelsea's troubles, see *VCH Sussex*, ix:62–75.

32 H.H. Lamb, *Climate, History and the Modern World*, 1962, chapter 11 (Decline again in the late Middle Ages).

33 A.J.F. Dulley, 'The level and port of Pevensey in the Middle Ages', *Sussex Arch. Coll.*, 104(1966), p.32; Alan R.H. Baker, 'Some evidence of a reduction in the acreage of cultivated lands in Sussex during the early fourteenth century', ibid., pp.1–5; J.R. Ravensdale, *Liable to Floods. Village Landscape on the Edge of the Fens AD 450–1650*, 1974, passim; R.A.L. Smith, *Canterbury Cathedral Priory*, 1943, p.156.

34 J.Z. Titow, 'Evidence of weather in the account rolls of the bishopric of Winchester 1209–1350', *Ec.H.R.*, 12(1959–60), pp.385–7.

35 Ian Kershaw, 'The Great Famine and agrarian crisis in England 1315–1322', *Past & Present*, 59(1973), pp.3–50; H.E. Hallam, 'The climate of Eastern England 1250–1350', *Agric. H. R.*, 32(1984), pp.124–32.

36 H.H. Lamb, op. cit., p.187.

37 Guy Beresford, 'Three deserted medieval settlements on Dartmoor: a report on the late E. Marie Minter's excavations', *Med. Arch.*, 23(1979), pp.142–6.

38 David Roden, 'Field systems in Ibstone, a township of the south-west Chilterns, during the later Middle Ages', *Records of Buckinghamshire*, 18(1966–70), p.52.

39 David Postles, 'Rural economy on the grits and sandstones of the South Yorkshire Pennines, 1086–1348', *Northern History*, 15(1979), pp.17–19. Some of the over-ready assumptions in the thesis about retreat from the margin are discussed by Mark Bailey, 'The concept of the margin in the medieval English economy', *Ec.H.R.*, 42(1989), pp.1–17; depending on where they were, not all thin soils were marginal, those closer to major settlements remaining (obviously) in demand.

40 Alan R.H. Baker, 'Evidence in the 'Nonarum Inquisitiones' of contracting arable lands in England during the early fourteenth century', *Ec.H.R.*, 19(1966), pp.518–32.

41 For the fortunate circumstances of the Titchfied manors, see D.G. Watts, 'A model for the early fourteenth century', *Ec.H.R.*, 20(1967), p.347.

42 Alan R.H. Baker, op. cit., p.530.

43 Christopher Dyer, *Lands and Peasants in a Changing Society. The Estates of the Bishopric of Worcester, 680–1540*, 1980, p.111.

44 Marjorie K. McIntosh, 'Land, tenure, and population in the royal manor of Havering, Essex, 1251–1352/3', *Ec.H.R.*, 33(1980), p.30.

45 R.H. Britnell, 'Agricultural technology and the margin of cultivation in the fourteenth century', *Ec.H.R.*, 30(1977), pp.60–2.

46 Bruce Campbell, 'The diffusion of vetches in medieval England', *Ec.H.R.*, 41(1988), pp.193–208.

47 J.Z. Titow, *Winchester Yields. A Study in Medieval Agricultural Productivity*, 1972, passim.

48 Ibid., p.32; J.A. Raftis, *Assart Data and Land Values. Two Studies in the East Midlands 1200–1350*, 1974, passim.

49 Bruce M.S. Campbell, 'Population change and the genesis of commonfields on a Norfolk manor', *Ec.H.R.*, 32(1980), p.185; Zvi Razi, *Life, Marriage and Death in a Medieval Parish. Economy, Society and Demography in Halesowen 1270–1400*, 1980, pp.94–8. But the argument goes back at least as far as Barbara Harvey's 'The population trend in England between 1300 and 1348', *T.R.H.S.*, 16(1966), pp.23–42.

50 For a notably cautious statement along these lines, see Andrew Jones. 'Caddington, Kesworth, and Dunstable in 1297', *Ec.H.R.*, 32(1979), pp.316–27; also Barbara Dodwell, 'Holdings and inheritance in medieval East Anglia', ibid., 20(1967), pp.53–66; J.Z. Titow, 'Some evidence of the thirteenth-century population increase', ibid., 14(1961–2), pp.218–24, and the same author's 'Some differences between manors and their effects on the condition of the peasant in the thirteenth century', *Agric. H.R.*, 10–11 (1962–3), pp.1–13; P.D.A. Harvey (ed.), *The Peasant Land Market in Medieval England*. 1984, pp.18–19 and passim.

51 A.R. Bridbury, 'The Black Death', *Ec.H.R.*, 26(1973), pp.590–1.

52 J.R. Maddicott, 'Poems of social protest in early fourteenth-century England', in *England in the Fourteenth Century* (ed W.M. Ormrod), 1986, pp.130–44.

53 Isobel S.T. Aspin (ed.) *Anglo-Norman Political Songs*, 1953, p.74.

54 Ralph B.Pugh (ed.), *Calendar of London Trailbaston Trials under Commissions of 1305 and 1306*, 1975, pp.1–2.

55 J.R. Maddicott, op. cit., p.142.

56 Richard W. Kaeuper, 'Law and order in fourteenth-century England: the evidence of special commissions of oyer and terminer', *Speculum*, 54(1979), pp.735–6.

57 Mavis Mate, 'High prices in early fourteenth-century England: causes and consequences', *Ec.H.R.*, 28(1975), pp.1–16; N.J. Mayhew, 'Numismatic evidence and falling prices in the fourteenth century', ibid., 27(1974), pp.1–15; Michael Prestwich, 'Currency and the economy of early fourteenth-century England', in *Edwardian Monetary Affairs (1279–1344)* (ed. N.J. Mayhew), British Archaeological Reports 36, 1977, pp.45–58; D.L. Farmer, 'Crop yields, prices and wages in medieval England', *Studies in Medieval and Renaissance History*, 6(1983), pp.117–55.

58 Edward Miller, 'War, taxation and the English economy in the late thirteenth and early fourteenth centuries', in *War and Economic Development. Essays in Memory of David Joslin* (ed. J.M. Winter), 1975, pp.11–31; J.R. Maddicott, *The English Peasantry and the Demands of the Crown 1294–1431*, 1975, passim; but for some correction of this emphasis, see A.R. Bridbury, 'Before the Black Death', *Ec.H.R.*, 30(1977), pp.393–410.

59 J.R. Maddicott, op. cit. (1975), p.49.

60 Art Cosgrove (ed.), *A New History of Ireland II. Medieval Ireland 1169–1534*, 1987, p.202.

61 Richard W. Kaeuper, op. cit., pp.734–5.

62 Barbara Hanawalt, *Crime in East Anglia in the Fourteenth Century. Norfolk Gaol Delivery Rolls, 1307–1316*, Norfolk Record Society 44, 1976, pp.14–15; also the same author's 'Economic influences on the pattern of crime in England, 1300–1348', *American J. Legal History*, 18(1974), pp.281–97, and *Crime and Conflict in English Communities 1300–1348*, 1979, passim.

63 For a re-dating of these ballads, see J.R. Maddicott, 'The birth and setting of the ballads of Robin Hood', *E.H.R.*, 93(1978), pp.276–99; for the criminal bands, see E.L.G. Stones, 'The Folvilles of Ashby-Folville, Leicestershire, and their associates in crime, 1326–1347', *T.R.H.S.*, 7(1957) pp.117–36; also J.G. Bellamy, 'The Coterel Gang: an anatomy of a band of fourteenth-century criminals', *E.H.R.*, 79(1964), pp.698–717, and the same author's *Crime and Public Order in England in the Later Middle Ages*, 1973, chapter 3 (The Criminal Bands); also B.A. Hanawalt, 'Fur-collar crime: the pattern of crime among the fourteenth-century English nobility', *J. Social History*, 8(1975), pp.1–17, and the same author's *Crime and Conflict*, 1979, chapter 6 (Criminal Associations and Professional Crime).

64 H.R.T. Summerson, 'The structure of law enforcement in thirteenth-century England', *American J. Legal History*, 23(1979), p.326. For a more cautious statement on the Huntingdonshire evidence, see Anne Reiber DeWindt and Edwin Brezette DeWindt, *Royal Justice and the Medieval English Countryside*, 1981, particularly pp.16, 89 (on the use of 'stranger' and 'vagabond' in the records).

65 J.F.R. Walmsley, 'The peasantry of Burton Abbey in the thirteenth century", *North Staffordshire J. Field Studies*, 12(1972), pp.50–1.

66 D.G. Watts, 'Peasant discontent on the manors of Titchfield Abbey, 1245–1405', *Proc. Hampshire Field Club*, 39(1983), pp.122–8; Anne DeWindt, 'Peasant power structures in fourteenth-century King's Ripton', *Mediaeval Studies*, 38(1976), pp.236–67.

67 Anne Reiber DeWindt and Edwin Brezette DeWindt, op. cit., p.64.

68 Zvi Razi, 'The struggles between the abbots of Halesowen and their tenants in the thirteenth and fourteenth centuries', in *Social Relations and Ideas. Essays in Honour of R.H. Hilton* (eds T.H. Aston, P.R. Coss, Christopher Dyer and Joan Thirsk), 1983, especially pp.156–60. For other comments on the Halesowen evidence, see R.H. Hilton, 'Lords, burgesses and hucksters', *Past & Present*, 97(1982), pp.3–15, and the same author's 'Small town society in England before the Black Death', ibid., 105(1984), pp.53–78.

69 H.E. Hallam, *Settlement and Society. A Study of the Early Agrarian History of South Lincolnshire*, 1965, p.222.

70 A.H. Davis (ed.), *William Thorne's Chronicle of St Augustine's Abbey, Canterbury*, 1934, pp.432–3; *Cal. Pat. Rolls, 1317–21*, p.98; Alfred Clapham, *St Augustine's Abbey*, 1955, p.25.

71 Naomi D.Hurnard, *The King's Pardon for Homicide before A.D. 1307*, 1969, especially pp.311–26; Michael Prestwich, *War, Politics and Finance under Edward I*, 1972, pp.288–90.

72 Michael Prestwich, op. cit., p.289.

73 *Cal. Pat. Rolls, 1338–40*, p.466.

74 The stories and their sequels were told at length by N.M. Trenholme, *The English Monastic Borough. A Study in Medieval History*, 1927, chapter 3 (Communal Revolts in the Early Fourteenth Century).

75 *Hertfordshire*, 1953, p.218.

76 A.B. Whittingham, *Bury St Edmunds Abbey*, 1971, p.29.

77 R.N. Hadcock, *Tynemouth Priory and Castle*, 1952.

78 The case for prestige building, somewhat qualified before its end, is put by Charles Coulson, 'Hierarchism in conventual crenellation. An essay in the sociology and metaphysics of medieval fortification', *Med. Arch.*, 26(1982), pp.69–100.

79 Una Rees (ed.), *The Cartulary of Haughmond Abbey*, 1985, p.13.

80 Eleanor Searle, *Lordship and Community. Battle Abbey and its Banlieu 1066–1538*, 1974, pp.154–8.

81 *Cal. Pat. Rolls, 1338–40*, p.92; Colin Platt, *The Abbeys and Priories of Medieval England*, 1984, p.190.

82 Colin Platt, op. cit., pp.103–5.

83 M.W. Thompson, 'Maxstoke Priory', *Arch. J.*, 128(1971), pp.243–4.

84 Michael Prestwich, *The Three Edwards. War and State in England 1272–1377*, 1980, pp.148–9.

85 N.W. Alcock, P.A. Faulkner and S.R. Jones, 'Maxstoke Castle, Warwickshire', *Arch. J.*, 135(1978), pp.195–233. For the term 'castles of law and order', not universally accepted, see my own *The Castle in Medieval England and Wales*, 1982, chapter 5.

86 Colin Platt, *Medieval England*, 1978, pp.111–15.

87 T.B. Barry, *The Archaeology of Medieval Ireland*, 1987, pp.84–93.

88 Charles Coulson, 'Structural symbolism in medieval castle architecture', *J. Brit. Arch. Assoc.*, 132(1979), p.84.

89 Brian K. Roberts, 'The historical geography of moated homesteads: the Forest of Arden, Warwickshire', *Trans Birmingham and Warwickshire Arch. Soc.*, 88(1976–7), p.70.

90 C.C. Taylor, 'Medieval moats in Cambridgeshire', in *Archaeology and the Landscape* (ed. P.J. Fowler), 1972, p.248.

91 Philip Dixon, *Aydon Castle*, 1988, pp.7–11.

92 John Bellamy, op. cit. (1973), p.79.

93 For the sequence at Penshurst, see the useful pamphlet by Marcus Binney and Anthony Emery, *The Architectural Development of Penshurst Place*, 1975.

94 Margaret Wood, *Thirteenth Century Domestic Architecture in England*, Archaeological Journal 105 supplement, 1950, pp.64–70.

95 For a recent description and somewhat unnecessary emphasis on the bishop's house as prestigious proto-keep, see Jeffrey West, 'Acton Burnell Castle, Shropshire', in *Collectanea Historica. Essays in Memory of Stuart Rigold* (ed. Alec Detsicas), 1981, pp.85–92; and see also C.A. Ralegh Radford, 'Acton Burnell Castle', in *Studies in Building History. Essays in Recognition of the Work of B.H.St J. O'Neil* (ed. E.M. Jope), 1961, pp.94–103.

96 W.G. Thomas, *Weobley Castle*, 1971.

97 *Cal. Pat. Rolls, 1307–13*, pp.144, 212. The licence to Henry Percy, dated 4 October 1308, granting him permission to crenellate Spofforth, also gave him the same right at another Yorkshire manor-house and (more significantly) at Petworth, in Sussex, remote from any danger of the Scots. John de Markenfield, 'king's clerk', got his licence to crenellate his dwelling-house on 28 February 1310.

98 For the raid, see Ian Kershaw, 'A note on the Scots in the West Riding, 1318–1319', *Northern History*, 17(1981), pp.231–9.

99 Stephen Hall, *Boarstall Tower*, 1979.

100 *Oxfordshire*, 1974, pp.492–8; E. Clive Rouse, *Longthorpe Tower*, 1964; N. Summers, 'Manor Farm, Halloughton', *Trans Thoroton Soc.*, 69(1965), pp.66–76; Arthur and Margaret Ann Elton, *Clevedon Court*, 1983; *Dorset*, 1972, pp.494–5.

101 S.E. Rigold, *Baconsthorpe Castle*, 1966; Arthur Bedingfeld, *Oxburgh Hall*, 1978.

102 For a recent firm statement to this effect, based

on Norfolk evidence from Coltishall, see Bruce M.S. Campbell, 'Population pressure, inheritance and the land market in a fourteenth-century peasant community', in *Land, Kinship and Life-Cycle* (ed. Richard M. Smith), 1984, especially pp.98–9, 127–8.

103 Mavis Mate, 'The estates of Canterbury Cathedral Priory before the Black Death 1315–1348', *Studies in Medieval and Renaissance History*, 8(1986), pp.3–30.

104 *Derbyshire*, 1953, pp.233–6.

105 Ibid., pp.40–4.

106 T.G.A. Baker, *Worcester Cathedral*, 1980, p.14.

107 R.M. Haines (ed.), *A Calendar of the Register of Wolstan de Bransford, bishop of Worcester 1339–49*, Worcester Historical Society 4, 1966, pp.li–lii; for a still useful pioneer study along these lines, see A. Hamilton Thompson's 'Registers of John Gynewell, bishop of Lincoln, for the years 1347–1350', *Arch. J.*, 68(1911), pp.300–60.

108 *Bedfordshire*, 1968, pp.296–7.

109 *Leicestershire and Rutland*, 1960, pp.187–8.

110 *Suffolk*, 1961, pp.314–15.

111 *North-East Norfolk and Norwich*, 1962, pp.113–15; C.L.S. Linnell, *St Margaret's Church, Cley-next-the-Sea*, 1959.

112 V. Pritchard, *English Medieval Graffiti*, 1967, pp.44, 181–3.

113 Eleanor Searle, op. cit., pp.258, 262.

114 R.B. Dobson, *Durham Priory 1400–1450*, 1974, p.270.

115 G.S. Haslop, 'The abbot of Selby's financial statement for the year ending Michaelmas 1338', *Yorks. Arch. J.*, 44(1972), pp.166–7.

116 Colin Platt, *The Abbeys and Priories of Medieval England*, 1984, pp.164–6.

117 Marjorie B. Honeybourne, 'The abbey of St Mary Graces, Tower Hill', *Trans London & Middx Arch. Soc.*, 11(1954), pp.16–26; David Knowles and R. Neville Hadcock, *Medieval Religious Houses. England and Wales*, 1953, p.111.

118 Aubrey Gwynn, *The English Austin Friars in the Time of Wyclif*, 1940, p.74.

119 Ibid., p.75.

120 Helen Sutermeister, *The Norwich Blackfriars*, 1977, p.4.

121 P.D.A. Harvey, *A Medieval Oxfordshire Village. Cuxham 1240 to 1400*, 1965, pp.76–9, 85, 135–7.

122 Edward Britton, *The Community of the Vill. A Study in the History of the Family and Village Life in Fourteenth-Century England*, 1977, pp.115–23.

123 Frances M. Page, *The Estates of Crowland Abbey. A Study in Manorial Organization*, 1934, pp.120–5.

124 D.G. Watts, op. cit., p.547.

125 Aubrey Gwynn, op. cit., p.74.

126 *North Somerset and Bristol*, 1958, p.372.

127 *Lincolnshire*, 1964, p.504.

128 John Charlton, *Mattersey Priory*, 1949; *RCHM Dorset*, 1970, iii:183–4.

129 S.E. Rigold, *Lilleshall Abbey*, 1969, p.6.

130 Charles Peers, *Kirkham Priory*, 1946.

131 Rose Graham, 'Excavations on the site of Sempringham Priory', *J. Brit. Arch. Assoc.*, 5(1940), pp.66–90.

132 *North Somerset and Bristol*, 1958, p.399.

133 Ibid., p.403, Allan Scott, *St Mary Redcliffe Bristol*, 1986, pp.11–12.

Chapter 6
Learning to Live with Death

1 David Knowles, *The Religious Orders in England*, 1979, ii:10–11.

2 John Hatcher, 'Mortality in the fifteenth century: some new evidence', *Ec.H.R.*, 39(1986), pp.19–38.

3 Ibid., p.33.

4 For a useful recent recalculation of the figures, see Bruce M.S. Campbell, 'The population of early Tudor England: a re-evaluation of the 1522 Muster Returns and 1524 and 1525 Lay Subsidies', *J. Hist. Geog.*, 7(1981), pp.145–54.

5 The phrase is Sylvia Thrupp's in 'The problem of replacement-rates in late medieval English population', *Ec.H.R.*, 15(1965–6), p.118.

6 E. Clive Rouse, *Longthorpe Tower*, 1964, pp.11–12, and see also E. Clive Rouse and Audrey Baker, 'The wall-paintings at Longthorpe Tower, near Peterborough, Northants', *Archaeologia*, 96(1955), pp.1–57; John Edwards, 'Widford wall-paintings: more new decipherments', *Oxoniensia*, 49(1984), pp.133–9; *Hampshire*, 1967, p.302; *Yorkshire. The North Riding*, 1966, p.382.

7 H. de S. Shortt, *The Three Bishops' Tombs Moved to Salisbury Cathedral from Old Sarum*, 1971, p.3; *VCH Hampshire*, iv:237.

8 E. Clive Rouse, 'Wall paintings in the church of St Pega, Peakirk, Northamptonshire', *Arch. J.*, 110(1953), pp.144–7.

9 *North-East Norfolk and Norwich*, 1962, p.342; Peter J. Caswell, *The Parish Church of Lutterworth in Leicestershire*, 1978, pp.10–11.

10 E. Carleton Williams, 'Mural paintings of the Three Living and the Three Dead in England', *J. Brit. Arch. Assoc.*, 7(1942), pp. 31–40.

11 Quoted by Andrew Breeze, 'The Dance of Death', *Cambridge Medieval Celtic Studies*, 13(1987), pp.94–5; the earl of Rosslyn, *Rosslyn. Its Chapel, Castle and Scenic Lore*, undated, p.31.

12 Ethel Carleton Williams, 'The Dance of Death in painting and sculpture in the Middle Ages', *J. Brit. Arch. Assoc.*, 1(1937), p.238; and see my own *Medieval England*, 1978, plate 95 (Norwich). For a general discussion, see James M. Clark, *The Dance of Death in the Middle Ages and the Renaissance*, 1950.

13 *Yorkshire. York and the East Riding*, 1972, p.209.

14 Ibid., p.348 and plate 73.

15 *Berkshire*, 1966, p.145 and plate 26(b).

16 *Suffolk*, 1974, pp.144–5.

17 Robert S. Gottfried, *Bury St Edmunds and the Urban Crisis: 1290–1539*, 1982, p.142 and passim.

18 Ibid., p.159.

19 Peter Heath, 'Urban piety in the Later Middle Ages: the evidence of Hull wills', in *The Church, Politics and Patronage in the Fifteenth Century* (ed. Barrie Dobson), 1984, pp.228–9.

20 F.N. Robertson (ed.), *The Works of Geoffrey Chaucer*, 1957 (2nd edn), p.483.

21 *Oxfordshire*, 1974, pp.596–9; the monuments are usefully described and illustrated in the *Guide to St Mary's Church, Ewelme*, undated.

22 Brian Kemp, *English Church Monuments*, 1980, p.161 (included in a general discussion of these *memento mori* monuments, pp.160–5).

23 *Gloucestershire. The Cotswolds*, 1970, pp.349–50.

24 Pamela M. King, 'The iconography of the 'Wakeman Cenotaph' in Tewkesbury Abbey', *Trans Bristol and Gloucestershire Arch. Soc.*, 103(1985), pp.141–8.

25 Two fifteenth-century carols are conflated here (Richard Leighton Greene (ed.), *The Early English Carols*, 1977 (2nd edn), pp.220–1).

26 *Nottinghamshire*, 1951, pp.83–4; Nevil Truman, *Holme by Newark Church and its Founder*, 1982.

27 *Nottinghamshire*, 1951, pp.106–10; O. Allen, *A Short History and Guide to the Parish Church of St Mary Magdalene, Newark-on-Trent*, 1965.

28 David Lloyd, *The Parish Church of Saint Lawrence (Ludlow). A History and a Guide*, 1980, pp.8–9.

29 Starting with A.R. Bridbury's influential *Eco-*

nomic Growth. England in the Later Middle Ages, 1962.

30 W.G. Hoskins, 'The wealth of medieval Devon', in *Devonshire Studies* (eds W.G. Hoskins and H.P.R. Finberg), 1952, pp.228–47.

31 *Gloucestershire. The Cotswolds*, 1970, pp.243–8; the high quality of this glass has led to the suggestion that it was in fact initially ordered by Henry VII for a project of his own (Hilary Wayment, *The Stained Glass of the Church of St Mary, Fairford, Gloucestershire*, 1984, especially pp.94–7).

32 *Yorkshire. York and the East Riding*, 1972, p.342 and plate 46.

33 *North-West and South Norfolk*, 1962, pp.308–10 and plate 17.

34 Nigel Saul, *Scenes from Provincial Life. Knightly Families in Sussex 1280–1400*, 1986, pp.116, 140–60.

35 Ibid., pp.148–52: the glass is now dispersed or lost.

36 *Church of St Mary and St Barlock, Norbury*, 1969; *Arch. J.*, 118(1961), pp.247–8.

37 *South and West Somerset*, 1958, p.94.

38 T.B. Dilks (ed.), *Bridgwater Borough Archives 1200–1377*, Somerset Record Society 48, 1933, pp.65–7.

39 Ibid., pp.159–64.

40 John James Wilkinson (ed.), 'Receipts and expenses in the building of Bodmin Church, A.D.1469 to 1472', *Camden Miscellany 7*, 1875; reproduced in part by A.R. Myers (ed.), *English Historical Documents 1327–1485*, 1969, pp.741–4.

41 Only Boston has a minus ratio in Dr Bridbury's table (Some examples of urban change) comparing tax receipts in 1334 and 1524 (op. cit., pp.112–13).

42 Quoted in Mark Spurrell's useful guide to *Boston Parish Church*, 1981.

43 *Lincolnshire*, 1964, p.464.

44 Dorothy M. Owen (ed.), *The Making of King's Lynn. A Documentary Survey*, 1984, pp.60–3, 317–19, 324–30; for Corpus Christi gilds, see Miri Rubin, 'Corpus Christi fraternities and late medieval piety', *Studies in Church History*, 23(1986), pp.97–109.

45 H.F. Westlake, 'The parish gilds of the later fourteenth century', *Trans St Paul's Ecclesiological Soc.*, 8(1917–20), p.104.

46 J. and L. Toulmin Smith (eds), *English Gilds*, Early English Text Society 40, 1870, pp.47–8.

47 Dorothy M. Owen, op. cit., p.61.

48 J. and L. Toulmin Smith, op. cit., p.198; quoted by David Lloyd, op. cit., p.2.

49 For plans of the two churches, see my own *The Parish Churches of Medieval England*, 1981, p.116.

50 *Warwickshire*, 1966, pp.269–70 and plates 16 and 18; Richard K. Morris, 'St Mary's Hall and the medieval architecture of Coventry', *Trans Ancient Monuments Soc.*, 32(1988), pp.8–27.

51 Caroline M. Barron, 'The parish fraternities of medieval London', in *The Church in Pre-Reformation Society* (eds Caroline M. Barron and Christopher Harper-Bill), 1985, p.30.

52 J. and L. Toulmin Smith, op. cit., p.229.

53 For the gilds' comparatively small contribution in this regard, see Caroline M. Barron, op. cit., p.27.

54 J. and L. Toulmin Smith, op. cit., pp.228–30.

55 *Yorkshire. York and the East Riding*, 1972, p.182; *St Mary's Church, Beverley*, 1979, p.2.

56 H.F. Westlake, op. cit., p.105.

57 *North-East Norfolk and Norwich*, 1962, pp.349–51; Paul Cattermole and Simon Cotton, 'Medieval parish church building in Norfolk', *Norfolk Arch.*, 38(1983), p.275; Simon Cotton, 'Medieval roodscreens in Norfolk – their construction and

painting dates', ibid, 40(1987), p.52.

58 Colin Platt, op. cit. (1981), pp.90–l.

59 Paul Cattermole and Simon Cotton, op. cit., p.241.

60 Ibid., p.251.

61 Ibid., pp.259–60; *North-East Norfolk and Norwich*, 1962, p.253.

62 *Cambridgeshire*, 1954, p.409; *South and West Somerset*, 1958, pp.310–11; *Lincolnshire*, 1964, pp.300–1.

63 David Jones and John Salmon, *Eye Church*, 1980, p.3; *Suffolk*, 1974, pp.206–7.

64 Paul Cattermole and Simon Cotton, op. cit., pp.244–5, 275–6; *The Abbey Church of Saint Mary and Saint Thomas of Canterbury, Wymondham*, undated, pp.5–8.

65 L.F. Salzman, *Building in England down to 1540*, 1967 (2nd edn), pp.547–9; for a view of the three towers, see my own *Medieval England*, 1978, fig.93.

66 Paul Cattermole and Simon Cotton, op. cit., p.254.

67 *Essex*, 1965, p.158; A.R. Johnston, *The Parish Church of St Mary, Dedham*, 1971.

68 *Suffolk*, 1974, pp.195–6; *The Bell-Cage and the Bells. The Parish Church of St Mary, East Bergholt*, 1979.

69 *Lincolnshire*, 1964, p.553.

70 *Nottinghamshire*, 1951, p.80.

71 *Suffolk*, 1974, pp.322–3.

72 *Wiltshire*, 1963, p.178.

73 J.F. Williams, 'The Black Book of Swaffham', *Norfolk Arch.*, 33(1962–5), pp.243–9.

74 Ibid., p.250.

75 Ibid., p.252; both pairs of bench-ends, later remade as clergy stalls, are illustrated in John H. Pink's *SS. Peter & Paul, Swaffham*, 1980, pp.6–7.

76 J.F. Williams, op. et loc. cit.

77 Ibid., pp.251–3; Paul Cattermole and Simon Cotton, op. cit., pp.266–8.

78 For a description and illustration of the tomb, see John H. Pink, op. cit., pp.4,11; the canopy is thought to have been reduced in height when the tomb was re-set in 1745.

79 Kenneth Arthur, *Historical Notes of Fishlake Church*, 1983, p.19; *Yorkshire. The West Riding*, 1959, pp.201–3.

80 *Church of St Mary and St Barlok, Norbury*, 1969.

81 *Gloucestershire. The Vale and the Forest of Dean*, 1970, p.366; Froissart, *Chroniques* (ed. George T. Diller), 1972, p.108.

82 A.W. Head and J.A. Head, *Lingfield Parish Church*, 1975, pp.11–16.

83 The achievements are described and illustrated in *Age of Chivalry. Art in Plantagenet England 1200–1400* (eds Jonathan Alexander and Paul Binski), 1987, pp.479–81.

84 *Gloucestershire. The Vale and the Forest of Dean*, 1970, p.101; *Bristol Cathedral*, 1984, p.4.

85 *County of Durham*, 1953, p.107 and plate 39(a).

86 *Yorkshire. The North Riding*, 1966, p.385; Anthony Goodman, 'John of Gaunt: paradigm of the late fourteenth-century crisis', *T.R.H.S.*, 37(1987), p.145 and passim.

87 *Cheshire*, 1971, pp.119–20; for Calveley's military career, see Philip Morgan, *War and Society in Medieval Cheshire 1277–1403*, Chetham Society 34, 1987, pp.136–8, 162.

88 For Tewkesbury and Lingfield, see notes 81–2; for Spilsby, see *Lincolnshire*, 1964, pp.373–4, and J.S. Thorold, *Spilsby and its Church*, undated; for Lowick, see *Northamptonshire*, 1973, pp.297–8, and Simon A. Cotton, *SS. Peter and Paul, Lowick*, undated; for Staindrop, see *County Durham*, 1953, pp.215–16; for Harewood, see *Yorkshire. The West Riding*, 1959, pp.243–4; for Tong, see *Shropshire*, 1958, pp.301–4; for Dennington, see *Suffolk*, 1974, pp. 188–9.

89 *Cheshire*, 1971, p.298; John Pritchard, *Church of Saint Lawrence, Over Peover*, 1985.

90 The Morley revenues are discussed by Colin Richmond, 'Thomas Lord Morley (d.1416) and the Morleys of Hingham', *Norfolk Arch.*, 39(1984), pp.1–12.

91 *North-West and South Norfolk*, 1962, pp.196–7 and plates 42–3; *Hingham Parish Church: Norfolk*, undated.

92 *Lincluden College*, 1966; J.R. Hume, *Lincluden Collegiate Church*, 1985; Ian B. Cowan and David E. Easson, *Medieval Religious Houses. Scotland*, 1976 (2nd edn), p.223.

93 The writer was the continuator of Higden's *Polychronicon*, quoted in H. M. Colvin (ed.), *The History of the King's Works*, 1963, ii:881.

94 For the foundation dates of these and other major orders, see Maurice Keen, *Chivalry*, 1984, p.179; and see also Juliet Vale, *Edward III and Chivalry. Chivalric Society and its Context 1270–1350*, 1982, chapter 5 (The Foundation of the Order of the Garter).

95 H.M. Colvin, op. cit., pp.870–82; for the expansion of households, see D'Arcy Jonathan Dacre Boulton, *The Knights of the Crown. The Monarchical Orders of Knighthood in Later Medieval Europe 1325–1520*, 1987, p.3 and passim.

96 C.J. Tabraham, *Threave Castle*, 1983; W. Douglas Simpson, *Hermitage Castle*, 1982; J.S. Richardson, *Tantallon Castle*, 1980; W. Douglas Simpson, *Bothwell Castle*, 1978.

97 For the Warwick and Tantallon show-fronts, see my *The Castle in Medieval England and Wales*, 1982, pp.146–8, and *Medieval Britain from the Air*, 1984, pp.147–8.

98 K.B. McFarlane, *The Nobility of Later Medieval England*, 1973, pp.92–3.

99 Ibid., pp.194–5.

100 For the most recent discussion of the dating of the Warwick facade, see Richard K. Morris, 'The architecture of the earls of Warwick in the fourteenth century', in *England in the Fourteenth Century. Proceedings of the 1985 Harlaxton Symposium* (ed. W.M. Ormrod), 1986, pp.161–74.

101 The Beauchamp legends are treated by Emma Mason, 'Legends of the Beauchamps' ancestors: the use of baronial propaganda in medieval England', *J. Medieval History*, 10(1984), pp.25–40.

102 K.B. McFarlane, op. cit., p.194.

103 Chris Given-Wilson, *The English Nobility in the Late Middle Ages: the Fourteenth-Century Political Community*, 1987, pp.124–59.

104 Philip Morgan, op. cit., pp.168–70.

105 P.S. Lewis, *Later Medieval France. The Polity*, 1968, pp.201–8; and for a recent discussion of the English evidence, see Christopher Dyer, *Standards of Living in the Later Middle Ages. Social Change in England c.1200–1520*, 1989, especially chapter 3 (The Aristocracy as Consumers).

106 W.M. Ormrod, 'The English Crown and the customs, 1349–63', *Ec.H.R.*, 40(1987), p.36 and passim; and see also the same author's 'Edward III and the recovery of royal authority in England, 1340–60', *History*, 72(1987), pp.4–19.

107 Quoted by J.W. Sherborne, 'Aspects of English court culture in the later fourteenth century', in *English Court Culture in the Later Middle Ages* (eds V.J. Scattergood and J.W. Sherborne), 1983, pp.11, 13; and see Juliet Vale, op. cit., p.56, arguing likewise that Edward III was a greater patron than he has sometimes been made out to be.

108 H.M. Colvin, op. cit., i:931–4, 959, 974–5, 995–7.

109 Ibid., pp.793–802.

110 Ibid., pp.662–6.

111 W.D. Peckham, 'The architectural history of Amberley Castle', *Sussex Arch. Coll.*, 62(1921),

especially pp.32–4.

112 *West Kent and the Weald* , 1969, p.378; S.E. Rigold, 'Lympne Castle', *Arch. J.* , 126(1969), pp.260–2.

113 *North East and East Kent* , 1983, pp.441–3.

114 Margaret Wood, *Donnington Castle* , 1964, p.5.

115 Ibid., pp.22–6.

116 H.M. Colvin, op. cit., i:236–7.

117 For these castles and for fuller references, see my *The Castle in Medieval England and Wales* , 1982, chapter 6 (Castles of the Hundred Years War).

118 For the argument about Bodiam and defence, see D.J. Turner, 'Bodiam, Sussex: true castle or 'old soldier's dream house' ', in *England in the Fourteenth Century* (ed. W.M. Ormrod), 1986, pp.267–77.

119 J.S. Richardson and C.J. Tabraham, *Dirleton Castle*, 1982.

120 C.H. Hunter Blair and H.L. Honeyman, *Dunstanburgh Castle* , 1982, p.6.

121 Carlisle's outer gatehouse is fully described and illustrated in M.R. McCarthy, H.R.T. Summerson and R.G. Annis, *Carlisle Castle: a descriptive and documentary survey from the 11th to the 20th century*, in press; for the contract in its original French, see L.F. Salzman, op. cit., pp.456–7.

122 Anthony Goodman, op. cit., p.145.

123 Beric M. Morley, 'Aspects of fourteenth-century castle design', in *Collectanea Historica. Essays in Memory of Stuart Rigold* (ed. Alec Detsicas), 1981, pp.104–13.

124 Beric M. Morley, 'Hylton Castle', *Arch. J.* , 133(1976), pp.118–34; and the same author's *Hylton Castle* , 1979.

125 P.A. Faulkner, 'Castle planning in the fourteenth century', *Arch. J.* , 120(1963), pp.225–30; L.F. Salzman, op. cit., pp.454–6.

126 For a recent characteristically shrewd analysis of the very similar advance of the Scropes of Masham, see T.B. Pugh's *Henry V and the Southampton Plot of 1415* , Southampton Records Series 30, 1988, pp.109–14.

127 J.M.W. Bean, *The Estates of the Percy Family 1416–1537* , 1958, pp.5–11; J.A. Tuck, 'The emergence of a northern nobility, 1250–1400', *Northern History* , 22(1986), pp.10–11.

128 Jill Rathbone, 'Alnwick Castle', *Arch. J.*, 133 (1976), pp.148–54.

129 For Beauchamp propaganda at Warwick of the same kind, see Emma Mason, op. et loc. cit. (1984).

130 C.H. Hunter Blair and H.L. Honeyman, *Warkworth Castle* , 1982, pp.17–19; Peter Curnow, 'Warkworth Castle', *Arch. J.*, 133(1976), pp.154–9.

131 J.A. Tuck, op. cit., pp.14–17.

132 David Neave, 'Wressle Castle', *Arch. J.*, 141(1984), pp.58–60 (including a useful *c.* 1600 perspective view and plan); Lucy Toulmin Smith (ed.), *The Itinerary of John Leland in or about the years 1535–1543. Parts I to III* , 1907, p.53.

133 *Yorkshire. The West Riding* , 1959, p.245; *Northumberland*, 1957, pp.85–6, 126, 143–4; Stephen Johnson, *Belsay* , 1984, pp.2–4.

134 For the adoption of all of these in late-medieval Scotland, see Geoffrey Stell's papers: 'Architecture: the changing needs of society', in *Scottish Society in the Fifteenth Century* (ed. Jennifer M. Brown), 1977, pp.153–83; 'Late medieval defences in Scotland', in *Scottish Weapons and Fortifications 1100–1800* (ed. David H. Caldwell), 1981, pp.21–54; and 'The Scottish medieval castle: form, function and "evolution" ', in *Essays on the Nobility of Medieval Scotland* (ed. K.J. Stringer), 1985, pp.195–209.

135 W. Douglas Simpson, *Bothwell Castle* , 1978; C.J. Tabraham, *Threave Castle*, 1983.

136 R. Denys Pringle, *Doune Castle* , 1987.

137 Roger Walden and John, his brother, were jointly granted the keepership of Portchester castle and town on 1 February 1397 (*Cal. Pat. Rolls, 1396–99*, p.64), but the treasurer's interest in the work there dated back to its beginnings on 29 April 1396 (ibid. *1391–6* , pp.700, 702); a grant of additional properties in the locality was made to the brothers on 26 September 1397, 'in consideration of their regard for the castle of Portchester and purpose to urge the king to repair it, and also of their great charges in its safe keeping and government' (ibid. *1396–99* , p.274). My former colleague T.B. Pugh - to whom I owe these references and the consequent reinterpretation of Portchester's 'palace' (usually thought to have been built for the king) – points out that whereas Richard II had no misgivings about his personal security, Archbishop Walden, a better politician in every way, saw clearly the dangers that surrounded the Court, never fully believing in his own elevation to Canterbury.

138 S.E. Rigold, *Portchester Castle* , 1965, pp.26–8; Barry Cunliffe and Julian Munby, *Excavations at Portchester Castle. Volume 4: Medieval, the Inner Bailey* , 1985, pp.101–9, 128–33, 151–62.

Chapter 7
Caim's Castles

1 A.R. Myers (ed.), *English Historical Documents 1327–1485* , 1969, p.840; and see Thomas Renna, 'Wyclif's attacks on the monks', in *Studies in Church History. Subsidia 5. From Ockham to Wyclif* (eds Anne Hudson and Michael Wilks), 1987, pp.267–80.

2 Anne Hudson, *The Premature Reformation. Wycliffite Texts and Lollard History* , 1988, pp.334–8.

3 Margaret Aston, ' "Caim's Castles" : poverty, politics, and disendowment', in *The Church, Politics and Patronage in the Fifteenth Century* (ed. Barrie Dobson), 1984, p.48.

4 A.K. McHardy, 'Bishop Buckingham and the Lollards of Lincoln diocese', *Studies in Church History* , 9(1972), pp.137–45.

5 K.B. McFarlane, *Lancastrian Kings and Lollard Knights* , 1972, pp.160–1; but for another opinion on how genuinely Lollard these knights were, see J.A.F. Thomson, 'Orthodox religion and the origins of Lollardy', *History* , 74(1989), pp.44–8.

6 Roy M. Haines, 'Church, society and politics in the early fifteenth century as viewed from an English pulpit', *Studies in Church History* , 12(1975), pp.150–1.

7 Margaret Aston, op. cit., pp.54–5; Anne Hudson, op. cit., pp.114–15, 339–40; A.R. Myers, op. cit., p.669.

8 K.B. McFarlane, op. cit., pp.190–2.

9 A.K. McHardy, 'The alien priories and the expulsion of aliens from England in 1378', *Studies in Church History* , 12(1975), pp.133–41.

10 A.R. Myers, op. cit., p.670; Donald Matthew, *The Norman Monasteries and their English Possessions* , 1962, pp.108–42; and see also Marjorie Morgan, *The English Lands of the Abbey of Bec* , 1968 (2nd edn), pp.119–35, and the same author's 'The suppression of the alien priories', *History* , 26(1941–2), pp.204–12.

11 A.R. Myers, op. et loc. cit.

12 Walter H. Godfrey and W. Budgen, 'Wilmington Priory: an architectural history and historical notes', *Sussex Arch. Coll.* , 69(1928), pp.1–52.

13 A.R. Myers, op. cit., pp.787–90.

14 David Knowles, *The Religious Orders in England* ,

1979, ii:184; and see also W.A. Pantin (ed.), *Documents Illustrating the Activities of the General and Provincial Chapters of the English Black Monks 1215–1540* , Camden Third Series 47, 1933, pp.98–134.

15 Ian Keil, 'The chamberer of Glastonbury Abbey in the fourteenth century', *Proc. Somerset Arch. and Nat. Hist. Soc.* , 107(1963), pp.79–92; R.A.L. Smith, *Canterbury Cathedral Priory* , 1943, p.198; and see also my own *The Abbeys and Priories of Medieval England* , 1984, pp.146–8.

16 Justin McCann (ed.), *The Rule of St Benedict* , 1972, pp.70–1.

17 A. Hamilton Thompson (ed.), *Visitations of Religious Houses in the Diocese of Lincoln II* , Lincoln Record Society 14, 1918, p.52.

18 Mackenzie E.C. Walcott, 'Inventories and valuations of religious houses at the time of the Dissolution', *Archaeologia* , 43(1871), p.241.

19 J.T. Fowler (ed.), *Rites of Durham (1593)* , Surtees Society 107, 1903, p.85; for the dating of the dormitory at Durham, see M.G. Snape, 'Documentary evidence for the building of Durham Cathedral and its monastic buildings', in *Medieval Art and Architecture at Durham Cathedral* , British Archaeological Association, 1977, pp.28–9; L.F. Salzman, *Building in England down to 1540*, 1967 (2nd edn), pp.473–7.

20 G.H. Rooke, 'Dom William Ingram and his account book, 1504–1533', *J. Eccl. H.* , 7(1956), pp.36–7.

21 Mackenzie E.C. Walcott, 'Inventories of (I.) St Mary's Hospital or Maison Dieu, Dover; (II.) The Benedictine Priory of St Martin New-Work, Dover, for monks; (III.) The Benedictine Priory of SS Mary and Sexburga, in the Island of Shepey, for Nuns', *Arch. Cantiana* , 7 (1868), p.296; for private property at the nunneries, see Eileen Power's *Medieval English Nunneries c.1275 to 1535*, chapter 8 (Private Life and Private Property).

22 R. Gilyard-Beer, *Cleeve Abbey* , 1960, passim; Robert W. Dunning, 'The last days of Cleeve Abbey', in *The Church in Pre-Reformation Society. Essays in Honour of F.R.H. Du Boulay* (eds Caroline M. Barron and Christopher Harper-Bill), 1985, p.59.

23 R. Gilyard-Beer, op. cit., p.16.

24 Glanmor Williams, *The Welsh Church from Conquest to Reformation* , 1962, pp.378–80; for useful wealth tables, see David H. Williams, *The Welsh Cistercians* , 1983 (extended edn), ii:374–5 (Appendix 3: Comparative Valuations).

25 David H. Williams, op. cit., i:97.

26 Ibid., i:113–14; and see Glanmor Williams, *Recovery, Reorientation and Reformation. Wales c.1415–1642* , 1987, p.133, for the state of the other orders: Augustinian houses averaging five inmates and Benedictine only three.

27 D.H. Evans, *Valle Crucis Abbey* , 1987, pp.15, 36–7.

28 Quoted by Glanmor Williams, op. cit. (1962), p.380.

29 J.T. Fowler, op. cit., pp.89–90.

30 G.H. Cook (ed.), *Letters to Cromwell and Others on the Suppression of the Monasteries* , 1965, p.109.

31 N.J. Baker, 'The west range of Ulverscroft Priory and its roof: a survey', *Trans Leicestershire Arch. and Hist. Soc.*, 56(1980–1), pp.10–17; and see also Gordon M. Hills, 'On the priories of Ulvescroft and Charley in Leicestershire', *J. Brit. Arch. Assoc.* , 19(1863), pp.165–83.

32 Mackenzie E.C. Walcott, op. cit. (1868), pp.301–2.

33 Mackenzie E.C. Walcott, op. cit. (1871), p.219.

34 C.A. Ralegh Radford, *Crossraguel Abbey* , 1988, pp.9–11.

35 A.G. Little and Eric Stone, 'Corrodies at the

Carmelite friary of Lynn', *J. Eccl. H.* , 9(1958), pp.8–29.

36 Ibid., p.13.

37 Robert W. Dunning, op. cit., pp.65–6.

38 For the abbot of Battle's diet, see Eleanor Searle and Barbara Ross (eds), *The Cellarers' Rolls of Battle Abbey 1275–1513* , Sussex Record Society 65, 1967, p.19.

39 Owen Ashmore, 'The Whalley Abbey bursar's account for 1520', *Trans Historic Soc. Lancashire and Cheshire* , 114(1962), p.51.

40 *VCH Lancashire* , ii:131–9; *North Lancashire*, 1969, pp.259–61.

41 Several of these abbots' lodgings are described and illustrated in my *The Abbeys and Priories of Medieval England* , 1984, pp.158–66, 209–14.

42 D.H.S. Cranage, 'The monastery of St Milburge at Much Wenlock, Shropshire', *Archaeologia* , 72(1922), pp.122–8; Rose Graham, *The History of the Alien Priory of Wenlock* , 1965.

43 Rose Graham, *English Ecclesiastical Studies* , 1929, chapter 6 (Roland Gosenell, Prior of Wenlock, 1521–6).

44 T.F. Mayer (ed.), *Thomas Starkey. A Dialogue between Pole and Lupset*, Camden Fourth Series 37, 1989, p.134.

45 Ibid., p.l03.

46 For the canons' continuing wealth, see Una Rees, 'The leases of Haughmond Abbey, Shropshire', *Midland History* , 8(1983), pp.14–28, and the same author's edition of *The Cartulary of Haughmond Abbey* , 1985, especially p.9.

47 There is some disagreement in detail about the dating of these individual modernizations, but the general domestication of Haughmond's buildings in the later Middle Ages is not in doubt (*Shropshire* , 1958, pp.140–3; *VCH Shropshire* , ii:68–9; David Knowles and J.K.S. St Joseph, *Monastic Sites from the Air* , 1952, pp.204–5.

48 *VCH Shropshire* , i:66–7.

49 Justin McCann, op. cit., pp.96–7.

50 David Knowles, op. cit. (1979), i:282.

51 R. Gilyard-Beer, *Fountains Abbey* , 1986, p.70; Charles Peers, *Byland Abbey* , 1952, p.13; *Yorkshire. The North Riding* , 1966, p.205; A. Hamilton Thompson, *Roche Abbey* , 1954, p.18; Charles Peers, *Rievaulx Abbey* , 1967, p.17. Sawley, the eighth Yorkshire house, is now counted part of Lancashire.

52 David E. Owen, C. Vincent Bellamy and C.M. Mitchell, *Kirkstall Abbey Excavations 1955–1959* , Thoresby Society 48, 1961, pp.5, 113–15; for the Kirkstall meat kitchen and bone evidence recovered there, see M.L. Ryder, 'The animal remains found at Kirkstall Abbey', *Agric. H. R.* , 7(1959), pp.1–5; for Battle, see Eleanor Searle and Barbara Ross, op. cit., p.18, and my own *Medieval England*, 1978, p.186.

53 *Churches of South-East Wiltshire* , RCHM, 1987, p.152.

54 D. Sherlock, *Bushmead Priory* , 1985, p.6.

55 *RCHM Dorset I* , 1952, pp.242–3.

56 P.K. Baillie Reynolds, *Croxden Abbey* , 1946.

57 C.A. Ralegh Radford, *Glastonbury Abbey* , 1973, p.17.

58 J.T. Fowler, op. cit., pp.86–7; *County Durham* , 1953, p.114 and plate 51.

59 J.T. Fowler, op. cit., pp.80–1, 85–6, 88.

60 For evidence of glazing and for rebuilt cloisters, see David A. Walsh, 'A rebuilt cloister at Bordesley Abbey', *J. Brit. Arch. Assoc.* , 132(1979), pp.42–9, and my own *The Abbeys and Priories of Medieval England* , 1984, pp.152–5. There is a good surviving cloister of this date at Lacock (Wiltshire), with fine fragments at Forde (Dorset) and Muchelney (Somerset), and good evi-

dence of a cloister remodelling of fifteenth-century date at Hailes (Gloucestershire), among others.

61 C.R. Peers, 'Finchale Priory', *Arch. Aeliana* , 4(1927), pp.193–220.

62 R.A.L. Smith, *Canterbury Cathedral Priory* , 1943, p.46.

63 G.H. Rooke, op. cit., p.36.

64 A. Hamilton Thompson (ed.), *Visitations of Religious Houses in the Diocese of Lincoln I* , Lincoln Record Society 7, 1914, p.97.

65 Ibid., p.75.

66 Rose Graham and R. Gilyard-Beer, *Monk Bretton Priory* , 1986, p.22.

67 R. Gilyard-Beer, *Fountains Abbey* , 1986, pp.65–70.

68 David M. Robinson, *Tintern Abbey* , 1986, pp.48–9.

69 Especially useful individual studies include Francis Woodman's *The Architectural History of Canterbury Cathedral* , 1981, pp.151–98 (The Perpendicular Cathedral); J.H.P. Gibb, 'The fire of 1437 and the rebuilding of Sherborne Abbey', *J. Brit. Arch. Assoc.* , 138(1985), pp.101–24, and the same author's 'Sherborne Abbey - Addendum to "The Fire of 1437" ', ibid., 141(1988), pp.161–9; and Stewart Cruden, *Scottish Medieval Churches* , 1986, chapter 4 (The Fourteenth and Fifteenth Centuries).

70 H.M. Colvin, 'The building of St Bernard's College', *Oxoniensia* , 24(1959), pp.40–1.

71 Glastonbury's properties in Bristol and in London are usefully discussed by Ian Keil, 'A landlord in medieval Bristol', *Trans Bristol and Gloucestershire Arch. Soc.* , 84(1965), pp.44–52, and 'London and Glastonbury Abbey in the later Middle Ages', *Trans London & Middx Arch. Soc.* , 21(1967), pp.173–7; for a rare Carthusian commercial initiative, leaving a most notable survival, see E.H.D. Williams, J. and J. Penoyre, and B.C.H. Hale, 'The George Inn, Norton St Philip, Somerset', *Arch. J.* , 144(1987), pp.317–27; one of many examples of a deliberate shift from arable to pastoral farming is discussed by David Postles, 'The Oseney Abbey flock', *Oxoniensia* , 49(1984), pp.141–52.

72 R.A.L. Smith, op. cit., pp.191–2; Mavis Mate, 'The farming out of manors: a new look at the evidence from Canterbury Cathedral Priory', *J. Medieval History* , 9(1983), pp.331–43, and the same author's 'Agrarian economy after the Black Death: the manors of Canterbury Cathedral Priory, 1348–91', *Ec.H.R.* , 37(1984), pp.341–54.

73 But John Hare takes a more favourable view of the monks' leasing policies in his recent study, 'The monks as landlords: the leasing of the monastic demesnes in southern England', in *The Church in Pre-Reformation Society* (eds Caroline M. Barron and Christopher Harper-Bill), 1985, pp.82–94.

74 Barbara Harvey, 'The leasing of the abbot of Westminster's demesnes in the later Middle Ages', *Ec.H.R.* , 22(1969), p.19.

75 Barbara Harvey, *Westminster Abbey and its Estates in the Middle Ages* , 1977, pp.161, 331.

76 R.H. Hilton, *The Economic Development of some Leicestershire Estates in the 14th and 15th Centuries*, 1947, pp.117–18.

77 R.B. Dobson, *Durham Priory 1400–1450* , 1973, p.291.

78 Ibid., p.270 and passim.

79 Deirdre Le Faye, 'Selborne Priory, 1233–1486', *Proc. Hampshire Field Club* , 30(1973), pp.47–71.

80 Ibid., pp.53, 57–8, 61.

81 For other failures, see J.C. Dickinson, "Early suppression of English houses of Austin canons", in *Medieval Studies Presented to Rose Graham* (eds Veronica Ruffer and A.J. Taylor), 1950,

pp.54–77, and David M. Robinson, *The Geography of Augustinian Settlement in Medieval England and Wales* , British Archaeological Reports 80, 1980, chapter 4 (Unsuccessful Augustinian Foundations).

82 Deirdre Le Faye, op. cit., p.68.

83 J.C. Dickinson, op. cit., pp.64–5.

84 Ibid., pp.62–3.

85 *Med. Arch.* , 10(1966), pp.202–4, and Christine Mahany (pers. comm.). The excavations at Grafton have yet to be published, but see my own *Medieval England* , 1978, fig. 106; for what little is known of the earlier history of the hermitage, see *VCH Northamptonshire* , ii:137; for Wormegay, see J.C. Dickinson, op. cit., p.65.

86 David M. Robinson, op. cit., p.92.

87 H.E. Hallam, 'The agrarian economy of South Lincolnshire in the mid-fifteenth century', *Nottingham Mediaeval Studies* , 11(1967), pp.86–95.

88 J. Ambrose Raftis, *The Estates of Ramsey Abbey. A Study in Economic Growth and Organization*, 1957, pp.292–5.

89 Useful comparative figures are given by David Knowles and R. Neville Hadcock, *Medieval Religious Houses. England and Wales* , 1953, passim; but see also Eleanor Searle, *Lordship and Community. Battle Abbey and its Banlieu 1066–1538* , 1974, p.261, and the more general conclusion on the final state of Bolton in Ian Kershaw (ed.), *Bolton Priory Rentals and Ministers' Accounts 1473–1539*, 1970, p.xxiv.

90 C.H. Williams (ed.), *English Historical Documents 1485–1558* , 1967, p.771 (First Act for the Dissolution of the Monasteries, 1536).

91 Charlotte Augusta Sneyd (trans.), *A Relation, or Rather a True Account of the Island of England . . . about the year 1500* , Camden Society 37, 1847, p.29.

92 D.J.H. Michelmore (ed.), *The Fountains Abbey Lease Book* , Yorkshire Archaeological Society Record Series 140, 1981, pp.xliv-xlv; and for a study of Huby himself, see C.H. Talbot, 'Marmaduke Huby, abbot of Fountains (1495–1526)', *Analecta Sacri Ord. Cisterciensis* , 20 (1964), pp.165–84.

93 Una Rees, op. cit. (1983), pp.21–2.

94 R.H. Hilton, *The Decline of Serfdom in Medieval England* , 1969, pp.51–2, but Professor Hilton makes it plain that other landowners (including laymen) were just as guilty of such exactions; for very similar evidence on the bishop of Worcester's estates, see Christopher Dyer, *Lords and Peasants in a Changing Society. The Estates of the Bishopric of Worcester 680–1540* , 1980, pp.269–75.

95 *Essex* , 1965, p.234; J.H.P. Gibb, op.cit. (1985), pp.102–3.

96 Edward Surtz and J.H. Hexter (eds), *The Complete Works of St Thomas More. Volume 4* , 1965, p.67.

97 T.H. Lloyd, 'Some documentary sidelights on the deserted Oxfordshire village of Brookend', *Oxoniensia* , 29–30(1964–5), p.125; and see Christopher Dyer, op. cit., chapter 11 (Deserted Villages).

98 Edward Surtz and J.H. Hexter, op. et loc. cit.

99 E. Bryan Burstall, 'A monastic agreement of the fifteenth century', *Norfolk Arch.* , 31(1955–7), pp.211–18.

100 Ibid., pp.211–12.

101 J.C. Dickinson, *Furness Abbey* , 1965, pp.8–9; William Rollinson, 'The lost villages and hamlets of Low Furness', *Trans Cumberland and Westmorland Antiq. and Arch. Soc.* , 63(1963), p.168.

102 Bartlett Jere Whiting, *Proverbs, Sentences and Proverbial Phrases from English Writings mainly before 1500* , 1968, p.245.

103 J. Ambrose Raftis, *Warboys. Two Hundred Years in*

the Life of an English Mediaeval Village , 1974, pp.216–17; Edwin Brezette Dewindt, *Land and People in Holywell-cum-Needingworth* , 1972, pp.263–4, 271–3.

104 Christopher Dyer, 'The social and economic background to the rural revolt of 1381', and A.F. Butcher, 'English urban society and the Revolt of 1381', in *The English Rising of 1381* (eds R.H. Hilton and T.H. Aston), 1984, pp.9–42, 84–111.

105 Alfred Clapham and P.K. Baillie Reynolds, *Thornton Abbey* , 1974, pp.11–15.

106 For a comparatively recent air view of Michelham, taken in 1972, see my *Medieval Britain from the Air* , 1984, p.158; and see also *VCH Sussex* , ii:77–9; Walter H. Godfrey, 'Michelham Priory', *Sussex Arch. Coll.* , 67(1926), pp.1–24; *Michelham Priory* , 1980, p.21. For Abbot Hamo de Offyngton at Battle, see Eleanor Searle, op. cit. (1974), pp.346–7.

107 W.H. St John Hope, 'On the Whitefriars or Carmelites of Hulne, Northumberland', *Arch. J.* , 47(1890), pp.105–29; David Knowles and J.K.S. St Joseph, *Monastic Sites from the Air* , 1952, pp.256–7; and my own *Medieval Britain from the Air* , 1984, pp.156–7 (Hulne), 220–1 (Ulverscroft).

108 Roger Stalley, *The Cistercian Monasteries of Ireland* , 1987, chapter 5 (Holy Cross and the Fifteenth-Century Revival).

109 Ibid., pp.67–8; some reductions may date to the post-Dissolution period, when a number of these buildings were reused as parish churches.

110 Ibid., pp.127–8, 148–9; Aubrey Gwynn and R. Neville Hadcock, *Medieval Religious Houses. Ireland* , 1970, pp.136–7.

111 Ibid., pp.150–2, 230–2, 242–3; Harold G. Leask, 'Bective Abbey, Co. Meath', *J. Royal Soc. Antiquaries of Ireland* , 46(1916), pp.46–57.

112 Harold G. Leask, *Irish Churches and Monastic Buildings III. Medieval Gothic: the Last Phases* , 1971, pp.26–7.

113 Quoted by C.A. Empey, 'The sacred and the secular: the Augustinian priory of Kells in Ossory, 1193–1541', *Irish Historical Studies* , 24(1984), p.149.

114 Ibid., pp.148–51; Harold G. Leask, *Irish Churches and Monastic Buildings II. Gothic Architecture to A.D.1400* , 1966, p.99.

115 Harold G. Leask, op. cit. (1966), pp.95–9; Aubrey Gwynn and R. Neville Hadcock, op. cit., pp.157–8.

116 C.A. Empey, op. cit., p.145; the association of coign and livery with the defences at Kells is not the least of the merits of this useful paper.

117 Aubrey Gwynn and R. Neville Hadcock, op. cit., p.257; for a plan of Quin, see T.B. Barry, *The Archaeology of Medieval Ireland* , 1987, p.194.

118 Aubrey Gwynn and R. Neville Hadcock, op. cit., pp.235–81 (The Franciscan Friars. Conventual and Observant); for surviving friary buildings, see Harold G. Leask, op. cit. (1971), chapter 6 (Friary Architecture A.D. 1400 to the Dissolution); T.B. Barry, op. cit., pp.193–5; Brian de Breffny and George Mott, *The Churches and Abbeys of Ireland* , 1976, pp.96–102.

119 A.G. Little, 'Introduction of the Observant Friars into England', *Proc. British Academy* , 10(1921–3), pp.455–71, and the same author's 'Introduction of the Observant Friars into England: a bull of Alexander VI', ibid., 27(1941), pp.155–66.

120 J.G. Coad, *Denny Abbey* , 1984, pp.8–9; James Lee-Warner, 'Petition of the prior and canons of Walsingham, Norfolk, to Elizabeth, Lady of Clare. Circa A.D.1345', *Arch. J.* , 26(1869), pp.166–73.

121 Patricia M. Christie and J.G. Coad, 'Excavations at Denny Abbey', *Arch. J.* , 137(1980), especially pp.152–8, 179–89.

122 *Wiltshire* , 1963, pp.208–12.

123 Bartlett Jere Whiting, op. cit., p.607.

124 Janet H. Stevenson (ed.), *The Edington Cartulary* , Wiltshire Record Society 42, 1987, pp.9–13.

125 R. Ian Jack, 'Religious life in a Welsh Marcher lordship: the lordship of Dyffryn Clwyd in the later Middle Ages', in *The Church in Pre-Reformation Society* (eds Caroline M. Barron and Christopher Harper-Bill), 1985, pp.152–3.

126 Ian B. Cowan and David E. Easson, *Medieval Religious Houses. Scotland* , 1976 (2nd edn), p.223.

127 *VCH Sussex* , ii:119–20; M.A. Tierney, *The History and Antiquities of the Castle and Town of Arundel* , 1834, ii: 600–1, 753–5.

128 J. Nichols, *A Collection of all the Wills . . . of the Kings and Queens of England* , 1780, especially pp.121 and 136.

129 E.F. Jacobs (ed.), *The Register of Henry Chichele, Archbishop of Canterbury 1414–1443* , Canterbury and York Society 42, 1937, p.xl.

130 P.S. Lewis, *Later Medieval France. The Polity* , 1968, p.204.

131 M.A. Hicks, 'The Beauchamp Trust, 1439–87', *Bull. Inst. Hist. Res.* , 54(1981), pp.135–49.

132 T.B. Pugh, 'Richard Plantagenet (1411–60), duke of York, as the king's lieutenant in France and Ireland', in *Aspects of Late Medieval Government and Society: Essays presented to J.R. Lander* (ed. J.G. Rowe), 1986, p.110; for the Fotheringhay statutes, see J.C. Cox, 'The College of Fotheringhay', *Arch. J.* , 61(1904), pp.244–9, and the identical text in *VCH Northamptonshire* , ii:171–4; for a recent discussion of the building sequence at Fotheringhay, see Richard Marks, 'The glazing of Fotheringhay Church and College', *J. Brit. Arch. Assoc.* , 131(1978), pp.79–109; the 1434 contract for the building of Fotheringhay's nave and tower is reproduced by L.F. Salzman, *Building in England down to 1540* , 1967 (2nd edn), pp.505–9.

133 T.B. Pugh, *Henry V and the Southampton Plot of 1415*, Southampton Records Series, 30, 1988, p.144.

134 Patrick Strong and Felicity Strong, 'The last will and codicils of Henry V', *E.H.R.* , 96(1981), p.91.

135 E.F. Jacob, 'Founders and foundations in the later Middle Ages', *Bull. Inst. Hist. Res.* , 35(1962), p.31.

136 Gervase Belfield, 'Cardinal Beaufort's Almshouse of Noble Poverty at St Cross, Winchester', *Proc. Hampshire Field Club* , 38(1982), pp.103–11; *Hampshire and the Isle of Wight* , 1967, pp.712–13.

137 Rotha Mary Clay, *The Mediaeval Hospitals of England* , 1909, p.120; *Oxfordshire* , 1974, pp.595–9.

138 G.H. Cook, *English Collegiate Churches of the Middle*

139 For KIng's College, see Francis Woodman, *The Architectural History of King's College Chapel* , 1986; for Eton's chapel, see A.H.R. Martindale, 'The early history of the choir of Eton College Chapel', *Archaeologia* , 103(1971), pp.179–98. Henry's specifications for the building of the two chapels are reproduced by L.F. Salzman, op. cit., pp.520–7.

140 *An Inventory of the Historical Monuments in the City of Oxford* , RCHM, 1939, p.88.

141 Ian B. Cowan and David E. Easson, op. cit., pp.213–30.

142 Ian B. Cowan, *The Scottish Reformation. Church and Society in Sixteenth-Century Scotland* , 1982, p.60.

143 David Knowles and R. Neville Hadcock, op. cit., pp.325–46; for Denston, see *VCH Suffolk* , ii:142, and Irene J.R. Fleming, *St Nicholas' Church, Denston, Suffolk* , undated; for Cobham, see A.A. Arnold, 'Cobham College', *Arch. Cantiana* , 27(1905), pp.64–l09, Aymer Vallance, 'Cobham Collegiate Church', ibid., 43(1931), pp.133–60, and P.J. Tester, 'Notes on the medieval chantry

college at Cobham', ibid., 79(1964), pp.109–20; for the collegiate church (now cathedral) at Manchester, and the surviving buildings at Chetham's Hospital, see the particularly full account in *VCH Lancaster* , iv:187–227.

144 David Knowles, *The Religious Orders in England* , 1979, ii:129–38.

145 Ibid., pp.175–82.

146 Shakespeare, *Henry V* , iv:i:294–8.

147 David Knowles and R. Neville Hadcock, op. cit., pp.83–93.

148 *Churches of South-East Wiltshire* , RCHM, l987, pp.149–53.

149 Christopher Harper-Bill and Richard Mortimer (eds), *Stoke by Clare Cartulary. Part Three* , Suffolk Charters 5, 1984, pp.2, 9; David Knowles and R. Neville Hadcock, op. cit., pp.90, 342; Marjorie Morgan, *The English Lands of the Abbey of Bec* , 1968 (2nd edn), pp.127–8; for useful inventories of the college furnishings, see William St John Hope, 'Inventories of the college of Stoke-by-Clare taken in 1534 and 1547–8', *Proc. Suffolk Inst. Arch. and Natural Hist.* , 17(1921), pp.21–77.

150 J. Nichols, op. cit., pp.217–18.

151 Richard Marks, op. cit., pp.95–6.

152 C.A.J. Armstrong, 'The piety of Cicely, duchess of York: a study in late mediaeval culture', in that author's collected papers *England, France and Burgundy in the Fifteenth Century* , 1983, p.150 (footnote 35); and see also Anne Crawford, 'The piety of late medieval English queens', in *The Church in Pre-Reformation Society* (eds Caroline M. Barron and Christopher Harper-Bill), 1985, pp.53–4.

153 N.R. Ker (ed.), *Medieval Libraries of Great Britain. A List of Surviving Books* , 1964 (2nd edn), pp.184–7.

154 C.A.J. Armstrong, op. cit., pp.141, 146–7.

155 N.R. Ker, op. cit., pp.179, 185; N.R. Ker and Andrew G. Watson (eds), *Medieval Libraries of Great Britain. Supplement to the Second Edition*, 1987, p.65.

156 Michael G. Sargent, 'The transmission by the English Carthusians of some late medieval spiritual writings', *J. Eccl. H.* , 27(1976), pp.225–40; Roger Lovatt. 'The *Imitation of Christ* in late medieval England', *T.R.H.S.* , 18(1968), pp.97–121.

157 Michael G. Sargent, op. cit., p.230.

158 C.A.J. Armstrong, op. cit., pp.141–2.

159 B.A. Windeatt (trans.), *The Book of Margery Kempe*, 1985, p.20; Susan Dickman, 'Margery Kempe and the Continental tradition of the pious woman', in *The Medieval Mystical Tradition* (ed. Marion Glasscoe), 1984, pp.150–68.

160 Ronald Knox and Michael Oakley (trans.), *The Imitation of Christ by Thomas à Kempis* , 1962, p.69.

161 Quoted by David Knowles, op. cit. , ii:225.

Chapter 8
God's Plenty

1 B.A. Windeatt (trans.), *The Book of Margery Kempe*, 1985, pp.67–8.

2 See the papers by Susan Dickman, 'Margery Kempe and the continental tradition of the pious woman', and David Wallace, 'Mystics and followers in Siena and East Anglia: a study in taxonomy, class and cultural mediation', in *The Medieval Mystical Tradition in England* (ed. Marion Glasscoe), 1984, pp.150–68, 169–91.

3 Susan Dickman, op. cit., p.157; for the early history of these women, see Brenda M. Bolton, 'Mulieres sanctae', *Studies in Church History*,

10(1973), pp.77–95.

4 For the Norwich evidence, discussed further below, see Norman P. Tanner, *The Church in Late Medieval Norwich 1370–1532* , 1984, chapter 2 (New Movements).

5 Dorothy M. Owen (ed.), *The Making of King's Lynn. A Documentary Survey*, 1984, pp.27–32 (Churches and Parishes), 32–3 (Religious Houses), 60–3 (Gilds).

6 For William Melton, see G.R. Owst, *Preaching in Medieval England* , 1926, pp.209–10.

7 B.A. Windeatt, op. cit., pp.187–90.

8 Ibid., p.191.

9 *North-West and South Norfolk* , 1962, pp.226–7 and plate 33b; two bench-ends from St Nicholas, carved with ships, are now in the Victoria & Albert Museum.

10 W.A. Pantin, *The English Church in the Fourteenth Century* , 1955, pp.193–4, 236–7.

11 H.G. Pfander, 'Some medieval manuals of religious instruction in England and observations on Chaucer's Parson's Tale', *J. English and Germanic Philology* , 35(1936), pp.251–2.

12 Gillis Kristensson, *John Mirk's Instructions for Parish Priests* , Lund Studies in English 49, 1974, p.68.

13 G.R. Owst, *Literature and Pulpit in Medieval England* , 1933, p.293.

14 Ibid., p.299.

15 G.R. Owst, op. cit. (1926), p.59.

16 *Leicestershire and Rutland* , 1973, pp.188–91.

17 J.G. Davies, *The Secular Use of Church Buildings* , 1968, especially pp.55–79.

18 *Lincolnshire* , 1964, pp.535–7, 633–7.

19 *Cheshire* , 1971, pp.65–7.

20 G.W. Saunders, *The Church of All Saints Martock* , undated; *South and West Somerset* , 1958, pp.231–2.

21 *Suffolk* , 1981, p.160 (Cavendish); *Cambridgeshire*, 1954, pp.333–6 (Isleham); *VCH Lancaster* , iv:188 (Manchester Cathedral); *Nottinghamshire* , 1951, pp.95–6 (Laxton); *North–West and South Norfolk* , 1962, pp.145–7 (East Harling); *Oxfordshire* , 1974, pp.536–8 (Chipping Norton).

22 *Suffolk* , 1981, pp.344–5.

23 Ibid., pp.194–5 (described by Nikolaus Pevsner as 'one of the richest in a county rich in rich roofs').

24 Ibid., pp.372–4 and plate 20.

25 Richard Haslam, *Powys* , 1979, pp.340–1, 362–4; for the Welsh tradition of wood-carving in the parish churches, particularly on screens, see Glanmor Williams, *The Welsh Church from Conquest to Reformation* , 1962, pp.436–41.

26 Clive Burgess, ' "For the Increase of Divine Service": chantries in the parish in late medieval Bristol', *J. Eccl. H.* , 36(1985), pp.46–65; for the identical point, see Clive Burgess's other recent papers: ' "By Quick and by Dead": wills and pious provision in late medieval Bristol", *E.H.R.*, 102(1987), pp.837–58, and 'A service for the dead: the form and function of the Anniversary in late medieval Bristol', *Trans Bristol and Gloucestershire Arch. Soc.*, 105(1987), pp.183–211.

27 Simon Cotton, 'Mediaeval roodscreens in Norfolk - their construction and painting dates', *Norfolk Archaeology* , 40(1987), p.46.

28 *Bedfordshire* , 1968, p.90; D.J.H. Knowles, *The Church of Saint Mary the Virgin, Felmersham* , undated.

29 *North-West and South Norfolk* , 1962, p.105; C.N. Moore, *St Margaret's Church, Burnham Norton* , undated.

30 *Cornwall* , 1951, pp.178–80 (St Neot); *Gloucestershire. The Cotswolds* , 1970, pp.119–21 (Bledington), 333–6 (North Cerney); *North-West and South Norfolk* , 1962, pp.281–2 (Oxborough), 365–6

(Walsoken); *An Inventory of the Historical Monuments in the City of Oxford* , RCHM, 1939, p.80 (Merton College Chapel); *Suffolk* , 1981, p.193 (Earl Soham); *St Mary's Church, Beverley* , 1979, p.1, and *Yorkshire. York and the East Riding* , 1972, p.183.

31 *Cambridgeshire* , 1954, p.334; the full text of the inscription is given in *A Short History of the Parish Church of S. Andrew, Isleham, and of the Priory Church of S. Margaret* , undated, p.4.

32 *West Kent and the Weald* , 1969, pp.292–4; *North-West and South Norfolk* , 1962, pp.308–10.

33 *South and West Somerset* , 1958, p.141.

34 Paul Cattermole and Simon Cotton, 'Medieval parish church building in Norfolk', *Norfolk Archaeology* , 38(1983), p.259; *North-East Norfolk and Norwich* , 1962, pp.249–52.

35 Norman P. Tanner, op. cit., pp.102–3, 128–9, 132; for the new devotions, see R.W. Pfaff, *New Liturgical Feasts in Later Medieval England* , 1970, chapter 4 (The Feast of the Name of Jesus), pp.84–91 (The Five Wounds).

36 Norman P. Tanner, op. cit., chapter 2 (New Movements).

37 Peter Heath, 'Urban piety in the later Middle Ages: the evidence of Hull wills', in *The Church, Politics and Patronage in the Fifteenth Century* (ed. Barrie Dobson), 1984, pp.217–18.

38 Norman P. Tanner, op. cit., p.102.

39 Peter Heath, op. cit., p.215.

40 M.G.A. Vale, *Piety, Charity and Literacy among the Yorkshire Gentry, 1370–1480* , 1976, pp.8, 21–2.

41 Nigel Saul, 'The religious sympathies of the gentry in Gloucestershire, 1200–1500', *Trans Bristol and Gloucestershire Arch. Soc.*, 98(1980), p.103.

42 P.W. Fleming, 'Charity, faith, and the gentry of Kent 1422–1529', in *Property and Politics: Essays in Later Medieval English History* (ed. Tony Pollard), 1984, p.50.

43 Peter Heath, op. cit., p.217.

44 P.W. Fleming, op. cit., pp.47–8; *West Kent and the Weald* , 1969, pp.411–12.

45 M.G.A. Vale, op. cit., p.9.

46 *Yorkshire. York and the East Riding* , 1972, p.230 (for the full text of Sir Marmaduke Constable's epitaph, of which I have modernized the spelling).

47 *Skelmorlie Aisle, Largs, Ayrshire* , 1977; *Northamptonshire* , 1973, pp.229–32 (Great Brington); John Salmon, *Rycote Chapel, Oxfordshire*, 1967; *Leicestershire and Rutland* , 1960, p.73 (Breedon-on-the-Hill).

48 Colin Richmond, 'Religion and the fifteenth-century English gentleman', in *The Church, Politics and Patronage in the Fifteenth Century* (ed. Barrie Dobson), 1984, especially pp.198, 202–3.

49 J.T. Driver, 'Richard Quatremains: a 15th-century squire and knight of the shire for Oxfordshire', *Oxoniensia* , 51(1986), p.101 (giving the whole 10-line inscription).

50 *Gloucestershire. The Cotswolds* , 1970, pp.437–8.

51 *Oxfordshire* , 1974, p.782.

52 A.J. Taylor, *Minster Lovell Hall* , 1958; T.L. Jones, *Ashby de la Zouch Castle* , 1953.

53 R.G.K.A. Mertes, "The household as a religious community", in *People, Politics and Community in the Later Middle Ages* (eds Joel Rosenthal and Colin Richmond), 1987, pp.128–9.

54 *Oxfordshire*, 1974, p.493 (Broughton); *Gloucestershire. The Vale and the Forest of Dean* , 1970, p.103 (Berkeley); *Gloucestershire. The Cotswolds* , 1970, p.105 (Beverston).

55 *Oxfordshire* , 1974, p.792; *Ightham Mote, Kent* , 1988; *Lytes Cary, Somerset* , 1981.

56 *Bradley, Devon* , 1978, p.7.

57 W. Douglas Simpson, *Bothwell Castle* , 1978,

pp.20–1; J.S. Richardson and James Beveridge, *Linlithgow Palace* , 1983, pp.23–4.

58 John Charlton, *Brougham Castle* , 1961; *Yorkshire. The North Riding* , 1966, pp.104–6 (Bolton).

59 *Herefordshire* , 1963, pp.141–2 and plate 38; *Cotehele House, Cornwall* , 1983, pp.13–15; *Compton Castle, Devon* , 1983, pp.8–9; *Cheshire* , 1971, p.112 (Bramall); *South Lancashire* , 1969, pp.89–90 (Smithills); *North Lancashire* , 1969, pp.216–17 (Samlesbury).

60 H.G. Wayment, 'The stained glass of the Chapel of the Vyne and the Chapel of the Holy Ghost, Basingstoke', *Archaeologia*, 107(1982), pp.141–52.

61 Dorothea Oschinsky, *Walter of Henley and other Treatises on Estate Management and Accounting* , 1971, pp.402–3, 406–7.

62 George Kane and E. Talbot Donaldson, *Piers Plowman: the B Version. Will's Visions of Piers Plowman, Do-Well, Do-Better and Do-Best* , 1975, p.412; for this modern English rendering, see A.R. Myers (ed.), *English Historical Documents 1327–1485* , 1969, pp.1138–9.

63 A.R. Myers (ed.), *The Household of Edward IV. The Black Book and the Ordinance of 1478* , 1959, pp.14, 203.

64 These chapters may be a borrowing on Boorde's part, for they appear in an earlier anonymous text (not certainly his own) of 1540. I have modernized the spelling of F.J. Furnivall's edition, *Andrew Boorde's Introduction and Dyetary* , Early English Text Society, Extra Series 10, 1870, pp.237–9.

65 *Baddesley Clinton, Warwickshire* , 1983; *Lytes Cary, Somerset* , 1981; *Great Chalfield Manor, Wiltshire* , 1980; *Oxburgh Hall, Norfolk* , 1981.

66 Although still little known outside its own county, South Wingfield Manor has attracted a considerable recent literature, beginning with Michael Thompson's 'The construction of the manor at South Wingfield, Derbyshire', in *Problems in Economic and Social Archaeology* (eds G. de G. Sieveking, I.H. Longworth and K.E. Wilson), 1976, pp.417–38; see also the same author's 'The architectural significance of the building works of Ralph, Lord Cromwell (1394–1456)', in *Collectanea Historica. Essays in Memory of Stuart Rigold* (ed. Alec Detsicas), 1981, pp.155–62. The buildings were described and illustrated in two articles by Anthony Emery and Marcus Binney in *Country Life* , 8 April and 15 April 1982, and have since been discussed at length by Anthony Emery again in his 'Ralph, Lord Cromwell's manor at Wingfield (1439–c.1450): its construction, design and influence', *Arch.J.*, 142(1985), pp.276–339.

67 Roger Virgoe, 'William Tailboys and Lord Cromwell: crime and politics in Lancastrian England', *Bull. John Rylands Library* , 55(1972–3), pp.459–82; S.J. Payling, 'Inheritance and local politics in the later Middle Ages: the case of Ralph, Lord Cromwell, and the Heriz inheritance', *Nottingham Medieval Studies*, 30(1986), pp.67–96.

68 Carole Rawcliffe and Susan Flower, 'English noblemen and their advisers: consultation and collaboration in the later Middle Ages', *J. Brit. Studies*, 25(1986), pp.157–77; S.J. Payling, op. cit., pp.94–5.

69 For a useful commentary and sequence of plans, see Anthony Emery, op. cit. (1985), passim.

70 Ibid., pp.316–26; M.W. Thompson, *The Decline of the Castle* , 1987, pp.87–91; *Tattershall Castle, Lincolnshire* , 1974.

71 Jane A. Wight, *Brick Building in England from the Middle Ages to 1550*, 1972, p.130; and see Patricia M. Ryan, 'Fifteenth-century Continental

brickmasons', *Med. Arch.*, 30(1986), pp.112–13; W. Douglas Simpson (ed.), *The Building Accounts of Tattershall Castle 1434–1472*, Lincoln Record Society 55, 1960, passim.

72 Anthony Emery, op. cit. (1985), p.323.

73 John R. Kenyon, *Raglan Castle*, 1988, pp.47–52, and the same author's 'The gunloops at Raglan Castle, Gwent', in *Castles in Wales and the Marches* (eds John R. Kenyon and Richard Avent), 1987, pp.161–72; for a less convincing later date for Raglan's Great Tower, attributing it to William Herbert, see Anthony Emery, 'The development of Raglan Castle and keeps in late medieval England', *Arch. J.*, 132(1975), pp.151–86.

74 For the Caister siege, see Norman Davis (ed.), *Paston Letters and Papers of the Fifteenth Century*, 1971, pp.340–7, 398–409, 540–8; John H. Harvey (ed.), *William Worcestre Itineraries*, 1969, pp.187–91.

75 S.E. Rigold, *Baconsthorpe Castle*, 1966, pp.3–4.

76 *Compton Castle, Devon*, 1983; Richard Haslam, 'Compton Castle, Devon', *Country Life*, 5 November 1981, pp.1546–50.

77 *Oxburgh Hall, Norfolk*, 1981.

78 *Cotehele House, Cornwall*, 1983, pp.5–6.

79 T.L Jones, *Ashby de la Zouch Castle*, 1953, pp.8–9, 24–6.

80 For the comparison with Rambures (Picardy), see my own *The Castle in Medieval England and Wales*, 1982, p.162.

81 A. Hamilton Thompson, 'The building accounts of Kirby Muxloe Castle, 1480–1484', *Trans Leicestershire Arch. Soc.*, 11(1919–20), p.193 (footnote).

82 D.J. Cathcart King, *The Castle in England and Wales. An Interpretative History*, 1988, p.162.

83 Charles Peers, *Kirby Muxloe Castle*, 1957, p.19.

84 Carole Rawcliffe, *The Staffords, Earls of Stafford and Dukes of Buckingham, 1394–1521*, 1978, p.95.

85 A.D.K. Hawkyard, 'Thornbury Castle', *Trans Bristol and Gloucestershire Arch. Soc.*, 95(1977), p.57; *Suffolk*, 1974, pp.262–4.

86 Carole Rawcliffe, op. cit., pp.88–9, 101.

87 D.E. Strong, *Eltham Palace*, 1958.

88 R.L. Storey, 'Lincolnshire and the Wars of the Roses', *Nottingham Medieval Studies*, 14(1970), pp.71–3.

89 *Lincolnshire*, 1964, pp.243–4; for a note on the Hall, see Anthony Emery, op. cit. (1985), pp.332–3; for a good plan, see M.W. Thompson, op. cit., p.60.

90 *Gainsborough Old Hall*, 1974.

91 A.J. Taylor, *Minster Lovell Hall*, 1958, pp.18, 21.

92 *Oxfordshire*, 1974, p.782.

93 *Bedfordshire*, 1968, pp.214–16; W. Douglas Simpson, 'Buckden Palace', *J. Brit. Arch. Assoc.*, 2(1937), pp.121–32.

94 Henry VIII rebuilt Hunsdon, and there has been much other work there since his time, leaving little but the cellars of Oldhall's building (*Hertfordshire*, 1953, pp.141–2); Anthony Emery, op. cit. (1985), pp.333–4.

95 J.W. Tonkin, 'Social standing and base-crucks in Herefordshire', *Vernacular Architecture*, 1(1970), pp.7–11.

96 *Berkshire*, 1966, pp.187–9; for a recent study of Norreys and Ockwells Manor, see Caroline Silk's *The Lifestyle of the Gentry in the Later Middle Ages, with Special Reference to John Norreys of Ockwells Manor, Berkshire*, University of Southampton unpublished B.A. dissertation, 1989.

97 Caroline Silk, op. cit., pp.25–8, 52–3, citing Everard Green, 'The identification of the eighteen worthies commemorated in the heraldic glass in the hall windows of Ockwells Manor House, in the parish of Bray, in Berkshire', *Archaeologia*, 56(1899), pp.323–36.

98 Hugh Dixon, *Three Tower-Houses. Audley's Castle, Strangford Castle, Portaferry Castle, County Down*, 1980.

99 For Irish tower-houses generally, see T.B. Barry, *The Archaeology of Medieval Ireland*, 1987, pp.181–90; also Brian de Breffny, *Castles of Ireland*, 1977, pp.54–5 (Blarney), 58–60 (Bunratty).

100 C.J. Tabraham, *Cardoness Castle*, 1983.

101 Quoted by Geoffrey Stell, 'Architecture: the changing needs of society', in *Scottish Society in the Fifteenth Century* (ed. Jennifer M. Brown), 1977, pp.161–2; and for the argument about increasing comfort, see also the same author's 'The Scottish medieval castle: form, function and 'evolution' ', in *Essays on the Nobility of Medieval Scotland* (ed. K.J. Stringer), 1985, pp.195–209.

102 Geoffrey Stell, op. cit. (1977), p.162; Colin McWilliam, *Lothian except Edinburgh*, 1978, pp.118–21; for an early engraving of the Borthwick chimneypiece, see Geoffrey Stell, op. cit. (1985), plate 15.

103 A.R. Myers (ed.), op. cit., pp.1145–6; and see Thomas Wright, *Anglo-Saxon and Old English Vocabularies. Volume I: Vocabularies*, 1884 (2nd edn, ed. Richard Paul Wülcker, pp.656–7; *Rufford Old Hall, Lancashire*, 1983.

104 John H. Harvey, 'Great Mllton, Oxfordshire; and Thorncroft, Surrey. The building accounts for two manor-houses of the late fifteenth century', *J. Brit. Arch. Assoc.*, 18(1955), p.52; the Milton contract is reproduced by L.F. Salzman, *Building in England down to 1540*, 1967 (2nd edn), pp.599–600.

105 *Dorset*, 1972, pp.289–90 (Milton); *North Devon*, 1952, pp.160–2 and plate 38 (Weare Giffard).

106 *North Lancashire*, 1969, pp.212–13 (Rufford), 216–17 (Samlesbury).

107 *Cumberland and Westmorland*, 1967, p.92 and plate 37.

108 *South Lancashire*, 1969, p.398 (Ordsall); for the Yorkshire material, see especially *Rural Houses of West Yorkshire, 1400–1830*, RCHM, 1986, pp.16, 201 (Horbury), 218 (Lees); also Eric Mercer, *English Vernacular Houses. A Study of Traditional Farmhouses and Cottages*, 1975, pp.220 (Bolton Hall), 222 (White Hall), 223–4 (Woodhouse Farm).

109 T.G. Manby, 'Lees Hall, Thornhill, a medieval timber-framed building in the West Riding of Yorkshire', *Yorks Arch. J.*, 43(1971), pp.112–27.

110 *Cheshire*, 1971, pp.54–6; *Adlington Hall, Cheshire*, undated.

111 Quoted by Glanmor Williams, *Recovery, Reorientation and Reformation. Wales c.1415–1642*, 1987, p.83.

112 Ibid., pp.83–5.

113 Peter Smith, *Houses of the Welsh Countryside. A Study in Historical Geography*, 1975, pp.422–7.

114 Richard Avent, *Criccieth Castle. Pennarth Fawr Medieval Hall-House. St Cybi's Well*, 1989, pp.32–7.

115 Peter Smith, op. cit., pp.112–13, 130–1.

116 Frank Atkinson and R.W. McDowall, 'Aisled houses in the Halifax area', *Ant. J.*, 47(1967), pp.77–94; and for both regions and their characteristic house-types, see Eric Mercer, op. cit., pp.11–16.

117 Andrew Jones, 'Land and people in Leighton Buzzard in the later fifteenth century', *Ec.H.R.*, 25(1972), pp.21–3; Zvi Razi, *Life, Marriage and Death in a Medieval Parish. Economy, Society and Demography in Halesowen 1270–1400*, 1980, pp.147–9; Christopher Dyer, 'Deserted medieval villages in the West Midlands', *Ec.H.R.*, 35(1982), p.30; H.S.A. Fox, 'The chronology of enclosure and economic development in medieval Devon', ibid., 28(1975), pp.189–92; for a

recent comment on some archaeological evidence of consolidation, supporting the historical record, see David Austin, *The Deserted Medieval Village of Thrislington, County Durham. Excavations 1973–1974*, Society for Medieval Archaeology Monograph Series 12, 1989, pp.13, 181, 197.

118 Christopher Dyer, *Standards of Living in the Later Middle Ages. Social Change in England c.1200–1520*, 1989, chapter 6 (Peasants as Consumers).

119 *Rural Houses of West Yorkshire*, op. cit., pp.33–6.

120 Ibid., pp.8–9, 197 and plate 17.

121 Eric Mercer, op. cit., pp.11–14, 174 and plate 2 (Old Bell Farm), 177 and plate 72 (Synyards), 209 and plates 6–7 (Pilgrims' Rest); *West Kent and the Weald*, l969, p.308 and plate 42 (Headcorn); *Weald and Downland Open Air Museum*, 1982, pp.18–20. For other Wealden houses, see R.T. Mason's *Framed Buildings of the Weald*, 1969 (2nd edn).

122 Eric Mercer, op. cit., pp.17–19; for the Tewkesbury terrace, see my own *Medieval England*, 1978, pp.163–4 and fig. 108.

123 Christopher Dyer, op. cit. (1989), p.204.

124 Charles Phythian-Adams, *Desolation of a City. Coventry and the Urban Crisis of the Late Middle Ages*, 1979, passim; *Warwickshire*, 1966, p.268 (Ford's Hospital).

125 Spon Street is now an open-air museum of urban housing (F.W.B. Charles, 'Timber-framed houses in Spon Street, Coventry', *Trans Birmingham and Warwickshire Arch. Soc.*, 89(1978–9), pp.91–122; however, 159–162 Spon Street (one of the more important terraces) is native to the street, probably dating to 1425–50 (ibid., p.116; S.R. Jones and J.T. Smith, 'The Wealden houses of Warwickshire and their significance', *Trans and Proc. Birmingham Arch. Soc.*, 79(1960–1), pp.24–35).

126 For some of the vast and growing literature on late-medieval urban decline, still a battleground for the economic historian, see R.B. Dobson, 'Urban decline in late medieval England'. *T.R.H.S.*, 27(1977), pp.1–22; Charles Phythian-Adams, 'Urban decay in late medieval England', in *Towns in Societies: Essays in Economic History and Historical Sociology* (eds Philip Abrams and E.A. Wrigley), 1978, pp.159–85; A.F. Butcher, 'Rent, population and economic change in late-medieval Newcastle', *Northern History*, 14(1978), pp.67–77, and the same author's 'Rent and the urban economy: Oxford and Canterbury in the later Middle Ages', *Southern History*, 1(1979), pp.11–43; S.H. Rigby, 'Urban decline in the later Middle Ages: some problems in interpreting the statistical data', *Urban History Yearbook 1979*, pp.46–59; Robert S. Gottfried, 'Bury St Edmunds and the populations of late medieval English towns, 1270–1530', *J. Brit. Studies*, 20(1980), pp.1–31; Jennifer I. Kermode, 'Urban decline? The flight from office in late medieval York', *Ec.H.R.*, 35(1982), pp.179–98; Robert S. Gottfried, *Bury St Edmunds and the Urban Crisis: 1290–1539*, 1982; Anthony Saul, 'English towns in the late middle ages: the case of Great Yarmouth', *J. Medieval History*, 8(1982), pp.75–88; Robert Tittler, 'Late medieval urban prosperity', and A.R. Bridbury, 'Late medieval urban prosperity: a rejoinder', *Ec.H.R.*, 37(1984), pp.551–6; S.H. Rigby, 'Urban decline in the later middle ages: the reliability of the non-statistical evidence', *Urban History Yearbook 1984*, pp.45–60, and the same author's ' "Sore decay" and "fair dwellings": Boston and urban decline in the later Middle Ages', *Midland History*, 10(1985), pp.47–61; Richard Holt, 'Gloucester in the century after the Black Death', *Trans Bristol and Gloucestershire Arch. Soc.*, 103(1985), pp.149–61; S.H. Rigby, 'Late medieval urban prosperity:

the evidence of the lay subsidies', and A.R. Bridbury, 'Dr Rigby's comment: a reply', *Ec.H.R.*, 39(1986), pp.411–22; R.H. Britnell, *Growth and Decline in Colchester 1300–1525*, 1986, part 3 (Change and Decay, 1415–1525); Michael Reed (ed.), *English Towns in Decline 1350 to 1800*, 1986, passim; Jennifer I. Kermode, 'Merchants, overseas trade, and urban decline: York, Beverley, and Hull c.1380–1500', *Northern History*, 23(1987), pp.51–73.

127 Christopher Dyer, 'The consumer and the market in the later middle ages', *Ec.H.R.*, 42(1989), pp.323–6.

128 *Suffolk*, 1981, p.242.

129 *Lincolnshire*, 1964, pp.546–7 and plate 37b (Angel and Royal); *South and West Somerset*, 1958, pp.180–1 and plate 40 (George and Pilgrims); *Gloucestershire. The Vale and the Forest of Dean*, 1970, p.248 and plate 59 (New Inn); *Gloucestershire. The Cotswolds*, 1970, p.477 (George); *Worcestershire*, 1968, p.149 and plate 52 (Round House); *North Somerset and Bristol*, 1958, p.237 and plate 49b (George); W.A. Pantin, 'Medieval inns', in *Studies in Building History* (ed. E.M. Jope), 1961, pp.166–91.

130 E.H.D. Williams, J. and J. Penoyre, and B.C.H. Hale, 'The George Inn, Norton St Philip, Somerset', *Arch. J.*, 144(1987), pp.317–27 and plates 33–4.

131 A.R. Bridbury, 'English provincial towns in the later Middle Ages', *Ec.H.R.*, 34 (1981), p.24; and see the similar emphasis in Susan Reynolds, 'Decline and decay in late medieval towns: a look at some of the concepts and arguments', *Urban History Yearbook 1980*, pp.76–8.

132 Derek Keene, *Survey of Winchester*, Winchester Studies 2, 1985, p.105.

133 *Essex*, 1965, pp.380–3.

134 Ibid., p.200 and plate 46a.

135 *Suffolk*, 1981, p.326 (Lavenham); *Wiltshire*, 1963, pp.332–3 and plate 30a (Potterne); David Lloyd and Madge Moran, *The Corner Shop*, Ludlow Research Papers 2, undated; *Shropshire*, 1958, p.272 (Shrewsbury); *North Somerset and Bristol*, 1958, p.82 (Axbridge).

136 Marjorie Keniston McIntosh, *Autonomy and Community. The Royal Manor of Havering, 1200–1500*, 1986, pp.223–35.

137 For the architecture which still shows this, see D. Portman, *Exeter Houses 1400–1700*, 1966, and Vanessa Parker, *The Making of King's Lynn. Secular Buildings from the 11th to the 17th Century*, 1971; and see also my own *The English Medieval Town*, 1976, chapter 2 (The Urban Landscape). The Norwich archaeological evidence for an improvement in housing quality in the second half of the fifteenth century is discussed by D.H. Evans and A. Carter, 'Excavations on 31–51 Pottergate (Site 149N)', and Malcolm Atkin, 'Excavations on Alms Lane (Site 302N)', in *Excavations in Norwich 1971–1978. Part II* (by Malcolm Atkin, Alan Carter and D.H. Evans), East Anglian Archaeology, Report 26, 1985, pp.9–85, 144–260.

138 William Brenchley Rye (ed.), *England as seen by Foreigners in the Days of Elizabeth and James the First*, 1865, pp.77–80.

Chapter 9
An Habitation of Dragons and a Court for Owls

1 H. Thorpe, 'The lord and the landscape illustrated through the changing fortunes of a War-

wickshire parish, Wormleighton', *Trans and Proc. Birmingham Arch. Soc.*, 80(1962), pp.38–77; C.H. Williams (ed.), *English Historical Documents 1485–1558*, 1967, pp.264–6 (The Spencer Family); A. Cameron, 'Sir Henry Willoughby of Wollaton', *Trans Thoroton Soc.*, 74(1970), pp.10–21.

2 Mavis Mate, 'Pastoral farming in south-east England in the fifteenth century', *Ec.H.R.*, 40(1987), pp.523–36; and for another comment on the mid-century collapse, see J.N. Hare, 'Durrington: a chalkland village in the later Middle Ages', *Wiltshire Arch. Mag.*, 74/5(1981), pp.141–3.

3 There is conflicting evidence for the date of the turning-point in population recovery. Family sizes are known to have been rising in the late fifteenth century: for the West Midlands evidence, see Christopher Dyer, *Lords and Peasants in a Changing Society*, 1980, pp.230–2, and R.K. Field, 'Migration in the later Middle Ages: the case of the Hampton Lovett villeins', *Midland History*, 8(1983), p.42; for eastern England, see R.S. Gottfried, 'Population, plague, and the sweating sickness: demographic movements in late fifteenth-century England', *J. Brit. Studies*, 17(1977), pp.12–37, and the same author's *Epidemic Disease in Fifteenth-Century England. The Medical Response and the Demographic Consequences*, 1978, especially pp.213–22. However, for an altogether gloomier view of the extent of the recession and a later date for the general recovery, see Bruce M.S. Campbell, 'The population of early Tudor England: a re-evaluation of the 1522 muster returns and 1524 and 1525 lay subsidies', *J. Hist. Geog.*, 7(1981), pp.145–54; also L.R. Poos, 'The rural population of Essex in the later Middle Ages', *Ec.H.R.*, 38(1985), pp.515–30; and John Hatcher, 'Mortality in the fifteenth century: some new evidence', ibid., 39(1986), pp.19–38.

4 Isaiah 34.13; Robert W. Dunning, 'Revival at Glastonbury 1530–9', *Studies in Church History*, 14(1977), pp.213–22.

5 B.A. Windeatt (trans.), *The Book of Margery Kempe*, 1985, p.148, but I have here chosen the more picturesque wording of the earlier Butler-Bowdon translation; Christopher Harper-Bill, 'Cistercian visitation in the Late Middle Ages: the case of Hailes Abbey', *Bull. Inst. Hist. Res.*, 53(1980), pp.103–14.

6 Antonia Gransden, 'Antiquarian studies in fifteenth-century England', *Ant. J.*, 60(1980), p.82.

7 Derek Baker, 'Old wine in new bottles: attitudes to reform in fifteenth-century England', *Studies in Church History*, 14(1977), pp.194–5.

8 N.R. Ker (ed.), *Medieval Libraries of Great Britain*, 1964, pp.88–9.

9 Roger Lovatt, 'The *Imitation of Christ* in Late Medieval England', *T.R.H.S.*, 18(1968), pp.115–16.

10 Derek Baker, op. cit., p.202; for a similar judgement on the quality of the English Cistercian abbots, see C.H. Talbot (ed.), *Letters from the English Abbots to the Chapter at Cîteaux 1442–1521*, Camden Fourth Series 4, 1967, pp.7, 15.

11 H.E. Butler (ed.), *The Chronicle of Jocelin of Brakelond*, 1949, p.96.

12 C.H. Talbot, op. cit., pp.13–14; H.M. Colvin, 'The building of St Bernard's College', *Oxoniensia*, 24(1959), pp.37–48.

13 Along with Marmaduke Huby's initials, this verse from 1 Timothy 17 is frequently repeated on his new buildings (R. Gilyard-Beer, *Fountains Abbey*, 1986, pp.35–6). For Huby's work on his granges at Bewerley and Brimham, see my own *The Monastic Grange in Medieval England*, 1969, pp.189–90, 192.

14 H.M. Colvin, *The White Canons in England*, 1951, pp.90–1; David Knowles, *The Religious Orders in England*, 1979, iii:51 (note 5); David Knowles and R. Neville Hadcock, *Medieval Religious Houses. England and Wales*, 1953, p.165.

15 H.M. Colvin and R. Gilyard-Beer, *Shap Abbey*, 1963, pp.10–12; for a useful summary of other monastic building work in this 'last phase', see David Knowles, op. cit., iii:21–4.

16 James P. Carley, *Glastonbury Abbey. The Holy House at the Head of the Moors Adventurous*, 1988, pp.65–6.

17 Ibid., pp.66, 68–9; Robert W. Dunning, op. cit., p.214.

18 Robert W. Dunning, op. cit., pp.217–20; and see the same author's 'The Abbey of the Princes: Athelney Abbey, Somerset', in *Kings and Nobles in the Later Middle Ages. A Tribute to Charles Ross* (eds Ralph A. Griffiths and James Sherborne), 1986, pp.295–303.

19 Lucy Toulmin Smith (ed.), *The Itinerary of John Leland in or about the years 1535–1543. Parts I to III*, 1907, pp.289–90.

20 C.A. Ralegh Radford, *Glastonbury Tribunal*, 1973; *South and West Somerset*, 1958, p.234.

21 *North Somerset and Bristol*, 1958, p.181 (Doulting); A.R. Dufty, 'Place Farm, Tisbury', *Arch. J.*, 114(1947), pp.168–9; and see my own *The Monastic Grange in Medieval England*, 1969, pp.202, 240–2 and plates 9–10.

22 Sybil Jack, 'Monastic lands in Leicestershire and their administration on the eve of the Dissolution', *Trans Leicestershire Arch. and Hist. Soc.*, 41(1965–6), pp.18, 22.

23 John H. Tillotson (ed.), *Monastery and Society in the Late Middle Ages. Selected Account Rolls from Selby Abbey, Yorkshire, 1398–1537*, 1988, pp.28–9.

24 David Knowles, op. cit., iii:102.

25 Ibid., p.105.

26 Ibid., pp.87–95; Lucy Toulmin Smith, op. cit., ii:52; Francis Woodman, *The Architectural History of Canterbury Cathedral*, 1981, pp.199–211.

27 John Pitcher (ed.), *Francis Bacon. The Essays*, 1985, p.79.

28 As said of the abbot of Bury in 1535, shortly before the suppression of his house (G.H. Cook (ed.), *Letters to Cromwell and Others on the Suppression of the Monasteries*, 1965, p.66).

29 A. Hamilton Thompson, *History and Architectural Description of the Priory of St Mary, Bolton-in-Wharfedale*, Thoresby Society Publications 30, 1928, pp.154–5 and fig. VIII.

30 Ibid., pp.111–12.

31 David Knowles, op. cit., iii:24.

32 Glanmor Williams, *Recovery, Reorientation and Reformation. Wales c.1415–1642*, 1987, pp.119–21.

33 Harold G. Leask, *Irish Churches and Monastic Buildings III. Medieval Gothic: the last Phases*, 1971, pp.59–72; Roger Stalley, *The Cistercian Monasteries of Ireland*, 1987, chapter 5 (Holy Cross and the Fifteenth-Century Revival), though there are reasons, even on the architectural evidence, for doubting the reality of this revival.

34 Stewart Cruden, *Scottish Medieval Churches*, 1986, p.183; Richard Fawcett, 'Late Gothic architecture in Scotland: considerations on the influence of the Low Countries', *Proc. Soc. Ant. Scotland*, 112(1982), pp.477–96, and the same author's 'Scottish mediaeval window tracery', in *Studies in Scottish Antiquity presented to Stewart Cruden* (ed. David J. Breeze), 1984, pp.148–86.

35 For the full text of Colet's sermon, see C.H. Williams (ed.), *English Historical Documents 1485–1558*, 1967, pp.652–60.

36 David Knowles, op. cit., iii:159–60.

37 Stanley W. Jackson, 'Acedia the sin and its relationship to sorrow and melancholia in medieval

time', *Bull. History of Medicine* , 55(1981), pp.178–85.

38 W.H. St John Hope, 'The Obituary Roll of John Islip, Abbot of Westminster, 1500–1532', *Vetusta Monumenta* , vii:4(1906), p.7 and plate XX; cited by David Knowles, op. cit., iii:98–9 (and footnote).

39 C.H. Williams, op. cit., p.676.

40 J. Nichols, *A Collection of all the Wills now known to be extant of the Kings and Queens of England* , 1780, pp.357, 386.

41 *London I. The Cities of London and Westminster* , 1973, pp.438–9, 441–2.

42 *Cornwall* , 1951, p.32 and plate 38.

43 *Essex* , 1965, p.340 (St Osyth's); George Hay, 'Scottish Renaissance architecture', in *Studies in Scottish Antiquity* (ed. David J. Breeze), 1984, p.197; *RCHM Dorset* , 1952, i:244 (Forde); W.H. Godfrey, 'The Abbot's Parlour, Thame Park', *Arch. J.* , 86(1929), pp.59–68.

44 For the heraldry at Thame, confirming these associations, see W.H. Godfrey, op. cit., pp.64–7.

45 Quoted by David Knowles, op. cit., iii:149.

46 *North Somerset and Bristol* , 1958, p.309 and plate 37.

47 G.H. Chettle and John Charlton, *Hampton Court Palace* , 1982, p.6.

48 For a recent comment on the pulpitum carvings, see Francis Woodman, *The Architectural History of King's College Chapel* , 1986, pp.237–41.

49 *Dorset* , 1972, p.417 and plate 43; Richard Marks, 'The Howard tombs at Thetford and Framlingham: new discoveries', *Arch. J.* , 141(1984), pp.252–68; and see also Lawrence Stone and Howard Colvin, 'The Howard tombs at Framlingham, Suffolk', ibid., 122(1965), pp.159–71.

50 George Hay, op. cit., p.205; J.G. Dunbar, *The Stirling Heads* , 1975, p.23.

51 For the well–documented link between the three, see *Staffordshire* , 1974, pp.119–20.

52 *Wiltshire* , 1963, pp.254, 282–3 and plates 32(a) and (b) (Lacock and Ludgershall); *Leicestershire and Rutland* , 1960, pp.134–5 and plate 24(a) (Launde); *Buckinghamshire* , 1960, p.296 and plate 22(a) (Wing).

53 *St Canice's Cathedral, Kilkenny* , undated, pp.10–11, 13–15; *South Devon* , 1952, p.297 (Totnes); *County Durham* , 1953, p.217 (Staindrop); *Warwickshire* , 1966, p.81 (Baddesley Clinton).

54 *West Kent and the Weald* , 1969, p.435 (Penshurst); *Shropshire* , 1958, p.104 (Claverley); *Oxfordshire* , 1974, p.121 (Christ Church, Oxford).

55 *Middlesex* , 1951, pp.142–3 and plates 20–1.

56 *Cheshire* , 1971, p.120.

57 *Essex* , 1965, p.264; for the Rendcomb glass and some comment on the earlier Fairford parallels, see Hilary Wayment, 'Fairford and Rendcomb Churches: the stained glass', in *The Cirencester Area* , RAI supplement, 1988, pp.43–4.

58 *Medieval Wall Painting in St Mary de Crypt Church, Gloucester* , undated.

59 *Hampshire* , 1967, p.176 (Christchurch); *Northamptonshire* , 1973, p.446 (Warmington); *Lincolnshire* , 1964, pp.397–8 (Theddlethorpe All Saints).

60 A.P. Baggs, 'Sixteenth-century terracotta tombs in East Anglia', *Arch. J.* , 125 (1968), pp.296–301 and plates XXIX-XXXVI.

61 Christopher Harper-Bill, 'Dean Colet's Convocation sermon and the pre-Reformation Church in England', *History* , 73(1988), pp.191–210; and see also, for another eloquent defence of the clergy, Christopher Haigh's 'Anticlericalism and the English Reformation', ibid., 68(1983), pp.391–407.

62 Virginia Davis, 'William Waynflete and the educational revolution of the fifteenth century', in *People, Politics and Community in the Later Middle Ages* (eds Joel Rosenthal and Colin Richmond), 1987, pp.40–59; and see also Nicholas Orme, *English Schools in the Middle Ages* , 1973, especially Chapter 7 (The Schools from 1400 to 1530).

63 *Lincolnshire* , 1964, pp.412–13 and plate 38.

64 *Northamptonshire* , 1973, p.258.

65 Helen Jewell, 'English bishops as educational benefactors in the later fifteenth century', in *The Church, Politics and Patronage in the Fifteenth Century* (ed. Barrie Dobson), 1984, pp.146–67; Joel T. Rosenthal, 'Lancastrian bishops and educational benefaction', in *The Church in Pre-Reformation Society. Essays in Honour of F.R.H. Du Boulay* (eds Caroline M. Barron and Christopher Harper-Bill), 1985, pp.199–211.

66 Helen Jewell, op. cit., p.156.

67 *An Inventory of the Historical Monuments in the City of Oxford* , RCHM, 1939, pp.6–7.

68 Bartlett Jere Whiting, *Proverbs, Sentences, and Proverbial Phrases* , 1968, p.455.

69 Virginia Davis, op. cit., p.47; Deirdre Le Faye, 'Selborne Priory, 1233–1486', *Proc. Hampshire Field Club* , 30(1973), p.67.

70 C.H. Williams, op. cit., p.761.

71 *An Inventory of the Historical Monuments in the City of Cambridge. Part 1*, RCHM, 1959, pp.82–3 and fold-out plan.

72 Malcolm G. Underwood, 'The Lady Margaret and her Cambridge connections', *The Sixteenth Century Journal* , 13(1982), pp.68–9.

73 A.L. Bedingfeld and R. Gilyard-Beer, *Creake Abbey* , 1970, p.8; Malcolm G. Underwood, op. cit., p.76; C.H. Williams, op. cit., p.762.

74 J. Nichols, *op. cit.*, p.365.

75 C.H. Williams, op. et loc. cit.

76 David Knowles, op. cit., iii:162.

77 S.E. Rigold, *Bayham Abbey* , 1974, p.10.

78 For a complete description, see RCHM *Oxford* , op. cit., pp.29–48.

79 Nicholas Orme, op. cit., pp.201–2; David Knowles and R. Neville Hadcock, op.cit., p.349 (Ipswich, Cardinal's College).

80 Joyce Youings (ed.), *The Dissolution of the Monasteries* , 1971, p.168.

81 Elizabeth M. Hallam, 'Henry VIII's monastic re-foundations of 1536–7 and the course of the Dissolution', *Bull. Inst. Hist. Res.* , 51(1978), pp.124–31.

82 H.M. Colvin (ed.), *The History of the King's Works* , 1982, iv:375.

83 The word is J.R. Hale's (ibid., p.377).

84 H.M. Colvin, op. cit., iv:455–65 (The Castles in the Downs: Deal, Sandown and Walmer), 595–602 (St Mawes and Pendennis); Beric Morley, *The Castles of Pendennis and St Mawes* , 1988.

85 Leland's reports are listed alphabetically by M.W. Thompson, *The Decline of the Castle* , 1987, appendix 2 (Condition of Castles mentioned in Leland's *Itinerary*).

86 Lucy Toulmin Smith, op. cit., i:5.

87 Ibid., i:65.

88 Ibid., ii:109.

89 H.M. Colvin (ed.), *The History of the King's Works* , 1975, iii:258.

90 Ibid., iv:2,5.

91 Ibid., iv:6.

92 For a summary of Henry's works, taken from Colvin's volume, see David Loades, *The Tudor Court* , 1986, appendix 1 (The King's Houses).

93 Martin Biddle, 'Nicholas Bellin of Modena: an Italian artificer at the courts of Francis I and Henry VIII', *J. Brit. Arch. Assoc.* , 29(1966), pp.106–21.

94 H.M. Colvin, op. cit., iv:200–1.

95 *Coughton Court, Warwickshire* , 1984, pp.9–10.

96 *Essex* , 1965, pp.263–5 and plate 50.

97 For an account of Compton's career, see G.W. Bernard, 'The rise of Sir William Compton, early Tudor courtier', *E.H.R.* , 96(1981), pp.754–77; for the house itself, see *Warwickshire* , 1966, pp.241–2 and plate 23.

98 Mary Dewar (ed.), *A Discourse of the Commonweal of the Realm of England, attributed to Sir Thomas Smith* , 1969, pp.83–4; C.E. Challis, 'The debasement of the coinage, 1542–1551', *Ec.H.R.*,20(1967), pp.441–66; J.D. Gould, *The Great Debasement. Currency and the Economy in mid-Tudor England* , 1970.

99 *Compton Castle, Devon* , 1983, pp.9–15.

100 For a recent study of these and other houses, see Maurice Howard, *The Early Tudor Country House. Architecture and Politics 1490–1550* , 1987, passim.

101 Iain Macivor, *Craignethan Castle* , 1978.

102 Claypotts is in Angus; Elcho and Castle Menzies in Perth; Glenbuchat and Tolquhon in Aberdeen; Earlshall and Scotstarvit in Fife; Rowallan in Ayr; Maclellan's, Drum Coltram and Carsluith in Kirkcudbright; Greenknowe Tower in Berwick. All date to the later sixteenth century.

103 For this rendering from the Latin, see Colin McWilliam, *Lothian except Edinburgh* , 1978, p.338.

104 Roy Strong, *The Renaissance Garden in England* , 1979, p.24.

105 W. Douglas Simpson and Richard Fawcett, *Edzell Castle* , 1982, pp.6–15.

106 For Roodstown (Louth), Ballygalley and Dalway's Bawn (Antrim), Ross Castle (Kerry), Kirkistown (Down), Ballynahow, Burncourt and Two-Mile Borris (Tipperary), Ballynacarriga, Mallow and Kanturk (Cork), Parke's Castle (Leitrim), Portumna (Galway), Benburb, Mountjoy and Castle Caulfield (Tyrone), Tully and Monea (Fermanagh), see Peter Harbison, *Guide to the National Monuments in the Republic of Ireland* , 1975; *Historic Monuments of Northern Ireland* , 1983; and Brian de Breffny, *Castles of Ireland* , 1977, passim.

107 Brian de Breffny, op. cit., p.69 (Ormond Castle, also known as Carrick-on-Suir Castle).

108 Leland H. Carlson (ed.), *The Writings of Henry Barrow 1587–1590* , 1962, p.468; quoted by Keith Thomas, *Religion and the Decline of Magic. Studies in Popular Beliefs in Sixteenth and Seventeenth Century England* , 1971, pp.58–9.

109 H.M. Colvin, 'Castles and government in Tudor England', *E.H.R.* , 83(1968), p.231.

110 W. Douglas Simpson, *Crichton Castle* , 1957; George Hay, op.cit., p.208.

111 William A. Oram et al. (eds), *The Yale Edition of the Shorter Poems of Edmund Spenser* , 1989, pp.234, 237, 401.

112 For these, see M.W. Thompson, op.cit., chapter 9 (A Continuing Theme); Peter Smith, *Houses of the Welsh Countryside* , 1975, pp.242–3 (Plas-teg and Ruperra); Mark Girouard, *Robert Smythson and the Elizabethan Country House* , 1983, chapter 6 (Bolsover Castle and the Revival of Chivalry); P.A. Faulkner, *Bolsover Castle* , 1972.

113 *Yorkshire. The West Riding* , 1959, pp.479–80.

114 *Nottinghamshire* , 1951, pp.114–16.

115 *Essex* , 1954, p.340.

116 *Oxfordshire* , 1974, pp.492–8.

117 D.J. Cathcart King and J. Clifford Perks, 'Carew Castle, Pembrokeshire', *Arch. J.* , 119(1962), pp.270–307; L.A.S. Butler, *Neath Abbey* , 1976, pp.23–6; O.J. Weaver, 'Moreton Corbet Castle', *Arch. J.* , 138(1981), pp.44–6 and fig. 10; *South Devon* , 1952, p.49 and plate 62a, and *Berry Pomeroy Castle* , undated.

118 For architectural conservatism in colleges like Peterhouse and Trinity (Cambridge) and St John's, Jesus, Oriel and Lincoln (Oxford), see the RCHM inventories cited in notes 67 and 71.

119 For a recent study of church towers in this con-

text, see Andrew Woodger, 'Post-Reformation mixed Gothic in Huntingdonshire church towers and its campanological associations', *Arch. J.*, 141(1984), pp.269–308; for other examples of archaizing Gothic, see the Pye Chapel at Faringdon Church (Berkshire), the east window at Holm Cultram (Cumberland), the south door at Dartmouth (Devon), the stall–backs at Cartmel (Lancashire), the screen at Geddington (Northamptonshire), the west tower and north porch at Deddington (Oxfordshire) and the Spencer Chapel at Yarnton in the same county, the chancel at Clare (Suffolk), and the chancel and west tower at Astley (Warwickshire).

120 B.H.St J. O'Neil, *Caerlaverock Castle*, 1982.

121 John Webster, *The Duchess of Malfi*, act 5, scene 3; quoted by Margaret Aston in 'English ruins and English history: the Dissolution and the sense of the past', *J. Warburg and Courtauld Institutes*, 36(1973), p.233.

Index

References to illustrations are given in **bold**; the counties are the medieval ones, pre-reorganization

William of Malmesbury (1095–1143), chronicler 3, 22, 44, 47
William of St Calais, bishop of Durham (1080–96) 25, 27, 78
William of Trumpington, abbot of St Albans (1214–35) 82
William of Wykeham, bishop of Winchester (1366–1404) 206, 223, 225, 279
Willingale, Doe and Spain (Essex) 30
Willingham (Cambs) 133, 238
Wilmington Priory (Sussex) 12, 196–7, **17**, **241**
Winchcombe Abbey (Glos) 25, 48, 74, 274; the George 264
Winchelsea (also New Winchelsea) (Sussex) 142–3, **169**
Winchester (Hants) bishop's palace 44, 61; castle 64, **76**; cathedral priory 2, 23, 27, 61, 119, 156, 206, **6**, **352**; college 227, 279; borough economy 265; parish churches 31; St Cross Hospital 61–2, 220–1, **74**, **270**
Windsor (Berks) castle 180, 181, 182-3, 257, **221**;

college of St George 155, 227
Wing (Bucks) 27, 30, 33, 278
Wingfield: see South Wingfield Manor (Derby)
Wingfield (Suffolk) 226, 232
Winterbourn Bassett (Wilts) 136, 137
Wintringham (Hunts) 97, 98
Wirksworth (Derby) 133
Wisbech (Cambs) 171
Witham Priory (Som) 73, 227
Witheridge (Devon) 232, **285**
Woburn Abbey (Beds) 54
Wolsey, Thomas (1475–1530), cardinal 172, 274, 278, 282, 284
Wolstan de Bransford, bishop of Worcester (1339–49) 154
Woodhouse Farm (Yorks) 259
Woodsford Castle (Dorset) 153
Woodsome Hall (Yorks) 262
Woodstock Palace (Oxon) 61
Woolpit (Suffolk) 238

Wootton Wawen (Warks) 12–13
Worcester Cathedral Priory 1, 23, 27, 110–11, 125, 154, 156, **31**, **126**; parish churches 31
Wormegay Priory (Norfolk) 208
Worksop Priory (Notts) 150, **177**
Worstead (Norfolk) 170–1
Worth (Sussex) 30
Wothorpe Priory (Northants) 159
Wressle Castle (Yorks) 189–90, **235**
Wulfstan, bishop of Worcester (1062–95) 1, 23, 27, 111
Wyclif, John, theologian (d.1384) 195
Wymondham Priory (Norfolk) 2, 80, 136, 171, 238, 279, **207**

Yaxley (Hunts) 136
Yeovil (Som) 164
York: castle 7; friaries 93; minster 2, 27, **30**; parish churches 31; St Mary's Abbey 25, 53–4, 125
Youlgreave (Derby) 59–60